HOLKHAM

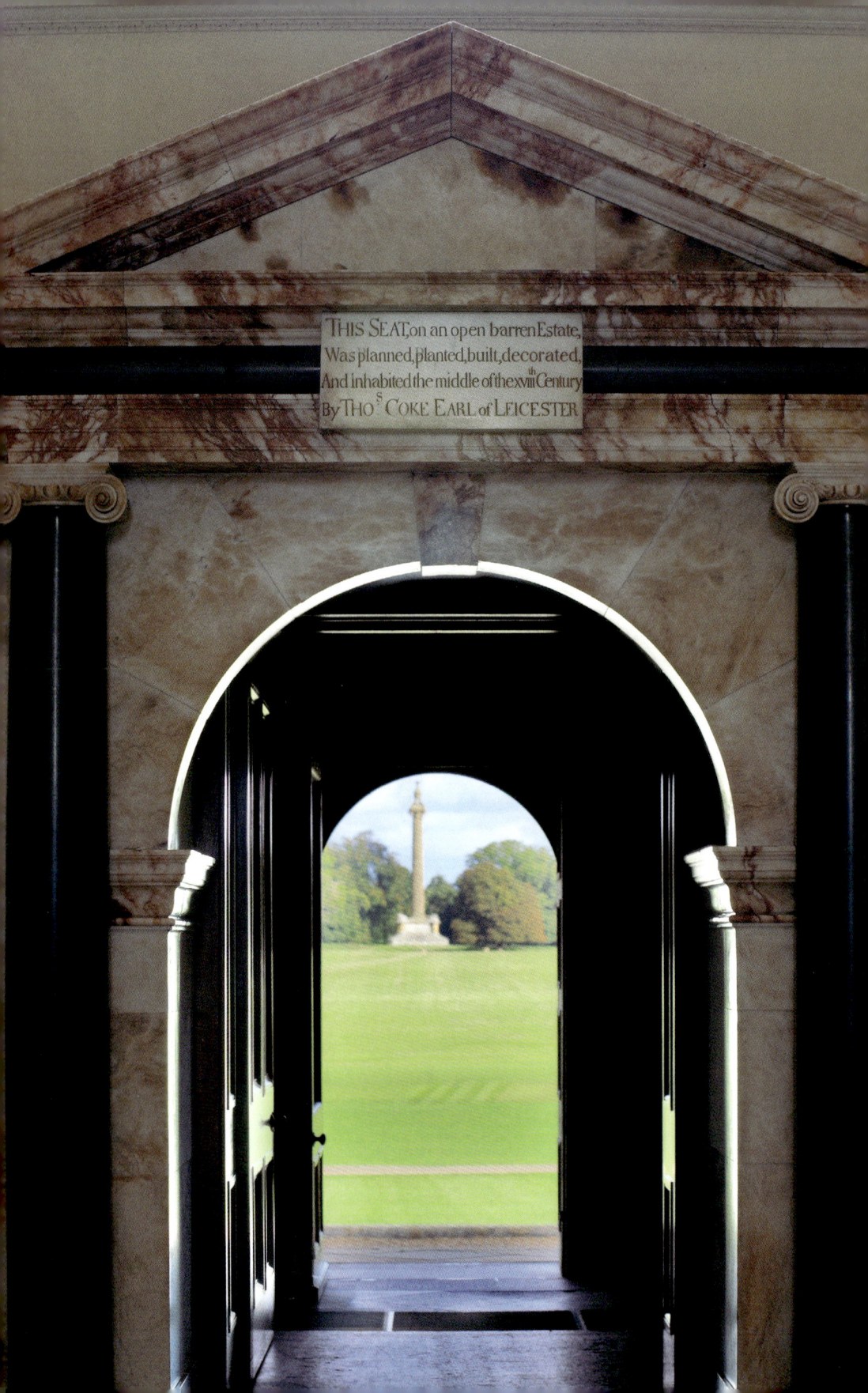

Dedicated to the memory of
Edward, 7th Earl of Leicester
(1936–2015)

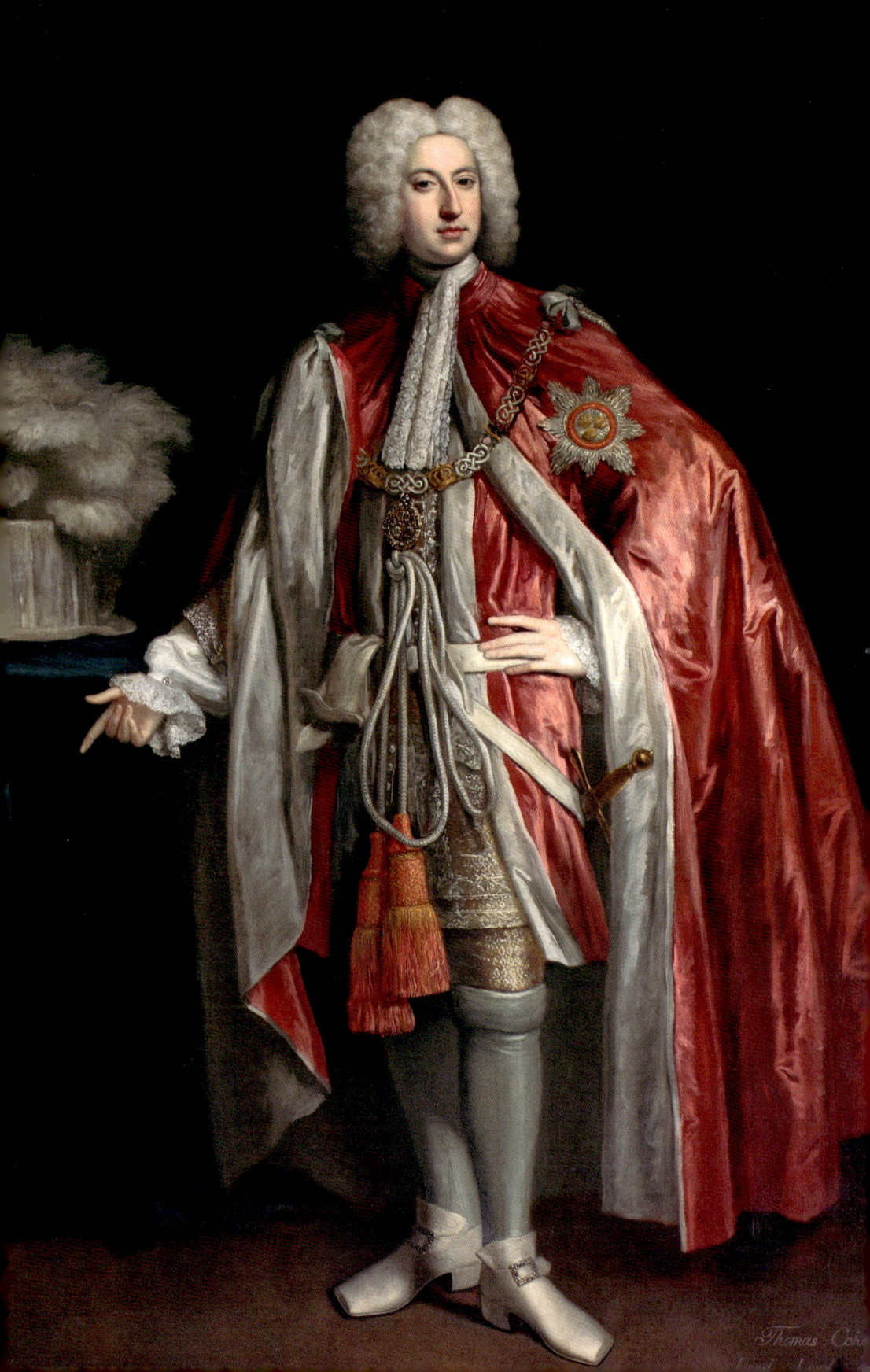

HOLKHAM
The social, architectural and landscape history of a great English country house

Christine Hiskey

Unicorn Press

First published in 2016 by

Unicorn Press
60 Bracondale
Norwich NR1 2BE

www.unicornpress.org

Text Copyright © 2016 Christine Hiskey
Images and material from the Holkham Collections and Archives
Copyright © 2016 the Earl of Leicester and the Trustees of the Holkham Estate
All other images Copyright © the owners as separately acknowledged

The moral right of Christine Hiskey to be identified as the author of this work
has been asserted in accordance with the Copyright, Designs and Patents
Act 1988

ISBN 978 1 910065 98 3

A Catalogue record of this book is available from the British Library

All rights reserved. No part of this publication may be reproduced, stored
in a retrieval system, or transmitted in any form or by any means, electronic,
mechanical, photocopying, recording or otherwise, without the prior permission
of the publisher in writing.

Designed by Nick Newton Design
Printed in Belgium by Graphius

This publication has been made possible by a subsidy from the Holkham
Estate and grants from the Marc Fitch Fund and the Scouloudi Foundation in
association with the Institute of Historical Research.

Endpapers Staffordshire alabaster from the walls of the Marble Hall.

Page ii View from the Marble Hall across the north lawn to the Monument.
The inscription above the door by Thomas Coke's widow pays implicit tribute
to 'the improvement of Planting and Agriculture' that accompanied the
building of the Hall. The Monument commemorates a later generation of
agricultural improvement.

Frontispiece Thomas Coke wearing the robes of the Order of the Bath,
by Jonathan Richardson, post 1726.

Contents

	Foreword	ix
	Preface	x
	Acknowledgements and Picture credits	xiii
	An Explanation of Names and Titles	xiv
Chapter 1	Introduction	1
Chapter 2	'A good man leaveth an inheritance' The First Sixty Years 1601–1661	13
Chapter 3	Mortalities and Minorities 1661–1718	45
Chapter 4	Thomas Coke: 'From the Old House to the New' 1718–1756	79
Chapter 5	Building the Hall: The Materials	119
Chapter 6	Building the Hall: The Craftsmen	137
Chapter 7	Building the Hall: 'Comfort and Convenience'	163
Chapter 8	Creating the Park	181
Chapter 9	Living in the New Hall: The First Twenty Years 1756–1776	213
Chapter 10	Farming, Whigs and Hospitality 1776–1842	247
Chapter 11	Expansion and Change in the Park	285
Chapter 12	The Victorian Hall 1842–1909	319
Chapter 13	Modernising the Practical House in the Nineteenth and Twentieth Centuries	363
Chapter 14	Overview: The Village	387
Chapter 15	Overview: Marsh, Sand and Sea	433
Chapter 16	Overview: Holkham and the Public	461
Chapter 17	Survival and Revival 1909–2000	487
Appendix 1	Thomas Coke's architecture lessons in Rome during his Grand Tour	530
Appendix 2	Time Line: Creating the Park	531
Appendix 3	Time Line: Expansion and Change in the Park	533
	Sources in the Holkham Archive	535
	Notes	536
	Archival image references	554
	Bibliography	556
	Index	559

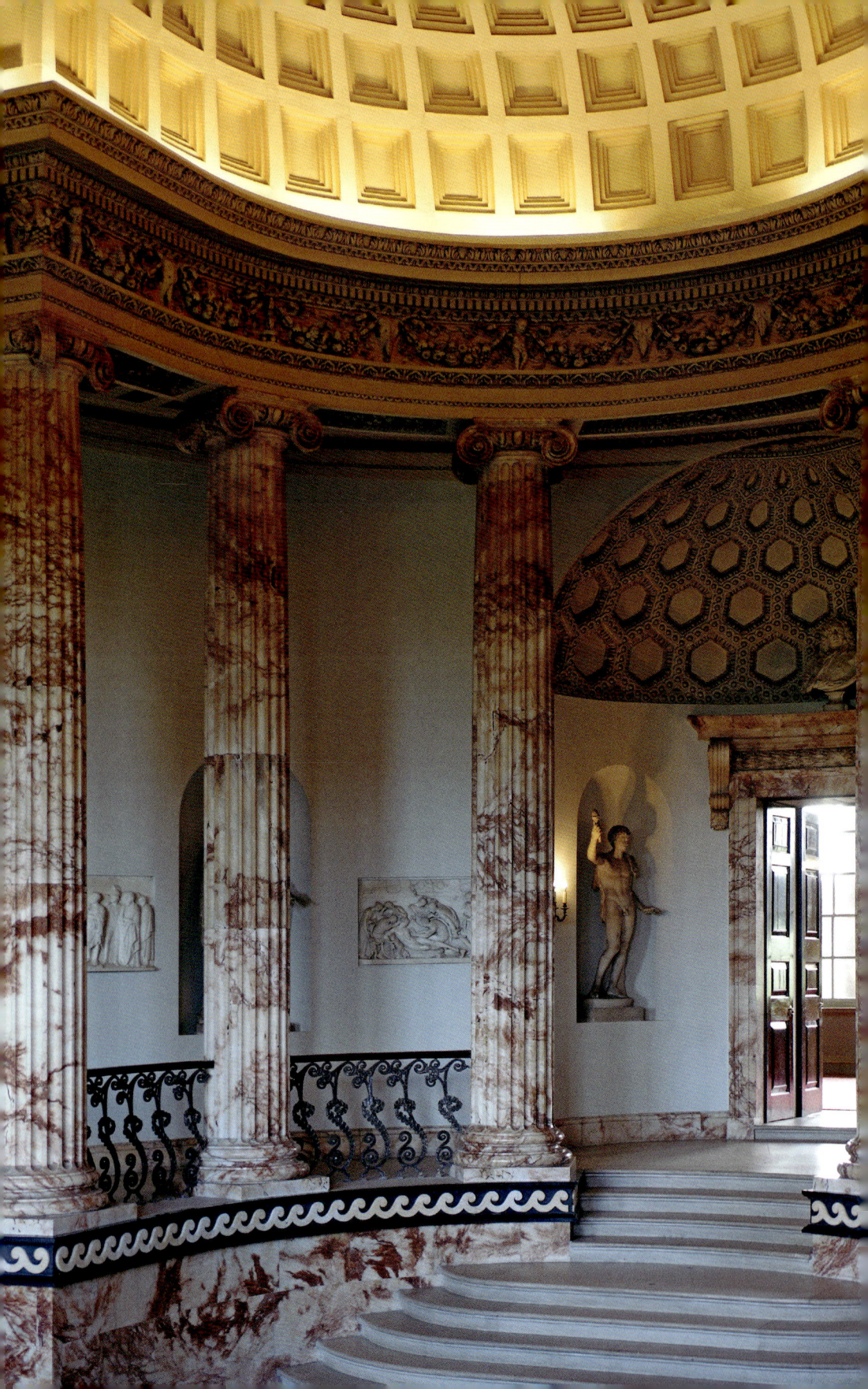

Foreword

This book on Holkham is the culmination of Christine Hiskey's forty-year career working in the Hall's archives. My father, a keen historian, had the great foresight to recognise the importance of the voluminous records in gaining a greater understanding of the family, its land holdings and the people who worked on the estate.

Holkham's architecture and collection are pre-eminent; Sir Simon Jenkins lists the Hall in his top twenty houses in England. Much has been written by art historians whose valuable and influential opinions have placed Holkham on some sort of a pedestal, but it is Christine's forensic examination of the documents that has led to the creation of this fascinating and eminently readable book. I wholeheartedly commend it and would make a strong case for it being arguably the most important, certainly the most authoritative, book ever written on Holkham.

I thank Christine for writing it, and for dedicating it to my father, a great man, without whose vision and unerring support it would not have been written.

Tom Leicester

8th Earl of Leicester

View across the Marble Hall at the stateroom level.

Preface

This work could be described as the autobiography of a great house, for it is the Holkham archive, the working documents of the Hall, the Coke family and the estate, which both inspired and made it possible. Less celebrated than the other treasures within the Hall, the archive nevertheless forms an integral part of Holkham's remarkable legacy.

Legal and property records had always been of practical importance to the Holkham family. The seventeenth-century manor house had an 'evidence room'; during the eighteenth century records were accommodated in the counting house next to the Hall, and in the following century a new Estate Office, still operating 160 years later, included a substantial strong-room lined with tin deed boxes and iron racks for maps. In the twentieth century, successive Holkham librarians with general responsibility for the archive, particularly C. W. James and Dr W. O. Hassall, used parts of it for research and information, but many of the records lay disregarded in outbuildings, tower rooms, cellars, family rooms, Estate Office, game larder and various hidden corners.

In 1977, hoping to continue archival work despite having moved to North Norfolk, I made tentative contact with Holkham. Edward, Viscount Coke, later 7th Earl of Leicester, had recently succeeded his predecessor in running the Hall and estate. He employed me to give occasional help to Dr Hassall, who had been honorary librarian since the 1930s, and on the latter's retirement in 1985 appointed me as Holkham's first archivist and arranged for the records to be gathered into a designated area (originally the footmen's rooms) within the Hall. For the next thirty years, until

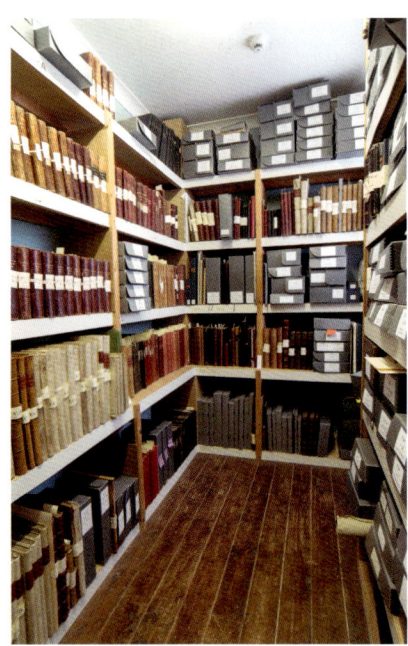

Part of the Holkham Archives.

his death in 2015, Lord Leicester gave me unfailing support in the task of organising and listing the archives, making the information they contain more available than ever before.

The impetus to use the archives for research came when I realised just how little was known about many aspects of the history of the Hall and its surroundings. What had happened at Holkham during the hundred years that elapsed after the death in 1634 of Sir Edward Coke, the great lawyer who laid the foundations of his family's wealth, before his descendant embarked in 1734 on building Holkham Hall? How was the prolonged thirty-year building process managed? What were the practical features of the Hall, and how was it used as a family home and for large-scale gatherings? What motives and strategies were at play in the creation of the park, the manipulation of the two Holkham villages and the alteration of the coastal landscape? What were the fortunes of Holkham after the death of the famous farmer, 'Coke of Norfolk', in 1842? Fundamentally, there was no continuous narrative history for anybody interested in Holkham. The 7th Earl gave me free rein to undertake research and waited patiently for it to turn into a history of the Hall. He delighted in archival discoveries along the way. During his retirement, he read the draft chapters and went through them with me. His grasp of detail and his knowledge of Holkham were inspirational. He applied them to all aspects of running the Hall and estate: it was only after his death that I discovered, from his recorded memoirs, that history had been his favourite subject at school in South Africa and had remained a life-long passion. It is a great sadness that he did not live to see this book published, and it is with respect, gratitude and affection that it is dedicated to his memory.

There are many others whose support and help I have valued during the fifteen years of research and writing. I am immensely grateful to Tom, the present Earl of Leicester, whose determination to maintain his father's curatorial legacy has ensured that a large subsidy from the Holkham Estate enables this book to reach publication. Working within the Hall has been a constant delight, enabling me to relate the past to the present in all sorts of ways, not least in conversations with colleagues. They have included Frederick Jolly, former Hall administrator, who encouraged me when I was a novice in the Hall and shared much information about its contents; Mick Thompson and Ian Barrett, whose practical knowledge of the nether regions of the Hall frequently illuminated my understanding of the records; and Michael Daley and Colin Shearer, former Hall managers, ever willing to seek answers to my queries. Among more recent colleagues, I am grateful to Sarah Henderson and her team at the Nature Reserve for information and images;

Laurane Herrieven and the 'two Emmas' in the Marketing Department who have responded patiently to requests for images; and Dr Mac Graham, room steward, for coping with various enquiries. Dr Anthony Smith, enjoying a phantom retirement from a career in national archives by volunteering in the Holkham Archive, has frequently emerged from the Middle Ages to lend me support. Dr Suzanne Reynolds, for fifteen years the Literary Manuscripts Curator, has been a valued kindred spirit, commenting on early chapters and lightening the often solitary role of a country house archivist and researcher with erudition and friendship.

On the wider estate, the interest shown in the archives and history of Holkham by employees in all areas of work has been a great motivation. Members of the public have given photographs and information relating to their ancestors at Holkham. Visiting researchers and enquirers have brought a fascinating range of interests and I have greatly appreciated their generous sharing of knowledge. Susanna Wade Martins, whose work on T. W. Coke frequently led her to Holkham, read early draft chapters for me, and Mary-Anne Garry's research into Holkham's domestic past prompted many enjoyable conversations. Staff at several Record Offices and fellow members of the Historic Houses Archivists Group have also given generous help.

Nevertheless, even an 'autobiography' based on primary sources, when it ventures into the fields of architectural, economic, environmental, family, landscape, legal and social history over a period of four centuries, will inevitably leave some areas incompletely explored and succumb to pitfalls elsewhere, for which I take full responsibility. This study set out to explore one great country house in its historical and geographical setting. It can confidently claim to have revealed along the way that there is much yet to be discovered and explained.

Other people have encouraged me on the long and winding road towards publication. Gillian Malpass found time in the early days to give positive feedback which played a big part in sustaining me in times of self-doubt. Paul Barnwell, Roger Last and Andrew Moore have given both practical advice and moral support. The trustees of the Scouloudi Foundation and the Marc Fitch Fund have given generous and crucial grants towards the cost of photography, scanning, graphics and design. Bob and Philip Farndon have taken great pains during several days of photography. Finally, I am most grateful to Nick and George Newton for their patience and skill in designing the book, and to Hugh Tempest-Radford of Unicorn Press for being such a calm and congenial editor and publisher.

The genesis of this book owes much to my late parents, Maurice and Nancy Cobbold, who introduced me as a child to Holkham and the North

Norfolk coast and nurtured my pleasure in writing and history. I am grateful to my children, Tom, Florence and Clara, for their good-natured forbearance as they grew up hearing rather more about Holkham than they might have chosen. Above all, I thank my husband, Rex, for his patience, encouragement and practical help while I indulged in such a time-consuming and engrossing project over many years.

Acknowledgements

I owe much to many people but I am particularly grateful to the following, in alphabetical order, for providing information or answering queries:

James Bamford, Sarah Booker, Amy Boyington, Peter Brears, Sarah Compton (National Trust), Alison Derrett (Royal Archives), the late Charles Fountaine, Mary-Anne Garry, Maureen Harris, Mary Jeske (Carroll of Carrollton Papers), Mike Macnair, Alison McCann (Petworth Archive, West Sussex Record Office), John Purser (British Banking History Society), Frank Salmon, Jane Sellars (Harewood House), Caroline Shenton (House of Lords Record Office), David Smith (Berkeley Castle Archive), John Stabler, James Stourton, Elisabeth Stuart (Duchy of Cornwall Archive), Hugh Torrens, Charles 8th Marquess Townshend, Jasper Weldon, Gillian White (Hardwick Hall) and the staff of the following Record Offices and libraries: Bedfordshire & Luton Archives, Greater Manchester County Record Office and the Manchester Local Studies Unit Archive, Lambeth Palace Library, Norfolk Record Office and the Norfolk Local Studies Library, Plymouth & West Devon Record Office, Rotherham Archives and Local Studies Section, Scottish Record Office, Suffolk Record Office, University College London Manuscripts Room, Wisbech Library.

Picture credits

I am most grateful to the Earl of Leicester and the Trustees of the Holkham Estate for permission to use copyright images of paintings, sculpture, furniture, books, documents and photographs at Holkham Hall.

Ownership of a few illustrations rests elsewhere and I thank the following for permission to use them:

Dr Susanna Wade Martins (page 63); Maurice Bray (pages 142 bottom and 143 top); the Hon. Rupert Coke (page 159); Mrs Sarah Penrose (pages 329 top, 348, 350, 360, 474); Michael Ryan (pages 335 top, 346); Aerial Archaeology Publications, photographer E. H. Horne (page 436); Mrs Robina Plowman pages 418, 450 top; Jonathan Holt / Nature Reserve (page 444); Photo © Christie's Images/Bridgeman Images (page 486); the Hon. John Coke (pages 509, 510); Valeria Viscountess Coke (page 521).

Photographs on pages 164 top, 165, 172 & 370 were taken by the author.

The following people have given photographs or digital copies to the Archives over a period of many years. Although I have tried to contact all to confirm that the photos may be used in this publication, in some cases I was unable to do so. I hope they take pleasure in seeing how their family photographs illuminate the history of Holkham.

Dean Walsh (page 304, Cuckoo Lodge); Mrs H. Paterson (page 309, Golden Gates); Mrs E. Mooney (page 310, Wells Lodge); Mrs M. Kearn (page 338, housemaids); Mrs Campbell (page 374, laundry maids); Mrs Carol Cox (page 485, room stewards); Miss Jean Scrivener (page 491, cars); Mr Hutchinson (page 503, menservants).

It has not always been possible to trace the photographers who have taken photographs for the Estate but I thank, in particular, Carl Impey, John Popham for the most recent village photos (2005), Campbell MacCallum for a set of photographs taken for the Estate in 1978, Fisheye Images, Andrew Bloomfield for going up in a 'nifty lifter' to recreate Robina Napier's watercolour view across the marshes and, above all, Bob Farndon and his son Philip for all other new photography for this book.

Preface xiii

An Explanation of Names and Titles

The leading figures in the history of Holkham from 1600 to the present day are the Coke family, descendants of Lord Chief Justice Sir Edward Coke (1552–1634). The name has been pronounced 'cook' since at least the sixteenth century. Sir Edward bought property at Holkham but at no time lived there.

1. John Coke, 4th son of Sir Edward, born 1590. Married 1612 Meriel Wheatley, of Hill Hall, Holkham; six sons, nine daughters. Died 1661.
2. John, youngest and only surviving son, born 1636, inherited 1661. Died unmarried 1671.
3. The Holkham estate passed to Robert, grandson of Sir Edward Coke's 5th son, born 1650, inherited 1671. Married 1674 Lady Anne Osborne, eldest daughter of Thomas Osborne, Earl of Danby, later Duke of Leeds. Died 1679.
4. Edward, only surviving child, born 1676. Married 1696 Cary Newton, daughter of John Newton and Abigail [Heveningham]; three sons, two daughters. Both Edward and Cary died 1707.
5. Thomas, eldest son, born 1697. Married 1718 Lady Margaret Tufton, third daughter of the 6th Earl of Thanet.
 Thomas was the first member of the Holkham line to receive titles:
 1726 Knight of the Bath: known as Sir Thomas Coke
 1728 Baron Lovell of Minster Lovell: addressed or referred to as Lord Lovell
 1744 The Earl of Leicester: addressed or referred to as Lord Leicester. The courtesy title of Viscount Coke (addressed or referred to as Lord Coke) was granted to the eldest son.
 Before 1726, Thomas Coke's wife, as the daughter of a peer, was known as Lady Margaret Coke. In 1734 she inherited in her own right the title of Baroness Clifford and was sometimes referred to as Lady Clifford. From 1744 she was the Countess of Leicester (Lady Leicester).
 Thomas and Margaret's only son, Edward (Viscount Coke from 1744) died 1753.
 Thomas Coke, 1st Earl of Leicester, died 1759. The titles of Earl of Leicester and Viscount Coke could pass only through the direct male line and so fell into abeyance.
 Lady Leicester held the Hall and estate under her husband's will until her death in 1775.
 After 1775, they passed down through the male descendants of the late Lord Leicester's sister Ann. She had eloped with and married Philip Roberts in 1716 and was the only one of Lord Leicester's three siblings to have produced male heirs.

6. Wenman, formerly Roberts, son of Ann Roberts, born 1717. Assumed the surname of Coke in 1750 on inheriting the Longford (Derbyshire) property. Inherited Holkham 1775, died 1776.

7. Thomas William, eldest son, born 1754. Inherited Holkham 1776. Married (1) Jane Dutton, sister of 1st Lord Sherborne; three daughters. Married (2) Lady Anne Keppel, daughter of 4th Earl of Albemarle; five sons, one daughter. Died 1842.

 T. W. Coke remained a commoner for most of his life. His second wife, however, as the daughter of a peer, was known as Lady Anne Coke. In 1837 he was granted the title of 'Earl of Leicester of Holkham'. He is usually referred to as the 1st Earl of Leicester of the 2nd creation. The title of Viscount Coke was again granted to the eldest son of each successive Earl.

 For the next four generations, the titles, Hall and estate passed down together from father to eldest son. As each was named Thomas William, they are referred to as the 2nd, 3rd, 4th and 5th Earls of Leicester.

8. 2nd Earl: born 1822. Married (1) Juliana Whitbread; two sons surviving to adulthood, seven daughters. Married (2) Georgiana Cavendish; six sons, one daughter. Succeeded 1842. Died 1909.

9. 3rd Earl: born 1848. Married Alice White, daughter of Baron Annaly; three sons, two daughters. Succeeded 1909. Died 1941.

10. 4th Earl: born 1880. Married Marion Trefusis; two sons, two daughters. Known in the family as Tom. Succeeded 1941. Died 1949.

11. 5th Earl: born 1908. Married Elizabeth Yorke, daughter of 8th Earl of Hardwicke; three daughters. Known in the family as Tommy. Succeeded 1949. Died 1976

 The 5th Earl had no sons and no surviving younger brother, so on his death in 1976 the title passed to his cousin Anthony, grandson of the 3rd Earl through the junior male line.

12. 6th Earl: Anthony Louis Lovel, born 1909. Married (1) Moyra Crossley; two sons, one daughter. Resided permanently in South Africa; renounced interests in the Hall and estate. Inherited the title (not the Hall and estate) 1976. Died 1994.

13. 7th Earl: Edward Douglas, elder son, born 1936. Married (1) Valeria Potter; two sons, one daughter. Married (2) 1986 Sarah de Chair. Known in the family as Eddy. Succeeded 1976 while still Viscount Coke to the Hall and estate, succeeded to title of Earl of Leicester 1994. Died April 2015.

14. 8th Earl: Thomas Edward, born 1965. Married Polly Whately; one son, three daughters. Known in the family as Tom. Succeeded during his father's lifetime to the management of the Hall and estate. Inherited the title 2015.

An Explanation of Names and Titles xv

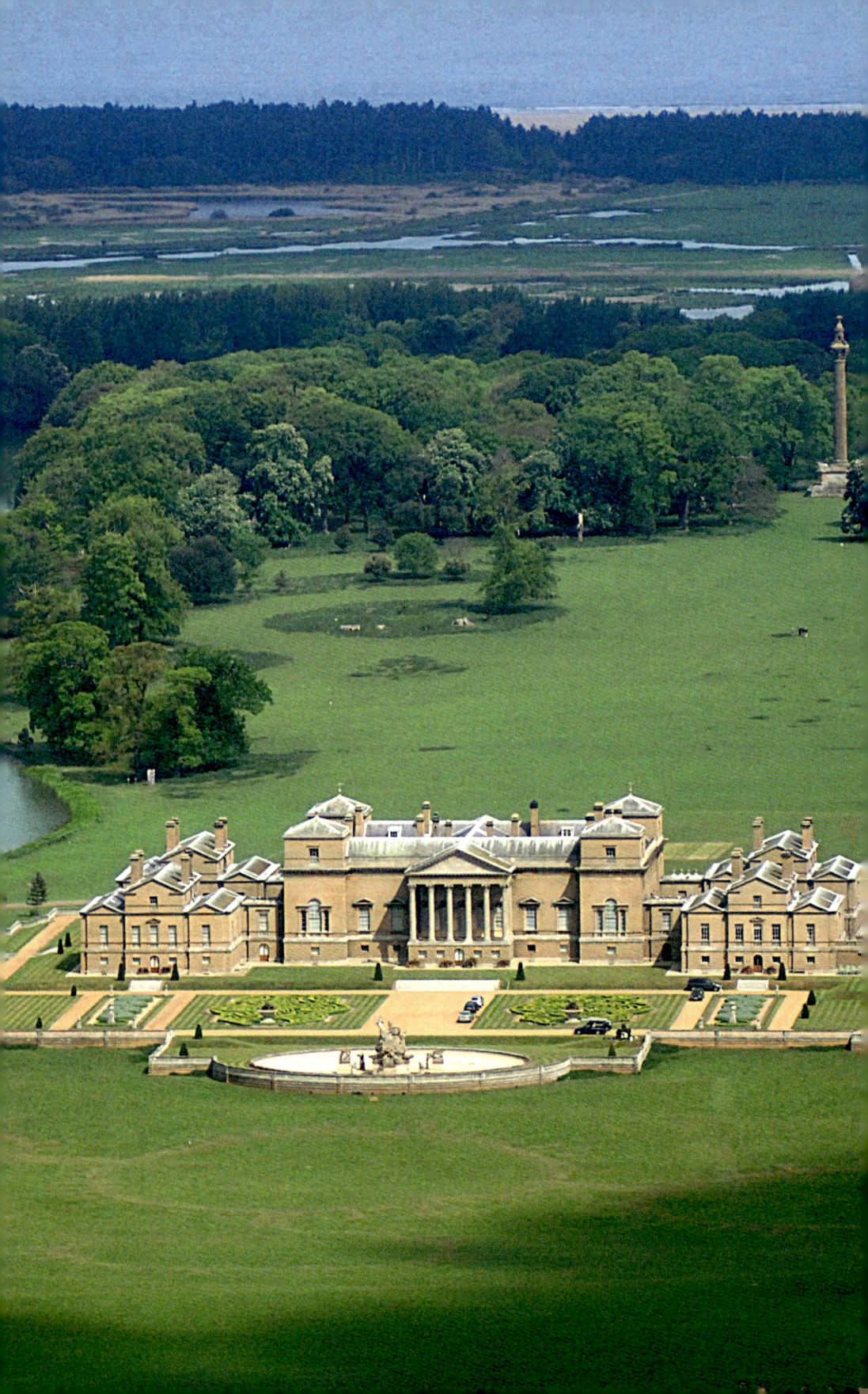

Chapter 1

Introduction

Holkham Hall is an eighteenth-century country house, family home, architectural masterpiece and treasure house. It lies on that short north-facing stretch of the east coast of England where the county of Norfolk, having bulged out into the North Sea, turns back towards the Wash. The Hall is set in a 3,000 acre park, encircled by a flint and brick wall nearly nine miles long. Beyond it to the north lie wide marshes, dunes, beaches and the sea; on other sides it is surrounded by arable farmland and a network of lanes and small villages, typical of the large agricultural estate, totalling 26,000 acres, that supports it.

Unlike the many country houses that found themselves jostled by new neighbours as manufacturing towns spread outwards during the nineteenth century, and others for whom mineral resources, valuable urban property or a large visitor catchment area proved to be an unexpected salvation, the Holkham estate remained predominantly agricultural until the end of the twentieth century. Although tourism has become an increasingly important source of income, it is on a relatively modest scale: the North Norfolk coast, although a popular destination for seaside holidays, is not an impromptu stop on the road to anywhere beyond, and Holkham lies at the limit of day-trip distance from any large conurbation. In country house history, however, Holkham Hall occupies a central position. Conceived, built and furnished by Thomas Coke, 1st Earl of Leicester, over a period of thirty years from 1734 to 1764, it attracted attention from the start. Today it is widely acknowledged as a quintessential and remarkably intact embodiment of Palladianism, the distinctive and dominant architectural influence in the early to mid-eighteenth century. Its architecture is complemented by furnishings designed for the house and by internationally renowned paintings, classical sculpture, books and literary manuscripts, the majority acquired by Coke as a young man during his unusually long Grand Tour of Europe or added by him as the house progressed and, remarkably, most still displayed and appreciated where he intended them to be.

Holkham Hall and Park from the south.

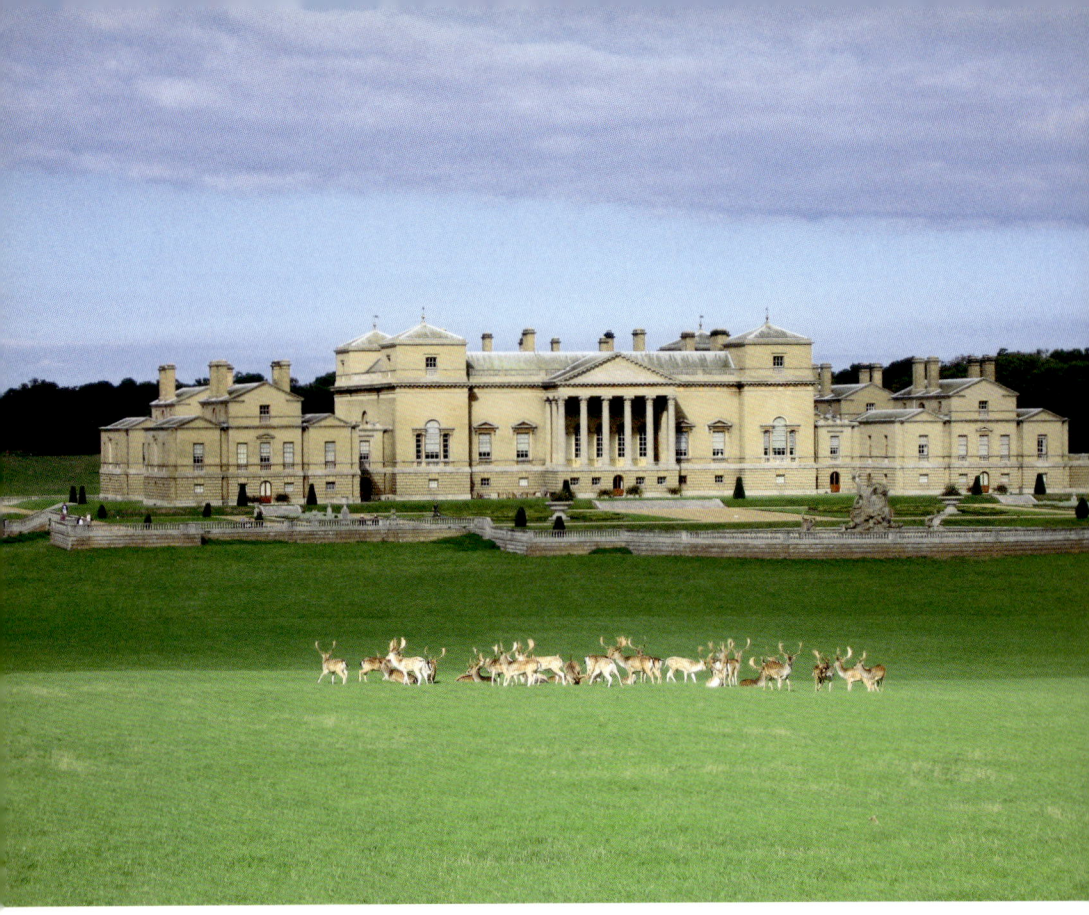

Holkham Hall, south front, 2006.

The creation and survival of such a treasure house is all the more fascinating because, in many other respects, the history of Holkham is typical rather than exceptional. Its origins lay in a fortune made in the law, leading to the rise of a family that managed to ride out the common seventeenth-century problems of a precarious line of inheritance, the Civil War and expensive litigation. Then came the inspiration of the Grand Tour, a massive building and landscaping campaign in the middle of the eighteenth century and a fashionable focus on agricultural improvement towards the end of the century. There followed a Victorian emphasis on shooting outdoors and privacy indoors, plummeting income during the agricultural depression at the end of the nineteenth century, a struggle to maintain the house in the first half of the twentieth century, a brief flirtation with the National Trust, the gradual turn of the tide and the growth of the visitor industry after 1950 and an increasing emphasis on commercial possibilities from the early years of the present century. Holkham can boast no aristocratic medieval forebears, few romantic legends (except for a 'phantom duel' and one misguided ghost)

and no great statesmen or famous military heroes. Nor is it unique in surviving as the home of the family that built it, close to the site of a manor house where earlier generations of the same family had lived. It is the combination of the remarkable and the typical that justifies this study of a single house.

Some forty-five years ago, the architectural historian, Mark Girouard, pointed the way to a fresh approach to the architectural history of the English country house, moving away from the traditional concentration on design, aesthetics and architects (although they continue to exercise many architectural historians) to a consideration of how country houses were intended to be used and how they fulfilled those expectations. He tracked trends and changes from the Middle Ages to the twentieth century across a wide spectrum of houses. Other historians have examined the financial and practical considerations involved in country house building or have focused on the houses' landscaped parks, country house visiting, the role of the ladies of the house, servants and early domestic technology. A rapid online survey reveals that country house studies are alive and well at many universities, ranging through non-accredited short courses and undergraduate modules to taught postgraduate degrees, many with a strong inter-disciplinary approach. The strength of these publications and academic courses is their wide geographical and chronological scope over a range of houses, the breadth of their sources and the generality of their conclusions.

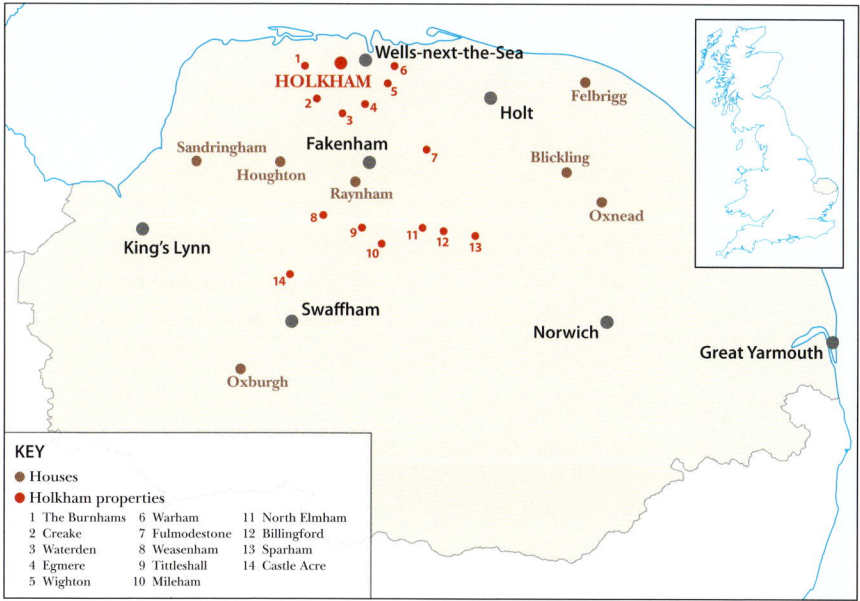

Map of Norfolk showing Holkham in relation to Norwich, King's Lynn and villages mentioned in the text.

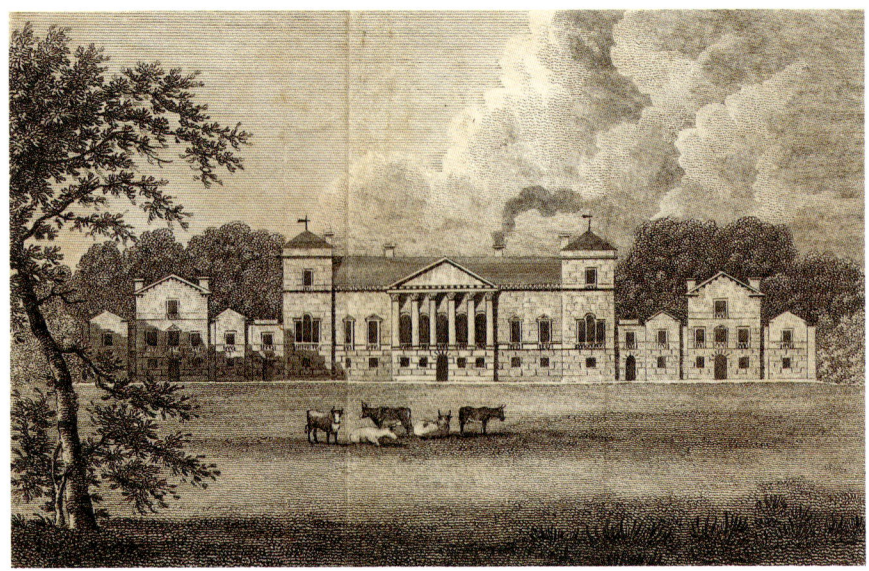
The Hall from the south, 1816, before the building of the Victorian terraces.

But what of an individual house such as Holkham? Although its architecture and collections have long given it national and international significance, it is not simply an exemplar of eighteenth-century achievement, appearing from the mist of the past and then somehow preserved in static survival mode. On the contrary, the relationship between innovation, continuity and change is as significant in one house over a period of 300 years as it is in a succession of new houses during the same period. It cannot be taken for granted that each generation was, at best, only too pleased to inherit, occupy and preserve a masterpiece or became, at worst, dutifully resigned to the financial commitment and sacrifice of personal choice that the inheritance imposes. Successive generations of heirs at Holkham were greatly attached to the Hall but this did not mean that they were particularly well-informed about their inheritance and certainly did not imply that they wished to preserve an eighteenth-century style of life serviced by eighteenth-century facilities. Architectural fashions, dynastic aspirations, life style, family circumstances, political ambitions, technology and finance have been identified as influences in the history of country houses in general: an individual house such as Holkham, however continuous its occupation and however intact its legacy has remained, is not immune to such influences. Holkham has been a Georgian house, a Victorian house, an Edwardian house, a struggling mid-twentieth century house. It has been an architectural obsession, a newly-built house, an old-fashioned house, the centre of a

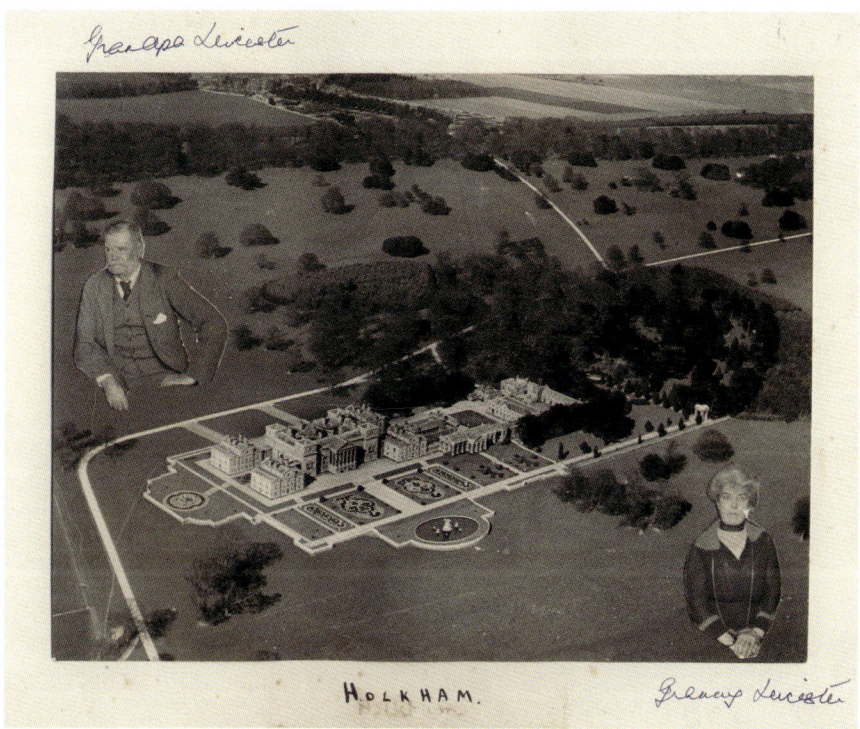

Aerial photograph from the south-west, personalised by David Coke, grandson of the 3rd Earl of Leicester, *c.*1930.

great landed estate, a focus of the so-called agricultural revolution, a mecca for sportsmen with guns, an open house, a private home, a tourist attraction.

Like other great country houses, Holkham long ago relinquished its original impact as a focus of landed power and a demonstration of aristocratic taste and culture. As it now welcomes in the paying public, its strongest attraction to modern society, its key to popular appeal, is perceived to be continuity and domesticity, a home occupied by one family for 300 years. This emphasis on stability and homeliness, blending both family and house into a continuum, blurs or conceals the historical realities right from the beginning. The great Elizabethan and Jacobean lawyer, Lord Chief Justice Sir Edward Coke (1551/52–1634), is acknowledged as the founder of the family fortunes, but the line of descent of the property has shifted sideways three times, in 1671, 1775 and 1976. It was Sir Edward who gave one of his younger sons, John (d. 1661), a foothold at Holkham in the early-seventeenth century yet, until recently, the family tree published in Holkham guide books omitted John and his heir, also named John (d. 1671), because the present family descends from the Lord Chief Justice through a different branch. The

Chapter 1 Introduction 5

two John Cokes were, however, the first generations of the family to live at Holkham and played a crucial role in ensuring the future prosperity of the estate and creating the conditions that enabled the building of the Hall a century later. Ownership of the estate and of the old Holkham manor house then passed down through a junior branch of Sir Edward's family to Thomas Coke (1697–1759), created Earl of Leicester in 1744, who dedicated his life to building the Hall and creating the park. Thomas's only son predeceased him but his widow saw the Hall to completion and ran the Hall and estate until 1775.

Although the focus of this study is on the Hall rather than the family, each phase in the subsequent fortunes of the Hall starts and ends with the successive heads of the family, because the greatest impetus for change came as each new generation moved into the Hall with new aspirations and priorities. On the death of Thomas Coke's widow, another sideways shift in the succession saw the Hall and the estate, but not the title, pass briefly to Wenman Coke (formerly Roberts), the son of the 1st Earl's sister, and then to

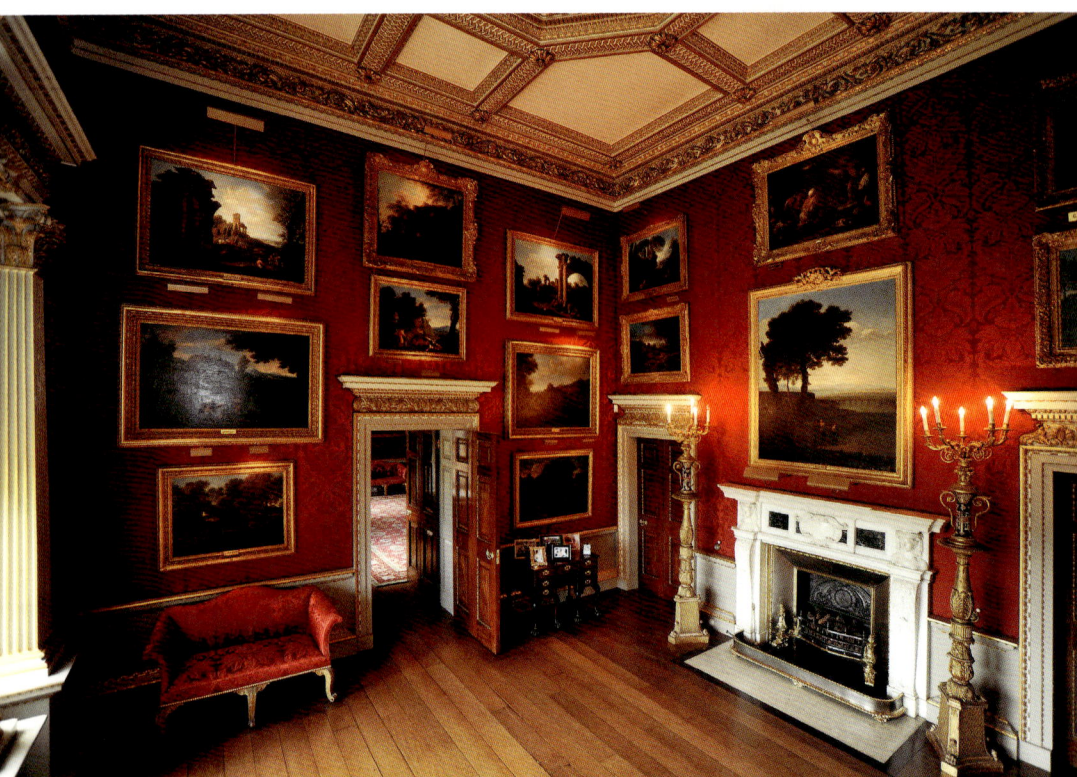

The Landscape Room, designed by Thomas Coke, 1st Earl of Leicester, to display some of the paintings he collected during his Grand Tour (1712–18) and throughout his life.

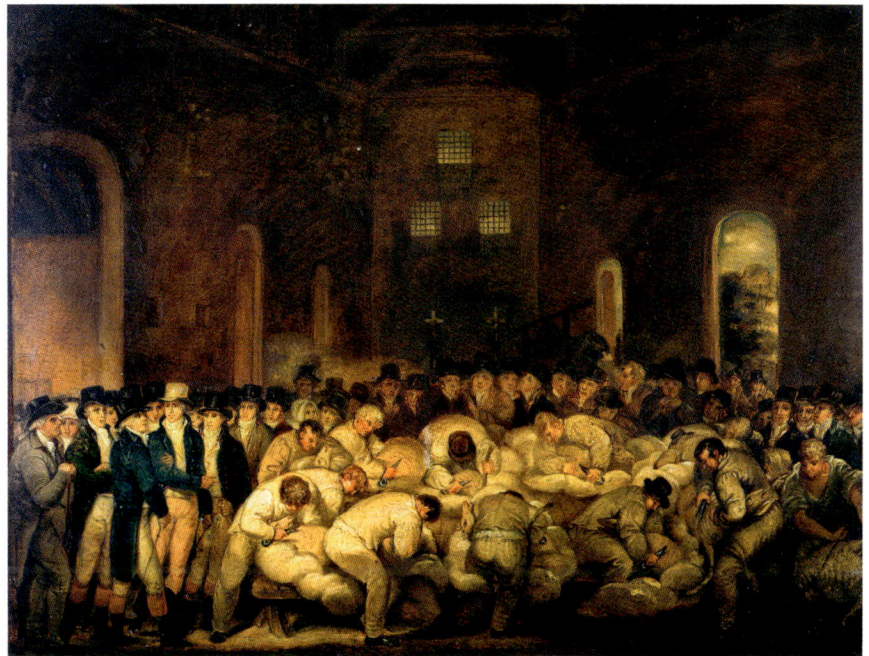

Holkham was famous in the early 19th century for its Sheep Shearings, the annual agricultural gatherings held by Thomas William Coke, the tall figure on the left in this painting attributed to George Garrard, *c.*1820.

his son, Thomas William Coke (1754–1842). He famously declared that he would not meddle with the Hall and was so successful in directing attention to his passion for agricultural improvement that, ever since, there has been little consideration of how he used the Hall and the full extent to which he drastically changed its relationship to the park and the village. Celebrated as a prominent agricultural reformer and long-standing Member of Parliament, he enjoyed his status as a wealthy and famous commoner until the title was re-created for him in his old age in 1837. The earldom, Hall and estate then descended together from father to son, each named Thomas William Coke, through four generations until 1976.

This study examines for the first time the varying fortunes of Holkham during the nineteenth and twentieth centuries when, no longer a newly-built architectural masterpiece nor a fashionable mecca for agricultural improvers, it succeeded in maintaining a precarious balance between stability and change. Direct succession from father to son (that is, in 1842, 1909, 1941 and 1949) did not guarantee continuity in knowledge or understanding of the Hall, park and estate. The 2nd Earl, inheriting in 1842 at the age of twenty, had been encouraged as a boy by his elderly father to appreciate

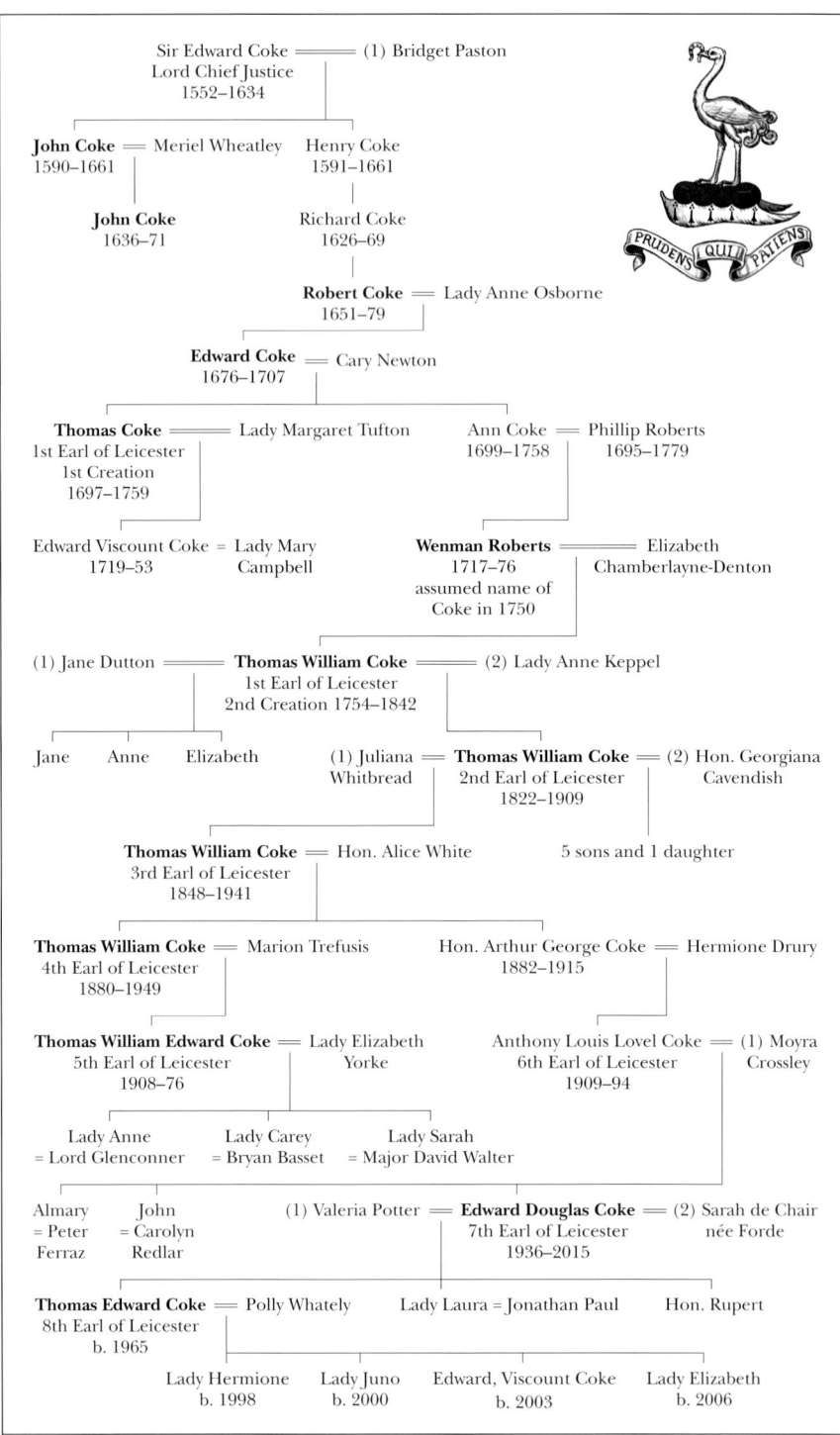

The Coke family tree, highlighting the Holkham branches.

farming, forestry and shooting but, away at school or travelling as a young man, he had probably absorbed little about the Hall, other than developing a desire for warmth and modern facilities. The 3rd Earl inherited in 1909 at the age of sixty and for many years beforehand had known the Hall only as a family visitor; he had been educated away from home, served in the army, brought up a family in homes far from Holkham and was consulted hardly at all by his elderly father in anything to do with his inheritance. He too embarked on modernisation but insisted on maintaining a traditional way of life, in the face of rapidly declining prosperity, until his death in 1941. A similar background applied to his son, who became the 4th Earl at the age of sixty-one. As a young man, convalescing from suspected tuberculosis early in the twentieth century, he had been provided with 'a dear little shelter' under the portico of the Hall (then still occupied by his grandfather) and loved wandering about, looking at books and pictures and 'hunting all sorts of things out' with the librarian. 'I feel I must try & learn something about them', he wrote to his future wife, but this clearly depended on the presence of a knowledgeable member of his grandfather's staff.[1] The successive Earls of Leicester managed their wide agricultural estates and enjoyed shooting, farming, forestry and the aristocratic social round, which at times included

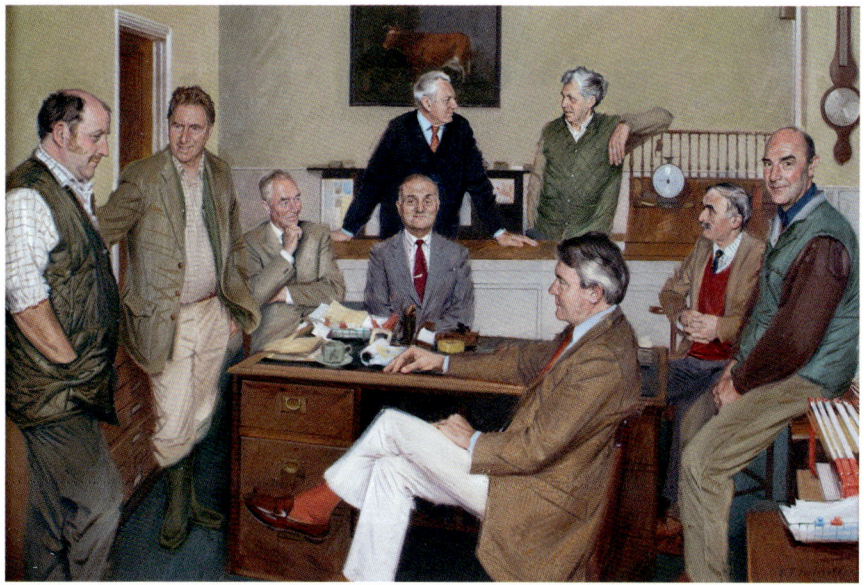

The first of a series of six staff portraits by Andrew Festing, commissioned by the 7th Earl, reflected the importance of the whole estate. Those depicted with the Earl (foreground) in 1993 were (standing at the rear) the estate agent and farm manager and (from left) the head forester, head gamekeeper, Hall administrator, chief Estate Office clerk, clerk of works and buildings foreman.

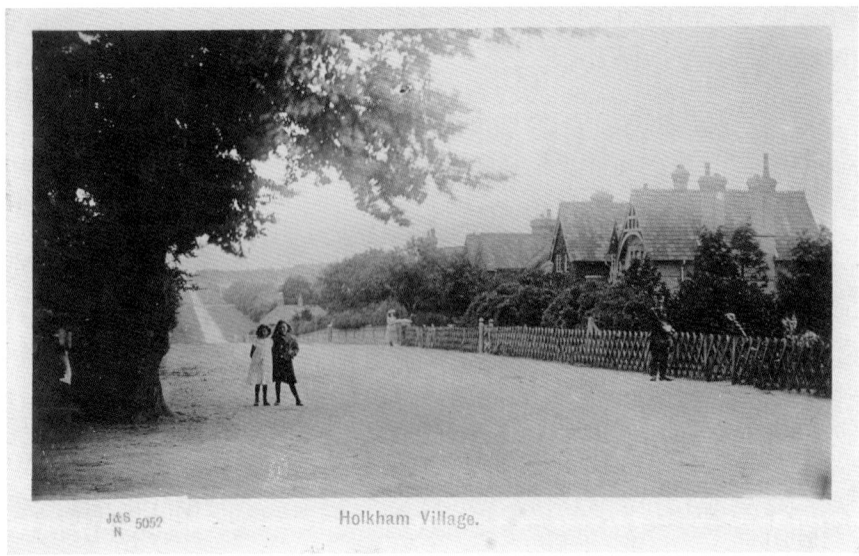

Holkham village in 1910.

close relationships with the royal family. They concentrated on their duties as landlords, employers and figureheads of the local community, participating hardly at all in national affairs. The centre of their world was Holkham.

The prospect of a third sideways shift in succession, as in 1671 and 1775, caused consternation in the mid-twentieth century, when it became clear that the direct male line would end with the 5th Earl. When he died in 1976, his heir, a cousin, inherited the title as the 6th Earl but had long since settled in South Africa and renounced all interest in the Hall and estate. His son, Edward Coke, subsequently 7th Earl of Leicester, had already moved to Norfolk from South Africa to learn the ropes and had been assisting his predecessor for some years before succeeding to Holkham: the first occasion in the history of Holkham when, through force of circumstances, there was a planned transitional period for the heir. Early fears that the unknown young man from a far corner of the Empire might destroy Holkham were confounded by his abilities and his determination to revive Holkham's flagging fortunes. In the early twenty-first century, he became the first in the family to retire in his lifetime in favour of his son, who became, on his father's death in 2015, the present and 8th Earl of Leicester.

Holkham is an entity of Hall, park and locality. The landscape created in the park was designed and re-designed to give pleasure to the occupiers of the house, delighting the eye, offering opportunities for leisure and sport and supplying a wide variety of produce and game for the table. The fortunes of the two original villages of Holkham, known as the town and the

staithe, had an equally close relationship with the Hall. It was not, however, the classic scenario of wholesale village clearance to make way for building a great house, for the greater changes came in the next generation under the influence of high farming. Similarly the wide expanse of marsh and sand, for all its apparently natural attractions, was shaped over 350 years by the owners of Holkham as they sought to increase their rental and farming income and to enhance the setting of their house. The history of the wider estate is a distinct area of research, the focus of reliable twentieth-century studies, but it is always present in the background, not least in providing the income from agricultural rents that supported the Hall. In the seventeenth and eighteenth centuries it included properties in ten other counties, all gradually sold in order to expand and consolidate the Norfolk estate, not only near Holkham but also in the centre and south of the county. Further sales in the middle of the twentieth century reduced the estate but, at 26,000 acres (10,522 hectares), it is still one of the largest privately-owned East Anglian estates. It was attentive and skilful estate management that made possible the creation of the Hall and, at least until the end of the twentieth century, it was chiefly farm rents, whether rising or falling, on which the fortunes of the Hall depended.

The 2nd, 3rd, 4th and 5th Earls of Leicester, 1908.

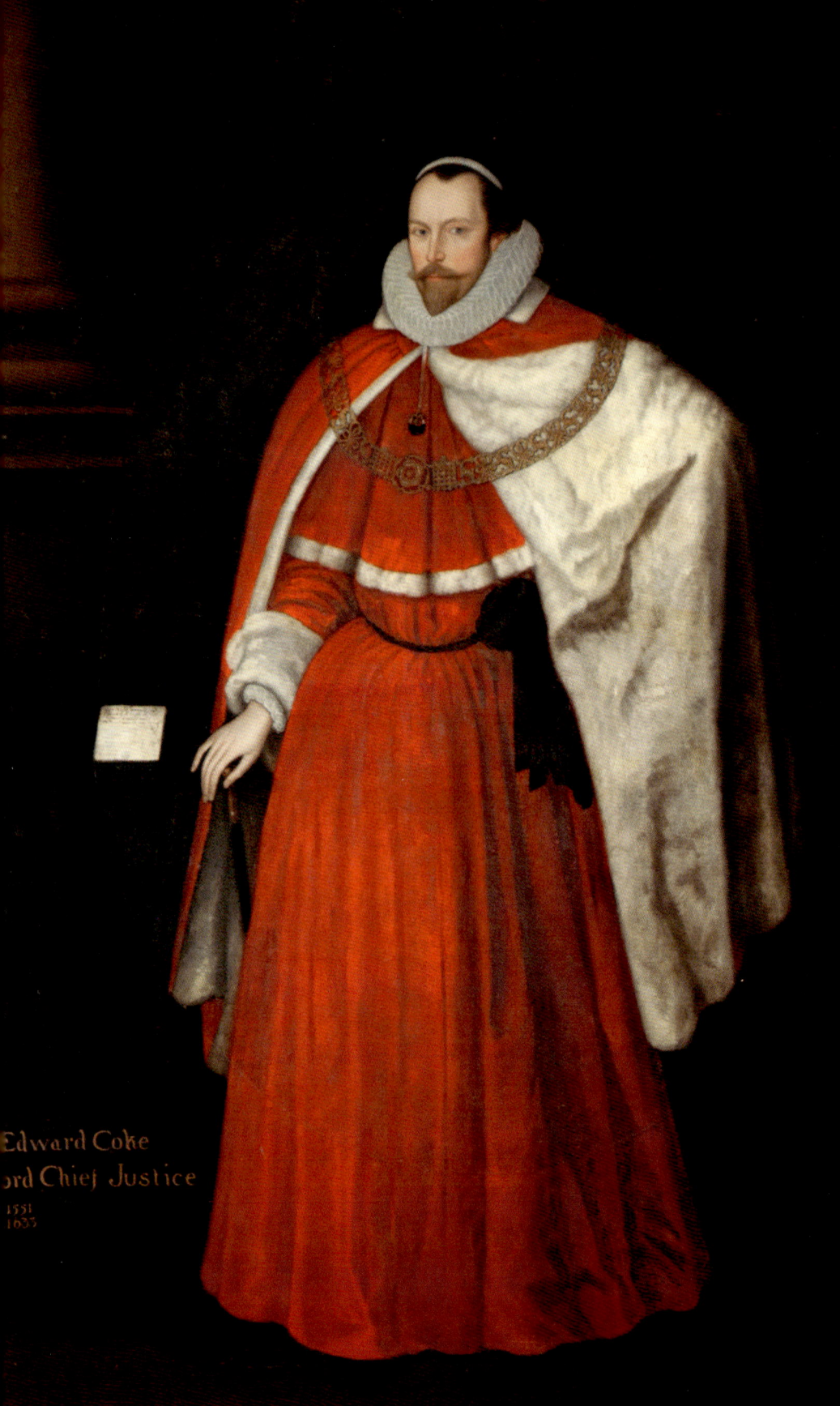

Chapter 2

'A good man leaveth an inheritance'
The First Sixty Years
1601–1661

Life in the seventeenth century has left few visible traces at Holkham: a slight ridge across the park, hinting at the line of a road linking the village that disappeared in the eighteenth century to the smaller settlement at the staithe, the basis of the modern village; a gable wall on the only house of that period to survive the nineteenth-century remodelling of the staithe village; the church on a slight hill equidistant from both settlements. When the creation of the Hall and its park transformed the landscape in the eighteenth century, it pushed the earlier history of Holkham into obscurity. Nevertheless, the first sixty years of the seventeenth century were equally a time of transformation. The century began with a minor legal transaction by Sir Edward Coke (1552–1634), a celebrated and wealthy lawyer, which enabled him some years later to establish his fourth son, John, at Holkham. From this modest start, John deployed a combination of luck, ambition and judgement to oversee fifty years of expansion and consolidation. By the end of his life, he had acquired most of Holkham parish, his manor house was sufficiently improved to serve the family for another century, and he was firmly established in the upper ranks of county society. Above all, Holkham had become the centre of the far greater estate, consisting of properties scattered throughout Norfolk and several other counties, created by his father, Sir Edward.

*

Sir Edward's roots were in Norfolk. Born the son of a lawyer at Mileham in 1552, he was called to the bar in 1578, soon established a reputation as a lawyer and rose rapidly through public service. By 1600 he had been Attorney General for six years and within the next few years would be responsible for the prosecutions of Lord Essex, Sir Walter Raleigh and the Gunpowder

Sir Edward Coke (1552–1634) by Marc Geeraerts the younger, *c*.1613.

Plot conspirators. The height of his fame still lay in the future: his appointment by James I as Chief Justice of the Court of Common Pleas, and then as Chief Justice of the Court of King's Bench, when he was the first holder of the office to be known as the Lord Chief Justice; his forthright championship of the supremacy of the common law over all persons and institutions except Parliament which resulted in his imprisonment in the Tower of London for nine months in 1622, and in Charles I's reign his formulation of the Petition of Right, tracing back to Magna Carta the liberties of the people against the royal prerogative. His career brought wealth as well as fame. As a young man, he had purchased a small property at Tittleshall, a couple of miles from his birthplace. Four years later he bought a large estate at nearby Godwick, where he built a house. By 1600 he had added other properties in Norfolk, Suffolk, London, Essex and Buckinghamshire and his purchases continued for another eighteen years, adding more in Norfolk and Suffolk and extending into Oxfordshire, Dorset, Cambridgeshire, Staffordshire, Somerset and Derbyshire. A massive volume in heavily studded binding, known as his Great Book of Conveyances, recorded over a hundred purchases, said to be in sixty-six manors and one hundred parishes, bought at a total cost of £80,000.[1] An important consequence of Sir Edward's acquisition of these numerous individual manors was the scope it gave him for settling landed property on his five younger sons without damaging the inheritance of the eldest.[2]

The village of Holkham town lay where the Hall was later built, slightly inland from the coastline, straddling a road linking Burnham Market and Wighton. In the centre of the village a track forked south towards the main routes to the county town of Norwich, about thirty-five miles away, and London, 135 miles. Just to the west of the village centre lay the manor house of Neales, while the larger manor house of Hill Hall or Wheatley stood on a slight rise to the east.[3] Between the two, a stream ran in the bottom of a long depression, called the Clint, northwards towards the coastal creeks, and a track led north-eastwards to the cluster of houses at the staithe.[4] By 1600, as the coastline moved northwards and channels silted, the staithe village had already lost its role as a port, but in the eighteenth century, as Holkham park was created and Holkham town was gradually removed, it would be left as the only village.

Beyond the closes or individual plots in Holkham town stretched the open fields: Church Field on the northwest, Staithe Field to the northeast and the South or High Field to the south. When Thomas Coke's widow set in stone 150 years later the legend that her husband had built Holkham Hall on 'an open, barren estate', she must have been unduly influenced

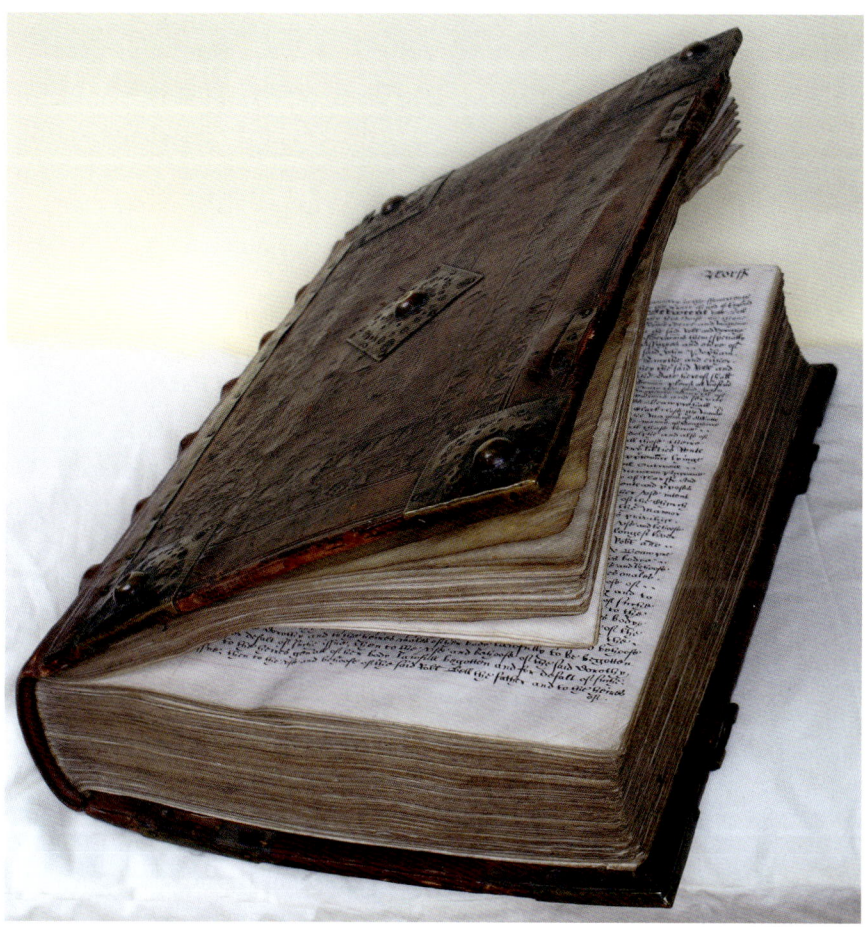

Sir Edward Coke's 'Great Book of Conveyances'. The binding is thought to be a later creation.

by the experience of spending most of her married life on a vast building site, for Holkham had a long history from at least the thirteenth century of successful sheep–corn husbandry.[5] It lay within the area described by the eighteenth-century agricultural writer, Arthur Young, as the 'good sand' region of Norfolk, 'the greatest barley county in the kingdom'. Husbandry was based on the foldcourse, a term denoting the area over which the manorial lords had the right to feed their sheep. Under this system, unique to Norfolk and part of Suffolk, the various owners and tenants of the arable land cultivated their intermingled strips in the open fields during the growing season, but in the winter, regardless of who had cultivated the ground, the manorial lord's flock (confined to commons and fallow areas in the summer) was free to range over the whole area that lay within its owner's foldcourse, feeding on the stubble and in return improving the light

land by manuring and trampling it.[6] Accounts of the crops liable for tithe at Holkham in the 1640s show thirty to forty men cultivating a total of about 1,000 acres (405 hectares); the six largest farmers accounted for nearly half

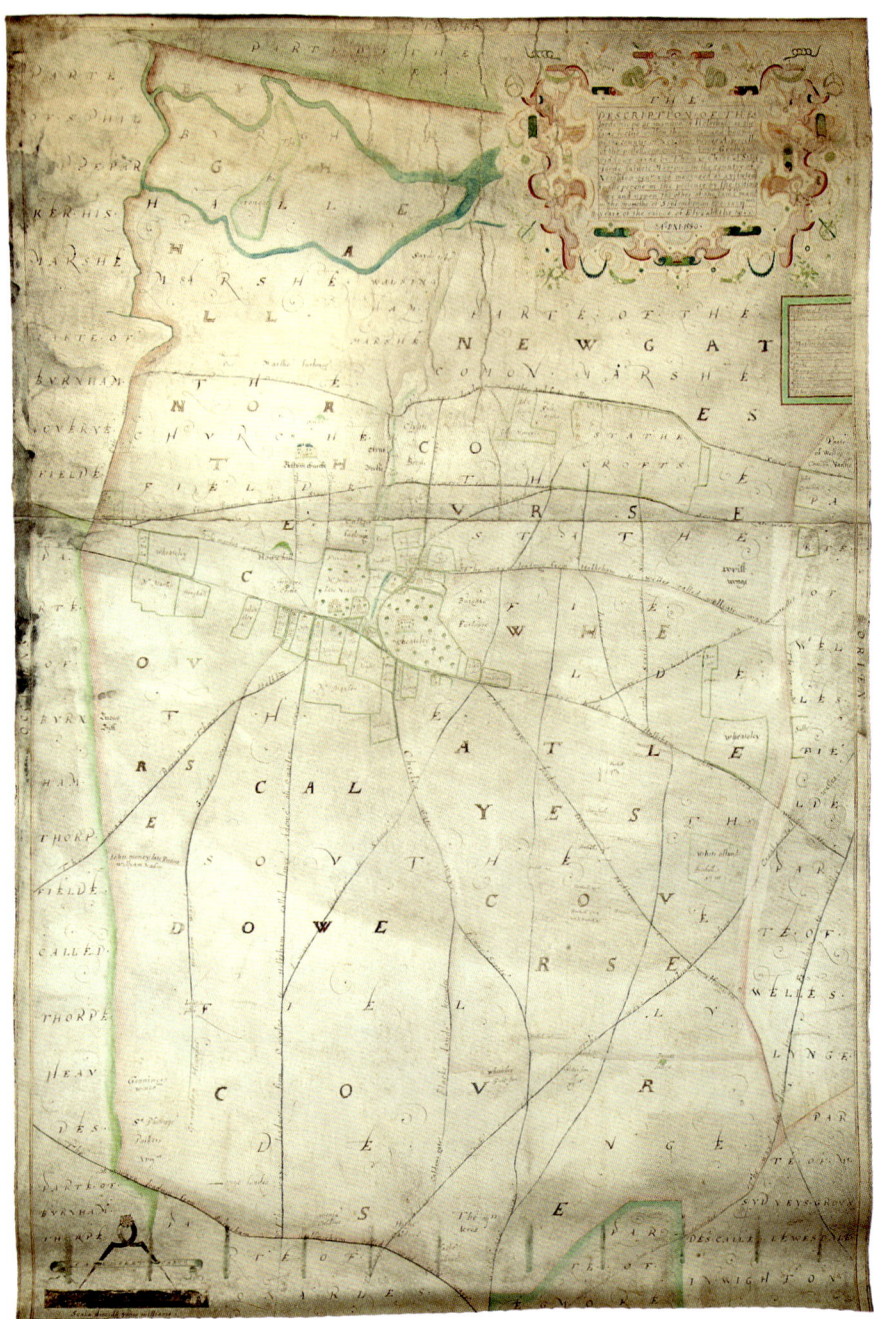

Holkham in 1590, drawn by Thomas Clerke of Stamford.

of the total, with the largest farming 250 acres. Approximately fifty per cent of their land was under barley, twenty-five per cent under peas or vetches, slightly less under wheat and rye, and a small amount under oats. In the winter, however, between harvest and sowing, it appeared as if the land supported only sheep.[7]

Sir Edward was perfectly placed to see the territorial possibilities developing at Holkham, some sixteen miles north of his Norfolk property at Godwick.

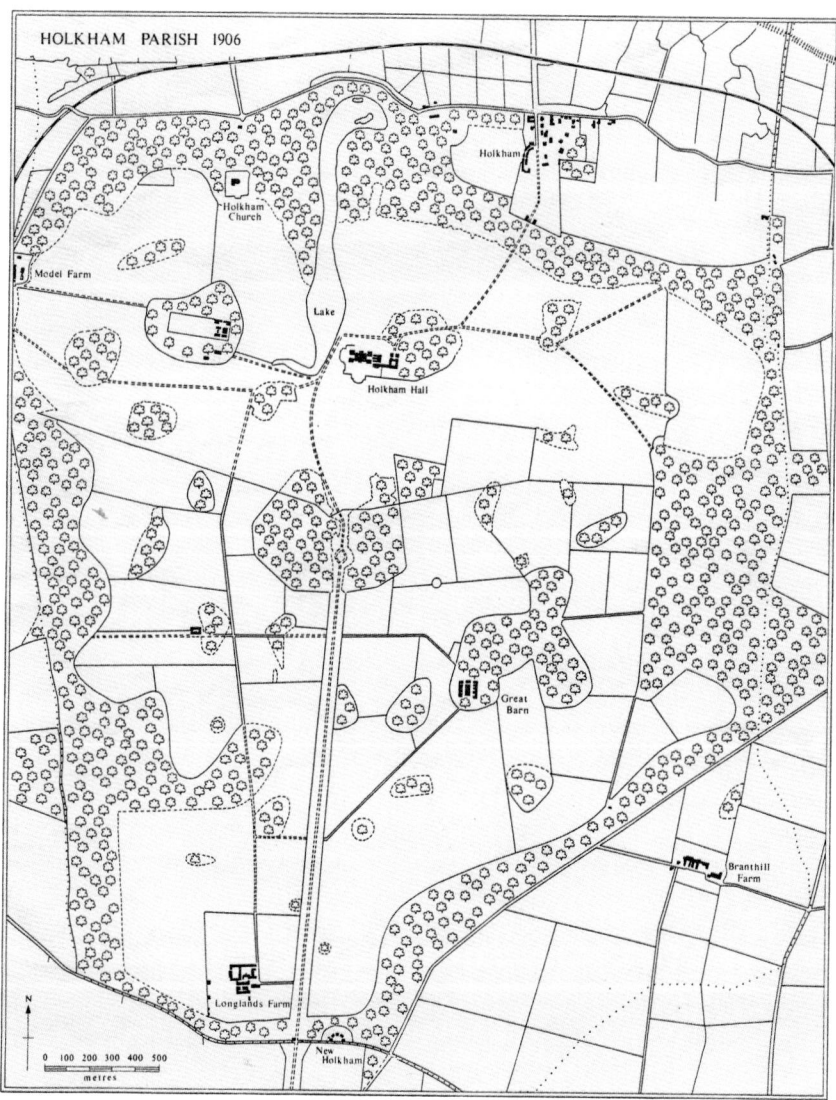

Features identifiable in both 1590 and 1906 are the church, coast road, village ('Stathe crofts' in 1509), parish boundary and Howe Hill (next to the walled gardens shown west of the Hall in 1906).

Chapter 2 'A good man leaveth an inheritance' The First Sixty Years 1601–1661 17

Like many Norfolk parishes, it was divided between more than one manor: by 1600 the three principal manors were Wheatley or Hill Hall, Neales and Burghall.[8] An old friend of Sir Edward's, Lady Ann Gresham, had owned Burghall manor and his secretary, John Pepys, was distantly connected to the Wheatley family of Hill Hall as well as the Armiger family of Neales manor and the Pepys family in the neighbouring parish of South Creake. When Anthony Wheatley, lord of the manor of Hill Hall, died in 1600, leaving a daughter, Meriel, aged only three, Sir Edward saw his opportunity. The young heiress became subject to the Court of Wards which exercised the power of the Crown to control the property and marriage of minors. This system had spawned a market in such profitable rights, causing expense and concern to landowners attempting to secure the future of their children. Late Elizabethan parliaments were restive about such matters and it would be one of the grievances raised by James I's first parliament a few years later, leading eventually to the abolition of the Court of Wards in 1646.[9] In Meriel's case, Sir Edward was on the other side of the fence, well placed to benefit from the existing law. He took care to conceal his involvement, ensuring that the Court of Wards granted 'the custody, wardship and marriage' of the young heiress to George Knightley, his maternal uncle and probably a member of his London household, but the real reason for the purchase is revealed by a note in his hand on the back of the grant of wardship, 'I took the wardshippe in my uncle Knightley's name and payed the fine for it, and it is only to my use.'[10] Shortly afterwards, Sir Edward started to acquire lands in the neighbouring manors of Waterden and (from the Pepys family) South Creake. As early as 1601, Sir Edward had fixed his eye on Holkham.

The lease of Meriel's property of Hill Hall was assigned to her maternal uncle, William Armiger, owner of the neighbouring Holkham manor of Neales. He was a lawyer of the Inner Temple whom Sir Edward probably already knew. When Sir Edward officially took over Meriel's wardship after the death of his uncle Knightley in 1608, his secretary Pepys promptly passed on instructions to the local steward to 'set down some indifferent order touching Hill Hall … and to be at a certainty with my cousin Armiger what he shall pay yearly for the same during the time he shall enjoy it'.[11] Shortly afterwards, Sir Edward opened negotiations for the purchase of Armiger's own manor of Neales, instructing his steward to assess 'its yearly worth and what you think it worth to be sold'. This was calculated by multiplying the annual rental value by twenty (the standard multiplier in the seventeenth century). In addition to the manor house, 'well and conveniently builded' with outbuildings and grounds of about fourteen acres, the property included a smaller house, 124 acres in Church Field and Staithe

Field valued at six shillings per acre per annum, and 300 acres of less fertile land in South Field at five shillings. Another three acres planted with saffron were worth much more, ten shillings per acre per annum. In this manor, the 'liberty of folding and feed for sheep' was restricted to a common called the Lyng lying just within Wells-next-the-Sea parish, a circumstance that benefitted Sir Edward's descendant T. W. Coke 200 years later, when it was divided and enclosed. Draft calculations valued the whole manor at £2,400 to £3,000. In 1609 Sir Edward, apparently willing to pay above market value, proceeded to buy Neales manor, with certain rights connected with the parish church, for £3,400.[12]

It was one of his more expensive acquisitions, although he had already paid over £5,000 each for properties such as North Elmham in Norfolk and Minster Lovell in Oxfordshire, and would later pay at least as much for several others. He took particular care with the conveyance, arranging for Armiger to bring 'the principal evidence' to London so that he could personally supervise the drafting. The manor had an interesting history, having been formed in the fourteenth century from portions of other manors and free tenures, and Armiger possessed a wealth of medieval charters which are still in the archives at Holkham.[13] Soon after buying the property, which was let to a tenant for £140 a year, Sir Edward arranged for it to pass on his death to his fourth son, John, and his male heirs. This was one of a series of family settlements by which Sir Edward, like many ambitious landowners, sought to protect the future of his estate. Throughout the following centuries, although the legal framework would vary, family settlements would be enormously important to Holkham in ensuring that successive heirs could enjoy the estate revenues for life without having unlimited freedom to dispose of property. Provision for immediate descendants, although desirable, was subordinate to the future of the estate: Sir Edward made formal mention of paternal love but specified that his long-term aim was to ensure that his lands 'may henceforth continue and remayne in the name, bloud and family of the said Sir Edward Coke, for longe as it shall please almighty God to blesse and continue the same'.[14] Three years later, in 1612, Sir Edward arranged the marriage of John, then aged about twenty-one, to his ward, Meriel Wheatley, the heiress of Hill Hall, the outcome that he had probably planned twelve years earlier. Meriel was just sixteen. The marriage took place at Tittleshall but Hill Hall became their family home and Cokes have ever since lived at Holkham.[15]

*

John Coke's marriage to the heiress of Hill Hall changed his status and income as a younger son. He had been admitted to the Inner Temple in

1610 with his younger brothers, Henry and Clement. Until then, much of their upbringing had been entrusted to the elderly rector at Thorington, one of their father's Suffolk properties, who was distantly related to them and was reimbursed for their clothing, 'dyett' and tuition.[16] Like many younger sons of landowners, particularly in families with a link to the law, they would have gone on to earn a livelihood from the law if their father had not been able to endow them with land and secure good marriages for them. The lands of Hill Hall were not as extensive as those of Neales (Sir Edward's first Holkham purchase, which John would not inherit until 1634) but were sufficient, at around 200 acres, to establish John at the lower end of the gentry.[17] Additionally, he gained a foldcourse extending over part of South Field, an asset greatly valued by Meriel's father, who had stipulated that, if lands were sold to meet his debts, they must be 'in such placis as that my fould course … may be least annoyed with the want of them'.[18] Although Hill Hall was a good-sized farm, John complained after his father's death that 'his estate is less than his younger brothers, by a third part at least'.[19] Unlike his brothers, however, by marrying his father's ward without the complications of a marriage settlement, John gained immediate possession of a house and a farming income relatively early in his adult life, giving him a springboard for territorial ambition.

The manor house of Hill Hall was the principal house in Holkham. The only picture of it, a stylised view on a map of 1590, suggests a typical E-shaped Tudor manor house. An inventory made on Anthony Wheatley's death in 1600 gives some idea of the accommodation that became the Coke family home twelve years later. The hall was probably the first room to be entered; its furniture suggests that, as was normal in such houses, it was the servants' eating room. The 'great parlour' was probably the equivalent of the first-floor great chamber of many a country house at the beginning of the century. It had already been superseded as a family room by the 'little parlour' whose

The manor house of Wheatley or Hill Hall.

card tables, cushions, green table cloth and three pictures hint at comfort and relaxation. The 'stodye' or dressing room, next to the principal bedchamber on the first floor, contained clothing and linen, a wide variety of arms, a valuable clock, an inkhorn and the only books in the house (unfortunately not itemised). The long gallery, a feature of many country houses, was listed as 'gallery store house' and used only for storage of miscellaneous items. Sleeping accommodation was limited to five bedchambers and eight bedsteads; the maids' chamber contained three beds. The domestic offices included a cellar, dairy and brew house but no separate still room or bake house. In the yard there was a well and a horse trough. In addition to the farm livestock, including thirteen horses, there were geese, turkeys, hens, capons and chickens.[20]

After twenty-two years of married life at Hill Hall, on his father's death in 1634, John became entitled to a life interest in the neighbouring manor of Neales under the terms of the settlement made by his father a quarter of a century earlier. In the same year he took steps to obtain the third Holkham manor, Burghall. This showed confident planning, a calculated risk in which the prospect of future benefits outweighed uncertainties. The manor had belonged to Lady Ann Gresham but was now held by her son's widow, Lady Mary Spencer, for life, and after her death would pass to the son's three granddaughters from his first marriage. It was two of these future shares that John now bought.[21] Burghall's manor house had long since disappeared. Its arable land, dispersed in the open fields 'by roods, half acres and acres', amounted to 240 acres, considerably less than Neales (427 acres) but more than Hill Hall (170 acres). This arable land was let at £50 per annum to two tenants, who were willing to pay £10 more under a new lease. The manor also included eight copyhold cottages and two meadows near the Clint, the site of the future lake.[22] The distinctive feature of the manor, however, was the great extent of its two foldcourses, a total of 630 acres including a large tract of marsh. This was John's first opportunity to acquire valuable marsh grazing. The foldcourses were capable of supporting over 900 sheep in two distinct flocks. The southern foldcourse for 500 sheep covered the whole of the South Field except for the part that belonged to Hill Hall foldcourse. The other foldcourse in the northern part of the parish supported 400 sheep. Between Michaelmas (which in Norfolk was 11th October) and Lady Day (25th March) this northern flock, joined by 160 sheep belonging to the shepherd, ranged over the Church Field but the foldcourse also included the Clint, two enclosed pastures nearby and 350 acres of the marshes. A small raised area in the marshes, the Borough, which gave its name to the manor and was later known as the Danish camp, yielded particularly good

The foldcourses of Hill Hall, Longlands, Borough Hall and Newgate's. Undated, about 1720. The map is orientated with north at the foot.

feed, supporting 180 sheep 'fit for the butcher, which is well worth 2 shillings [extra] a sheep'.[23]

Burghall manor as a whole was valued at £2,520 but, taking into account the life tenancy and the fact that only two of the three reversionary interests in the manor were for sale at the time, John Coke acquired it for £1000.[24] He added the remaining third part in 1647 for £730. The reduction in price because of the life tenant, Lady Mary Spencer, was calculated at 'five years purchase' but it was twenty-five years before Coke's man of business in London, alerted by rumours of her death, reported that she 'is yet living but (as I am informed) very weak and not like to recover'. Although direct benefits from the purchase were thus delayed longer than expected, the acquisition of the manor showed masterly strategic planning by Coke. His agent had pointed out at an early stage, 'Memorandum [it should to be borne in mind], it is very considerable that by uniting this manor with one other in the same town, it is one fourth part at least to be improved above the present'. So it proved, for ownership of Burghall would be crucial to the future shape of the Holkham estate.[25]

After the death of his father in 1634, John was in a comfortable position. In addition to the house and farm of Hill Hall manor, he had a rental income from Neales manor and had taken steps to secure Burghall, the third Holkham manor. He also gained on his father's death a life interest in the manor of Fulmodestone, some twelve miles from Holkham, which provided an annual rental income of at least £250, profits on timber from its woods, additional winter pasture for some of the Holkham flock, a quantity of wool each year and hops for the Holkham brew house.[26] For some years, however, John had had even greater expectations. A precarious line of inheritance, a common experience for many seventeenth-century landed families, proved particularly significant for the Coke family. Sir Edward Coke's 'great estate', that is, all his estate apart from properties settled on the younger sons, was settled on his second but eldest surviving son, Sir Robert Coke of Huntingfield (Suffolk) and his heirs. Robert had married in 1613 but no child had long survived birth. Sir Edward's next son, Arthur, had died in 1629, predeceased by his only son. It had been clear for some years, therefore, that John, the fourth son, would eventually succeed to the bulk of the wider estate founded by their father. His succession was by no means an easy transition, however. For nearly twenty years, between the deaths of his father in 1634 and his older brother in 1653, John exercised constant vigilance for the interests of his own branch of the family and the future of the great estate.

'A good man leaveth an inheritance to his sonnes and to theire children' (Proverbs 13.22) wrote Sir Edward Coke in large script at the front of a volume in which he recorded his children's marriage settlements.[27] The

> **Prov: 13.22.**
>
> **Bonus relinquit hæredes filios et nepotes.**
>
> **A good man leaueth an inheritance to his sonnes and to theire children.**
>
> The mariage betweene S.r Edward Coke and Bridgett Paston daughter and coheire of John Paston of Paston Esquire, And the mariage of Robert Coke of Sperham Esquire father of S.r Edward and of Wenefrida Knighteley daughter and coheire of William Knightley of Morgraues Esquire, and of other the Auncestors and family of the said S.r Edward doe appeare in the Pedegree allowed by M.r Camden Clarenceux kinge of Armes vnder his hande &c: ~
> This booke onely conteyneth the mariages of the sonnes & daughters of the said S.r Edward Coke knight.
> Benedicat dns.

Inscription at the front of Sir Edward's book of family settlements, *c*.1613–26.

volume included a copy of the deed by which he settled Neales manor on John and his heirs. This was an early example of a landowner, who happened also to be a skilful lawyer, doing his best to protect the descent of his

24 HOLKHAM

landed estates by creating two successive life interests and then anticipating all eventualities by specifying the next heir in each possible instance should the direct line of descent fail.[28] It is easy in hindsight, however, to overestimate how smoothly this was achieved. Despite Sir Edward's eminent career in the law and the measures he took to settle the descent of his vast properties, the situation at his death was confused. Whereas he had recorded his other sons' marriage settlements in one volume, under the relevant names (Coke and Berkeley, Coke and Lovelace, and so on) the only entry for 'Coke and Wheatley' was an afterthought, a separate paper sewn onto one of the parchment pages. Here he recorded that there were various deeds relating to lands settled on John, 'of all which indentures there being two parts, one part thereof in the iron chist in the Temple and the other part in the iron chist at Godwick, but because the same are with power of revocation they are not entered here'. After his death, documents went missing, including some in an 'unfortunate miscarried black box', and John was suspicious to hear 'of none to be wanting but such as concerns his own estate'. He also complained that he had no access to the deeds by which the estate was settled, but this was not an unusual situation for a younger son entitled to only a minor share of the estate: John probably kept his own son, Edward, in similar ignorance, for he was advised by a relative, one of his father's men of business, 'when the black box is opened, if you fynd any present estate is settled upon my cosen Edward, you will conceal it … it will be better he should conceive himself wholly in your power till you have well matched or disposed of him'.[29]

John's determination to protect the interests of his own branch of the family was clear from the time of his father's death. The immediate point at issue was provision for Sir Edward's younger grandchildren, that is, all those apart from the eldest son in each family. At a time when he was clearing some of his sons' debts and re-settling lands, Sir Edward had arranged for the income from specified properties to provide for his grandchildren. On his death, however, his executors decided instead to make a single payment for each child. John objected strongly: his children were older 'so that time will not much augment their portions', the proposed sum was not equivalent to the original provisions in the will and it did not match the marriage portions that Sir Edward had given in his lifetime, such as the £2,500 that John's eldest daughter had received. Faced with the prospect of providing for the marriage of five more daughters, John still refused some years later to accept the sum offered 'upon unjust and dangerous conditions'.[30]

In the early 1640s John confronted a more serious problem. His elder brother, Sir Robert, now the life tenant of the great estate, had long been inclined to what John described as 'improvident and excessive expence'.[31] He

had married an aristocratic wife, Theophila, sister of the 8th Baron Berkeley, and his situation was a prime example of what one authority has called 'a recipe for financial trouble': a small income (at 1,000 marks, about £660, perhaps unusually small for an eldest son) combined with the prospect of inheriting much more on his father's death.[32] This combination was exacerbated by his father's longevity. By the mid-1620s, a letter from Sir Robert to his mother-in-law shows him lying low to avoid creditors:

> I have noe news what my father doth concerning my business, and whereas you writ that out of sight, out of minde, and doth advise me to go to him … being credibly informed that theare is much baight layd for the taking of me, I had rather content myself with this life at New Park than in prison, likewise my brothers who are deaply ingaged for me are all ways soliciting my father in my behalf.[33]

Around this time, his father cleared debts for him amounting to nearly £22,000 (around £2,000,000 in modern terms) 'upon the first great list' followed by £6,000 more.[34] His succession in 1634 to the bulk of his father's estates did not end his propensity to pile up debt. John estimated that the settled estate was worth over £4,000 a year, with unsettled copyhold land adding another £600, but Robert spent 'a vast sum of money' on the house, 'Durdans' (near Epsom, Surrey) that he inherited from his wife's family. One of the visitors who enjoyed the splendid surroundings was young Samuel Pepys, accompanying his father's distant cousin, Sir Robert's secretary.[35] Eventually Sir Robert resorted to initiating a private Act of Parliament, seeking power to sell some of the settled lands 'for payment of his debts and that his ladies jointure may be encreased'. John vigorously opposed the proposed Bill with an emphatic declaration of the importance of family settlements:

> The manors and lands intended to be sold … were conveyed and settled by Sir Edward Coke in this manor, viz, after the death of Sir Edward Coke to persons in trust for Sir Robert for his life only with remainders to his first and so to any son in tail, with other remainders to trustees for Sir Edward Coke's other sons, and therefore to overthrow this settlement thus made for the protection of the estate, upon any pretence whatsoever, were against common justice, and a dangerous precedent tending to the destruction of many families as well of the nobility as gentry, whose estates are settled in the same manner by their careful and prudent ancestors.[36]

Sir Robert's timing suggests either that he was desperate or that the speed of political developments took many people by surprise. His bill was introduced in the House of Lords in April or May 1642 and read once in the

House of Commons, but early in June an order was made 'that it shall not be read a second time but in a full house'. It is surprising that it proceeded even so far, for Parliament had far more pressing concerns as the country slid towards civil war. By May, Charles I had fled London and Parliament had raised an army. John, who had 'come up on purpose to hinder the passing of his brother's unreasonable bills and hath stay'd here now about six weeks to his great charge', sought to have a day set about Michaelmas, in the autumn, for the second reading and in the meantime to go home to Norfolk without prejudicing his case.[37] Long before Michaelmas came, however, the Civil War had begun. Sir Robert's bill disappeared from view.

It would not have been a good time for Sir Robert to free settled land, for it was better to have the limited value of a life tenancy at a time when lands could attract fines or confiscation. Sir Robert, a royalist, within a matter of weeks was imprisoned in the Tower of London, where he remained for four years, and some of his lands were sequestrated and charged with taxes, repairs and fines. Possibly, however, this helped to protect the settled estate from further extravagance, for his sister remembered him as having sometimes lacked 'wherewith to bie himself bread'. The same situation may have helped the trustees of Sir Edward's settlement to limit the effects of Sir Robert's attempts to vary it for, although the private bill had fallen a victim to circumstances, one of the trustees told John after Sir Robert's death,

> I believe Sir Robert was displeased with my brother and me ... because we would not part with the freehold of his estate, although they obtained a decree under the Great Seal to indanger the altering & destroying the estate, yet we refused to yield unto that decree, and did choose to lie by the heels rather than yield to it; upon wch resolution of ours, the decree was altered & so the freehold continued in use [that is, under settlement] still; if we had parted with the freehold estate, then perhaps some of it might not have come to you & your children; but notwithstanding that difficult & sharp suit ... now yourself see the same estate is firm still on his feet, as my dear deceased Lord Coke conveyed and settled it.?

Even then, however, the situation was not fully resolved. The son of his fellow trustee, taking over his father's role, had to covenant 'that he will endeavour to the utmost to secure the whole estate ... according to the said Sir Edward Coke's intentions' and 'secure the surviving person [John] invested in the premises by Sir Edward Coke ... from unjust suffering'. At a period when the structure of family settlements and the role of trustees were developing rapidly, John's situation reveals that trustees were at times obliged to take an active rather than nominal role.[38]

During the same period, John also faced problems with the next generation. His family circumstances had changed considerably around the time of his father's death in 1634. His second son, John, died in 1633, aged nineteen; his fourth and fifth sons both died as infants and in 1636 his wife Meriel's death followed the birth of their sixth son, also named John.[39] When the third son died in 1644, the only surviving sons were the eldest, born in 1613, and the youngest, born twenty-three years later. The eldest son and heir, Edward, was following in the footsteps of his uncle, Robert. He married the niece of Sir Robert's wife and, even more than his uncle, succumbed to the temptation of spending on the expectation of his future inheritance. The marriage settlement has not been traced so it is not known what provision was made for his household but, by the time his father succeeded to the great estate in 1653, Edward was said to have accumulated debts to the

Monument to Meriel Coke in St Withburga's, Holkham, designed by Henry Stone c.1639, incorporating a memorial to her parents and grandparents in the Armiger and Wheatley families.

```
                        Sir Edward Coke
                      = (1) Bridget Paston
                            d. 1634
                                              Anthony Wheatley
                                              of Hill Hall, Holkham
                                              = Anne Armiger
                                                 d. 1600
   ┌──────────┬──────────────┬─────────────┐                    ┌─────────────┐
 Edward      Arthur         John  ═══════ Meriel Wheatley      Clement
 1583–c.1600 1588–1629      1590–1661      d. 1636             1594–1629
             4 daughters,                                      (had issue)
             son died young
       Robert                                      Henry
       1587–1653                                   1591–1661
       = Theophila                                 (had issue)
         Berkeley

   ┌──────────┬──────────────┬─────────────┬─────────────┐
 Edward      Robert         infant son                  John
 1613–53     1616–44        b. & d. 1631                1636–1671
 married,                                               d. unmarried
 no issue
         John              9 daughters,        infant son
         1614–33           6 reached adulthood 1634–35
```

Simplified family tree showing how John Coke senior and junior succeeded to Holkham and the 'Great Estate'.

tune of £40,000. As a result, the Elmham estate in Norfolk was mortgaged for £10,000 to 'the great usurer Hugh Awdley' and ultimately, in default of payment, it was divided, although the Coke family managed to retain the deer park.[40] It was a significant loss, for Sir Edward Coke had described Elmham as 'one of the best things I have'.[41] Its loss was young Edward's only lasting effect on the history of the Coke estate, for he died before his father, leaving no children.

In the meantime, the Civil War in the 1640s had little effect on life at Holkham. Whereas John's brothers, Robert and Henry, and his sister, Anne Sadleir, were committed royalists, John was a parliamentarian but his interests were local rather than ideological and he was opposed to the more extreme Puritan elements.[42] There is no evidence to show if he had been drawn into public life in the 1630s as his lands and income increased but in the following decade he appears clearly in the ranks of the county gentry. At one of the local meetings organised in the autumn of 1642 for the collection

John Coke (1590–1661) by Henry Stone, *c*.1645.

of money, plate and horses for the parliamentary cause, he pledged a fairly modest £50. Then, after the removal of the royalist Sir Nicholas Le Strange of Hunstanton from a militia command, he was appointed commander of a foot company, an important sign of his status as a member of the gentry. A splendid portrait by the artist Henry Stone (d. 1653) shows him an imposing figure in full armour, holding the baton associated with his command.[43] Nevertheless, he did not relish responsibility for musters and exercises. On one occasion at Fakenham, he reported 'wee had appearance of souldiers beyond expectance. All the coates and knit stockings are bestowed, the cotton stockings are soe little that they are not fit for serving … Wee proceeded with much cheerefulness until wee came to march away, and then all cryed out, wee will not stirre until wee have our arrears, wee have bene deceived heretofore with faire promises but wee will trust noe more until wee have our old pay.'[44]

Norfolk was relatively untouched by the battles of the Civil War but belonged to the Eastern Association, formed by Parliament to coordinate financial and military supplies, and John found himself fully involved. He played his part as one of the forty members of the Norfolk committee nominated to raise the weekly levy, impose penalties on those reluctant to pay and superintend the sequestration of estates of 'notorious delinquents'. He was also one of the commissioners appointed to gather the levy 'for our

Receipt to John Coke in 1643 for payment of £100 in parliamentary taxation in addition to his earlier 'loan' of £50.

brethren of Scotland' in return for their military support.[45] The presence of parish rate lists among his papers indicates that he took an active part in such duties but, like military musters, it was often an irksome business: 'I found great disorder by reason some hundreds had attended two or three days, ye old soldiers complained that they were behind nine weeks pay, many towns brought noe monies having not anie warrant to levie it, with these difficulties I struggled as I was able ... My desyre is that some of the [Norfolk] committee that are present when you send your directions may be at the place appointed to assist in the effecting them, especially in business of so high concercuence & of such speedy executuion.' Like many local gentry, especially in Norfolk, John was reluctant to see local contributions used outside the county boundaries or to act against friends, relatives and neighbours. One local 'delinquent', Mansuer Armiger of North Creake, was a relative of his late wife. The Norwich committee had already complained about Armiger's arrest by an agent of the Cambridge committee and Coke fired off letters on his behalf when the Governor of King's Lynn sent a warrant for horses to be procured from him.[46]

By now John had added authority. Early in 1643, Robert, Earl of Warwick, appointed by Parliament as Lord Lieutenant of the county, nominated him as a deputy lieutenant. A year later he served as High Sheriff. This latter office was always a mixed blessing. Its ceremonial aspects, particularly the entertainment of visiting dignitaries at the assizes, brought a certain prestige but involved heavy expense, a fact of which John was extremely wary. Other duties included 'regulating of prisoners within the goales [sic]' and he was immediately confronted with a mutiny in Norwich castle, where the prisoners 'have pulled off their irons ... and made much outrage by making and digging many greate holes in the castle'. John lamented that 'these times produce such accions as former ages have not bene acquainted withal'. Corrupt subordinates and excessive fees to pass the accounts at the end of the year were other normal burdens of the office. He appears to have found an efficient under-sheriff, whom he encouraged with presents of honey and saffron, but it was three years after his term had ended before his fines for 'not coming to swear to account' were cleared, his lands were no longer under threat of seizure and he was reassured that '(for matters of your sheriffalty) you are a free man'.[47]

In 1653, John's elder brother Sir Robert died. Two other older brothers had died long ago and, like Robert, left no sons to inherit. The two youngest brothers, Henry, of Thorington in Suffolk, and Clement, of Longford in Derbyshire, both had heirs who were to be significant, in varying ways, in the history of Holkham, but that lay well in the future. The great estate of Sir

Edward Coke, having survived Robert's extravagances, an attempt to vary his settlement by private Act of Parliament and sequestration during the Civil War, now, thanks to accidents of succession, passed to the fourth son, John. His moderately-sized property at Holkham was transformed into the focal point of a major estate, as it has remained ever since.

This involved significant changes in the administration of the estate. Sir Robert had maintained his father's arrangements for managing the Norfolk and Suffolk properties from the house at Godwick, near Tittleshall. The rents had been paid there and its 'evidence chamber' housed the voluminous audit books, surveys, valuations, counterpart leases and manorial court rolls. John Pepys, who had been Sir Edward's secretary, had continued to work for Sir Robert, and John Stubbe, Sir Edward's nephew, had continued as steward of the Norfolk and Suffolk manors. In the early 1630s they had both occasionally helped John Coke, particularly in a dispute over tithes which he referred to as 'my first suit', but by now John had his own agents and lawyers. Stubbe was instructed to hand over the manorial court records and the management of estate and household expenditure was transferred to Holkham, where it was in the hands of Edmund Wise (c.1654–55), succeeded by Will Linstead (1655–57), Phillip Palgrave (1657–60) and John Brewster (1660–61).[48] Henceforth, the Norfolk audit or payment of rents was held at Holkham and the Suffolk audit at Norwich. Local bailiffs collected the rents and paid them in at the audits at Lady Day and Michaelmas. The large sums of money thus collected were stored at Holkham in bags in the 'porch closet' or in a chest or little trunk, as noted in typical entries in the accounts:

> May 25 1658 the money received at the Auditt at Our Lady last is putt into the closett cupboard, in all £1,000
> 3 November 1660 puttt into the chest of the money rec[eived] att Holkham audit then £800; putt more into the porch closet which was then recd £935.6.8.

Expenditure was met by taking out the requisite amount of cash, whether it was £25 for a coach horse or £2,300 for the purchase of a large property. Most of the withdrawals were payments to the steward; one volume survives of Phillip Palgrave's separate detailed account showing how he spent it.[49]

It was probably at this time that Sir Edward's library first came to Holkham, where much of it still remains. In 1642, when Sir Robert had attempted to sell some of the settled lands, he had also claimed the right to print his father's manuscript books. John had contested Sir Robert's claim on the grounds that the books were settled in the same way as the lands. After

Sir Edward's library catalogue, a parchment roll over 12 metres long.

Robert's death, John's legal advisers gave 'long and serious' consideration to the best way of retrieving the chattels or personal belongings entailed by Sir Edward, presumably including his library and manuscripts. They hoped that Sir Robert's servant would hand over 'those which were not imbezelled in the life of Sir Robert Coke' but they also contemplated an action in Chancery to obtain the others. The books were not mentioned in the household inventory made after John's death in 1661, perhaps because they had been settled as heirlooms.[50]

Holkham remained the focus of John's ambitions even after he had inherited the great estate: possession of the latter enabled him to pay for major purchases at home. His investment in Holkham was not at all diminished by the fact that his long efforts to protect the descent of the whole estate had met the greatest problem yet, in the obduracy of his only surviving son. This culminated in a complete breakdown of their relationship after the latter came of age in 1657, but by now the interests of Holkham had acquired an identity of their own, overriding any concerns about his heir. Early in 1659, when John finally gained possession of the third Holkham manor, Burghall, he immediately set about embanking and draining its extensive marshes (described in the chapter 'Marsh, Sand and Sea'). Later in the same year he made another major purchase crucial to the future shape of Holkham,

paying £2,300 for the extensive land and property of Edmund Newgate, gentleman. It included his 'capital messuage' which dominated the village at the staithe and, more than two centuries later, gained its present appropriate name as the Ancient House. The rest of Newgate's property, still known many years later as Newdigate's farm, included four other houses, six gardens, 300 acres of land, thirty acres of meadow, thirty acres of pasture and 450 acres of marsh, all concentrated in the north of the parish. The arable land alone increased John's existing arable by more than one third, bringing it to over 1,100 acres. Although Newgate was not a manorial lord, he had a foldcourse that stood comparison with those of Burghall and Hill Hall. Known as 'the Stath, otherwise the Marsh, otherwise Newgate's foldcourse', it consisted of his own marshes, lying east of the Borough channel and the marshes that John had just drained, and most of the Staithe Field.[51] The Newgate family had been acquiring land in Holkham since the mid-fifteenth century; when Edmund died in 1671 his epitaph traced his family back for six generations. He had been increasing his holdings over the same period of time as John Coke and had undertaken the earliest known drainage of marsh land at Holkham, but by the late 1630s he was complaining of incursions and

A Norfolk yeoman depicted in a Holkham deed of 1658.

oppressions by Coke, 'a man of very great estate and owner of most parte of the lands and tenements lyinge in Holkham'.[52] Newgate's property was a particularly important acquisition for the Coke estate, both financially and territorially. This land on the northern edge of the parish was part of the narrow coastal strip of 'singularly fertile sandy loam' that Arthur Young described 150 years later, and it was already valued as such.[53] This had been evident in the valuations of the Neales and Burghall manors many years earlier and it was emphasised by a stipulation in John's will in 1661 that land in Staithe Field should be let at ten shillings an acre, whereas land in South Field was worth only six shillings. Even more importantly, the purchase of this block of freehold land completed John's ownership of most of the parish. Several decades later it enabled Thomas Coke to reclaim more marshland and to shape the northern boundary of his newly-created park.[54] John was also alert to any smaller properties to round off the Holkham estate. In 1658 he bought an estate from the executors of Robert Congham for £439, which he immediately conveyed for his daughters' benefit, and in 1660 he bought Richard Curtis's house with four roods of land for £70, John Julian's land for £350 and the lands of Robert Thorogood, a King's Lynn merchant, for £625. In the early-eighteenth century, Thorogood's farm would be the first to disappear under Thomas Coke's landscaping.[55]

*

John and Meriel had had fifteen children but no more than three sons had been alive at any one time and, within two years of John inheriting the great estate in 1653, only the youngest was still living. Of the nine daughters, the eldest, Bridget, had married in 1634, lost both her husband and young daughter, married again to Isaac Astley of Melton Constable, and was again widowed. Perhaps because of the dispute over the provision by their grandfather for their marriage portions, the five surviving younger daughters did not marry until the 1650s at the relatively advanced ages of twenty-three to twenty-seven. Two married on the same day in 1651, Winifred to William Cobb of Gray's Inn, son and heir of a Yorkshire baronet, and Theophila to Charles Legard, also of Yorkshire. Two more married in April 1653, Margaret to Alexander Rokeby, son and heir of William Rokeby of Skyers Hall, Wath, in Yorkshire, and Elizabeth to Jeffrey Cobb, merchant, of Yarmouth. The last daughter, Mary, was married in April 1657 to Sir Nicholas Le Strange of Hunstanton.[56] The reason for the Yorkshire connection in three of these marriages has not yet been traced. At least four of the daughters either lived in their father's house at Holkham with their husbands, a common arrangement in the seventeenth century, or were there often enough to have designated rooms and for their father formally to absolve them from all debts

John and Meriel's nine daughters and six sons depicted on the memorial in St Withburga's church.

due for their board and that of their servants, horses and dogs. There are tantalising glimpses of the daughters' role when Mary received bags containing the audit money and Theophila paid the house steward during her father's absence in London. Theophila's situation was unusual, for by 1661 her father was paying towards 'the maintenance and bringing up of my daughter Legard's children, by reason of their father having so unnaturally left them'. He was, in fact, imprisoned for debt in the Marshalsea, the London debtors' prison.[57] Reminders of the precarious nature of seventeenth-century life were ever present. Mary had a stillborn son the year after her marriage, Theophila must have given birth to her third daughter around the same time, for the child died, aged two, in 1660, and both Mary and another of her sons died soon after her father in 1661. On the other hand, there were also traditional celebrations, maintained by Coke, as by many local gentry, regardless of the policy of godly reformation pursued by the central government during the Interregnum of the 1650s. Christmas was heralded by the appearance in the accounts of long lists of dried fruit, spices and nuts early in December, then extra help was hired in the house, a butcher was paid for 'helping in Christmas' and fiddlers and pipers provided entertainment.[58]

'Holkham Hall' used as John Coke's address in 1634.

John Coke was described in anecdotes recorded by Sir Nicholas Le Strange. They were not particularly flattering in tone so it was perhaps fortunate that Sir Nicholas died before his son married Coke's daughter. Coke was said to have been offended by 'one that ignorantly wrote him Cooke, not Coke' but an onlooker commented, 'Any man that ever saw him (for he was a great fellow in large folio) would swear he should be written oo rather than o.' His large stature was matched by his 'loud vociferation and bawling at all conferences' which must have been felt by his colleagues on the county committees in the 1640s.[59] Other evidence gives glimpses of a typical prosperous gentleman. He enjoyed flying hawks and his man of business in London reported on the availability of a wide variety of merlins, falcons and other birds. Dogs were kept and a 'setting bitch' was bought, so he evidently also hunted with dogs. He may have regularly spent some time in London, as was increasingly fashionable; certainly he was there in May and June 1657 when £300 was taken 'to carry to London'. He dispensed charity, paying a school dame's quarterly account and providing clothing for poor children. The contemporary description of him as 'a great fellow in large folio' hints at a love of books. The carrier and the post frequently delivered books and 'news books' and, four centuries later, the library at Holkham still includes many political pamphlets and official publications dating from the time of the Civil War and Protectorate.[60] His contacts with Thomas Lushington (1590–1661), clergyman and author, who lived at nearby Burnham Norton while

in forced semi-retirement from the Church, reveal that he was interested in Soccinian theology, a forerunner of Unitarianism. Soccinian works had been circulating in England for some years and in the mid-1650s Lushington sold on to him four books that he had obtained from Octavian Pulleyn, a London printer or bookseller, who also offered Lushington (and through him, Coke) 'a few Soccinian pieces my servant met lately wthall in Holland'. A couple of years later, Lushington sent Coke 'the tract that you required of me … concerning the Nature of God' and asked for it to be returned after Coke had copied it, so that he would have it to hand to defend 'against the objections and cavils which hereafter will assault it'.[61] Coke bequeathed his library of books and manuscripts 'of what art or science whatsoever … for the benefit of my heirs male and posteritie' and the four books from Lushington can be tentatively identified in the Holkham library today.[62]

There is no information about Coke's household in earlier years but by the 1650s he had twenty-three servants, indoors and out. The most highly paid was Edmund Wise, the steward, on £30 a year. The five maids on £2 to £3 earned less even than the cook's boy and butler's boy but one of them, Susan Heydon, was left the great sum of £50 in John's will. She was probably a relation who, after the early death of the lady of the house, had filled the role of housekeeper. The household possibly included a chaplain, for in 1658 John's man of business was trying to recruit one in London 'but if I cannot speed here, I will take Cambridge in on my way and provide you one there if possible'.[63] John's income, household and status had long since outgrown Hill Hall. It was occasionally known as Holkham Hall as early as 1634 and it is unlikely that he delayed improvements until his old age, but no account book survives from earlier than the late 1650s.[64] Then in 1659 large numbers of bricks were bought, two bills were paid 'for colouring the dininge room' and a carpenter was making new dressers. Tantalisingly, there is a gap in the accounts from November 1659 to May 1660 but another flurry of activity in May to November 1660 shows that work was being done 'about severall buildings'. A bricklayer was paid 'for the lodge building', 'about the house att home' and for work on the brew house, malt house and kitchen. John Edge, mason, was paid for three weeks work on the porter's lodge and 'for work about the great house'. Various people were paid for bricks and Dutch tiles; brick moulds were made, showing that brick making was carried on at Holkham as in the following centuries. The total expenditure over nearly five months was more than £256, followed by about £160 during the next five weeks that included some non-building expenses. These amounts indicate considerable extension and improvement when compared with building elsewhere on the Norfolk estate, such as Longham Hall, rebuilt in

1621–22 for £290, and a new house at Appleton for Sir Edward Coke's chief estate steward which had cost £220.[65] By the time of an inventory made after John's death in 1661, there were about eighteen chambers (compared to five in 1600) with more servants' rooms in the outbuildings. It may be, as was often the case in other houses, that some of the new chambers had been created by reducing the height of the great hall to a single storey and placing chambers above it. The long gallery was not mentioned in this inventory but evidently survived, for nearly fifty years later it contained drawers holding important papers. There was a new parlour as well as the old, and a spacious new dining room. The old dining room was still furnished with tables, a large couch, eighteen chairs and a pewter cistern but the new one was large enough to need thirteen window curtains, an oval table, three side board tables, two couches and twenty-seven chairs, with embellishments such as a picture and a large looking-glass. The porter's lodge was a two-storey building, with a chamber over the lodge and possibly also chambers for John Brewster, the house steward, and Mr Wythe. The latter was probably the chaplain, for Edward Wythe appears a few years later as the vicar of Holkham.[66]

Although a gentleman's residence, the house was still the centre of a working farm, already a slightly old-fashioned arrangement. The husbandmen or farmworkers had two rooms somewhere near the porter's lodge, the farm bailiff and one of the stable staff, whose room contained a press in which to hang saddles, were housed in the vicinity of the yard, and even the harvest-men were allocated a chamber, although it lacked bedsteads. The premises near the yard included a barn, stable and mill, with 'a horse that use to grind in ye said mill'.[67] Two surviving account books and a few individual bills show the farm and household in action under the steward, Philip Palgrave, during the last two years of John Coke's life.[68] Sometimes he was handed money from the closet or one of the trunks but he also directly received rents and proceeds from the sale of wool, rye, hides, skins, barley, malt and livestock. He paid out for both estate and household expenditure. He settled the bailiff's bills for farm labour and paid for livestock, seed, sheep clipping, hay making, threshing and harvest. John Coke's three flocks totalled over 2,100 sheep; bullocks and steers were also bought, sold or killed for the table. Farming at Holkham, so celebrated in later centuries, was already vital for supplying the considerable consumption of a large household and a significant income. Saffron was grown and dried, probably for export from Wells-next-the-Sea. In the July before John died, twenty-four saffron gatherers spent four days collecting the saffron corms to be cleaned and divided, four men ploughed and fourteen people worked for two days clearing stones from the saffron ground before the corms were replanted.

A page from Philip Palgrave's accounts for John Coke, listing building work at the manor house in 1660.

When the blue crocus flowers, whose orange 'chives' or stigma would be harvested, appeared in September, there were payments 'for setten up ye saffron hille' (a canvas pulled taut above a gentle fire on which the saffron was dried).[69] When John died in September, a painted box in a closet (a small room) in the house was found to contain 28 pounds (over 12kg) of

Inventory of John Coke's manor house after his death in 1661.

dried saffron.[70] On the domestic front, Susan (Heydon) and a few other servants presented lists of their outgoings to the steward for payment, only the totals being recorded in his book, but Palgrave himself paid for individual items in great variety: olives and capers, pipes and tobacco, cloth for pudding pokes, a pan to souse fish, an hourglass, cherries and apricots, spices such as 'anniseeds, cominseed, colianderseed', soap by the firkin, candles by the hundred, scurvygrass and wormwood (for medicinal use), ribbon and yarn for Peg Mansuer (a seamstress), silk to make napkins, shoes and gloves for servants, two coal cradles and nets for the larder windows. 'Making pyes' was a special skill, paid separately. Tradesmen also presented their bills to Palgrave: they included the plumber, the carriers, the cooper, the pump-maker, 'Hookes the post', the chimney sweep, the hop-man at Fulmodestone, the basket-maker and the smith.

In September 1661, despite the powders, cordials and elixirs that Dr Smith had supplied with increasing frequency, John Coke the elder died.[71] It was nearly fifty years since his marriage to Meriel Wheatley had established the Coke family at Holkham. During that period, through marriage, inheritance, purchases and draining of marshes, he had acquired about 2,000 acres, the majority of arable land in the parish. He had seen Holkham become the centre of the great estate that had been founded by his father, with lands in several counties. He had married his eldest son into an aristocratic and politically prominent family, though to little effect, and two of his daughters had married local baronets. He had served as a deputy lieutenant and High Sheriff of Norfolk. Although he had supported the parliamentarians during the Civil War, he had apparently welcomed the restoration of the monarchy in 1660 and it was said that, if Charles II's proposed Order of the Royal Oak had been established, in the last year or so of his life he would have received a knighthood.[72] He had improved and extended the old manor house, which would continue as the home of the Coke family until replaced by the new Holkham Hall in 1756. Soon to be assessed for hearth tax on thirty-four hearths, it had at least twice as many rooms as in his wife's father's time. It was now much grander than its neighbours at Holkham (where the next in size had five hearths), larger than the Walpole family's old house at Houghton (about twenty-three hearths), roughly the same size as Thomas Bedingfield's Oxburgh (thirty-four hearths) but smaller than the Pastons' luxurious Oxnead (forty-five hearths) or John Hobart's Blickling (fifty-eight hearths).[73] His great failure was his relationship with his only surviving son, John the younger, who now inherited the estate.

The English Gentleman

YOUTH

Virtute tute / *Vox laeta nescia lethi*

RECREATION

Non arcum semper tendit Apollo

DISPOSITION

Nitimur in vetitum

ACQUAINTANCE

Certus amor morum est

EDUCATION

Vbera et verbera

MODERATION

Moderata durant

VOCATION

Patimur et patimur

PERFECTION

Hac cælum petitur via

Spes in Cælis

Pes in Terris

Generoso Germine Gemma

Ro: Vaughan fecit

Chapter 3

Mortalities and Minorities 1661–1718

Throughout the remainder of the seventeenth century, a comfortable lifestyle at Holkham barely concealed a series of significant misfortunes. Two short-lived and largely ineffectual heirs involved the estate in costly mistakes in the disposal of land, protracted legal proceedings and an expensive foray into politics, and they were followed by a long minority at the end of the century that failed to benefit the estate. Only eleven years later, another minority began as the next heir, Thomas, at the age of ten, lost both his parents within a matter of weeks. Then, however, skilled and dedicated management by his guardians during this second long minority, from 1707 to 1718, transformed the situation. Controlling expenditure, improving the estate and nurturing the remarkable personal potential of the young heir were to have far-reaching consequences, setting the scene for the building of Holkham Hall.

*

John Coke the younger, who succeeded on the death of his father in 1661 to both the Holkham property and the greater Coke estate, had been the heir apparent since the death of his older brother in 1655. It was normal when the heir came of age for his father to draw him aside for a man-to-man chat, inviting him to join in a re-settlement of the estate to secure its continued descent through the family line. Under the existing settlement, the father was tenant for life and the son was tenant-in-tail, due to inherit on his father's death. Encouraged by the promise of an income in the meantime, the son would agree to his future interest being reduced to a second life tenancy, with his own (as yet unborn) son becoming the new tenant-in-tail. The process would then be repeated in succeeding generations, ensuring that the man in possession of the land could enjoy the income but not have

Richard Brathwayt, *The English Gentleman, containing Sundry excellent Rules or exquisite Observations* (London, 1630). Bookplate of Cary Coke, wife of Edward Coke of Norfolk Esq, 1701.

outright power to sell. It was unusual for the heir to a settled estate to refuse to join in such a re-settlement, not least because lack of cooperation usually left him without an income during his father's lifetime, but this is exactly what happened when John Coke the younger came of age in 1657: 'John Coke the father being by the settlement of Sir Edward Coke but tenant for life desired John his son who was the issue-in-tail to join in a resettlement, so as to make him also but tenant for life, according to the pattern of Sir Edward Coke, but he refused.'[1]

Whatever the reasons for the younger Coke finding his father's proposed resettlement so unattractive, he was said to be supported by a friend, Andrew Fountaine, 'who by that means set him at difference with his father, and to his high displeasure drew him into France'. Fountaine was a member of an old Norfolk family at Salle, distantly related to Coke and a fellow student at the Inner Temple.[2] He maintained that it was 'at John Coke's entreaty' that he neglected his studies to travel in France but Coke family lawyers in the future had little doubt that self-interest came into play. The breach between Coke father and son was dramatic. The two young friends spent three years in France (unfortunately leaving little record of their activities) and on their return Fountaine persuaded Coke, 'for prevention of his extravagances', to live with his father, Brigg Fountaine, 'where he lived for a year with three servants and four horses, and paid but £30 for it'. The young Coke therefore probably did not return to Holkham before his father's death in September 1661.

As he picked up the threads of his inheritance, life at Holkham changed little. A close glimpse of lavish household consumption and the daily routine of the home farm is revealed by individual bills that survive from the first two or three years, pinned together and dated by the steward as he paid them each Saturday: the type of bills that had been entered as totals in Phillip Palgrave's slightly earlier account book. Improvements to the old house continued with payments to a glazier 'for work at Holkham Halle', expenditure on a variety of locks (perhaps a consequence of the change of ownership from father to son) and the spreading of numerous loads of gravel in the courtyard.[3] Furniture was needed, for John the elder had instructed in his will that his household goods should be sold for the benefit of his grandchildren, prompting one of his son's servants to write to the steward at Holkham, 'if your master think of withstanding the Dutch and staying at Holkham, send me the depth and wideness of the parlour chamber and I shall send you down furniture'.[4] This undated letter probably refers to the outbreak of the Second Anglo-Dutch War (1665–67) when a naval battle off Lowestoft brought hostilities particularly close to Norfolk, but John the younger was

The carrier's bill, 1662.

already established in residence at Holkham, for earlier bills show the carrier bringing coats and boots belonging to various members of his household.[5] These included 'Lawrence Lund, a sweade', who was Coke's butler until he 'took shipping for Swendland', and a Frenchman, referred to as 'mounsier', probably a valet acquired during Coke's sojourn in France. An even more fashionably exotic touch for North Norfolk was a 'black boye': the carrier delivered his clothes and the school dame purchased a book for him.[6]

The school dame's bill, 1662.

Despite being unmarried, Coke maintained a considerably larger household than his father's, the increase being mostly in sporting and outdoor servants. Thirty-nine servants were given legacies in his will. Indoors, these included a chaplain, butler, cook, 'caterer' (possibly forerunner of a house steward), usher of the hall, two footmen and four maids. In the stables and outbuildings there were a coachman, postilion, three grooms, two huntsmen, the dog keeper, a farrier and his boy, brewer and brewer's helper, a gunner and a carpenter. The grounds and farm employed a gardener, fisherman, two ploughmen, harrow boy, four shepherds and four husbandmen.[7]

Because of John's earlier refusal to cooperate in re-settling the estate, it was a simple legal matter after his father's death for him to break the entail (the line of descent specified in the family settlement) and thus make himself absolute owner of the estate. By now, Fountaine, the companion in his French travels, was 'the chief manager of his concerns, and there was great familiarity and friendship between them'. Coke had given him a bond for £5,000 while they were in France and within three months of his father's death he added a rent charge (the right to rents from specified properties) of £1,000 per annum from three Norfolk properties and from Minster Lovell in Oxfordshire.[8] This was soon followed by leases of Farnham Royal (Buckinghamshire) for one hundred years at £53 per annum and lands in Mileham (Norfolk). Farnham Royal was one of the most valuable properties outside Norfolk, worth nearly five times what Fountaine was paying for it. In addition, Fountaine was said to have received over £20,000 in cash during

the next seven years. 'John Coke would often say that tho' many envied [Fountaine] yet he was resolved that as he had borne part of the sour, so he should have part of the sweet' and it was 'the general report of the country' that Coke had made plentiful provision for Fountaine's future. In 1666 Fountaine was able to buy the manor of Brookmans, near North Mymms, Hertfordshire. When he married in 1669, his estate was said to be worth £100 a year in land and £18,000 in money on securities, nearly all of the latter derived from Coke's estate.[9] Fountaine's marriage forced Coke to take stock of the situation. He had entrusted Fountaine 'with the custody of all his evidences, he living in the house with him' but now that Coke was ill and wished to settle his affairs, Fountaine delayed returning the documents on the grounds that they were at his house in Hertfordshire. A year or so later, Coke was contemplating marriage with 'a fine woman and a vast fortune' and needed the documents to negotiate the marriage settlement. Fountaine still delayed and the marriage negotiations failed.

Coke was described by the family biographer, C. W. James, as 'a singularly foolish, easily swayed person'. After the rift with Fountaine, he filled the vacuum in managing his affairs with another lawyer of the Inner Temple, William Gwavas, a native of Cornwall. Like Fountaine, Gwavas appears to have been a regular member of Coke's household, for he wrote to Coke's steward at Holkham that he was about to pay poll tax at the Temple, so 'pray let me not be named with you at Holkham & by that means pay twice'. In April 1671, after parting with Fountaine, Coke granted Gwavas a forty-one year lease of Huntingfield Hall in Suffolk, worth £150 per annum, for a rent of only £50, in consideration of his 'faithful service'. The loss to the estate from this low rental continued until negotiations to end the lease finally succeeded only a few years before it was due to expire.[10] Coke's will, made shortly before his death, appointed Gwavas as an executor jointly with Captain Robert Coke (1623–81) of Nonsuch, Surrey, a former naval captain, probably his only surviving male cousin.[11] At the same time, he leased to them at a nominal yearly rent of five shillings several Norfolk and Suffolk manors, worth around £1,500 a year and including the manor of Neales at Holkham, upon trust to pay his debts, legacies and funeral expenses; after four years, the properties were to revert to the estate.[12] Eight years later, however, the situation was still unresolved and it was again left to the guardians of the next generation to attempt to call the executors to account.

Although over-generous to favourites, John Coke the younger showed an unexpected degree of vision for the future of the estate. He purchased half a dozen small properties in Holkham, continuing his father's policy of consolidating his lands, but even more important was his decision in 1665

to place the whole estate under a general settlement, 'in his owne and the name family and Bloud of Sir Edward Coke late Lord Chieffe Justice … his grandfather'. This settlement has been cited as a prime example of a particularly effective form of strict family settlement that was devised in the middle of the seventeenth century, and as evidence of a strong feeling of obligation to the founder of the family fortunes.[13] Yet, as has been seen, only a few years earlier Coke had refused to join with his father in a re-settlement. His change of mind might have been motivated by the fact that he was still young enough to marry and to father an heir. Possibly it also reflects the involvement (before their quarrel) of his lawyer friend, Fountaine, for knowledge of the new form of strict family settlement was becoming widespread among young members of the legal profession; Fountaine, who allegedly had encouraged Coke's refusal of the earlier settlement, and his elder brother James, also of the Inner Temple, were named as the trustees to preserve the contingent remainders, the crucial element in the new form of settlement.[14]

Coke was elected unopposed as MP for King's Lynn in 1670, the year before his death, but played no known part in parliament. He died unmarried, aged thirty-five, in August 1671. The journey to his 'long home', his last resting place, at Holkham was witnessed by chance by an acquaintance on his way to London, whose comments show that, even some thirty-seven years after the death of John's grandfather, the Lord Chief Justice, his legacy to his descendants was still a matter of general repute:

> I saw the carcasse of your great Cook of Norfolk conveying to his long home … The attendance was very moderate, consisting of three coaches, whereof one had but two horses, and about six or eight horsemen in a disorderly manner. I perceived the heire & executors had the gift of parcimony, that however they should bee provided for in wit, the wealth of the family was like to continue yet some time, and that the blessing of crescere and thrivare [accumulating and saving] bestowed on the old lawyer was not yet effete.[15]

*

The death of John the younger ended the brief direct line of descent of the Holkham property amassed by his father, and caused the great estate created by his grandfather (into which Holkham had been absorbed) to pass again to a junior branch of the family, only eighteen years after John senior had inherited it in similar circumstances. John senior had been the Lord Chief Justice's fourth son; the heir this time was Robert (1651–79) grandson of the Lord Chief Justice's fifth son. His father having died a couple of years earlier, Robert lived with an uncle, Roger, at Thorington, in north-east Suffolk, but

was probably still a student at Queens' College, Cambridge. Although three generations of Robert's family had lived at Thorington, in the house settled on that branch of the family by the Lord Chief Justice, there was no hint of any possibility of it becoming the centre of the great estate. The Holkham property was now pre-eminent, to the extent that, when Robert obtained a private Act of Parliament to remedy defects in the family settlement, the power to grant leases specifically excluded the 'capital messuages' of Holkham as well as the ancestral home at Godwick and the much-valued park of North Elmham.[16]

Robert was the first of the family, although still a commoner, to marry into the ranks of the nobility. The wealth of the Coke estates was now such that he was quickly recognised as a suitable son-in-law by Thomas Osborne (1632–1712), Earl of Danby, later Duke of Leeds, who was appointed to the powerful government post of Lord Treasurer in 1673. Robert's marriage to Danby's eldest daughter, Anne, took place in November 1674 when she reached the age of sixteen, but his prospective father-in-law, whose ruling passions were 'pride and ambition', had already been at work on his behalf, seeking (unsuccessfully) to secure his election to Parliament for King's Lynn at a by-election in 1673.[17] He succeeded two years later but the election was 'not so easy and cheap, for his managers did not keep in due bounds, but let loose the tap, all over that large town, and made an account of £7,000 or more due to the town, besides what had been paid for expenses'. This saddled Robert with a loan from Danby of £5,000 (equivalent to well over £400,000 in late twentieth-century values) at six per cent interest, only paid off more than thirty years later by the guardians of his grandson. Despite such heavy investment in his election, Robert was not active in Parliament, needing 'to be spoke to attend', and there is little to suggest that his father-in-law inspired in Robert any ambition for an active public role. The year after the election, when there was 'a great gathering' of the royalist or court party at Holkham, the house was so full that the mistress of the house, Lady Anne, gave up her chamber for a visitor and her father had to share a room with a relative, but it was Danby's presence, not Robert's hospitality, that drew the visitors and guests.[18]

In 1673 Robert was appointed a deputy lieutenant of the county. He did not, as was once thought, serve as High Sheriff but he appears to have been involved on the fringes of a controversy about the burdens of the office in the early 1670s. Forty men had recently put their signatures to a document known as the Norfolk Subscription, stipulating limitations on the expensive trappings of the office if any of them were appointed. Coke had a copy of it, with only thirty-nine signatures. Many of the subscribers were connected

with the emerging 'country' party, supporters of the Lord Lieutenant, Lord Townshend, and possibly they had hoped Coke might join them. Thanks to the machinations of Robert's father-in-law, however, Townshend was replaced as Lord Lieutenant by Robert Paston, Lord Yarmouth.[19] Robert continued as a deputy lieutenant and when Lord Yarmouth prepared to welcome the Justices at his first Assizes in the summer of 1676, he knew he could count on Robert's attendance: 'I heare my cousin Coke will bee very splendid att the assizes, with new liveries, and he very fine'. Nevertheless, Robert was not moved to start attending lieutenancy meetings.[20]

Much of Robert's time was spent in London, where his household arrangements were closely dependent on his parents-in-law. He lived in lodgings until his wedding, after which his man hired 'a coach to carry my master's night cloathes to Wallingford House', recently occupied by his father-in-law, on the site of the present Admiralty in Whitehall. By 1677 Robert and his wife had moved to Hampden House, on the site of Downing Street, another house recently connected with Danby and next door to one of Danby's homes, the Cockpit Lodgings. They made frequent visits to Danby's house across the river at Wimbledon. A sole surviving account book, covering the period May 1673 to May 1675, and numerous individual bills for board and lodging at inns, show Robert frequently on the move. He might spend a few days at his property in Kingsdown, Kent, combined with a visit to his cousin, Captain Robert Coke; a few summer weeks at his old Suffolk home, Thorington, with visits to Gwavas, the tenant at Huntingfield; and a week or so in Bath, breaking the journey at his Oxfordshire property at Minster Lovell. The only obvious visits to Holkham during the period of the account book were about ten days in October 1673, three weeks after Christmas 1674 (shortly after his wedding) and a week in the following March, but other sources show him busy in the local social round at other times. His running footman wore out numerous pairs of pumps but enjoyed ample refreshment at inns on errands to and from Newmarket, Swaffham and Dereham, runs of up to sixty miles each way. Robert interrupted one visit to Newmarket to dine with the new Lord Lieutenant, Lord Yarmouth, en route for Norwich, and organised an 'abundance' of his tenants to join the splendid procession escorting him into the city. On one of his visits to Lord Yarmouth's house at Oxnead, his host was not greatly impressed by him: 'they plied the cup att that rate that I ... could not chuse butt pitie a young man soe given to it, that I doubt it's a hard task for him to live one day without an excess in that way. He has gotten the new way of despising marriage, more especially a mann's owne wife, butt payed mee this visit with much respect.' Robert was then going on to Godwick and a 'venison feast' at Elmham before setting

out for London a week or so later. His country life revolved round the favourite gentry diversions of hawking and hunting, with hounds and spaniels kept at both Godwick and Holkham. Otter hunting expeditions could occupy ten days, when ten or more horses, huntsmen and dogs were accommodated at inns. Payments for 'stopping the fox burrows' and for digging out foxes show that the relatively new pastime of fox hunting had also reached Norfolk.[21]

Robert's lifestyle concealed the fact that his finances were stretched. His predecessor, John the younger, had died before proceedings could be taken to require Fountaine to give up the deeds of the disputed properties and several Norfolk and Suffolk manors were still in the hands of his executors. Lord Yarmouth was frustrated to find, visiting Holkham in 1675 when Lord Danby was there, that 'it was impossible to have opportunity to entertaine my Lord Treasurer long with intreagues, the affair of Mr Coke's executor and business of the settlement of differences betweene them taking up all the time that was not spent in discourse of publicke natures and divertissements of going to the seaside & cards'. John Ramsey, who had been 'by recomendacon of the Earl of Danby concerned and employed to assist Robert Coke in his affairs', later testified that Robert had been 'much in debt and importunately presst by his creditors' and had borrowed from several persons as well as from his father-in-law. Probably for that reason, unlike his two predecessors he made no purchases of land or dwellings at Holkham.[22] Robert died from smallpox at Hampden House, his London home, in January 1679, aged twenty-eight, after fewer than eight years as head of the great estate. 'I am sorrie for the fate of my pore cousin Coke', wrote Lord Yarmouth to his wife, 'who as you say has had little joy in his match and things are now in a distracted posture, every body fearing to lose their money, and [King's] Lynn £4,000 behind though £6,000 has been payd'. Despite embodying the social aspirations of a wealthy gentleman's family, Robert's time at Holkham was not remembered as significant or successful. Thomas Coke commented many years later, on hearing news of another marriage, 'I wish he may have better success in marrying a treasurer's daughter than my grandfather Coke had.' Robert's greatest success was to produce an heir. He died ten months after his little daughter and a few weeks after a new-born son but left a three-year-old son, Edward, to inherit Holkham and the rest of the great estate.[23]

Robert died intestate and Lady Anne, 'a fine young widdowe' then aged about twenty, took upon her the guardianship of their infant Edward.[24] She immediately moved next door into one of her father's London homes but, with strangely coincidental timing, Robert had died just as his father-in-law

was facing impeachment. Within three months, Danby's fall from grace was complete and he spent the next five years in the Tower of London. He maintained a busy social life there and his family had free access, so it is possible that he kept an eye on his widowed daughter's and grandson's interests but, for eighteen years or so, during the minority of Edward, the history of Holkham becomes virtually invisible.[25] Lady Anne and her father appointed an estates receiver, William Dewes (c.1638–1717) who 'came to live with her as her steward after the death of her husband' but little information survives about the running of the Holkham house and estate.[26] In 1683 she was described in a legal document as 'of Holkham' but it is not clear that she spent much time there.[27] In 1691 she married Colonel Horatio Walpole, uncle of Robert Walpole, the future prime minister, and they took up residence at Beck Hall, a Coke property near Billingford, about twenty miles from Holkham, after which Danby, the Duke of Leeds, now back in power as a minister, took over the guardianship of Edward.

John Coke the younger's dispute with Fountaine still haunted the family. Attempts to retrieve Fountaine's leases and rent charges had been thwarted when Fountaine promptly brought his own legal action and gained possession of the disputed lands. It was not until 1694 that the Duke of Leeds at last reached an agreement with Fountaine that, when Edward Coke came of age a few years later, Fountaine would be paid £10,000 to surrender the leases and the rent charge lands. This sum was considerably less than the demands he had been making but it must have helped to finance his purchase, only a year later, of the Narford estate in Norfolk (near the Coke property at Castle Acre) which is still the Fountaine family home. Thus one family prospered as a result of the legal carelessness of another. A generation later, Fountaine's son, also named Andrew (c.1677–1753) would become a well-known art collector and amateur architect, and a friend of Thomas Coke, twenty years his junior, the builder of Holkham Hall.[28]

The provisions of the younger John's will for payment of his debts and legacies were still unresolved. The infant Edward's guardians attempted to call the surviving executor, Gwavas, to account and to retrieve from him the properties charged with clearing the debts. The courts decided in their favour but Gwavas died in 1685 before the judgement could be enforced. In 1692 they were still attempting to gain satisfaction from the executors of both Captain Coke and Gwavas who, they calculated, after payment of John Coke's legacies and expenses, owed £10,000 to the present heir, Edward Coke.[29] It would be easy to dismiss such legal convolutions as illustrating little other than the cumbersome procedures of the law, but the situation demonstrates the problems facing a great estate if the life tenant or his predecessors

Cary Newton's library list.

lacked trustworthy advisers, trustees or executors. The result was that, after many years of claims and counterclaims, exacerbated by the untimely deaths of protagonists on either side, the successors of John the younger were still faced with a situation where estate income was reduced by the loss of rents from the lands in dispute and encumbered with the expenditure needed to retrieve them.

This was still the situation in 1696 when Edward married Cary, the sixteen-year old daughter of John Newton, who three years later would inherit a baronetcy and properties at Barr's Court in Somerset and Culverthorpe in Lincolnshire. Through her mother, Abigail, a member of the old

Edward Coke (1676–1707) by Michael Dahl, *c.*1700.

Cary Coke (1680–1707) by Michael Dahl, c.1700.

Suffolk family of Heveningham, Cary had inherited estates in Suffolk and at Conisborough in Yorkshire, and also a library of books, many of which bear her personal book plate and are still at Holkham. She had lived with her maternal grandmother for ten years after her mother's death but remained close to her father, a relationship that was to prove crucial to the future of Holkham. There is little evidence to show how the estate was managed by Edward for the next ten years. He employed two old family servants as his stewards: John Rogers, who had been responsible for some of Edward's father's accounts, and Humphrey Smith, possibly the former servant boy of the same name who had been left a bequest by Lady Catharine Coke of Longford eight years earlier, 'towards putting him out an apprentice'.[30] If so, Smith was the first of many servants supplied over the years to Holkham from the Longford estate; he went on to serve as the Holkham estate steward until 1722. Edward's short tenure of Holkham was beset by debt. The estate that he inherited when he came of age in 1698 was estimated to yield £6,271 annually in rents, of which Holkham parish accounted for about £630.[31] This was nearly £1,800 more than in 1691, partly because the properties left in the hands of Fountaine had at last been brought back into the estate. On the other hand, however, Huntingfield Hall and park were still under lease at a low rent to Gwavas. Edward's mother was also benefitting unduly from his estate. The rents allocated for her jointure or widow's income were estimated to have reached £1,488 annually, although the family settlement had limited jointure lands to a maximum of £1,000, and Lady Anne and her second husband had not been called upon to account for the large increase in income.[32] Furthermore, when Edward came of age in 1698, he 'never took or demanded any account of his mother touching his guardianship', which typically should have been a period of retrenchment.[33] He was still liable for the large debt incurred by his father at the King's Lynn election more than twenty years earlier and his grandfather, the Duke of Leeds, did not scruple to request payment of the interest. In 1702, Edward and Cary had to borrow £3,000 at short notice.[34] Just a few weeks before Edward died in 1707, Sir John Newton was urging his daughter, Cary, that her husband should attempt to 'have an estimate of the debts, which will best show [him] what can be done out of the personal estate' rather than making a further charge on the landed property that should descend to their children.[35]

It is unclear how much time Edward and Cary spent at Holkham. Immediately after their wedding they stayed for a few weeks with the Duke of Leeds but planned to spend the summer with Edward's mother in Norfolk, presumably at her home at Beck Hall. They would return with her to take a

house in London for the winter 'but my lady [Anne Walpole] to have the management of it'. Given that Cary was only sixteen, such an arrangement is not surprising but it probably ended with the advent of children. Thomas was born in June 1697, the year after the wedding, followed by Cary in 1698, Ann in 1699, Edward in 1702 and Robert in 1704. By 1698 the family was living in St James's Square, first renting the Countess of Thanet's house and then Lord Dover's. Their household soon grew to an impressive size, including a steward, groom of the chambers, five footmen, porter, butler, houseman, two house maids, cook, kitchen maid and two nursery maids, in addition to personal servants who were not paid through the domestic accounts. From at least 1700, they also rented Sir Thomas Pope Blount's house at Tittenhanger, near St Albans, Hertfordshire. In contrast to Holkham, this was a modern house, conveniently situated only twenty-five miles from London, and their only surviving domestic accounts book suggests that they spent much time there between May and November.[36]

Nevertheless, Holkham soon took over as their favourite summer and autumn home. The distance, and the overturning of a wagon during their first recorded journey in May 1704, did not deter them from taking the whole family again in the following May. Cary reported that the children 'all bore thare journey vary well' and the baby was 'as well pleased with lucking about him, as the rest of the children could bee'. They liked Holkham. Cary thought 'the countrey vary pleasent' and on another occasion Edward mentioned that 'we have had so many neighbours always with us that I could not find time to write to any body'. Even the receiver at Cary's property in Yorkshire heard of Edward's 'generous receptions and entertainments' and his 'hospitality towards the poore'. In 1706, the family was still at Holkham in November and Edward 'had a minde to keep his Christmas heare'. Their eldest son was developing fast, according to his mother: 'Tommy is grone a mighty horse man. Mr Brooks [the tutor] gives him a great Charecter as to his Book, & says hee is foreder then any of his Age; Mr Coke has put the hole government of the child to him, as indeed he has a vary preaty way of manigine of him.'[37] By now, however, Mr Brooks' assistance was particularly necessary. Cary had been ailing for over a year but it was her husband, Edward, who died less than four months later on 13th April 1707, at the house in St James's Square. He was aged thirty or thirty-one and his heir, Thomas, was not yet ten.

*

By his will Edward appointed three guardians for Thomas and his siblings. The first was Sir Edward Coke (1648–1727) of Longford, Derbyshire, the oldest member of the family but in hierarchical terms junior to young

Thomas, his grandfather having been the youngest brother of Thomas's great-great-grandfather. The Lord Chief Justice had bought the Longford estate for his youngest son in 1616 and the present Sir Edward had inherited it through his grandfather, father and elder brother; it was the only property bought by the Lord Chief Justice that had not been absorbed into the great estate. Throughout the seventeenth century, Longford seems to have had a more settled history, certainly a more settled line of descent, than Holkham and in later years it was to provide many men of expertise for Holkham. Another of the guardians, Charles Bertie, of Uffington in Lincolnshire, was one of Edward's great-uncles, brother of the Duchess of Leeds; he died in 1710. The third was a younger man, John Coke (1678–1736), a lawyer, of Baggrave in Leicestershire. He was a younger brother of the Vice-Chamberlain to Queen Anne, Thomas Coke (1674–1727), belonging to a separate Coke family long associated with Trusley and Melbourne in Derbyshire. Despite the coincidence of family names and the proximity of their Derbyshire properties, it has long been thought that there was no blood connection between the Cokes of Trusley and Melbourne on the one hand and the Cokes of Holkham and Longford on the other, but it is clear that, however distant the relationship, it was strong enough to involve John Coke in the guardianship and for his fellow guardian, Sir Edward, to call him 'cousin'.[38] These three guardians were immediately joined by Cary's father, Sir John Newton.

The choice of guardians had been carefully considered, for they all acted with remarkable commitment in both personal and estate affairs. They swung into action soon after Edward's death. Minutes were recorded in a book and initially, as a tactful courtesy, referred for approval to the Duke of Leeds. They met frequently, probably in London: about twenty-three times in 1707, gradually reducing to five times in 1714 when the surviving minute book ends. A separate account book was kept. The stewards were immediately instructed to report on various specific aspects of the estate, including how long 'it will be convenient for Mrs Coke to continue the lands at Holkham in her own hands'. On 4th August, however, only four months after her husband's death, Cary finally succumbed to her long illness, adding to the guardians' responsibilities the care of the children, the household and the house at Holkham. Three weeks later, 'the family broke up'.[39] The guardians' concerns now covered the full range of financial, estate, domestic and personal matters. They arranged for Thomas, who had been looked after by his tutor and five servants since his father's death, to go to school at Isleworth, near London, attended by Matthias Longstreth, who had been with the family since his days as footman to Thomas's grandfather. The plate, domestic goods, horses and carriages at both London and Holkham were

sold but the guardians took care to keep back certain goods 'appraised by the heire'. They also 'agreed to buy the books belonging to Mr Cokes and Mrs Cokes librarys at the house in St James [London] for the use of the heir, as also the books that were brought up from Holkham', an early indication of the influences that shaped the young Thomas's understanding of the importance of a 'fine library'. At the same meeting they arranged for the steward, Humphrey Smith, to become tenant of the farm at Holkham and to look after the mansion house. The remaining servants were discharged but care was taken that the butler, 'who lost his eyes in Mr Coke's service', the porter and Nurse Smith should all receive annual allowances during the minority, as Mrs Coke had always intended to provide for them. Arrangements were made for the two younger boys to lodge with Mr Casey, probably an old family servant, and the two girls joined the household of their grandfather, Sir John Newton.[40]

The guardians' relationship with the children was reinforced by a strong sense of family history and status. Sir Edward wrote that 'the affection I have for so near relations, and in their circumstances as orphans, does extremely heighten my inclinations to do em all the service I am capable of'. When eleven-year-old Thomas acquired his first wig, Sir Edward's indulgent response blended pragmatism with a touch of pomposity: 'in prudence

The guardians' minute book.

The final section of the Coke family pedigree by William Camden.

and as relations, we ought so to carry o'selves to him as to make him love & esteem us here after; there is no harm in a perruque, ruffles and other new clothes, his estate sets him above the consideration of these things'. Although of the same generation as young Thomas's grandfather, he paid deference to Thomas's position as heir to the great Coke estates: inviting Thomas to Longford a couple of years later, he promised 'an hearty and affectionate welcome as is most due to so nere a relation, and the Head of my Family'. Sir Charles Bertie expressed himself equally ready to concur 'in any thing that may be judged for the service of the heir' and John Coke, not so closely related, earned the other guardians' gratitude for employing 'so much of his time and study for the improvement of Tommy's Person and estate'.[41] The guardians' sense of family history was shown by their prompt decision to seek advice from Gregory King, a prominent herald and engraver, about cleaning or replacing the family pedigree, probably the one compiled by William Camden (1551–1623) Clarenceux King of Arms, that is still preserved, with a contemporary copy, in the Holkham archives. They ordered the church at Godwick, next to the Lord Chief Justice's old house, to be repaired and a

The family mausoleum at St Mary's, Tittleshall.

burying place for the family to be built at nearby Tittleshall, where a plain brick mausoleum attached to the church still houses generations of Coke coffins, from tiny to large. The importance of family and estate records was fully recognised and the evidence room at Holkham was locked and sealed until arrangements could be made to catalogue the contents. Mr Bedingfield was the last of several men so employed and spent two months 'taking an account of all the evidences & books'. There were also seven drawers of papers in the Long Gallery to be taken to the lawyers.[42]

Minorities tended in any case to be periods of recuperation for family finances, young children being much cheaper to maintain than large households, but Thomas's guardians demonstrated on his behalf both expertise and ambition, evidently drawing on considerable experience in running their own estates. Immediately after taking control, they gave orders tightening up aspects of general estate management, varying from the maintenance of hedges to expenditure on repairs, the latter to be done 'by the direction of the steward not at the discretion of the tenants'. Tenants were to be required to live on their farms and the stewards were instructed to report on 'the condition of the tenants and their farms … for the better distinguishing between the good and bad husbands in order to encouraging the one and timely admonishing the other'.[43] Such attention to both practical details and long-term strategy laid the foundations for the fame of Holkham farming in

later decades. Under the guardians, estate income increased from £4,203 in 1707 to £10,188 in 1717. Holkham parish was the prime focus of their attentions, where rents rose from £595 to £1,064. The increase was accounted for almost equally by lands purchased by the guardians and rents 'improved by management'. Smith was instructed 'to agree for the purchase of lands in Holkham if any are to be sold', a policy that had been pursued effectively by John Coke senior and junior, abandoned by their successors, and would now continue for more than a hundred years until the Coke family owned the whole parish. Some of the farms at Holkham were reorganised, including the old Parsonage or Honclecrondale farm, which was taken in hand for a year, improved by enclosures and then let to a new tenant for £99, an increase of fifty per cent on the old rent. Among the guardians' earliest interests was the possibility of enclosing the marshes and of creating a deer park at Holkham to replace the old deer park at North Elmham. In the event, the former became one of Thomas Coke's earliest projects and the latter was achieved in a later century by the 2nd Earl of Leicester.[44]

The young heir remained at the Isleworth school for two and a half years. In March 1710, however, illness caused him to miss lessons, a matter of regret for the schoolmaster, who felt that he had 'never had in appearance a greater inclination to study', and alarm for his elderly guardian, Sir Edward, who promptly invited him to Longford. He hoped that 'a proper kitching diet' and exercise would improve Thomas's health but he soon realised that more was required in caring for a lively twelve-year-old. His education immediately caused 'great Thought and Concern' and a tutor, Mr Wilkins, was employed. Wilkins found young Thomas to be 'a gentleman of extraordinary good natural parts, of a great capacity, who has applied himself extreamly much in reading some of ye best Classick Authors and Latin as well as English poets' but all too easily distracted by his favourite pursuit of cockfighting and bored by the lack of opportunities to go shooting. The guardians were already discussing the possibilities for him to travel abroad and in the summer of 1711, when Thomas was just fourteen, they agreed that he should gain experience by touring the Peak District for a few weeks with his tutor. The latter reported afterwards that he had gained 'great credit and reputation among the gentlemen of the county for one of his years'. He was rapidly outgrowing what Longford and Mr Wilkins could offer, as Sir Edward described that autumn:

> … he grows tall, is plump and looks fresh and vigorous and … his behaviour better fashion'd, yet I can't prevent his conversing with my servants, and ordinary people in the neighbourhood, wch may have no

good influence upon his morals, neither his going too often abroad an hunting often with the gentlemen about us, wch I find makes him grow more cool towards his studies, and less tractable towards his Governor; his passions are strong and violent, and should be early regulated, civilizd and softend, and this requires a Governor of sound judgement and admirable addresse. My cosen withal has a quick apprehension, a faithful memory, and a good understanding, qualityes that if they take an happy turn and tincture from a good education will make him an ornament to his country, and a comfort to his friends; else he may prove unfortunate in all respects both to his friends himself and his estate, for he will either be very virtuous or – [Sir Edward here wrote a dash, implicit of unspoken foreboding] for his sanguine complexion will not let him act a moderate lazy part.

There was some thought of Coke going to study at Cambridge, which he visited in the autumn, taking in the houses at Boughton and Burghley on the way, but soon Sir Edward was urging, 'the sooner he goes abroad, the better it will answer the improvement of his mind & person'. Early in 1712 a visit to London included a trip to his old school haunts at Isleworth but his stay was disrupted by illness; despite his precocity, he was not too old to be tended by his old Nurse Smith. Wilkins returned to Longford and, after Thomas's recovery, his former tutor, Mr Brooks, returned temporarily to take him on a trip to Salisbury, Bath, Bristol and Oxford.[45]

Greater plans were moving ahead quickly, however. By June the guardians had secured the services of a new governor, Dr Thomas Hobart, a Fellow of Christ's College, Cambridge, who had recently returned from escorting a young nobleman on his Grand Tour.[46] In July, after he had first sent a trunk round to Dr Hobart's and bought some books 'to take beyond sea', young Thomas left London for Norfolk, escorted by the Holkham steward, Humphrey Smith. He spent a few days with his grandmother at Beck Hall, taking the opportunity to kill a buck which he proudly despatched to Sir John Newton, and then enjoyed a fortnight's stay with Smith at Holkham, his first visit since his parents' deaths five years earlier.[47] It was a hail and farewell occasion: church bells rang out to greet him at villages en route, ships' crews fired their guns and Wells-next-the-Sea men came to Holkham to salute him with drums and firearms. He enjoyed at least one sea fishing trip, evidently keenly anticipated for he had bought fishing tackle just before leaving London, and dined with several neighbours. He also gave orders for fruit trees and evergreens to be planted near the house. Then, towards the end of August, a few weeks after his fifteenth birthday, again escorted by Smith and Smith's son as well as his personal servants, he set off for Dover,

where Dr Hobart joined them. The party waited five days for a fair wind and then crossed the Channel to Calais.[48] Smith returned to England after a few days, leaving Coke ready to move on with his entourage of Hobart, the latter's Italian friend and assistant, Domenico Ferrari ('Sinior Ferare Puncanella' as young Thomas christened him), his valet and grooms and his own horses, which 'Dr Hobart was so kind as to carry over'.[49] It would be six years before he returned to England.

*

Thomas Coke (1697–1759) by Francesco Trevisani, Rome 1717.

The Grand Tour of Europe was the normal fashionable way for young gentlemen to bridge the gap between boyhood and manhood, broadening their horizons geographically, culturally and socially. What each drew from it varied greatly but Thomas Coke's character, abilities and circumstances ensured that his unusually long tour would shape the future transformation of Holkham. Its duration, ending just before he came of age, was not pre-determined by his guardians but grew out of his own wishes, encouraged by Dr Hobart, as he developed an insatiable appetite for all that foreign travel, and particularly Italy, could offer. He was highly intelligent, eager to learn, self-willed and active. He was supported, not least financially, by understanding and far-sighted guardians and accompanied by an experienced and scholarly governor who was eminently capable of guiding his academic and artistic interests. The servants who travelled with him included his valet, Edward Jarrett, an old Longford servant who had looked after him since he first arrived at Longford and who would keep the daily accounts that now reveal so much of his master's activities in Europe, making it possibly one of the best documented of all Grand Tours.[50]

Typical pages from the Grand Tour accounts, Rome 1717. At the foot of the left hand page, payment to Trevisani 'for cloath to draw my master pictur on(e)'.

During the first two or three years of his tour, until he was about eighteen, Coke received a certain amount of formal education at academies in France and Italy, starting with six months at Angers and then a shorter spell at Aix 'to make Mr Coke remember what he has formerly learnt'.[51] After crossing into Italy towards the end of 1713, he spent time at academies in Rome, Naples and Turin. He was not impressed by them. The Turin academy had been particularly recommended by his guardians but he was relieved to find that, having a governor of his own, he could avoid being whipped and 'treated like a child as the Piemontese are in this academy'.[52] The courses at the academies concentrated on the courtly skills of riding and fencing but Dr Hobart added elements of the humanities and civil law and arranged for private lessons from masters in language, mathematics, geography and the flute.[53] Already, however, Coke was developing strong interests of his own. Soon after arriving in Rome for the first time in February 1714, still only sixteen years old, he discovered the passion for architecture that was to dominate the rest of his life and leave a remarkable legacy to posterity. Visits to villas, palaces and gardens were frequent and varied. Before long an architecture master was paid for two months' daily tuition and Thomas bought royal paper (that is, large sheets measuring 20 by 25 inches, 508 × 635mm), rules and other 'instruments to larne architecture'.[54]

He soon also met William Kent (1685–1748), under whose initial guidance he rapidly developed a life-long enthusiasm for art. Now in his late twenties, Kent had been in Rome for the past four years, supported by various patrons in return for purchasing works of art on their behalf and producing copies of original paintings for them, while developing his own talents as an artist in the studio of established artists, Benedetto Luti and Giuseppe Chiari. Despite his humble origins, Kent was an affable and interesting character, with wide artistic contacts in Rome. By May, Coke could write to his grandfather, 'I am become since my stay at Rome a perfect virtuoso, & a great lover of pictures, even so far as to venture to incroach on the kindness of my guardians in having bought some few.'[55] In fact, according to Kent, during this first stay in Rome Coke commissioned pictures from 'six of the best painters', as well as one from Kent himself which was probably aborted. The first published description of Holkham, Brettingham's *Plans and Particulars* in 1773, specifically identified three, by Chiari, Procaccini (since lost) and Conca, as having been painted for Coke in Rome. In each the young patron was depicted as one of the figures.[56] In the summer of 1714 Coke and Hobart left Rome for three months to visit Florence, Venice and other northern Italian towns. Kent accompanied them for a while and, after they had parted company, continued to buy pictures and drawings on Coke's behalf. In the

Sebastiano Conca, 'Vision of Aeneas in the Elysian Fields'. The young Thomas Coke appears as the lyre player on the left.

autumn Coke again apologised to his guardians that his love of pictures had caused him to 'a little outrun in those I have bespoke, but being myself at Rome, & seeing such a number of fine things, I must confess ... that I could not hinder myself from making free with more money than my allowance, & I am afraid incroaching too much upon the good nature & kindness of my guardians'.[57] Hobart's great personal interest was in manuscripts and books and it was during this period that Coke developed a similar enthusiasm, writing to his grandfather that 'during my voiage round Italy I have bought several of the most valuable authors that have write in Italian or about the country, the reason that I incroach so far on your kindness to me ... is, that if I miss'd the occasion of buying books while I am travelling, I should not be able to find several of the best of them, and it's impossible to buy them to my mind unless I myself am present, & certainly one of the greatest ornaments to a gentleman or to his family is a fine library'.[58]

In the spring of 1715, Coke crossed back into France to spend a few months there, mainly in Chambéry. He had now been abroad for nearly three years, Hobart's leave of absence from his college had been for three years and, back home at Holkham, there were signs that they were expected

Thomas Coke's letter to his grandfather from Rome, 24 May 1714.

to continue northwards and return to England. Repairs at the Holkham house included 'painting the wainscot once over in the great room before the paintings were put up'. Young oaks and ashes were planted on the north side of the house, kennels and stables were repaired and brought into use, and a huntsman and a groom, supplied with 'a thorough livery', were employed. The groom went into Lancashire to find breeding mares; two horses presented by Sir Edward Coke were brought from Derbyshire and another came

from Coke's new brother-in-law, Wyvill.[59] Coke, however, was in no hurry to return. He wrote somewhat disingenuously to his grandfather in July 1715, after the death of Queen Anne and the fall of the Tory government, that he had heard that 'all good company & conversation are intirely lost in England by the great inverateness of the parties, that reason made me more desirous of staying longer abroad & to be able to pass away the time & see what curiosities I could I desired leave of Sir E & Mr John Coke to make a little tour in Germany' and then to spend one more winter in Italy, 'to confirm myself in the language & the virtuosoship of that country'. Accordingly he travelled into Switzerland, on into Germany as far as Frankfurt, then back into France, still buying books. During a stay in Lyon, he bought an important collection of manuscripts from the convent of the Discalced Augustinians, a spectacular start to his interest in literary manuscripts. Reaching Marseille at the end of 1715, he embarked for Sicily, further south than most men ventured on the Grand Tour, and spent six weeks there, sufficiently memorable for him to hang five 'views of the ports of Sicily' many years later in the Family Wing dining room of his new house.[60] He again sought reasons to prolong his travels: 'my curiosity pushes me so far as to imbark tomorrow morning for Malta which will finish my journey but while things continue to be troubled in England I think one can't keep too far from it'. A month later it seemed that his plans might be disrupted by 'the most unwelcome & surprising news' that his sister Ann had eloped with Philip Roberts, the son of one of her grandfather's neighbours in Soho Square. He declared that he would 'have nothing more to say to her' but, for the sake of his family's reputation, he was anxious to arrange matters properly and wrote that, 'if there is no other way, I am ready myself to return, tho' I should be very sorry to interrupt the course of my travels'.[61]

This proved unnecessary and he returned from Sicily to Italy, meeting up again with William Kent to spend the summer of 1716 in Rome, buying pictures, drawings and his first recorded sculpture, the colossal bust of Lucius Verus that would eventually stand in the North Tribune of Holkham Hall. He immediately resumed architecture lessons, payments for them equalling tuition in music, language and mathematics as an integral part of his studies during the three months of his stay. This time the master was identified in the accounts as 'Signor Giacomo', the architect Giacomo Mariari. He was already known to other English visitors but Coke sought his tuition to an exceptional extent. Mariari supplied him with paper and they also roamed the buildings of the town, examining and discussing what they saw: as Thomas left Rome in September, Mariari was paid extra 'as a present for goeing about the town with my master and larning of him architecture'.[62]

'Lucius Verus' in the North Tribune.

Coke spent the remainder of 1716 again exploring Florence, Bologna and the towns of northern Italy. A year after the 'one more winter in Italy' for which he had sought permission, he wrote from Bologna to one of his guardians, 'You will be certainly much surprised to find me at this present in th[ese] parts. I assure you I myself never thought it but m[y] great love for the company & curiosities in Italy made [me] willingly hear to Doctor Hobart's desires of passing the winter here & returning for a small time to Rome, but not to come home so young [he was then nearly twenty] & to profit of that town & Florence.' By now, collecting was an essential aspect of his travels: 'I should not nevertheless have been prevail'd on to continue in Italy without being able to justify my curiosities in buying some other things here, which Doctor Hobart promis'd to do, & answer my Guardians for the expence.' Thus he returned for a third and last visit to Rome, arriving early

in 1717. Among his purchases this time were the massive statue of Jupiter that never achieved the prominent position he perhaps already envisaged for it in his future new Hall, and the statue of Diana, destined for a happier future at Holkham but which, according to Kent, nearly led to Coke's imprisonment for attempting to export it without a licence.[63]

In the midst of his passion for collecting works of art, he did not fail to resume his architecture lessons. There were further lessons with Giacomo Mariari but the emphasis was increasingly on payments for permission to make drawings at various places and for 'adjusting' drawings, such as 'to Signor Jacomo for adjusting drawings with a cornish [cornice]'. It is not clear who was doing the drawings for which permission was sought but it is possible that some were Thomas's own efforts: if so, they have almost certainly not survived.[64] It is possible to calculate from the accounts that, during the course of his three spells in Rome in 1714, 1716 and 1717, his regular formal tuition, probably daily, from Giacomo totalled about eight months, in

'Jupiter' eventually found a home in the Victorian conservatory.

Chapter 3 Mortalities and Minorities 1661–1718

'Diana' in the Statue Gallery.

addition to an unspecified amount of time spent examining buildings with him.[65] The fact that Coke came back to his classes each time with increasing maturity, and ever-widening experience of innumerable visits to notable buildings throughout Italy, can only have enhanced the effectiveness of the lessons. He would return home to England not only fired with nascent ambitions to design and build a classically-inspired masterpiece but also equipped with an informed and intellectual approach to doing so, backed by a considerable degree of practical training in architectural principles, drawing and how to learn from observing existing buildings.

Francesco Bartoli, *Church of the Gesù in Rome*. Thomas Coke and Hobart are shown silhouetted in profile against the Capella Sant'Ignazio.

By now, Coke's purchases were arriving in England. His guardians paid out on several occasions 'for taking up chests, cases etc at the Custom House sent from Thomas Coke Esq' and for the freight of statues, pictures and books. Coke left Rome for the last time in April 1717 but was still in no hurry to return home. He spent several weeks in Florence, Venice and Padua, where he made important purchases of manuscripts. He then travelled north by

Van Dyck, 'The Duc d'Arenberg', purchased in Paris, May 1718.

way of Vienna, where he had to be restrained from joining a military campaign, and on to Prague, Dresden, Berlin, Hamburg, Hanover, Amsterdam and Brussels. Ten months after leaving Rome, he reached Paris, where he bought more pictures, including van Dyck's large equestrian portrait of the the Duc d'Arenberg which hangs in the Saloon at Holkham. In Paris he was reunited with his young brother, Edward, just embarking on his own Grand Tour. He was tempted to accompany him to Lorraine, 'had not my Guardians required my return'.[66]

```
                          Sir Edward Coke
                                |
   ┌──────────┬────────────────┼──────────────────┐
3 older    JOHN              Henry             Clement
brothers  1590–1661         1591–1661         of Longford
                                                1594–1629
              |                 |                 |
   ┌──────────┤         ┌───────┼──────┐   ┌──────┴──────┐
 JOHN              Richard    Roger   Edward      (Captain) Robert
1636–1671        of Thorington       cr. Baronet 1641   of Nonsuch
d. unmarried      1626–69                                 1623–81

Thomas Osborne
Earl of Danby 1632–1712
His wife's brother Charles Bertie
joint guardian of Thomas
   |
Lady Anne Osborne ══ (1) ROBERT        Robert           Edward
= (2) Horace Walpole    1651–79     2nd Bart., d. 1687  3rd Bart., d. 1727
                                                  joint guardian of Thomas
                           |
          John Newton = Abigail Heveningham
                   joint guardian of Thomas
                           |
                   EDWARD ═════════ Cary Newton
                   1676–1707         1680–1707
                           |
   ┌───────────┬───────────┼───────────┬───────────┐
 THOMAS      Cary        Ann         Edward      Robert
1697–1759   b. 1698    b. 1699      b. 1702     b. 1704
```

BOLD CAPS – the Holkham family
Italics – other persons mentioned in the text

Family tree showing the descent from Sir Edward Coke to Thomas Coke.

Chapter 4

Thomas Coke:
'From the Old House to the New'
1718–1756

Observant neighbours at Holkham would have noticed in the summer of 1718 that Humphrey Smith, steward of the Coke estate, was absent for the unusually long period of four months. Perhaps it occurred to them that young Thomas Coke must soon be of age to come into his inheritance: he had last been seen at Holkham six years earlier, a fifteen-year old boy enjoying a short visit on the eve of his departure for the Grand Tour. In fact the steward and his son had travelled to Boulogne to escort Coke and his party back to England in due style. They landed at Dover on 13th May and arrived in London on the following day. On 17th June, Coke came of age. On 3rd July he married Lady Margaret Tufton, 'a Lady of Great Beauty, Singular Virtue and Goodness', third daughter of the Earl of Thanet, who had celebrated her eighteenth birthday the day before her bridegroom came of age.[1] Sixteen years later, having landscaped, planned and pondered throughout the 1720s, Coke would embark on the inspired and massive building project that was to dominate the rest of his life. After another twenty-two years, when he had long since become the Earl of Leicester, Holkham Hall was ready for occupation and the old manor house for demolition. He died only three years later, leaving Lady Margaret, the dowager Countess, to guide his life's work to completion. In the course of forty years, alongside the daily life of the household, the improvement of the wider Norfolk estate and his busy social round, Coke transformed every aspect of Holkham – countryside, farm and village – and created at its centre an architectural masterpiece.

*

In 1718, despite Coke's long absence on the continent and the speed with which the arranged marriage took place, the new household was established smoothly, partly thanks to a strong contingent from Longford, the

The Obelisk, erected 1730–32.

Derbyshire home of Coke's guardian, Sir Edward Coke. Long-standing family servants filled at least half of the twelve indoor male posts, including Jarrett, the former Longford servant who had accompanied Coke throughout his six years on the continent. John Casey, rewarded for 'his great care' of Coke's young brothers, was to oversee extensive alterations at Thanet House on Great Russell Street, the London house provided by the bride's father as part of the marriage settlement.[2] Abraham Thomas, another Longford servant, ever willing to lend pocket money when Thomas Coke had arrived there as a thirteen-year-old, joined the household as Coke's valet; adaptable and efficient, in later years he was promoted to 'secretary' and meticulously ran the Norfolk or 'country' accounts.[3]

The new household spent the next four months at Longford, enjoying the hospitality of Sir Edward Coke, with whom Thomas had lived before his Grand Tour, and rediscovering the pleasures of country living. 'I have retrieved my old faculty of hallowing the hounds as well as ever', Coke wrote to his grandfather.[4] Humphrey Smith returned to his duties in Norfolk, running the estate and the home farm. His son, Edward, as Gentleman of the Horse, kept the Holkham domestic accounts, whose contents reflected the pre-eminence of the stables, hounds, hunting and gardens.[5] By the time that Coke and his household settled into the refurbished London house at the end of February 1719, Lady Margaret was expecting a child; her son, Edward, was born in June and Coke's old nurse Smith came out of retirement to take charge of the nursery. It was September 1719, well over a year after the wedding, before the household came to Holkham for the first time. For the next few years, life at Holkham followed a regular pattern. For the first eight or nine months of each year, the old house was occupied only by a housemaid. Occasionally she 'boarded' the brewer, entertained a visiting tenant to a drink and catered for the tenants' audit dinners on rent days. The few other permanent servants worked outdoors: 'Old Mary' looking after the poultry and pigs, a rat catcher, two gardeners, the farm bailiff, four husbandmen, and half a dozen hunt staff, who were based at Holkham but travelled with the hounds when Coke was hunting elsewhere. Then, every September, the scene changed dramatically. Leaving the London house in the care of the porter and a housemaid, the full household descended on Holkham for a stay of three to four months. About ten servants, often including a French cook, arrived by stagecoach, wagon or sea.[6] The lower servants were joined for their meals, probably still taken as in previous centuries in the panelled hall of the old house, by the outdoor men who had been on board wages (an extra payment in lieu of meals) while the rest of the household was in London.[7]

Food consumed during the household's first stay at Holkham in 1719.

It was at least twelve years since Holkham had last played host to such a large household. The revival of life in the manor house was a welcome windfall, not only for the local girls who, in these early years, were hired by the week as kitchen maids, but also for local farmers. Although some goods were sent ahead from London by the carrier, during the three months of the family's first long visit in 1719, and despite a bout of illness that swept through the house in the autumn, the household consumed 933 stones of meat, 875 pounds of butter, 1,946 eggs, 375 chickens and 60 turkeys, all supplied by the home farm, local tenant farmers and a butcher who rented the marsh grazing land. They also supplied large quantities of hay, straw and beans for the horses, horsemeat and milk for the hounds and puppies. Oats for the horses were not a worthwhile crop where barley could be grown and

were often freighted from the Derbyshire estate or from Yorkshire: Arthur Young, the agricultural writer, commented in later years on the farmers' trade through the port at Wells-next-the-Sea, 'carrying wheat, barley and pease thither, the wagons bring oats back'.[8]

Coke rapidly made the transition from the freedom of travelling to the responsibilities of his new role, interesting himself in estate affairs and filling the blank endpapers in his guardians' minute book with queries and instructions for his steward, Smith, such as 'to have all my woods survey'd … to have the tenants pay their rents half yearly as other gentlemen even in Norfolk

Thomas Coke's notes and queries about estate matters, written on the endpaper of his guardians' minutes book.

doe ... to inform myself of Smith concerning [leases]'.[9] During his first visit to Holkham, he took expert advice about enclosing the salt marshes, a move that his guardians had considered several years earlier, and within two years had let 'the new enclosed marshes' for £400. Otherwise the focus of his winter visits to the country was hunting, 'which diversion wee pursue so earnestly', wrote Coke's uncle, Michael Newton, 'that wee have hardly time to repair by eating or sleeping the loss of spirits wee sustain, by such continual exercise'.[10] Expenditure on the stables and hunt exceeded that on the gardens or the farm. The hunt servants looked after approximately thirty-five horses, with additional breeding mares and foals at Godwick, and up to thirty couple of foxhounds and thirty-six couple of harriers or hare hounds, some of which were kept at Beck Hall, about twenty miles from Holkham. Local people (including shepherds) were paid for 'preserving' foxes, finding hares, killing predators such as pole cats and informing on people who killed foxes or game; numerous fox covers were protected by enclosing them. Otter and deer hunting also featured occasionally.[11]

The Grand Tour, however, was by no means a distant memory; six years of education and travelling remained a lively influence in Coke's new life. Edward Spelman, dedicating his translation of Xenophon to Coke years later, recalled the variety of life at Holkham, 'when we were Fox-hunters, and a long Day's Sport rather tir'd than satisfied us, we often pass'd the evening in reading the Ancient Authors' who 'made us forget not only the Pains, but the Pleasures of the Day'.[12] When in London, servants were sent to pay freight and customs charges or 'to enquire about ships coming in with pictures and books' and Coke had the pleasure of re-discovering his purchases as they arrived in England at intervals during the next four years. They included 'the large Claud Lorain ... the great Van Dyke, Albano etc', a Leonardo da Vinci manuscript, other manuscripts from Hamburg, cases of books shipped from Ostend and 'statue and pictures brought over in the Superb man of war'. Consideration was given to cases in which to house the manuscripts in the London house. A bookbinder, John Brindley, who held the post of bookbinder to Queen Caroline and to Frederick, Prince of Wales, and a Frenchman, Pelletier, whose task was 'pasting' or mounting drawings, were kept busy intermittently for several years. Dr Hobart was paid for several purchases (wine, books and manuscripts) that he had made on Coke's behalf.[13] These included the manuscript of *De Etruria Regali*, written by Thomas Dempster in 1616–19, the first comprehensive study of the ancient Etruscan civilisation, whose publication at Coke's instigation came to fruition in 1723; the original manuscript volume, the drawings, copper plates and accounts for the publication process, and the printed edition, all at

Thomas Coke's books on architecture, listed in 1727 in a 'foul Draught of the Catalogue of Books'.

Holkham, bear remarkable testimony to Coke's vision and involvement.[14] Other entries in the accounts reveal that Coke maintained his Grand Tour interest in the practical side of architecture. It is not surprising that he soon subscribed to the second edition of Andrea Palladio's *Four Books of Architecture* and the first two volumes of Colen Campbell's *Vitruvius Britannicus*, both of which had first been published in 1715 while he was abroad but, more significantly, in 1720 he bought two cases of mathematical instruments, one of them costing the considerable sum of ten guineas, and had similar older instruments cleaned. Itemised in the accounts by a different servant, they were undoubtedly similar to the 'instruments to larne architecture' that he had needed during his Grand Tour.[15]

Coke's household served him well for his first four years but it was to some extent a stopgap arrangement. Changes were inevitable on the domestic front when the two old hands, Jarrett and Casey, departed. Lady Margaret now became closely involved at both London and Holkham, receiving at least some of the housekeeping money from her husband or from the London cashier, paying out most of it to the new house steward and settling some bills directly. Perhaps this was partly a diversion from personal sadness, for the son born in 1719 was destined to be an only child: during the next three years, three little Thomas Cokes and another baby were miscarried or died soon after birth. Nevertheless, Lady Margaret's involvement marked the beginning of lifelong supervision of the accounts.[16] On the estate side, the need for a change in management became imperative. Thanks to the prudence of his guardians, Coke had succeeded to an estate cleared of his father's debts and yielding rising rents. Within two years of his marriage, however, his enthusiastic expenditure on establishing himself in London and county society had incurred debts of £15,000. Then in 1720 he joined the frenzy of speculation in South Sea stock. Failing to extricate himself before the bubble burst a few months later, he lost well over £37,000. The interest on this debt in a typical year (1722–23) was equivalent to a third of his net income of £7,302. After expenditure on the household, stables, hunting and other expenses, and despite a sizeable profit from the gaming tables, the result was a deficit of £992.[17]

Urgent measures were needed to overhaul estate management, maximise income and control finance. The steward of Sir Edward Coke's Longford estate, George Appleyard, was sent over to inspect the Holkham estate in 1721, for a fee of fifty-five guineas, and in the following year he replaced Humphrey Smith as its steward. He also took over from Smith's son the supervision of expenditure on the stables, hunting and gardens. Appleyard was by far the most important recruit from Longford, his abilities and status warranting a salary of £200, a house at Holkham and the tenancy of an estate farm. Only a few letters survive from Coke to Appleyard, written in the summer of 1724 when Coke was in Bath suffering from both ill health and pressing debts. They show him anxiously assuring Appleyard that his expenditure was 'very moderate', asking Appleyard to visit him and bring the account books, considerate of the pressure of work on Appleyard, and signing himself 'your loving friend'. For twenty years, until his death in 1742, Appleyard was a key figure at Holkham. Under his stewardship, rents continued to rise: gross rents from about £9,102 in 1720 to £12,629 in 1740.[18]

It was not only the unexpected debts incurred by Coke's venture into South Sea stock that prompted the overhaul of estate management. By now

it was well known in Coke's circle that he wanted to build. His uncle, visiting Holkham in 1721, the year after the South Sea debacle, wrote that Coke 'likes this place so will [sic] now that I believe if ever he builds it will be here, & he will find it necessary to add something, for there is not convenient Room for the company he usually has with him'.[19] In the following year, the death of Coke's grandmother, Lady Anne Walpole, relieved the estate of the annual payment of £1,200 for leasing back her jointure lands.[20] With Appleyard now at the helm of estate management, this was sufficient encouragement for Coke to make a start on his long-term plans for Holkham. Beginning with the transformation of the landscape, such plans were already sufficiently well formulated by 1722 to require the closure of the road from Burnham Market to Wighton where it ran through Holkham village, along the southern boundary of the grounds of the old house. This was the prelude to extensive landscaping to the south and new walled kitchen gardens in the old village centre, followed by work to create a stretch of water to the north-west (see chapter 8). This comprehensive planning and large-scale landscaping work was accompanied by a major shift in the balance of Coke's life between London and the country, testimony to his close involvement: instead of spending only the three or four winter months at Holkham, from the middle of the decade he and his household were settled there for at least seven months of each year.

The fact that Coke now saw Holkham rather than London as his principal residence was reflected in the household. By the end of the 1720s, 'the number in family at Holkham' reached thirty-seven. At 'my lord's table' Coke and his wife were joined by the vicar and by Dr Ferrari, who had accompanied Coke for the early part of his Grand Tour and was now his librarian. The housekeeper, lady's maid, secretary, valet, butler and gardener dined at 'the Steward's Table' and twenty-seven lower servants gathered at 'the Servants' Table.'[21] Although the list is reminiscent of the old arrangement of upper and lower tables in a central hall, the house had long since had a separate family dining room (built by John Coke in 1659) and increasing residence at Holkham prompted the construction of a servants' hall in 1729.[22] The three footmen, two French cooks, kitchen maid, three housemaids and two laundry maids were joined for meals by about sixteen outdoor workers, most coming over from the stables and kennels but including also the game keeper, cocker (in charge of the fighting cocks), gardener's apprentice, wheelwright and farm bailiff. The husbandmen or farm workers, on the other hand, no longer ate in the house as in earlier years but were 'boarded' in the village.

There are glimpses in the records of the household at work and play. There was something approaching a household orchestra, an old-fashioned

feature of country house life that continued at Holkham at least until the late 1730s. Abraham Thomas, the valet, had been a 'fiddler' since his Longford days; a footman, Hiero Somering, played the bass, and other servants played violins, a bassoon, hautboy and French horn, all bought and repaired on the household account, along with 'songs'.[23] Visiting fiddlers entertained at Christmas and the New Year, just as they had in the previous century, and a barn was rented one Christmas for a company of travelling players. A different country custom was experienced in 1732, the first year that the household was still at Holkham in May, when a donation was made 'to the people going about on May Day'.[24] Senior servants when visiting London were treated to

'The Number in Family at Holkham' in 1730–31.

the opera, to which Coke subscribed, and throughout the 1740s and 1750s in the country there were numerous outings for all Holkham servants to enjoy plays at nearby Walsingham, followed by supper.[25] Women were paid to nurse ill servants, even those suffering from smallpox, and wine was often provided for the invalids.[26] There were more shadowy figures, too, in the household, such as Mun Saunders, 'a sort of scullion in ye kitchen during Lord Leicester's lifetime … most commonly call'd the Fool'. He was not paid a wage but was possibly a distant relation, for in earlier years there had been a long-standing annual donation to Mrs Saunders, a grand-daughter of John Coke, who was 'in extreme want'.[27]

Coke was described by contemporaries as 'the fat, laughing joking peer' or, less sympathetically, 'the oddest character in town; a lover, statesman, connoisseur, buffoon'.[28] His household accounts reveal another side to his personality, for he and his wife were also enlightened employers, unusually aware of their servants' abilities and aspirations. Philip Bender, for example, a footman since 1722, was provided with a spaniel and a gun in 1729 so that he could shoot game for the kitchen. Three years later he left his post as one of the four footmen, on wages of twelve guineas a year, to become park keeper at the old and much-valued deer park at North Elmham, on a salary of £24 plus nine guineas 'to make up his perquisites'. In future he employed a maid of his own. With the valet and secretary, he was admitted as a Freemason in 1731 when Coke was Grandmaster.[29] A decade later, another footman, John Neale, was encouraged by Coke to make an even greater change, gradually turning to a full-time and profitable career in house painting and gilding.[30] Relationships between servants were tolerated, an attitude that was the exception rather than the rule in country houses. At least two footmen married housemaids and moved into estate houses in the village, and one of them later became the porter at the London house.[31] Several servants lent money on bond to their employer, contributing in a small way to cash flow during the period of building and in return benefiting from a trustworthy savings facility. In 1734, the year that building started, interest was paid on £82 from Abraham Thomas, the secretary; £84 from Philip Bender, the former footman, and £40 from Jerry Somering, footman; £100 from Will Tomley, the London house porter, and £50 from Sarah Smith, the housekeeper. Similar loans from servants or former servants continued for many years. One or two of the principal estate workers were granted leases of farms, such as Thomas Morecraft, recruited as estate carpenter from Longford in 1722, who moved into an estate house at Tittleshall, soon became tenant of Little Wicken Farm there and promptly added a new parlour, chamber and garret to the house. By 1734, he had £300 on loan to Coke.

In the following year, he took on a twenty-one year lease of a larger farm at Wellingham.[32]

As Coke started to spend longer periods at Holkham in the 1720s, his fighting cocks were brought over from Longford and he enjoyed visits to 'cockings' at Holt, Thetford, Swaffham and King's Lynn. In one probably typical year, fifteen cocks and fifteen pullets were kept.[33] Less obvious in the accounts was the fact that Coke owned at least one race horse, kept at Newmarket, which was easily visited on the way to London. His brother, Edward, had a stud at Longford and owned a particularly famous horse, 'Sham', later known as the Godolphin Arabian. His brother-in-law, Marmaduke Wyvill, and his uncle, Sir Michael Newton, also owned or bred race horses. Many of Sir Michael's horses in the late 1720s were said to be 'got by Lord Lovell's Arabian'. Several horses bought by Coke in the 1720s and early 1730s exceptionally cost as much as £52 10s each, suggesting that they were for racing or breeding. He attended race meetings, both locally, such as the annual meeting at Holt, and in Oxfordshire.[34]

While the pleasures of country life continued and landscaping work progressed, Coke's thoughts were focused increasingly on building. With his appointment as a Knight of the Bath in 1726 and his elevation to the peerage as Baron Lovell in 1728, his social status was growing and a story soon circulated in London political circles, causing some amusement, that he had openly voiced his opinion that his wealth warranted a peerage.[35] Debts continued but income from the estate was rising.[36] His finances received an encouraging boost in 1729 when, on the death of his father-in-law, Lord Thanet, he acquired an annual income from the Dungeness lighthouse dues as part of his wife's dowry. In the following year, the culmination of nine years' work on land south of the house, the Obelisk started to rise, surrounded by the saplings that would form Obelisk Wood, on high ground exactly aligned with the centre of the intended house.[37] It was a striking visual statement of intent.

A detailed planning map of the whole parish, drawn and updated during the 1720s, shows the old house, new features superimposed on the old landscape and, immediately east of the old house, a blank space destined for the new Hall.[38] Responsibility for the design that was to fill that space has long exercised commentators and architectural historians.[39] The process of designing Holkham, a process which continued until the Hall was nearing completion, embodied on the grandest scale many elements typical of its time: a circle of erudite and enthusiastic gentlemen who were profoundly interested in discussing and evolving the application of classical models to domestic architecture; a stage in the development of the architectural

profession when it was by no means unusual for craftsman builders, such as Henry Flitcroft, Thomas Ripley, Isaac Ware and Matthew Brettingham, to make (with varying degrees of success) the transition to architect; a design process that was not solely reliant on paper plans but involved continuous on-site collaboration, adaptation and even trial and error; and a tradition of skilled craftsmen who were accustomed to taking responsibility for interpreting details.[40] It is generally accepted that, as Matthew Brettingham junior wrote in 1773, the 'general ideas' for Holkham were 'first struck out by the Earls of Burlington and Leicester, assisted by Mr William Kent' but the extent of their respective contributions has long been, and still is, a matter of debate.[41]

Richard Boyle, 3rd Earl of Burlington (1694–1753), was in the 1720s the most celebrated proponent of Palladian architecture and the acknowledged arbiter of architectural taste. Traditionally, however, there has been more conjecture than evidence for his direct contribution to the design of

Detail from a large planning map of the mid-1720s, showing the old hall or manor house, the site for the new Hall and the beginning of landscaping work.

Holkham. Although slightly older than Coke, he had come later to an interest in architecture and during his two short visits to Italy in 1714–15 and 1719 he could not match the formal architectural tuition and indefatigable visits to buildings of architectural interest that so greatly appealed to Coke during his Grand Tour. Once back in England, however, he rapidly made his mark in the 1720s with prominent buildings in and around London, including his own villa at Chiswick.[42] Coke knew him socially and, as Brettingham indicated, these two knowledgeable and enthusiastic men must have enjoyed lengthy discussions about architecture. Lord Hervey referred to an early plan for Coke's proposed hall as 'a Burlington house', a description that loses significance, however, when seen in the light of Hervey's generally dismissive attitude towards Palladian orthodoxy and his definition of a Burlington house on another occasion by comparison to a place 'where light & warmth are as great strangers as in a house of Ld Burlington's building'.[43] A triumphant letter from Coke, writing to Matthew Brettingham, his site architect at Holkham, after he had shown his plans to Lord Burlington in 1734, reveals that, however much they had previously talked about Coke's ideas, it was only now that Burlington had seen the proposals more fully developed on paper. 'It is with pleasure', wrote Coke, 'I can inform you our whole design is vastly approved of by Ld. Burlington … so now we have gaind all we desire'. By this time, as building work was about to start at Holkham, Lord Burlington had retired from both public life and architectural activity. Coke valued his approval but felt no need for him to see work in progress, even writing, as one projected visit drew near, 'I am in some hopes his lordship will have business for I can't now think of a country journey'.[44]

The second great name linked with Holkham, William Kent, with whom Coke had formed a friendship in Italy, had since returned to London as Lord Burlington's protégé, initially as a painter. He transferred his efforts from painting to the design of interiors during the later 1720s and then moved on to architecture in the early 1730s. He was promoted in 1735 to Master Mason and Deputy Surveyor in the Office of Works, an official body that now had more to do with patronage than the training role it had previously fulfilled.[45] His name is closely associated with Holkham. Coke's letter on the eve of building specifically mentioned Lord Burlington's approval of 'Kent's outside' and the younger Brettingham, in his publication of the plans of Holkham in 1773, acknowledged his role in designing the 'first sketches' for the elevations.[46] Kent's other great contributions were for interior design, particularly the décor of the Family Wing rooms, the spectacular Marble Hall, which was completed several years after his death with significant alterations by Coke, and, either directly (although posthumously) or

Thomas Coke's letter to Matthew Brettingham on the eve of building, 13 March 1734.

derivatively, elements in the décor of the staterooms and Strangers Wing. It was possibly these elevations and interior designs for which Kent was paid £50 in 1737, when the building of Family Wing was well under way; this is the only significant payment to him recorded but, frustratingly, the entry in Lady Margaret's domestic accounts simply states 'To Mr Kent, £50 carried to the Building Account'.[47]

Kent's ideas were often transmitted to his patrons informally, leaving little imprint in written plans or accounts but great scope for architectural historians to detect his influence in surviving buildings.[48] Unlike Burlington, Kent and Brettingham, Coke was concerned to build only his own house and so left no opportunity for a comparative assessment of his abilities and style. Around half a dozen manuscript plans by Kent and Brettingham survive for Holkham, none at all by Coke. On the other hand, Coke's general involvement in the design process can be tracked through documentary evidence.

Even more crucially, detailed account books and other records enable a reliable and revealing chronology to be constructed for the events leading up to the finalisation of the plans in 1734 and at critical periods during the long years of building. In the early 1720s, as already noted, it was no secret that Coke wanted to build at Holkham and he had settled the site, orientation and approximate size of his proposed house by 1722, when he started constructing a landscape that depended on them. As a young man on the Grand Tour, he had assiduously studied architecture, accumulating several months of daily formal lessons spread over three formative years. He continued his interest after his return home. It is highly significant that he is recorded buying mathematical instruments or drawing implements not only in 1720, in the immediate aftermath of his Grand Tour, but also (as will be seen) in 1731, 1734 and three sets in 1739–42, which were all crucial dates in the genesis of Holkham, that is to say, the first reference to a plan of the Hall with four wings, the start of work on the first wing and the beginning of the main house. Architecture was Coke's 'passion and delight'.[49] None of this automatically made him an inspired architect or a competent draughtsman, but it was at least as strong a background as Kent's or Burlington's. It ties in with his consultations with architects during the later 1720s, the period when he started spending the larger part of each year at Holkham, quite some time before Kent turned to architecture.

His first recorded contact with Matthew Brettingham (1699–1769), who was to become his site architect, came in 1726, when he paid 'Mr.

The Library in Family Wing, by William Kent.

South Front by William Kent.

South Front by Matthew Brettingham.

Breckingham' £10 'for drawing a plan of a new house'.⁵⁰ Brettingham was twenty-seven, a couple of years younger than Coke, conveniently resident in Norwich, trained as a bricklayer, competent as a draughtsman and eager to extend into architecture. The amount he was paid indicates something more than a piece of unsolicited work and the fact that it was a gratuity 'by Sir Thomas's order', rather than the fee for a commission, suggests that he might have drawn an idea proposed by Coke. Around the same period, a payment of sixteen guineas was made to 'Mr Colin [sic] Campbell, surveyor'. The 'Mr Campbell' who visited Holkham twice in quick succession (or possibly spent two weeks there) in the summer of 1729 was undoubtedly the same

man, Colen Campbell (1676–1729), the pioneering proponent of Palladian architecture. He died shortly afterwards, however, and the extent to which his ideas influenced the design of Holkham is still a matter of debate.[51] The work for which Brettingham and Campbell were paid on those occasions has not been securely identified but the payments confirm that Coke was actively involved in architectural discussions, on site at Holkham, in the mid to late 1720s. In 1730 the first payment to Kent was recorded, the modest sum of £3 3s 'for drawing', probably for designs for the Obelisk and other garden structures in the park that were then in course of construction. Even this payment was followed immediately in the accounts by the purchase of pencils (and an ivory knife, doubtless for sharpening them) specifically 'for my lord'.[52]

The most elusive element in the evolution of the design of Holkham is the floor plan, which was both innovative in concept and effective in practice. There is little evidence that Kent was involved to any great degree before drawing elevations in 1734 but a ground plan is known to have existed by 1731, when Kent was still feeling his way into architecture. In that year Coke spent his usual four months enjoying the London social round, including several visits to Lord Burlington at Chiswick. Before leaving for Norfolk in July, he bought a 'measuring instrument' and a 'drawing table, a T and level' and two or three weeks later returned to Holkham, armed with a plan for 'a Burlington house with four pavilions on paper', such as he would finally build and which he was ready and willing to show to visitors.[53] It could not have been the fruit of some sudden flowering of architectural ability by Kent.

Most unusually, probably for the only time in his life, Coke now stationed himself at Holkham for a lengthy stay of twenty months, from July 1731 to February 1733. Clearly he had reached a point when it was more important to him to be on the site of his great project and within easy reach of Brettingham, who lived in Norwich, rather than in London, close to William Kent and Lord Burlington. Brettingham was becoming a familiar figure in everyday life at Holkham, making various purchases for Coke including a microscope and a 'prospective glass', cloth from a Norwich mercer for the best dining room (in the old house) and a 'book of Palladio'. When Coke eventually left for the London season in late February 1733, Brettingham remained busy at Holkham, spending a total of twenty-two days there, looked after by the housemaid in the otherwise empty manor house. Coke returned to Holkham at the end of June that year, having secured the post of joint Postmaster General, which gave him a useful additional annual income of £1,000 as he looked forward to building.[54] When he next visited London, after several more months at Holkham, he took with him well-developed plans to show to Lord Burlington. Triumphantly reporting the latter's unequivocal

South front.

approval to Brettingham, Coke's reference to 'our whole design' embraced Brettingham as a significant collaborator of some long standing. Buoyed by this enthusiastic reception, in March 1734 Coke was at last in a position to 'settle the whole affair … & get the whole fairly drawn out & begin the foundations of the wing forthwith'. 'Figur'd rules' were promptly bought for Brettingham.[55]

The plan, as built, attracted admiring comments from the start. Arthur Young, wrote in 1768 (before the publication of the younger Brettingham's description of the plans) 'let me come to what of all circumstances is in Holkham infinitely the most striking, and what renders it so particularly superior to all the great houses in the kingdom – convenience'. Brettingham junior emphasised that 'commodiousness was one of the Earl of Leicester's leading maxims; and this sensible principle is diffused through every part of the plan, which, though extensive and numerous in its divisions, is nevertheless constructed with beautiful simplicity, and that symmetry of disposition, from whence conveniency uniformly results'. The architect Sir William Chambers (1723–96) agreed that the plan was 'exceedingly well contrived, both for state and convenience'.[56] Recent research has highlighted stylistic connections between the Holkham ground plan and its later adaptation by Kent for important public buildings.[57] The possibility should

be acknowledged, however, that the continuing interchange of ideas that characterised the design of Holkham gave Kent the opportunity to absorb as well as to contribute.[58] The Holkham floor plan is indicative of long and careful consideration by the owner, content to develop and refine his ideas over several years, determined to build a house where he could display his treasures, entertain his guests and live with his family in both splendour and comfort. 'Talk not, ye admirers by wholesale, of the fronts [elevations]', exclaimed Arthur Young, 'contrivance must have been the characteristic of Lord Leicester, for so convenient a house does not exist, so admirably adapted to the English way of living, and so ready to be applied to the grand or the comfortable way of life'.[59]

Coke had intellect, education, wealth and, long before the house was completed, a peerage. Building only for himself, he had no motive to emphasise to others the extent of his own role in planning the Hall. Brettingham, concerned to expand his future career, overstepped the mark when in 1761 he published the plans of Holkham (without any accompanying text) with little or no attribution to Kent, but it is significant that he felt able to do so while Lady Leicester was still alive and the Hall not yet finished, and that he dedicated the volume to the Duke of Cumberland (1721–65), George II's second son, who knew Holkham well. In the second edition of the plans published with explanatory text in 1773, still during Lady Leicester's lifetime,

Thomas Coke by Andrea Casali, 1758.

the younger Brettingham justified his father's implicit claims by explaining that, during the long process of building, he had been responsible for 'proportioning the parts at large, and the detail of each member of the buildings in particular'. Above all, however, Brettingham junior was concerned to make clear that the late Lord Leicester had 'continued with uncommon diligence to improve and elucidate' the plans and that 'in the space of time which passed from the commencement of the building … very few traces of the original thoughts remained untouched'.[60]

The design was innovative. It was the epitome of Palladianism, the dominant theme of contemporary architecture, characterised by the application of Roman temple features to domestic buildings, and it succeeded supremely well in applying what had been essentially a villa style to a great house.[61] The Marble Hall was unprecedented as a ground floor entrance, filling the full height of the building and leading the visitor up to the staterooms on the principal floor by means of an internal broad sweep of stairs. Coke's letter to Brettingham in March 1734, announcing Lord Burlington's approval of the plans, continued ambiguously, 'Kent's outside is also vastly in favour *& the going up steps from the hall also*' (author's italics). Was Coke implying that Kent was responsible for the Marble Hall stairs (an innovative feature) or, in his excitement, was he simply adding to the sentence another highly significant element that had attracted Burlington's admiration?[62] The latter interpretation accords with Brettingham's statement that the Marble Hall, in particular, had been 'suggested by the Earl [of Leicester] himself'.[63]

From the head of the Marble Hall stairs, a visitor could continue either straight ahead into the Saloon, the principal stateroom, or turn onto the colonnaded 'gallery of communication' that gave striking views into and across the Marble Hall. The gallery led, on the one side, into the North Dining Room and onwards to the Statue Gallery, which conveniently linked Family Wing and guests' accommodation in Strangers Wing. On the other side, the gallery led into the North State Dressing Room and North State Bedroom. In any direction, either a complete or a half circuit of the staterooms was made possible by the two unseen internal courtyards. The enfilade or long sequence of rooms along the principal south front, extending to 340 feet (nearly 103 metres), echoed a traditional feature but was devoted to reception rooms; the state bedroom apartments that had traditionally occupied the principal enfilade in eighteenth-century Baroque and early Palladian houses were relegated to the eastern and northern sides of the house. Indeed, the old idea of apartments received little emphasis. Although Brettingham referred to the staterooms as the 'Grand Apartment' and the 'State Bedchamber Apartment', Lady Leicester, who knew the house in use,

The Marble Hall, exploded plan by William Kent.

The Marble Hall by Brettingham, section showing the early version of the stairs passing the statue of 'Jupiter'.

The Marble Hall.

referred in her inventories only to the private rooms in Family Wing and, later, her own rooms in Chapel Wing as apartments. Although called the 'state dressing room' by Brettingham, the room in the south-east corner was known even in the earliest inventories as the Landscape Room: any functional role it played in the sequence of staterooms was reduced to insignificance by the magnificent collection of twenty-two landscapes that Coke assembled there, including seven by Claude Lorrain, his 'favourite Painter'. From the practical point of view, locating all the principal rooms on the first floor and linking them to guest and family rooms on the same floor but in separate wings, enabled the upper servants' rooms to be accommodated on the ground floor, within easy reach of 'the master and his company'.[64]

*

However great was Coke's 'delight and passion' for architecture, he was fully alert to the organisational challenges inherent in a major building project.[65] While working on the designs for the house, he used his long stay at Holkham in 1731–33 to put the necessary infrastructure in place. There are no surviving letters or memoranda to explain the changes but a clear shift in emphasis can be detected in a re-arrangement of the accounting system. On the domestic front, Lady Margaret, who since 1730 had been

The principal floor. This differs slightly from Brettingham's published plan.

The enfilade, from the Library to the Chapel along the south front.

writing the household accounts in her own hand, now took over from the house steward the receipt of all housekeeping money, so that in future all domestic receipts and payments were under her supervision.[66] On the estate side, the steward, Appleyard, was now to concentrate solely on the estate accounts, recorded in the Audit Books, together with the husbandry or farming accounts. This was a reflection of the fact that progress on the Hall

would be intimately dependent on the prosperity of the estate. The country accounts or 'accounts of domestic disbursements in Norfolk', which had also been Appleyard's responsibility, were now placed in the hands of Abraham Thomas, the valet. His salary was doubled to £40 and he was soon designated as the secretary.[67] The accounts that he kept meticulously for the next ten years showed ever-increasing sections devoted to the brick kiln, the new buildings, building materials and the park. Expenditure on the hunt ended within two years and the stables account, greatly reduced, was recorded elsewhere. Building was now indisputably the focus of attention at Holkham.

When building work started, a few surviving letters show Coke's crucial personal role, directing priorities, interpreting plans, checking on progress, suggesting best methods and chiding any sign of neglect. His presence at Holkham coincided with periods of peak planning or building activity. Conversely, when, for example, preoccupation with politics kept him in London in 1740–41 as Walpole's ministry struggled, he wrote that, 'it is most likely I

Lady Margaret, by Sir Godfrey Kneller, before 1723.

shan't come into the country till very late and at most stay but a little time next year' with the result that 'I don't think my buildings can go forward this year'. Expenditure on building dipped accordingly.[68] Even with such close involvement of the owner, however, a project of this scale required another layer of supervision. Matthew Brettingham, already involved with Coke in developing plans for the house, was the obvious choice. As soon as building work started on the first wing in 1734, he was appointed on an annual salary of £42 'for looking after the buildings', rising to £100 when work started on the main house in 1741. As a bricklayer by training, he was an ideal supervisor for the first stage of building but was initially inexperienced in other areas. Coke helped him along as he planned the rooms at the top of the first wing which would be young Edward Coke's suite ('I approve intirely of your attick but as you enrich't the alcove etc you must do the same round the windows') and complimented him when the faults were rectified ('I like the attick extreamly').[69] When Coke recommended him to the Duke of Richmond to measure completed piece work (probably at Richmond House) in 1736, Brettingham was nervous about dealing with London craftsmen, 'a combination of rogues and villains who clearly make it their study to impose upon my kind', but Coke encouraged him to accept the task, as 'by measuring and examining thoroughly the Duke of Richmond's ornaments you will much improve in your knowledge of that affair of ornaments'. By the time that the first wing neared completion, Coke could confidently write, 'as to the execution of a building, I will do you the justice to say no body understands that better, and scarce any one so well'.[70]

Although the building process was supervised by Brettingham and the building accounts were compiled by Abraham Thomas, it was the estate steward, George Appleyard, and his successor, Ralph Cauldwell, who had the difficult task of juggling the financial and practical demands of the building work on the one hand, and of the farm and estate on the other, and on at least one occasion there were 'dissentions & divisions … amongst our Ministry at Holkham'.[71] The chance survival of one letter from Appleyard to Coke in 1737 gives a snapshot of the steward bargaining with workmen and implementing Coke's orders for landscaping:

> I have not yet gott another team to work in removing the earth, the men at present being unwilling to comply with the price I give to the other men that fill the earth in the carts that are now at work, but I have desired Mr Aram [the gardener] to turne of all the men now imployed under him for a little time, which will be a means to reduce the men to terms, for if I could gett hands for filling ye carts I should be in hopes of finishing that

piece of work in three weeks or a months time at the farthest. As for the lawn I have ordered as much earth or rich soyle to be carried thereon as can be gott at this season.[72]

The same letter reported the arrival of plasterers and the measures he had taken to procure suitable plaster. When Coke decided to reduce the scale of building work for a few months in 1741–42, it was Appleyard whom he instructed 'to put the materials in order and discharge all the workmen'.[73]

A further element in the management of men and materials was provided by a handful of master craftsmen who each worked on the Hall for twenty to thirty years. They are the subject of a later chapter but it is worthy of note here that they fulfilled many of the functions that on other sites required a clerk of works. They paid their teams of men, allotted and supervised their work and supplied some materials. The roles of the accountant, the site architect and the owner-builder were all eased by dealing with a relatively small and stable group of master craftsmen, whose familiarity with the site and with each other played a large part in the quality and progress of the work. In the early 1730s, however, this relationship was still in the future.

In April 1734, with the new management structure in operation and his plans blessed by Lord Burlington, Coke returned from London just before the first foundations were dug.[74] He had long since decided to build the house slowly, financed from estate income. To this end, improvements had recently been made to the old house so that it should better meet the family's needs for some years to come, including the addition of a servants' hall and scullery, a new dairy and installation of a piped water supply to a bathroom.[75] When work on the new house finally started, Coke intended only 'to begin the foundations of the wing forthwith'. This was the south-west wing, the Family Wing. He reminded Brettingham in the autumn that there was no need to go much higher than the foundation trenches, 'for you know we are in no great hurry'. Eighteen months later, as he arranged credit for Brettingham for £200, he commented that 'I don't know where [we] shall get more, we [should] not have begun so soon'.[76] The wing was built during the next six years while no other part of the house was even started. This was deliberately slow progress: some ten years later, it was possible to build each of the last two wings much more quickly.

The financial constraints on building the first stage of the Hall reflected the fact that Thomas Coke's desire to build an architectural masterpiece was a long-term objective, as Brettingham acknowledged, 'amidst the improvements of Planting and Agriculture, carried on with success at Holkham'. All was dependent on the estate's prosperity. Purchases of land to round off

the Holkham estate continued, regardless of debt or architectural ambition. Efficient tenants were encouraged by contributions to the cost of enclosures, fencing and marling, and there was similar investment in improvement on the home farm. New buildings, too, were already an important element in estate improvement, although it would become famous only in the next generation; even as work started on the Hall, several new farm houses were erected on the Norfolk estate, one at Weasenham costing £505, nearly half the amount spent on Coke's new house that year.[77] Nor was the building of Holkham allowed to overshadow the London house. While the first wing was slowly progressing at Holkham, refurbishment at Thanet House prompted the light-hearted and cryptic comment by Will Tomley, its longstanding house porter, in a letter to Appleyard, the estate steward, 'There is nothing new here and everything is new, so you may make that out, as well as you can.' When the attic and rustic floors of the new wing at Holkham were being furnished a few years later, half as much again was spent on furnishing

Family Wing.

the heir's apartment at Thanet House.[78] Expenditure continued, too, on the gardens and park.

The first wing was roofed in 1736, two years after work had started. After another two years, the secretary, valet and housemaid moved into their rooms on the ground floor of the wing. This must have been an inconvenient arrangement while the family rooms and all domestic offices remained in the old house but it helped both security and the drying-out of the new building. In 1740, when the wing was ready for more general occupation, a passage was built to link it to the old house.[79] When this connecting passage and the old house were eventually demolished, the bricklayer's bills for 'bricking up part of the west door of the inhabited wing' and 'cleaning the rusticks and arch of the door where the covert [covered] way joined it' reveal that the passage, which was probably not very long, gave access to the new wing through the central west door on the ground floor, into an area sometimes appropriately called the 'guard room'.[80] This is a more likely scenario than the suggestion that the passage entered the wing from the south through the cellars, which would have been an undignified and inconvenient access for family and guests while the old house and the new wing were used together for sixteen years.[81] The wing had an independent water supply and sewerage system so that bedrooms could be brought into use with all the sanitary facilities that Coke required in his new house, but the kitchen and all other domestic offices, servants' hall, steward's room, the main dining room and most servants' and guest accommodation remained in the old house.

The wing was designed to be the family's accommodation and has nearly always been used as such. The principal rooms were arranged in a circuit round a central staircase, an innovative feature that was to have a great influence on the design of London houses.[82] On the ground floor, the largest of four spacious, light rooms was the rustic dining room or parlour. The others were assigned to the valet and secretary (either side of the guard room) and the lady's maid, whose room had an adjacent service staircase leading directly to the lady's closet on the floor above. A footman and a housemaid had smaller rooms, and Coke's bathroom was also on this floor. Once the main house was built, the butler's quarters would be close at hand. On the principal floor were the bedchamber shared by Coke and his wife, lady's dressing room and closet, lord's dressing room and, filling the west side, the Long Library. Eventually, the anteroom and a short connecting corridor would lead through to the south tribune of the Statue Gallery, the room where family and guests would assemble. On the upper floor of the wing, misleadingly called the attic floor, was a suite of bedchamber, dressing room, servant's room and closets for the heir, Edward Coke. The completion of

Family Wing, the principal floor, from Brettingham's *Plans and Particulars*.
F anteroom leading from the North Tribune of the Statue Gallery, **G** dressing room, **H** library, **I** lady's dressing room, **K** bedchamber. The spiral stairs led down to the lady's maid's room.

the first wing gave added zest to the celebration of Edward's coming of age in June 1740, particularly as it was possible to hold the ball in 'the room that is designed for My Lord's library', although it was considered 'a little too strait' for dancing. A band of fifteen musicians played while outside there were bonfires of tar barrels, fireworks from London 'play'd off upon the water' and men hired to fire guns and ring bells. Two thousand small lamps illuminated tents and 'the wilderness', and chandeliers were hired for the orangery where 130 guests dined.[83] The completion of the Library heralded the arrival in 1742 of a leading bookbinder, Jean Robiquet, to work at Holkham with his wife and assistant for nineteen weeks; they returned at intervals during several years, leaving at least 480 identifiable items of their work in the Library.[84]

In 1742, the death in London at the age of sixty-four of George Appleyard, Coke's estate steward for twenty years, marked another milestone. He was succeeded by Ralph Cauldwell, who had been steward of the Western Manors (the estates in Dorset and Somerset) and for the past ten years Appleyard's assistant and farm bailiff at Holkham.[85] Within a few months,

The Library.

Cauldwell also took over the country or building accounts from Abraham Thomas; the latter retained his place in the household but died a few months later, living just long enough to see his master become Earl of Leicester in May 1744.[86]

The change in management so soon after the completion of Family Wing was fortuitous. It had always been intended that work would start on the main house only when Family Wing was finished but there was now a lull in building work, with labourers working on the foundations on and off for three years. Entries in the accounts reveal that the delay coincided with work on perfecting the design of the main house, for 'a case of drawing instruments and rulers' was bought in 1739, rulers and drawing pens were needed in 1741, this time in connection with the pleasure gardens, and in the following year, under the 'Buildings' heading, 'rulers, compasses etc for drawing of Plans'.[87] It is possible that another reason for the pause was financial, for generally country house building slumped throughout the 1740s, affected by the War of Austrian Succession, poor harvests and rising interest rates and land tax. In 1741, however, Coke succeeded in mortgaging the Buckinghamshire, Kent, Oxford (Minster Lovell) and Suffolk estates to his lawyer, Matthew Lamb, for £48,000. This appears to be the point when it was accepted that

progress on building the house out of income was just too slow, a situation thrown into focus by the coming-of-age of the heir. The death of Appleyard, the careful older man who had overseen the recovery of estate finances, and the promotion of Cauldwell, young, ambitious and eager to please, probably sealed the decision to accelerate work on the main part of the house. In 1743 bricklaying was resumed in earnest. Building expenditure suddenly rose to around £1,000 and remained high, on average, throughout the decade.[88] It was Cauldwell who oversaw the financial management of the next twenty years' work on the Hall to its completion in 1764.

The general aim was to complete the carcase and roofing of each section so that interior work could proceed under cover. As the building rose, part-built walls were thatched at the onset of winter to prevent damage by frost and uncovered in the spring. Window spaces were filled with 'paper lights' to give some protection from the elements. Paling had been erected round the first wing but security does not appear to have presented a problem: entries in the accounts for 'watching the house' invariably relate to the London house. Landmarks such as raising the towers were celebrated with drink, sometimes also dinner and entertainment, for the workmen.[89]

Building did not follow a continuous sequence. The principal staterooms were to be the glory of the Hall but the order of building shows that, after the provision of accommodation for the family and senior servants in Family Wing, the earliest concern for Lord Leicester (as he now was) was what his uncle had anticipated many years earlier, 'convenient room' for guests.[90] The south-west tower was roofed in 1748 and the south-east tower in the following year but when Lady Grey visited in August 1750, during a tour of East Anglia, she noted that 'the corps de logis', the south front between these two towers, was 'not quite cover'd in' and the rooms merely a shell.[91] Building progressed quickly along the east side of the main house, where the lower ceilings of the staterooms, compared to those on the west and south, allowed for an intermediate storey of bedrooms and dressing rooms, and on to the north-east tower. By 1753–54, long before any of the staterooms other than the Statue Gallery was in use, the four so-called tower rooms on the corners of the main house and the 'attics' of the east side (the bedroom floor above the staterooms) were painted and furnished, right down to ink stands, in readiness for guests, and the galleries or passages linking the tower rooms were furnished with press beds (beds that could be folded up into a press or cupboard) for servants.[92] Strangers Wing, although devoted to guest accommodation, was built later, because concentration on the towers and the east side enabled guest accommodation to be provided relatively quickly while also completing the carcase of the staterooms and the principal façades.

Early house guests must have found it a strange experience to occupy fairly isolated rooms within the unfinished house.

Throughout the sixteen years of this phase of building, from 1740 to 1756, most domestic life and entertaining took place in the old house. A visitor, Sir Thomas Robinson, a Yorkshire landowner who had designed his own Palladian house at Rokeby Park, described the old house as 'exceedingly bad' but, until three years before Lord Leicester's death, it provided comfort and hospitality sufficient to compensate for living next to a vast building site.[93] The French chef and under-chef were presented with beef, mutton and fat pigs from the home farm, an abundance of game (at a fraction of London prices) and wild fowl, poultry, fish, oysters and crayfish. Even truffles were found locally, justifying employment of a 'truffle boy'.[94] The kitchen gardens, already twenty years old, supplied figs, peaches, cherries, gages, nectarines, apricots, plums, pears, grapes, mulberries, apples, raspberries, gooseberries, currants, strawberries, quinces, medlars, filberts and almonds. Pineapples came from the 'ananas house' built in 1736: thirty-six new pineapple boxes were needed in 1750.[95] The wine books suggest capacious cellars under the old house and its brew house supplied, in one typical three month period, eight butts and one hogshead of ale (about 918 gallons or 4,173 litres) and more than eighteen butts of beer (about 2,025 gallons or 9,205 litres), and far more during the Christmas quarter.[96]

Building the Hall never precluded the enjoyment of normal country pursuits. Cocking continued on a small scale into the 1750s but expenditure on the hunt had ended during Coke's long stay at Holkham, although he occasionally hunted with other packs and still maintained part of Beck Hall, at Billingford, for use as a hunting lodge. By the 1740s, although three brace of greyhounds (bought in Norway) were kept, most of the occupants of the kennels, often more than twenty dogs, were 'setting dogs', pointers, terriers and a spaniel. This shift from fox hunting to shooting had the advantage of economy. The average annual expenditure on hunting in the 1720s had been over £350 but running the dog kennels in the 1740s cost about a seventh of that amount. A celebrated dispute in 1759 between Lord Leicester and his neighbour at Cranmer Hall, George Townshend (later the Marquess Townshend), revealed how far the pendulum had swung, for Townshend, an enthusiastic fox hunter, nursed a seething resentment that the Holkham gamekeepers killed foxes in order to preserve 'the pyed pheasants your lady Leicester is so fond of'.[97]

Landscaping continued to be a major interest. It was essentially a landscape to be used and enjoyed, although Horace Walpole, on the eve of a visit to Holkham in 1743, was relieved that 'I have the comfort of not having it

the first time of my being there, and so need not be dragged to see clumps, nor sailed over the lake, nor drove two miles into the sea when the tide is down'.[98] Years earlier, Coke's grandfather had blamed the family's bouts of ill-health on the proximity of the sea but boating and fishing were now part of Holkham's attractions. By the early 1740s there were 'a red shallop boat', 'a green shift boat', a pleasure boat, a ferry boat, an old boat, and a new one brought over from Norway: an array that was typical of boats on lakes in designed landscapes. There was a thatched boathouse by the Broad Water or lake, as well as others on the marshes and the Borough creek.[99] Thousands of flounders and other fish were bought to stock the ornamental basin and the lake. Robert and Henry May, enterprising local men who turned their hand to many activities, were paid for 'attending his lordship a fishing with their nets, 6 times this year & 4 the last at 3s [shillings] per time'. Occasionally there was an excursion out to sea, as when a payment was made to 'three men with their boat at sea to attend my Lord and Lady, [her sister] Lady Isabella, Master Coke etc'.[100] Wild ducks and geese were bought to stock the old stew ponds and the 'Clint waters' and were encouraged to stay by supplies of barley.[101] An early attempt to establish an aviary apparently ended with the death of the man recruited from London to run it but the idea was revived in 1742–43 with the building of a menagerie, which had a small thatched and glazed two-storey building, a dovecot and a pond.[102] Fifty brace of pheasants

Drawing by William Kent for the south basin and pavilions.

costing £21 and five bustards, much more expensive at five guineas, were bought for it, and storks were imported from Amsterdam. Under the management of a 'menagery man', it supplied the kitchen with turkeys, geese, chickens, ducks, pigeons and pheasants. Lady Beauchamp Proctor admired it in 1764, describing it as 'filled chiefly with India pheasants' and one memorable bird 'from Barbary' whose loud doleful call, like 'the humming of a base string of a violincelli' echoed round the garden.[103]

*

In the middle of August 1753, the usual summer at Holkham was interrupted by the sudden departure of Lord and Lady Leicester for Greenwich, where their only son, Edward Coke, died on 30th August at the age of thirty-four. The 'young master' had grown into a dissolute and alcoholic adult. His marriage, arranged in 1747 with Lady Mary Campbell, youngest daughter of the 2nd Duke of Argyll, had been disastrous from the start, probably unconsummated, and had ended after only two years in the public spectacle of a legal separation. His widow lived until 1811, eccentric to the last. Her ghost, it was said in the early twentieth century, 'flits, weeps and finally vanishes' along the corridors between the tower rooms on the corners of the main house. If this were so, she maintained her eccentricity in the afterlife, for those areas had not been built when she had stayed at Holkham and she could not have 'trod so mournfully' along them in her lifetime.[104] Except for his widow's entitlement to an annual jointure of £2,000, Edward's death removed the need to provide for his household and for any children he might have had in the future.[105] This has often been cited as the primary reason for another sudden and dramatic increase in the pace and cost of building, as the loss of his heir liberated Lord Leicester from any compunction about leaving a burden of debt and reinforced the significance of the Hall as his only legacy.[106]

A more practical and logical factor was at work, however, beginning at least a year earlier, well before Edward's death. A series of legal transactions in 1752 had been directed at raising additional finance from outlying estates that had already been mortgaged to fund the start of building work on the main house eleven years earlier. The Kent and Oxford estates were re-mortgaged for £16,000 to Lord Leicester's lawyer, Matthew Lamb, who promptly assigned the mortgage; the Suffolk estate was re-mortgaged to Sir Joshua Vanneck and then sold, and Farnham Royal in Buckinghamshire was sold. Knightley (Staffordshire) had been sold two years earlier and Durweston, part of the Dorset estate, was sold two years later.[107] Initially this was to the detriment of income, the immediate effect of the sales being a fall in rental income from a peak of £14,410 in 1749 to £12,000 by 1755, but income recovered to £13,665 by 1759.[108] Some of the proceeds were used to clear

earlier debts and to fund the purchase of land at Burnham and Wighton, close to Holkham, in 1756. It is likely, however, that the chief purpose of the exercise was to raise a disposable sum to devote to the completion of the Hall. It is this context, too, that explains Lord Leicester's decision to call in external surveyors in the summer of 1752 to check expenditure to date. John Sanderson (probably the well-known architect of that name) and George Bascubee (identifiable as a bricklayer) spent twenty-one days each 'measuring the bricklayers and carpenters work of the body of the house', in other words, the majority of the work of the past ten years. The bricklayer, Elliott, and the carpenter, Lillie, were found to have overcharged by about £315 and £250 respectively, which was not a great annual average over the period. Elliott's amount was deducted from his next bill, Lillie's was possibly not pursued.[109] It was not, as has been depicted, a row between Leicester and his chief craftsmen but a matter of business, the patron double-checking his expenditure at a critical point in a vast and complicated project.[110]

Then in April 1753, over the Easter weekend, still some months before Edward's death, the building workmen were invited into the Hall to be entertained with rum and brandy: four master craftsmen in the Steward's Room and thirty-two others in the Servants' Hall.[111] This was an unprecedented event, surely accompanying an announcement of a great push to complete the Hall, the promise of extra work, a request to pull out all the stops. Annual expenditure on building, which had been around £1,400 while the first wing was under construction and had averaged about £2,300 for the next ten years, now rose again and remained high for the last six years of Lord Leicester's life, averaging £4,000 a year.[112] Apart from the year after his son's death, when he understandably avoided the London season in favour of a long summer tour of the north and midlands, Leicester continued his normal routine of spending three months of each year in London, but more than ever he was known to be 'devoted to building and planting'. Brettingham, on the other hand, 'having much business in Town, could not at that period give up so much of his time to a single Building'. With his London practice expanding as interest in building great houses revived in line with growing national prosperity, Leicester's increased demands meant that Brettingham 'began to be disgusted with Holkham'. His son frequently attended in his place and from 1756 shared his salary of £100.[113]

The complete concentration on Family Wing for the first six or seven years of building had lent itself to an orderly progression, from labourers digging the foundations, through structural brickwork and carpentry, to plastering, carving, painting and furnishing. When work gathered pace on the main house in the 1750s, however, the accounts give a bewildering

impression of overlapping work, not only between the trades, but also within each trade, particularly bricklaying and carpentry. In one year (1754), for example, the bricklayers worked on a model of stone steps for the portico, recesses in the North Dining Room to take busts, paving the ground floor, fitting sash frames in the principal storey north and west fronts, building the southeast wing and constructing various chimneys. The carpentry team moved between fixing the busts in the dining room, erecting scaffolding in the Saloon, timberwork for the foundations of the northeast wing, floors in the southeast wing, windows for staterooms and cupboards and drawers in the housekeeper's rooms. During the same year, carvers, plasterers and glaziers worked in the dining room, Statue Gallery and Drawing Room.[114] With Brettingham's role decreasing, the Earl's personal involvement and the contribution of the semi-permanent craftsmen became ever more important.

The priority was still to bring the house into use, regardless of whether all the staterooms were ready. Leicester was keen to complete his Statue Gallery in 1753 and the date was uniquely incorporated into the décor above the window of the Tribune at its southern end, celebrating the completion of the first stateroom. During the summer statues were moved into the Gallery from their temporary home in the greenhouse.[115] The other rooms completed in

The rustic floor.

The south window of the South Tribune, surmounted by the date 1753.

that year, however, were the domestic offices on the rustic floor below, while the foundations were being dug for the north-east Kitchen Wing. This wing was built relatively quickly. In 1756, with the kitchen fitted out, the water supply operating and the drains connected, the Hall was at last capable of independent life.

Chapter 5
Building the Hall: The Materials

The archives at Holkham are particularly valuable in enabling the process of constructing this great house to be followed in detail. The building accounts and other records make it clear that Coke's quest for perfection in architectural design was matched by his determination to procure the most suitable materials and the best available craftsmanship. Faced with building over a long period of time, and building to one coherent design rather than extending or amending, it was a remarkable achievement to maintain the quality and consistency of materials and craftsmanship that would be crucial to the Hall's appearance and to its long-term survival as an architectural masterpiece. The next chapter will consider the men who built the house. This chapter examines the materials they used, principally bricks, mortar, timber, stone, alabaster, marble, plaster, roofing slate, lead and glass.

The white brick of Holkham is striking. Sombre on a dull day, light and bright in sun, and hardly touched by two and a half centuries of exposure to all weathers, 'to the edge of doom Holkham will never look old'.[1] Coke's original intention, thwarted by problems of supply, had been to build in Bath stone 'in deference to its fine yellow tinct' but brick proved to be practical, economical and authentic. Brettingham noted that 'brick edifices were held in higher estimation, by the old Romans, than even those of marble, for durability and firmness' and the Holkham bricks proved a good match for 'the modern yellow brick of the Romans'.[2] Bricks for any building project were made locally wherever possible, to save on transport costs. They had probably been produced at Holkham in the mid-seventeenth century but towards the end of the guardians' time (1716–17) they were bought from the tenant at the staithe farm, who was also a merchant supplying timber and coal. In 1725, however, Thomas Coke bought a brick kiln, soon warranting a separate section in the accounts; he took it in hand when the tenant died a couple of years later, just as work started on building the new kitchen garden walls. In 1728 John Parker appeared for the first time as the brick

Detail of exterior rustic brickwork. All shapes were moulded, not cut.

maker.[3] Brick makers as a breed had a poor reputation but Parker was one of the heroes of Holkham. Within two years, white bricks were needed for the Temple. A seam of white clay was known at Burnham, a few miles away, and initially a brick maker there supplied a small number of white bricks at the great price of twenty shillings per thousand. Parker then made six journeys to Burnham kiln 'about the white earth' and subsequently the estate rented the 'piece of ground in Burnham Field where the white brick earth is gotten'.[4] Henceforth, although a new kiln was built at Burnham Norton and remained in use for many years, large quantities of the white earth were regularly carried to the Holkham kiln and, 'with proper seasoning and tempering, produced an excellent well-shaped brick, approaching nearly to the colour of Bath stone, full as ponderous, and of a much firmer texture'.[5] Many decades later, the Holkham agent highlighted the skill involved in making white bricks, explaining that, in his day, out of 8,000 white earth bricks put in the centre of every kiln, it was not uncommon to draw out fewer than a tenth satisfactorily white, the rest ending up all colours between red and white.[6] Parker's skill in producing white bricks for the Temple and garden porches undoubtedly played a large part in Coke's decision to abandon the idea of building the Hall in stone.

As work on the first wing rose to the ground floor, Coke, in London, was anxious to hear from Brettingham that 'your kiln of bricks succeeded'.[7] Evidently it had done so, for Parker was given five guineas 'for his extraordinary trouble in burning the rustic bricks'.[8] These formed the panels of brickwork that give the impression of a carved surface. No bricks were cut, to avoid discolouration, so fifteen different brick moulds were needed for the standard rustics alone, and many more for the frames and lintels of doors and windows.[9] Parker received similar additional payments for the next seven years (during the building of the first wing) after which his skills were apparently taken for granted. It has been calculated that 140 different shapes and sizes of bricks were used in the building as a whole: in a typical year, as work progressed on the south front, Parker was making red and white bricks, large and small coping bricks, arches, rustic bricks and 'great bricks' for rustic arches, at prices varying from seven shillings per thousand to twenty-five shillings per hundred.[10] Paying labourers for cutting the whins (gorse) for firing the kilns initially added more than a third to the cost of ordinary bricks, until the brick maker undertook to supply them at an agreed (lower) price. Although coal, readily available at Wells-next-the-Sea, was used at the lime-kiln, the use of whins for burning the bricks bears out T. W. Coke's advice in later years that it was impossible to manufacture a good white brick with a coal fire.[11]

A typical page from the building accounts, 1750, for expenditure on brickmaking.

Over a period of thirty-four years, Parker made most of the bricks used in the Hall, probably over 2.7 million. A chance reference in a detailed day book reveals that he had five kilns in production in 1752. He also made bricks at Fulmodestone, twelve miles from Holkham, for general estate use.[12] Brick making consisted of a series of distinct processes, each performed by a different individual within a gang of six, often members of a single family,

Chapter 5 Building the Hall: The Materials 121

PETERSTONE BRICK YARD.

PRICES OF WARE.

		£ s. d.
Best White Bricks	per Thousand	2 10 0
Seconds ditto	,,	2 5 0
Red Bricks, Hard	,,	1 15 0
Ditto, Soft	,,	1 10 0
Rustic, Drip and Flance Bricks, white	,,	2 10 0
Ditto, red	,,	2 15 0
Round Corners, white	,,	2 10 0
Ditto, red	,,	2 15 0
Door-jamb Bricks	per Hundred	0 10 0
4-inch Splay Bricks	,,	0 7 6
3-inch ditto	,,	0 6 6
Fancy Chimney Bricks	,,	0 6 6
11-inch Window Sills	,,	1 10 0
9-inch ditto	,,	1 0 0
Large Skirting Tiles	,,	1 5 0
Small ditto	,,	0 17 6
18-inch Arch Brick, white and red	,,	0 18 0
16-inch Arch Brick, white or red	,,	0 16 0
14-inch ditto ,,	,,	0 14 0
12-inch ditto ,,	,,	0 12 0
10-inch ditto ,,	,,	0 10 0
Tudor Chimneys, red	each	3 10 0
Ditto white	,,	3 15 0
Octagon Chimneys	,,	1 15 0
Turrets, complete	,,	1 0 0
Fineals	,,	0 1 6
Post Blocks	,,	0 1 6
Eave and Chimney Cornice	,,	0 0 3
Ditto returns	,,	0 0 6

A legacy of specialist brickmaking: price list for the later estate brickyard at Peterstone, 1888.

but the other people whose skills contributed to the production of millions of consistently high-quality bricks warranted no mention in the accounts. Parker's own name last featured in the accounts in 1762, when the kiln was demolished.[13] Fortuitously, however, papers from a much later date, relating to the purchase of two dilapidated cottages, reveal that Parker had three sons, who probably worked with him, and that he acquired the cottages in the year that he started supplying bricks to the estate, only to mortgage them when work for the Hall ended. A second mortgage in 1774, when he was still described as a brickmaker, was not redeemed before he died intestate about a year later, suggesting that thirty years of skilled brickmaking for the Hall had not made his family's fortune.[14] The exact location of Parker's brickworks is not known, although a century later the names of Brick Kiln barn, yard and pasture persisted towards the east side of the park. Estate brickworks operated at Peterstone, just outside the park to the west, until the middle of the twentieth century and were considered by Arthur Young, writing in 1792, 'of the first, at least to rank very high among the first in the Kingdom'.[15]

The building accounts give the impression that all materials and workmanship were directed towards building the Hall but the estate accounts give continuous reminders that the estate as a whole still demanded attention and also provided materials, particularly bricks, timber and lime. In the 1720s and early 1730s, several named brick makers operated briefly at the same time as Parker and were possibly itinerant, as was common on building sites. Henry May, however, a local man who was also a thatcher and general labourer, made bricks and tiles for over twenty years, sometimes at clamps or temporary kilns in the marshes. His were mostly ordinary bricks for estate work, entered in the audit or estate account rather than the building or country account; some of his 'marsh bricks' were sold to local people at fifteen shillings per thousand, showing a good mark-up. On occasion, however, he also made white bricks and in 1747 made 'hund'd thousand bricks in ye marshes at 6s [shillings] per thousand' for the Triumphal Arch.[16]

The mortar for laying the bricks was prepared, as Brettingham noted, with 'like diligence'.[17] The lime was made at the farm's lime kilns, using local chalk. As soon as the foundations were started in 1734, Coke entered into the details of supply in a letter to Brettingham:

> Appleyard [the estate steward] tells me the kiln can't supply enough lime for your workmen tho' it is kept continually employ'd. I fear it is too late to build another kiln in the same place but if you think it requisite we will build one there the very beginning of next year, but I suppose during all

winter we may be heaping up lime & I suppose if we get such a heap as we had last year beforehand that heap and [what] can be burn't in the present kiln will sufficiently do your business.[18]

It is not clear how many kilns were eventually at work but they maintained production on a massive scale, supplying, for example, 273 chaldrons for Family Wing in 1736 and 450 chaldrons (approximately 600 tons) in 1746.[19] Sand for mixing with the lime came from a variety of places, from nearby Church Hill or even, imported through Wells-next-the-Sea, from Holland; sand brought from the seaside was probably for other uses.[20] Brettingham found it noteworthy that the mortar was then '(to render it of sufficient fineness for close brick-work) ground between a pair of large millstones, fitted to an engine for that purpose'. The essential water supply for bricklayers and masons came from two or three wells, sunk in different places as the building progressed, one of them associated with a temporary engine house. On one occasion when the normal arrangements failed, a labourer had to be employed for two days a week 'at water cart, there being none in the cistern'.[21]

Much of the softwood timber for the house was bought through Richard Curtis, a merchant in Wells-next-the-Sea who also supplied paving stones, coal, lead, and peas for animal feedstuff, sometimes taking rye and barley in part payment, and whose keels (flat bottomed barges) were hired for unloading the ships bringing cargoes of stone.[22] Occasionally a whole shipload of deals (Scandinavian timber) was shipped from King's Lynn to Wells-next-the-Sea. Other suppliers appeared less often but were also used over a period of years, especially for mahogany. William Edwards, for example, supplied mahogany for twelve 'whole doors', six 'blank doors' and framing 'prepared for locks with double mergents'.[23] The accounts give few details about the types and origins of timber but when construction reached the stage at which timber was required, expenditure on it was heavy. During construction of the first wing, for example, from 1735 to 1740, annual expenditure on the brick kiln was between £211 and £238, while in the two years 1736–37 over £1,000 was spent on timber.[24] Oak for the remarkably fine floors throughout the staterooms was probably sourced from the Norfolk estate but, for that reason, left little record in the accounts. One surviving rough account book reveals the estate steward in 1752 on a visit to Tittleshall and Fulmodestone woods to mark trees for felling; he selected them for specific uses, including estate repairs and the wheelwright as well as the new building, and on these two occasions marked fourteen oaks at Tittleshall and thirty at Fulmodestone 'for Holkham'. The length, fine grain and uniformity of the floor boards

testify to the availability on the Norfolk estate of well-grown mature oaks, possibly 200 years old when felled, and to the skill of the men involved in selecting the trees and sawing the boards. Such quality in the floors demonstrates that no expense was spared in the finishing of the building.[25]

Stone was not a local material: all had to be brought by sea. The first supplies arrived at Holkham in 1730 for the Obelisk. More followed during

The high-quality floor boards seen from the Landscape Room along the south enfilade.

the next three years from Ralph Allen's quarries near Bath for the garden porches or pavilions, the Temple and the seat in the orangery.[26] Allen was a thriving Bath entrepreneur who had profited from 'farming' local postal services (perhaps one reason why Coke, the new Postmaster General, knew him) and had invested in quarries and in the means of transporting his stone to London and elsewhere. When final preparations were made in April 1734 to start building the first wing of the house, Coke intended to 'agree with Allen for so many tuns of stone [per] year'. As they had 'several transactions' together, Coke believed that Allen would be 'glad to keep up a correspondence with me' and supply stone delivered at Wells-next-the-Sea at one guinea per ton. It soon became clear to both Coke and Allen, however, that there would be problems in obtaining sufficient ships to keep up a regular supply.[27] At some point later that year, the decision was taken to build in

Joseph Howell the mason's bill for supplying and working alabaster, Portland and Bath stone and Bremen paving in the dairy and scullery in 1757.

126 HOLKHAM

white brick but the external design still incorporated stone, particularly for the portico and cornices. Every year for the next thirty years, with a pause in the mid-1740s when shipping was disrupted by war in Europe, the small port of Wells-next-the-Sea coped with the arrival of cargoes of stone and all the paraphernalia of ropes, crabs (hoists), blocks and pulleys needed for unloading them. Most cargoes were Bath stone but later there was also stone from the Coke estate in Conisborough (Yorkshire), Portland stone for staircases, Bremen paving, Purbeck paving for the kitchen floor, Newcastle flagstones (polished, for the Servants' Hall and rough, for the cellars and court yard) and, eventually, the alabaster for the dairy and the Marble Hall.[28]

The choice of brick over stone for the main structure, initially prompted by the difficulty of obtaining regular ships, proved fortunate on the grounds of durability, for in the mid- nineteenth century, again a hundred years later, and again fifty years later, it was external stonework, not brickwork or pointing, that needed repair. Transport costs, too, would have been a problem, because shipping Bath stone from Bristol typically doubled the cost of the stone. It was even worthwhile to pay labourers to unload stone from the wreck of a ship stranded near Lowestoft, in Suffolk, so that the cargo could continue its journey to Wells-next-the-Sea.[29] The numerous payments for transporting stone indicate a much bigger tonnage than the very few entries relating to its purchase because it was normal for stone to be purchased by the mason.[30] Usually flat-bottomed keels were hired to move the stone to the quay at Wells-next-the-Sea, where the channel was always tricky to negotiate and large ships had to lie at anchor some way from the quay. On one occasion, when Captain Cross was paid £35 for the voyage from Bristol (typically six weeks), he received £1 extra 'for bringing his ship up to the key'.[31] The captain often came ashore to spend a few hours at Holkham, probably to receive payment but also, as the butler's wine book reveals, to enjoy the company of two or three of the master craftsmen at dinner with the upper servants, with wine and port supplied: 'Steward's table on account of the captain of the stone ship, Mr Lilly [carpenter], Mr Howell [mason], Mr Hingham [brazier] & several others, port' and on another occasion, 'Joseph Howell & the captain of the stone ship in the morning Lisbon, to ditto at night by my lord's order'.[32] Doubtless, between Lisbon wine in the morning and port in the evening, the captains enjoyed seeing how their cargoes were becoming part of a great house.

The alabaster for the columns in the Marble Hall came from quarries at Castle Hay, near Tutbury, in Staffordshire, about ten miles south of the Coke family property at Longford in Derbyshire. Lord Leicester himself paid a visit to 'the alabaster pits' during a long tour in the north and midlands

Detail of exterior stone work.

The butler's Day Book: wine served at the Steward's Table when the stone ship captain dined with the senior craftsmen in 1749. Lady Mary Coke, wife of Edward, Viscount Coke, was also in residence and supplied with wine.

in 1754 and in the following spring the first payment was made to Thomas Wilkins, 'what he paid in getting alabaster'.[33] Wilkins was the long-standing bailiff at Longford, at that time in the hands of Wenman Coke (formerly Roberts), the son of Lord Leicester's sister and now heir presumptive to Holkham.[34] Henceforth Wilkins kept the accounts of all expenditure for

supplying alabaster. The first load, probably destined for the dairy in the ground floor of Chapel Wing, fitted out in 1756, was obtained from George Taborer of Tutbury but later that year an agreement was drawn up 'for alabaster to be got' from the same pits more economically through Joseph Pickford. This was either Joseph Pickford senior (1684–1760), who had just completed several of the chimneypieces at Holkham and would soon be engaged on working the alabaster, or his nephew and apprentice, Joseph Pickford junior (1734–82), who, a few years later, married Wilkins' daughter and established himself in Derby as a clerk of works and architect.[35] Typically, overland carriage from the quarry to 'Burton turnpikes' or Willen ferry on the River Trent added eight to thirteen shillings per ton to the cost of the alabaster. From there it was moved northwards along the river to Gainsborough and then along the Humber to the North Sea. Sea freight from Gainsborough to Wells-next-the-Sea, a journey of about two weeks, cost from ten to thirteen shillings per ton.[36] Unlike cargoes of stone, the alabaster was always unloaded from the ships and then from the wagons at Holkham by the alabaster masons and their labourers. The columns, bases and plinth were worked on site but the capitals for the columns were carved in London.

Bill of lading for alabaster and lime, shipped in the *Good Intent* from the River Trent to Wells-next-the-Sea in August 1757.

The marble for chimney pieces was mostly Italian, from Carrara, Siena and Sicily. Some was described as statuary marble, other pieces were veined and others were 'antique' marble of various types. Colours ranged from purple and white to black and gold. Much of the marble for the Family Wing

Detail of alabaster in the Marble Hall.

pieces was bought from a supplier but later pieces were supplied and worked in their entirety by the craftsmen who carved them in London and sent them to Holkham with a man to set them up.

In some years, plaster appears as a separate item in the accounts, originating from the Derby area ('Croitch' plaster) and shipped from Hull or Gainsborough, in different qualities, grey or white, and in huge quantities. Sometimes, as in the case of stone, the surviving accounts lack records of purchase. In 1737, for example, a great amount of plastering work in Family Wing was paid for, but it is the chance survival of a letter from Appleyard, the estate steward, to Coke that throws light on the challenges of sourcing suitable materials:

> I expect the plaister I sent for to be landed at Wells in a few days the same having layne at Hull a considerable time as I have been advised, and I hope the plaister will answer the beauty of your lordship's designs which if it does not I do not believe there can be any better sort gott in any part that I know I having had plaister from severall pitts for your lordship but never any from these pitts before and should have avoyed these pitts if I could have gott any as good and higher for although it be cheapest at ye pitt where it is gott the long land carriage & freight make the expence run high besides the prices of freight, warfage, lock dues, warehousing & porterage of any goods is almost double in price to what they were a dozen or 15 yeare agoe so that a man that has any dealing amongst those sort of people is to have his pockets well pick.[37]

Large quantities of hair and oil for mixing in the plaster were brought from Hull, Nottingham or unnamed sources. Freight to Wells-next-the-Sea, typically costing twice the price of the plaster, and onwards in carts to Holkham was not the end of the story, for in 1752 two labourers worked for three days 'getting plaister into the new building'. If amounts were miscalculated, the reverse applied, as on another occasion when fourteen garden labourers worked a total of nineteen days 'wheeling plaister out of the new building'.[38]

Whereas remarkable uniformity was achieved in the bricks for the Hall, some of the slating on the roofs was replaced after only twenty years, probably because of colour variations. Like stone, slate was not a local material and was sometimes supplied by the slaters, who also came from afar. The first wing was slated in 1736 by three men from London; the origin of the slates is not known but the wing was re-slated twenty-two years later to match the other wings. In 1742, a small sample of blue slates (probably Welsh) came from Liverpool but shipments of slate for the main house, starting in 1748–51, were Westmorland slate, then much in vogue. Some was supplied

by Gerald Fitzgerald, who came from London to do much of the slating of the main house; in 1749 two of his men spent twenty weeks at Holkham, presumably working on the south front.[39] A different slater, Richard Hughes, worked on Chapel Wing in 1754, Kitchen Wing in 1755 and Strangers Wing and the re-slating of Family Wing in 1758; five years later, the south-east tower was also re-slated.[40] A Ministry of Works survey, two centuries later, noted that the green Westmorland slates had been used on the frontages but purple Bangor (Welsh) slates faced the inner courts.[41] The cost of the slate varied between £2 and £4 per ton and freight added from £1 to £3 per ton, with more for unloading at Wells-next-the-Sea, supervised by the brick maker or mason. Most work was priced per square (ten by ten feet). The high price of thirty-five shillings per square for the first wing probably included the price of the slate; the usual price later was nine shillings per square.[42]

Most lead was supplied by the plumbers, chiefly George Devall and Edward Ives, both London specialists, although some was bought from merchants in Wells-next-the-Sea and small amounts were recycled from the London house on Coke's instructions, 'for it will do as well as new lead'.[43] A twentieth-century surveyor was impressed to find that the roof lead was all twelve pounds per square foot cast lead; he considered eight pounds sufficient for repairs.[44] Nails were bought in large quantities directly from the manufacturing centre of Wolverhampton or from local suppliers in Norwich and James Furnis, a cutler in Wells-next-the-Sea. Locks, hinges, screws and shutter hinges and turns also came from named specialist suppliers. The glaziers often supplied glass; one of the few sources detailed in the accounts for a direct purchase was Thomas Bonnick of Clerkenwell, who in 1752 supplied plate glass, the highest category of glass, costly to produce and heavily taxed, for the Statue Gallery.[45]

Carriage by the husbandry horse teams appears frequently in the accounts. Within a few months of starting work, Coke was aware of 'great complaints that the carriages are used in carrying materials [which] hinders the farming business'. He responded by telling the steward to buy more horses for the farm and it remained responsible for carriage of most building materials throughout the whole period of building.[46] Surviving invoices from the 1750s show that a horse cost two shillings per day (the same as a bricklayer) and a team cost 7s 6d per day. Other jobs were charged by the load, regardless of whether it was laths or lead: a load from the quay at Wells-next-the-Sea or Burnham cost four shillings but bringing timber from the estate meant a longer road journey and was much more expensive, typically fifteen shillings per load from Tittleshall or Sparham. Bricks were carried from the kiln for one shilling per thousand.[47]

1757 The Most Noble Thomas Earl of Leicester to
John Sowter D.r on Acco.t of the Building

1.st Augu.st	To mending a 3 wheel'd carte	0	1	6
	To making a hand barrow	0	1	6
	To rimming a pair of cart wheels	0	5	6
	To making a Carriage and wheel	0	7	6
3 Sep:	To mending a 3 wheel'd cart	0	3	6
	To making a 3 wheel'd carte	0	7	6
	To mending a Barrow	0	0	6
	To mending a 4 wheel'd carriage	0	2	10
	To helving a bill	0	0	2
	To mending a Barrow	0	0	6
	To helving a bill	0	0	2
	To fixing up 2 Drugs	0	1	0
	To fixing up 2 Stone carriages	0	1	0
	To treeing a Drug and Setting fast 2 furs	0	2	0
	To gitting home y.e Drug and Stone when Broke down	0	1	6
	To 1 day fixing up a Stone carriage	0	1	8
		1	18	4

Rec.d 31 Jan.ry 1758 by M.r Cauldwell
one pound Eighteen shillings and fourpence

 p.r me John Sowter

Carriage of building materials: John Sowter's bill for mending and making various types of carts, 1757.

Substantial wooden sheds, tiled, glazed and fitted with locks, were built for the masons, joiners and sawyers and for storing mortar and plaster. As work progressed round the building, they were dismantled and re-built in more convenient places.[48] The organisation of the storage and distribution of materials on site, in great variety and quantities, developed with experience. Coke was alert to initial problems and demanded improvement, writing to Brettingham, 'as for the nice laying up of materials etc I ever thought your hon[or]ary high genius overlook't it, & that they laid slovenly about, therefore … they sd [should] be taken account of & better lay'd up'.[49] An absentee owner might not have been so concerned, but as the old house and the new wing were occupied for several months each year, stockpiles of materials and workmen's sheds were very much part of the daily scene for himself, his household and his guests.

Lines of supply for building materials.

Chapter 6

Building the Hall: The Craftsmen

The names that are usually associated with the building of Holkham, as with any great building, are those of the owner, architects and certain principal specialists in decorative arts who achieved wider renown. It is normally taken for granted that the dozens of men who wielded the tools must remain indistinct and nameless, yet it is their workmanship that is exposed to view in the general appearance of the building, bears close scrutiny in the detail and shares the credit for the durability of the construction. No contracts have survived, although it would have been normal for separate contracts to be drawn up with each of the master craftsmen, but building accounts, audit books (estate accounts) and scattered mentions in other records enable an unusually vivid group portrait to emerge. It shows a mixture of local craftsmen and labourers, some of whom already worked on the estate, employed alongside specialists who were brought from London or elsewhere, many of them, whatever their origins, working on the Hall for twenty to thirty years. It was a remarkable community of workers whose skills ensured consistency of workmanship over the long period of building and produced an enduring structure worthy of its architecture.

Initially, particularly for bricklaying, it took some time to establish a regular team. The bricklayers who built the kitchen garden walls in the 1720s and worked on the Obelisk, Temple, garden porches and greenhouse between 1730 and 1732 were rarely mentioned when work started in earnest on the new buildings.[1] A full-time estate bricklayer, Robert Jackson, was employed from about 1730 and was still working at Holkham more than twenty years later, when his work included some time spent on the Hall.[2] He had probably been recruited in the Longford (Derbyshire) area by Wilkins, the bailiff there, for he and another man travelled to Holkham around the time that Wilkins was hiring 'masons' and paying them 'earnest'.[3] It was however a London bricklayer, Thomas Griffin, who was employed for most of the work on the Temple and the greenhouse. He spent several months at Holkham in

The Marble Hall ceiling, plasterwork by Thomas Clark.

both 1730 and 1731 but returned to London, expenses paid, with his man and his chest of tools in December each year. He later re-appeared working on repairs at the London house; perhaps he was simply unwilling to commit himself to long-term work in Norfolk.[4] Another bricklayer worked on the first stage of the new house, the foundations of Family Wing, in 1734 and Henry Oliver built the wing in 1735–37. Oliver was possibly a local man, for he provided lodgings for the bricklayers and by 1738 was renting an estate house in the village, large enough to be divided in two when he left in 1740. Having moved on to plain plastering in the attics and rustic storey, his last work was plastering the passage built to link the old house to the newly-completed wing. He also worked at other local sites, such as the new house for Branthill farm. Like his predecessors, there is no clue why he did not continue at Holkham.[5]

His successor as bricklayer, John Elliot, appeared in 1737 helping to build the farmhouse at Branthill and on minor jobs in the new park, but there was apparently little work for him in 1738–40, the period when finishing touches were being put to the first wing. In the following year he worked on repairs at the London house.[6] It would be interesting to know whence he had come, whether work on smaller local houses supplemented his income and whether he was playing a deliberate waiting game for more Holkham work. In 1743, as work gathered pace on the main house, he and his team earned a total of £298, rising to £737 in 1746.[7] In this year he bought a house, divided into two tenements, at Holkham staithe and several acres of land in Wells-next-the-Sea. By the following year, when he made his will, he had lent money as a mortgage on premises in Burnham Market. He soon sold the land in Wells to Lord Leicester but the tenanted building at the staithe remained in his family's ownership until his heirs sold it to T. W. Coke in 1803.[8] In 1752 he built a new house in Holkham town for his own occupation, for which he was allowed ten years rent free. In that year he also travelled to London to do a considerable amount of repair work on Thanet House.[9] By now, his well-established connection with Matthew Brettingham had brought him work on other great houses, including the Duke of Norfolk's London house in St James's Square and Euston, the Suffolk seat of the Duke of Grafton, a close friend of Lord Leicester's.[10]

Elliot was in charge of overseeing all the bricklaying work on the Hall for over sixteen years. He is one of the few craftsmen for whom some weekly bills survive, listing at least thirty-one men (not including unnamed labourers) who worked under him in the four years 1754–57.[11] Between four and seven of the men were at work in any one week. These bills were only for day work, however, which was additional to measured work or work covered by a

Bricklayers: a typical page in building accounts for work on Kitchen Wing, 1755.

contract, and in the absence of earlier bills, it is not possible to say if the men were a long-established team. Most earned 1s 4d per day, suggesting that they were relatively unskilled: day wages in 1753 were noted as 'best bricklayer 2s 4d per day in summer, 2s per day in winter; 2nd bricklayer 2s per day in summer, 1s 10d per day in winter, a labourer 16d per day in summer, 12d per day in winter'.[12] Elliott's own daily rate, on the odd occasion that it was mentioned, was three shillings. One such job was 'raising ladders & mending the slating of the North Towers'.[13] It was Elliott who knew the men's work and allocated them either to the external walls, where such a remarkable consistency of craftsmanship is displayed, or to internal work. One of his bills noted that 'turning funnels' in the state bedchamber was 'trusted to common

workmen not seen by Mr Elliott'.[14] He presumably directed similar teams of bricklayers at Norfolk House (London) and at Euston, where for a year or so he was in charge of paying the labourers on site.[15] He continued to work at Holkham until his death in November 1759, surviving Holkham's owner by just five months.[16] Other independent bricklayers were also employed occasionally, such as William Lack, sometimes with his son, brother and a labourer, who worked in the cellars of one of the wings and pointed part of the Chapel Wing.[17] After Elliott's death, a Francis Lack led the team of bricklayers until the Hall was completed and was perhaps the same Francis Lack still active as a bricklayer towards the end of the century.[18]

Most of the carpentry and joinery in the house was worked by James Lillie and his team. He appeared working on the Temple by 1731 and was soon joined by Edward Copeman.[19] Lillie was possibly a local man for when Coke, ever alert to the going rate for various crafts, found out in London that the Board of Works paid fourteen shillings 'per square' for laying 'the best oak floors', he commented, 'if so, Lilly has still 1s [one shilling] per square more than London workmen, which I shan't allow ... unless I find he works cheaper than the fellows here, I shall bargain with another to take his place at Holkham'.[20] Lillie, a married man, soon rented one of the larger estate cottages at Holkham, a few years later took over a house from the gardener and then, like Elliott, built a new house at his own expense, to be rented from the estate after ten years.[21] Edward Copeman also lived in the village with his wife and family; the cost of thatching his house was paid although apparently it was not rented from the estate.[22] For eleven years until Copeman's death in 1743, he and Lillie worked in partnership. As was the case with other crafts, they headed a varied team of men with considerable individual skills but shadowy identities. They were responsible for a wide range of work, from heavy structural carpentry to models, pattern chairs, plain furniture, moulds for the brick maker and plasterer, and external work such as bridges, ornamental seats and boats. In the mid-1750s, the only period for which original bills survive, Lillie employed from four to eight men a day, although, as in the case of the bricklayers, these surviving bills are for day work and do not necessarily reflect how many men were doing measured or contract work. He took on three apprentices at various dates.[23] His own day rate was three shillings and his men, including a relative, John, were paid 2s 4d, considerably more than the 1s 8d paid to the carpenter at another Norfolk house, Wolterton.[24] Lillie worked at the Hall for nearly thirty years; when Lord Leicester died in 1759, he made the two wooden coffins, helped at the funeral and fixed the hatchment at the Hall.[25] His own death came less than a year later, in February 1760, barely three months

after Elliot, the bricklayer, and followed within two weeks by his own wife and adult daughter, possibly victims of a smallpox epidemic that was decimating the neighbouring parish of Wells-next-the-Sea. After Lillie's death, payments were made under the general entry of 'carpenters and joiners', suggesting that his long-established team continued as before. In 1760–65 two of his joiners, Robert May and Peter Moor, were employed in the Marble Hall and the chapel.[26]

From 1753 William Townson, from the nearby village of Burnham Westgate, also appeared doing carpenter's and joiner's work, from structural carpentry and mahogany doors to making furniture. He was evidently recruited as part of Lord Leicester's marked acceleration of building in the mid-1750s. He employed two men, occasionally three or four, and a boy.[27] He took four apprentices between 1741 and 1760 including Thomas Morehouse, the son of Coke's gamekeeper, whose premium was paid by Coke.[28] Townson did

Joiners: a bill from Lillie for one week in March 1754 including a case and board for the Dining Room chimney piece 'for ye fable of ye wolf and piggs'.

The Dining Room. The chimney pieces each feature one of Aesop's fables.

Joiners: An exact replica under construction for a Family Wing external door, destroyed by fire at a workshop, by Maurice Bray, 2005.

Traditions continue: joiner Maurice Bray (employed 1958 to 2013) renovating windows and Hall carpenter Ian Barrett (employed 1963 to 2016) repairing furniture.

little work at Holkham after 1757 apart from doors and the mahogany rail for the banisters in the Marble Hall.[29]

Bricklayers and joiners appear unannounced in the accounts but other craftsmen were deliberately recruited from outside the locality, particularly for work on materials that were foreign to the county, such as stone and slate. The first cargo of stone for the Obelisk in 1730 was closely followed by a mason from Bath, John Parsons. He was possibly related to Robert Parsons (1717–90) who was employed as a mason by the well-known Bath builder, John Wood the elder, and became known for decorative items worked in Bath stone.[30] John Parsons was paid for the travelling expenses of four men, only two of whom returned to Bath. On the recommendation of the quarry owner, Ralph Allen, they were paid 2½d per foot for cutting the stone, which Coke belatedly discovered was 'much too dear … double pay is too much tho' they work [away] from home'.[31] Parsons settled in Wells-next-the-Sea and during the next three years worked on the Obelisk, Temple, the two porches or pavilions, 'the new stone seat' and the greenhouse or orangery. By the spring of 1734, Coke was concerned to keep him busy until stone could arrive for the house. Although the decision was then taken to build in brick, Parsons did some stone work on the first wing but he was supplanted for most internal work there by a well-known London mason, Andrews [sic] Jelf.[32] Parsons continued to work occasionally on the house until about 1750, including a month's visit to Yorkshire 'for stone'. He worked with Matthew Brettingham in the late 1740s on the new Shire House in Norwich, an association that ended in a claim by Parsons for non-payment.[33]

Most stone work, however, was by a local man, Joseph Howell. While Parsons was working on the first wing, his name was often linked in the accounts with Howell, possibly one of the men who had accompanied him from Bath although by 1742 he, too, was living in Wells-next-the-Sea and had invested in a mortgage on two tenements in Holkham.[34] The masons' bills, varying widely in amount from year to year and including work on features such as the stone bridge, the 'new seat on the mount' and the Triumphal Arch, were frequently in Howell's name, and as early as 1740 it was Howell who was to accompany Brettingham, the architect, to visit Coke in London for instructions.[35] By the 1750s, he employed up to four masons at 2s 6d per day and labourers at 1s 6d, considerably lower than the rates charged by the London mason, Jelf. In order to put up the statue of Apollo over the chimneypiece in the Statue Gallery, he mustered six masons and additional labourers for half a day. His son, probably quite young as he received only ten pence per day, gained useful experience 'waiting on Mr Roback' for ten days, when the sculptor Roubiliac was working at Holkham on busts of Lord Leicester.[36] Howell's work at Holkham continued for thirty years. Unlike the Earl, his bricklayer and the joiner, he lived to see the Hall completed in the mid-1760s.

The other craftsmen usually recruited from outside the locality were those skilled in specialist decorative arts in plaster, wood or stone. In February 1737, Coke wrote from London to Appleyard at Holkham, 'the plasterer I suppose by this time is come to you, he is a sad dog if he went without calling on Kent for his last directions, which I believe he did not do'.[37] This was 'the ingenious Mr Thomas Clark, of Westminster', who became one of the most successful plasterers of the late eighteenth century.[38] Coke's letter crossed with Appleyard's, reporting that 'your lordship has three or four plaisterers lately come to Holkham', the only indication of the size of Clark's team.[39] During the following eighteen months, they plastered the main floor of Family Wing and the staircase, charging 8d per yard for plain work and 18d per foot for other work, although a note in the margin in Coke's hand complained 'plain work [should] be but 6d'. The total came to £193. A third of the total was for the library, whose beautifully restrained ceiling relies on consummate plaster work rather than painted decoration. By contrast, the bricklayer Oliver's bill for the plain plastering in the rustic and attic floors together was only £41.[40] After the completion of Family Wing, Thomas Clark was not needed again until May 1752, fourteen years later, but was then more or less steadily employed for ten years on both plain and decorative work, first in the 'uppermost storey of the body of the house' (the tower rooms and passages) for nine or ten months, for a total bill of £208, then a year's

Masons were responsible for placing 'Apollo' above the Statue Gallery fireplace.

Plasterer: a bill from Thomas Clark, 1754, for work in the the Dining Room and the Statue Gallery.

work chiefly on the attic storey (the top floor of the east side, £95) and the Dining Room, Gallery and anteroom (nearly £500), then, moving round to the south front, the Saloon and the two adjoining rooms, totalling £631. A

The Statue Gallery showing one of the 'two large niches fully enriched' by Thomas Clark.

total of £806 was paid in 1757, probably for two years work, only specified as 'work at new hall' and including plain plastering in the rustic floor and in the kitchen and laundry wings. Plastering the Marble Hall, completed in 1760, cost over £1,025, about £270 less than the alabaster masons' work there. Then the next three years were spent chiefly on Strangers Wing, the stables and the chapel.[41] Like many of the craftsmen, Clark's bills appear as annual block entries in the accounts but one surviving daily account book shows that he was paid 'on account' in small monthly sums.[42]

It is difficult to tell from the accounts how much of the work was done by the master craftsmen in whose name payments were made. By the time that Clark was needed for the main part of the house in the 1750s, he had duties as Master Plasterer to the Office of Works in London (1752 to his death in 1782) and during the same period was responsible for the plasterwork at Norfolk House, including the celebrated Music Room.[43] Nevertheless, Holkham was a massive commission where the total cost of his work reached £4,127, compared to about £225 for the principal floor at Norfolk House, and it is clear that he became almost part of the Holkham household. He was allocated a bedchamber next to Brettingham's on the upper floor of Kitchen

Chapter 6 Building the Hall: The Craftsmen 147

Plasterers: the Marble Hall ceiling.

Wing.[44] The housekeeper, Mrs Staniforth, left him a ring in her will, and his daughter married the nephew of Cauldwell, the estate steward.[45] When the servants were treated to an outing to the theatre in Walsingham, followed by supper, Clark was included in the upper servants' party. 'Master Vardy' went, too, possibly a young relation of the architect John Vardy (1718–65), who had been an assistant to William Kent, or his brother Thomas Vardy, a furniture carver, although the account books do not show that either worked at Holkham.[46]

Wood and stone carving were often done by the same hands but remarkably little is known about the Holkham craftsmen.[47] A carver, John Woodward, was at work in the first wing by February 1738, when Coke twice wrote to ask, 'how do's the carver perform'.[48] One entry in the accounts gives a hint of the long hours worked even by skilled craftsmen, when Woodward was paid for 272 days work at two shillings a day, 'ditto for 387 over hours, 10 to a day & 6 days to a week at 17s.' He also received board wages for 200 days, at the rate of five shillings per week. Fish skin (a forerunner of sandpaper) and pencils were bought for him.[49] Having seen a London carver's work on frames for pier glasses and over chimney pieces, Coke decided that Woodward was 'not yet in so true a taste of those things as he [should] be' and gave instructions that friezes for doors and other items were to be cut out by Lillie, the joiner,

148 HOLKHAM

Carver: the Library chimney piece, probably 'the very rich frame' carved by Marsden.

and sent to London to be carved. Woodward was to continue with 'the doors and members for the rooms' but 'hand work [should] be done in another stile'.[50] The London carver preferred by Coke was 'Mr Marsden' who was paid in 1739 and 1742 for 'very rich freezes' for doors, 'a very rich frame for a chimney' and pier glasses, all items that were recorded in domestic rather than building accounts.[51] The regular carver from 1741 until his death in 1748 was William Roberts, probably the same man who had carved marble chimneypieces at Wolterton, also in Norfolk. He occupied an estate cottage at the staithe village. He carved items of furniture such as picture frames as well as work under the building account.[52] After Roberts' death, Brettingham was paid for large amounts of carvers' work in both wood and stone.[53] This was the only area in which Brettingham had this role of intermediary and it is not clear why. When Brettingham was replaced in 1760, he was

succeeded as supervisor of the buildings by one of his men, James Miller, another craftsman of whom little is known but who continued also to be paid for carving, particularly in the chapel, until the Hall was completed in 1765. If Miller can be identified with James Miller, carver, of Marylebone, he was declared bankrupt two years later.[54]

Marble chimneypieces were usually a speciality, distinct from other carving. At least seventeen of the Holkham pieces were by Joseph Pickford (1684–1760), a prominent sculptor and master mason based in Piccadilly, London. Early in his career he had been assistant to Giovanni Battista Guelphi, a protégé of Lord Burlington's, and subsequently worked on many great Palladian buildings in partnership with his stepson, William Atkinson.[55] His first work at Holkham was carving five chimneypieces for the major rooms of Family Wing in 1739–40 but Coke was not pleased with his execution of William Kent's design for Lady Margaret's dressing room and decided to commission another man for the chimneypiece in his wife's closet, 'that I may try the difference'.[56] The man he chose was Thomas Carter (d. 1756/7) who had been building up his London business as a sculptor and for the past few years had been specialising in chimneypieces.[57] He was paid the modest sum of £19 for the chimneypiece and slab in the closet. He also worked in wood, later carving 'two large panels of lime tree to the side of the dining room niche'.[58] After a break of some years while structural work was proceeding, both Pickford and Carter reappeared at Holkham in 1755–56, Pickford to carve the chimneypieces for the Statue Gallery, Drawing Room, 'East Drawing Room' (later known as the South Dining Room), Landscape Room and an unspecified room (probably North State Dressing Room) and Carter, now heading a well-established family firm, those in the Saloon (two), Dining Room (two), State Bedchamber and North State Bedchamber.[59] Many of these chimneypieces were based on designs by Inigo Jones (1573–1652). William Kent, who had designed most of those in Family Wing, had long since died but Coke owned copies of *Some Designs of Mr Inigo Jones and Mr Wm Kent* by John Vardy (1744) and *The Designs of Inigo Jones* by Kent (1727). There is no clue how Coke decided which piece should be carved by

Masons: bill for a Holkham mason spending ten days with Mr Carter's mason to put up the Saloon chimney pieces.

The Saloon, one of the two chimney pieces.

which sculptor and it was perhaps merely a matter of expediency, as he accelerated work on the house. Those in the Family Wing had cost on average about £16 for the marble and between £17 and £52 for workmanship; those in the staterooms, for materials, labour, transport and fixing, cost from £124 11s (Landscape Room) to £181 4s 1d (Drawing Room).[60] The pieces were carved in London and sent to Holkham with a mason and labourer to set them up. The younger Brettingham, in his *Plans and Particulars*, attributed to Pickford at least seven more chimneypieces in Strangers Wing but Pickford had died in 1760 and the account books indicate that at least some of these later pieces, and others in the rustic basement such as the Portico Room and Octagon Room, were by his partner and stepson, William Atkinson.[61]

The firm of Pickford and Atkinson also employed the team of marble masons who worked the alabaster columns and frieze in the Great Hall, later known as the Marble Hall. Their account book (held in the National Archives) is a unique record for Holkham, the only known document that was the craftsmen's rather than the employer's record.[62] The first three men arrived early in July 1757 after completing work at Audley End in Essex. Their tools came separately, by sea to King's Lynn and then by road to Holkham. They set to work cleaning chimneypieces, working column bases and sawing alabaster. A month later, they were joined by six more men, some travelling

for six days, others for only two, to reach Holkham. Whether it was to reunite an old team or to cement the formation of a new one, they celebrated their arrival with a gallon of beer at the *Ostrich* in Holkham village and five times as much at the *Horse and Farrier* at Holkham Staithe.[63] Work now began in earnest on the columns and bases, sawing, 'working', setting and polishing them. By October, there were up to fifteen men at work, including Thomas Johnson and his three sons. Although recruited as a specialist team, the alabaster masons were paid no more than Howell's stonemasons. Michael Hope, apparently the foreman, earned 2s 6d a day, while most of the others were on 1s 5d to 1s 8d a day. The Johnson family received about four shillings a day as a team and Johnson senior sent money home to his wife through Pickford. It is not at all clear from the accounts to what extent Pickford and Atkinson were present on site; one of the men was responsible for 'drawing and taking dimensions for Mr Pickford' and the foreman accounted for money received from the Earl's agent and remitted on to them. Pickford was already supplying carved marble chimneypieces for several of the staterooms but at this period he and Atkinson were also heavily involved in work on the new University Library at Cambridge.[64] Nevertheless, on several occasions the laundry maids were paid for 'Mr Pickford's washing' and he had a room in Kitchen Wing, next to those for Brettingham, the architect, and Thomas Clark, the plasterer.[65]

The marble masons had three days off for Christmas 1757 and another on 5th January, Twelfth Night; perhaps this was the occasion for the 'wake goose' to which they had contributed. Six more men arrived in January and one or two left, so that for some weeks up to eighteen men were at work each day in the Great Hall. Numbers reduced to about eleven in the summer, perhaps because labourers were lured away by more lucrative outdoor work, but several of the remaining men were working '1 day and two hours', or fourteen hours each day, for a six day week. By now, most work was on the dado and plinth. Numbers fell again in late summer, leaving seven men to work mostly on chimney pieces, Portland stone steps and cleaning the alabaster in the dairy. Then in April 1759, the death of Lord Leicester brought the masons' account book to an abrupt end. By then, three of their men had been working continuously at Holkham for fifteen months and others, including three members of the Johnson family, for at least eighteen months.

When work resumed, it can be followed only through the Holkham accounts. In August 1760, after just over three years work, William Atkinson & Co were paid 'to the remainder of their bill of £1294 5s 7d to finish the marble work in the Great Hall'. In November, the men, ending in the same way as they had begun, were given two guineas (forty-two shillings) 'to

Next room

A Bed Stead & furniture as above
Feather bed, bolster, 2 pillows, 3 blankets
1 Colour'd Calico Quilt
A mahogany table
2. Rush bottom'd chairs

5. Iron Locks 2 keys

Mr Pickford's Room

A four post bedstead white dimithy furniture
A Feather bed, bolster and pillow
1. check'd matrass
4. Blankets
1. white Quilt
1. Bedside Carpet
a mahogany table
a Dressing Glass
a Compass back'd chair
4. Rush bottom'd chairs
a Brass stove, fire shovel, Tongs
Poker, fender and Broom
Brass Lock and Key

Closet

A Close stool

Mr Brettingham's room

A four post bedstead blue Harateen furniture
Feather Bed, Bolster, 1 pillow
a check'd matrass
4 Blankets
a white Quilt
a mahogany table
a Dressing Glass
a walnuttree chest of drawers
a compass back'd chair
2 Rush bottom'd chairs
An Iron stove, fender, Tongs, shovel
Poker and broom.
Brass Lock and Key

Mr Clark's room

A four post bed, green and white stuff damask furniture
Feather bed, bolster, 1 pillow
1 check'd matrass
4. Blankets
1. white Quilt
1. mahogany table
an old table
a Dressing Glass
a compass back'd chair
3. Rush bottom'd chairs
1 Brass stove, Fire shovel, Tongs, Poker
fender and Broom
A Brass Lock & Key

Senior craftsmen's rooms in Kitchen Wing, above the Servants' Hall, listed in an inventory of 1760.

entertain themselves on finishing the hall.'[66] If beer still cost one shilling a gallon at the local inns, as it had done when they arrived, the men were well entertained. At least some of them stayed on for another four years to work in more mundane areas, fixing chimney pieces in the Counting House, Strangers Wing, the Portico Room and Chapel Wing, paving the Great Hall, fixing statues in the niches in the Hall and repairing the external balusters at the top of the house. The bill for much of this work was disputed and settled only in 1766; perhaps it was not coincidental that this happened after the personal connection between Lord Leicester and Pickford had been ended by their deaths in 1759 and 1760.[67] Nevertheless, the widowed Lady Leicester employed William Atkinson to erect the monument in Tittleshall church in memory of her husband and their son.[68]

Plumbers, glaziers and smiths made less splendid but nonetheless crucial contributions to the building process. George Devall, a London plumber who had worked at Coke's London house as early as 1723 and at Houghton Hall, was probably the same Devall who was paid for plumber's work on the Temple and the new wing in the 1730s.[69] 'Mr Devall, plumber' and 'Devall, mason' (possibly John Devall, a London mason and plumber) subsequently installed water closets and baths in the first wing.[70] A plumber and glazier in Wells-next-the-Sea, William Loads, supplied lead and glass and was paid for glazing the greenhouse and 'ananas house' but seems to have been primarily a merchant.[71] When the Family Wing was ready for glazing, Coke told Brettingham to send to him in London 'deal boards representing the exact size of every sash square' so that he could obtain prices from glaziers and 'send a man to put the glass in'.[72] A suitable tradesman, however, was found much nearer home: for the next twenty-three years, most of the glazing and some of the lead work was done by John Bullin of Wells-next-the-Sea. He also supplied materials and items such as 'leaden cisterns for flowers' in the kitchen gardens. In the 1750s he was often paid for the work of two men at 2s 6d per day (summer rate) as well as two sons and another 'young son' at 1s 6d per day. When the Earl of Leicester died in 1759, it was Bullin who made the lead coffin.[73] He died in 1761, aged fifty-two, one of the few men whose occupation the rector of Wells thought fit to record in the burial register.[74] The three sons were probably the reason why Mary Bullin, John's widow, still invoiced for glazing, plumbing and painting work more than twenty years later.[75]

Bullin's work was supplemented from around 1750 by John Ivory, a Norwich builder, and Edward Ives. It was Ives's men who laid water pipes 'in sundry parts of the house' in 1755 and both Ives and Ivory worked on water closets. Ives's two men were paid 21s and 18s a week, considerably more than

Glazier and plumber: a typical bill from John Bullin, 1757.

Bullin's, but Ives was a London plumber who also worked, for example, for the Earl of Egremont at his house in Piccadilly.[76] Plumbing was not the only speciality where the day rate for technology was much more expensive than for traditional crafts. Mr Blockley, who was paid a daily rate of six shillings and his man five shillings, plus travelling expenses, to install a bell system in

1757, was probably Thomas Blockley (1705–89), a prominent and fashionable Birmingham locksmith.[77]

There was, of course, a local blacksmith. Robert Knotts (or Knatts) in the 1730s was tenant of both Peterstone Farm, just to the west of Holkham, and the smithy in Holkham town.[78] His work appears occasionally in the accounts and he supplied cramps, nails and other ironwork for the Obelisk in 1730–31.[79] Around that time, however, when work was planned on the new house, a master smith, Thomas Hall, was recruited as the estate blacksmith from Longford, where he had had a shop (workshop) at the hall. He was paid £40 a year for himself and his boy under the estate account.[80] The smiths were particularly important in mending and sharpening tools for the other craftsmen but did some specific work at the new house. Coke enquired about Thomas Hall's progress on 'the rails to the staircase' in the Family Wing in 1738 and one of his nine children later made 'four brass grates to carry the water off the portico'.[81] By 1760 there was also a journeyman smith, Edward Emerson, whose annual wages were entered under the building account while the Hall was being completed and who worked on the estate until his death in 1793.[82] One of his sons, a carpenter, built several houses (still occupied) at the staithe village around 1820 and a grandson, also a carpenter, became the estate architect or clerk of works. A lack of surviving account books for twenty years after the completion of the Hall makes it impossible to judge how many of the craftsmen continued to work on the estate and passed on their skills to sons, but there is no reason to think that Lack the bricklayer, Bullin the plumber and Emerson the smith were exceptional.

The last stages in the construction of the house, painting and gilding, produced a surprising recruit to the ranks of the craftsmen. John Neale had been employed by Coke since 1731 as a footman but must have shown an aptitude and interest in house painting. As a footman, he earned £8 a year plus board or board wages, but in 1736 and 1737 he received also 'a gratuity' of one guinea 'on account of painting,' either at the old hall or the London house. In the following year, still serving as lady's footman, he received a gratuity of five guineas for painting and gilding and was provided with clothes to paint in.[83] In 1740–41 he married one of the housemaids, Ann Coats (the sister, perhaps sister-in-law, of Abraham Thomas, the secretary). They soon rented an estate house in the village but both continued working as domestic servants in the household until November 1743, and their son Thomas (no doubt named after their employer) was baptised at Holkham a few months later.[84] At this period, most of the painting in the first wing was being done by 'Old Sturgeon' and his son; other painting and gilding was by John Hart

and Philip Ince of whom nothing is known except that they were not local men, as villagers were paid for lodging them.[85] Soon, however, Neale, the former footman, was being paid for paint pots and gold leaf and from 1746

Gilder: one of John Neale's bills, 1758.

onwards was doing most of the painting and gilding. With Family Wing completed and the next stage not yet ready for painting, work was initially spasmodic. He gilded the vane on the first tower, painted the tower rooms and dozens of sash windows and did a variety of jobs on the domestic side, such as 'laying his lordship's crest in 17 buckets', 'guilding 2 figures for desserts' and 'painting a floor cloth'.[86] Perhaps he was obtaining other work locally; he also did some gilding at Euston Hall (Suffolk) which Brettingham was remodelling.[87] Then, as the main rooms were completed in the mid-1750s, he came into his own. In 1755 he was paid for painting and gilding the Dining Room and Statue Gallery (over £221 for materials, £252 for workmanship) and in the next two years £800 for the other staterooms. The gilding amounted to 7,227 feet paid at 2s 9d per foot; painting was 3d per yard. His work encompassed a wide range, from plain painting in the passages to gilding picture frames, table frames, chairs and settees. He ground and mixed his own colours, which in one year, for example, occupied sixty-one days.[88] This suggests that he had acquired traditional expertise, despite the increased availability of ready-mixed colours in the mid-eighteenth century which led one writer to note that 'several Noblemen and Gentlemen' had decorated their houses 'by themselves and Servants, without the Assistance or Direction of Painters'.[89]

Neale was reimbursed for some of his colours, linseed oil and gold leaf and other colours and brushes were purchased from Robert Keating (a specialist London colourman) or other named suppliers.[90] For early work on the Temple, gold leaf and a gilder had been provided by Coke's friend and fellow connoisseur, Sir Andrew Fountaine (son of the lawyer who had played such a mixed role at Holkham some seventy years earlier) but gold leaf for the large amounts of gilding in the Hall was bought by Neale or direct from suppliers. In 1738, for example, thirty-eight dozen books of gold were bought at eighteen shillings per dozen, and more of the same, with ten dozen of 'thick gold' costing twenty-four shillings per dozen, in the following year.[91] There is no reference in Neale's few remaining bills to his employing other men but it is likely that he did so. His last year of activity seems to have been 1759. A London painter, Charles Rathbone, who had previously worked on the London house, spent at least forty-eight weeks at Holkham in the following year or two, probably completing the staterooms.[92] Then in 1764 Strangers Wing was painted and gilded by a newcomer, Matthew Scatchard. John Neale's name reappeared briefly in the accounts for a smaller amount of work in the same wing and some of the painting in the Great Hall but a parallel account book indicates that the work was done by Thomas Neale, probably his twenty-year old son.[93]

Gilder: traditional cushion and tip used by the Hon. Rupert Coke, professional gilder, when renovating gilding at Holkham.

The steady employment of so many craftsmen who were either local by origin or chose to settle locally does not appear to have been prompted by lower wage rates. Much of the work was priced as 'measured' work, according to a complicated hierarchy of length, area and detail that differed for each trade. Where day rates can be ascertained, they showed little of the differential that might be expected between trades, and between rural Norfolk and London. Thus Elliot, the bricklayer, and Lillie and Townson, joiners, all commanded three shillings a day, with their most skilled men on 2s 4d, rates that matched those in London.[94] The first mason from Bath, the longstanding mason (Howell), the plumber (Bullin) and the painter (Neale) were slightly lower on 2s 6d a day, as were, surprisingly, the alabaster masons. It was in

The North State Dressing Room window after renovation of the gilding by Rupert Coke.

these trades that London men were paid more for working at Holkham, but only for brief periods of time: three shillings for the mason sent by Jelf, 3s 6d for the specialist plumber, Ives, and 3s 6d per day or 21 shillings per week for Rathbone, the painter.[95] Coke was alert to wages and measured work rates at London and elsewhere but a high standard of craftsmanship, available locally, loyal over the whole long period of building, earned reasonable rewards.

The striking continuity among the master craftsmen and among many of their assistants and labourers was of great benefit on such a large and complex building site, where the different trades were often interdependent in everyday work. At the estate's expense, the carpenters made troughs for the plasterers, mandrills (forms to shape metal) for the plumbers, moulds for the brick makers, centres (to support arches) for the bricklayers and templates for the alabaster masons; they planed boards for the plasterer and carver to draw on (the normal method for drawing detailed plans) and made 'a machine' for moving statues.[96] The masons worked the smith's grindstone 'fit for his use' and rub stones for the bricklayer 'to rubb the Dutch tiles on'.[97] The plumber kept the mortar engine working and the alabaster masons treated the blacksmiths to beer at the inn, no doubt in return for maintaining their tools.[98] The carvers made such items as 'reverse patterns

of the rail in the Great Hall for the smith to work from' and reverse mouldings of ceiling details for the plasterers.[99] The bricklayers cooperated with all trades, as shown by one typical bill for six days work by two men 'to assisting the masons in setting up the chimney piece in drawing room, cutting away the under parts of trimmers for the plaisterers & making a brick fender for the joiners'.[100] The safety of many men depended on the skill of both bricklayers and joiners in selecting timber for scaffolding and in setting it up.[101]

In addition to the men whose names dominate the building accounts, there are numerous entries recording the role of lesser local craftsmen and labourers, many of them over long periods. William Jolly, for example, a village carpenter frequently employed on estate jobs during forty years, was also called on for jobs associated with the building works, such as repairing the paling round Family Wing, building a 'plaster house' and helping to unload stone at Wells-next-the-Sea quay.[102] Carpenters and joiners depended on teams of sawyers, again including names that recur over a period of thirty to forty years, such as Nicholas Winch and James Ellett. Such men also made and mended barrows, timber drugs (two-wheeled carts for moving large trunks), timber and stone carriages, water carts and trestles for the bricklayers. On occasion, however, Winch and Ellett also cut 'finnears [veneers] and quarter stuff out of mahogany' for doors, indicating a high level of skill.[103] It is impossible to quantify either their contribution to the house or the extent to which the building process provided them with a living, but each must have been significant. For all but the most specialised work, the neighbourhood yielded skilled craftsmen and reliable suppliers and merchants who were capable of meeting unprecedented demands. In return, the reverberations from building a great house, over a period of thirty years, were felt in the local economy far beyond the sound of workmen's tools and the rumble of carts.

Chapter 7

Building the Hall: 'Comfort and Convenience'

Holkham Hall is celebrated as an expression of Thomas Coke's architectural taste and for its paintings, sculpture, books and furnishings, but contemporaries were well aware that the design of the house also incorporated outstanding technology: practical aspects such as water supply, sanitation, heating and cooking were no more left to chance than was the appearance of the house, and in their own way they were as remarkable.[1] Coke's knowledgeable enthusiasm for architecture was matched by a concern for practical excellence. He checked on the progress of a water-pumping 'engine' erected as work began on the new house. When building of Family Wing proceeded in the 1730s, he gave personal instructions to Matthew Brettingham on the fitting of his bathroom and water closet. Twenty years later, as Kitchen Wing neared completion, he was busy 'setting out' the kitchen court with Brettingham. When fireplaces gave problems, it was Coke who consulted a book by an expert. Practical aspects of the Hall warranted mention in the younger Brettingham's description of Holkham, published in 1773, and impressed visitors.[2]

One such feature was the water supply, designed to provide a high standard of sanitation in the family and guest wings at the west end of the house and a separate liberal supply to the domestic offices at the east end. In the early 1730s as preparations were made to start building, a specialist well sinker, Mr Capper, was brought from Derbyshire. He was paid £40 per annum, a high salary reflecting his skills, but he and a colleague were killed in 1734 in a farm well. By 1738, when work was well advanced on Family Wing, a well had been sunk in its vaults and two men, perhaps mindful of Capper's fate, were given a gratuity of one shilling each for going down it. There are now no traces of this well, nor is it shown on plans, but Brettingham described how an engine, of unspecified type, pumped water from it to a lead cistern on the

The icehouse viewed from the terrace.

'Plan of the Vaults', *c*.1750, showing the water engine house, laundry and dairy below Chapel Wing (top) and the cellars of Kitchen Wing (bottom). Lines showing water pipes and drains have faded.

The octagonal water engine house from the north, flanked by Victorian buildings, *c*.2000.

lower roof of the wing, to supply its baths and water closets. Consequently, as soon as Family Wing was completed in 1741, it had an independent water supply which, unusually, was designed solely for water closets and baths. Kitchen, laundry and other services were still provided by the old house. A similar water supply was installed in the north-west Strangers Wing, built some fifteen years later.[3]

In the central part of the house, a covered pump and a cistern in each of the internal courtyards, Steward's Court and Pantry Court, gave a ready supply for the housemaids and butler. The principal well was sunk near the south-east corner of the house in the mid-1750s, when the domestic offices it would serve were being built.[4] The engine, worked by a horse walking a circular track in an octagonal engine house, was supplied and installed for £40, plus travelling expenses of six guineas, by John Broadbent, a London engine-maker who later worked at Petworth (Sussex) for the Earl of Egremont.[5] A knowledgeable foreigner, visiting some thirty years after the system was installed, particularly commented on the fact that 'a machine in the yard, set in motion by a horse for three-quarters of an hour every two days, raises water into good lead reservoirs on the roof which supply all necessary water in each apartment and generally throughout the house. What with that great convenience and every refinement in its distribution, everything

The former horse-walking room, entered at a lower level from the south.

is provided for living in the English manner'.[6] The water fed by gravity from the cisterns in the engine house roof to cisterns above the laundry and dairy in the south-east wing, the kitchen in the north-east wing and the stillroom along the east side of the main house. The engine house was modelled in miniature before it was built and stood slightly apart as an imposing building in its own right. For a short period, its shape was echoed by a much smaller octagon, enclosing a larder in the centre of Kitchen Court.[7] The horse engine remained in use until the mid-nineteenth century but around 1800 the upper floor was re-modelled by the architect Samuel Wyatt to form a slate-lined game larder. The building still stands with its well, now covered, next to it, but its original importance as an eighteenth-century engine house rather than 'Wyatt's game larder' is often overlooked.[8]

Most of the water supply to the house was used in the laundry, kitchen and stillroom. A minor supply was required for the buffet, a fashionable aid to serving meals which appeared in country houses from the late-seventeenth century. The Holkham version combined elegance and convenience, with

The serving room behind the apse of the Dining Room, reached by back stairs.

a semi-circular 'beaufet' forming an apse in the North Dining Room as an architectural rather than practical feature while, out of sight, the 'room behind the beaufet' had a water supply ('a lead pump') for washing glasses and was fully equipped to warm and serve food as it arrived from the kitchen, some 318 feet (97 metres) away.[9] From the start, however, a crucial function of the water supply was to serve water closets and bathrooms. Although some notable houses such as Chatsworth (Derbyshire) and Cannons (Middlesex) already had elaborate water supplies and sanitation, water closets were not common in country houses before the early-nineteenth century. Even the Duke of Chandos, owner of Cannons, had been thwarted in his intention to provide water closets in the lodging houses he built in the 1720s in Bath by the inability of his builder to master the plumbing. Coke knew the Duke's chaplain, Dr John Desaguliers (1683–1744), who was also engineer to the York Water Company and author of works on physics and mechanics; he employed him in 1735, just as building work was starting on the Hall, to teach 'philosophy' to his heir and he entertained him at Holkham at least once. A crucial figure was the plumber, Mr Devall, a specialist from London whom Coke had employed for plumbing repairs in his London house as early as 1722 and who was probably the same George Devall who worked at Houghton.[10] Houghton, however, conformed to Isaac Ware's guarded opinion from the 1750s that 'a water closet, far removed ... is a useful addition'.[11] It must have been Coke himself who had sufficient confidence in the 1730s to plan water closets throughout Holkham, even in positions where there was no external ventilation. Devall was paid the large sum of £204 in 1736 for work in the old manor house and in 1741 was responsible for installing in Family Wing a water engine, pipes, baths, sink and three water closets, the latter including '3 setts brass work wth cocks, washers etc'. These first three water closets were next to Coke's dressing room, his wife's closet and the lady's maid's room; the inclusion of the latter strongly suggests that Coke's wife, Lady Margaret, had a say in the arrangements. Coke's dressing room became the Manuscript Library under his successor and its closet later became a drinks cupboard but the 'light' or window that Coke ordered to be made onto the staircase is still there, confirming that the water closet was almost certainly installed as planned. It is frustrating that his enthusiasm for water closets is the reason why his few surviving letters to Brettingham do not discuss them in more detail, for he wrote to Brettingham, 'I delay orders about the water closets etc. till I see you'.[12]

Coke took a keen interest also in the fitting of his bathroom on the ground floor of Family Wing. He already had a 'bathing tub' in his London house and in the old Holkham house. The latter had a piped water supply

The plumber Devall's bill for installing water closets and baths in Family Wing in 1741.

installed or repaired in 1736, the year that the plumber Devall first appeared at Holkham, when nearly 60 yards of lead pipe was bought 'to convey water up into the great Bathing Tub'. The bathroom now built in Family Wing was equipped with a 'bath that stands on the floor for a hot bath', another 'mahogany bathing tub' and a 'biddeau'. The accounts refer to more than one bath in the wing, suggesting that Coke's wife had a bath in her closet on the first floor. The baths were fitted with cocks or taps and the purchase in

168 HOLKHAM

The cupboard for the water closet opening off Thomas Coke's dressing room, subsequently the Manuscript Library, has been put to new use. The 'light' onto the stairs survives.

1742 of 'a copper boiler for the bathroom' suggests that hot water was piped to at least one of the baths, a refinement that was by no means universal many decades later. Coke hoped also to have a cold plunge bath, much in fashion at the time, in the cellars beneath a trap door in his bathroom floor. Examination of the cellar suggests that this may have been anticipated but never built.[13]

Guests in the north-west Strangers Wing had at least two water closets and there was another in the south-east Chapel Wing. In the central part of the house, 'the Duke of Grafton's water closet' opened off the North State Bedroom in a room (subsequently a bathroom) also occupied by a manservant, a not unusual arrangement. 'The State Water Closet' was at the south-east end of the Marble Hall gallery, conveniently placed for the main rooms on the principal floor and for guests entering the house through the Marble Hall. Such a degree of thoughtfulness was not generally echoed in other houses until Victorian times. It was expected to be well used, for plans show it as a sociable two-seater.[14] Another two-seater directly below it on the ground floor opened off the Steward's Court and was therefore available to the upper servants. Thus at least nine water closets were installed when the house was built, of which six or seven were on the first floor. This was more

Chapter 7 Building the Hall: 'Comfort and Convenience' 169

The 'two seater' off the Marble Hall gallery, subsequently updated and now a store cupboard.

Where plumbing did not reach: concealed niches for chamber pots in the South Dining Room.

than the Duke of Chandos had at Cannons and nearly as impressive as the ten water closets installed much earlier at Chatsworth.[15] The plumber responsible for installing many of the pipes and water closets in the later phases of the building was, like Devall, a London specialist, Edward Ives. Twenty-five years after the installation of the first water closets in Family Wing, 'a forcing pump etc to a water closet' still commanded the high price of £9 18s.[16]

For less important family members and guests, each room had an adjacent closet containing a close stool.[17] On the upper floor of the east side of the house, later called Nelson Wing, where housemaids had to clear close stools or chamber pots, at least one waste chute was built into the wall down into Steward's Court.[18] In the attics, open channels for conducting rainwater from the front of the house to downpipes in the inner courtyards ran through closets next to the four corner rooms and were covered with removable wooden boards, suggesting some ingenuity in providing an additional convenience in the highest rooms occupied by bachelors, children or servants.[19] The presence of an electric light switch suggests that at least one of these closets was still in use in the early decades of the twentieth century. While the owner and his wife and some of their guests at

Holkham in the eighteenth century enjoyed the most up-to-date plumbing that money could buy, servants were provided with two-seater earth closets in the Kitchen and Laundry Courts, with another for the gardeners near the engine house.

An inevitable concomitant of a large-scale water supply was an efficient sewerage and drainage system. Family Wing was provided with its own brick 'shore' or sewer running out to the west, either into a small cess pit or directly into the lake. With its independent water supply, this enabled the wing to be fully functional as soon as it was ready for occupation in 1741. Strangers Wing, also on the west, was eventually added to this sewer. Use of the lake to receive sewage would have been perfectly acceptable for, as Isaac Ware noted, 'the only consequence will be that there are more and better fish of many kinds there than elsewhere'.[20] The old manor house had undoubtedly made use of the stew ponds, on the site of the lake, in this way. The rest of the house was served by a large brick sewer, running eastwards. In 1756–57, as the domestic offices at the east end were completed and brought into use, this house sewer, the smaller drains from the offices or working areas and some rainwater drains were linked to the 'common shore', the external main sewer, then being built, running from the east end of the house north-westwards under the north lawn, a distance of several hundred feet, to a cess pool about fifty feet (15 metres) from the lake. This sewer, built of brick, involved surprisingly large excavation work, as shown by the fact that the bricklayer, John Elliot, gave unusually detailed information in one of the few surviving building vouchers; it was up to 12 feet 6 inches wide at the top, nine feet wide at the base and 8 feet deep (3.8 by 2.7 by 2.4 metres) terminating in a cesspool 32 feet long, 22 feet wide and 9 feet deep (9.7 by 6.7 by 2.7 metres). During construction (in August) labourers had to keep a chain pump working at the lake end for three weeks.[21] The cesspool, apparently originally an open pool, although no evidence of it remains on maps or on the ground, was subsequently replaced by a covered brick cesspit or settling tank, with a piped overflow into the lake.

Inside the house, connections into the sewer were made during construction as the need arose. In 1754, for example, bricklayers were 'cutting way into the shore & levelling for a stack of pipes to come from the water closet'. Subsidiary sewers could be constructed after the shell of the building had been completed, as in April 1757 when the 'shore in the corridor' was dug and again in October when the men were 'digging out for shore in new wing'. Stink traps were constructed at intervals along the drains and there are frequent references to cleaning them.[22] Some use was still made of fish ponds, for in 1757 drains from the brew house and mangling room fed into

Inside the main sewer running under the North Lawn.

a pond between the east wings.[23] The original sewers are still the basis of the present system. Early in the twentieth century, the sewer running under the house was piped through the original tunnel, which is so large that a small man, straddling the pipe, can still move along it. At a later date, Family and Strangers Wings were linked to the main system.[24] The external main sewer was not piped and is still fully operational: the bricklayers who built the Hall also built sewers to last. A high standard of planning and surveying was also required, up to twenty years before the main sewer would be operational, to ensure that eventually it would serve all parts of the house and achieve sufficient fall across long distances. In May 2006, the collapse of a manhole cover in the North Lawn fortuitously exposed part of it to view.

Heating 150 rooms was another challenge, particularly in a situation where, as Thomas Coke's widow commented to a visitor, there was 'nothing between her and Norway'.[25] Brettingham was proud of the 'furnace beneath the floor of the [Marble] hall, for the conveniency of warming it; which it does by means of brick flues, that have their funnels for the conveyance of smoke carried up in the lateral walls'. William Kent's plans for the Marble Hall had originally provided for two fireplaces, incongruously domestic features in this temple-like space, so it was probably Coke's knowledge of classical Roman central heating that inspired this early application of domestic central heating. Notable examples such as Pakenham Hall (Ireland), Coleshill (Berkshire) and Woburn (Bedfordshire) installed hot air heating at least fifty years later and it was unusual before the early-nineteenth century. In 1754 a William Day of Lambeth was in Norwich to advertise his heating system, by which 'he rarifies cold Air until it is hot, and conveys it into Gentlemen's Libraries and Grand Rooms', but he failed to name any houses in

which he had installed it.[26] On the other hand, by the 1750s there had been long experience at Holkham of hot air heating to 'fire walls' in the kitchen gardens. Even so, adapting the technology to the house was challenging. In 1753 Coke wrote to Brettingham, "I beg[ged] Elliott [the bricklayer] write you word that our fire from below won't do as it is. I desire you'll buy for me to have here [at Holkham] Disaguilier's construction of fires, & bring it with you'. The required volume was promptly bought for four shillings. There are hints that partial central heating was installed in other parts of the house. In 1757, for example, in the 'octagon room under the Statue Gallery', Elliot was replacing a German stove with a different type and 'turning the flew of the works round the cavity to heat the above Gallery'.[27]

Thanks to the proximity of the port of Wells-next-the-Sea, coal had been used in the seventeenth-century manor house and heated many of the boilers and coppers in the new house, with relatively small amounts destined for the brewhouse, stables, counting room, menagerie and temple. Most heating was by open wood-burning fires. There were approximately 102 fireplaces in the house and twenty-three more in the outlying offices and stables. The fires were of varying design. In the 1750s, John Durno was paid for 'a new invented stove grate' and by 1760 two of his stoves heated the long south passage on the rustic or ground floor. On first sight, this appears an unusual touch of comfort in a corridor used mostly by servants but the fireplaces were in the central section, outside the Portico Room, later known

Wood cellar.

as the Smoking Room, where two sets of doors could separate it the from the servants' areas. 'German stoves' and 'machine stoves' are mentioned elsewhere, perhaps enclosed stoves, rarely adopted in English country houses but popular on the continent, where Thomas Coke could well have admired them.[28] The fires were started with faggots or tied bundles of wood. Typical entries in the account books in 1750 show T. Large and Gregory supplying 2,500 small faggots at one shilling a hundred and 200 large faggots for three shillings. Some of these would have been destined for the bread-baking oven, a traditional domed brick oven pre-heated by burning faggots inside it.

Unlike the sanitation and heating arrangements, the kitchen was not mentioned in Brettingham's published description of Holkham but Caroline Girle (later Mrs Libbe Powys) visited Holkham just as the kitchen was completed in 1756 and was overcome with admiration: 'such an amazing

Kitchen: 19th century fitments fill the original fireplaces either side of the roasting range.

Charcoal stoves in the stillroom.

large and good kitchen I never saw, everything in it so nice and clever'.[29] It rose through two storeys, with windows to north and south and ventilation grilles in the ceiling connected to flues 'to carry off the steam'. In addition to the traditional open roasting range in the centre of the long west wall, there were several innovative fitments. The north wall, 21 feet 3 inches (6.5 metres) wide, was occupied by a brick structure, shown on Brettingham's published plan, which contained thirteen iron grates or trivets, each above a charcoal fire.[30] These were 'sauce dish stoves' designed for gentle cooking; perhaps it was no coincidence that the cook and under-cook when the kitchen was built were highly-paid Frenchmen. The row of stoves, which would have dwarfed similar fitments that are still in place at Hardwick (Derbyshire) and Harewood (Yorkshire), were removed at an unknown date but a smaller pair remains in the former lower stillroom.[31] Use of charcoal stoves indoors must have been perilous but maximum ventilation was available by placing them under the north window. The charcoal was supplied by charcoal burners working in Obelisk Wood or neighbouring villages.[32]

Brick piers shown on Brettingham's plan indicate additional fireplaces on each side of the traditional open roasting range. A few surviving bills from the bricklayers for fitting-out the kitchen in 1756 give some clues about the equipment that filled them. One item was a 'perpetual oven', set up in conjunction with a grate. Sheet-iron ovens were just becoming common, with

Chapter 7 Building the Hall: 'Comfort and Convenience' 175

Bricklayer's bill for fitting out the kitchen in 1756.

William Day of Lambeth describing himself in 1754 as 'the first inventor of Perpetual Ovens'. Heated externally by a coal or wood-burning grate, they were 'perpetually' hot, in contrast to the traditional bread oven, heated internally by burning faggots before cooking started, whose heat therefore dropped as the cooking session progressed. Other vouchers mention the perpetual oven in connection with the range; the incorporation of an oven into a roasting range is a later development, credited to a London iron-monger, Thomas Robinson, in 1780, so any such arrangement at Holkham was well ahead of its time. The bricklayer also specified building a 'broiler', consisting of an iron plate on a brick support, separated by a brick partition from a warming stove, and a boiler, appearing to distinguish it from the coppers that he built in the scullery and elsewhere. The traditional copper was a pot made of copper or cast iron supported on iron bars over its own fire, whereas a back or side boiler attached to a cooking range was more a feature of the last quarter of the century. The impression emerges of a grate heating an iron oven, a broiler or grilling plate, possibly a boiler and a gentler warming compartment to the side.[33] Although, as a unit, this was

typically a later arrangement, there are clear indications that Coke's bricklayer built something similar. It was not without its problems, for over a year after its installation the bricklayer was 'pulling down the iron oven in the kitchen and resetting it'.[34] The kitchen, its fitments updated in the nineteenth century, remained in use until the early 1940s. It was added to the public tour of the hall in 1964 and prompts reactions from modern tourists very similar to Caroline Girle's two centuries earlier.

The brewhouse (replaced in the nineteenth century) was next to the octagonal engine house. When building work started in this area in 1757, the brewer and the bricklayer were sent to Milton in Northamptonshire to see Lord Fitzwilliam's brewhouse. The machinery for grinding malt was worked by the horse engine.[35] Barley, from which the malt was made for brewing, had been grown locally for centuries, as it still is. In the days of the old manor house, hops to flavour the beer had also been grown on the estate. The scale of production is shown by the fact that lead pipes along the south of the house delivered the beer directly to the ale cellars, an arrangement also known at Chatsworth.[36]

The other original domestic offices owed more to thoughtful planning and construction than to technology. The fall in the land towards the east, possibly emphasised by building up the ground level at the west end, enabled

Wine cellar.

the builders of the Hall to place wine, beer and wood cellars underground at the west end of the house, while the domestic offices on the same level at the east end benefitted from natural light, ventilation and ground-level access. The original bakehouse was at the bottom of Kitchen Wing, opening off Kitchen Court, a convenient situation for the baker's hot and dusty work. It was directly below a boulting room, next to the kitchen, where the bran was sifted from the flour; the sacks of flour would have had to be carried up to this room but a hole 'cut thro' the arch under the boulting mill' apparently allowed the flour to be fed directly down to the bakehouse.[37] It is not known when this bakehouse ceased to be used and signs of the oven are difficult to detect. Also opening onto Kitchen Court was the salting larder, next to the lower scullery at the foot of the kitchen stairs. Although long since used as a workshop, its deep slate troughs and counters, meat hooks and the remnants of mid-nineteenth century white hexagonal tiles are still redolent of its cool clean functioning in the past. The fish larder beyond it is the only underground room at this end of the house, extending under the north terrace. It has a fixed central table, edged with a drainage gully, below an access hatch in the ground, reputedly for the direct delivery of ice. Opening onto the corresponding court outside Chapel Wing was the dairy, 'the neatest place you can imagine, the whole marble', and the laundry.[38]

In the eighteenth century, ice was cut from the lake and stored in the thatched icehouse, which still stands near the south end of the lake. The

The icehouse from the south-west.

accounts record it being filled in December 1742 but a couple of years earlier it had been 'ye underpart of the porches' (the ornamental pavilions flanking the formal basin south of the Hall) which the labourers had packed with ice.[39] The icehouse was enlarged in 1752 and again in 1755, when bricks were used from the old manor house whose demolition had just started; it is possibly the presence of these older bricks that has given the impression that the ice house might date from an earlier century. It took twenty-six men, fortified with brandy and ale, to fill the icehouse in one day.[40]

While Thomas Coke sought out the most modern forms of sanitation, heating and cooking, there was little he could do to improve on candles, 'lanthorns' (lanterns) and oil lamps for lighting. When his widow died in 1775, her stock of wax candles filled five chests, weighed 700 pounds (317 kg) and was worth £87 10s.[41] The cost of candles was off-set by selling the waste tallow from the kitchen to the tallow merchant or chandler. In 1752, for example, nearly 98 stone (622 kg) was sold at 2s 8d per stone. In this same year there was an unusual opportunity to profit similarly from oil, when payment was received for '152 gallons of oyl made of the liver of the Great Fish taken at Holkham at 15d per gallon, cash £9 11s. Note 22 gallons was dregs of no value'.[42]

With up to thirty-five indoor servants, the house could not operate without internal communications. A dinner bell hung in a roofed frame near the Pantry Court. Individual servants could be summoned by means of a wired bell system (a great improvement on bell ropes) installed in 1757, some years before such systems became common, by Mr Blockley, who had also fitted bells in the London house. He was probably Thomas Blockley, a prominent Midlands locksmith. He supplied fifteen bells with springs and carriages, springs to twelve more bells, one large bell with spring and carriage, and cranks, bell bolts, handles and wire. He was paid the large sum of six shillings per day, his man at five shillings, and travelling expenses.[43]

It is still unclear to what degree Thomas Coke was interested in technology for its own sake but his approach to achieving the practical facilities that he wanted in his new Hall was typical of his enquiring intellect. Not at all deterred by the fact that some of his requirements were unusual, he sought out both established experts and skilled practical men who, between them, could understand and implement his ideas. Thirty years after the completion of the Hall, a foreign visitor still admired it as not only one of the 'most elegant' of English houses, but also, 'above all, one of the best provided with every kind of comfort and convenience'.[44] It would be a hundred years before any significant changes were made.

Chapter 8
Creating the Park

The surroundings of the old manor house to which Thomas Coke took his new wife and household for the first time in 1719 were a far cry from the park that reached its present outline 120 later. As he envisaged the setting that he wanted for his proposed new Hall, he gazed out onto gravelled courtyards, a walled bowling green, geometric ponds to the west and wooded gardens running down to the village street on the south. Together they probably amounted to not much more than twenty acres.[1] On the far side of the road, arable land swept up the slopes of a gentle but noticeable hill, the highest point in sight. Beyond the grounds of the house, in any direction, he would know that he owned most of the land that he could see, thanks to the good fortune and foresight of John Coke in the seventeenth century, but such concentration of ownership had not destroyed the imprint of medieval manorial agriculture. The land of his farm was concentrated to the south-east of the house and village, corresponding to the land of Wheatley manor which John Coke had acquired by marriage in 1612. The land to the west and south, broadly the land of the other two manors, and the land to the north-east, the old Newgate estate purchased in 1659, was farmed by his tenants. It was a landscape that Coke had known in his childhood, when his love of country pursuits would have drawn him south to the heaths and commons and north to the marshes, nurturing even then an eye for the lie of the land and an awareness of wider possibilities.

His development of those possibilities involved three major elements, all initiated many years before embarking on building the Hall, overlapping chronologically and varying in prominence at any one time. The first was an understanding and manipulation of land holdings, particularly farm tenancies. This was an important process, requiring imagination, organisation and confidence, for it entailed major changes to the farming environment. Compared to the design aspects of landscape and garden history, it is a process that has been largely ignored by historians but, thanks to the documents

View across the park from the south-east.

preserved at Holkham, it is possible to trace how Coke set about gaining control of the land he wanted, without irremediably damaging his rental income, his own farm and his relationship with his neighbours. His successor, Thomas William Coke, would take the process to its ultimate extent by bringing almost the whole parish into his park and farm. The second element was to transform open farmland into a park worthy of the proposed house, encompassing a home farm, lawns, waters, woods and pleasure grounds, punctuated by ornamental buildings and structures. Finally, within the park, Coke would require a more intimate and domestic element of pleasure gardens and walled kitchen gardens, the latter designed to be prestigious as well as productive. The park that surrounds the Hall today still displays some of his original features (notably the Obelisk and the Temple) and in some other respects (most obviously the terraces near the house) it reveals the imprint of changing fashions in later centuries, but even where its grassland, lake and woods present an illusion of untouched nature, it is a manmade creation of the eighteenth century.

The highly organised re-structuring of the Holkham farms on which Coke's plans depended began with the arrival of his new estate steward, George Appleyard, who took up his duties in 1722 just as Coke embarked on his landscaping projects. Their first step was to take back in hand Hall Farm, which had been let to the previous steward, Humphrey Smith, during Coke's minority.[2] Entries in the audit books throughout the remainder of the decade show the local farm tenants renting portions of other farms, including parts of the Hall farm, in addition to their main tenancies, but the apparent complexity in the accounts reflects the process of rationalising land holdings on the ground. This in turn allowed more open field strips to be enclosed into new fields, a development that had already started. At the same time, at least ten years before he would begin building the Hall, Coke gradually took back from tenants the land that he wanted to landscape. A few small village tenants lost land to the great south lawn and the new kitchen garden in 1723–24. Of the larger farm tenants, the first to see the writing on the wall was James Bircham, tenant of Thorogoods, a sizeable farm owned by the estate since 1660. His farmhouse, malt house and home closes were in the village (Holkham town) while most of his land lay in the High or South Field between two ancient tracks running south from the village, exactly where Coke's earliest landscaping was planned. Bircham had been the tenant only since 1723, possibly on the understanding that changes were in the offing: four years later he lost twenty-six acres 'enclosed in the wood' that was to surround the Obelisk, in the next year his malthouse in the village was sacrificed to the new kitchen gardens, and a year later in 1729 he

moved to another estate farm in Fulmodestone, twelve miles from Holkham, after which the old Thorogoods farm disappeared for ever under Coke's designed landscape.[3]

Meanwhile, in 1727 Edward Cremer gave up the tenancy of a farm called Lushers (bought by John Coke junior in 1671) whose land lay mainly to the south-west of the village. Like the other farms, its house and premises were in Holkham town.[4] During the next six years new farm premises were built at Longlands at the southern edge of the parish; they included a good-sized house measuring forty-one feet (12.5 metres) square and a 'Great Barn' (an interesting use of the name more famously attached to a later building), brick-built and tiled, measuring 24 by 120 feet (7.3 by 36.5 metres). These were destined for a new farm formed in 1733 by combining the former Lushers land with 'the part of the Hall Farm call'd Longlands'. The terms

Longlands Farm, created in 1733.

of the lease demonstrate the careful attention being paid to farming at a time when the long-anticipated start on the Hall might have been thought to absorb all energies, some fifty years before Holkham agriculture achieved celebrity. The tenant (new to the parish) took a twenty-one year lease that stipulated improving the land by marling, whose cost was shared by landlord and tenant; the landlord was to enclose the remaining lands and complete the farm premises and the tenant was to follow a basic rotation for cropping.[5] In this southern area in particular, as a later retrospective account vividly describes, Coke was working on a blank canvas, a heath or sheepwalk 'covered with whins or furz & some old white thorn trees' where 'the bounds between Longlands sheepwalk belonging to Holkham, and Quarles sheepwalk was never certainly known before the Earl of Leicester [Coke] himself, being possessed of both estates, enclosed & divided that open country, which he did without any regard to precincts or bounds'.[6] Also in 1733, but at the other end of the parish, the widow of the last tenant left Staithe Farm. This was the property that had been bought from Newgate in 1659 and whose house (known today as the Ancient House) and premises, unlike the other local farms, were at the staithe rather than the town. Coke incorporated some of its land into his park and let the house and remaining land, newly consolidated into neat fields outside the park paling, to Edward Smith, possibly the son of the former steward, Humphrey Smith.[7]

The start of building work on the Hall in the following year has been the primary focus of attention for historians but, in the background, the restructuring of the parish farms continued with barely a pause. In the same year, Coke took in hand Roger Anger's farm centred on Neales manor, Sir Edward Coke's original purchase of 1609. He retained the land immediately west of the lake, which he was planning to enlarge, and let most of the other fields, gradually enclosed in the preceding years, to the new farm of Longlands or to neighbouring tenants.[8] The greatest gainer was Henry Knatts, also known as Knotts, a local yeoman or small farmer–owner whose brother, Robert, was tenant of another Holkham farm and the village smithy. The bare bones of the transactions between Coke and Knatts, as recorded in the audit accounts, reveal an unexpected degree of mutual goodwill and cooperation between the major landowner, engaged in transforming the locality, and one of his lesser neighbours. In the mid-1720s Knatts had sold to Coke some pightles and four cottages in the old village centre, leaving the purchase money of £245 on loan to him. In the later 1720s he appeared as the tenant of land worth £70 to £90 per annum but he gradually relinquished back to Coke the Clint (the low area to be flooded by the lake), a pightle taken into the new kitchen gardens, and the Burnt Yard adjoining the old ponds that were to be

Staithe Farm, restructured in 1733.

incorporated into the lake. In 1736 the restructuring of the old Neales farm brought him his reward: a fourteen-year lease (extended until his death in 1763) of about 300 acres, with the old Neales farmhouse and premises that backed onto the new kitchen gardens. It is not known if Knatts also owned land elsewhere but he was sufficiently comfortably situated to continue lending to Coke so that by 1754 the debt had reached £1,790 at 4½% or 5% interest.[9] Probably because it was the only large tenanted farm still based in the village, his farm was soon listed in the accounts as 'the home farm' while the demesne farm in hand was called 'the Hall farm', a confusing dichotomy that survived into the next generation.

Finally, during the next couple of years, a new farm, Branthill, was carved out in the south-east corner of the parish from land that old men later testified 'was all like a common with furzes … a sort of waste'.[10] Craftsmen who were soon to be fully occupied on the Hall built a new farmhouse there in readiness for letting the farm on a twenty-one year lease, 846 acres plus marsh grazing for £266 annual rent.[11] Thus between 1727 and 1738, one farm was eliminated, two new farms were created and two others underwent major restructuring. A portfolio of plans of the farms, including ground plans (unusual at such an early date) of the houses, indicates the

Henry Knatts's farm, restructured in 1734–36. On the extreme right it abutted the walled kitchen gardens.

importance attached to this process.[12] For the next forty years there were only relatively minor adjustments of the tenancies. There was, however, one other important change when in 1745 Henry Knatts's farming operation was moved to premises a little further west in the village and a new farmhouse

was provided for him at a cost of £417, again constructed by the craftsmen building the Hall. Evidently he was one of the men, along with the steward, clergyman and senior craftsmen, whom Coke was perfectly happy to keep as his neighbours in the old village.[13] Knatt's move within the village was highly significant because it released the old Neales premises to be developed as the centre of the Hall farm. Previously the farm had been run from the Hill Hall manor house, an old-fashioned arrangement that was particularly undesirable now that the house was linked to the new Hall whose construction was gathering pace. In future the Neales farmhouse accommodated the estate's farm bailiff, cow boy, rat catcher and husbandmen.[14]

By 1759, when Lord Leicester died, his Hall farm occupied about 797 acres of arable land, 318 acres of woods and water, 99 acres of the common

Hunclecrondale Farm, later re-built as New Inn and Model Farm, in 1730.

Chapter 8 Creating the Park 187

ling (heathland) and 154 acres of marsh. The tenanted home farm, Hunclecrondale, Longlands and Staithe farms each had 300 to 340 acres of arable and variable acreages of marsh grazing, while Branthill was much larger.[15] The names alone exemplify the major changes since 1722, whereby lands that had earlier been identified by the names of a multiplicity of tenants or

The park and farms in 1745.

long-departed former tenants had been rationalised into six distinct consolidated farms. Two of them, the Hall farm and Branthill, had massive acreages by contemporary standards. Holkham town had not entirely lost the bustle of farming life, for it still embraced the farmhouses and yards of the Hall farm, Knatt's home farm and a small farm attached to the inn, but the new Longlands and Branthill farms, built in isolated situations well away from the village, and the transformation of open field land and rough grazing to form neat enclosed fields around them, were startlingly novel. The great expansion of the park in the next generation obscures the crucial significance of these early changes in demonstrating, as did many other country house landscapes, that ownership, control and improvement extended beyond the relatively small park into the wider estate.

*

The mid-eighteenth century was the great era for the development of the landscape park in preference to formal gardens as the most desirable setting for any country house.[16] In many ways Holkham epitomised the transition. Immediately after his return from Europe, Coke was already thinking on an expansive scale about the surroundings of Holkham, draining the marshes to the north and (as will be discussed later) negotiating a sub-lease of land south of the parish. He intended from the start to create a park, for in 1722 there were payments 'in relacon of turning the roads at Holkham to make a park' and the outline of the park, particularly on the south, is evident from the large-scale planning map in use throughout the 1720s.[17] Formalising the park boundary, however, was a secondary consideration until much of the major landscaping was in place. Most activity during the 1720s was directed at creating a dramatic formal setting in keeping with the proposed Hall (and for the benefit of the old house in the meantime) while maintaining a farm in hand and maximising rents from the tenanted farms. Coke was already gathering ideas and paid a gardener, Benjamin Townsend, 'for drawing a draft of Lord Peterborow's & copying a print of Greenwich Park'.[18] Townsend (who a few years later dedicated his book, *The Complete Seedsman*, to Coke) was described by a contemporary as a gardener and surveyor possessing 'judgment in preserving and even improving the natural beauties of an irregular ground, especially where there is any advantage to be made of wood and water'. The plan of Lord Peterborough's park that he drew for Coke probably included Bevis Mount, near Southampton, noted for 'a kind of wilderness, through which are various winding gravelled walks, extremely romantic and agreeable'.[19] Coke doubtless also developed ideas from seeing other parks and gardens during his frequent visits to friends and acquaintances round the country and often despatched his gardeners to see

places of interest.[20] He bought gardening books including, for example, two (unnamed) in 1733, Robert Furber's lavishly-illustrated catalogues of fruit and flowers in 1735 and others for which his gardener was reimbursed.[21] He spent increasingly long periods of time at Holkham and, when absent, checked on the progress of planting and the construction of slopes, lawns and gravelled walks. He ordered the raising of 'ever greens of all sorts' in the nurseries and the building of 'the little walls for grapes in the gardens'.[22] Above all, as an unknown contemporary (possibly his estate steward, Cauldwell) later commented, he displayed a remarkable ability to form 'his great designs & plan of ornamenting the country roundabout his seat with inclosures, plantations etc before any inclosures were made'.[23]

Although William Kent's name is often cited by historians in connection with Holkham park, the extent of his involvement is uncertain. Recent work has probably overstated his contribution by relying on a starting date of about 1730, whereas much of the landscape was laid out in the 1720s, long before he established an interest in gardens. Even during the next decade, when he designed the principal garden structures (the Obelisk, Temple and pavilions) it is by no means clear, despite the survival of five attractive sketches of various proposals, to what degree he influenced landscaping and planting. His fame has to be balanced against the acknowledged fact that the owners' role was often crucial in developing some of the most famous gardens.[24] Coke developed his landscape over many years and maintained his own enthusiasms, tastes and ability coincidentally with Kent's emergence as a famous practitioner, a situation that caused no surprise to their contemporaries. It was in this context, for example, that Kent, writing to Viscount Raynham with a design for a garden structure, could make jocular reference to leaving the choice of materials to 'my Deputy my Ld Lovell' [Thomas Coke]. Coke's knowledge and experience gained their own authority beyond Holkham, reflected in a letter to him from Lord Cornwallis after Kent's death in 1748: 'I have been in hopes your lordship would have made another visit to Euston this autumn, to see how your orders were put into execution. The Plantation you directed was began, as soon as ye ground was moist enough to begin planting, by which it seems, as if your commands there would be as absolute as Kent's were'.[25]

Coke's right-hand man as head gardener was John Aram, who came to Holkham from Nottinghamshire in December 1723, about a year after the arrival of the new estate steward, Appleyard, and served throughout the major landscaping campaign until 1739. His nephew and namesake worked as his under-gardener until killed by falling into a well in 1737. Aram senior subsequently took the tenancy of an estate farm at Flitcham and developed

Landscaping design marked on a large planning map in the 1720s.

another career in surveying and map-making, complementary skills that must already have been invaluable at Holkham. It is possible that he was responsible for the large-scale planning map of the parish made in the 1720s and may have been the creator of the map showing Holkham after Coke had become Earl of Leicester (1744), for he was paid £46 in 1745 for 'surveying, contracting and mapping land at Holkham'.[26] The scheme on which Coke and Aram embarked was in many ways typical of its time. Traditional geometrical elements appeared in the central symmetry of a lawn, gravel paths and straight lines of trees due south of the house, in the strong north-south axis through the centre of the (as yet unbuilt) Hall, and in straight vistas from various vantage points. All these features, clearly determined by the site for the proposed Hall, appeared on the detailed planning map used in the 1720s. They were combined with wide grassy areas and ornamental 'wildernesses' of woodland and shrubbery placed apart from the house, quite different from the walled courtyards and gardens surrounding the old house that had been typical of an older style of geometrical gardening.[27]

Soon after Aram's arrival at Holkham, the closure of the road through the village in 1722 announced the beginning of work on the immediate environs. Gangs of men were engaged to start transforming some thirty-three

The Obelisk, 1730–32, and garden seat, 'The Seat on the Mount', 1743. Brettingham, *Plans and Particulars*, 1773.

acres of arable land due south of the old house into 'the Lawn', stretching up the slope towards the hill that would later be surmounted by the Obelisk. Given that the local topography is not noted for variety and drama, the hill was crucial to the whole scheme, dictating the north–south axis of the designed landscape that also determined the central point of the Hall. By 1726, the labourers were 'digging 473 holes for planting the trees in the lawn', probably those shown on a map twenty years later in formal parallel lines running up the lawn to the hill.[28] A start was then made on 'the new wood', Obelisk Wood, covering sixty-nine acres, where work continued for six years on stubbing out old hedges, erecting a paling, ploughing, planting, hoeing and 'frighting the crows'.[29] During the last two years of planting in 1730–32, the Obelisk, eighty feet tall, was erected at its centre, heralding the many years of building work that were soon to start on the Hall.[30] By the time the Obelisk reached completion, work had begun on the Temple further west in the wood, completed in 1734, and on two porches or pavilions at the foot of the new lawn, flanking a formal basin that had been created in the hollow south of the house in 1729–31. The Obelisk, Temple and porches

Work on Obelisk Wood and gardens, a typical page from the account books.

were all 'deduced from sketches of Mr Kent', although Matthew Brettingham junior pointed out that there had been 'considerable alterations made in the designs, long before these works were erected'.[31]

In the meantime, attention turned also to the area north-west of the house, particularly the possibilities offered by a long natural depression between 'the breasts of the Clint'. The northern end had been marsh until reclaimed

earlier in the century but a freshwater stream still ran out into the creek at the edge of the marshes, a convenient spot at which to dam it. The first mention of proposals to create a lake there came early in 1728, when some change of mind resulted in a payment for 'quitting a bargain for making a bank at the bottom of the intended canale in the Clint'. A year later, plans had firmed up, with labourers 'making the Clint dam' and gangs of men, under named leaders, digging, filling and spreading hundreds of loads of earth, clay and gravel for the puddled clay floor. Natural contours caused the dammed water to form a thin and fairly straight 'canal', by no means equivalent to the present lake.[32] South of the canal, separated from it by meadows, lay two old stew or fish ponds, the Walled Pond and the Shoulder of Mutton Pond, west of the old house. Faint lines on the map of the 1720s show that their outlines were geometric, a legacy from the heyday of the manor house.[33] While the Clint was being dammed, work began on incorporating these ponds into a sequence of water features, a common course of action in the early eighteenth century.[34] A 'drain' linking them to each other and to the new basin south of the house was large enough to provide 'passages for the boats' and to require a bridge across it. Entries in the account books relating to these works were sometimes grouped together under the

William Kent, proposal for the Seat on the Mount, showing one of the pavilions and the basin near its join with the serpentine river.

heading 'Great Water', indicating that the work was envisaged as part of a larger ongoing project, but during this first phase of work the ponds were still separate from the lake.[35]

The landscaping considered so far proffered long views but many of its features were intended to invite closer exploration. Although an onlooker in the house could gaze south over wide acres of grass towards Obelisk Hill, the lawn and ornamental basin in the immediate foreground were separated from the parkland beyond by a 'foresea' (a brave phonetic spelling of fosse, in other words a ditch or ha-ha containing a wooden fence or 'pallisadoes') stretching for 507 feet (155 metres) between the two pavilions on the south side of the basin. On both east and west, wooded areas eventually reached to the corners of the south wings of the new Hall, giving the near lawn a more enclosed and sheltered feel than in the view from the house today. Gravelled walks round this area, including one 20 foot (6.1 metres) wide along the side of the basin, invited leisurely perambulation, with sheltered resting places or viewpoints at the ornamental pavilions and, later, the Seat on the Mount. The basin promised opportunities for a little gentle boating or fishing.[36] The lake lent itself to similar pastimes. A walk 'on top of the slope to the Clint' was made as soon as the Clint was dammed, there were boats and a succession of boat houses, a flower walk by the lake and even a thatched seat in a chalk pit (although not the ornate fantasy designed by Brettingham) twenty years before Humphrey Repton suggested something similar.[37] The woods, too, were intended for pleasure as well as for forestry. Obelisk Wood was a more secluded spot than appears today, for the carriage drive skirted the west side of the wood rather than circling the Obelisk at its centre as in later years. Occupying the highest area south of the house, the wood drew the eye and invited exploration, in return giving vistas back towards the house and the sea. Close by, the Temple, a little Palladian gem partly hidden in the trees, was furnished with crimson damask hangings and chairs, a comfortable spot to pause or picnic. There were also seats in the Staithe Wood, a flower border by Church Wood, where more vistas or rides radiated from a central clearing, and flower beds in 'Lady Leicester's clump'.[38]

Although the wider landscape gave opportunities for leisure, there was also a more intimate and private element, the pleasure gardens, designed for enjoyment at close quarters, particularly by ladies. The gardens of the old house were swept away by 1730. In line with the current fashion for pleasure gardens to be tucked out of sight, away from the setting of the Hall in its landscape, the pleasure garden designed for the proposed Hall was a wooded area or wilderness covering about four acres to the east of the lawn, south of the surviving nineteenth-century garden known as the arboretum. It was

The Temple.

Section view of the Temple. Brettingham, *Plans and Particulars*.

cut by vistas and walks, some leading to an orangery, which in the eighteenth century was typically an outdoor area for summer displays of citrus trees that would be taken under cover only for winter protection.

Work began on the orange ground in 1731 and on its associated greenhouse in 1732–34; the latter was a substantial building, plastered, with a flagged floor and adorned with statues and vases.[39] Orange trees were added each year, joined by bergamots, limes and 'sweet lemons' until in 1738 Coke wrote, 'I think the orange trees I have sent down this year will compleat my Green house'. Ten years later, there were forty-six orange trees and four citrons (lemons) in tubs and seventy seedling oranges in pots. A stone seat in the orangery and around fifty chairs of various sorts suggest that the gardens and orangery were much appreciated.[40] In June 1740, on the occasion of the heir's

A classical orangery, from a book owned by Thomas Coke, Giovani Battista Ferrari's *Hesperides sive de malorum aureorum cultura et usu libri quatour* (1646).

Seat in the orangery. Brettingham.

coming of age, the wilderness was lit with thousands of little lamps and the orangery (a popular venue at many houses for parties and banquets) accommodated 130 guests at 'one magnificent table'.[41] Initially these features must have seemed strangely isolated from the old house and the first wing of the new Hall but Lady Beauchamp Proctor, visiting in 1764, said that she enjoyed the orangery 'very much, 'tis in a retired place and the trees are disposed with very great taste'.[42] These pleasure grounds were still known in 1778 as the 'Greenhouse Plantation'.

The walled kitchen garden was an important feature both for supplying the kitchen at the Hall and for impressing visitors. Built in 1726–28 across the line of the old road through Holkham town, it covered just over four acres, with another acre outside the walls. It lay cheek by jowl with some of the remaining village buildings, for a few of its fruit trees were trained against the south-facing walls of Mr Cauldwell's and the Rev. Dr Alston's houses. For its first thirty years it supplied the old manor house. Coke took an interest in more than just 'the apricocks, my favourite fruit'. A detailed record in September 1748 of the locations of a wide range of stoned and soft fruit, each

Survey of the fruit grown in Thomas Coke's walled gardens.

Thomas Coke's orders regarding his fruit garden, 1748.

Dovecot. Brettingham, *Plans and Particulars*.

in several varieties, was followed by a page of orders in his hand for grafting, planting and moving selected trees.[43] The 'ananas house' built in 1735–36 was probably also in this area; Lord Burlington's gardener looked after the pineapple plants at Chiswick until the building was ready for them to be sent down by sea.[44] The icehouse to the south of the kitchen gardens was probably built in 1742, unless payments recorded in that year for carpentry, bricklaying and thatching were for renovation rather than new work. Now a

picturesque feature, the icehouse was a practical building that received no comment at all in early descriptions and guidebooks. The menagerie house, built at about the same time, and the octagonal dove house, built soon afterwards in 1745 and warranting inclusion in Brettingham's published plans, do not survive but were also thatched brick buildings, probably located just outside the south-west corner of the kitchen gardens where later maps name the dove house pightle.[45]

*

By the mid-1730s, as building work started on the Hall, the major designed landscape features were in place, although not necessarily completed. Attention now turned to the park as a whole. From 1734 the accounts had a specific section headed 'New Park' and for the next fifteen years there was constant work on building a timber fence to encircle it, establishing it as a defined entity on the ground. 'Enclosure by pale, wall or hedge' was one of the legal requirements for creating a park; the others were a royal licence and 'Beasts of a Park, such as the Buck, Doe etc'.[46] The requirement for a licence, although largely obsolete, was probably acknowledged by a gift of £21 to the High Sheriff of Norfolk in 1736 but the last requirement was almost certainly not met for another hundred years.[47] Trees were one of the features in the park most remarked on by visitors; aesthetically pleasing, they also represented wealth, control and long-term investment. Coke had been buying 'forest trees for Holkham' as early as 1721.[48] Planting in the 1720s had been concentrated on creating the designed landscape but, now that the extent of the park was established, wider tree planting came to the fore, warranting a separate section in the accounts from 1737 until about 1752. The grounds immediately around the old house had been wooded but many trees had been felled to clear the building site and, in the absence of an old deer park, such as formed the basis for many other landscape parks, Coke started from a low base. Several nurseries were established for raising saplings and an increasing number of plantations, often called clumps, were planted. Evergreen oaks (*quercus ilex*), for which Holkham became famous, were present by 1738 when some were moved and replanted.[49] The reorganisation of Staithe Farm in the north made possible an immediate start on planting a boundary woodland belt. This and other early planting, including Lucar Hill clump, Sir John's Plantation and Belt (named after the previous owner of that site, Sir John Turner of Warham) and Scarborough Wood and Clump, formed the nucleus of woods that survive with the same names today, although a later visitor lamented the fact that 'tho' the plantations are surprisingly extensive … the situation being so flat … they don't look so large and grand as they really are'.[50]

With the southern extent of the park now established by the completion of Longlands farm just beyond it, the time had come for ownership to be emphasised and access controlled by a suitably impressive entrance. The southern approach to Holkham was the principal route for visitors arriving by carriage or wagon. Until the road from Fakenham to Wells-next-the-Sea was improved by a turnpike trust in the nineteenth century, carriages bypassed Fakenham and headed directly for Holkham, the last stretch being across Quarles parish where much of the land belonged to Christ's College, Cambridge, and was let to a tenant. With remarkable foresight, Coke had secured an assignment of the existing lease in May 1719, only months after taking control of his inheritance. As it was exceptional for the estate to take a lease of any land, the only possible motive was that he already anticipated the importance of this area to his future plans. These now reached fruition

The Avenue.

with the creation of the great south avenue, begun in 1733. It started on the Quarles land and ran through the neatly-enclosed fields of the new Longlands farm to reach the park boundary in the hollow just south of Obelisk Hill. By the early eighteenth century, avenues were ubiquitous in landscape design but the Holkham avenue remains unsurpassed as a dramatic approach to a country house, so exactly surveyed and constructed that its length is unsuspected, gradually unfolding with each gentle incline. A 'foresee' or ha-ha on the Quarles land and another before reaching Obelisk Wood ensured that no visible barrier interrupted its route, an inspired response to making the most of relatively flat land when it could have been tempting (even in more varied terrain as, for example, happened at Castle Howard) to erect gateways, arches and walls.[51] Its impact at the time must have been remarkable, especially for those who did not know that it was designed to line up with the centre of a house that was yet to be started, for it ignored all old boundaries and its effect relied entirely on consummate exploitation of a modest topography. As a contemporary remarked, 'the Avenue to his [Coke's] seat was terminated, the roads turned & laid as it now is by the rising and most natural laying of the ground, and for no other reason'.[52] The point where the Avenue entered the park was marked by a lodge, designed by William Kent and built in 1735–37, two simple cuboid buildings on either side of a wide fence and central gate. Each side contained two rooms and a corner staircase to an upper room. Described by Arthur Young as 'small, but very neat structures', their simplicity preserved the drama of the Avenue.[53]

Closer to home, the time was ripe for erecting 'ye great seat in the lawn', 'the great wooden seat at the west side of the lawn', a new stone seat, two circular seats and a double seat, creating pleasant spots for the onlooker to pause and admire the transformation of farmland and, from a suitable distance, the start of work on the first wing of the new house.[54] For two to three years, resources were concentrated on building but landscaping activity near the Hall resumed in 1737. At this period Thomas Coke can be seen actively seeking assistance for implementing his ideas but happy to take the lead. He wrote from London to Brettingham at Holkham in 1736 or 1737, 'I am sorry you could not be here with Mr Oram, who I think does more than answer your character. It is great ill luck he is engaged but he has so plain a way of doing things that I hope I myself shall learn.' Little is known about Oram. He was apparently recommended by Brettingham and was possibly related to a William Oram who had been head gardener to the Duke of Beaufort early in the century or a gardener of the same name at Brompton in the 1730s. Brettingham hoped that he would visit Holkham to advise on measures taken by the regular gardener, confusingly named Aram, and

South Lodge. Brettingham, *Plans and Particulars*.

the accounts indeed noted a payment of ten guineas 'to Mr Oram a gift on account of the woods and lawn'. Around the same time, the garden accounts recorded the purchase of a set of surveying instruments.[55]

This phase of landscaping began with several years' work constructing a 'New Mount called the New Work' at the west end of the ornamental basin, completed in 1743 by the 'New Seat on the Mount', a stone structure designed by Kent and embellished with four stone heads by the sculptor, Peter Scheemakers.[56] Two attractive watercolour sketches show beguiling suggestions by Kent for the mount, quite different from each other, but their survival does not imply that either design was implemented. A map drawn probably in 1744–45 suggests that Lord Leicester adopted a scheme somewhere between Kent's strongly theatrical and Italianate proposal and the more naturalistic setting of the other.[57] It has been suggested that the new work marked a significant shift in design under Kent's influence and that it dramatically altered the view south from the house, replacing axial and linear features with a highly novel idealised Italian landscape.[58] If this were so, it is surprising that a knowledgeable German visitor, the year after it was completed, did not note it in his sketch of the grounds. A few years later, Coke was pleased that Henry Pelham had admired his house (at this date, only the Family Wing and the south façade, both by Kent) and his arch (the Triumphal Arch, also by Kent) but he made no mention of having shown him an innovative piece

of landscaping by Kent, which surely would have been of equal interest to a visitor whose house at Esher Place had been designed by Kent and who was, as Coke put it, 'brought up under the same great Master Kent'.[59] An alternative interpretation of the new feature, less dramatic but more convincing against the background of Coke's previous activity, is that the new mount was a logical stage in framing the lawn, screening it from the carriage drive and complementing the established wilderness on the opposite side of the lawn. It might even have provided a fortuitous solution to using spoil from excavating the lake. Far from transforming the view from the Hall, the new mount was set to the west of the basin; the central lawn, rectangular basin, pavilions and lines of trees marching up to the Obelisk were unchanged. Because it was to provide both an attractive scene from afar and a vantage point from within, the seat on the mount was more prominently sited and the planting around it more open than was the case with the Temple in Obelisk Wood, or the seat in the orangery among the trees on the opposite side of the lawn, but it sat appropriately within the existing scheme.[60]

The later 1730s also saw the resumption of work on the water features. The 'drain' linking the canal (that is, the nascent lake) to the Walled Pond was widened and deepened, an island was made in the Shoulder of Mutton

Seat on the Mount, one of the proposals by William Kent.

Plan showing brick and oak foundations exposed when the lake was drained in 1909.

Pond, an old wall at the Walled Pond was demolished (brick and oak foundations exposed when the lake was drained for repair in 1909 were probably its last legacy) and work started on digging out the 'Broad Water' or 'the great water called the Clint'.[61] In other words, the two old ponds and the long canal were being amalgamated to form a lake stretching from due west of the house northwards as far as the creek at the edge of the marshes. The relatively narrow shape of the lake between 'the breasts of the Clint' still betrayed its origins as a natural stream but at its southern end, where it swallowed up the old stew ponds, it managed to achieve a fairly relaxed bulge around a wooded island. In 1743 there was renewed work on the channel linking it to the basin south of the house. This channel must always have been curved and from the start had been large enough to allow the movement of small boats, so its promotion in the accounts from prosaic 'drain' to 'Serpentine River' reflected a newly-fashionable name rather than a significant innovation in design. There was also work of an indeterminate nature on the basin but its formal rectangular shape survived to be disparaged by a visitor forty years later.[62] Many such features often needed fine-tuning and

the Serpentine River was widened and deepened again six years later. Two bridges, one stone, designed by Kent, the other wooden, both modelled in miniature before construction, carried the footpath and carriage road over it.[63] Coke was pacing his landscaping in the same way that he paced his building: completing individual water elements (the Clint canal, the channels, ponds and basin) enabled him to control expenditure and achieve a more acceptable and enjoyable interim result than spasmodic work on the whole.[64] Waters and Fishery appeared as a separate section in the accounts for the last time in 1745, indicating that the major works had been completed.

During the later 1740s, the approach to the park was completed by the construction of the Triumphal Arch at the southern end of the Avenue, on the Quarles land. From the south it announced the proximity of Holkham, from the north it epitomised the continuation of influence beyond the park pale. Construction began in 1747 after several years of stock-piling stones for the facing and the last finishing touches were added ten years later. The pyramid side roofs as shown in William Kent's design were built (for the accounts record that they were pointed in 1752) but they were removed at some date before 1818.[65] Some years after Thomas Coke's death, his widow sought an arrangement with Christ's College 'so as to secure the said Arch,

Triumphal Arch by William Kent.

Triumphal Arch sketched by Elizabeth Blackwell, 1818.

Buildings and little plantations thereon, to go along with Holkham House … she having a great desire to accomplish and perpetuate the approaches and distant decorations of Holkham in the manner the said late Earl designed them'.[66]

As the Arch neared completion, the north lodge was built in 1751–53 at the opposite end of the park, the timing dictated by the fact that it was primarily a feature to be seen from the Hall, completing the north–south axis through the Triumphal Arch, the Obelisk and the central staterooms that were then under construction. The north lawn was levelled at the same time but the clumps of trees proposed by Kent are not clearly identifiable in account books and are not shown on maps, although a visitor thirty years later commented that 'in front of the house, someone has planted trees in clumps of varying size but similar shape, giving an unfortunate, slightly shocking sense of regularity'.[67] The lodge barely served as a means of controlling access into the park for the few visitors who might approach along the coast road, for there was no defined route onwards to the Hall. Like the south lodge, it was a double lodge designed by Kent, a simple pair of

Clumps on the North Lawn, proposal by William Kent.

single-storey single-room cuboid buildings, but in this case each of the two rooms had a circular domed ceiling. There must have been also a basement room, as stairs are mentioned in accounts. Outside there was a flanking wall and central gates. Surprisingly, Humphrey Repton, planning the lakeside in 1789, thought that its occupier, Francis Crick, the former valet turned clerk of works, could spare a room to provide a sea view for people enjoying the proposed lake walk.[68] It survived less than a hundred years, until it ceded place to the Monument.

The south and north lodges were the only ones built in Thomas Coke's time. Entries in the accounts in 1735–37 for building an east or 'easternmost' lodge must refer to the first half of the south lodge, for the map of about 1745 shows no lodge on the east side of the park. Although both the 1761 and 1773 editions of the *Plans and Particulars* included a remarkably elaborate design for 'East Lodges', twin buildings each containing three rooms and a portico facing the park, they were not built – a cautionary tale on the significance even of published plans.[69] Similarly, there is no indication on maps of a formal northern entrance into the park from the staithe village in the first half of the eighteenth century. Tradesmen, labourers and craftsmen probably followed the line of ancient paths that were still discernible in the new field boundaries, or a track that headed eastwards away from the village for some distance before turning south into the park, where a

slight ridge survives to indicate its route onwards to the Hall.[70] The village almshouses that flank the present north gate formed a three-sided courtyard when built by Lady Leicester in 1756 and did not mark an entrance into the park until altered ninety years later.[71] From the west, too, the approach to the Hall lacked formality. Brettingham included in his published plans a 'west entrance to the park' consisting of a central gate, arched pillars and fence (with no dwelling) but there is no record of it being built.[72] The old road through Holkham town that had been truncated in the 1720s could still be followed as far as the kitchen gardens, passing on its way the few remaining village buildings, and for fifty or sixty years the gardens and the lake were probably all that separated the Hall from the remnants of the village.

The landscaping work from the mid-1740s came under the direction of a new head gardener, William Oram, who arrived in about 1745 and was possibly the expert who had been consulted eight or nine years earlier. After the kitchen gardener (his son) left in 1750, he took on responsibility for all the gardens and plantations 'by contract' for the large sum of £200 a year. He was assisted and then succeeded by William Aram (born 1728) son of the head gardener of twenty years earlier. After 1752 the park and gardens, now becoming a routine maintenance job, were managed together by Aram as a single concern for a lesser wage. He married one of the housemaids and left in 1757 to set up in Norwich as a nurseryman, well patronised by his former employer.[73]

As the Hall neared completion, the Earl's widow called on the leading landscape gardener of the time, Lancelot 'Capability' Brown (1716–83). From 1762 to 1764, labourers were employed on 'levelling and sloping the ground on the west, north and east fronts according to Mr Brown's direction and making the roads about Holkham House'. Brown was paid fifty guineas a year for three years, plus travelling expenses, 'for his attendance and journeys to direct and assist herein'. Whether he was responsible for any more dramatic changes in the wider landscape is not recorded. It is tempting to surmise, but there is no evidence, that his influence might have led to the removal of the formal lines of trees that flanked the south lawn: they were now forty years old, their formality was thoroughly old-fashioned, and they do not appear on T. W. Coke's first map of his estate in 1778, only three years after Lady Leicester's death.[74]

The creation of Holkham as a country seat was an integrated enterprise in which radical changes in local farming, the establishment of a designed landscape and the building of the Hall were interdependent. The park, like the Hall, was not the product of a master plan by a single designer, but reflected Coke's vision of how he wanted it to be seen and enjoyed. Imaginative use

North Lodge. Brettingham, *Plans and Particulars*, 1773.

of the lie of the land, particularly to the south and the north, was combined with elements of traditional formality close to the house, a lake and associated water features, wide expanses of unproductive turf (as sure a sign of status and wealth as were more dramatic features), woods both near and distant and a restrained number of architectural highlights designed by William Kent. Despite the dramatic change from farmland to park, the emphasis on exclusivity and privacy was much less than in the next generation: Coke's tenants still farmed the surrounding land and the Hall lay close to the western park boundary, beyond which lay the remaining village buildings. Even so, Coke knew better than anyone what a change he had wrought on the parish landscape: 'It is a melancholy thing to stand alone in one's own country. I look around, not a house to be seen but my own. I am a Giant, of Giant's Castle, and have ate up all my neighbours'.[75]

Chapter 9

Living in the New Hall: The First Twenty Years 1756–1776

If there was bustle and excitement in 1756 as maids, footmen and labourers moved the last of the furniture, equipment and belongings along the covered way from the old house to the new Hall, it has left no record, for there are no surviving domestic cash books or ledgers for that year, an uncharacteristic gap that testifies to the disruption of routine. The carpenters had already started stripping out the old house. Some of the fire grates were saved for use in Strangers Wing, the floors of the brewhouse and laundry were re-laid in the new brewhouse and at least one door still in the cellars appears to have been recycled from the old house. As demolition gathered pace, the bricklayers salvaged 715,000 bricks for use in the foundations of the last wing, the sewers and the icehouse. Finally, in the spring of 1757, while workmen celebrated raising the roof of Strangers Wing, five labourers worked for four or five days 'wheeling rubbish from the front of the house into the old cellars'.[1] In the new Hall, where finishing and building work was still going on in the staterooms and along the north front, nearly as much manpower was needed just for 'clearing the passage from old wing [Family Wing] to kitchen all thro' the main house'.[2]

The indoor servants who now took occupation of the new house numbered about twenty-five. Some of them, including the housekeeper, had probably moved in a couple of years earlier as soon as their rooms were ready, joining the senior personal servants who already occupied the ground floor of Family Wing.[3] The housekeeper at this time was Sarah Staniforth, who had come as a dairymaid seventeen years earlier. She had been promoted to housemaid around the time that the first wing came into use but her further elevation to the position of housekeeper, a far superior status, was

Detail from 'America', one of the Flemish tapestries depicting the continents in the Green State Bedroom.

highly unusual, although typical of the open-minded way in which the Earl and Countess treated their servants. It proved well judged, for she remained in that post for twenty-two years, until her death in 1772.[4] She took dominion over a suite of rooms on the ground floor, known as the rustic floor, at the east end of the south corridor near Chapel Wing, where she ruled five housemaids (two more than in the old house), a stillroom maid, two laundry maids and a dairy maid.[5] Her bedroom was furnished with purple and white wallpaper, white dimity hangings and good furniture, including a large press for household linen. Nearby were her dessert room, equipped for the preparation of tea, coffee, 'jocolot' (chocolate), sweetmeats and desserts, and the senior servants' breakfast room.[6] In the basement below those rooms, 'the housekeeper's distilling room' or stillroom was equipped with traditional distillery equipment including pewter stills, worms (condensers) and an alembic, as well as equipment and moulds for preserves and ices. Either the dessert room or the stillroom would occasionally be used by a temporary London confectioner; in the days of the old house, a Mr Fricotte had been paid ten guineas for three months' work for 'setting out desserts and preserving'.[7] Following on from the stillroom, in the cellars under Chapel Wing, were the laundry, wash house, mangle room and two dairy rooms. The maids slept in two rooms at the top of Chapel Wing, one furnished with three four-post beds and the other with two, and in one or two single-bedded rooms in the rustic floor of the same wing.

The stillroom: the remains of 18th century distilling equipment on the left, mid-19th century ovens to the right and 20th century plumbing and wiring above.

○ Butler's pantry
• Butler's bedchamber
● Footman's room, later plate room (for silver)
○ Steward's room (senior servants' dining room)
• Steward's store rooms
● Steward's bedchamber
○ Senior servants' breakfast room
• Housekeeper's room
● Dessert room

The senior servants' provinces on the rustic floor.

The head of the male servants was the house steward, whose rooms occupied the north-east corner of the rustic floor, near Kitchen Wing. The Steward's Room was the dining room for the senior servants (steward, housekeeper, butler, valet and lady's maid) and visiting servants of equivalent rank. The Wine Books show that it was liberally supplied with port each day.[8] The steward's bedchamber, papered in blue, white and red, with blue and white checked hangings to the bed, was well furnished, and his adjoining store room, evidently where he wrote up his household accounts, contained a writing table, ink stand and shelves for books. The butler, whose responsibilities extended over the footmen, the wine and beer cellars and the plate or silver, had rooms at the west end of the south corridor, conveniently close to Family Wing. His bedchamber, smaller and less comfortably furnished than the steward's, opened off his pantry. A footman's room off the other side of the pantry contained little more than a 'turn up bedstead'. Later it became the plate room but at this period, whenever the household moved to Holkham, most of the London plate was sent to a bank for safekeeping and the plate used at Holkham was stored in a press in the butler's pantry. The pantry's other contents reflected the butler's duties: cases to hold bottles

Chapter 9 Living in the New Hall: The First Twenty Years 1756–1776 215

The housekeeper's rooms, from an inventory of 1760.

and ice pails, trays for glasses and knives, tobacco stands, punch bowls, backgammon and chess sets, and a 'wheelbarrow with partitions to carry bread, bottles etc to the garden'.[9] Across the corridor were stairs down to his wine

Distilling equipment, probably used for making cordials.

and beer cellars, and across Pantry Court (partly enclosed only in later years) were stairs up to the room behind the apse of the Dining Room where food was received from the kitchen prior to serving. Also at this end of the house, directly below the Statue Gallery, was the Audit Room. It was used for the first time in 1757 for the tenants' annual audit dinner, which previously had been held in the great hall of the old house.[10]

Subordinate to the butler were five or six footman, a couple more than in the old house. They slept in three or four rooms at the top of Kitchen Wing (subsequently a staff flat and now the archives rooms) one furnished with two four-post beds, the others with one bed in each, all with blue and white checked hangings and little other furniture. An adjacent 'gallery', containing presses and looking glasses, was probably where the footmen stored their blue and scarlet dress liveries and powdered their hair. In 1755, as the new house neared completion, a house porter was appointed, a novelty at Holkham although there had long been one at the London house. He was paid much the same as the footmen and wore similar scarlet and blue livery.[11] His room was on the ground floor in the northwest corner of the

The butler's pantry, now a kitchen.

main house, next to the Guard Room or Armoury Room, conveniently situated between the central entrance door into the Marble Hall and the lesser entrance near Strangers Wing. It was only in the twentieth century that the door at the other end of the north front became known as 'the porter's door'. He was responsible for the security of the house and also presided over the lower servants in the Servants' Hall. Just beyond the Servants' Hall, closed off by a door in the corridor, Kitchen Wing was a self-contained province, restricted to the French cook, his undercook (a compatriot) and the kitchen maid and scullery maid, a segregated way of life that continued well into the twentieth century. Even their bedrooms, above the small rooms designated as the 'pastry', upper scullery and larder along the east side of the kitchen, were reached by their own staircase at the end of the wing.

In the new Hall, now occupied by the entire household, different areas were still busy with the full range of building activity. Family Wing had been occupied for fifteen years. Kitchen Wing and the laundry and dairy in the cellars below Chapel Wing were brand new and equipped to the highest

The Saloon.

standards but the chapel itself was little more than a brick void. Strangers Wing was still being built. Consequently, the household went about its daily business amidst building and finishing work. The priority now was to complete the rooms of 'common resort' on the principal floor. Those nearest Family Wing on the west side of the house (the Statue Gallery, Dining Room and Drawing Room) had been the first to be painted and gilded but the southern rooms (the Saloon, East Drawing Room and Landscape Room) were about a year behind. The Saloon was 'hung with crimson velvet, the cornishes richly gilt, many capital pictures standing there to be put up' when Caroline Girle saw it in 1756.[12] Work was less advanced on the two State Bedroom apartments on the east and north sides of the house, a situation that possibly reflected the general shift in emphasis away from such formal apartments. Finally, the Marble Hall, designed to be the centrepiece of the house, was still an empty shell.

Consequently, while the gilder was quietly at work in the North State Bedroom, the bricklayers were building Strangers Wing; while the joiner was hanging tapestry, velvet and pictures in some rooms, the plasterer was still at work in the East Drawing Room (later called the South Dining Room) 'redoing and increasing the number of griffens … half part of the first bill being allowed as that work was pulled down.'[13] The characteristic portico

The Drawing Room griffins from Brettingham, *Plans and Particulars*.

The griffins in the ceiling frieze of the Drawing Room, later known as the South Dining Room, as executed.

caused problems, prompting the Earl to experiment in vain with models and even a trial construction to design external stairs that would incorporate an entrance into the portico, as shown in the earliest elevations.[14] The Marble Hall gave Lord Leicester the greatest occupation. It had already proved necessary to change the order of the columns from Corinthian to Ionic in order to reduce their height to fit the brick shell. Another change from the

original plan seems to be indicated by the bricklayer's bills in 1756 for 'bricking up windows in great Hall'.[15] Then in the spring of 1757, while the joiner was making and re-making models for the columns and stairs, Lord Leicester had a radically new idea about the shape and proportions of the Marble Hall. He ordered the removal of 'the wall and arch' that were being built at its north end and abandoned the original design for a horseshoe shape for the stairs, intended to pass either side of the massive statue of Jupiter that he had bought in Rome forty years earlier, in favour of a broad unbroken curve, whose effect was to bring the visitor almost imperceptibly up to first floor level.[16] Despite these late changes, the marble masons who arrived in the summer of 1757 were soon able to start work on the columns. In 1758 the joiner started 'raising and fixing up the frame to the ceiling'.

In the meantime, completed rooms were ready for furnishing. Coke's few surviving letters and the account books give some idea of the multitude of choices and decisions, and the wide availability of materials, that lay behind the final appearance of the rooms. As Family Wing neared completion, Coke's mind had been buzzing with details for finishing and furnishing the rooms. He instructed which walls were to be painted on plaster, which to be papered, and which to be 'lath'd & plastered & hung with paper for the hangings to hang over them'. The bedchamber was to be hung with tapestry except for the fireplace wall, 'for we find the tapestry will come much dearer than I thought'. Brettingham was to send to him in London detailed plans for each room, 'on a large scale & the dimensions wrote on it', so that he could decide exactly what furniture and pictures were required.[17] A few pieces probably came from the old house, for the bed and matching chairs in the bedchamber were described as 'very old'.[18] Most furniture was supplied by a London upholsterer, Mr Bradshaw, who was either William Bradshaw or George Smith Bradshaw, both of whom were based in Soho. Bradshaw was paid £185 for the attic and rustic floors and, two years later, a further sum of nearly £430, presumably for the principal floor, but the accounts give no details.[19] Nevertheless, Coke and his wife added other fabrics and furniture from a wide variety of sources. Marsden, the London carver employed on the rooms, made two large 'peer glasses' for Lady Margeret's dressing room.[20] Some of the plain furniture was made locally; Lillie and Copeman, the joiners working on the house, made tables and chests and Richard Hacket, a tailor, 'made up' two or three beds.[21] The green damask for the lady's dressing room and the yellow 'armozeen' for Edward Coke's attic room were supplied by a London mercer, Mr Hinchcliff. Paper for at least three rooms came from Robert Dunbar's shop, also in London, while the foremost Norwich upholsterer, Paul Columbine, supplied 'blue varnish't

An outstanding individual chair, probably 'a pattern chair for Holkham' recorded in the accounts as bought from William Hallett in 1737. It would have have been made for the old house, unless Thomas Coke was looking well ahead to the completion of the first wing of the new Hall.

paper' and borders and more expensive green paper and borders. He also supplied 111 yards of crimson damask, probably for the curtains in the rustic dining room, anteroom and lord's dressing room. He was also paid for his time at Holkham, so presumably made and fitted the curtains.[22] Painted floor cloths for the library, rustic parlour and lord's dressing room came from yet another source, Mr Emos or Emon.[23]

When the towers and attic rooms of the central block were furnished between about 1753 and 1755, papers, furniture and fabrics were again chosen individually from a wide variety of suppliers. Dunbar, who had supplied papers for Family Wing, was supplanted by Bromwich, another London paper stainer and upholsterer, supplying 'sprig'd paper & borders' and paper for seven more rooms. Brettingham procured 120 yards of yellow damask and 83 of 'cloth coloured' damask for two beds. Other fabric came from various shops, probably in London, but also from a local tradesman, Elliot, who supplied everything from 'figur'd dimithy' for a tower room bed, check fabric for servants' beds, linen and wool for mattresses, cloth for 'a

frock & waistcoat for my lord,' to groceries and gunpowder.[24] Even in the case of furniture, the Earl and Countess did not favour any one particular cabinet maker. William Vile, a leading London cabinet maker, supplied a dome bedstead for one of the attic rooms and Columbine of Norwich supplied another bedstead. The bedstead itself was only the beginning: Columbine's required thirteen yards of material for curtains, 'brass rings, lining, glueing, making up the inside of the bed' and a feather bed, bolster, pillows, calico quilt, paper, curled hair and silk binding. On this occasion Columbine himself attended at Holkham in person for a week, his man Notley for ten days, and his man Kreger for eight weeks.[25] Townson, the joiner from Burnham Market who was working on the Hall, made a model of a bed, four bedsteads (three of which were sent to London) and servants' press beds for the tower gallery or passage.[26] Seat furniture came from a similar variety of sources. Vile supplied three pattern chairs; Paul Saunders, another leading London craftsman, featured for the first time, supplying two individual carved chairs and eighteen 'matted bottoms' chairs; Burnet, also of London, supplied another chair; and, more surprisingly, the local joiner, Townson, made four Chinese cherry tree chairs, four walnut tree chairs and a model of a chair.'[27]

Furnishing of the staterooms was in full swing from 1756. Design and craftsmanship were supremely important for the hangings and furniture in these rooms. Perhaps the greatest change from furnishing the earlier rooms was in obtaining fabric. Of the rooms furnished so far, only three rooms in Family Wing had their walls covered in material (damask or mohair); curtains were mostly damask; the chairs in the rustic dining room were rush bottomed and Coke had favoured black leather for those in the antechamber, lord's dressing room and library. The blue leather upholstery and white damask curtains in the Statue Gallery were deliberately restrained in order to concentrate attention on the statues. Now, however, in the sequence of staterooms along the south front, wall coverings, curtains and upholstery rivalled in colour and opulence the paintings that were to be the artistic focus of these rooms. According to a list by Lady Leicester, the fabrics were nearly all obtained from one man, Robert Carr, silk mercer. They cost a total of over £3,000 and included 257 yards of velvet (the variegated velvet for the State Bedroom) for £899 10s, crimson velvet (considerably less expensive at £668 for 349 yards), crimson damask (£210 for 280 yards) and a variety of other slightly cheaper fabrics. When Lord Leicester died, several of these fabrics were still stored in chests, waiting to be put up.[28]

When it came to furniture for the staterooms, greater use was made of pattern or model chairs to decide final designs. Bradshaw and Saunders

Purchases of state room furniture in 1757.

made seven mahogany chairs 'very richly carved to match a pattern one', Goodison made a pattern couch and a pattern elbow chair, and fourteen chairs were listed in 1760 in a 'memorandum of pattern chairs'.[29] Experience had confirmed Lord Leicester's confidence in buying from a wide range of

Detail of the blue leather furniture for the Statue Gallery bought from Paul Saunders in 1757.

craftsmen. Saunders' name is most prominent in the accounts, supplying the mahogany settees and chairs, covered in blue Turkey leather, for the Statue Gallery, 'very fine History Tapistry made to a Design enriched with Gold & silver in the Drapery' for the State Bedchamber, and the state bed (only partly made up when the Earl died) for which he had previously made 'a very neat model'.[30] Goodison made the 'table press' for the Gallery, a table, possibly also chairs and other furniture, for the Drawing Room, and 'burnished' table and picture frames. His frames for two large pictures in the Saloon cost £72 and £74, far more than most items of furniture.[31] The entries in the account books under such famous names do not appear, however, to cover even all of the finest furniture. The Saloon furniture, in particular, is intriguing. The Holkham joiner, Lillie, made four small settees for the Saloon for £3, a large 'sopha' for the Drawing Room for £1 1s and two frames to go over the Saloon chimney pieces for £4 4s.[32] The modest prices indicate that these were not completed items. Brettingham's carvers (paid at the rate of eighteen to twenty-one shillings a week) finished the picture frames for a further £50 but the accounts do not make it clear how the other items reached their finished state.[33] Perhaps they were among the thirty-five chairs, four 'sophas' and four settees that Brettingham was paid (as an intermediary)

Lady Leicester's record, made a year before she died, of the furniture she had purchased, brought from the London house or moved from other rooms to complete the state rooms.

for carving, and their upholstery was perhaps part of the many weeks work done by Columbine's man. Perhaps they were also included in the frames, nineteen chairs and settees gilded by Neale, the former footman.[34] Townson

also made several carved mahogany chairs, some of them gilded, and a reading desk. Lady Leicester extracted details from the accounts for furniture bought from 1752, the beginning of furnishing 'the body of the house', to its completion, including everything from fine carved furniture to coal scuttles and warming pans, from velvet and damask to hair and feathers, and calculated that up to her husband's death in 1759, expenditure on furniture and furnishings totalled £5,466.[35]

The cost of furniture, however, was exceeded by expenditure of nearly £6,000 on sculptures, pictures and other works of art in the 1750s, a period of intense collecting activity by Lord Leicester. He used Matthew Brettingham junior, collecting works of art in Italy for various patrons between 1747 and 1754, as his agent to purchase numerous classical statues and busts, whose number and quality were such that he adapted the arrangement of the rooms in order to display his greatly increased collection.[36] Gavin Hamilton, artist and dealer, was also commissioned to buy pictures in Italy in the later 1750s: Lady Leicester listed eighteen pictures and fifty-five drawings, as well as Hamilton's own work, *Juno and Jupiter*, which were purchased by Lord Leicester but did not arrive until after his death. In addition to more 'pictures from Italy' (not itemised), casts, statues and repairs, about fifty pictures were purchased during the 1750s.[37] Some were bought at various sales but they also included commissioned works and, soon after the household had moved into the new Hall, Lord Leicester entertained several artists and art restorers. An Italian restorer, Bartolomeo Matteveli, spent several months cleaning statues there in 1756. The Italian artist Francesco Zuccarelli, who spent two long periods in England, travelled to Holkham with his family in January 1757 and probably stayed until April, when he was paid for ten views of Holkham (which are not known to survive), four of 'ye seasons', portraits of Lord and Lady Leicester and paintings for tapestries. He possibly overlapped with Louis-François Roubiliac, the sculptor, who was working at Holkham on busts of Lord Leicester and his deceased son in 1757. In the following year, Andrea Casali, another Italian artist who spent a long period working in England, was paid to travel to Holkham, where he painted nine family portraits, several of them retrospective. Around the same time, a picture restorer, Collivo, was cleaning pictures; he can probably be identified as Isaac Collivoe junior, a London picture collector, dealer and cleaner.[38] The sculptor Joseph Wilton also worked at Holkham towards the end of Lord Leicester's life and was paid by the Earl's executor for repairing statues and for making a bust of Lady Leicester, almost certainly the bust subsequently placed on the family tomb in Tittleshall church. Among his restoration work were the arms and hands of the great statue of Jupiter, whose 'new turned

Peter Paul Rubens, *The Return of the Holy Family from the Flight into Egypt*, one of the paintings bought by Thomas Coke during the 1740s and 1750s, in this case from General Sir James Campbell in 1745.

arms', commented Lady Beauchamp Proctor, 'must have been copied from the Colossus'.[39]

In the spring of 1759, however, all activity ceased and the account books, like the workmen's tools, fell suddenly silent, with the death on 20th April of Thomas Coke, 1st Earl of Leicester, aged 61.

Juno and Jupiter by Gavin Hamilton, in the Green State Bedroom.

The 1st Earl's funeral expenses, 1759.

*

When work resumed, it was in accordance with Lord Leicester's will. He had safeguarded the immediate future of the Hall, particularly its completion according to his wishes, by the unusual step of leaving the Hall and estate to his widow for the rest of her life and providing for £2,000 a year to be spent on

building and finishing the Hall, offices, stables and gardens, 'until the same are fully and compleatly finished according to the Plan and Design which I have made, and which I have signed and approved of or which I shall have at the time of my decease'.[40] His widow 'took the first opportunity' to dismiss Brettingham, encouraged (according to Brettingham junior) by the steward, Cauldwell, who 'could bear no Rival brother near the Throne'. One of Brettingham's men, James Miller, the carver, was paid to supervise the remaining work at the lesser salary of £50.[41] Even the centrepiece of Coke's creation, the Marble Hall, was unfinished at his death. The innovative and striking stone stairs were probably no higher than their foundations, the alabaster masons would be at work for another eighteen months, the local joiner Townson made the mahogany doors in 1761 and statues were still being placed in 1764, along with the iron railings and mahogany rail between the columns.[42] The fourth wing, Strangers Wing, had been built and roofed in 1757 but its rooms were still being painted and gilded in 1764. It had been realised quite quickly that a short-cut for servants would be needed between Family Wing and Strangers Wing, for an underground passage (still in existence) was built in 1759, an improvisation strangely at variance with the service corridors carefully incorporated throughout the rest of the house.[43] The chapel was the last major internal area to be completed and the only area that was entirely Lady Margaret's responsibility. It deviated in several significant features from the plans that Brettingham published in 1761, when work on it had barely started. Niches for statues were abandoned in favour of paintings, and the gallery was re-designed to project into the chapel.[44] Carving by James Miller and plastering by Thomas Clark proceeded throughout 1762–64 and models for the lectern and seats were made in 1764.

The final sign that the building was complete was the plastering, carving and paving of the room under the portico, known in later centuries as the Smoking Room.[45] In the centre of the south front on the rustic floor, it was soon to become the room where visitors gathered as they waited to be shown round the house. For the past twenty years of building work, however, it had been reserved for use as a craftsmen's work room, the modelling room, with an important role in the process of design and construction. Significantly, it was next to the room formerly called Mr Brettingham's.[46] It was here that the joiners constructed models (none surviving) to test the appearance and construction of a wide range of proposed features. Some of the models were sufficiently exceptional to be itemised in the accounts, including the pillars and staircase of the Marble Hall, external steps to the portico, the octagonal engine house and the cupola for the stables.[47] It was probably here, too, that the joiners made moulds and templates for the masons and plasterers.

The Chapel. Above the altar: *The Assumption of the Virgin* by Guido Reni, sent from Italy in 1759–60.

Activity in the modelling room had much to do with the final appearance of the Hall.

The exterior of the Hall was completed by the erection of 'palisades' or balustrades of brick, stone and iron, between the Kitchen and Laundry Courts on the east, marking their boundary against the park, and, more unexpectedly for those accustomed to the present appearance of the house, between the two wings on the west.[48] The remaining building work was on

The Stables on the far side of the lake, replaced c.1850.

detached buildings. The stables were built beyond the south end of the lake, to the west. Their foundations had been started before the Earl's death and the coach stable, at least, was attached to older stables, probably those associated with the old Neales manor house. The detached situation of the stables and the incorporation of parts of existing buildings did not preclude elaborate flourishes, such as a cupola (removed by T. W. Coke some forty years later) and an elaborate clock face, which James Miller's man spent thirteen days carving and five days gilding.[49] The Counting House or steward's lodge, replacing a counting house and evidence room associated with the old house, was also started before Leicester's death and completed in 1760.[50] It no longer exists but, situated to the south-west of the Hall, beyond a line of trees, it was a substantial two-storey building with a portico, steward's bedchamber and closet, clerk's bedchamber, octagonal office room, evidence room, counting room, parlour, waiting room, bailiff's closet and kitchen. A plaster bust of the Earl by Roubiliac presided over the principal room. Nothing could better illustrate the central importance to the Coke family of the estate and its management, revenues and records.[51]

In August 1764, thirty years after work had begun on the first wing, Lady Leicester, the heir Wenman Coke, and the trustees, Matthew Lamb and Ralph Cauldwell, gathered at Holkham to inspect the buildings and declared 'that all the works are finished and completed ... which were intended to be done by the late Earl of Leicester'. The annual payment of £2,000 under his will

The Steward's Lodge, from Brettingham, *Plans & Particulars*.

was to cease after the payment of 'some few' unpaid bills; with small amounts of new work, these amounted to about £2,416 during the next two years.[52]

*

Although Leicester had directed the trustees of his will to complete the building work, the remaining furnishing was undertaken by his widow with her own money, a contribution that she took pains to record for posterity.[53] Arthur Young, followed by other writers, wrongly recorded that, after her husband's death, she moved from Family Wing into the north staterooms, giving rise to a myth, still current until quite recently, that she did so in order to have ready access to inspect the kitchen (for there was a concealed service

234 HOLKHAM

The Green State Bedroom.

door from the North State Bedroom through a closet into Kitchen Wing) and to keep an eye, across the Marble Hall, on the comings and goings of her guests in Strangers Wing. Entries in the building accounts in 1760–61 under the heading 'Lady Leicester's apartment' appear to relate to the north staterooms, suggesting that she briefly contemplated such a move despite the large amount of finishing work still to be done. In fact, however, she moved into Chapel Wing, where the two suites of bedchamber and dressing room on the principal floor were rearranged to become her anteroom, dressing room, closet and bedchamber.[54] Perhaps, in her widowhood, she merely wanted a change from Family Wing, or to move further away from building work on Strangers Wing. Her new rooms were conveniently placed for supervising the furnishing of the East Drawing Room, where the griffins had caused the plasterer so much trouble, the State Bedchamber and Dressing Room, and the North State Bedchamber, Dressing Room and closets.[55] The north staterooms had long been destined for Leicester's good friend, the Duke of Grafton, the Lord Chamberlain, and although he had died in 1757 without having the chance to enjoy them, his name was still associated with them three years later.[56] During the next six years, the Countess spent £2,795 on completing the furnishing of these rooms, the Chapel and the whole

Chapter 9 Living in the New Hall: The First Twenty Years 1756–1776 235

'America', one of the Flemish tapestries depicting the Continents in the Green State Bedroom.

of Strangers Wing.[57] Finishing the state bed, including a final flourish of four coronets embellished with velvet and ermine, cost more than the gilded chair and four stools that she bought for the same room, despite the fact that the major expenditure on it had already been made.[58] The hangings for several rooms had already been chosen and were stored in chests but Lady Leicester bought tapestries for the North State Bedchamber, moved in the early-twentieth century to the adjoining North State Sitting Room.[59]

In addition to completing the furnishing of the house, Lady Leicester was faced with the task of integrating into the general scheme the contents of the London house and the numerous pictures that her husband had commissioned Gavin Hamilton to buy in Italy. The first six pictures, including Hamilton's own *Juno and Jupiter*, arrived from Italy seven months after the Earl's death; twelve more and a collection of drawings arrived in May 1760. By July, the Countess had completed the removal of the contents of Thanet House to Holkham, including sixty-four pictures, the library (the bound

The North State Bedroom. The walls were originally covered with tapestries depicting three of the four seasons, later moved to the adjoining North State Dressing Room.

books going by sea and the manuscripts by land), statues, busts 'and other valuable things' and the goods and furniture 'all except what was given to Mr [Wenman] Coke in London'.[60] Even though the walls of the Drawing Room had not yet been hung with their 'crimson flower'd velvit' and the State Bedchamber with its tapestries, these rooms had already been hung with pictures, few of which were to remain in the same positions.[61] Unless the Earl, aware of what pictures were on their way from Italy, had discussed their future positioning well in advance with his wife, the changes that were

made were his widow's decisions. Even *Juno and Jupiter* had not been hung two months after its arrival, suggesting that the Earl might not have decided its position in the State Bedchamber where his widow eventually placed it.[62] The Countess also moved paintings that had already been hung in completed rooms. Zuccarelli's *Four Seasons*, for example, were originally hung over the doors in the Saloon but she replaced them with Scilla's *Winter* and *Summer*, newly arrived from Italy, and moved them to their present positions above the doors in the State Bedchamber. The furniture from Thanet House was distributed to many rooms, all carefully recorded by the Countess.[63] She accommodated the additional books and manuscripts by putting up bookcases in the attic 'galleries', the corridors linking the tower rooms. Later, she changed the two western tower rooms, hitherto guest bedrooms, into additional library space, apparently with the encouragement of William, Duke of Cumberland (d. 1765), for whom a table and two stools were specially made to use there. She arranged for two local clergyman, the Revd Scott and the Revd Henry Carrington, to 'regulate' the library, resulting in a three-volume manuscript catalogue listing the books and manuscripts in the Long Library, the South Tribune and the attic rooms and corridors.[64]

The Countess was an excellent curator. She provided all the upholstered furniture in the principal rooms with 'false covers' in appropriate colours to protect against sunlight and dust. The variegated velvet hangings of the State Bed had false curtains of green serge, while the 'satin quilt and pillows embroidered with gold,' possibly those for which a Mrs Ganeron had been paid the great sum of £101 forty years earlier, were kept in an oak box. The windows of the south-facing rooms had blinds or 'false stuff curtains to keep off the sun'.[65] Despite such good housekeeping, in later years the Countess found herself replacing original furnishings. When she moved to Chapel Wing, she refurnished the Tapestry Bedroom there in yellow damask because the chintz on the bed and chairs was 'so rotten it was with difficulty it made up for a small bed' for a servant. By the early 1770s, however, the yellow damask itself 'was so ragged it is laid by' and had in turn to be replaced.[66] At the same period, Lady Beauchamp Proctor found on her second visit to Holkham that the Family Wing 'was new doing up' and that the original green damask hangings in the Countess's former rooms there, now thirty years old and 'too bad to be removed', were covered with new blue hangings.[67]

Although the inventories so presciently completed by the Countess only four months before her death reveal how Holkham was furnished, she left written instructions with her will that ensured that virtually no other record survives for most of the first twenty years of life in the new Hall. Her instructions to Cauldwell, her steward, 'that you may burn all my accounts books

The Countess took charge of over £2,000 at the end of the fourth day of the winter audit or rent days in 1771.

& papers when of no further use' and to her sister, Lady Gower, 'to destroy & keep others as she thinks proper' were apparently followed without discretion. The surviving domestic account books end in 1759, the Country Accounts of non-domestic expenditure end in 1767 and even the estate accounts or Audit Books are lacking from 1759. Only the provision in her will for mourning clothes for servants reveals that in her widowhood she maintained a household of about twenty-nine, indoor and outdoor.[68] Thanet House having reverted to her father's estate, she leased a house in Hanover Square and presumably used it regularly for the London season. Fortunately, some of her visitors and neighbours mentioned life at Holkham. She maintained local friendships, for she gave a writing desk to Mrs Henley of Docking, a widow noted for her good farming, and bequeathed a ring to her. Mrs Poyntz, mother of the rector at North Creake, frequently received presents of fish and 'sweetmeats for the child' but was rather surprised to receive a visit, as Lady Leicester did not normally 'mix with the people here' although, she added, she was 'beloved by the poor' for she 'does great good, keeps

Chapter 9 Living in the New Hall: The First Twenty Years 1756–1776 239

The Countess's record, in her own hand, of provisions for the poor.

many families'.[69] This is borne out by Lady Leicester's own record of the food and clothing that she distributed to the poor at Holkham over many years, and her building and endowing of the almshouses at the edge of the park. She also took on her late husband's role as landlord of the estates. The stray survival of a letter from her agent, Cauldwell, to a tenant mentioned that she 'saw all her … tenants together at the Audit'. A small audit notebook reveals that, just as for many years she had kept a tight rein on domestic finances, so a large proportion of the estate cash receipts, placed in coloured or numbered bags, was handed directly to her at the end of each audit day.[70] Although she

described herself as 'an old woman that did not love to go abroad', she frequently entertained guests. The Duke of Cumberland evidently enjoyed the library; other visitors included Mrs Boscawen, widow of the admiral who had so admired Holkham years earlier, and on several occasions, Charles Yorke, brother of the Earl of Hardwick, and his wife, who received such hospitality that they avowedly felt part of the family.[71] Lady Leicester made the house available for general viewing every Tuesday, when visitors were conducted round by the housekeeper, but people who could claim some connection with her were welcomed on Thursdays, her 'publick day' when it was 'her delight to show the House' and when she would provide 'an elegant good dinner, for she is very well served and there is no fuss'. The young Thomas William Coke, who in later years prided himself on a relaxed style of hospitality, gained a less congenial impression of 'terrible punctiliousness' and 'oppressive ceremony' when he was invited to Holkham in 1771.[72] This was the first and only meeting between the elderly dowager and the young son of the heir to Holkham. She died at the end of February 1775, leaving generous provision for her steward, most of her personal estate to her surviving sister and as little as possible to her successor.

*

The completion of the building and furnishing of the Hall by the widowed Lady Leicester was fully in accordance with what can be glimpsed of her character throughout her married life. She was well-educated, intelligent, diligent, apparently delighting in paperwork such as accounts and inventories, and intimately knowledgeable about the Hall and its contents. What it confirms above all, however, are two apparently contradictory characteristics that she shared with her husband: she was totally committed to the Hall for its own sake, never stinting on workmanship and furnishings, regardless of the fact that it would pass to future generations with whom she had little connection, but she was remarkably careless of any practical measures to ease the transition of the Hall and estate to the next generation. Since 1750, with the collapse of the brief childless marriage of their only child, Edward, Viscount Coke, to Lady Mary Campbell, it had been inevitable that Holkham would eventually be inherited by the family of Lord Leicester's sister, Ann Roberts. Many years earlier, Ann's elopement at the age of sixteen had shocked the young Thomas Coke to the core but, by a twist of fate, she was the only one of his brothers and sisters to have raised a family. His two younger brothers had in turn inherited the Longford estate in Derbyshire from their old guardian, Sir Edward Coke, but both had died by 1750. Longford then passed to Ann's eldest son, Wenman, who accordingly changed his surname to Coke. As this coincided with the end of Viscount Coke's

The Countess of Leicester, by Casali. One of the group of family portraits painted by Casali in 1758 but showing the sitter at a younger age.

disastrous marriage, it was already clear that Wenman's future interests lay not merely at Longford but, above all, at Holkham. The widow of the previous generation at Longford soon detected the Holkham influence at work when she was not invited back to Longford for a visit. She had remained friendly with Viscount Coke's estranged wife and 'Mr [Wenman] Coke and his whole family have taken their leave of me, and I now neither hear nor see anything of them; this behaviour to me is by Lord Leicester's order, who will not have anybody that expects favours from him live in friendship with me.'[73] Three years later, the death of Viscount Coke confirmed Wenman as the heir presumptive to Holkham. In the following year Lord Leicester visited Longford and attended the christening of Wenman's eldest son.[74] During the next few years he made use of the bailiff at Longford, presumably with Wenman's consent, to obtain alabaster from local quarries, just over the border in Staffordshire, for the Marble Hall at Holkham. He borrowed £7,000 from his brother-in-law, Philip Roberts (Wenman's father) and in 1757 another £3,500 from Wenman himself.[75] Nevertheless, although their paths probably crossed during the London season, there is no hint of regular contact between the nephew at Longford and the ageing and now childless Earl and Countess at Holkham. Indeed, the Countess commented about Wenman, soon after her husband's death, 'I knew nothing of him nor of his Family but as a common acquaintance believed him a very good sort of a Man.'[76]

The terms of the Earl's will, leaving the Hall and estate to his widow for her life, probably took Wenman by surprise, but Lady Leicester had no qualms: 'if he was disappointed I did not wonder at it, but as I had not taken any clandestine means to get the Estate I should make myself easy on that article'.[77] Wenman unsuccessfully disputed the will, which was probably the reason why Lady Leicester by her own will, made in 1766, left as much as possible to her surviving sister, declaring that Wenman's conduct towards her had not been 'such as I had just reason to expect'.[78] Wenman had visited Holkham in the meantime in August 1764, in order to join with Lady Leicester and the trustees of Lord Leicester's will in formally confirming the completion of building work in accordance with the Earl's will, but apparently neither the Countess nor Wenman, during the sixteen years of her widowhood, contemplated any steps to initiate him into the glories and responsibilities of his inheritance.[79] Their relationship was not improved when Wenman was persuaded by a group of Norfolk Whigs to stand for election (unsuccessfully, as it turned out) for Norfolk in 1767. He was already Member for Derby but clearly his future prospects in Norfolk were well-known in local circles and Lady Leicester accused him of trying 'to *nose* me in the county'.[80]

```
Thomas Coke          Cary            Ann              Edward         Robert
1st Earl, 1697–1759  1698–1732       1699–1758        1702–33        1704–50
= Margaret Tufton    (no issue)      = Philip Roberts unmarried      (no issue)
                                       d. 1779

        Edward                    Wenman
        1720–53                   1717–76
        (no issue)                took the surname Coke 1750 on inheriting
                                  the Longford property from his uncle Robert

                          Thomas William Coke, 1754–1842
                              (Earl of Leicester 1837)
                          = (1) 1775 Jane Dutton who died 1800
```

Family tree: the sideways shift of the inheritance from Thomas Coke, builder of the Hall, to his great-nephew, T. W. Coke.

The dowager turned her attention to Wenman's eldest son, Thomas William, who had been born in 1754, the year after her own son's death. In 1771, when he left Eton, Lady Leicester unexpectedly contacted him with an offer of £500 a year if he would travel abroad rather than attend 'one of those Schools of Vice, the Universities'. When he accepted, she invited him to Holkham for the first time, to spend a month there before setting out for Europe, an echo of her late husband's stay at Holkham on the eve of his own Grand Tour fifty-nine years earlier.[81] Thomas William's compliance with her wishes mollified Lady Leicester and she added a codicil to her will, leaving him some of her china and linen 'and all my crystal branches for lighting the gallery at Holkham'.[82] He returned from the continent nearly three years later, in the summer of 1774. With his sister's husband, James Dutton, later Lord Sherborne, he then rented a house in Oxfordshire, where they established a pack of hounds and indulged their passion for fox hunting. In the following year he came of age and married James's sister, Jane Dutton.[83] There is no record that he visited Holkham before Lady Leicester died in February 1775 and his father, Wenman, succeeded to Holkham.

Wenman took up residence at Holkham, installing a new housekeeper and employing extra help in the house and stables, but for much of the year the parliamentary season kept him in London. By now he was representing Norfolk, having been returned unopposed at a general election in September 1774.[84] One of his earliest decisions regarding the estate was to undertake new building work and repairs at the Coke property at Bevis Marks in

the City of London (Coke's Court, Camomile Street and the Saracen's Head Inn), work completed by his son in 1779 at a total cost of over £6,000.[85] The property was sold only a few years later to help finance the purchase of an estate at Warham, close to Holkham, but the work is significant as the first known connection between the Coke estate and the architect Samuel Wyatt, who had settled in London a couple of years earlier and whose country house practice was rapidly expanding.[86] Having been responsible for the plans, building accounts and letting of the Bevis Marks properties, Wyatt was later employed extensively by Wenman's son at Holkham and elsewhere on the Norfolk estate, leaving a distinctive stamp on its farm buildings. Wenman himself, however, had little chance to leave any imprint on Holkham, for in April 1776 he died suddenly in London, aged not yet sixty, after little more than a year in possession of the Hall and estate. Rather sooner than might have been expected, Holkham found itself with a new young master, Wenman's son, Thomas William Coke, aged twenty-one.

Chapter 10

Farming, Whigs and Hospitality 1776–1842

For forty years, visitors had been drawn to Holkham by the spectacle of the new Hall slowly taking shape and the splendour of its artistic treasures. During the next sixty years, however, the house would become the focus of enthusiastic discussion and fulsome admiration for quite different reasons. Holkham farming, the charismatic character of its proponent and publicist Thomas William Coke, his staunch Whig politics and the liberality of Holkham hospitality became the stuff of legends. The transition within little more than a year from the elderly Countess, widow of the man who had conceived and built the Hall, to T. W. Coke, young enough to be her grandson, is the first opportunity to see the Hall and park adapting to a new generation, an occupant intent on developing his own interests and establishing a different way of life. As he was descended from the late Earl's sister rather than directly, he could not inherit the title of Earl of Leicester but for nearly fifty years, until the title was recreated for him in his old age, he relished his status as a wealthy and prominent commoner. Not at all daunted by inheriting a large estate and a great country house, he had no difficulty in recognising the remarkable combination of opportunities, particularly in the realms of politics, farming and hospitality, offered by his inheritance.

Holkham, like most great country houses, was a symbol and instrument of political influence. The size and wealth of the Holkham estate placed it alongside Houghton and Raynham, all within a few miles of each other, as one of the great Whig seats in Norfolk but, in years past, the old manor house and the slow building of the new Hall had limited the extent to which Holkham could bear comparison with the splendours of Sir Robert Walpole's Houghton, started in 1722 and completed by the time that the long years of building began at Holkham, or with the older house at Raynham, extensively renovated around the same time by the 2nd Viscount Townshend.

The Hall from the north in 1782, by W. Watts.

The Hall from the south, 1820s, probably by George Hayter, in an album presented by him to Lady Anne Coke.

Now, however, the glory days of both had passed. Lacking an estate sufficient to support the cost of building and maintaining the house, even Houghton was in decline and rarely occupied.[1] Holkham now stood unrivalled as the local focus of the Whig cause. Coke was persuaded immediately after his father's death to stand in his place for parliament and in the following month, two days after his twenty-second birthday, was elected Knight of the Shire for Norfolk. From an uncompromisingly Whig background, he soon allied himself with the leading Whig, Charles James Fox. Eventually even his favourite daughter felt that she had 'seen enough of staunch Whigs to dread the very name'.[2]

During that first summer, however, there were pressing matters nearer to home. Ownership of Holkham propelled Coke into the management of the largest estate in Norfolk, amounting to 30,000 acres divided between about sixty-four tenanted farms, with other properties in Kent, Somerset, Oxfordshire and London.[3] At Holkham itself, the farm, the park and the tenanted estate farms encompassed virtually the whole of the parish. The estate was well run and profitable, in an area already famous for the high standard of

its farming. It was still under the direction of Ralph Cauldwell, estate steward since 1742. Lord Leicester had stipulated in his will that Cauldwell retain the office for life at his usual salary of £200, with an additional annuity of £200 for acting as trustee of the will, and Lady Leicester had subsequently increased Cauldwell's salary to £300, strengthened his right to the annuity 'as a reward for his ... faithful and judicious management and improvement of the estate' and left him a legacy of £2,000.[4] Cauldwell had been tenant of Godwick Hall, the old Coke seat near Tittleshall, since at least 1761 and recently had built a country house at Hilborough, near Swaffham, some thirty miles from Holkham, not only with Lady Leicester's advice and encouragement but 'in a larger and handsome manner than it would have been' thanks to a contribution of £1,000 from her a year before her death.[5] By the time that T. W. Coke took over, therefore, Cauldwell was an absentee agent, employing a clerk 'residing at Holkham to transact the necessary business of the trust estates in Norfolk'.[6]

It mattered little, however, that Cauldwell was not on hand to offer the new owner the benefit of his long experience, for Coke voiced strong suspicions about Cauldwell's probity during the period when the widowed Countess had been life-tenant of the property that he was waiting to inherit. Under legal advice, he did not pursue the matter but it took him four years to remove Cauldwell from the estate management in return for an annuity of £400; his final audit account was signed off in June 1782.[7] During his first summer at Holkham, Coke created a new post of estate auditor-general but his only connection with the man he appointed, Richard Gardiner, had been through electioneering earlier that year and he quickly had second thoughts, terminating the post after only six months.[8] Routine handling of the accounts was left in the hands of Cauldwell's former clerk, succeeded in 1792 by Francis Crick, who had come to Holkham a few years earlier as 'groom of the chambers' and had risen quickly to become Coke's valet and then 'superintendent of the workmen'. With only such basic assistance, for forty years T. W. Coke managed the estate without a steward or agent.

This was a major departure from the policy of the previous fifty years, when management by Appleyard and then Cauldwell had proved highly effective in modernising the estate and raising its rental. Coke emphasised the change by abandoning use of the Counting House or Steward's Lodge that stood to the south-west of the Hall. The bust of the late Earl that had presided over the activities there was retired to a high niche in the Marble Hall and Coke's estate business was run for the rest of his life from offices on the ground floor of Strangers Wing, a most convenient position for his direct involvement.[9] The incorporation of the estate office into the house

Thomas William Coke (1754–1842) by Pompeo Batoni, Rome 1774. Commissioned by the Countess of Albany, wife of the 'Young Pretender' and presented by her to Coke while he was in Rome on his Grand Tour.

exemplified a general shift in attitude towards farming and rural affairs: whereas the late Earl's stewards had quietly but effectively managed and improved his estates, T. W. Coke was of a generation that wanted to be seen personally embracing farming and agricultural improvement.

The earliest changes made by Coke, however, show that his priority was to improve the setting of his new home, described in detail in another chapter. Within five years of coming to Holkham, he placed the Hall centrally in its park by taking in hand a considerable area of land to the west, built new kitchen gardens out of sight of the house, extended the lake and initiated a massive tree planting campaign. On the other hand, for the first few years of Coke's time, the Hall farm, despite its later fame, is almost absent from the record. Coke liked to recount in later years that he took up farming almost by accident, a result of two Holkham tenants refusing to renew their leases, but in reality the farm had long been a well-established feature. Indeed when his father, Wenman, had inherited in 1775, the terms of Lady Leicester's will had obliged him to pay £1,740 for the 'husbandry stock, implements, corn sown, land plowed, corn and malt in the granaries, etc'.[10] Even if the young Coke had absorbed some appreciation of the 'Norfolk husbandry' principles already adopted by his father at Longford, in Derbyshire, where they were admired by the agricultural writer Arthur Young, his absence on the Grand Tour in 1771–74 followed quickly by his early marriage would have given him little time for learning the practicalities of running an agricultural estate.[11] Within three years of inheriting Holkham, however, he found a reliable farm bailiff, Edmund Wright. His early salary, slightly less than the master bricklayer's, reflected the comparative lack of importance initially attached to the farm but over the course of thirty years he grew to be highly esteemed by Coke for 'his abilities as an agriculturist and his valuable qualities as a truly honest man'.[12] Supported by Wright, Coke took early measures to improve his own knowledge of farming. A naturally sociable young man, he 'began at once to collect around him practical men, and invited to his house annually a party of farmers at first only from the neighbouring districts'.[13]

There were plenty of experienced farmers on the estate to attend such gatherings. When Coke inherited in 1776, twenty-eight tenants (out of a total of about sixty-four) were the same men, or from the same family, as in 1759, the last year of the late Earl's life; at least a third of those families had been tenants since 1725 or even earlier and were well into their third twenty-one year term.[14] Carr of Massingham, admired by both Coke and Arthur Young, had recently finished as a tenant but Benoni Mallet, for example, had farmed at Dunton, a few miles from Holkham, since 1734, the year that work started on building Holkham Hall, and his father had been

there since at least 1723, shortly after George Appleyard had arrived as estate steward.[15] Such men were not necessarily all exemplary farmers but many were well steeped in the improvements in cropping, arrangement of fields, farm buildings and soil management that were already normal on the estate:

> At these meetings agricultural topics were discussed, [Mr Coke's] farm was examined; and his management of it either criticised or approved, and by thus receiving information, and again communicating it to others, not only did [Coke] himself arrive at the knowledge of agricultural management, but the practical men who attended these meetings left them better informed than when they came.[16]

Coke found himself with an unrivalled opportunity to champion the fashionable cause of improvement on an estate that had long since benefited from it.

As Coke during his first few years at Holkham settled into politics, arranged for the management of his estates, began enthusiastically transforming the landscape of the park and developed an interest in agricultural improvement, there is no evidence that indebtedness or financial constraint played any part in deciding his priorities.[17] The late Earl, builder of the Hall, had left debts of £90,000. These included debts of about £30,600 that could not be covered from his personal estate and a mortgage was raised in 1763 to clear these. The remaining £60,357 was the sum borrowed by mortgages on the estate.[18] Coke's father, Wenman, left another £15,000 of debt. Until agricultural prices slumped in the early 1820s, however, Coke had no difficulty in delaying repayment of mortgages, borrowing heavily for his own purposes and meeting interest charges. He spent freely on elections, particularly in 1806, and consistently overspent on living expenses. He also had to provide marriage portions for his three daughters. Purchases of important properties near Holkham, notably Warham and Egmere, were partly balanced by sales of land outside the county: the one remaining Somerset manor and the Kent and London properties were sold when Warham was purchased in 1785–87, the Lancashire properties went in 1790–1804 and the sale of most of Minster Lovell in Oxfordshire in 1812 coincided with the purchase of Egmere. Debt did not deter him from spending lavishly on farmhouses and buildings for many tenants on the Norfolk estate as well as on the farm, park and village at Holkham. By the early 1820s, his total debts had reached about £230,000 but presented no insuperable problems so long as net income from the estate was also rising: from an average of about £17,000 a year during his first ten years, to an average of about £29,000 when prices were high during the Napoleonic Wars in 1806–15.[19]

It was not the pressure of debt, therefore, but a preoccupation with other interests that lay behind his declaration that he would 'certainly not rashly venture to interfere with what has been the result of years of careful study in Italy'.[20] He had spent a month exploring the Hall as a youngster, under the eagle eye of the Countess who had played such a key role in completing it, and his own Grand Tour, immediately after that visit, had given him some further introduction to the influences that had shaped the house and its outstanding collections, but it was many years before he developed any real interest in those aspects of his inheritance. His Grand Tour yielded a few important additions to the Hall, principally his portrait by Batoni, a first-century mosaic of a lion attacking a leopard, and two marble reliefs. The mosaic replaced the landscape by Griffier that had hung above the fireplace in the Long Library since 1742 and the two marble reliefs were placed in their present positions, either side at the top of the Marble Hall staircase.[21]

The mosaic, purchased by Coke on his Grand Tour, above the Library fireplace.

Entries in an account book for gilding the windows on the south front, 1810.

One of the reliefs had been purchased (mistakenly) as a Michelangelo, which would have been a most desirable acquisition for a young man on the Grand Tour, while the other, the *Death of Germanicus*, was by Thomas Banks, a sculptor working in Rome when Coke was there, an opportunity for Coke to commission a modern work.[22] There is no hint that Coke inaugurated any major degree of refurbishment, as did future generations on succeeding to the Hall. Most parts had now been occupied for at least twenty years, with sunlight, candles, open fires and regular use taking their toll on fabrics and furniture. A visitor in 1780 commented that the rooms 'in general have been magnificent' but noticed that 'the furniture seems greatly past its meridian, and the apartments want a great deal of beautifying'.[23] There was, however, one aspect of the Hall, its austere external appearance, which Coke had no hesitation in altering, deciding within his first year to gild the exterior of the window bars. Charles Shard, visiting three years later, thought the gilded sashes 'give the front a grand appearance'. The gilding was renewed in 1808 and again shortly before a guide book in 1835 declared that it gave 'a truly magnificent appearance'.[24]

The major novelty inside the Hall was the presence of children. Before the nineteenth century, country house design took little account of children and rooms were found for them as necessary. The result was that nursery life

had a greater impact on the Hall than might be expected, requiring flexibility in the use of rooms as well as the addition of a nursery layer into the staff hierarchy. The builder of the Hall had been in his forties and his ill-fated son aged twenty-one before even the first wing was completed; he and his wife had been approaching sixty before they could occupy the whole house. Now, however, the new occupant was a twenty-two year old whose wife was expecting their first child. Seven months later, she was 'brought to bed of a dead son, occasioned by a fright; a mouse got into her night cap and demolished the heir to Holkham'.[25] So succinctly reported by Lady Mary, whose brief marriage to Edward Coke thirty years earlier had notoriously failed to come anywhere near producing an heir, this stillbirth seemed destined to leave Holkham yet again without a direct male heir. A daughter, Jane, was born in December 1777 and another, Ann, thirteen months later. A nurse and nursemaid joined the household and rooms were allocated for day and night nurseries, possibly the suite of bedchamber, dressing room and servant's room on the top floor of Family Wing, but more probably the rooms at the top of Chapel Wing that had originally been allocated to housemaids. As the girls grew up, a governess and young ladies' maid joined the household and another room was designated as the schoolroom, where morning lessons began at seven o'clock. Ann was still not quite sixteen when in 1794 she married Thomas Anson (later Viscount Anson) owner of the Shugborough estate in Staffordshire, and her old nurse left Holkham 'to attend Mrs Anson with her first child'.[26] This was the first of eleven children who, during the Ansons' frequent return visits, provided plentiful company in the Holkham nursery for Coke's third daughter, Elizabeth, born in 1795. A year later, at the age of nineteen, the eldest daughter married Lord Andover but had no children before his death in a shooting accident in 1800.

*

In 1784 Coke's political loyalty to Fox cost him his seat in the Commons. The six-year gap that followed was the only break in his parliamentary career but Coke put it to good use in raising his profile in politics, farming and hospitality. Holkham gave him an ideal setting for celebrating the centenary in 1788 of the Glorious Revolution, claimed by the Whigs as the epitome of their battle for liberty and parliamentary power. Coinciding with the need to strengthen his political standing before the next election, Coke marked the occasion with a magnificent ball for over 500 guests, demonstrating his political allegiance, his personal status and the regional pre-eminence of Holkham. A specialist from Norwich, Martinelli, spent ten days setting up fireworks and 'illuminations' that featured the Prince of Wales's feathers in the Whig colours of buff and blue, highlighting Coke's support for the

Replies to invitations to the Glorious Revolution Centenary Ball were carefully filed and registered.

Whigs against the King.[27] It was Holkham's first experience of hospitality on such a scale, heralding a transformation in how the Hall could be used.

Coke returned to Parliament two years later. Having begun his political career as the youngest Member of Parliament, he retired fifty-six years later in 1832 as the Father of the House, but his daughter warned her future husband (allegedly the only Tory tolerated at Holkham) 'whatever you do, keep out of Parliament ... I am too tired of the whole *farce*, for it is only larger children's play'.[28] Coke did not become a great parliamentary politician and held no high office; much of his involvement was typically on matters that reflected local interests. Gainsborough's portrait of him, hanging in the most prominent position in the Saloon, showed him in country dress of leather breeches and boots, out on his estate with his gun and dogs, capturing his character so clearly that it needed no explanation. Nevertheless, aspects of Coke's political career became enshrined in Holkham history, for in later years the portrait (which was signed and dated by Gainsborough in 1778) was paired with a portrait of Coke's political ally, Fox, and was retrospectively taken to epitomise Coke's stance as 'an English Country gentleman' against George III and the American War. Coke's own accounts, accepted without reserve by family and admirers, exaggerated the extent of his participation

> **Mr. COKE's FETE,**
>
> WAS, as we have said before, very sumptuous. Mr. and Mrs. COKE were very assiduous in their hospitalities and their kindness—tho' much of both was flung away on poor people of the Party quite undeserving of them.
>
> There were Illuminations and Fireworks without end, in the Portico, the Pediment, the Egyptian Hall, &c. There was a Plume of Feathers, and that was all there was of the PRINCE of WALES; for at Newmarket, in his way to Holkham, the sad Express fetched him to Windsor.
>
> Mr. and Mrs. COKE stood at the door of the Saloon, to receive the guests as they entered—and the words, *"Liberty and Our Cause,"* were in a transparency.
>
> After the Supper, which was very elegant, the Marquis TOWNSHEND gave WILLIAM III. and the REVOLUTION—the HOUSE of HOLKHAM—House of RUSSELL—House of ROMNEY.
>
> The Duke of BEDFORD gave the PRINCE of WALES.—It is not true that he added, and may he come to Newmarket—
>
> But Mr. COKE, with much propriety, subjoined, upon his absence, and the *cause of his absence.*
>
> Mr. DUTTON gave the House of RAYNHAM.

Newspaper report of the Centenary Ball.

in presenting to the King in 1782 the Commons' address against the continuation of the war, and served to nurture the legend.[29]

Coke's short break from politics gave him the opportunity to intensify his focus on farming. The chronology is unclear for the transition from his early local farming meetings into the internationally famous Sheep Shearings, annual three-day summer gatherings that regularly attracted large numbers of renowned agricultural experts, nobility and foreigners.[30] In later years, both the 1819 and 1821 Shearings were said to be the forty-third (apparently by counting back to Coke's earliest local gatherings) but their origins can be more reliably attributed to the 1790s, when Coke established Longlands, at the southern edge of the parish, as the centre of his farming operation, with extensive new barns, granaries and wool chambers that would be worthy of public inspection, probably all designed by the architect, Samuel Wyatt. The Shearings were first reported in the local press in 1798, precisely the year that a 'sheep shew house' completed the new buildings. Sheep breeding

T. W. Coke by Thomas Gainsborough, 1778.

offered the agricultural improver particular scope for, as Arthur Young had commented in 1770, the 'contemptible' local breed of sheep was one of the few deficiencies of Norfolk husbandry.[31] The native Norfolk Horn sheep were lanky, ill-suited to confinement in enclosed fields instead of ranging the old fold courses, and slow to mature. Coke tried crossing them with the New Leicestershire sheep bred by Robert Bakewell, and with Southdowns. By the 1790s, his breeding flock of Southdowns was the prime feature of the Hall farm.[32]

Large-scale house parties for the Shearings started around 1800, when entries first appeared in the accounts for the hire of extra beds, looking glasses and other furniture. In the 1800s, fifty to eighty guests, often including dukes, Members of Parliament, Americans and 'liberal men from all parts of the kingdom and from abroad' were accommodated in the Hall for the three or four days. They were joined by ever-increasing numbers for the tours of the farms, followed by dinner: ninety in 1799, 200 who 'dined on plate' in 1802, 600 on the third day of the 1818 gathering. The accounts give no clue as to how the kitchen catered for the dinners but the butler's wine book shows that eighty-three dozen bottles of port, sherry and wine were drunk over the three days in 1818. Seven hundred dined on the third day of the 1821 meeting, which was to prove to be the last Shearings.[33] The high state of farming achieved by Holkham tenants and the example of agricultural improvement set by their landlord owed a great deal of their fame to the setting in which they were publicised: however impressive were the farms thrown open to inspection, visitors returned from their day in the fields to dine and talk in one of the most magnificent of eighteenth-century houses.

The Shearings were the most publicised but by no means the only occasions which made Holkham, as an American correspondent wrote, 'so long the renowned theatre of a refined and unbounded hospitality'. The traditional audit dinner, following the twice-yearly audit or rent day, continued to be a regular gathering for the tenants, presided over by their landlord. On these occasions, sixty or seventy tenants and friends gathered in the Audit Room, below the Statue Gallery, for a typical spread of '40 dishes, besides vegetables and mince pies and 25 bowls of punch'. No wonder that William Windham of Felbrigg, arriving in January 1786 on one of his frequent visits, wrote in his diary, 'feel of great satisfaction on my arrival, which was not lessened by the circumstance of arriving in the midst of the audit'.[34] Thomas Moore, a tenant at Warham who often attended the Shearings, recorded smaller gatherings throughout the summer. On one occasion, only three weeks after the Shearings, he 'breakfasted and farmed and dined with Mr Coke at Holkham with a party of 14, spent a very pleasant day'. Such

The Wine Book for June 1818 showing consumption at the Shearings that year.

gatherings continued when the Shearings themselves were no longer held. A 'farming party' in July 1823 consumed forty-three bottles of port and sherry and an 'Easter party of amateur agriculturists' was a regular occurrence. Summer hospitality was informal. One of Coke's grand-daughters recalled, 'it was the custom at Holkham to dine in the south dining room till a certain

T. W. Coke inspecting his Southdown sheep with Mr Walton and the Holkham Shepherds, by Thomas Weaver, about 1808.

BAS-RELIEF—THE SHEEP SHEARING.

Mr Gurdon. 3. Sir W. Folkes. 5 Lord Colborne. 7. Late Earl of Leicester.
2. Mr. Leamon. 4. Sir J. P. Boileau. 6. Earl Spencer.

The Sheep Shearings depicted on the Monument erected to the memory of T. W. Coke.

Chapter 10 Farming, Whigs and Hospitality 1776–1842 261

date ... Up to that time, anyone who came was received as a family friend, and not as a visitor, and whoever they might be, no alterations in the ménage were made on their account.'[35]

In the winter, when life at Holkham was dedicated to hunting and shooting, lengthy house parties continued unabated throughout Coke's life. 'Holkham is always full and very like an Inn', wrote one observer, 'for people arrive without any previous notice and seem to stay as long as they like.' Each year, 'for three successive months Mr Coke kept open house for his friends'.[36] As a young man, Coke's sporting passion was fox hunting, a sport that was developing rapidly with improvements in the breeding of hounds and horses. In the 1780s he employed a huntsman (William Jones, 'the best man of his class in the kingdom') with two whippers-in and a kennel man, and kept more kennels at North Elmham and hunting stables there and at Tittleshall. He was said to have had other kennels in Suffolk, Cambridge and Essex and to have hunted the entire area from Holkham to Epping Forest.[37] Increasingly, however, the focus of Holkham sporting life

The game larder arranged by Samuel Wyatt in the upper floor of the water engine house.

turned to shooting. In the early years it warranted only two gamekeepers, one of whom doubled as butcher, but by the late 1780s their numbers had increased to five or six. By 1842 six were employed at Holkham, one at Quarles and one at Warham.[38] Green liveries with red waistcoats were bought for them each year. Coke's daughter complained that it was 'utterly impossible to get out of the sound of firing at Holkham, which is like a field of battle'.[39] Letters and memoirs refer to battues, often held twice a week in season, throughout Coke's time. On the first day of the battue in 1822 (6th November) nearly 800 head were killed; on the following day, 'the return of slaughter' was 860 'and three people hit'.[40]

The Hall proved capable, without alteration, of adapting to the unprecedented frequency and scale of entertaining required by the new generation. Its formal Palladian design was now somewhat out of fashion but it had been built with an eye to practicalities as well as splendour and Coke, the wealthy commoner, delighted in the scope that it gave him for dispensing liberal hospitality on an aristocratic scale. The Marble Hall was remarkably well suited to receiving large numbers, whether they came for a ball or from inspecting the farm. The Statue Gallery, designed as the first private gallery in England to be devoted to the display of sculptures, now proved capable of accommodating two long tables for up to 200 dinner guests during the Shearings, although the spacing must have been more convivial than elegant. The sequence of adjoining rooms (the Dining Room on the north and the southern enfilade of Saloon and drawing rooms) meant that many more could dine within earshot. The American envoy, Richard Rush, described how toasts proposed in the Statue Gallery were taken up in the neighbouring rooms and 'echoing through the apartments of this stately mansion, standing alone in the midst of a rural domain, and heard somewhat faintly in our statue gallery from the distant rooms, but still heard, had something in them to fill the fancy. The whole scene seemed to recall baronial days ... It brought back the remembrance of feudal banquets, as if here seen in alliance with modern freedom and refinements'.[41] It was exactly the impression that Coke wished to create.

On the rustic floor, the Audit Room on the west and the Billiard Room (later known as the Smoking Room) on the south lent themselves to the new fashion of rooms opening directly to the outside. Thomas Creevey, the Whig politician and diarist, was delighted to have 'a charming bedroom on the ground floor with a door at hand to go out of the house if I like it'. Attention to paving round the house between 1804 and 1811 suggests that family and guests liked to stroll round the exterior, where a strong iron fence kept the heavy cattle in the park from intruding on the gravelled walks and sloping lawns near the house.[42] House guests relished the combination of

old-fashioned privacy and the new mode of informal social life. Lady Sarah Lyttleton, praising the unobtrusive skills of Coke's daughter, Lady Anson, as a hostess, was greatly impressed by the fact that 'every person at Holkham did exactly what they chose all day, & you might go out, stay at home, sit in your room or in society, work, read, or do nothing without any inquiries or pressings, or even proposals being made to you by the lady of the house, of whose control one is, I think, always more jealous than of any other in the world'.[43] Guest rooms were in Strangers Wing, Chapel Wing (mostly used by visiting members of the family) and the upper floor above the staterooms on the eastern side of the house. The studious William Windham acknowledged that the house itself had 'no small share' in his enjoyment of a visit:

> Of the modes of existence that vary from day to day, none is to me more pleasing than habitation in a large house. Besides the pleasure it affords from the contemplation of elegance and magnificence … there is no other situation in which the enjoyment of company is united with such complete retirement. A cell in a convent is not a place of greater retirement than a remote apartment in a house such as Holkham.[44]

The Duke of Sussex, who regularly spent two months at Holkham, enjoyed less privacy in the North State rooms, which were reminiscent of an earlier style of hospitality. A favourite pastime for guests on a wet day was a tour of the house and on one such occasion a large party 'piloted' by Lord Albemarle was amused to find 'the ducal stockings' warming by the fire in the North State Bedroom. 'The Duke was in the little sitting room close by … he called us in, and we found him enveloped in smoke, with the little Duchess reading aloud to him.'[45]

One of the delights of staying at Holkham for many guests was the discovery of the library, the room that attracted the most comment in letters and memoirs. In part this reflected the popularity of a library as an informal living room in country house circles at this period but many of Coke's guests had a genuine appreciation of the treasures it contained, as Richard Rush recorded:

> There on one of the days that I entered it, during a short interval between the morning excursions and the dinner hour, did I catch stragglers of the home guests, country gentlemen, too, who had not been out to the fields or farms at all, though they had come all the way to Holkham to attend the sheep shearing! And no wonder! In fact they were of the younger portion of the guests … not long from the university, so recently that the love of practically inspecting wheat fields … had not so deadened classical ardour

as to keep them from stealing off to where they could find curious editions of Pliny and Ovid and the Georgics ... or turn to something else seducing or curious in literature.[46]

Real enthusiasts, climbing to the top of the house, discovered the other library occupying two of the original tower bedrooms and their connecting corridor, converted by Lady Leicester to accommodate the books and manuscripts transferred from the London house after her husband's death.[47] William Windham recorded how, during a visit in 1786, he 'went for the first time into the library at the top, which I had heard of when I was last there, and forgot again. The room and collection answered fully to my expectation'.[48]

The successful provision of large-scale and prolonged hospitality depended not only on the facilities of the house, important though they were, but also on the character and energy of its owners. Coke's skill as a host was proverbial. Sir James Smith, the botanist, described him as 'one of the most gracefully kind and benevolent men, to all in their proper places

Entries in the account book for the payment of taxes in 1817 give a glimpse of the size of the household.

I ever saw'.[49] Coke's obituary in a local paper recalled that 'every visitor, on leaving Holkham, dwelt on the reception he received from the master of the house and imagined himself the favoured guest'.[50] The role of the mistress of the house was also crucial. Coke's first wife, Jane, entered into her husband's interests with enthusiasm. Two farmers on a visit to Holkham in 1792 were pleasantly surprised to meet 'such an amiable lady in high life, so well acquainted with agriculture, and so condescending as to attend two farmers out of Kent and Sussex a whole morning to show them some Norfolk farms'.[51] In 1800 her sudden death at Bath at the age of forty-four left Holkham without a mistress but Coke's daughter, Lady Andover, who had been widowed a few months before her mother's death, was invariably willing to come to Holkham whenever a hostess was required. After she remarried, her sister, Lady Anson, often took her place. The youngest sister, Elizabeth, as soon as she reached the age of eighteen in 1813 'passed straight out of the schoolroom to take her place as mistress of the house'.[52] Elizabeth prided herself for many years to come on her ability to take control of the household. When servants left, she wrote 'every character both of the men and women' and she supervised the dress of the female servants, 'banishing curl papers and all tendency to finery'. She found it, however, 'such a task and charge'.[53]

Coke was a widower for twenty-two years but in 1816 he lost his heart to 'Bessy' Caton, one of three beautiful young American sisters who took London society by storm. They were granddaughters of Charles Carroll of Carrollton, a signatory of the Declaration of Independence.[54] They soon visited Holkham, whose owner was revered in America for his support of Independence, and Bessy rapidly became Coke's 'Dear Companion in some of the very happiest days and hours of my life'. In late 1817, however, she apparently rejected a marriage proposal (although they continued to correspond) and brought to an end 'the happiest period' of Coke's life. He began to tire even of the Shearings, which in 1819, he wrote to Bessy, were 'more of a trial than a pleasure', and to feel that 'every dog has his day, and I have had mine'.[55] In February 1822, however, at the age of nearly sixty-eight, he took everybody by surprise by marrying his eighteen-year old goddaughter, Lady Anne Keppel, daughter of his old friend, the Earl of Albemarle. His agent, Blaikie, wrote to Coke's London solicitor, 'Mr Coke's marriage could not possibly be more unexpected to you, than it was to me.'[56] Lady Anne knew Holkham well, for 'the Cokes and the Keppels lived at this time as one family' but Coke's daughter, Elizabeth, thankfully leaving Holkham a few months later to become mistress of her own married establishment in Yorkshire, guessed that Lady Anne 'finds probably what I have found during

several years, that this house entails a perpetual sacrifice of all one's own feelings and inclinations'.[57]

*

Holkham hospitality is well recorded, thanks largely to the letters and memoirs of visitors, but the daily management that supported it is more elusive. Elizabeth Coke's great-granddaughter regretted that few details of the early days 'loom out of the oblivion which enshrouds the life at Holkham'.[58] Domestic account books are lacking before 1783. It is risky to suggest that this reflected a neglect of routine by the staff or nonchalance in financial matters by Coke but fair to say that the surviving accounts do not match, for organisation and thoroughness, the meticulous domestic day books and ledgers kept in Thomas Coke's time by Lady Margaret and her house steward. Nevertheless, the role of the lady of the house appears to have been crucial in regulating expenditure, particularly when the whole household was settled at Holkham, for during Coke's long widowhood the household was put on board wages (an additional sum paid in lieu of meals) for six to eight months after the end of the winter hospitality season in February. From 1813, however, when either Elizabeth or Coke's second wife was in charge, board wages were paid only for the two or three months between April and July that the family and part of the household spent in London.[59]

The London season in the spring was often followed by a visit to Longford, perhaps an 'agricultural tour' of Scotland and visits to friends or to Coke's married daughters at Shugborough in Staffordshire and Cannon Hall in Yorkshire. Greater ease of travelling and his involvement in politics meant that Coke came and went frequently, sometimes staying at Holkham for only a few days, regardless of whether the household was resident there or in London. He did not own a London house, preferring to stay with his daughter, Lady Anson, or to rent a house for the season. After his second marriage he used a house belonging to Lady de Clifford, his new wife's grandmother, in Paddington, which his friend Roscoe thought 'so much preferable to one in the streets of London and uniting most of the advantages of both Town and Country'.[60] His son, Henry, had fond memories from slightly later years of a house in Kensington, 'completely surrounded by fields and hedges'.[61] Whatever the location of the seasonal London residence, however, Holkham was designated as 'Home' and the transition from 'housekeeping' to board wages was distinct, expressed in formal phrases: Coke would 'move the Family to town' on a certain date, and its return 'Home' was 'when housekeeping commenced'.[62]

There were about thirty-eight servants in the household by 1783, of whom twenty-seven were indoor servants, with an annual wages bill (excluding

board wages) of about £780. The head gardener, farm bailiff and two or three estate craftsmen were included in the list because they boarded (dined) in the house. Ten years later, the total number had risen to forty-nine, far more than it had ever been, and the wages totalled over £1250. The increase reflected both the importance of outdoor pursuits, with five gamekeepers, a huntsman and two whippers-in, and the demands of hospitality, with three footmen, a groom of the chambers and occasionally a confectioner. Sometimes Lady Anson, during her long visits to her old home, brought her butler to act as a temporary groom of the chambers, or her cook to assist in the kitchen.[63] Through the years there were slight fluctuations in servant numbers. An expensive French cook might be engaged only for the height of the winter season, footmen were allocated to specific members of the family so their numbers rose or fell accordingly, and some of the maids were taken on only for the busy winter months. After about 1827, possibly as a result of greater control by the new Mrs Coke and the incentive of retrenchment for the sake of the heir, the total servants wages bill was regularly kept below £800. Tax was paid on twenty male servants (indoors and out) and on hair powder for five indoor servants in livery.[64]

Servants' living conditions were more crowded than before, regardless of increases in the number of staff, because rooms originally planned as servants' quarters were now needed as nurseries or guest rooms, with bed space also to be found for visitors' servants. An inventory in 1842 recorded two or three four-post beds in most servants' rooms, with additional 'tent' or 'press' bedsteads in the tower passages and smaller Nelson Wing rooms, including the dubiously named Lob's Hole.[65] There were also rooms to be found for additional members of the family, particularly the sisters of Coke's first wife. One of them, Mrs Anne Blackwell, spent long periods at Holkham with her three daughters long after Mrs Coke had died. Their personal maids added to the size of the household but rarely appear in the records because they were not paid through the Holkham accounts.

Supplies for this large household came, as always, from the estate, local tradesmen and London shops. Meat was supplied from the home farm but tenants also sent presents of beef. On Christmas Day 1818, Thomas Moore of Warham sent a joint of ribs of beef from 'the first Devon Beef (slaughtered in Norfolk) of my own breeding & feeding'. The agent, Blaikie, was moved to respond with a eulogy, declaring that 'there can be no greater example given of *true patriotism*' than landlord and tenant working together to improve breeds of animals 'destined by the Allwise Providence to become food for man'.[66] This gift was almost certainly the inspiration behind the plaster model of ribs of beef that has been displayed for nearly two centuries

Plaster model of ribs of beef. Colours have faded but the joint clearly had a good layer of fat.

in a glass case in the room at the north end of the Audit Room. This was an appropriate location because the room had always been called the Beefsteak Room, perhaps reflecting the famous London beefsteak clubs, but in the twentieth century it became known as the Mutton Room, apparently because the maker of an inventory somehow mistook ribs of beef for a leg of mutton.[67] The lake continued to provide fish although, before one large house party, the tenant at West Lexham was told to expect Coke's keepers 'to fish the waters upon your farm, in particular the lake in front of your house' because stocks had been exhausted at Holkham. Tenants and neighbours sometimes sent servants bearing presents of trout.[68]

Many local tradesmen were used. When approached for a share in the 'favours from the hall' by a Wells-next-the-Sea shopkeeper who was also a freeholder, with a vote at his disposal, Blaikie replied that Coke would not 'deprive any of the shopkeepers in the neighbourhood of any little benefit they derive from serving the family with goods'.[69] Those patronised at Wells included the apothecary, brush maker, saddler, basket maker, sieve maker, cooper, cabinet maker, druggist, pump maker, draper, pipe maker, glover, stationer and ironmonger. Various merchants there supplied coal, cinders,

deals, tiles, oil, vinegar and freight of other goods. Servants' liveries came from a hatter at Holt and a tailor and boot maker at Wells. The wool merchant at Foulsham who supplied the green plush for the gamekeepers' jackets also purchased Holkham wool: Blaikie assured him he was 'a most acceptable visitor at the audit, particularly so as you bring the wool money in your hand'.[70] Groceries and wine were mostly bought in London and sent by sea. A hogshead that rolled into the quay while being unloaded from the *Union Trader* at Wells contained goods, including tea and sugar, that 'cannot be supplied in the country', at least in the types, quantities or price required.[71] Wine was bottled in the Hall by the butler: the bottles (over 2,000 on one occasion) ordered from Tyneside glass makers were specially embellished with a raised ostrich crest.[72] Some items came from further afield: a Parmesan cheese spent a month travelling from Genoa to Portsmouth, from where it continued by road to London and onwards by the Swaffham wagon, and three casks of American hams from Baltimore survived a journey of over six months by ocean, canal and sea.[73]

Fragment of bottle stamped with the ostrich crest.

The increasing scale of hospitality eventually exercised a reciprocal effect on the Hall. Initially there were few alterations. Bramah's patent water closets were being installed by 1789 and during the next few years some of the statues were repaired, the floor of the portico was re-laid and Mr Wilder (James Wilder, an artist and actor who became a reputable picture restorer) was paid over £206 for cleaning pictures at a guinea a day.[74] In the early 1800s, as rooms that had been intended for servants were more frequently allocated to guests, two men were brought from London to paper Strangers Wing, whose attic rooms were also embellished with new Italian marble fireplace slabs, and payments were made in most years for 'modernizing' and repairing furniture. Ceilings were cleaned and furniture and picture frames re-gilded. The stables on the far side of the lake were modernised and a new riding house added. These were all relatively small matters, particularly when compared to expenditure of over £5,000 at the same period for modernising Longford Hall for Coke's brother, Edward.[75] Busts of Whig friends appeared: C. J. Fox and William Windham in 1792–93 and the 1st Marquis of Hastings and the Duke of Bedford in 1802–3, all by Nollekens and all given prominent places in the Drawing Room and South Dining Room. Elsewhere there were busts of Sir Joseph Banks, the botanist, Henry Bathurst, who was Bishop of Norwich, and the Duke of Sussex.[76]

The greatest benefit to the Hall from Coke's wide hospitality proved to be the knowledge and expertise of guests. As a new young chaplain, Napier, perceived many years later, 'Lord L is not nor ever was literary. He has no interest in anything save party politics and agriculture ... All he knows is that he *has* books, and pictures and statues and that they are splendid and valuable, and this because judges of each have told him so.'[77] Many of his visitors, however, had literary and artistic interests which Coke increasingly appreciated and respected, with lasting results for the Hall. In the early days he had

> troubled himself little about the literary treasures contained within the walls of Holkham – devoting all the energies of his mind, and the activity of his fine person, in the arrangement and improvement of his large estates; his leisure hours being fully occupied in the pleasures of the chase, and the convivial entertainment of his numerous guests. It was not till after the death of his first wife, a circumstance which ... disposed him for pursuits of a graver kind, that he began to examine his hereditary stores of art and science, to which his friends had already been anxious to call his attention.[78]

One of his first steps was to engage William Seguier, an expert picture restorer and art adviser who later became the first Keeper of the National

The Classical Library.

Gallery, who 'commenced a regular investigation'. This incidentally brought to light the manuscripts in the tower library, which over the years had ended up 'in the greatest possible confusion'. Coke had been unaware of their importance and was 'highly gratified at finding himself the possessor of so unexpected a treasure'.[79] Soon afterwards, William Roscoe, the Liverpool banker, attorney and man of letters, visited Holkham for the first time in 1814, the beginning of a close friendship with Coke. Roscoe undertook a programme of reorganising and cataloguing in the library and, working with a Liverpool bookbinder, John Jones, a long campaign of book binding from 1815 to 1822. They showed far-sighted discretion, where appropriate, in preserving rather than replacing bindings.[80] In 1816–19 Coke's former dressing room and the adjoining anteroom in Family Wing were reorganised to form two new library rooms, known as the Classical and Manuscript Libraries, fitted with carved and gilded shelving to house many of the volumes and manuscripts brought down from the towers.[81] The result, giving a progression of four book-lined rooms from the South Tribune through to the original Long Library, remains today Coke's major contribution to the Hall. One of the tower rooms and the adjoining corridor continued as a library. It was probably this library that the Duke of Sussex, an enthusiastic bibliophile,

found had been 'converted into bedrooms' for guests at the 1821 Sheep Shearing.[82]

In the meantime, Seguier 'established the reputation of [Coke's] numerous and splendid pictures'. As with the books and manuscripts, Coke apparently had little prior knowledge of his collections and it was a conversation with Seguier about the unrivalled group of paintings in the Landscape Room that first gave him 'an exalted idea of the value of his pictures'.[83] Annotations in a copy of the 1817 guide book by Dawson Turner, a banker from Great Yarmouth who was a knowledgeable art and book collector, evoke the enjoyment that such a range of treasures gave to visitors who were eminent artists and connoisseurs, including Gainsborough (who visited several times and was particularly smitten with the Van Dyck), Benjamin Haydon, Thomas Phillips, R. R. Reinagle, Sir Joshua Reynolds, Sir Thomas Lawrence, the archaeologist Richard Payne Knight, the art collector George Hibbert, and the engraver William Harvey.[84] It may have been his awakening interest in the classical paintings that prompted Coke to add portraits of friends. He

Head of a ram, by Thomas Weaver.

already had a portrait of his old friend C. J. Fox by Opie (1804) hanging in the Saloon and now commissioned M. A. Shee to paint the Earl of Albemarle, the Bishop of Norwich and William Roscoe.[85] Portraits of his agent, Blaikie, and his tenant at nearby Egmere, Mr Denny, followed in later years. Family portraits of Coke's first wife and daughters, all by Thomas Barber, and a portrait of Coke himself by Reinagle (c.1814) were hung in Family Wing. After friends and family, several portraits reflected Coke's third love, the breeding of animals. Early subjects included horses and Southdown sheep but by the 1830s the focus was on North Devon oxen.[86]

A significant development came with alterations to the picture hang in the staterooms, initially prompted by Coke's attachment to friends and family. In the Saloon, his own portrait by Gainsborough and Opie's portrait of Fox replaced Chiari's *Perseus and Andromeda* and Procaccini's *Rape of Lucretia*, probably bought by the late Earl during his Grand Tour but now rolled up and sent to the attics. The two Whig friends dominated the room until about 1970, when the 5th Earl of Leicester replaced Fox with a portrait of

A North Devon ox, by William Carmichael Baker.

Tarquin and Lucretia, or *The Rape of Lucretia*, by Andrea Procaccini, probably commissioned by Thomas Coke in 1714, put into store by T. W. Coke and replaced in the Saloon by the 7th Earl in 1988.

the 2nd Earl, and it was only in 1988 that the two classical paintings were replaced in their original positions. In the Drawing Room, pride of place was given to a 'copy of Belisarius' painted by Coke's daughter Lady Andover

at the age of fifteen, placed opposite Van Dyck's *Duc d'Arenberg*. A few years later, the Van Dyck itself was replaced by a portrait of Coke's second wife, Lady Anne Coke, with her eldest child. In the South Dining Room, a painting of *Susannah and the Elders* by Coke's other daughter, Lady Anson, copied from the Guido original, and a portrait of Pope Leo X, bought by Coke from his friend Roscoe's collection, replaced other pictures. Subsequently, expert advice perhaps played a part in moving 'with great judgement' the Van Dyck from the Drawing Room and the Rubens from the South Dining Room to their present places at either end of the Saloon. The pictures they replaced (*Scipio* by Chiari and *Coriolanus* by Cortona) were 'carried to an attic, there perhaps to remain for ever' but in fact probably sold in the 1840s.[87]

The Whig presence in busts and portraits was repeated in two more reliefs placed in the Marble Hall. It has been suggested that the two reliefs acquired by Coke on the Grand Tour represented subtle connections between their subject matter and Coke's future prospects at Holkham but this seems unlikely, as Coke bought them when the Countess was still alive and his father, Wenman, was set to succeed her. Fifty years later, however, it was a different matter. Richard Westmacott's *Trial of Socrates* was commissioned in 1821 at a time when Coke was presenting county petitions to parliament calling for parliamentary reform, so here was a clear parallel between Socrates' criticism of a corrupt government and Coke's role in the Whig opposition. Similarly, Francis Chantrey's relief, the *Signing of Magna Carta*, proposed in the later 1820s but executed some years later, became an explicit depiction of

Bas-relief by Sir Francis Chantrey: the signing of the Reform Bill in 1832 depicted as the signing of the Magna Carta. T. W. Coke is seen on the right with his young son.

Coke and other leading Whigs, in the guise of medieval barons but their features identifiable, observing the King signing the Reform Bill in 1832.[88] The achievement of limited parliamentary reform, the epitome of the old Whig cause, was soon followed by Coke's retirement from politics at the age of seventy-eight.

*

Coke's increasing interest in his heirlooms and in commissioning new work coincided with a new freedom from management of the estate. Crick, receiver of the rents, died suddenly in June 1814 and early in 1816 Coke appointed his first professional land agent, Francis Blaikie, who had been farm bailiff and then agent on Lord Chesterfield's estate in Derbyshire. Coke, who was now over sixty, possibly foresaw that the end of the Napoleonic war would usher in a more difficult period for farming. General Fitzroy, a tenant at Kempstone, writing to Blaikie a few months after his appointment, also hinted at underlying problems in management.

> I speak my mind and all I can say is, I never more rejoiced at any one circumstance than I did when I heard Mr Coke had secured your services. I wrote to congratulate him on the event at the time, for tho' I did not know you by sight, I had frequently heard of you from several people, and from Lord Chesterfield himself, with whom I was very intimate … Mr Coke wanted an upright man, whose integrity was not to be intimidated & who would boldly correct abuses, which were getting a head [sic] too fast by all accounts in every department at Holkham.[89]

Coke's personal charisma and tireless activity had carried him through but Blaikie lamented many actions or omissions when Coke had been 'a young man and but little acquainted with business generally'. These included confusion between settled and personal estate, ill-advised and poorly recorded exchanges of land, failure to keep track of pensions and annuities arising from Coke's liberal generosity and, to Blaikie's particular dismay, the sale of the Lancashire estate, with its potential for coal royalties, 'little better than given away' in the 1780s.[90] Blaikie's thorough initial survey of the estate, noting tenants' characters as well as the state of the land and buildings on each farm, revealed that, by 1816, there were problems in ensuring that tenants maintained high standards even on the farms closest to Holkham that were showpieces during the Shearings. Waterden, for example, just to the south of Holkham, had recently been enhanced by a new house and premises that made it 'perhaps one of the finest (for a farm premises) in Great Britain' but the farm was badly managed, 'a most disgusting spectacle' in such a situation.[91]

Francis Blaikie, by Chester Harding, *c*.1823.

Blaikie immediately improved the general and domestic accounting system, introduced copy letter books and devised a 'general form of leases' that incorporated several variations on crop rotations, geared to the circumstances of each farm.[92] For the next seventeen years until his retirement in 1832, he identified completely with the Coke family and the interests of Holkham, often adopting towards recalcitrant tenants or importunate applicants a loftier tone than might have been expected from his employer.

Despite his high salary and status, his office, with that of his assistant and eventual successor, William Baker, remained in Strangers Wing. It was only in the second half of the nineteenth century that a new estate office was built, reflecting a return to a more detached though no less conscientious attitude towards estate business.[93] The home farm, too, was under efficient management. Wright's successor as farm bailiff, Miles Bulling, although 'an excellent Agriculturist' had been dismissed by Coke because of 'the sulkiness of his disposition', not a good attribute to display on a show farm. He was succeeded by his brother John, who managed the farm until Coke's death and trained pupils 'at a considerable salary'.[94]

The Shearings of 1821 proved to be the largest and the last. Despite the fame of Holkham agriculture, Coke's daughter told her future husband in the following year that farming was, beyond supplying 'just enough for one's own wants and to supply the ménage – further than that ... a most expensive amusement'. The Shearings had sometimes imposed on Coke, according to Blaikie, 'a fatigue almost beyond the power of man to bear'. More significantly, post-war agricultural depression was hitting even the well-run Holkham estate and at the beginning of 1821 many tenants were already in arrears with their rents. Management of the Shearings that year cannot have been helped by the departure of four senior male servants only a couple of months beforehand. Blaikie led the principal estate staff in taking reduced salaries and it may be that the exodus of domestic staff was caused by similar economy measures.[95] In February of the following year, Coke's unexpected second marriage raised the possibility that he could yet have an heir but, at the age of sixty-seven, could also die quite soon, leaving massive debts. The situation alarmed Blaikie intensely. Coke's expenditure had 'exceeded his income even when his rents were paid in full' and despite considerable rent reductions, 'a very alarming arrear of rent still remains ... the price of produce still continues to sink lower and lower, and ruin stares every farmer and landowner in the face ... The effect upon Mr Coke's finances has been distressing in the extreme'.[96] Despite attempts at retrenchment, by the autumn (when Coke's new wife was several months pregnant) Blaikie was 'quite appalled with the present and future prospect of Mr Coke's affairs'.[97] In the event, however, his fears were not realised. The sale of the Hillesdon estate in Buckinghamshire resolved the immediate crisis and agricultural rents recovered, to the extent that during the 1820s, and particularly in the following decade, it was possible to clear large amounts of debt from income.[98]

The Shearings were not resumed, however, and domestic life once again came to the fore. During Coke's long widowhood there had often

```
                    (1) 1775 ═══════ Thomas William Coke ═══════ (2) 1822
                    Jane Dutton    |      1754–1842         |   Lady Anne Keppel
                     d. 1800       | (Earl of Leicester 1837)|      d. 1844
          ┌─────────────┬──────────┘                        
        Jane          Ann         Elizabeth
       b. 1777      b. 1779        b. 1795
     = Viscount   = Viscount       = John
      Andover       Anson          Spencer
                                   Stanhope
                         ┌─────────────┬─────────┬──────────┬─────────┐
                    Thomas William   Edward    Henry     Wenman    Margaret
                      1822–1909      b. 1824   b. 1827   b. 1828   b. 1832
```

Family tree showing T. W. Coke's two marriages. His eldest and youngest children were born 55 years apart.

been children in the Hall because of his married daughters' long visits. The widowed Lady Andover had married Sir Henry Digby (but kept her former title) and the eldest of their three children, Jane, born in 1808, later to achieve notoriety for her marital affairs, remembered 'wonderful, rumbustious, old-fashioned Christmases at Holkham'.[99] Perhaps nursery staff enjoyed similar memories, for in January 1821, when both 'Lady Anson's nursery' and 'Lady Andover's nursery' were resident, the staff of the two nurseries managed to consume forty-five bottles of port and sherry, a good total when compared to the seventy bottles sent to the Steward's Room for senior servants.[100] After 1822, the occupants of the nursery rooms were once again Coke's own children. Children were normally a shadowy presence in the history of a great house but the birth of Coke's first son, also named Thomas William, in December 1822, ten months after his second wedding, was greeted in the House of Commons with 'a ringing cheer, even from the Ministerial benches'.[101] Three more 'equally robust' sons followed: Edward in 1824, Henry in 1827 and Wenman in 1828, and a daughter in 1832. The Duke of Sussex, godfather to the eldest son, fondly remembered 'the little fellow's buttoning and unbuttoning my coat' and Christopher Hughes, one of many American visitors to Holkham, had a soft spot for 'Tom, Ned and their ponies … Hal and that little pugilist Wenny'.[102] They were often joined by Coke's latest grandchildren. His third daughter, Elizabeth, had married John Spencer Stanhope a few months after her father's second marriage but they and their family left their Yorkshire home to spend every winter at

Holkham. With the nursery fully occupied, the Spencer Stanhope grandchildren took up quarters in one of the tower rooms. Their nurse vied for authority with Mme Baton, the governess: 'she had her rooms on one side of the passage, Baty had hers on the other; they were the rival powers and we the bone of contention'.[103] Occasionally their young uncles, the Coke boys, who acquired a tutor when the eldest was just five, erupted onto the scene: 'outside our room there was a very wide passage, which we made our playground, and there was one specially attractive place in it, a sort of black hole, which served as a prison for the boys. When they were naughty they were dragged up to the tower by their tutor, Mr Paine, and locked up in this dark closet until they repented'.[104] The closets or cupboards remain, unchanged, one next to each tower room.

This tutor was followed in 1832 by the Rev. Robert Collyer, who served also as chaplain and librarian and whom Henry, the studious third son, was to remember particularly fondly as an eccentric, with a penchant for imagining himself ever on the verge of marriage. Soon, however, the account books show the boys travelling to and from school in London each term, accompanied by their mother and a footman, or by Collyer, or occasionally by themselves on the mail coach. Increasingly the boys were seen at Holkham only during the holidays. In the summer a local man was paid for attending them while bathing but their principal pastime was shooting, each 'provided with his little single-barrelled flint and steel Joe Manton' (the flintlock gun perfected by Joe Manton in the 1800s).[105] The heir was given his first game book in September 1837, in which he proudly inscribed his age, fourteen years and eight months, and recorded good sport before he returned to Eton. At the age of nineteen he was 'all engrossed with sport … in fact does nothing else' and his father put him in charge of the game department.[106]

The childhood visits of the Spencer Stanhope grandchildren ended when they were old enough for a school room to be established at their Yorkshire home. Their parents continued to spend the six winter months at Holkham but the children returned for a long visit only when the eldest, Anna Maria Wilhelmina, was seventeen, the year before her grandfather died. This time, her younger siblings and the servants were settled at the inn, later known as Model Farm, at the western edge of the park. Anna was allowed to sleep at the Hall but spent the day with the children at the inn, for her mother's time was still 'very much taken up in looking after the guests, and she very wisely considered me far too young to be turned independently into a house of that sort'.[107]

Throughout this period, it was part of the ethos of Holkham that it was owned by the great commoner, Coke of Norfolk, 'King Tom'. The peerage,

Royal charter granting the title of the Earl of Leicester of Holkham, 1837.

which could pass only by direct succession through the male line, had died with his great-uncle in 1759. He himself had refused a peerage, according to his own account, on at least two occasions and in 1831, when he would have accepted for the sake of his heir, another offer was withdrawn because he had insulted the late king George III in a speech.[108] In 1837, however, with the death of William IV and the end of the Hanoverian line, the accession of the young Queen Victoria heralded a new age. Coke was immediately offered a peerage, the re-creation of his great-uncle's title of Earl of Leicester, and accepted 'for the sake of Tom – his eldest son – for his own part he had always a contempt for the hospital of Incurables, as he calls the House of Lords'. During the last years of the Earl's life, hospitality at Holkham continued unabated, still characterised by talk of politics and farming. The young

chaplain, Alexander Napier, newly arrived at Holkham in 1841 when Lord Leicester was eighty-seven, wrote to his family in October that the house 'begins to fill with company, and will go on increasingly throughout the winter ... and all to please the old earl, who keenly enjoys society'.[109] The family still resided for nearly all the year at Holkham but the death of Coke's brother, Edward, in 1837 had brought Longford, the Derbyshire house that traditionally passed down through the junior branch of the family, temporarily into Coke's custody, so that the next few years were the only period when the Holkham family had an alternative country seat. Retired from active politics and with no daughters of marriageable age to consider, Coke now chose to miss the London season in order to spend the spring months at Longford, his childhood home. It was here that he died at the end of June 1842, aged eighty-eight. His funeral procession took five days to reach Swaffham, in south Norfolk, where it was joined by the Holkham agent, tenants, upper servants, friends and neighbours, passing along roads lined with thousands of onlookers. The procession was said to stretch back for three and a half miles by the time it reached his burial place at Tittleshall, the small mid-Norfolk village close to Godwick Hall where the great Sir Edward Coke had lived and where most of the Holkham family had since been buried.[110] Two remarkable generations over the past hundred years had made Holkham renowned for its house, artistic treasures and park, its agriculture, politics and hospitality, but it was attachment to the ancestral roots of the family in the sixteenth century that still prevailed in death.

Chapter 11
Expansion and Change in the Park

When the young T. W. Coke took possession of Holkham in 1776, the Hall lay near the western edge of the park and, by contemporary ideas, most undesirably close to the last remaining village houses, farm buildings, public roads and its own kitchen gardens. Prominent parts of the designed landscape were fifty years old, a long lifetime in terms of both fashion and growth. The straight lake, still betraying its origins as a stream that had been dammed, the rectangular basin to the south of the house, despite flowing into a serpentine river, and other regular features had been rendered unfashionable by the subsequent rise of an apparently natural style of landscaping popularised by 'Capability' Brown. The setting of the Hall in its landscape was a priority in T. W. Coke's immediate reorganisation of the farms and enlargement of the park, as it had been for Thomas Coke, and the process was similar: take back land at a suitable opportunity, reorganise the farm and re-let the land that was not to be retained. The results in this generation, however, wrought even greater changes on the local topography and community: the final disappearance of Holkham town, the end of tenanted farms in the parish and the growth of the park to encompass almost the whole of the parish.

In order to acquaint himself with his Norfolk estates immediately after his succession, T. W. Coke commissioned a series of surveys and maps. For Holkham itself, the surveyor H. A. Biedermann also compiled a file, only recently rediscovered, containing smaller maps of the parish and the staithe village and a schedule provided with two columns for both 1778 and 1782.[1] It clearly shows that, within two years of inheriting Holkham, T. W. Coke launched a four-year plan to reorganise the farms and reshape the park. He later encouraged a story that he was prompted to take up farming in the first place because two of his Holkham tenants, Brett and Tann, short-sightedly refused to renew their leases.[2] This legend, helping to support his character as a practical farmer and to justify his absorption of four sizeable tenanted farms into the park, was repeated well into the twentieth century, until

The park from the north-west.

In 1778 the park boundary was defined by the tenanted farms that surrounded it, running close to the Hall on the west and Obelisk Wood on the south.

examined and refuted in R. A. C. Parker's study of Coke in 1975. The rediscovery of Coke's own schedule and map makes it possible, by identifying the land in question, to detect motives that had as much to do with landscaping as farming, and to trace the strategy that brought these and other tenanted farms to an end. Thomas Brett, one of the protagonists in the story, had for twelve years been the tenant of the village inn and its few adjacent acres.

1778	Longlands Cremer
	Branthill Meck
	Home Winn
	Hunclecrondale Tann
	Staithe Richardson
	Inn Brett

The six tenanted farms, arranged by the 1st Earl forty years earlier.

1782	Longlands Sherwood
	Branthill Waller
	Home Brett
	Hunclecrondale Sharpe
	Staithe Richardson

The Inn, part of Home farm and part of Hunclecrondale taken into the park.

| 1786–91 | Branthill Waller |
| | Staithe Sharpe |

Home farm, Hunclecrondale and Longlands taken in hand.

| 1809 | Branthill Waller |

Staithe farm incorporated into the park.

Expansion of the park, 1778–1809. The tenancy changes made by T. W. Coke transformed the position of the Hall within the park.

Chapter 11 Expansion and Change in the Park 287

During 1779, his neighbour, Henry Winn, tenant of the home farm (where he had succeeded Henry Knatts) accepted a larger estate farm some miles away at Tittleshall, enabling Coke to take back a discrete area of his land, west of the lake, which was crucial to his plans for improving the setting of the Hall. The remainder of Winn's vacated land, further south, west of Obelisk Wood and the Avenue, was taken on by the innkeeper Brett; he held it from year to year without a lease, suggestive of either a trial period or a stopgap. After four years of running this much larger farm, he refused a new lease at five shillings an acre for the small amount of land traditionally held with the inn; a new tenant took over the inn (with just a grazing marsh) and the land that a few years earlier had been Winn's and then Brett's was added to Coke's Hall farm.[3] Coke thus succeeded in absorbing the last two farms based in the village (the home farm and the small inn farm) and extending his land in-hand as far as a long stretch of the western parish boundary.

Further north, the land west of Howe Hill and the church belonged to Hunclecrondale Farm, whose tenant since 1758 had been Thomas Tann, the other protagonist in Coke's story.[4] When Tann's lease expired in 1779, Coke took back the farm, bisected it by a new road much further away from the lake and the Hall, and in 1781 re-let only the land beyond that road to a new tenant, Jeremiah Sharpe. Only six years later, Sharpe accepted £200 as an inducement to move to Staithe Farm and Coke took the last of the Hunclecrondale land into the Hall farm.[5] This meant that the western park boundary now followed the parish line all the way from the marshes down to the northern edge of Longlands Farm, with the result that the Hall lay centrally within land that was either parkland or was farmed in-hand. The geographical relationship of the Hall to the park was transformed.

These major changes opened up a succession of opportunities for Coke to improve the surroundings of the Hall. Public traffic was pushed much further away from the Hall by the closure of the road from the village to the church and its replacement by the new road further to the west. The walled kitchen gardens could be relocated to a new and larger site on the newly repossessed land near Howe Hill: a visitor found in 1780 that Coke was 'laying out a new kitchen garden, computed at £10,000, at a distance from the house' for which he was said to be 'universally condemned'.[6] The new gardens covered about fifteen acres including seven acres within the walls and an orchard of three acres. Building the walls, fourteen feet high, was under way by 1782 and the 'sunk fence' or ha-ha against the parkland was built in 1783–4. They were completed by the vinery, just outside the walled area, whose exact date of construction cannot be ascertained because of gaps in the accounts. The design of the vinery and gardens is attributed to Samuel Wyatt, making them

The vinery.

The walled gardens.

Chapter 11 Expansion and Change in the Park 289

Planted 1794 –

	A. R. P.
Plantation by new Road to Wells from Cecah, Wells Common to the Triangle Wood	44 . 0 . 3½
Addition to Plant:n by New Barn	6 . 3 . 15
Addition to Plant:n Stoney Brake Longlands	11 . 2 . 39
Plant:n North side Longlands House	12 . 2 . 12
	75 . 1 . 10

Trees Planted –

Oak	44000
Ash	19700
Sycamore	22300
English Elm	18400
Beech	16600
Cherry	13000
Spanish Chesnutt	7400
Horse D:o	1300
Lombardy Poplar	6350
Blk: Italian D:o	6600
Willow	2850
Weeping D:o	3100
American Acacia	1100
White Thorn	1000
Birch	6000
Weeping D:o	1000
Mountain Ash	1500
Hornbeam	700
Larch	2000
Scotch Fir	16000
Spruce D:o	2000
Hazel	700
Alder	700
Sea Buck Thorn, Privet, Laburnum, Sweet Brier Elder &c	2400
Total	198700

A page from John Sandys' tree planting record, 1794.

The Farmhouse, formerly the New Inn, later known as Model Farm, 1905.

the earliest of the many buildings at Holkham thought to be his work during the next two decades, but the surviving records give few details.[7] Soon afterwards, the absorption of the remaining Hunclecrondale land meant that its farmhouse and yard on the Burnham to Wells-next-the-Sea road, at what was now the western edge of the park, became available as the ideal site for a new inn. Building started immediately to designs by Samuel Wyatt and a year later, in 1787, the tenant of the *Ostrich* in the old village moved to the *New Inn* (which later formed part of Model Farm), completing a further step in Coke's campaign to clear the surroundings of the Hall.[8]

In the meantime, attention turned also to the lake, whose northern stretch had a particularly old-fashioned straight-sided and straight-ended appearance. In 1782 Coke pushed the coast road out onto the marshes so that the lake could be extended in a curve eastwards along the line of a creek. The work was put in the hands of William Emes, a prominent landscape designer based in the Midlands, with a particular reputation for his work with water.[9] He had previously drawn a plan for Wenman Coke 'for an intended piece of water in the car' at Longford so he was an obvious choice for T. W. Coke. The main project lasted from 1784 to 1786 but work continued under Emes's foreman for another two years.[10] The 1780s also saw the start of a massive and sustained tree-planting campaign in the park. Between 1781 and 1804, Coke's head gardener, John Sandys, designed and planted approximately 700 acres of woodland, containing over two million trees. In the 1820s, the agent estimated there were about 1,500 acres of woodland, planted thickly at 4,000 trees to the acre. A survey at the end of Coke's lifetime gave the slightly smaller total of 1,213 acres – still three times the acreage of woodland that he had inherited. Maps reveal the striking development of the perimeter belt and large plantations.[11] Obelisk Wood, on the other hand, was a relic

The occupants of the Temple in 1922.

of earlier taste. A visitor in 1780 commented that it was 'chiefly evergreen cut in Dutch formal vistas, and looks very artificial, which is unpleasing in everything'. Nevertheless, some of the lines of view were still shown on a map of 1843.[12] The Temple, hidden in the same wood, went out of fashion as a leisure destination and henceforth, until well into the twentieth century, was used to house estate workers.

These large-scale changes in the 1780s to the park, its boundaries, public roads, kitchen gardens, lake and woods were both dramatic and enduring. They were not, however, the sole focus of attention at the time, although it has largely escaped historians' notice that the more intimate element of pleasure gardens was at least as important at this period as it had been earlier in the century. The original orangery and wilderness to the east of the house are perhaps relatively easy to imagine today because the later pleasure garden, now known as the arboretum, survives in roughly the same area, just a little further north, but T. W. Coke inaugurated equally notable pleasure grounds to the south-west of the house that have left no trace. Here the antiquary, Craven Ord (1756–1832), visiting Holkham in about 1780, found 'a most charming plan is now executing, which is to have a flower garden from the house to where the new kitchen garden is now forming'. He had some doubts about the location of a conservatory, which he thought 'at first sight … could be better placed opposite the centre of the garden, but the reason of its present situation is its more convenient vicinity to the capital mansion'. He still thought it too remote, 'as well as several other similar buildings that

'Arch gate to the garden', location unknown, from Brettingham, *Plans and Particulars*, 1773.

is placed so far from the house … the comfort of it would be to drop into it immediately from one's house from a fireside perhaps at Christmas into a region of spring … The way to it from the house is near half a mile and is to be planted with trees and shrubs'.[13] Charles Shard, however, visiting at about the same time, had no such reservations about the glasshouse. He called it a grape house, measuring one hundred feet long, eighteen feet high and twenty-four feet wide (the same length but six feet wider than Wyatt's vinery that still stands near the kitchen gardens) and saw it full of fruit trees, unusual flowers and the finest grapes, 'the most elegant thing I ever saw in my life … a peaceful little Paradise' where 'large parties in the cool of the evening, when the glasses are all open, drink tea'.[14] A guide book in 1826 enthused far more about these gardens than those to the east of the house: 'To the west of the Mansion, a plain gravel walk conducts us to the pleasure grounds leading to the Flower Garden … This wilderness of sweets occupies nearly five acres … Here a thousand beauties originating from design, appear fortuitous to the eye.' From the conservatory, 'a beautiful building and well supplied with exotic and other choice plants' on the north side of the gardens, a path continued westwards through trees for a short way and then 'through a fine open walk to the Vinery' opposite the main gate into the kitchen gardens.[15] This description of its location confirms that this conservatory, almost certainly the grape house that had captivated Shard, was not the vinery that survives

'Walk to garden' through an arch, by Elizabeth Blackwell, 1818. The arch no longer stands and its location in the park is unknown.

Detail from a map of 1843, showing the site of the lost pleasure gardens west of the Hall. The schedule names 341 as the Old Garden Plantation, 308 as a shrubbery and 310, east of the Hall, as the newer Pleasure Gardens, later known as the Arboretum.

today next to the walled gardens. By the time of a revised edition of the guide in 1835, however, this pleasure ground warranted barely a mention. Account books are lacking for the period when it was constructed and it has left no obvious trace on the ground. Only the visitors' descriptions, the 1826 guidebook and a later map recording 'Old Garden Plantation' testify to the meandering walks and evening tea parties that were enjoyed there for forty or fifty years, and remind historians of the transient nature of gardens, however carefully planned and beautifully executed.[16]

Less than a decade after the creation of the western flower garden in 1780, a third pleasure ground was added, this time on the banks of the lake. It was based on a scheme by Humphrey Repton, who was just launching a new career as a landscape designer. In 1789 the first of his famous Red Books, dedicated to Mrs Coke as befitted a design for pleasure gardens,

Humphrey Repton, designs for pleasure gardens by the lake.

Chapter 11 Expansion and Change in the Park 295

Humphrey Repton, design for a chain ferry on the lake.

envisaged walks through the existing evergreen oaks to the North Lodge and along the water's edge, leading to 'an elegant pavilion' and boat house, an arched tunnel concealed by creepers and trees, and a ferry across the lake, its mechanism capable of being worked by a lady. Hidden in the 'rural but not neglected' setting of the western shore, he wanted a 'snug thatched cottage' to give 'an affectation rather than the reality of penury'. His ideas were adopted at least in part: a ferry boat, boat house, gravelled walks on the west bank and a 'subterranean passage to the garden' all featured in the accounts during the coming years.[17]

The next phase of reorganisation in the park during the 1790s was clearly driven by farming but it was still closely connected with Coke's determination to modernise the vicinity of the Hall. In 1791 the tenant of Longlands, the farm created near the southern edge of the parish nearly sixty years earlier by Thomas Coke, was persuaded to move to a farm at Fulmodestone in return for rent rebates and the promise of a new house that together cost the estate £1,200.[18] The Longlands fields, about 300 acres, were incorporated into the Hall farm, thus pushing the park boundary out to the parish line on the south as well as the west. Coke's intentions, however, involved much more than the land. During the next eight years the Longlands farmyard was furnished with extensive new premises that were to become the focus of Coke's famous annual agricultural gatherings, the Sheep Shearings.

The Great Barn, built *c.*1790. The separate cattle sheds have been demolished since this photograph taken in 1965.

In the fields to the east, Samuel Wyatt's masterpiece, the Longlands Field Barn, ready for roofing in 1792–94, became world famous as the Great Barn, another venue for the Shearings. Sixty years later, the Holkham agent still considered it 'probably the handsomest and best proportioned barn in England'.[19] As the Longlands buildings neared completion, in 1795–97 the accounts recorded old buildings and foundation walls being demolished 'at the farm yard'. This was the site of the old Neales manor house in the village, the last reminder of Sir Edward Coke's original purchase of 1609, which for the past fifty years had served as the headquarters of the Hall farm. Repton, the landscape designer, had been aware some years earlier that its demolition was intended, for he had recommended that a path from his proposed lakeside gardens back to the house should be 'deferr'd till the farmyard etc shall be displaced'. Henceforth the Hall farm, later known as Park Farm, would be run from Longlands, as far away from the Hall as was possible while still within the park.[20] The changes epitomised T. W. Coke's attitudes to farming and the landscape. It was acceptable and laudable, although slightly unusual, for the extended park boundaries to include large areas of arable, greatly impressing visitors who saw it 'cultivated in the most garden-like manner, scarce a weed to be seen'.[21] An idiosyncratic result of

Chapter 11 Expansion and Change in the Park 297

Coke's fascination with sheep breeding was that he provided at least one 'pleasure house' or 'summer house' in the same area as a sheep house.[22] On the other hand, all farm and estate premises, although open for inspection during the annual Shearings, were no longer considered desirable anywhere near the Hall.[23]

By 1800, with the kitchen gardens, the inn, the former tenanted home farm premises and the Hall farm premises all removed from the old village, the way was clear to transform the blunt south end of the lake by means of a sinuous westwards extension. The work took two years under the direction of John Webb, a former pupil of Emes, who brought six experienced men from Cheshire to assist him.[24] The author of a guidebook published in 1826 described the result as 'indisputably the most superb piece of artificial water in this kingdom'.[25] The basin to the south of the Hall, on the other hand, had long been considered unfashionably 'square and formal, not better than a fish pond'.[26] A house guest had skated on 'the pond at the back of the house' in 1786 but, together with the pavilions, the serpentine river and William Kent's stone bridge, it was probably removed in 1800 when the lake

The heads from the Seat on the Mount outside a house in Burnham Overy Town *c.*1971. Photographed with Jack Satchell, whose wife's grandfather, a local vet, had received them from the 3rd Earl in payment of a debt.

was extended.[27] According to anecdotal evidence, on open days T. W. Coke had often removed a wooden bridge over the serpentine river to prevent curious tourists gaining access to the lawn between the basin and the house; by 1817, however, it was cattle grazing in the park that had to be kept away from the south side of the Hall, a sure indication that the formal basin and lawn had given way to open parkland.[28] The Seat on the Mount facing eastwards along the basin survived much longer, until at least 1882. The carved stone heads that decorated it were said to have been given in the twentieth century (probably by the 3rd Earl) in payment of a debt to a local vet and for many years they have flanked the front door of a house in Burnham Overy.[29]

The pace of change lessened after 1800 but by no means ceased. Another major extension to the park was made in 1808–9 when the lease expired for Staithe Farm. The tenant (Jeremiah Sharpe's widow) and her daughters moved to a small estate farm elsewhere, most of the land was taken in hand, the remainder was let without premises and the old house, dairy and barn were converted into eleven dwellings.[30] Although the house still stands today, known as the Ancient House, the valuable estate at the staithe bought by John Coke from Newgate exactly 150 years earlier had finally run its course as a farm, succumbing to both the expansion of the Hall farm and the need for accommodation for Coke's farm labourers. Now the only farm of any great size that had not been swallowed by the Hall farm or the park was Branthill, to the south-east, most of its land lying outside the parish; this remained as a tenanted farm, although losing some land to improve the new southern boundary of the extended park. A different type of opportunity to enlarge the park arose about four years later with the Wells Enclosure Award of 1813, sponsored by Coke. His 'right of soil' as lord of the manor of Wells-late-the-Dukes and his right of sheep walk or foldcourse as lord of Neales manor together entitled him to about 122 acres of the common land on Wells heath. He laid some to Branthill Farm but took most into the park, forming a distinctive triangular projection to the south-east; by 1831 his former head gardener, John Sandys, was setting out a plantation there. For twenty years or more, Coke took every opportunity to buy up other allotments (the allocations made by the Enclosure Award to individual owners) on the heath, particularly along the road leading from the park to Gallow Hill, where he built an isolated lodge, later known as Cuckoo Lodge, but this land in Wells-next-the-Sea parish remained outside the park.[31]

Thus in the course of thirty years, from 1778 to 1808, T. W. Coke transformed and monopolised landholding in the parish. A survey at the end of his life showed that, out of a parish total of 5,159 acres, the Hall or Park Farm occupied 1,202 acres of arable land, 1,343 acres of pasture and 1,213

acres of woodland: nearly three times the acreage under his predecessor. Four sizeable tenanted farms had been completely absorbed. Tenants now occupied only 437 acres of arable (primarily outside the park at Branthill) and just under 1,000 acres of pasture, including marsh grazing. Only about five acres, including the churchyard, were owned by others.[32]

The last changes within the park by T. W. Coke returned the focus to pleasure gardens. His first wife Jane, for whom Repton had designed the lakeside gardens, had died in 1800 and it was probably the advent of his second wife in 1822, coincidental with the departure of his youngest daughter, Elizabeth, to her new married home (taking with her some favourite dahlias) that caused the gardens to the west of the house to fall out of favour. Assisted by a 'florist' from London, the new lady of the house revived the original pleasure ground to the east of the Hall and put her own stamp on it, with a new thatched summer house and a greenhouse, home to caged birds, 'a Temple dedicated to Flora … replenished with plants of the greatest delicacy and the richest odour'.[33] Scope for improvement was perhaps too limited, however, so that in the early 1830s, John Sandys, who had been in business as a nurseryman in Wells-next-the-Sea since leaving his post as head gardener, was consulted about 'setting out new pleasure garden', the fourth to be either created or re-modelled in T. W. Coke's time.[34] This was the origin of the present arboretum, east of the Hall but north of the earliest

The grotto in the fernery, c.1920. The young girl was Lady Silvia, born 1909, daughter of the 4th Earl.

wilderness or pleasure ground. It was not completed when Sandys died in 1833, after which Coke's friend, the sculptor Francis Chantrey, took a hand in designing the flower garden within it. Lady Anne's florist, Jonathan Buck, had switched to a career as the village schoolmaster so another nurseryman was called in 'for looking over Holkham gardens and for plants thereto'. His assistant, Hugh Girvan, a Scotsman, was soon established as head gardener and remained until retirement on a pension in 1871.[35] A new glass house with verandas and hot water heating, built in 1832, was described in the 1835 edition of a *New Description of Holkham*: 'through the pleasure grounds at the east of the mansion we arrive at length at the spacious Conservatory, of recent structure ... fronted by the Flower Garden of Lady Anne Coke'.[36] This conservatory has disappeared but soon afterwards Girvan built the shell house in the fernery that still stands today.[37] In the 1850s the 2nd Earl called in the landscape gardener William Nesfield to advise on rearranging the walks, the planting of 'masses of evergreens' and the design of the kerbed beds and central basin of an 'American Garden'.[38]

*

Lodges epitomised not only T. W. Coke's enlargement of the park but also its complete segregation from village and tenants. Just as William Kent's name is associated with many of the structures built by Thomas Coke, the next generation of buildings is linked with the architect Samuel Wyatt (1737–1807). He was introduced to Holkham after doing some work for Wenman Coke in London in 1775 and was active on the Norfolk estate (not merely at Holkham itself) by 1782–83, the date of the earliest surviving account books for T. W. Coke's time. Some years later he was paid £73 10s for his 'drawings and journeys' during the two years 1792–94 and in the intervening years cash had often been advanced to slaters 'on Mr Wyatt's account'.[39] No correspondence, plans or detailed accounts survive, however, and except when contemporary guidebooks identify his work, attributions are dependent on recognising his style in surviving buildings, a task made more difficult by the fact that the octagonal design that characterises several of the lodges had already been used much earlier in the century by the builder of the Hall for various small buildings.[40] The first of his lodges was 'a simple but elegant building', later known as Palmer's Lodge after a mid-nineteenth century occupier, built in 1783–87 on the south-east boundary of the park. It was a double lodge consisting of a living room with basement kitchen and washhouse on the east side and one room only on the other side of the drive, the two parts linked by an arch and colonnades. The central arch was plastered some years later in 1799, using 'Parker's Cement' (also known as Roman Cement, a quick-hardening and waterproof plaster patented by Parker only

Palmer's Lodge.

Church Lodge.

three years earlier) and embellished with a decorative Coade stone plaque by 'Mr Barnasconi' (Frances Bernisconi, a specialist plasterer).[41] Church Lodge, on the north-west boundary, was also built in 1785–86 around the time that the church was repaired.

Four more lodges were built in 1803–5, coinciding with a period of building activity in the village itself. They were Guest's Lodge at Highfield Clump, named after its first occupant, a gamekeeper, but subsequently called Scarborough Lodge, which did not control any route into the park; the octagonal West Lodge at the Burnham road entrance on the new western boundary; 'Wells Lodge' which was probably the lodge now known as Greenway Lodge where the road from Wells-next-the-Sea (as it then was, now only a track) entered the park on the east; and Branthill Lodge.[42] The last of T. W. Coke's lodges, the 'lodge on Wells heath', Cuckoo Lodge, was built in 1828. Thus by the date of a revised guide book in 1835 there were nine lodges.[43] The northern entrance, however, was still given little emphasis. The growth of the perimeter woods had increasingly segregated the staithe village from the park, although extensive remodelling of the village had included a new entrance into the park between the old almshouses and the Octagon Cottage built near them in 1801, and the northern curl added to the lake had destroyed any access from the coast road to the North Lodge, now hidden in the woods and no longer serving any purpose other than accommodation.[44] More surprising was the apparent neglect of the important south entrance. In 1780–81 T. W. Coke closed the public road skirting the south side of Obelisk Hill and replaced it with a road along the new boundary of his extended park, further south, but there are no account books from

West Lodge sketched by Elizabeth Blackwell *c*.1818.

Cuckoo Lodge and the Haylett family c.1890.

those years and no evidence on maps that he marked the new entrance with a lodge.

Finally, the privacy, privilege and power represented by the park were defined on the ground by encircling it with a brick and flint wall. Taking six years to build, it was begun on 4 May 1833 and finished on 23 September 1839, just three years before the death of its owner. At nine miles long, give or take twenty yards, it is still the longest park wall in East Anglia.[45]

*

T. W. Coke's son, the 2nd Earl of Leicester, succeeded to Holkham in 1842 and in his turn immediately initiated changes in the park. The influence of the younger generation had already made itself felt with the creation of a cricket ground on the north lawn in the preceding year.[46] The fate of the North Lodge beyond it was soon sealed by plans for the erection on the same site of a monument in memory of T. W. Coke. This was a unique feature in the park, not only because all other decorative structures were part of the eighteenth-century scheme but also because it was initiated, organised and financed through a public committee. The first stone was laid amidst elaborate public celebrations in 1845 but it was five years before the completed monument was quietly handed over to the 2nd Earl.[47] It was doubtless the prospect of visitors flocking to see the Monument that prompted the creation of a new northern park entrance at the village. The Earl's half-sister

304 HOLKHAM

The park in 1843 at end of T. W. Coke's time.

described the existing entrance (of which no details are known) next to the Octagon Cottage as 'hideous' and in 1846–47 it was replaced by the dignified screen and gates in use today, constructed between the much older almshouses. The entrance was designed by the eminent architect, S. S. Teulon, after suffering rejection of his first ornate proposals for a massive gatehouse.[48] The new entrance proved even more justified twenty years later when the building of the West Norfolk Junction Railway across the marshes, with a station part way down the drive to the sea, ensured that the principal approach to Holkham would henceforth be from the north.

The North Gates: an elaborate rejected proposal by S. S. Teulon.

The new park wall highlighted the fact that neither the Triumphal Arch nor the site of the old south lodge marked the southern entrance into the park, a situation rectified with the building of the present South Lodge, also in 1846–47. This was a late example of a double lodge, designed by Teulon. Like the northern almshouses entrance, it was considerably less elaborate than Teulon's first proposals shown in two attractive surviving drawings.[49] The south-east entrance into the park remained unmarked because Palmer's Lodge, on the boundary when built in the 1780s, had been left isolated when the park expanded onto Wells heath. In 1851 the situation was rectified by the construction of the present Golden Gates Lodge, designed by William Burn, a Scottish country house architect who had established a London practice in 1844 and, having replaced Teulon as the favoured designer for Holkham, was just then embarking on major works near the Hall. Greatly improving on the earlier small double lodges, he was instructed to provide 'one sitting room, small scullery and pantry and two fair sized sleeping rooms for a man with a wife and family, all to be upon the ground floor'.[50] The gates, facing south along the Fakenham to Wells-next-the-Sea turnpike road, were gilded a couple of years later, giving it its modern name.[51] A similar design was adapted for the 'Wells Entrance Lodge', built in 1862 on the line of a new road laid down within the park to lead to Wells-next-the-Sea. This

The North Gates.

RIGHT: The Monument erected in memory of T. W. Coke, 1845–50. Watercolour by the architect, William Donthorn.

Detail of the top of the Monument.

Chapter 11 Expansion and Change in the Park

South Lodge: a rejected proposal by S. S. Teulon, 1845.

South Lodge.

was probably in response to a shift in road use in Wells-next-the-Sea, for the old Greenway Lane further south (on which a lodge had been built sixty years earlier) was eventually left as little more than a field track.[52] Most of the lodges and the Triumphal Arch were occupied by gamekeepers, retired

Plan for Golden Gates Lodge by W. Burn, 1851.

Golden Gates Lodge c.1890.

Chapter 11 Expansion and Change in the Park 309

The Hibbert family at Wells Lodge.

estate workers or senior married domestic staff such as the valet and butler. Double lodges usually housed two households. All of the lodges built from 1783 onwards, and the earlier Triumphal Arch, were still in use in 2000, the larger ones for estate staff, the older ones as holiday lets.

The changes on the periphery of the park, including the Monument and the new lodges, paled into insignificance against dramatic changes nearer the Hall in the 1840s and 1850s. Garden fashions had changed again. Formality was back in favour, as were gardens within view of the house, and the young 2nd Earl was quick to follow the trend.[53] Alterations to the lake again proved irresistible. An island was added and lakeside planting and walks (probably those designed by Repton fifty years earlier) were removed, to the dismay of the Earl's half-sister, although she conceded that opening up a sloping green bank down to the water and creating a new walk all round the lake would be 'certainly more magnificent in effect'.[54] The most dramatic changes, however, were close to the Hall. During six years work from 1849 to 1854, the parkland that for the past four decades had swept up to the south front was replaced by wide terraces and parterres, defined by stone balustrades, gravelled paths, a stone pavilion at the eastern end and a central massive stone basin and fountain. They were more elaborate than Thomas Coke's original scheme but a strangely appropriate echo of the formality of his gravelled walks, basin and pavilions. Teulon had submitted proposals in 1847 but was passed over in favour of the leading landscape designer, William Andrews Nesfield (1793–1881), working in conjunction with the

architect, William Burn.[55] The earthworks alone took over two years. Burn's specification for the terrace walls appears to have been drafted without a site visit, for the Estate Office assistant, Shellabear, had to correct him on the size of Holkham bricks, the local use of chalk lime rather than stone lime, and the bond: 'the house and every building about here is built Flemish bond … I imagine therefore you will reconsider this'.[56] The dressed stone work, balustrades and steps were built during 1852 by the Norwich masons, Watson's, who had built the Monument in the park and repaired stonework on the Hall in the 1840s.[57] When the Holkham agent lost patience with Watson's, now run by his widow whose foreman 'fancies no one else can do stone work', it was Bramall and Buxton, a Manchester firm already engaged on building the domestic offices, who in 1854 built the pavilion at the east end of the terraces.[58] Nesfield was still finalising plans for the parterres, for he had warned that, being now employed by the Queen, he would require several months' notice to prepare details.[59] The centrepiece, the massive fountain depicting St George and the Dragon, with flanking jets issuing from dolphins, shells and swans, was the work of Charles Raymond Smith (1799–1881), a well-established sculptor. He also provided sculptures for the terraces (principally vases or tazzas) at an additional cost of £541. The fountain was plumbed in during 1856, costing over £1,300 plus £930 for the pipework, and there was belated realisation that its consumption of water necessitated an entirely new water supply to the house and gardens.[60] The whole scheme had taken seven years to complete. 'It seems as if a fairy wand had waved over the well-remembered scene', commented the *Gardeners' Chronicle*, two years later. 'Persons who visited Holkham twenty years since, although they may have heard rumours of change, will yet be not a little surprised when they enter the park … There stands the hall – the same, yet changed … Terrace upon terrace rises, broad and noble as are the walks – sloping banks of velvety green intervene, while on the broader verdant surfaces small beds of flowers … give the surface a gay beauty'.[61] The new terraces were completed by a brick conservatory, standing today without its glass and its iron-framed roof. The roof was constructed by Thomas Turner, who can probably be identified (with his partner, Richard Turner) as having submitted unsuccessful designs for a massive conservatory to house the 1851 Great Exhibition.[62] In contrast to earlier glass houses at Holkham, it was built as close as possible to the Hall, for the latest fashion was for conservatories attached to the house. The head gardener, Girvan, was consulted about the internal layout; it seems to have been a place for strolling amongst displays of plants rather than for sitting or entertaining.[63] For a hundred years it gave a home to Jupiter, the massive statue that had never achieved the prominence

Working drawing for the west parterre, by W. A. Nesfield.

The parterres and conservatory in the late 19th century.

312　HOLKHAM

The fountain playing *c*.1930.

Modern photo of fountain.

in the Hall fleetingly intended for it by Thomas Coke. This conservatory and Wyatt's vinery near the kitchen gardens are the only survivors of many generations of ornamental glass houses at Holkham.

Functional hot houses, on the other hand, continued to be added, or improved by the extension of heating systems, within the walled gardens. The most spectacular additions were two massive heated glasshouses, each subdivided into three sections, comprising early and late peach houses, muscat house, fig house and early and late vineries. With two ranges of pits or sunken greenhouses, these were all built in 1872 by Messrs Ormson of

Chapter 11 Expansion and Change in the Park **313**

Chelsea, specialist horticultural builders, for a total cost of £1,395. The fig house, peach house and late vinery were restored in 2001–3 at a cost (partly grant aided) of £200,000. A mushroom house, now unused but still in situ in the side of Howe Hill behind the gardens, was built in 1842.[64] These gardens continued to provide fruit, vegetables and flowers to the Hall on a traditional scale until 1949.

The interior of the conservatory c.1911, with the statue of Jupiter glimpsed at the far end.

The clumps and belts of woodland planted in T. W. Coke's time afforded ideal woodland-edge habitat for pheasants, contributing greatly to the pre-eminence of the Holkham shoot and, in particular, the driven or covert shooting that was brought to perfection by his son, the 2nd Earl. Forestry itself long remained a passion in the family. The 2nd Earl personally directed its management well into old age. One of his sons by his second marriage, Richard Coke (1876–1964), who inherited the Weasenham (Norfolk) estate, told the 4th Earl in 1945, 'Forestry, when you understand it, is the outdoor equivalent of what music and painting are indoors: soul satisfying'.[65] The sinuous perimeter belts and scattered clumps were also ideal for walks or carriage drives, wending in and out of the trees. During both winter and summer house parties in 1899–1900, the invariable programme for the ladies was to drive out every morning and afternoon, when 'very delightful it is driving round the woods with either Peter the old white pony or Ruby the chestnut' drawing the tub or pony carriage.[66]

Any park or garden presents a changing scene as the natural cycles of growth and decay interact with design and maintenance, but the park was also an inhabited landscape. Sheep continued to play a role in maintaining light arable land in a good state for cultivation and they grazed the parkland, although the north and south lawns were also used for hay. The agent Blaikie still cited the sheepfold, so typical of medieval agriculture at Holkham, to defend large farms against criticism in 1831: 'Half the nation would starve to death but for the Sheep Fold.'[67] In 1873, at the height of prosperous farming, there were about 2,300 ewes, lambs and rams within the park.[68] It was only in the late-twentieth century that sheep largely disappeared from the park and shepherds from the payroll. During the nineteenth century, cattle were equally evident in the park. Humphrey Repton hoped that the trees on his proposed lake walk 'now being fenced from cattle will assume a luxuriance of foliage happily contrasted with the naked stems of those trees which are seen on the lawn'. In the early-twentieth century, the park cattle that scared local children were shaggy Highland bullocks.[69] Partridges and, after the tree planting campaigns of the early nineteenth century, pheasants, were the most important birds, yielding famously enormous bags for the guns. For many years wild turkeys were also well-known residents. They were flourishing by 1817, when the gamekeeper saved twenty eggs for Coke's friend the Duke of Bedford, and a century later flocks inhabited various parts of the park, sometimes amounting to 200 birds. They were wiped out in the severe winter of 1939–40, re-introduced after 1945 but by 1962 were failing again and subsequently disappeared. According to the 5th Earl, 'they fly quite well when

The conservatory before the roof and glass were removed in the 1950s.

flushed' but were shot at the end of the season only to reduce the number of stag turkeys.[70]

Whereas many eighteenth-century landscaped parks developed from medieval deer parks, the park at Holkham was created long before it was stocked with deer. There are one or two tantalising references in the early-nineteenth century that hint at the presence of deer, possibly wild animals that arrived by chance. In 1822, for example, a Burnham man was considered to have trespassed when, in hot pursuit of a deer, he chased it into Holkham, which the agent described as 'a chartered deer park'.[71] In 1836 'six new buck hovels' and an old one rebuilt in the plantations suggest the presence of deer requiring winter shelter.[72] The majority of the deer, however, arrived in 1845, when the fallow deer from the old Coke family deer park at North Elmham were transported to Holkham and eleven red deer, from Woodchester Park in Gloucestershire, were obtained through a menagerie in London.[73] During the 1939–45 war, the 4th Earl of Leicester was on the point of culling the whole herd in order to meet demands to plough up the deer park for additional arable land but, in the event, the herd was greatly reduced and confined to a smaller area.[74] At the beginning of the twenty-first century, the deer park, fenced and gated, covered 400 acres of grassland within the walled park, supporting about 880 fallow deer,

managed carefully in order to preserve the vigour of the herd and to provide up to 600 venison carcases a year. Red deer were re-introduced from Woburn and established well.[75]

An elusive feature, slipping in and out of the eighteenth-century estate accounts, was Coney Hall and its associated rabbit warren. A map of the old foldcourses or sheepwalks gives Coney Hall as an alternative name for the Hill Hall foldcourse, south-east of Holkham town.[76] An occasional payment was recorded for 'the rabbits in Coney Hall cover' and there was also a dwelling, possibly a typical warren lodge, although not included in the estate rentals or marked on maps. A gardener was killed when he fell into the well at Coney Hall in 1737 and as late as 1755 one of the recipients of Lady Leicester's charity was a man at Coney Hall. It may have been a traditional name for Branthill. This warren was superseded by another in the sand dunes but its name lingered on: Coney Hall plantation and breck, east of the Great Barn, were still named on a map in the middle of the next century.[77] Rabbits flourished regardless and made the relationship of farming, park and shooting a permanent balancing act for future generations, requiring constant vigilance. This was the only grain of truth behind the comment by 'the witty dowager Lady Townshend' when she famously told T. W. Coke's wife that all she would see at Holkham would be 'one blade of grass and two rabbits fighting for it'.[78]

Tennis on the north lawn, *c.*1920.

Chapter 11 Expansion and Change in the Park 317

Chapter 12

The Victorian Hall 1842–1909

The death of the head of the family invariably heralded changes at Holkham, and never more so than in 1842. The heir, another Thomas William, unable to find a companion to complete a tour of Spain and Portugal, had fortuitously returned in time to be at his father's deathbed at Longford; he was six months short of his twentieth birthday. Of the younger sons, Edward, aged eighteen, was studying French in Switzerland before entering the army; Henry, sixteen, was being invalided home from the China seas, in two minds about pursuing his naval career; and Wenman, fourteen, was a pupil at Rugby. The dowager Countess, still only thirty-eight, was given Longford for life under her husband's will and, as was to be expected, disappeared from the Holkham scene; a year later she married their old family friend 'Bear' Ellice but died in childbirth in 1844. At Holkham, the estate office in Strangers Wing continued to function as the centre of the estate but the Hall for the time being had no role: within a month of the old Earl's funeral, it was closed up. The agent, expecting it to remain closed for at least two seasons, asked suppliers to take back unused goods, sent the silver to the bank and discharged the servants.[1]

Events then took an unexpected turn. An astute mother, Mrs. Julia Whitbread, wife of Samuel Charles Whitbread (brother of the famous brewer) of Cardington, Bedfordshire, had not forgotten that the heir to Holkham had 'shown some admiration' for her eldest daughter, Juliana, during her family's visits to Holkham. Juliana had now left the schoolroom and had 'the youth of England at her feet'. Her mother promptly invited the young Earl to Cardington, 'and thus she secured him'.[2] In April 1843, less than ten months after the Earl's succession, the couple married quietly at Cardington and took up residence at Holkham. Their arrival was celebrated by an entertainment laid on in nearby Wells-next-the-Sea for 800 schoolchildren, dinner

The 2nd Earl (1822–1909) by George Richmond, *c*.1850.

for 1,400 poor inhabitants, and a cannon salute, recorded in the accounts because it incurred doctors' fees for people injured when it was fired accidentally.[3] The Earl led Holkham for the next sixty-seven years, during which he transformed the immediate environs of the Hall, modernised many practical aspects of the house, established the celebrity of the shoot, completed the reclamation of the marshes and oversaw periods of both maximum prosperity and a potentially disastrous agricultural slump.

*

That first summer, the Earl, aged twenty, and his bride, aged seventeen, were 'supremely happy at Holkham, enjoying themselves like boy and girl, as indeed they were, either riding together about the park or he teaching her to drive her ponies in a pretty little pony carriage which he had bought her before they were married'.[4] Setting the pattern for many years to come, the summer was punctuated by cricket matches on the north lawn, after which around forty people 'dined and supped'. In the autumn, the chaplain, Napier, thought that 'my lord seems bent low on leading a quiet life' but at Christmas an immense house party gathered to celebrate the Earl's coming-of-age.[5] 'Not a creature entered the house, I believe,' reported the young Countess's great-aunt, 'who reached my age by twenty years, and almost all were in the first flush of youth & joyousness … We never sat down less than 25, and several times we were 35; swarms of young men, shooting all the morning, and often dancing to the piano forte in the evening'. Tenants and servants were invited to 'a *real* ball in the great gallery, in which all the company joined, Lord L leading, down the middle and up again, in a country dance a farmer's daughter, and Lady L a young farmer. Reels & jigs etc by the young sportsmen & the girls, till we all went to supper on one hand, & the others feasted & drank and danced & hurrahed till 6 in the morning. It was all well done.'[6]

The change of atmosphere in the house was noticeable. Arthur Young had long since turned against the Shearings and other such exclusively male gatherings of 'rich and profligate' Norfolk farmers.[7] Even in more recent years, however, something had still been lacking in the tone of the houschold, for the new Earl's much older half-sister, Lady Elizabeth Spencer-Stanhope, who was usually critical of any change from her father's time, noticed how 'the atmosphere of purity which always surrounds dear Julia [the young Countess] is most carefully kept up by Leicester, no objectionable word is ever heard in our presence, indeed there never was a house so radically reformed in all ways'. Lady Elizabeth's approval of the new regime was helped by the deference she was shown during her visits by 'poor dear Julia', who welcomed her assistance in taking 'entire charge of the whole party here – no easy task'.

The Countess, Juliana, and her first child, Julia, by Sir Francis Grant, *c.*1850.

It was four or five years later when she noticed that the young Countess 'takes more upon herself and actually orders dinner'.[8] There was a fresh start even on the domestic level. Most of the household servants had been discharged, their final wages augmented by a legacy of additional wages and an allowance for mourning clothes.[9] Consequently, when the new Earl and his Countess took up residence, even the most senior menservants came new to the house, an interesting indication of the extent to which experienced servants were capable of adapting their skills to a new situation. The only continuity was provided by William Baker, who had worked in the estate office for twenty-two years, for the past ten as agent, and by the skeleton staff of the housekeeper and her maids who had been kept on to look after the empty Hall.

The new Earl was not only young, he was also wealthy. When his grandfather (Wenman Coke, previously Roberts) and father had in turn succeeded to Holkham, their inheritance had included the financial burden arising from building the Hall. By 1842, however, the massive debts which twenty years earlier had threatened to engulf his father had been cleared. The only sizeable commitments were his father's legacies to his younger brothers and sister, amounting to £65,000, and the sum of £19,000 settled on his cousin William Coke, who before the new Earl's birth had been the heir presumptive. In the event, however, the Earl retained the capital until the 1860s, paying interest to his brothers, sister and cousin.[10] The arrangement had the reciprocal advantage of preventing youthful extravagance by his siblings. It even suited William, who wrote that the Earl was 'conferring a great kindness on me by retaining the principal in his hands', where it remained until William's death in 1867.[11]

The young Earl inherited the estate not only virtually free of debt but also free of legal restriction. As he was under twenty-one, the age at which he could enter into legal agreements, it had not been possible to re-settle the estate in the normal manner during his father's lifetime. When he married, still under the legal age to enter into a contract, a private Act of Parliament was required to secure his wife's jointure but it did not entail the estate (that is, impose a family settlement). Consequently, when he came of age, he was able to disentail all the settled estate. Although his London solicitor expected this to be merely the prelude to re-settling it, it remained out of settlement throughout the Earl's life, even when his eldest son came of age, and was re-settled only by his will, which came into effect on his death in 1909.[12] Uniquely in Holkham's history (except for the brief period when John Coke the younger had held free of settlement in 1661 to 1665) this gave him freedom to buy, sell or exchange land but it was a freedom that

he used with great circumspection. The estate that he inherited produced gross receipts of nearly £36,600 in the year ending Michaelmas 1842, rising to nearly £45,000 in 1851 and to a peak of £59,300 in 1878, but the steady increase resulted from high farming and buoyant prices rather than increase in land. Net profit was nearly £29,000 in 1842, rising to £38,700 in 1878.[13]

Not surprisingly, the Earl immediately inaugurated a long and expensive programme of improvements and alterations in the Hall. After the installation of central heating, described in chapter 13, frenetic activity within the house during 1844 and 1845 was concentrated on refurbishment and redecoration. Newspaper reports on the occasion of laying the foundation stone for the Leicester monument in the summer of 1845 digressed to mention that the whole of the Hall 'is now under contract for complete reparation in every part. The exterior stone work will be repaired ... The interior will be entirely renovated and gilded'.[14] The London decorating firm of Dowbiggin, handling a range of work that a hundred years earlier had required numerous separate retailers and craftsmen, overhauled many of the staterooms. Work on doors to put them in 'thorough good order' was complemented by new knobs, handles and escutcheons. New grates were ordered for the Library, Landscape Room, North Dining Room, Statue Gallery and Chapel. Lord Leicester was most particular about their design but his half-sister was unimpressed to see them proudly displayed when she visited Holkham for

The south front showing the large window panes of the 1840s and 1850s.

Christmas that year: 'fancy the 300 guinea grate in the gallery without an atom of fire and every door left studiously open to show the suite of rooms ... So much for vanity and vexation of spirit, and comfortless magnificence'.[15] Pictures were cleaned, furniture reupholstered and gilded, patterns for carpets pondered over for months. Stonemasons worked for over six weeks in the Chapel and Dowbiggin looked out for suitable stained glass for its windows, which Leicester particularly wanted but failed to achieve. Dowbiggin's total bill for 'decorations and improvements' from 1844 to 1849 was £6,852 4s 9d.[16]

In the course of this work, the question arose of modernising windows. The Earl was pressing Dowbiggin for plans in the middle of 1844 and a local newspaper reported in the summer of 1845 that 'upwards of 100 windows will be re-glazed with plate glass, in large squares'.[17] The manufacture of plate glass had developed rapidly during the past decade but Lord Leicester was ahead of the fashion for ever-larger panes (although not so far ahead as the 6th Duke of Devonshire at Chatsworth in the 1820s) which generally gathered pace only after the abolition of window tax in 1851 had halved the cost of glass.[18] It was Baker, the agent, who foresaw problems: 'it must be well considered about the size of the windows, as well as what is to be done to those below as well as above, so that the character of the house may be uniform'.[19] There was indecision over designs during the next two years, then abnormally high payments for carpenters' work in 1848 to 1851 suggest that many windows were altered by estate craftsmen but alteration of the principal windows was delayed until 1855.[20] The large panes of glass sat uneasily in the Palladian façade until the 5th and 7th Earls of Leicester restored the original pattern in the second half of the twentieth century. In other respects, the 2nd Earl made positive contributions to the conservation of the Hall that have been largely unrecognised. Defective external stone work, 'both plain and ornamental', was cut out and replaced in 1845–46 and there was also thorough repair of parts of the roof, involving 'immense scaffolding'.[21] The total cost, so the Earl's half-sister heard, was £12,000, a figure confirmed by the account books, and much higher than expenditure on internal refurbishment.[22]

The Earl was by no means in awe of his inheritance and could not resist experimenting. His half-sister, Lady Elizabeth, reported at the end of 1847, 'the portico has been entirely new done, and the house – in my opinion – entirely spoilt on the outside, as it [the portico] is painted, and a sort of mud colour, so different to the beautiful tone of the bricks'. Inside, the Earl found scope even in the Marble Hall for new ideas: Lady Elizabeth's daughter was astonished 'at going into the hall and seeing the balustrade on one

side vanished, and all the plaister casts descended from their niches and placed between each pillar, looking, as Collyer [the former chaplain] says, like Madame Tussaud's exhibition'. The statue of Apollo was brought from the Statue Gallery to see how it looked at the bottom of the steps, flanked by Sir Francis Chantrey's busts of Thomas Coke and T. W. Coke. 'This by way of experimentation,' noted the Earl's half-sister, 'but I will not answer for its

The kitchen and laundry yards before the alterations of the 1850s, in an unexecuted plan by Teulon for a terrace (shaded red lines) at the east end.

not being carried into effect – such is the rage for innovation.'[23] Refurbishment in 1845 nearly extended to the contents of the library: the chaplain, Napier, was shocked by Leicester's declaration that 'he meant to empty the house of the Law Library of Sir Edward Coke, as a heap of rubbish'. He was dissuaded from such 'utter vandalism' on this occasion but many rare items, as well as duplicate volumes, were sold in Norwich in 1851.[24] Even before refurbishment and repairs were completed, attention returned to practical improvements. During the summer of 1846, the kitchen was cleared for the installation of 'hot water apparatus' and between 1851 and 1855 it underwent a major refit.[25]

The annual total for 'repairs, decoration, improvements etc' in 1844 and 1845 was £8,300 (although the total in 1844 included over £3,000 spent on silver) and not much less in the following year, equivalent to nearly four times the normal household running costs.[26] Other schemes, such as a north vestibule, terraces near the Hall and improved stables, were already under consideration but plans submitted by the architects S. S. Teulon and J. C. Buckler did not meet with approval.[27] Meanwhile, major changes were taking place in the park – the introduction of deer, remodelling the islands in the lake, reroofing and altering the almshouses, improving the north entrance and constructing new lodges. The foundation stone of the monument to commemorate the Earl's father was laid amidst great celebrations in August 1845.

The household had a brief respite from repairs and alterations in the late 1840s. Towards the end of 1849, however, major construction work started near the south and west fronts of the house, where sloping lawns were to be replaced by broad formal terraces, parterres and a central fountain. While work continued there for seven years, the years between 1851 and 1856 were also dominated by extensive building work at the east end of the house. The beginning of the project coincided with the retirement of Baker from the estate office in early 1851 and the promotion of H. W. Keary, previously the farm bailiff, who soon showed an enthusiasm for extravagant building on the estate.[28] Nothing survives in writing to show the Earl's initial brief but William Burn, a Scottish architect who specialised in country-house work and had established a London practice in 1844, produced a scheme to build a large group of domestic buildings to the east of the house. The two courts opening off Kitchen Wing and Chapel Wing had always housed most of the external domestic offices, now chiefly fuel stores and workshops, and these were retained, having been rebuilt in 1845, but Burn's plan extended far beyond them.[29] His design was for an estate office and a porter's lodge flanking the approach to two ranges of buildings: stables and coach houses

RULES
AND
REGULATIONS
To be observed by the Porter, the Establishment, and Visitors' Servants.

The Porter is always to be in Livery, and never to be called away to discharge other duties than those which strictly belong to his Office.

The outer doors are to be kept constantly fastened, and their bells to be answered by the Porter only, except when he is otherwise indispensably engaged, when the Assistant, by his authority, will take his place.

Every Servant is expected to be punctually in his place at the time of meals,

No Servant is to take any knives or forks, or other articles, nor on any account to remove any provisions, nor ale or beer out of the Hall.

No Gambling of any description, nor Oaths, nor abusive language are on any account to be allowed.

No Servant is to receive any Visitor, Friend or Relative into the house except by a written order from the Housekeeper, which must be dated, and will be preserved by the Porter and shown with his monthly accounts; nor to introduce any person into the Servants Hall, without the consent of the Porter.

No Tradesmen, nor any other persons having business in the house, are to be admitted except between the hours of **9** a.m. and **3** p.m., and in all cases the Porter must be satisfied that the persons he admits have business there.

The Hall door is to be finally closed at Half-past Ten o'clock every night, after which time no person will be admitted into the house.

The Servants' Hall is to be cleared and closed, except when Visitors with their Servants are staying in the house, at Half-past Ten o'clock.

All Washerwomen and Needlewomen employed by the Servants, are to receive and deliver their parcels through the hands of the Porter, and on no account to be allowed to go to the different apartments of the Servants.

No credit upon any consideration to be given to any person residing in the house or otherwise for Stamps, Postal Orders, &c.

Servants' regulations.

surrounding an 80 feet (24 metres) square stable yard, and another enclosed rectangle formed by new domestic offices and the back wall of a great new conservatory. In a scene reminiscent of Thomas Coke setting out the original kitchen court a hundred years earlier, the Earl spent several hours one day 'staking out the different positions' in which the estate office and porter's lodge could stand, placing them slightly further east and south than originally planned in order to save several fine oak trees.[30]

Plan for the stables, William Burn, *c.*1855.

The new Estate Office was a detached building consisting of the agent's room, another for the two clerks, a muniment room, for which tin deed boxes were soon bought, and a large waiting room.[31] For many years estate business had been conducted from a couple of offices on the ground floor of Strangers' Wing and Keary, in post for little more than a year, was understandably pleased with the architect's efforts 'to give me a well arranged and comfortable office'.[32] Apart from later subdivisions to the general office and waiting room, the building remained essentially unchanged into the twenty-first century as the centre of estate administration.[33] Opposite it, the porter's lodge replaced a previous one that had been built somewhere to the

Mabel (born 1878) daughter of the 2nd Earl, in the stable yard towards the end of the century

The porter's lodge, subsequently at different times an exhibition area, accounts office and ticket office, 1852.

east of the house in 1836: the 'old courtyard premises, porter's house range' were demolished in 1853.[34] The porter was in charge of security, locking and unlocking the external doors of the house, answering the doorbells and keeping order in the Servants' Hall. Although he had a sitting room and

Chapter 12 The Victorian Hall 1842–1909 329

bedroom in the Hall, it was evidently normal for him also to have living accommodation outside, reflecting his lighter duties for the months that the family was absent and the Servants' Hall closed. In the late-twentieth century, the building accommodated the estate's accounts department.[35]

The new stables and coach houses replaced those that had been built in 1759 on the far side of the lake, which Lady Elizabeth Spencer Stanhope had heard in 1847 were to be 'totally transmogrified'.[36] There is little information about the occupants of the stables. Coach horses were treated strictly as a utility, hired from stables in London and returned by train when they needed replacing, an arrangement that continued into the twentieth century.[37] The second large courtyard was formed by the west side of the stables and new domestic offices. Compared to the rambling and highly departmentalised domestic quarters favoured in many new houses of the time, of which Burn was a leading proponent, it was a restrained and practical plan, for there was no need to interfere with the original convenient and logical arrangement within the house, where suites of rooms and their associated cellars formed the butler's, housekeeper's, steward's and kitchen departments. The new buildings housed, on the south, modern replacements for the well, pumping engine, malt mill and brewhouse. The octagonal engine house, with Samuel Wyatt's later game larder occupying its upper floor, was the only original building retained. With its roof lowered to match the new buildings, it linked them to the back wall of a great new conservatory, together forming a most

The southern range of buildings for the well, steam engine and brewhouse, by William Burn, 1850s, photographed in 2004.

emphatic screen between the working areas on the north and the new terraces to the south. On the west side of the rectangle, a separate laundry building, the only department to move out of the Hall, was built across the gap between the old Kitchen and Laundry Courts, where previously a balustrade wall had separated the courtyards from the park. On the north side of Kitchen Court, cellars were added beneath the north terrace.[38] The new buildings were erected in succession between 1853 and 1856. The whole area, which in the eighteenth century had retained a hint of the farmyard, now acquired quite an industrial air. The new steam engine, working the pumps on two or three days a week to raise water from the lake to a new reservoir in the park, must have been both audible and visible, accompanied on occasion by the aroma of malt milling and brewing. Smoke rising from the laundry chimneys on the other days, when waste steam was not available to heat the coppers, was sufficiently near the house to concern the agent.[39]

Alterations and additions were proceeding in other areas of the Hall at the same time. After a hundred years, the occupants of Holkham had finally tired of direct access to the Marble Hall by cold winds off the sea and both Teulon and Burn submitted plans for a north entrance or vestibule, eventually erected in 1855 to one of Burn's designs.[40] In the same year, earlier designs by Teulon again having been rejected, Burn redesigned the Saloon and Marble Hall windows with new large panes. The Saloon windows, made by outside specialists, Messrs South & Co, cost over £359.[41] Just as the agent

The north vestibule, a rejected version by William Burn.

had made suggestions about the window designs ten years earlier, now his successor, apparently without direct reference to the Earl, had no compunction about suggesting to the architect that the division of the panes should be modified.[42] The new window putties, like those they replaced, were gilded, as shown by remnants of gilding found during repair and decoration in 1909.[43] A new floor on wrought iron girders was laid under the portico, perhaps in anticipation of increased use: for a ball in 1865 the portico was enclosed to accommodate the orchestra.[44] Alterations were made in Chapel Wing, principally to add a bathroom, and it was probably at this time that part of Pantry Court, the western internal court, was enclosed to form additional workrooms and covered access across the court.[45]

These building works of 1851–56 were greater than any work since the construction of the house a hundred years earlier. There was a marked contrast in the management of the two periods of building, reflecting the emergence during the first three decades of the nineteenth century of large firms of general building contractors. Nearly all of the building work in the 1850s, after competitive tendering, was put in the hands of Messrs Bramall and Buxton, a Manchester firm.[46] This unlikely connection may have been due to Burn, the architect. During 1852–54 Bramall and Buxton also executed extensive alterations, designed by the great agricultural architect, G. A. Dean, at the *New Inn* (later known as Model Farm) on the west side of the park, Longlands at the southern edge of the park and nearby Egmere Farm. At least one member of the firm settled at Holkham: an agreement for building the Wells sea bank a few years later was signed by W. Buxton of Manchester and I. Buxton of Holkham, builders. The use of these general contractors, whose own records are not known to have survived, has left few clues regarding the management of the work. In the 1840s the Holkham agent was closely involved in the refurbishment of the Hall, inspecting progress with the Earl and communicating with the contractors. He summoned the decorator, Dowbiggin, to sort out 'the arrangement of the workmen, for we have painters, gilders and carpenters all at work in the same room which is not considered quite consistent'.[47] Watson, the Norwich stonemason, probably directly supervised external stonework. For the larger-scale works in the next decade, however, the architect, Burn, provided a foreman who was paid by the estate to superintend the work on the terraces but the Holkham agent complained about his 'constant mistakes' and he was dismissed.[48] He was replaced by A. W. Colling, employed by the estate from 1853 to 1857 specifically as clerk of works at the mansion; he was perhaps related to Burn's chief clerk, William Bunn Colling.[49] The major works were based on estimates submitted by the builders with reference to specifications

The Longlands complex near the southern entrance to the park, established as a farm *c.*1733, enlarged in the 1790s, expanded to include the forestry and building concerns in 1852–54 and partly converted to business units in the early 21st century. Photographed in 1965.

and there were apparently no disputes with Bramall and Buxton. The total cost of their contract work around the Hall was £20,217.[50]

There were still, however, occasions when the traditional system of measured work was used and caused problems. The clerk of works answered to the architect, Burn, which left significant gaps in supervision of other work, such as when Watson's men were employed instead of 'our own regular men' to hasten completion of kitchen alterations. Watson's furnished a schedule of prices and it was intended that Burn's clerk of works would measure the work. He, however, made 'a most decided objection' to undertaking any measuring, with the result that an outside surveyor, one of the new breed of professional quantity surveyors, had to be called in to adjudicate on the price. Similarly, when Feetham's bill for improvements in the kitchen was disputed, it appeared that 'Burn had nothing whatever to do with Feetham … Salmond, the late butler, is the only person who gave any superintendence to Feetham's workmen'.[51] The estate 'architect' (Stephen Emerson, succeeded in 1848 by Henry Bolger) had no role, supervisory or otherwise, in work at the Hall.

For around twelve years, building craftsmen and labourers were a constant presence near the Hall. In 1845, the stonemason, Watson, had 120 men working at Holkham, including those starting work on the monument to T. W. Coke; his masons, dressed in white with leather aprons and new straw hats, and the labourers, wearing red caps, formed striking contingents in the procession preceding the foundation stone ceremony. Some of these masons were kept on by Watson at his works in Norwich during the winter, an exceptional arrangement in anticipation of securing the next phase of work on the Hall in the spring. Many workmen probably walked in from neighbouring villages, for even before the major building work began, the agent wrote that the new steam engine man would not be able to find a house nearer than Wells-next-the-Sea, a couple of miles away, and that 'many of our labourers and mechanics too live there and walk still further to their work every day'.[52]

There is no record of the effect of the building works on the life of the household. A bonus paid in 1861 to the laundry maids, headed by Susan Stimpson, a most experienced laundress, was too late to be an acknowledgement of the difficulties they must have endured as building work went on around their bleaching ground but perhaps there were already problems with the new water supply, which nearly failed a couple of years later.[53] The laundry maids always stayed at Holkham but other servants, returning after months away at the London house, saw great changes.

The major building works in the immediate surroundings of the Hall were completed by 1856. A visitor a few years later, writing to Lord Brougham, greatly approved the changes: 'It is a much finer place than in your time – a splendid terrace by Nesfield has given it quite a new character, and there are many other great improvements'.[54] As soon as these were finished, the Earl's attention returned to enclosing the salt marshes between Holkham and Wells-next-the-Sea, which he had postponed in 1845 and again in 1854 on the grounds of expense. Messrs Buxton, who had recently finished work at the Hall, started building the mile-long embankment from Wells quay to the beach in 1857 and completed it in 1859, the 2nd Earl thus completing the work started by John Coke in 1659 and continued by Thomas Coke in 1719.[55]

Each subsequent decade was marked by further changes in the Hall and park (see chapters 11 and 13). In the 1860s these included a new water supply, installation of gas lighting, 'heating apparatus' for Strangers Wing, a bowling alley built in 1867 between the laundry and the east end of the house (still in use in 1913, when red serge coats were provided for the boys in attendance), heating systems for hot houses in the kitchen gardens, a new lodge at the Wells entrance to the park and the restoration of the church

The Princess of Wales in the bowling alley, 1872.

The west end of the bowling alley, built in 1867, seen from the Hall in 1987.

Chapter 12 The Victorian Hall 1842–1909 335

within the park.⁵⁶ Another significant change in this decade was the coming of the railway. After initially opposing the Dereham and Fakenham Railway, the Earl had pressed for its extension to Wells-next-the-Sea in 1857, 'without which it would be absolute destruction to Wells'.⁵⁷ Nine years later, when the West Norfolk Railway extension linked Heacham and Wells-next-the-Sea, crossing Holkham marshes north of the coast road, the Earl immediately realised 'that will in future be the principal entrance to Holkham'. He was particular that the station, part way down the drive to the sea, about a mile from the Hall, should be 'as neat as it can be made, with nothing superfluous'. It was to be used for passengers and light domestic goods only, so horses and carriages, for example, were still to be sent to Wells.⁵⁸ Early in 1866, the Prince of Wales was keen to travel by train from Sandringham at least as far as Burnham for his annual visit to Holkham; by March, as one of the vicar's young sons reported to his brother, the station was finished and 'Lady Gertrude's going to be married on the fifth of April and they are trying to get the railroad finished for the Prince and Princess of Wales to come to the wedding and dance'. Nearly three years later, Annie de Rothschild, joining a royal house party at Holkham with her sister and father, arrived at the station half an hour before the royal train: 'we found grand preparations for royalty

HOLKHAM

The two most convenient trains from LONDON are:—

LEAVE.	ARRIVE.
ST. PANCRAS.	HOLKHAM.
12.20	4.15
2.40	6.40

CHANGE AT HEACHAM.

Please send servants and luggage by the **12.20** from ST. PANCRAS.

Train information for guests, undated.

Holkham station.

in the shape of red cloth and Lord Leicester who looked as red as the cloth, but jolly and good natured; and, thank goodness, carts of all dimensions, in which our box could sit without any inconvenience'.[59] Improvements continued in the 1870s. The Marble Hall (at the time called the Egyptian Hall) was redecorated, always a considerable exercise, although new silk curtains for the Saloon cost even more, and massive new glass houses were added to the kitchen gardens. In 1871 the Earl commissioned a bronze lion and lioness from Joseph Boehm (1834–90), soon to be the most prominent sculptor of his time. He had recently created the marble monument in the church in memory of the Countess. The lion and lioness were exhibited at the London International Exhibition of 1872 before being installed to give added dignity to the north front of the Hall. In the 1880s, Holkham village was extensively rebuilt (see chapter 14).[60]

Building work and other improvements, incessant though they seemed to be, were only one aspect of life at Holkham. Their first child, Julia, was born to the Earl and Countess in December 1844 and within eleven years they had nine children, all girls apart from the heir (another Thomas William) born in July 1848 and Wenman, born in 1855. Chapel Wing was the nursery wing, as it had been during the childhood of the Earl: three rooms on the top floor, which in the eighteenth century had been maids' bedrooms, were used as two night nurseries and a nursery maid's room, and the day nursery and (later) the young ladies' sitting room were on the ground floor of the same wing.[61] Like the family, the household gradually increased in size. The new indoor staff of 1843 was relatively modest, consisting of five upper servants (house steward, housekeeper, cook, valet and lady's maid)

Housemaids in a later generation pose on the lion.

A group of servants in 1860. From left: butler, clerk, rat catcher, gamekeeper, under keeper, Hall porter, valet.

and fifteen or sixteen lower servants, mostly maids. Soon an under-butler, footman and five more maids were added and the normal total for the rest of the century was about twenty-six indoor servants.[62] The house steward appointed in 1843 was soon re-designated as butler, in recognition of the fact that the eighteenth-century post of house steward had effectively disappeared, with oversight of household disbursements ceded to a clerk in the Estate Office. As always, the lower servants, joined until 1865 by five or six stables staff, ate in the Servants' Hall, presided over by the porter, who 'sits at the head of the hall table and keeps order'. Later in the century he was briefly given the more imposing title of 'House Sergeant'. He carefully noted

The hall porter's daily record of the lower servants and visitors' servants dining in the Servants' Hall.

movements within the hierarchy, such as 'Albert Cocking to the [steward's] Room', 'Elizabeth Hagon to nursery,' 'Mary Sparks from nursery'.[63] The nursery staff had their meals in the nursery or schoolroom and their wages were entered in the accounts separately from the domestic servants'. The nurse and nursemaid were joined by a governess when the eldest daughter was about six; from 1857, when there were seven daughters aged from three to twelve, an additional junior governess was employed, usually German.[64] Although the post was relatively highly paid, no governess stayed longer than two years, perhaps because Holkham could not provide the social contacts with their peers that London governesses enjoyed. As the daughters grew up, three young ladies' maids replaced the nursery staff and a young ladies' footman was employed to wait on the schoolroom.[65]

The cook was usually a woman, paid between £40 and £65 a year, but for Christmas and other important occasions a male cook, usually French, was hired from London for a few weeks.[66] The temporary chefs had to slot into place quickly. One was told to take the nine o'clock train from London, arriving at two o'clock, and 'take the management of the kitchen and cook the dinner the day you arrive'. There was a hint of temperamental behaviour when another French chef 'lost his head' and walked out in the New Year; the agent wrote to him in French but nothing was heard from him until, nine years later, he asked for his unpaid wages.[67] During the 1870s a French cook, Jean Pelletier, was appointed to the permanent staff, starting on a wage of £125, rising to 160 guineas in his last year, 1876. He must have been a notable cook, comparable to a French chef at Harewood (Yorkshire) who was paid £100 at this period and was soon recognised as an award-winning member of his profession.[68] Christmas hospitality was heralded by the recruitment of extra staff, swelling the number of servants to around fifty, including a temporary Groom of the Chambers and several waiters hired from London.[69] From the mid-1860s there was invariably a ball during the Prince of Wales' New Year visit, when the regular servants could be joined by around 130 extra helpers, police and visitors' servants, including the Prince's entourage of at least seven servants and four postilions.

The household revolved, as always, round the presence or absence of Lord and Lady Leicester. As in the eighteenth century, the year was divided, although now with considerable flexibility, between the sporting season at Holkham in the autumn and winter, and the London season during the late spring and early summer. The young Earl and Countess had arrived at Holkham after their marriage in 1843 'both rejoicing that they had turned their backs on the London season and its frivolities'.[70] In the following year, they spent only the last two weeks of April in London. A few days before

leaving Holkham, almost on the first anniversary of their marriage, they treated the servants (and themselves) to a performance at George Fisher's theatre in Wells-next-the-Sea. For the next few years, the pattern was established that the Earl and Countess, accompanied by part of their household, spent between four and nine weeks away between April and July, mostly in London, where each year a different house was rented for the season. Their participation in the London season was purely social; the 2nd Earl, unlike his father, had little interest in parliamentary political life. In some years the household was away again for the month of September, usually in Scotland.[71] At Holkham, cricket remained as much a feature of the summer as shooting was in winter. 'The gentlemen of Holkham' had played 'the gentlemen of Wells' nearly fifty years earlier but the cricket ground on the north lawn had been laid out (or renewed) in 1841, the year before the Earl's succession. Regular two-day matches were played and soon two large striped marquees, capable of seating nearly seventy people, were bought for the dinners that followed each day's play and remained a feature of the grounds for several years.[72] When the Game Book shows a three-day break from shooting in September, the Servants' Hall book reveals a cricket match to be the reason, noted because of extra servants 'assisting at the marquee'.[73] The Earl was an accomplished cricketer, playing for Norfolk and for the Houses of Parliament, and Holkham became a notable team, on one occasion in September 1851 only narrowly losing to the celebrated touring team of I Zingari. It was perhaps for this game that Mathew Daplyn, a retired Norfolk player who lived at Hindringham, not far from Holkham, and William Caldecourt, a famous umpire, were paid for umpiring, and S. and R. Gibson (possibly Robert Gibson, a Nottinghamshire player) were paid for coming from Nottingham to play.[74]

In the 1850s, however, when the building work was at its height, the household stayed away for at least five months in each year. After the birth of her eighth child in January 1854, Lady Leicester left Holkham in early March 'until the end of the year', first for London and then for the summer and autumn in Folkestone, Tunbridge Wells and Brighton.[75] She thus avoided the building work on the stables, brewhouse range and conservatory, as did the servants who accompanied her, for the Servants' Hall was closed and the remaining servants put on board wages for eight months. Even the Earl did not return for the shooting season until 10th October, a month later than normal.[76] Although most of the building work had been completed by the late 1850s, the household was still regularly absent from Holkham for four months between May and September throughout the 1860s. After the London season, during which the young ladies received dancing, music and

drawing lessons, rail travel allowed great flexibility in arrangements. The Countess and her children often went to a hired cottage in Scotland or to the Isle of Wight, Eastbourne or Tunbridge Wells, while her husband went fishing or shooting in Scotland, Ireland or Norway.[77]

Life at Holkham came into its own from September to April, when the full household was settled there for the shooting season and for Christmas. The Earl had a passion for shooting from an early age and had been placed in charge of the game department a year or so before his father's death. He had immediately taken steps to remedy 'the negligence and remissness from which the game has suffered'. He knew that Baker, the agent, 'always was opposed in some measure to the keepers, and always will want a little urging about the game' but that did not deter him from ordering that rabbits 'must be preserved very strictly, particularly during harvest time' in order to ensure that there would be plenty for shooting by November. The gamekeepers were told to stop their 'too ready access' to the Servants' Hall and were forbidden

A royal shooting party, undated, 1860s.

to enter public houses unless on duty. Measures to remedy 'poaching being detected by other means and never lately by the keepers' must have borne results, as a couple of years later the local doctor's fee for attending keepers hurt by poachers was £6 12s.[78] In future years, Leicester usually returned to Holkham in early September, ahead of the main household. Often accompanied only by a keeper, he went out shooting on most days, interrupted only for cricket matches. In October and again around Christmas, large house parties assembled for several days shooting by up to fourteen guns, often including royalty.[79] In 1847, Lady Elizabeth Spencer Stanhope wrote to her husband from Holkham, 'tomorrow they are to kill 500 pheasants and 500 hares, which are all to be driven to one spot – a regular massacre. How different to old days!'[80] It was the 2nd Earl's perfection of such driven shooting that made Holkham renowned as a great shooting estate for many years to come, yielding not only large bags but also challenging sport, as the pheasants flew high and fast out of cover.

In the 1860s, there are hints that some of the old ways were changing, both below and above stairs. The Servants' Hall still hosted occasional celebrations such as the Harvest Supper (for 83 men in 1864) and the gamekeepers' annual dinner, but its daily use became exclusively for indoor servants, a marked change from the past 200 years. Gamekeepers had been excluded twenty years earlier; now the four stables staff ceased having their meals in the Servants' Hall and instead received board wages. This may have been their choice, for an unmarried coachman declined an offer of boarding in the house, perhaps finding the possibility of saving from his board wages even more appealing than dining with the maids. The laundry maids, on the other hand, despite their new separate laundry, continued to dine in the Servants' Hall. They went onto permanent board wages only around 1880, an indication that, as had often been the case much earlier in other large houses, they would in future cook for themselves in the laundry quarters.[81] The traditional bonus of dinners in the Servants' Hall for outsiders was gradually ended. The coal carters, for example, for whom the Servants' Hall had been opened specially during the three days in the summer when they were filling the cellars with coal, henceforth received an allowance in lieu.[82] Later in the century the chimney sweep, too, was paid a sum in lieu of dinners for himself and two boys. 'Strangers' Beer,' the old custom of giving a drink to all who called, was discontinued in 1864. In the same year, Leicester told his servants and the surgeon, Dr Rump, of Wells-next-the-Sea, that he was ending the tradition of paying for medical attendance on servants, although it continued to be provided for residents of the almshouses. This had been a considerable perquisite: some years earlier, 'attendance & medicine' and

funeral expenses for a gamekeeper, John Guest, had equalled nearly half his £50 annual wage.[83] Other traditional perquisites were curtailed. A new house porter was told that he would have £30 per year, board wages when the family was absent, two livery suits and one working suit each year, and a guinea for making up the mail bag from the private post office 'and beyond these there are no wages nor perquisites whatever'.[84]

Control of all aspects of the household with financial implications became ever more firmly concentrated in the Estate Office, a marked change from earlier generations. A newly-appointed butler was told in 1861 that 'no perquisites nor gratuities from tradesmen are allowed, and that all orders for goods pass through the office, and all bills are paid direct from there'.[85] In 1885 the management of the household finances by the Estate Office was reflected in the designation of one of the junior office staff as 'comptroller' or 'house steward' on a small additional salary, an arrangement that continued into the new century. Despite such precautions, the value of orders from Holkham was such that servants' connections with tradesmen presented temptations. A temporary French cook was authorised to order fish but the agent asked the fishmonger to let him know, in confidence, if the chef 'applies to you for discount in the bill'. One of the regular meat suppliers was warned, 'if you should give any presents to the servants, that his lordship's orders will immediately cease'.[86]

The household continued to obtain most of its meat, dairy products and flour from local suppliers, usually tenant farmers. The amounts were considerable. In a three month period in the late 1870s, a total of 5,342 people dined, each consuming an average of 1lb 11ozs (about 775g) of meat per day, giving a total for the quarter year of nearly 629 stone (4 tonnes).[87] The home farm maintained up to thirty-five cows to supply the Hall dairy.[88] Subsequently, John Doggett, the tenant at Model Farm, had a clause in his tenancy agreement to supply the Hall with milk, much of it in the form of butter, at the rate of 18 gallons (nearly 82 litres) per day, an over-calculation that was rapidly rescinded.[89] Even so, local supplies were sometimes supplemented by large quantities of butter sent by parcel post twice a week from shops or commercial dairies in London, Derby and elsewhere.[90] Many groceries and household goods were bought in bulk from London shops such as the Army and Navy Stores, the Civil Service Cooperative Society and Harrods. The clerk in the Estate Office directed how the goods were to be delivered; even after the coming of the railway, this was often still by sea, by 'the next Wells trader' to sail from Harrison's Wharf at St Catherine's, or the Burnham packet sailing from Union Wharf, Wapping. Increasingly, however, goods were sent by rail to Holkham. Tea, sugar, tinned foods and cleaning

equipment were joined by more surprising items, including eggs (up to 700 at a time), ice and fish. A hundred years earlier, there had been fishing from the staithe and on the lake, and large quantities of fish had been supplied by a local fisherman; now, however, fish was sent daily from shops in New Bond Street. Usually the order was in general terms – 'fish for dinner for 16 to 18 persons', with a strict embargo on turbot and salmon, which the Earl particularly disliked. Bloaters were sometimes obtained from Great Yarmouth but it seems to have been only at the very end of the century that a fish merchant at King's Lynn obtained a regular order. While fish was sent from London to the North Norfolk coast, the railways permitted an equally incongruous return trade when, for a short period, baskets of peaches, nectarines, figs and grapes, grown in the great new range of glass houses built in 1872, were sent by the morning passenger train from Holkham to reach the London market that evening. Game was regularly sold to London dealers, causing frequent problems when items went astray during the journey.[91]

Above stairs, too, there were changes during the 1860s. The Countess had recently given birth to two more sons, her last children, but they died as infants in 1858 and 1860.[92] The heir, Lord Coke, went away to school in 1859 and Wenman, the youngest surviving child, in 1866. They had been taught from the age of seven to eleven by two successive Holkham village schoolmasters, James Bolton and William Belcher, who were paid about ten shillings a week for this extra duty. After Harrow, Lord Coke received 'military instruction' at the privately-run Military Training College at Sunbury before being commissioned into the Scots Fusilier Guards, the start of a long military career. Wenman went briefly to Trinity College, Cambridge, before joining the Rifle Brigade.[93] The eldest daughter, Julia, married Lord Powerscourt in 1864 and two years later the third daughter, Gertrude, married Earl Dunmore. A young guest at Holkham around this time described the large family as 'all very kind and friendly, but many ... do not contribute much to the general hilarity,' the younger daughters being 'all more or less shy'.[94] The Prince of Wales, nineteen years younger than the Earl, came for a day's shooting for the first time in October 1863, the year he married, aged twenty-two.[95] 'No man in the county was less of a flutterer on the polished surfaces of high society' than Lord Leicester but this marked the beginning of a long and close connection between Holkham and Sandringham. The Prince and Princess of Wales and their family became regular visitors at Holkham for three or four days in December or the New Year.[96] Lord Leicester served on the Council of the Duchy of Cornwall from 1866 to 1898 and was appointed Keeper of the Duchy's Privy Seal in 1870.[97]

Juliana, the Countess (died 1870) with her eldest son (born 1848) and second daughter (born 1845) in a photo collage by a family member.

In April 1870 Juliana, the Countess, died aged forty-four. A pencilled note in the hall porter's book is the only surviving indication that her death had any effect on the household.[98] It was perhaps the reason, however, combined with the importance of the London season for the marriage prospects of his five remaining daughters (Anne, Mary, Winifred, Margaret and Mildred), that caused Lord Leicester in 1871 to buy a London house, 19 Grosvenor Square, instead of continuing to rent.[99] Every year all the upper servants, and even less exalted colleagues such as the steward's room boy and the kitchen and scullery maids, disappeared from Holkham to the London house for most of May, June and July. Two large horseboxes were added to the train to take the luggage.[100] The Hall was left to the housekeeper, the six housemaids and one stillroom maid who worked under her, the house porter (a lone male) and the four laundry maids, a considerably larger staff than that left at Holkham in the family's absence in the eighteenth century. As always, because the Servants' Hall and the kitchen were closed, they received board wages, now paid monthly from the Estate Office, in addition to annual wages which were

paid quarterly. For the lower paid servants, in particular, the amounts were considerable: a junior housemaid, for example, on a wage of £3 per quarter, received board wages of £2 4s per month.[101] Presumably they pooled their resources and were perfectly capable of cooking for themselves in the still-room. Thanks to the ease of travelling by rail, the Earl and members of his family came and went individually whenever they pleased but in the 1870s the official return of the household to Holkham was around the middle of July. Even with twenty-six servants in residence, however, the household, including the family, remained on board wages until late September or early October. Under this system, which lasted at least until the end of the century, all servants received board wages (giving signed receipts for the cash) and the cook signed for receipt of set amounts for the family and visitors, ranging from twenty-one shillings per week for the Earl to twelve shillings each for visitors' servants. Meals for non-resident visitors, and even 'soup to poor' and food for Puck the dog, were treated as board wages at set rates.[102] The system was designed to regulate expenditure on food, particularly at times when family members might come and go more than usual and, increasingly, servants take holiday leave, but the payment of board wages to the full complement of servants is puzzling for it seems both unlikely and undesirable that so many servants could be expected to eat out or cater for themselves for a month or more until the resumption of normal housekeeping in October.

Five years after the death of his first wife, the Earl, 'a somewhat elderly man' of fifty-three years, succumbed to the 'bright looks and charming expression' of Georgiana Cavendish, aged twenty-three, the eldest daughter of the 2nd Baron Chesham.[103] He married her in 1875, when the youngest child of his first marriage was aged twenty-one, and by 1888 six children under the age of twelve (this time all boys except one) again occupied the nursery quarters in Chapel Wing. The two remaining daughters from his first marriage, Mary and Mildred, probably had rooms at the top of Family Wing until they married in the late 1870s. As a family biographer commented, it became 'a hardy annual in the Press' to comment on the peculiarities that this created between generations, as there were exactly one hundred years between the first marriage of the Earl's father and his own second marriage, and fifty years in age between the Earl's eldest daughter and youngest son.[104] When the whole family assembled, parts of the Hall were full of children. One year a dozen extra basins 'for children's bread and milk breakfasts, for school room use' were bought in anticipation of 'a very large party of children and visitors'. Throughout the 1880s the 'Children's Journal' kept by Viscountess Coke described large family gatherings at Christmas: 'all the cousins and relations were there as usual and they had a big Christmas tree and enjoyed

Family children at Holkham, Christmas 1882.

The Earl with his second wife, Georgiana, and children from his two marriages, c.1888.

themselves very much indeed'. On one occasion, she listed about nineteen young family visitors, aged from two to nineteen, in addition to the six children of the Earl's second marriage. On the same occasion, there were thirteen extra servants in the Servants' Hall but no record of how many superior servants in the Steward's Room and nursemaids in the nursery.[105] The Earl was said in his old age to have asked a footman about the children playing on the terraces, to which the servant replied, 'They are yours, my lord'. Fortunately the house was big enough for both old and young and as the younger generations grew up, they added their contributions to house parties at the turn of the century. One of the lively Trefusis sisters described a 'ripping shoot' that included the Earl's grandson, Tom (who had fallen in love with her sister, Marion) and two of the Earl's sons by his second marriage, all of whom were aged nineteen or twenty: 'we made such a noise at dinner ... they all rag like mad directly we are alone. Cushions fly!'[106]

The second Countess rarely missed the London season, although towards the end of the century both her husband, in his seventies, and his youngest son, born in 1893, stayed at Holkham.[107] Lord and Lady Leicester then often spent a few weeks in Scotland at Stack Lodge, the Duke of Westminster's shooting lodge, which remained a favourite destination for future generations, while the children, governess and nurses remained at Holkham or spent part of the summer in south coast resorts. The summer was sometimes enlivened by the advent of various grandchildren, such as Lady Powerscourt's 'three bouncing girls'. Ladies spent the days driving round the woods in the park or to the shops in Wells-next-the-Sea. Three young ladies amused themselves by visiting Mrs Wood, the agent's wife, 'that choice spirit' who could be relied upon to cause secret hilarity by inviting them 'in her miserable voice' to admire her hens, flowers and cats. The waggonette often took a party down to the beach and hire of a 'bathing machine' appeared regularly

One of the notes written by the agent for the Earl, whose sight and hearing were failing.

'Peter' (the pony) and his cart going to the sea.

in the accounts.[108] Holkham Cricket Week was still an important feature of the summer.[109] One of the bits of news that the agent scribbled down for the Earl, now old and extremely deaf, told him that a possible candidate for the post of village school master in 1903 was 'good in all ways but appearance, he is rather fat & 44; Lord Coke thinks 44 too old; he and Lady Leicester would like a cricketer'. Alexander Napier the younger, who had succeeded his father as librarian at the Hall, ran the village cricket club and was remembered by a family member as 'alright' because he 'played cricket with the boys and never looked at the books'. Napier, however, confided in 1908 that he would be 'truly glad when the cricket season is over, for it is no pleasure to me, the boys at the hall are enough to craze one'.[110]

The change from one Countess to another, the young second family, changes in customs and social life, even the increasing age of the Earl, all influenced the way in which rooms were used. During house parties in the late 1840s and probably in the following decades, 'the Billiard table is always lighted up for the gentlemen when they come in from shooting, and then they sit smoking'. This was in the portico room, below the Saloon in the

centre of the south front. Its change of use from a century earlier, when it had been the gathering place for strangers wishing to view the house, neatly encapsulates the different priorities of life in a typical Victorian country house. Dinner was in the North Dining Room, 'far pleasanter and quieter than the [statue] gallery', a comparison that suggests that T. W. Coke had often used the latter. In the early years, the evening might be enlivened by an impromptu dance, with one of the family or a female guest playing the piano in the Saloon or downstairs in the Audit Room, for 'Leicester delights in dancing' which he did with tremendous energy. Otherwise the company moved to the Drawing Room for whist, in which Lord Leicester was 'as deeply interested as if it were played for thousands', or to play charades.[111] The young Prince and Princess of Wales, regular visitors in the 1860s, liked 'nothing so much as a romp'. During one royal Christmas visit, the schoolmaster, 'a most elegant looking gentleman', played the piano for dancing in the Gallery, then a day or so later the house guests, including the Prince and Princess, attended a Servants' Ball, and on the following day there were to be 'romps' including 'blind man's buff, tapping hands, snapdragon etc'.[112] For more formal entertaining, a small band of three to seven musicians might

The scene in the Saloon for a ball in 1865, from *Illustrated News*.

be hired from Norwich or London. On the occasion of a grand ball in 1865, the Marble Hall was decorated with flowers intertwined between the pillars, dancing was in the Saloon and Drawing Room, with the portico enclosed 'in imitation of a bower' to accommodate the orchestra; the Statue Gallery was the supper room and the south-east drawing room (the South Dining Room) was arranged for those who preferred to play cards.[113]

By the end of the century, the billiard room had lost its role as a male domain. For a time it kept its old name but, subsequently known as the Smoking Room, it became an informal family sitting room. The billiard table, subject to changing fashion or merely the personal taste of the ageing Earl, yielded place to a piano, which the second Countess played in the evenings. A visiting female relative captured the atmosphere of relaxed family routine at the end of the century:

> Gounod's Faust will always remind me of evenings spent in the billiard room at Holkham, with the smell of the logs on the fire, and the musty old books, and the empty chair which the master of it all, of the gorgeous rooms upstairs and the 43,000 acres outside, has just risen from to go to bed, with the little Scotch terrier Fan. I love the life at Holkham, very much for Georgie [the Countess] and Mabel [her daughter] but quite as much for the strangeness and absolute uniqueness of it.[114]

The young men of the family, when at home, presumably followed the billiard table to its new, rather less comfortable place in the old Armoury or Guard Room.

The staterooms continued to be well used at the end of the century, when comfortable Victorian furniture rubbed arms with eighteenth-century heirlooms. The Drawing Room contained settees and easy chairs in green and purple flowered cretonne covers; there were tables, fire screens and settees in loose cretonne covers scattered about the Saloon, and the classical purity of the Statue Gallery was softened with carpets, numerous chairs and a grand piano. Breakfast was sometimes taken in the Audit Room on the ground floor, five minutes after prayers had been read in the Chapel by the Countess, but the South Dining Room on the state floor was now also known as the Breakfast Room. Luncheon was at 1.30, attended by the agent on Tuesdays, which was 'office day', and sometimes by Alec Napier, 'the untidy loafing librarian'. On one occasion, probably typical of the way rooms were used, a small party for a meeting of the Soldiers' and Sailors' Association gathered in the Drawing Room, took luncheon in the 'breakfast room' (the South Dining Room), listened to the speakers in the Hall and had tea in the Statue Gallery: 'then they all went, and we descended to the billiard room again'.[115]

Inventories made when the 2nd Earl succeeded in 1842 and when he died in 1909 suggest that the state bedrooms were also regularly used throughout the nineteenth century.[116] In the Green State Bedchamber, the state bed and the matching suite, upholstered in the glorious original eighteenth-century variegated velvet, shared the room with such mundane items as a washstand with a double set of toilet ware, footbaths, bidet, commode and towel horse. Its dressing room (normally listed as one of the two closets or small rooms that separated the two state bedrooms) was equipped with similar items. The North State Bedroom, hung with the tapestries that were later moved into the adjacent sitting room, was also furnished with a washstand, deal dressing table, wardrobe and day bed. Its dressing room (the closet or servant's room behind a concealed door) had a brass single bed, chest of drawers, dressing table, toilet glass, writing table, clothes stand and two chairs.[117] The adjoining North State Sitting Room, also containing a commode, towel horse and chests of drawers, must have looked comfortable rather than stately with its red carpet, blue sateen curtains and settee, and three easy chairs in turquoise flowered satin. The bell board near the butler's pantry showed twenty-seven rooms that could be identified by their temporary occupants' names on cards slotted into brass holders. Annie and Constance Rothschild, young unmarried ladies accompanying their father, Sir Anthony, on a visit to Holkham in December 1869, were given rooms 'on the ground floor, those usually given to bachelors; they are large and comfortable, but neither bright nor elegant, and resembling very much the bedrooms of an old-fashioned English inn'.[118]

*

There had always been a direct and uncomplicated relationship at Holkham between the estate and the Hall: agricultural rents paid for life in the Hall. The 2nd Earl had no desire to emulate his father's celebrity as an agricultural publicist but he was intensely interested in farming, nature and the estate. Even as a young newly-married man with a fondness for dancing and whist, he was usually 'on his pony at half-past five every morning. They breakfast as the clock strikes eight, and after he has written his business letters, he is off again for the day, with a pouch slung round his waist which carries his luncheon'. He kept detailed daily meteorological records for sixty years and his collection of specimens of birds, shot locally, carefully recorded and displayed in a hundred glass cases, bore witness (by contemporary standards) to his interests as a countryman.[119] Throughout his life he was 'a man of practical workaday affairs, with a wonderful grasp of detail extending into all sorts of technical directions'. One summer he excused himself from joining his wife and eldest daughter, 'Juey' (Julia) on holiday in Scotland because 'I have so many people to look after and in many things there is no hand

Birds were shot, stuffed and listed as a means of recording numerous varieties. The bustard, already extinct in England, was an old specimen discovered by chance.

for the work'. He told them that he had saved 'some hundreds' by putting 103 men, women and children to work one evening to clear a field of barley before it rained, 'which would not have been done if I had not been here'. As late as 1875 he was still directly superintending the work of the forester in the woods and plantations.[120] It was normal for him to 'look over' particular farms and he was 'at all times glad to discuss any matter of business with his tenants, except when he is shooting over their farms with his own friends'. Estate policy was sometimes reinforced in his speech at the twice-yearly audit dinner, still maintained as a regular event for a hundred or more tenants and other guests. The chaplain, Napier, attending in 1846, dreaded having to respond to a toast but described the occasion in other respects as 'always a pleasant one with lots of fun … for there is a large body of young men visitors who enjoy the "lark" of the audit dinner'.[121]

Under the stewardship of H. W. Keary, agent from 1851 to 1863, the farm and estate workshops at Longlands were rebuilt in lavish style.[122] There were also, however, significant innovations and improvements on the estate under Keary's successors. In the late 1860s there was a concerted programme of rearranging farms in various parishes, reflecting the increasing importance of livestock farming on the estate.[123] In 1871 a new form of lease was introduced, following discussions between the Earl and the members of a Tenants Lease Committee, who were entertained overnight at the Hall. It departed from T. W. Coke's leases, and from the traditional leases still granted on other

Norfolk estates, in removing all restrictions such as crop rotation, in recognition of the fact that new fertilisers enabled more grain to be grown without exhausting the soil. Lord Leicester disliked any suggestion that the new lease should be designated a model lease, declaring it was merely one suited to his estate and his tenants.[124] Similarly, although the Hall farm continued to breed cattle, the Earl made it clear that 'he has ceased exhibiting any breeding stock and that it is not his intention to exhibit in future except at the Smithfield Show'.[125] Improvement still featured strongly, however, whether a request to a tenant for a particular seed wheat 'by way of trial' or 'experiments upon a large-scale with deep cultivation' using 'first class manures'.[126] Visitors to Holkham still talked farming. One found the improvements to the Hall and grounds impressive but 'what interested me perhaps as much as these was the steam plough, which Ld Leicester puts to great account in his marsh land [the land recently reclaimed by the building of the Wells bank], & it will I suppose at last do wonders in agriculture'.[127] When cereal farming slumped in the late 1870s, Lord Leicester took a proactive approach on the Hall farm, laying 400 acres of the lightest land down to grass for six or eight years, then cropping it for four years, with 'the advantage to him that he has doubled his ewe flock'.[128]

Unlike his father, the 2nd Earl had the freedom to buy and sell land without the constraints of a settlement. He added approximately 2,490 acres, bought in 152 transactions, at a total cost of £184,907.[129] By far the largest addition was Quarles, 615 acres, immediately to the south of Holkham. First leased by Thomas Coke in 1719, the Earl finally acquired it in 1880 after many years of trying to negotiate its purchase from Christ's College, Cambridge.[130] He bought land at Fulmodestone because of its proximity to his other land there, centred on the manor inherited by John Coke from his father in 1634, but emphasised that 'he has no desire to extend his estate, and would prefer not to do so'.[131] The rest of his purchases bore this out, as most were very small acreages or individual cottages. He also built many cottages. By 1869 he owned 'more than 600 cottages in probably more than twenty parishes', rising to 840 by the end of his life.[132] He was interested in cottage improvement and he preferred to let cottages directly rather than with farms, for he strongly objected to labourers 'being constantly shipped about from one cottage to another'.[133] As a result of the Earl's purchases, by 1891 the estate acreage was slightly larger than in 1841. The gross annual rental, however, was slightly lower. Income had peaked in 1878 but within two years the national agricultural depression that particularly hit cereal farming was affecting Holkham tenants.[134] By 1893 all sixty-seven tenancies had considerable rent reductions. The net rental figures were dramatic: the

The 2nd Earl in 1889, aged 67.

Earl's income from the estate, which had been nearly £33,000 in 1842, was fifty years later nearly £10,000 lower. Furthermore, those figures took no account of the amount spent during the intervening years on buildings, fences, under-draining and land purchases.[135]

The exclusive economic importance of the estate for the history of the Hall lasted until the early 1870s. Until then, Lord Leicester made only small outside investments in local and agricultural concerns, particularly the Wells and Fakenham Railway and the West Norfolk Junction Railway. He refused to invest in other Norfolk railways for the specific reason that he was 'but slightly interested as far as my estate is concerned'. He then started to invest much more widely. This was unprecedented in the history of Holkham since Thomas Coke's unfortunate speculation in South Sea stock in 1720. It was given extra impetus by Leicester's second marriage in 1875: he later wrote that 'it never was my intention that Lord Coke [his heir] should derive any advantage from any investment I might make, beyond giving him entire freedom from any charges on the estate that might accrue from my second marriage'.[136] He may have been influenced also by the growing crisis in

farming already evident in other areas of the country. According to calculations made at the time, over the fifty years from 1842 to 1891 he had invested £558,156 in his estate in the form of buildings, repairs, fencing, under-draining and purchases of land, and during the thirty years after 1875 this figure was matched by his non-estate investments, valued at his death at £571,365.[137] His choice of investments followed national trends: initially British and Indian railways stock, joined in the later 1880s by investments in British breweries and in railways, banks and government stock in Australia, Canada, South America and South Africa, and in the 1890s adding South African mines, including gold mines. While his investments accumulated for the eventual benefit of his second family, they also enabled him to invest or donate a total of £58,000 between 1876 and 1902 for the new Norfolk and Norwich Hospital, its convalescent home and nurses' home, and the Jenny Lind children's hospital.[138] Investment income cushioned Holkham during his lifetime against the severe and sustained drop in estate income but, as early as 1884, Lord Leicester feared that future estate income would be insufficient to enable his son to live at Holkham. He considered that the minimum net income needed from the estate was £30,000. In 1891–92, however, the net profit of the estate was £22,751 while the interest on investments was £17,439. By the last year of his life, 1908–9, net estate profit had fallen to £18,767 while interest on investments reached £25,025.[139]

The longevity of the Earl, the existence of his young second family and the lack of an entail or settlement on the estate caused an unsettled situation towards the end of his life. The marriage settlement when he married Georgiana Cavendish in 1875 had provided for a jointure of £5,000 per year for her after his death and a sum for each child of £15,000. When he made his will in 1897 at the age of seventy-five, he had to take into account that she was thirty years younger, their six surviving children ranged in age from twenty-one down to four years, and any provision for them had to be made in his lifetime. He left the Weasenham and Wellingham estates to her and thereafter to their sons, the Kempstone estate to the second son, and an additional £5,000 to each child at the age of twenty-five. His executors were directed to spend £3,000 on fitting out Weasenham Hall, increased to £10,000 by a codicil in 1901 and increased again by codicils in 1903 and 1904. A further codicil made additional provision for the adult children.[140] The contrast with the situation when he had succeeded in 1842 was remarkable: legacies to the younger children were larger, and whereas then Longford had been left to the widow for life, now Weasenham, Wellingham and Kempstone, a total of 2,462 acres, were to be permanently alienated from the estate.[141]

Viscount Coke in 1908, the year before he inherited Holkham.

The heir, Viscount Coke, was nearly four years older than his step-mother. He was coming to the end of a long military career but his position regarding Holkham was insecure until he finally succeeded his father at the age of sixty. In 1904 his father offered him Model Farm, on the western edge of the park, and both the tone and content of Lord Coke's letter to his wife Alice on this occasion hint at the extent of his dependency (as a middle-aged man) on the Earl:

> I had a most satisfactory interview with the Father yesterday, far better than I expected, I can have practically a free hand, planting in the park ... This morning he cleared the room and had a long talk to me, the Model Farm ... is vacant next Michaelmas, and he has offered me that ... He wants me to look after the whole Estate, and I have very little doubt, from what he said, he will make it over to me, if he finds we mean to live there; it is all important that we should live there, and if he lives another two years, I think we shall probably get the whole thing, besides which there are other

reasons why we should do this … he made some very amusing remarks about Georgie, practically saying it was impossible to look upon this as our home, whilst she was here.[142]

In the meantime, the next generation had grown up. The Earl's grandson, Tom, born in 1880, had fallen in love at the age of nineteen with Marion Trefusis and was eager to marry her. Increasing tensions arose from the need to reconcile future expectations, current limitations and personal wishes in three generations. Around this time, the Earl's mental faculties began to fail: 'he has since that been worked upon when in failing health and has done things he has always said he would never do'. In the midst of this situation, Tom wrote to Marion that he had 'walked up to the house with the intention of seeing whether it would be possible to write anything down to my Grandfather [who was extremely deaf] … I opened the subject by telling Aunt Georgie [the Countess] we had both made up our minds to get married in October. She was so delighted to hear it'. Tom then discussed the matter with Wood, the Holkham agent, who warned him 'that it would not be at all wise to get my Grandfather to sign his name to any money matter now, as it would at once show that he was capable of altering his will, which was what both Wood and Father were doing their utmost to prevent'. Indeed, when Lord Coke learned of Tom's attempted approach to the Earl,

> [He] started off and worked himself up to the very worst temper I have ever seen him. He told me I was trying to do things behind his back, and that by being friends with Aunt Georgie, I had been the indirect cause of Grandpapa leaving another £25,000 away from the estate which he has apparently done the other day … He told me my marriage was a minor detail compared with the interests of the estate … you have no idea what a raging temper he was in … he ended up by saying "Remember it is quite within my power to leave the whole estate away to your brother if I chose."[143]

Tom's marriage hopes were then thwarted by suspected tuberculosis, forcing him to spend the winter of 1904–5 in Switzerland. In May 1905 the Earl was taken seriously ill; he rallied unexpectedly but Lord Coke was more than ever anxious that the Earl should not sign any document. Explaining the situation to Lady Trefusis, mother of Tom's intended bride, Coke wrote,

> He [the Earl] is more than ever under the influence of Lady Leicester but … she quite recognises that whilst he has two nurses and in his present state, anything he did would probably not be legal; but I am quite certain

that when the subject of Tom's marriage comes up, she will do everything she can to get my father to make a settlement knowing that ... then there will be nothing to prevent her getting him to sign other things ... if so, I look upon it as morally certain that Tom will never be in a position to live at Holkham.[144]

Instead, Lord Coke arranged a modest settlement for Tom from his own resources and Tom and Marion at last married in December 1905. At their wedding celebrations the Earl attended 'lying upon a couch in the presence

The 2nd Earl visited by his old friend, Edward VII, in 1907.

of his guests'. He spent much of the rest of his life 'as an old and rather terrifying bearded figure who lay, wearing a sombrero hat and dark glasses, in a wheeled bed in a corner of the drawing room'.[145] When he died on 24th January 1909, he left the Holkham estate slightly larger but considerably less profitable than at his succession sixty-seven years earlier, and a massive personal fortune derived from investment outside the estate. Holkham had not before seen such personal wealth and was not to see it much longer, as seventy per cent disappeared in legacies and estate duties. There was still a financial cushion for the next generation at Holkham but it proved to be uncomfortably thin. Moreover, the major repair, modernisation and refurbishment work on the Hall undertaken by the Earl was now forty to sixty years in the past.

Hotkham Hall. Nº 102. (superseding Nº 99)
Laundry Buildings, &c.

Elevat

The Rain-water
measur

Stove Room

Upper part of
Coal Cellar

Drying Closet

Maid

Mangle Room.

Laundry

Scale of

Chapter 13

Modernising the Practical House in the Nineteenth and Twentieth Centuries

The high standard of domestic technology incorporated during the building of the Hall served it well until a massive modernisation campaign in the middle of the nineteenth century. Improved water closets patented by Bramah were installed (as in many country houses) from the late 1780s; towards the end of the eighteenth century, when cooking by steam was coming into favour, a 'steam kitchen' was introduced, and a 'shower bath complete' was provided near one of the tower (attic) bedrooms.[1] Otherwise, however, there were no significant changes to the water supply, sanitation, heating, lighting and cooking facilities that supported both everyday life and large-scale hospitality, until the 2nd Earl inherited Holkham in 1842.

The most urgent requirement for the young and newly-married Earl and Countess was central heating, installed in 1843 in time for their first winter at Holkham. Although hot-water systems were becoming more common, the 'patent apparatus' fitted by H. C. Price at a cost of £1,328 18s was based on hot air, like the original, much smaller, installation. Air drawn in from outside was heated by passing over 'flat hot-water vessels … cased in a brick chamber, a boiler and furnace fixed contiguous to the vessels'. Four sets of apparatus, parts of which still remain, were spaced round the cellars, from which flues (including, it seems, the original eighteenth-century ones) delivered hot air through gratings in the floors, and by means of regulating valves, to most of the ground floor and parts of the principal floor. In the 1850s one man was employed specifically to tend the hot air furnaces.[2] As in the previous century, these and other boilers and coppers were heated by coal, usually brought by sea to Wells-next-the-Sea, two miles to the east, although in 1817 Mr Dewing, a local merchant, wrote to offer a load of coal from Liverpool lying at Burnham Overy Staithe, a much smaller port a couple of miles to the west. Tenants' leases still included a requirement to provide horse teams to

Detail of plan for the new laundry, 1856.

DIAGRAM OF APPARATUS.

SECTION OF BUILDING, SHOWING WARMING AND VENTILATING APPARATUS.

Reference to Warming Apparatus.

- A. Boiler.
- B. Expansion Box.
- C. Flow Pipe leading into flat warming vessels.
- D. Warming vessels.
- E. Main warm-air supply.
- F. Fresh-air shaft from exterior of building.
- G. Supply Cistern.
- H. Safety pipe.

Reference to Ventilating Apparatus.

- A. Boiler.
- P. Flow-pipe rising to warming vessels in rarefying chamber.
- C. Hot-water vessels.

Leaflet describing the central heating system installed in 1842.

bring the coal from the ports by road to Holkham and when a shipment lay ready to be collected, the Estate Office sent messengers to the farmers, who were to say 'the number of teams and days they will serve'. Typically, fifteen teams were needed to clear a ship in two days. After about 1866, some of the coal came by rail to the Peterstone siding, close to the Holkham brick works, on the West Norfolk line, although not without a threat from the agent of 'sending the trade back to the sea' when he discovered that the railway company was overcharging. In addition to coal for the house, different types

The oil boilers of 1997.

were ordered for the steam engine, blacksmith, gas making and brickworks; in 1868 the agent estimated the total consumption at 800 to 1,000 tons a year.[3] The total for the house itself, stored in the coal cellars, kitchen yard and the arches below the conservatory, was calculated at over 400 tons, 'and there is still storage to be found for coke'. It took twenty carters and trimmers a week, every May or June, to unload the coal destined for the house, recorded only because they dined each day in the Servants' Hall.[4]

Room heating continued to rely on open wood fires. The wood cellar along the west side of the house, stacked with faggots and graduated sizes of logs, has probably looked much the same for nearly 300 years. As staff numbers declined in the twentieth century, however, heating the house, which was necessary for conservation as much as comfort, became increasingly difficult. Successive models of coal furnaces heated only parts of the house, using the earlier flue system, and were supplemented by paraffin heaters and electric fires. For much of the twentieth century 'the result was an uneconomic and unhealthy combination of a few warm rooms with a majority of very cold and damp ones, where sub-zero temperatures were recorded in winter'. Improvements were made by the 7th Earl from the late 1970s, particularly the phased installation of hot-water radiators throughout the house. In 1997 highly efficient twin German oil-fired boilers were installed, providing nearly all heating and hot water for the whole house.[5] Seventeen years later, these in turn were superseded, this time by a bio-mass boiler, burning wood from the estate to heat the Hall and outlying buildings.

The spacious and airy kitchen was also refitted during the 1840s and early 1850s. Messrs Feetham & Co, a London firm of stove makers and heating

The kitchen, re-fitted in the 1850s.

The bread oven in the lower stillroom, later known as 'the old bakehouse'.

engineers, made extensive improvements, including a hot water apparatus, in 1846 and were paid in 1851–55 for ironwork in the kitchen, including the massive serving closets, warming cupboard and roasting range that are still in place and bear their name. It was probably at the same period that a new bread oven was built in the stillroom, where it is still in place. It is a traditional

Plan for the bread oven. Undated.

brick construction but, unlike the original bread oven, it was heated by an external coal grate.[6] Some of the other existing iron fitments bear the name 'George Wright Ltd', the successor of a Rotherham firm founded as George Wright & Co. in 1854, but details of their installation have proved elusive. The kitchen remained in use well into the twentieth century. The future 4th Earl filmed, for a few seconds, the open roasting range in operation in the 1920s and a former kitchen maid recalled that it was still used on special occasions as late as 1936–37. During the 1939–45 War, however, the kitchen was in the part of the Hall requisitioned by the army and a partition wall was built to protect the range. Although the wall was removed at the end of the war, the kitchen was not used again.[7]

By the beginning of the nineteenth century, when two dozen bell cranks appear in the accounts, a system of wires and cranks probably enabled all main rooms to be connected to a central bell board.[8] The major refurbishment in the Hall during the 1840s included a new bell system, installed by Messrs Feetham, at a cost of £812 12s.[9] In 1910, electric push buttons supplemented the old mechanical system in parts of the Hall.

Other major improvements were connected with the great range of new domestic offices built at the east end of the house in the 1850s. The greatest innovation, a water supply to replace the original well and horse engine in the octagonal engine house, proved to be a difficult and expensive technical challenge, involving not one but two new systems. The quantity of water consumed in the house, kitchen gardens, terraces and pleasure grounds was reckoned as a minimum of 20,000 gallons (91,000 litres) a day, but it was belatedly realised that the new fountain, centrepiece of the terraces under construction on the south side of the house in the 1850s, required at least 400 gallons (1,818 litres) per minute, far beyond the capacity of the original system. A leading London firm of waterworks engineers, Easton and Amos, was called in. James Easton had been responsible for sinking an artesian well to supply the new Trafalgar Square fountains, so successfully that the supply was extended to Buckingham Palace and major public buildings; he also built many town water supplies and 'a vast number of waterworks for different noblemen and gentlemen'.[10] He was not, however, entirely successful at Holkham. The new system took two years to complete, at a cost of £2,730.4.0, and was in operation by May 1855. It relied on pumping water from the lake, west of the house, by a steam engine erected in the new buildings east of the house. The engine also powered the malt mill, brewhouse machinery and the oat crusher and chaff cutter in the stables, while 'waste' steam was piped across the yard to heat the coppers in the new laundry. The lake water was filtered through fine gravel and an iron 'strainer' into an underground tank

near the lake and then pumped along a 'suction pipe' under the north lawn, for the full length of the house, to a well next to the steam engine. This new well received the water drawn from the lake and did not itself tap any source of water. At this point, a supply for the house was taken off along a seven-inch main; it linked up to the old pipes from the original engine house but fears that 'we shall make sad havock among the old pipes, some of which have been in a hundred years' proved unfounded.[11] As cisterns were insufficient to store the supply now needed, a reservoir was constructed in the park, about a mile to the south of the Hall, where a slight rise in the ground was sufficient to allow gravity feed back to the house, stables, fountain, terraces, pleasure ground and kitchen gardens. The reservoir was 136 feet in diameter at the top, ninety feet at the bottom, and eight feet deep (41.5 by 27 by 2.4 metres), with a 'puddled' base, replaced with brick some years later.[12]

The new water source failed within nine years. A dry season in 1863–64 affected the springs feeding the lake and exacerbated the problem of water quality, for 'the overflow from the sewers (not the actual sewage, which is deposited in a large cess pit on the lawn)' fed into the lake. As a result, the supply to the house nearly ceased. The only long-term solution was to sink a new well, 'to run no risk of having to go back to the lake water again'. The 'dry suction main which takes its supply from the lake' still had some use as late as the 1930s, but only as a source of water for the estate fire engine.[13] Sinking the new well began early in November 1864, again in the hands of Easton and Amos, working with a well sinker, Thomas Tilley. It was expected that the sinking would have to go to more than one hundred feet (30.5 metres) to obtain a regular supply. The amount of incidental water from the chalk springs, up to a hundred gallons (455 litres) per minute, soon caused problems, although, as the months passed, it served to provide a temporary supply for the house. At a depth of twenty-four feet it became necessary to continue by means of a six-inch (15 cm) bore. By March of the following year, at 230 feet, there was still 'no immediate probability of obtaining a supply of water'. At this point Holkham lost patience with Easton and Amos (now both on the eve of retirement) and turned to another London firm of hydraulic engineers, Messrs Clinton and Owens, who recommended a London well sinker, Thomas Clark. A year passed before he reached a supply at 700 feet in April 1866. It had been a demanding job but the Holkham estate agent wrote, 'I see your team have earned about £600 in the year, so that, bad as the work was … I don't think you will complain of the job'.[14] At this point, Clinton and Owens were consulted about piping the supply and reinstating the pumps. Sand rose into the bore, however, so that water was clear only above 500 feet. The bore was then piped but the Holkham

agent was tempted to advise Lord Leicester 'to submit to the annoyance of considering the artesian well a failure and abandon the work'. Nevertheless, the shaft of the well was deepened to fifty-eight feet and lined with cast iron cylinders. The two pumps were at last re-fitted early in 1868, more than three years after the start of sinking. Up to 540 gallons (2,455 litres) a minute could be pumped, so it was expected that the engine would need to be run not more than three days a week. The well aroused considerable interest in local geological circles, as one of few wells sunk through such a great thickness of chalk (635 feet, or 193.5 metres) and casting new light on the strata below.[15]

Illness in the household in 1868 prompted the local doctor to send samples of the well water to Alfred Taylor, Professor of Chemistry at Guy's Hospital, who was a well-known forensic toxicologist. The professor replied that he had 'never analysed better water … and very rarely indeed any so good' and was inclined to blame symptoms of lead poisoning on the use of patent hair restorers. In later years, rust from the cast-iron cylinders lining the well discoloured the water so much that the laundry maids resorted to tying flannel bags over the taps, after which a charcoal filtering system was installed. The steam engine working the pumps was replaced in 1910 by an electric engine. Nearly a hundred years later, the steady thumping of the

Looking down onto the pumps in the artesian well.

pumps for a few hours each week, gently audible even in the archives rooms at the top of Kitchen Wing, ceased when they were replaced by a single submersible electric pump; it is often overlooked that sounds and smells, as well as buildings and landscape, have disappeared into the past. The artesian well supplied the Hall until two mains supplies were connected in about 1960. It continued to supply the fountain and gardens, by way of the reservoir, until pipes to and from the reservoir finally failed in the first decade of the twenty-first century.[16]

Most water was used in the laundry, which was originally in the cellars of Chapel Wing. In the 1850s it was moved into a new purpose-built building at the east end. Here the coppers were heated by excess steam from the new steam engine across the yard, 'instead of in the usual mode', and the drying room was heated by hot water pipes. On a typical Monday in 1882, the laundry used 160 gallons (727 litres) of water each hour for five hours. By that period, commercial laundries were generally taking over the work of large domestic laundries and, nationally, there was a sharp decline in the number of laundry maids. At Holkham, however, coping with the laundry was a major exercise well into the twentieth century, requiring four or five laundry maids and a manservant who worked the steam engine on Mondays and Tuesdays, stoked the laundry boiler three or four times daily (with the disadvantage of smoking chimneys relatively near to the house) throughout the rest of the week, and on Saturdays spent two hours carrying linen to and from the house.[17] Washing for servants with particularly dirty jobs, such as the roasting cook, was often sent out but paid for on the household account. Otherwise servants made their own arrangements; household regulations stated that washerwomen delivering parcels for servants were strictly forbidden to enter the Hall. One such washerwoman was Widow Ransome, who in 1884 had a ten-year-old son working in the blacksmith's shop and four younger children; she took in washing for one servant at the Hall and another at the vicarage.[18] The laundry building (subsequently converted for other uses) fell out of use as staff numbers declined and electric washing machines became available. By the 1940s there was a much smaller laundry in the cellars of Family Wing, using a rainwater supply piped from a pond between the west wings. Perhaps unusually, all laundry in 2000 was still done in-house, the laundry maids replaced by one woman, aided by modern appliances.[19]

Despite the new water supply of the 1860s, bathrooms remained in short supply, by later standards, well into the twentieth century, even for the family and guests. A daughter-in-law of the 3rd Earl, visiting Holkham early in the century, recalled (slightly inaccurately) that 'at this time there was only one

Plan by William Burn for the new laundry and servants' washhouse, 1856, later changing successively to pottery shop, gift shop and, in 2016, events venue.

bath at Holkham and we all had tubs in front of lovely fires', an arrangement which generally was considered by no means unusual or undesirable.[20] Servants' washing facilities are less clear. Before the 1840s, they had a wash house in Kitchen Court and the architect William Burn proposed a similar arrangement in the new laundry building of the 1850s.[21] Indoors, their washing arrangements were probably not much improved before the twentieth century. After one of the menservants' rooms in the upper floor of Kitchen Wing was partitioned to form a bathroom, a former kitchen maid recalled many years later that, once a week, the men were banished from their quarters so that the female kitchen servants could take a bath, the only time that they were allowed out of their own area of Kitchen Wing.[22]

The domestic offices built in the 1850s included a new brewhouse, fitted out by a London firm, Pontifex and Wood. The old brewhouse pump was reused but was powered by the new steam engine. Brewing was ordered by the butler but was in the hands of a part-time brewer. In the early decades of the nineteenth century, a year's supply of hops, about twelve to fifteen hundredweight (up to 0.75 of a tonne), was ordered in early September,

The laundry c.1910.

The laundry building.

ready for brewing within the next few weeks. Different types of hops were used 'for the house consumption' and 'for the mild beer which he [the butler] brews exclusively for Mr Coke's table'.[23] The new brewhouse probably fell into disuse within two or three decades; commercial breweries were expanding rapidly and houses built after 1870 rarely had a brewhouse. The

Laundry maids Molly & Mary on the drying ground, 1920s.

servants' beer allowance lasted until about 1882, after which it was replaced by a fortnightly cash payment, but by then the beer was already being bought in. The brewhouse survives but without any machinery, its original function indicated only by the louvres in the roof.[24]

Another original feature which fell out of use at the same period was the icehouse. It was still in use in 1857 but in the second half of the nineteenth century American or Norwegian ice was supplied by dealers in London or, from the late 1880s, King's Lynn. It was delivered, winter or summer, by rail to Holkham station, at busy times as much as 300 to 600 pounds every three days, even occasionally 1,000 pounds (454 kg). It cost about five shillings per hundred pounds. The frequency of deliveries by rail suggests that ice was now kept in an icebox in the house and used immediately.[25] In about 1912, the new private electricity system led to the conversion of one of the original dairy rooms at the bottom of Chapel Wing to accommodate an ice-making plant, consisting of a motor, brine pump, compressor and condenser, and an ice tank about four feet square and three feet high (122 by 91 cm). Brine pipes ran from this apparatus to a heavily-insulated cold room, divided into two. The latter is the only part of the installation still in place; its survival enabled a plan of the ice-making plant to be matched with the location.[26] Here, country house technology was ahead of commercial firms, at least locally. Arthur Ramm, the butcher in Wells-next-the-Sea, knew of no commercial refrigerator nearer than Norwich and refused to go to the expense of a well, pump and engine, to install one. He said that it would add ten per cent to the cost of his lordship's meat and added, 'I believe I am correct in stating that during the summer months, the mansion refrigerator is kept working for the preservation of dairy produce, fish and poultry, as well as for making ice, and I venture to suggest that it would be cheaper for his lordship

to utilize his own plant for the preservation of meat also'.[27] The requirement that Ramm mentioned for 'an unfailing and liberal supply' of water for such plants was demonstrated by a broken pipe in the room in 2001. The supply had apparently been taken off the main pipe from the reservoir and, with no stopcock visible either on site or on archival plans, the forceful jet was lessened only by running the fountains and fire hydrants overnight.[28]

In the nineteenth and twentieth centuries, lighting prompted two of the most extensive technical innovations in the Hall: a private gas supply and, later, installation of electricity. On 16th October 1865 the house porter noted at the front of his book that gas was lit for the first time at Holkham.[29] Because of the expense of private gas works, the typical country house lagged behind municipal improvements; even in North Norfolk, the small town of Wells-next-the-Sea, two miles from Holkham, and the market town of Fakenham, twelve miles away, had had gas works in operation for the past nineteen years. The agent briefly considered connecting to the public supply at Wells-next-the-Sea but instead a private gasworks for the Hall was erected in 1865 next to the kitchen gardens, a safe distance (770 yards or 704 metres) from the house.[30] Built by Messrs Porter & Co. of Lincoln, it

Plan for the ice plant installed in an old dairy room in the cellars of Chapel Wing, *c.*1912.

consisted of a gas-holder 22 feet in diameter and 10 feet deep (6.7 by 3 metres), capacity 310 cubic feet (nearly 9 cubic metres), and a gas house containing three retorts.[31] The brick and flint retort building survives but the plant was removed and the gasholder demolished in the 1960s. The total cost of the installation was about £1,000, the pipes within the Hall, so the Holkham agent wrote, making 'the expense ... from the construction of the mansion, very much greater, as I am informed, than is generally the case'. In the same year, by comparison, the whole of the factory and residential buildings at the Quarry Bank cotton mill at Styal (Cheshire) were equipped with a private gas works and gas lighting at a cost of £1,453.[32] At Holkham, the total number of burners was 167, mostly on brackets, and the annual cost of gas was £30. The system was capable of being extended to 300 lights, 'in case the principal rooms in the house should hereafter be lighted', but gas was still rather dirty and smelly and, as in many other country houses, it was installed only in the passages, kitchen, servants' rooms, stables, laundry and estate office.[33] Indeed, at the beginning of 1865, the year in which gas was installed at Holkham, a specialist firm, Perry & Co, was paid £107, roughly equivalent to one month's normal total household disbursements, 'for lighting the rooms' with candles, including 300 in the Saloon, for a ball attended by the Prince of Wales.[34] For everyday purposes, the housekeeper issued and recorded every Saturday the candles required by the housemaids and for the laundry, kitchen, stillroom and nursery; the children and nursery maids sometimes had to make do with cheaper tallow candles.[35]

The gas house.

Plan for the gas house, differing slightly from the works as built.

The expensive gas system installed in 1865 lasted less than fifty years. Gas lights were improved by the invention of the incandescent mantle in the 1880s but a report in 1905 revealed that Holkham had failed to switch to the new type.[36] In 1908, towards the end of the 2nd Earl's life, a rather half-hearted attempt was made to switch to 'Loco Vapour Gas'. This was 'ordinary air mixed with the minimum amount of petrol vapour necessary to form an illuminant'. It was advertised as non-explosive, inexpensive, clean and safe, and was enjoying a brief vogue in large houses, as a cheaper alternative to electricity. Indeed, having seen it at Holkham, Sir Savile Crossley made enquiries about it even though his house at Somerleyton (Suffolk) was already lit by electricity.[37] At Holkham, three machines, to run up to eighty lights each, were installed at a total cost of about £370. The supply, however, was connected to the existing gas pipes and problems in 'the adjustment of over 150 lights in large rambling buildings on old coal gas pipes' resulted, on the one hand, in complaints by the Loco Company that 'the foul and choked condition of the pipes is doing much harm to the reputation of our machine' and the verdict of the Holkham agent, on the other hand, that the system was 'disastrous': 'I can assure you I wish I had never heard of the Loco System'.[38]

Compared to many country houses, electricity came late to Holkham, probably because of the conservatism and increasing infirmity of the elderly 2nd Earl when such an installation might first have been possible. Just as his succession in 1842 had been marked by major modernisation, his death in

Chapter 13 Modernising the Practical House in the Nineteenth and Twentieth Centuries 377

1909, at the age of eighty-six, opened the way for extensive refurbishment. This included the immediate construction of a private electricity generating plant, powered by a producer gas plant. The power house, built as an extension along the west side of the stable block, contained the gas production area at the north end, the engine room in the centre and the battery room at the south end.[39] The two twenty-five horsepower four-cylinder engines powered twin 250 ampere, 110 volt direct current generators. The engines were usually run alternately, not necessarily every day, but both engines could be used together when demand was exceptionally high. The electrician kept a detailed daily record. In essence, this was a typical country house system but it was distinguished by the enormous storage capacity of its batteries, avoiding the fluctuations in supply that affected some country houses.[40] Each battery consisted of positive and negative plates suspended in sulphuric acid in a rectangular glass-lined wooden box measuring three feet high by six feet long by two feet wide (91 by 183 by 61 cm). There were fifty-five of these cells, plus five spare, arranged in four rows. Fully charged, they allowed 800 light bulbs (each of one hundred watts) to be used simultaneously for a discharge period of at least twelve hours, even with both engines at rest.

Advertising leaflet for the Loco Vapour Gas system, installed in the Hall in 1908.

The power house building added onto the stables.

During three to four years, an army of men installed the heavy underground distribution cables, the white marble switchboards in elegant wooden cases and the wiring and fitments throughout the Hall, including the conversion of chandeliers. The installation provided for a total of 1,920 lights. The first demonstration happened remarkably quickly, for the future 4th Earl delayed going back to London to see his newborn daughter, Silvia, in October 1909, because 'they hope to start the electric light on Tuesday and I should so much like to be here for that'.[41] Completed at a cost of £2,730, in time for a royal visit early in 1913, 'it was all regarded as a major technical achievement'.

Less than twenty years later in the early 1930s, the Holkham agent learned that the East Anglian Electric Supply Company was bringing a mains supply along the coast. By now, the equipment in the power house and the wiring in the Hall were showing signs of age and the agent told the Company that 'if your charges were fairly reasonable, it is quite possible we should be good customers'. He calculated that the annual consumption was about 30,000 units. After more than two years of bargaining over the cost of laying the cable through the park, the mains connection to the Hall was made in 1933.[42] The proximity of the mains supply was, however, only the first step. The ageing and unearthed wiring in the Hall was unsuitable for connection to the higher voltage AC (alternating current) mains, so a transformer was installed to reduce the input supply. This then had to be changed to 110 volts DC (direct current) to match the earlier system, a problem that was solved by a

Diagramatic plan of the generating system.

The producer gas area.

380 HOLKHAM

The twin generating engines.

The battery room.

newly-invented device, a mercury arc rectifier, also known as a Hewittic rectifier. The type used at Holkham was a glass bulb or valve, six foot high with a maximum diameter of two feet six inches (183 by 76 cm), held in a frame; it contained a pool of mercury and had three projecting terminal arms, connected to the AC output from the transformer. The whole apparatus was contained in a perforated steel cabinet, about eight feet (244 cm) high. In operation, the mercury in the valve boiled and vapourised, then condensed

Tommy, the future 5th Earl, and his sister Silvia with the electrician and chauffeur, outside the generating engines room, c.1917.

and trickled back into the pool. It flickered constantly and emitted a blue ultraviolet light, while up to three small flames, called 'chasers', moved on the surface of the mercury pool, their number, size and speed depending on the load on the system. Consequently it was 'an awe inspiring sight and at first glance rather frightening, all this accompanied by a variable strength AC hum, the noise ... of the comparatively heavy mercury droplets falling back into the pool and the intermittent automatic starting and stopping of the cooling fan'. It performed well, despite frequent power cuts in the mains supply before the district ring supply was completed in 1937. It was probably the largest mercury valve in use at that time, and a great novelty. The Holkham electrician, having transferred to the new company, continued to visit the old Power House at Holkham in the course of his duties and 'always took the opportunity to enjoy the gasps of surprise by visitors who he thought might be interested and saw the Rectifier for the first time'. By the mid-1940s, however, the DC electrical system was proving inconvenient, as the domestic appliances that were increasingly available were designed for 240 volts AC, and in 1950 it was found to be in a dangerous state.[43] Rewiring the Hall started urgently and took eight to ten years. 'So ended a system which was regarded as a "local wonder" in its day.' The obsolete rectifier and a spare were eventually broken up to recover the mercury; similar rectifiers are now collectors' items, although a few are still in operation in old

The mercury arc rectifier, in operation from 1933 to c.1950.

installations. In 1994 the sight of pitch dripping from an overheated electricity cable warned that rewiring was again due. A new supply was connected and, again over a period of ten years, one electrician replaced all wiring and fittings throughout the Hall.[44]

It could appear a matter of luck that the house, its art treasures and occupants have survived nearly 300 years of candles, open fires, gas, petrol vapour and early electrical systems, but precautions against fire were always important. Accidents did happen. During the first stage of building, Widow Lack was paid for ale for 'some men who assisted when Mr Brettingham's room was on fire'.[45] During extensive redecoration in the early-twentieth century, soot doors in a chimney breast, in a room used by visitors' valets, were obscured by a wooden panel, resulting eventually in a chimney fire that spread to furniture. As the room was above the Landscape Room and near a linen cupboard, 'it was very fortunate', wrote the agent, 'the whole wing of the house was not gutted entirely'. One of the primary safeguards had always been regular attention by local sweeps but no plans of the chimney runs have survived. There was a fire engine, equipped with leather hoses, by 1750 and many subsequent models.[46] In 1854, for example, an 'engine for 20 men, price £140' was bought from Messrs Merryweather. The hydrants

ORDERS IN CASE OF FIRE
HOLKHAM HALL.

1.—The Fire Alarm is placed close by and near the Telephone Box on the left side of the Hall Porter's door.

2.—The person first discovering the fire will proceed to the Fire Alarm, break the glass and start the hooter and bells ringing, by pressing in the push.

3.—All Female Servants will at once assemble in the front hall. All Male Servants not told off for other duties will assemble on the front lawn, and in front of the smoking room on the terrace, and wait for further instructions, the under Butler will secure the key and open the smoking room door, which is kept in Porter's room.

4.—The fire detachment will be composed and numbered as follows:

No. 1 will be 1st Electrician.	No. 8 will be 4th Groom.
2 ,, 2nd Electrician.	9 ,, Oddman.
3 ,, 1st Chauffeur.	10 ,, Kitchen Boy.
4 ,, 2nd Chauffeur.	11 ,, Laundryman.
5 ,, 1st Gooom.	12 ,, Hall Boy.
6 ,, 2nd Groom.	13 ,, Stewards room Boy.
7 ,, 3rd Groom.	

The Hall Porter will be in charge of the Fire Ladders.

5.—Duties of detachment: Nos. 1, 2, 3 & 4 will man the Fire Engine. No. 4 will at once proceed to light the fire and warn Nos. 1, 2 and 3.

6.—Nos. 5, 6 and 7 will proceed with all haste to the Fire Engine shed and secure one length of hose each, and will be marched under No. 5 to where the fire is, and find out the nearest hydrant. No. 13 will turn on the water at the top reservoir. No. 12 will secure the turn cock and two branches and proceed with 5, 6 and 7.

7.—Nos. 8, 9, 10 and 11 will secure the Fire Ladders and proceed to where the fire is, under charge of the Hall Porter.

8.—The Groom of the Chambers will at once proceed to warn His Lordship, Her Ladyship and Family.

9.—The Butler and Housekeeper will assemble the Male and Female Servants respectively at the places indicated and wait for further instructions.

10.—The 1st, 2nd and 3rd Footmen will at once proceed to warn all Servants in the house and then return to their places of assembly.

11.—No one to disperse until orders are given by His Lordship.

12.—The Park Gates are to be locked at once, and no one allowed in except on duty.

13.—All men employed in Kitchen Garden will assemble with the Male Servants.

14.—All persons employed in the Estate Office will assemble in the front hall.

15.—The Clerk of the Works will attend at all times to give assistance.

16.—Fire Ladders can be obtained *from the wall outside the lower Kitchen*

17.—All Servants are requested to make themselves acquainted with the above orders.

Orders in Case of Fire, *c.*1912–30.

round the exterior of the house, which continued until recent years to be a source of water for modern fire brigade pumps, were the first item to be tested when the new water supply from the reservoir was ready in 1854; they were required to throw the water 'over the towers, or at least over the body of the house'.[47] When the house was overhauled in 1910, a Fire King steam engine was bought, capable of delivering 500 gallons per minute, but its usefulness was somewhat limited by the fact that it took fifteen minutes to raise steam. It saw action for the first time eight years later against a fire at the timber yard at Longlands but failed to prevent extensive damage.[48] In the early 1930s, a report by Messrs Merryweather declared Holkham 'one huge fire risk' but their recommendations were shelved because, the agent admitted, 'the expense of keeping up this large estate leaves very little to provide new fire appliances'. Eventually, in 1935, a second-hand petrol engine was bought. The introduction of electricity in 1912 made possible an electric fire alarm in the Hall, with one break-glass push-button near the Porter's Door, connected to hooters and bells. Printed regulations detailed the servants' duties if the alarm sounded. Installation of a modern fire detection and containment system, with direct communication to fire brigade headquarters, began in the 1980s. More recently, Holkham was said to be the first great country house to install a photo-luminescent way guidance system in the cellars and attics, for use of fire brigade (or trapped staff) in darkness.[49]

Fire engine drill with the steam 'Fire King', c.1930: from film footage shot by a member of the Coke family.

Chapter 14

Overview: The Village

The great attraction of Holkham Hall to modern visitors and scholars is the fact that so much from the eighteenth century has survived intact. The village is far more enigmatic. There is now no visible hint that originally there were two villages: like others on this stretch of coast, such as Burnham Overy and Brancaster, one settlement, the 'town', lay on the road linking villages slightly inland, while a separate settlement clustered at the staithe or landing place, hugging the creeks, more or less navigable, on the edge of the marshes. Holkham town lay around the manor house that preceded the Hall on almost the same site. Many of its cottages were removed to make way for the Hall but it lived on as a small group of houses, farm premises and inn for another forty to fifty years, disappearing completely only after 1800. Holkham Staithe, the surviving village, a mile to the north, appears at first sight to be a formal estate village, its late Victorian semi-detached houses and Reading Room dignifying the approach from the coast road up to the park. The partial remodelling of this village in the late-nineteenth century, however, obscures the fact that for centuries it had been a traditional village of owner-occupiers and small absentee landlords, whose cottages and tenements clustered haphazardly round a central focal point. At least one building (the Ancient House) dates back to the sixteenth century, two cottages are known to have been occupied since the eighteenth century and there are several survivals from a massive but little-known building campaign in the first half of the nineteenth century. A third village, Longlands, later known as New Holkham, a small group of houses just outside the southern park boundary, did not exist at all before 1796 and was later rebuilt, while the church, standing isolated on a hill at the northern edge of the park, might seem to hint at the site of an early lost village that, in fact, never existed. Written records reveal how the long slow transition from two medieval villages to one closed estate village, the creation of New Holkham and the fortunes of all other buildings in the parish, including the church, were

Octagon Cottage, built 1801, and the almshouses.

dictated by the creation of the Hall, the development of the park and the eventual hegemony of the parish under Coke ownership.

*

Both Holkham town and Holkham staithe had a long medieval history. Thomas Clerke's map of 1590 shows at least twenty houses worth identifying at the town and the separate cluster of 'stathe crofts'.[1] The focal points of the town throughout the seventeenth century were the two manor houses, one occupied by the Coke family, the other a tenanted farm, but the Coke family also acquired other houses and cottages as part of larger purchases. Eight cottages, for example, came with Burghall manor and four more as

The village of Holkham town in 1590, and the key naming some of the occupiers.

Thomas Coke's first purchase.

part of Newgate's estate, as well as several farmhouses associated with purchases of land. The parish also contained many smaller, separately owned properties, a peculiarity dating from the Middle Ages when a multiplicity of weak manorial lordships had allowed considerable scope for activity in the land market by small freeholders.[2] The process of acquiring these individual properties by successive members of the Coke family during the next 200 years reflected their territorial, building, farming and social ambitions.[3]

In the early-eighteenth century, Thomas Coke's guardians made purchases whenever properties became available, including at least seven dwellings at one or other of the villages.[4] Thomas accelerated the process as soon as he took possession of the estate in 1718: the deed for his first purchase in that year was annotated 'No. 1, New Purchase', presaging a determined policy.[5] Inevitably, many of his transactions targeted land but, out of sixteen purchases in the parish during the next seventeen years, at least ten included a house or cottage. Not all the cottages bought by his predecessors survived (one had been demolished by the guardians because an alternative house was better situated for a particular farm) and he himself removed at least four cottages in the late 1720s to make way for the new walled kitchen gardens, but by 1734–35, when building work started on the Hall, he was receiving rent from about twenty-three cottages and a new house on the marsh.[6] It is significant that his purchases after that date included no more dwellings, indicating that he had acquired all the village cottages that could affect his plans. In the 1740s, as work progressed on the main part of the Hall,

Cottage tenants in 1748: a typical page from the Audit Book or estate rental.

he still had tenants occupying seven houses at the town and thirteen dwellings at the staithe, plus the marsh house, now divided in two.[7] At least four more houses were repaired (and therefore presumably owned) by the estate but paid no rent, and farmhouses were included in tenanted farms. The prevalence of small landlords and owner-occupiers willing to sell, combined with the proximity of the old settlement at the staithe, enabled Coke to acquire the cottages that he needed to demolish and others that could accommodate

his displaced tenants. Creating the park and building the Hall did not entail a significant reduction in the total number of cottages in the parish, a complete clearance of Holkham town or (as had happened at the Walpole seat at Houghton) the construction of a new estate village outside the park.

The process of relocation and demolition first becomes apparent in the accounts in 1727–29, just as work started on building the walled gardens. Four cottages were demolished nearby but all the tenants were found new homes, including 'the new house at the marsh' and a farmhouse in the staithe village which had just been converted into cottages.[8] The old Neales manor homestead still stood to the west of the new kitchen garden and there were a few remaining buildings and closes on the opposite side of the road but the town well and the stocks, mentioned in earlier deeds, probably disappeared under the walled gardens. A few cottages further east were sandwiched uneasily between the gardens and the newly landscaped south lawn. North-west of the old hall's yards, on either side of the road that led from town to staithe, a larger cluster of buildings included a smithy, Jolly's carpenter's yard, a homestead with an orchard and several cottages lining Sanders Lane, the old Wellgate Waye that branched off eastwards to Wells-next-the-Sea.[9] It was in this area that demolitions, hot on the heels of purchases, accompanied the start of building work on the Hall, but still the first wing rose between 1734 and 1741 cheek by jowl with humble cottages. A tenanted cottage near Sanders Lane was bought from John Kemp of Burnham Overy, yeoman, and a small dwelling next door from John Oaks, a Holkham yeoman; the latter, formerly part of a barn and measuring sixteen feet in length, was demolished in 1739.[10] Two more tenanted cottages on Sanders Lane were bought from Thomas Faircloth, a Titchwell man, and Henry Anderson, a Holkham yeoman. A widow continued as tenant of one of them, with its acre of land, until her death in 1737 and it then housed another widow whose previous house had blown down, before being demolished a couple of years later. Slightly closer to the village centre, the west end of a tenement 'conteyning one low room and a chamber over it' was bought from a blacksmith, William Dow, and destined for demolition in 1741, while a tenanted cottage was acquired from William Jolly, the village carpenter.[11] Some cottages were left empty for several years before demolition; there were five such vacant cottages in 1734–35. Robinson's, for example, bought in 1726, immediately lost some outbuildings to the walled gardens and stood empty for five years, its occupier having moved to a staithe cottage, before being demolished in 1737. In other cases, nature lent a hand: a cottage occupied by Thomas Gooch collapsed and part of Widow Shulthram's cottage, one of a couple bought from Henry Knatts, was blown down.[12]

Holkham town in about 1745.

Vacant cottages and accidental collapses hint at the poor state of cottages. Tenanted cottages were particularly likely to have been neglected and if this were the case when the previous owner had been one of the larger Holkham farmers, such as Henry Knatts, it was even more likely when the former landlords had lived outside the parish. Sometimes the inclusion of a wife as a vendor indicated that it was her inheritance that was being sold to Coke: a yeoman of Stiffkey and his wife sold a tenement, and an apothecary of Bury St Edmunds and his wife sold a house and fifteen acres.[13] On the other hand, a house at the staithe bought by Coke's guardians as part of the estate of William Nettleton, gentleman, was a large sound house, capable of conversion into four cottages in 1727. Subsequently their rent was paid by the overseers of the poor for many years, possibly even until 1809 when the four 'poor houses' (distinct from the endowed almshouses) were described as dilapidated.[14] There is little evidence to indicate whether or not the condition of cottages improved under Thomas Coke's ownership but there were frequent entries in the accounts for repairs and thatching.

By the 1740s, when the first wing of the new Hall was occupied and work was proceeding on the main part of the Hall, it is likely that most of the old dilapidated cottages had been removed. It is striking, however, that Holkham

town was by no means a village in the course of wholesale clearance. In 1745 a new farmhouse was built there for Henry Knatts at a cost of over £419, improvements at the inn cost £219 and £105 was spent on the smith's and wheelwright's shops.[15] There were new arrivals, too, notably James Lillie, the carpenter who was to work on the Hall for thirty years, his partner Edward Copeman and the bricklayer, John Elliott. These were men of some standing. Lillie moved into a house previously occupied by the head gardener and then into the house that had been the home of George Appleyard, the estate steward, and Copeman lived in a house next to the walled gardens that was later considered suitable for the Rev. Dr Alston.[16] Their neighbours included a few key domestic and estate employees: John Neale, footman turned house painter, a journeyman smith, the coachman and Clement Seels, whose services crop up in the accounts in various roles. Five of the seven houses were demolished in 1752 but only after Lillie and Elliot had built new estate houses for themselves, under an arrangement whereby the rent, which at £5 was considerably more than for most cottages, was abated for ten years.[17] Clearly Lord Leicester was in no hurry to lose such tenants as neighbours. As the former clergyman's house was soon divided into three, the number of tenants living at Holkham town remained at seven. Other houses rarely appeared in the accounts because the tenants lived rent free, including the steward, the gardener and the farm bailiff, the latter at the old Neales manor house which became the centre of the Hall farm.[18]

Apart from the principal craftsmen living in Holkham town, no marked correlation can be traced between Coke's cottage tenants and the men known to be employed in building the Hall. A few coincide: tenants at the staithe included Gamaliel Gregory, a labourer, Robert Jackson, a bricklayer, Nicholas Winch, a sawyer, and William Metcalf, who had moved there from the old village and headed teams of labourers working on the new landscaping. It is impossible to draw any conclusions, however, as there were still many cottages in other ownership whose tenants could well have worked for Coke. It is nearly as difficult to trace any link between the availability of building, domestic and farming work and the prosperity of villagers. Lady Margaret provided clothing for the poor of the parish for at least fifty years, from 1722 to 1772, for which she characteristically kept meticulous records.[19] Most was supplied to women and children, the annual number of recipients until about 1760 varying from fifteen to seventy-one. A sharp rise in the number of male recipients after 1763 might reflect a decrease in labouring work as the Hall at last neared completion but more general conditions might also have played a part, for poor harvests in the mid-1760s precipitated food riots in Norwich and further afield.[20] By 1772, clothing was given to a total of 115

A typical page, 1748, from Lady Leicester's record of gifts of clothing and food 'to the poor', 1722–74.

people, including twenty-one men, twenty-six women, thirty-seven girls and twenty-nine boys. From 1752, Lady Margaret also gave beef and flour at Christmas to a larger proportion of the inhabitants, ranging from fourteen pounds (6.35kg) of beef and meal for a family to eight pounds for single people. In 1757, when there was still building work at the Hall, recipients included forty-three households or 129 people (nearly half of them children) whereas in 1773, the year before her death, sixty-six households (whether families or individuals was not specified) received meat and flour. Clearly the proximity of a great household, six farms and building work on the new Hall did not ensure universal prosperity. If T. W. Coke's later assertion that the population was under 200 at this period was correct, then over half of the inhabitants needed help with clothing and even more received a Christmas bonus of beef and flour. The charity dispensed by Lady Margaret did not differentiate between estate tenants and other villagers; in that respect, the staithe village, distanced though it was from the Hall, was already treated as an estate village. Lady Margaret had her finger on its pulse, noting that two women did not receive their gowns one year 'because they would not go to

service' and Widow Pickford forfeited her beef one Christmas 'for keeping the girle at home'.[21] In addition to such general charity, in 1755 Lady Margaret bought land from Staithe Farm in order to build and endow almshouses, completed in 1759 and still in use.[22] They stood apart from the rest

The almshouses, built in 1757, with a wall or screen separating them from the village to the north but open to the park on the south, as shown on an unexecuted plan by S. S. Teulon for a new gatehouse to the park, 1846.

The almshouses *c.*2005.

Chapter 14 Overview: The Village 395

of the village, perhaps to avoid the hurly-burly of a working village, perhaps symbolically hugging the park pale. A wall or outbuildings originally linked the two pairs of dwellings to form a three-sided courtyard facing the park and it was only in 1846 that they were altered to frame a public entrance into the park. The six occupants received a weekly allowance and a suit of clothes every other year, specified in the trust deed as a greatcoat for each man and gowns for the women, 'to be always of a blue colour'.[23] The estate also paid for nursing by village women, medical attendance and funeral expenses for the occupants.

Buildings in the parish landscape were not, of course, confined to cottages and houses. Farms and smaller tenancies had barns, granaries, stables and hog sties. Barns that were rebuilt in brick and tile after a great storm in February 1714 included three that were twenty-two or twenty-three yards long (over twenty metres) and six to eight yards wide, while two at Honclecrondale (probably former tithe barns) were forty-nine yards long (nearly forty-five metres) by nine yards wide.[24] The importance of the barley crop and the brewhouse was reflected in malthouses. In the early decades of the eighteenth century, there were at least three in the parish, at the Hall farm, Thorogood's farm and Newgate's. Near the centre of Holkham town there were a carpenter's shop and yard, belonging to William Jolly, and the village smithy, let with the adjoining house and 'the Old Dogkennel yard' to Henry and then Robert Knatts.[25] The first mention of a village inn comes in the audit book for 1744 when Wilfrid Browne rented the inn and seven acres of land; this coincided with the disappearance from the rent accounts of Widow Lack (and before her, John Lack) who had evidently kept an alehouse of sorts, providing 'entertainment' (refreshments) for tenants' servants when they carted wood to Holkham.[26] In the following year, there was extensive building work at the inn and the land attached to it was doubled. It had two parlours and another little room, four chambers, four garrets (for servants) and a kitchen, scullery, dairy (with chamber over), bakehouse, beer and wine cellars, stable, cart house, corn chamber, yard and grounds.[27] Lord Leicester's house painter was paid for 'gilding the bunch of grapes' at the inn. It is not known if the sign also displayed a name but the inn appears in records as both *'The Ostrich'* and *'The Leicester Arms'*. Wilfrid Browne's widow maintained continuity at the inn by marrying John Nevill who took over as innkeeper.[28] Thomas Brett became the landlord in 1766 and remained until 1783. He apparently tried to elevate the *Ostrich* into the *Leicester Arms*, for the masons arriving in 1757 to work on the Marble Hall had celebrated with a drink or two at the *Ostrich* but, in Brett's time, Arthur Young stayed at the *Leicester Arms*, which he found 'clean, civil and reasonable'.[29] A few years

later, both names appeared in the Norfolk Chronicle, a local man designating the *Ostrich* as the meeting place for a tradesman's creditors and Brett himself advertising the Leicester Arms, where he had 'added this summer to the house' and could now make up ten beds for ladies and gentlemen and six for servants, with stabling for forty horses.[30] The new name, however, lost its relevance with the succession of plain Mr Coke in 1775 and although the audit books rarely gave the inn a name, it was clear that Brett's inn remained known as the *Ostrich*.[31] Brett's successor, William Fodder, ran the *Ostrich* for three years before moving in 1786 to the newly built *New Inn* at the western edge of the park.[32]

The church was not located in either town or staithe but stood isolated on a prominent hill in the north of the parish, where its tower served as a landmark for mariners. Its situation was equidistant from the town, the staithe and Hunclecrondale farm (later the *New Inn* and, later still, Model Farm) which had been the medieval centre of a church estate belonging to the Abbey of West Dereham.[33] When Lord Leicester died in 1759, the church was not yet within the park but, standing high above the lake, it was inevitably one of the points of interest in his new landscape. Repairs in the 1750s included the roof of 'the burying place' although they were evidently insufficient to justify Lord Leicester, his son or his widow being buried there rather than at Tittleshall. Soon after completing the Hall, the widowed Lady Leicester undertook more extensive renovations:

St Withburga's Church.

In the spring of 1767 her ladyship began to repair Holkham church. All the outside walls and stone window frames were repaired throughout; the roof made strong and part of it new leaded; the inside of the whole stuccoed and new ceiled; the floors entirely new paved; the pews and seats all new and erected in a regular form. The pulpit, desks, communion table and rails thereto all mahogany; a marble font, plate for the communion, linen and books for all the services, the old monuments restored, the vestry room fitted up, and all the windows new glazed. The whole was finished at Easter 1768, at the sole expence of her ladyship, amounting to about one thousand pounds.[34]

To commemorate the restoration work undertaken at her 'sole expence', Lady Leicester commissioned an armorial window panel, displaying her coronet above the arms of Coke, Tufton and Clifford, enamelled by William Peckitt (1731–95), a renowned glass painter based in York.[35]

*

Meanwhile, the demolition of the old manor house in 1756 had a dramatic effect on the appearance of Holkham town, showing at last how the new Hall stood in relation to its surroundings. Lord Leicester died only three years later. No audit books survive for the widowhood of Lady Leicester but there was apparently little change in the two villages. When T. W. Coke inherited in 1776 there were still five tenants paying rent at the town and fourteen at the staithe.[36] However, the focus of attention was shifting, for when he had the parish surveyed soon after his succession, the report included a large-scale map and schedule of the staithe village. The map shows a jumble of cottages clustered round an open area with a central feature, possibly a well or a cross. The coast road was little more than a space between the village and the marshes, probably still functioning as the staithe or landing place for pulling up small boats used on the creeks. A drawbridge gave access across the main creek to the grazing marshes, at the point where Lady Anne's Drive was created some sixty years later, but opposite it, where the present Park Road leads up from the coast road, there was nothing more than an irregularly shaped gap between cottages and fields. The high street of the village was the track that still runs southwards from the coast road along the eastern or back boundary of the staithe farm premises (the present Ancient House). It then divided, one branch continuing towards the park boundary and the other south-westwards to the village centre.[37] T. W. Coke was from the start assessing the possibilities for change at the staithe and purchases soon followed. Four cottages were bought in 1782, two years later a pair from Coulsey and nine years later three more cottages, which he converted

The staithe village in 1590.

The staithe village *c.*1745.

into five, bought as part of Bower's estate.[38] From 1800 onwards, a sustained campaign gathered pace to establish sole ownership of the staithe village. In the first decade Coke bought a total of fifteen cottages from six owners, in the 1810s he acquired eight more, in the 1820s at least two houses and a

shop and in the 1830s a house (divided into three dwellings), three cottages and a public house. The total number purchased was about forty; only one cottage and a house, divided into three tenements, remained in other hands.

Whereas Thomas Coke had limited himself to buying cottages that impinged on his plans for the Hall, the attention paid by T. W. Coke to the staithe village reflected a combination of circumstances: an increase in the rural population, his determination to shape the entire parish and his interest in improving estate buildings generally, particularly those that represented the estate to visitors. The parish population, according to Coke, had been under 200 when he inherited in 1776. Twenty years later, it had more than doubled: a note in the parish registers in 1794 recorded a total of 467, plus fifty living in the Hall. By 1818, if Coke is to be believed when speaking in defence of agricultural improvements and large farms, it had increased to 600 'since cultivation, by the union of capital and skill had advanced'. Only three years later, a census recorded 801. In 1830, Coke told a visitor that the population was over 1,100, 'and all fully employed'.[39] Much of the increase was in response to the demand for agricultural labour. Tenant farmers were expected to employ a proper proportion of labourers in order to avoid a burden on the poor rate and it was considered that 2,300 acres should employ about forty-six men.[40] The 2nd Earl of Leicester in the 1840s considered that the number of inhabitants in the village was 'far too many for the size of the farm and the other work about the place' but in 1851 the 1,800 acres of his park farm still employed fifty men, fourteen boys and twelve women.[41]

Many of the cottages at the staithe village were not in keeping with the public face of the Hall, park and showpiece farms. Probably the only ones (apart from the Ancient House) surviving in the present village from before T. W. Coke's time are those reached by a path from the coast road at the eastern end of the village, now two cottages but originally a row of three and a pair.[42] Each half of the pair originally consisted of a living room approximately twelve to fourteen feet square (about four metres square) with a pantry taken off it, and two attic bedrooms reached by a spiral corner staircase next to the chimneybreast.[43] It is not known when these cottages were built, other than before 1778, but their survival, helped by being in a hidden position, suggests that they were among the best at the time. At least twenty-nine of the cottages subsequently bought by T. W. Coke were acquired not from owner-occupiers but as part of properties that each included from two to four cottages and, as had been the case in Thomas Coke's time, many such tenanted cottages were in a parlous state. They were immediately either demolished or repaired. The double cottage bought from Coulsey in 1784

One of the earliest surviving cottages at the staithe, built before 1778; number 52, originally a pair. West elevation in 2005.

'Coulsey's cottage' behind the Ancient House, now no. 42–43, rebuilt in 1784. East elevation.

had to be rebuilt immediately; it can be identified as the cottage that still stands opposite the back of the Ancient House, on the east side of the old village high street.[44] A double cottage bought from Thurston was demolished within four years and four cottages bought from Booty were soon charged

Chapter 14 Overview: The Village 401

only half a year's rent because of dilapidation.[45] When a single cottage and another divided into three tenements, with no garden ground, were bought in 1819 for £250 from Susanna Stocking of Wells-next-the-Sea, the agent wrote that, 'Mr Coke's object in buying the estate as he did, so much above its then value, was with a view to being enabled to correct the disgraceful dilapidation into which the buildings had fallen and to make them look more of a piece with those upon his estate adjoining'.[46] Poignantly, these cottages had belonged decades earlier to John Parker, who had made most of the bricks for building the Hall; when that work ceased, he had mortgaged his home and his rented tenements to Susanna Stocking's father and the mortgage had not been redeemed.[47]

As late as the 1820s, there were still eyesores to be tackled. Lloyd's cottages (one single and another divided into two tenements) were 'so much dilapidated that the inhabitants live in continued jeopardy of their lives' and it was 'Mr Coke's intention as soon as the premises are conveyed to him to pull the houses down and to rebuild them from the ground'.[48] One failure was an attempt to buy three cottages, land and premises in 1829 for £350. The agent Blaikie wrote that the property was of 'comparative little value but its situation in the centre of Holkham village renders it of much consequence to Mr Coke' but, before the purchase could be completed, the owner sold to Tuttell Moore, until recently a farm tenant at Warham. Blaikie took this transaction as a personal affront to Coke, mentioning that Moore could not be approached about the property 'because that would give him an opportunity of adding another insult to Mr Coke'. It was a telling comment on the extent to which the agent, and presumably his employer, now saw the whole of Holkham as Coke territory.[49]

Purchases in the staithe village, giving Coke control of nearly every existing dwelling, were more than equalled by new building at his expense. The earliest additions were outside the village, perhaps because, until the determined purchasing campaign of the 1800s, there was little scope in the village itself. The first were two pairs, back to back, now known as Rose Cottages, erected in 1785–86 on the coast road west of the village. The style of these cottages suggests that they were designed by Samuel Wyatt. Built of yellow Holkham brick with slate roofs, each had an entrance porch, pantry, cellar and two bedrooms (although one was on the ground floor) and so met many of the requirements promulgated by contemporary writers on cottage improvement.[50] Nine or ten years later, a semi-circular group of ten or eleven cottages, originally known as Longlands village and later as New Holkham, was built at the other extremity of the parish, just outside the southern edge of the park, to accommodate thirteen tenants who worked at the new farm

and estate workshops at Longlands. Also designed by Wyatt, no plans survive but a recently-discovered photograph shows that they were single-storey cottages each with a central semi-circular attic window. These houses were demolished and replaced in the early twentieth century. More accommodation for estate workers was provided by the conversion into cottages in 1818 of a brewhouse and 'sheep house' at Longlands itself. The farm steward lived in the farmhouse there, his household later including four pupils.[51]

The building of Rose Cottages and the Longlands village finally settled the fate of old Holkham town. By 1783 the audit books no longer made any formal distinction between town and staithe tenants and before long the last residents in the old village were paying a mere acknowledgement of 2s 6d instead of rent of £1 or £2. They included a carpenter, Robert Hagon, who soon moved to the staithe, two tenants who moved to the new Rose Cottages, and the smith, Edward Emerson, who moved to the staithe in 1791; a few years later, two more estate craftsmen moved to the new houses near Longlands. The inn was replaced by the *New Inn* at the western edge of the park and the old farm buildings in the village were demolished. Soon after 1800, the only building to give any hint that here had been an ancient village was a carpenters' shop, which survived until after 1843 next to the walled gardens.[52]

Rose Cottages, built 1785–86.

Longlands Village or New Holkham, as designed c.1795 by Samuel Wyatt. Rebuilt completely c.1918–37.

The staithe village was then transformed by a building campaign that, as in the case of purchases, reached a peak in the 1800s. The forerunner was the Octagon Cottage (two dwellings), built in 1801 next to a new but still rather insignificant northern entrance into the park; one of its first tenants, Jemima Pierce, a former laundry maid and widow of an under-butler, moved there from old Holkham town. Like the slightly earlier Rose Cottages and Longlands village, the Octagon Cottage is said to have been designed by Wyatt but its shape echoed the octagonal engine house, dovecot and other features at the Hall built long before Wyatt's time, and until 1822 its roof was thatched with reeds, like many of the village cottages, rather than with Wyatt's hallmark slate.[53] Then approximately twenty-two cottages were built in the village between 1805 and 1809, few of which survive. It must have been these houses that drew the attention of Edward Rigby, a great admirer of T. W. Coke, when he commented in 1818 on 'the well-built cottages of the various labourers employed on his farms'. Their location, size and style have to be deduced from estate accounts, maps and later written surveys.[54] A comparison of maps dated 1778 and 1839 shows that their construction accompanied a radical alteration in the village plan. North of the village centre, a jumble of cottages was replaced by a straight road running north and south, and two double and three single cottages were erected along its east side. They were single storey, described in a survey in 1851 as having

Aerial view, 1968, of the oldest surviving cottages. On the right is the late 19th century Red House.

Octagon Cottage.

Chapter 14 Overview: The Village 405

Plan of the village in 1778.

two bedrooms on the ground floor, and survived until the 1880s.[55] They were constructed by local men, Edward Johnson, bricklayer, and Edward Emerson, carpenter, and roofed with blue pantiles or cinder tiles.[56] More were built along the old village street running southwest towards the village centre, and a haphazard group of buildings further south was replaced by three double and two single cottages erected along a new track leading to the park entrance next to the Octagon Cottage. This track was not aligned with the new stretch of road north of the village centre but instead followed the line of an earlier path, which would be echoed again in the next phase of building by the line of Chapel Yard. These cottages and their gardens appear on the map of 1839 to be much smaller than those built opposite them a few years later to form Chapel Yard but they were demolished in the 1840s and so do not appear in the useful survey of 1851.[57]

Widows' Row appears to be the sole surviving example of the single-storey cottages built at this period. Two cottages at the west end of the original row of six or seven, each of which had only one bedroom, were demolished in the 1850s when the verges of the park road were widened; by then, the detached outhouse at the other end of the row was being used as a shop.[58] The row was

The village from the Tithe Map of 1839. Comparison with the 1778 map reveals the houses and new road layout of 1805–09.

later converted into two cottages. The other houses that appear to date from this phase of building, 1805–9, were four two-bedroom two-storey houses in a row (later converted into two larger houses) showing a date stone of 1809 on their south side, lying beyond the south end of Chapel Yard.[59] As Chapel Yard did not exist when they were built, their position was perhaps dictated by a purchase of land or the site of demolished cottages.

Chapter 14 Overview: The Village **407**

Widows Row, built 1805–09, south elevation.

Two years after this building campaign, when the land of Staithe Farm was taken in hand, its house, dairy and barn were converted to form a total of eleven cottages, of which only the former farmhouse (the Ancient House) is still standing. The six cottages converted from the barn in the farmyard (on the site of the present Ancient House car park) each had three bedrooms, giving some indication of the size of the barn.[60]

The next phase of building took place in 1817–20, when the cottages now known as Chapel Yard were built, consisting of two pairs and a row of four.[61] More is known about this phase of building, not only because the houses are still in use but also because their plans were published in 1842 in the *Report of the Poor Law Commissioners into the Sanitary Conditions of the Labouring Population*, as an example of 'the most conspicuous improvements of labourers' tenements'. The double cottages each had a living room, seventeen feet by twelve feet and at least seven feet high, a back kitchen, separate pantry, and three first-floor bedrooms. 'At a convenient distance behind' was a washhouse, dirt bin, privy and pig cot. The assistant Commissioner described the new cottages as 'perhaps the most substantial and comfortable of any which are to be seen in any part of England'.[62]

Cottage conditions were widely discussed in print in the late-eighteenth and nineteenth centuries but, unless a famous name such as Samuel Wyatt was involved, usually little is known about those directly responsible for building well-designed cottages at this period. At Holkham, however, it is clear

Chapel Yard cottages, plans published in the report of the Poor Law Commissioners in 1842.

A pair of Chapel Yard cottages with date stone of 1819, east elevation.

Chapter 14 Overview: The Village **409**

that the rapid advance in cottage design between the one phase of building up to 1809 and the next starting in 1817 coincided with the appointment of an experienced local carpenter, Henry Savage, as estate architect (in place of the former valet, Crick, who had been acting as clerk of works) and the arrival of Francis Blaikie, Coke's first professional land agent. The assistant Poor Law Commissioner later obtained the plans of the new cottages from Mr Emerson, whom he named as their builder. This was Stephen Emerson, Savage's successor as estate architect, but it was undoubtedly Savage who had designed them and it was Stephen's father, Richard Emerson, also a carpenter (died 1824) and a long-standing local bricklayer, Guy Hagon, who had built them. The role of T. W. Coke was to be willing to build cottages that cost, according to Stephen Emerson, £110 to £115 each, for which the annual rent was three guineas: as the Poor Law official pointed out, not a feasible return on capital expenditure for most landlords.[63]

Other cottages were built around the same time as Chapel Yard, including the single-storey cottage (still occupied) at the top of Lady Anne's Drive, the new road across the marshes.[64] In the centre of the village, on the village square or green, a village shop with an attached dwelling replaced the dilapidated premises recently bought from the Lloyd family; it was described in a later survey as a good three-bedroom house but disappeared with the changes of the 1880s.[65] At least some of the daily business of the village was conducted in a local currency, for the Holkham agent asked Gurney's bank at Fakenham early in 1817, 'to what date do you propose receiving Bank Dollars in payment. Will you take the trouble (and at what expence to Mr Coke) of exchanging for currency the Bank Dollars now in circulation in Mr Coke's family, amongst his servants and labourers, and the poor of Holkham'. Messrs Gurney of Norwich were consulted and replied that 'the bank will not avow an intention of extending the time for the circulation of the Dollars' but considered it 'not improbable' that they would continue to receive them for some time 'at the rate at which they were issued'. They added, 'they have not, we think, found their way to London in great amount'.[66]

With the majority of cottages at the staithe now belonging to the estate, there was increasing intervention in village life. In 1818 a field between the village and the park was divided by fences and privet hedges into seventy-three allotments of various sizes, allocated to cottage tenants 'proportionate to the number in family and capability of cultivating the land'. According to the agent, Blaikie, writing some years later, 'the cottagers were much pleased with their large occupations of land and commenced cultivating the gardens with much spirit'. For many years, Coke offered prizes for the best gardens, 'until the whole of the occupiers were thoroughly grounded in good

horticultural practice'. Elizabeth Coke, then aged twenty-five and (until her father's remarriage two years later) mistress of Holkham, 'being desirous of encouraging honest industry and general good conduct among the inhabitants of Holkham', offered prizes of one to three guineas to the cottage occupier 'whether male or female who by his or her honest industry supports their family in the cleanest and most comfortable state, with the greatest degree of economy in food and clothing, and without contracting debt'. The perceived need to exclude from eligibility those who led immoral lives, lived in debt or 'dress themselves or their families in a ridiculous, superfluous or extravagant manner … which is a growing evil in the parish of Holkham' suggests that there was still some lively variety in the *mores* of the village.[67] The provision of education was a slightly later consideration. In 1810 the estate had paid for a village carpenter, Charles Clarke, to have a blacksmith's shop (part of a recent purchase) converted into a schoolroom and a few years later there was a school chest in his cottage next door, but nothing else is known about his or, perhaps, his wife's venture.[68] Perhaps it was thanks to them that Sarah Biller, born in 1805 as the eldest of eight children of Lord Leicester's head coachman, acquired sufficient education to publish, as an adult, a collection of poems, including 'Holkham, the Scenes of My Childhood'.[69] The first school provided by the estate was built in 1822 at the north end of the new road subsequently known as Chapel Yard. It consisted of a master's house flanked by boys' and girls' single-storey schoolrooms and

The former Mixed School and school house, 1822, later used as the Methodist chapel and the eastern schoolroom demolished, as shown by the gable wall.

still stands, although now lacking the schoolroom next to the park road. In 1830 a visitor to the village described the school as being 'under the peculiar care' of Lady Anne, the wife of T. W. Coke.[70] It would be interesting to know if she shared the opinion of Francis Blaikie that 'the more poor children are instructed in the useful arts of industry and economy, the better; I think it far more desirable that those children be taught to read the Bible, than that they be instructed in writing and arithmetic'.[71] The estate also paid for an adult evening school, where for many years the teacher was John Crook, who succeeded his father as the estate 'engineer'. It is tempting to surmise that his extra work at the evening school was an easy option, as well as a financial necessity, as by 1841 he had ten children under the age of thirteen at home, and more to come.

There had been an alehouse at the staithe since at least 1757, when the thirsty marble masons congregating at Holkham seem to have found the *Horse and Farrier* at the staithe even more congenial than the *Ostrich* in the town. It is thanks to their account book that this one mention of it survives, for it was not, apparently, an estate tenancy. It is impossible to tell if it can be identified with an unnamed public house, in the south-west extremity of the staithe village, rented from the estate by William Parnell in 1778 but then soon listed simply as a house.[72] Probably, like the *Ostrich* (or *Leicester Arms*) in the town, it soon gave way to the *New Inn*, equidistant from both villages. There was a village bakery from at least 1788 when John Copping first rented a cottage with a 'baking office', replaced by a new bakehouse built for him in 1797 at the south end of the staithe farmhouse (the Ancient House). It did not supply the Hall, which had its own bakehouse. When Copping retired from baking in 1819 at the age of nearly eighty, his neighbour, Richard Emerson, the carpenter, took over the business. The Emerson family was prominent in the village for many years, spanning several stages of its development. Edward, a blacksmith, was first employed by the estate in the 1750s and around 1790 was one of the last inhabitants to leave the old town near the Hall, where his son Richard would have been brought up. Richard moved into part of the Ancient House when it ceased to be a farm house and played a large role, as carpenter and builder, in shaping the staithe village. Among his ten children who survived infancy, Stephen, a carpenter, went on to become the estate architect (although by 1848 he had left Holkham with a pension and was living in circumstances of 'great anxiety') and another, Russell, took over the Ancient House and bakehouse on his father's death, continuing as baker and flour dealer until his death in 1861.[73]

The church also received attention. Fewer than thirty years after Lady Leicester's extensive renovations, in 1794–5 T. W. Coke had the roof repaired

and re-slated, a staircase made in the tower 'and a room made where the bells hitherto hung; two of them being sold, the remaining one was hung upon a new floor, made underneath'.[74] A music master was paid for 'teaching the Holkham children to sing in the Church' and later a regular donation was made to Holkham Psalm Singers. Richard Emerson was reimbursed for buying musical instruments to be used in the church and in 1837 an organ, removed from Weasenham Hall, was installed and Russell Emerson was paid £10 a year as organist.[75]

Contemporary accounts by admirers of Coke emphasised the prosperity of the village. One of the speakers at the 1818 Sheep Shearing, addressing Coke, said that he had 'seen your poor … provided with abundant employment; all well fed, well cloathed, happy, cheerful and contented … that your population has been doubled, and your poor rate diminished one half; that your workhouse has been levelled in the dust, or left without a single tenant to pine within its walls'. Coke in his response emphasised that 'in all his parish, there was scarcely a single individual that did not find full employment'. Enlarging on the mention of the workhouse, he explained that it had been built in Warham twenty-five years earlier (that is, in about 1793) to serve Warham, Wighton and Holkham but had been demolished in recent years when his farm tenants said that it could be dispensed with because 'there was so much employment for the poor'.[76] His agent was more cautious, only four years later making careful enquiries from a legal adviser as to whether the appointment of a schoolmaster and schoolmistress could lead them to 'gain settlement after a year' and become a potential burden on the parish.[77] A visitor in 1830 considered it 'worth a journey of 100 miles to see the village of Holkham, what a contrast does it present to that of Houghton … every cottage is neat and clean, each cottager has a garden of considerable size, and for this neat house and garden he is charged two guineas a year rent'.[78]

By the mid-1830s, however, the days of full rural employment were over, locally as well as nationally. If Coke's figure of 1,100 inhabitants in 1830 was accurate, about 470 people died or left the parish in the following decade, so that by 1841 the population had fallen to 731. Coke contributed to the funds raised in several estate villages to help emigrants going to seek their fortunes overseas and in 1836 a total of twenty-six young men left Holkham to work on the Great Northern Railway, armed with a gift of ten shillings each from the estate and a matching loan from the parish.[79] Nevertheless, although the pace of cottage building declined after 1824, five more cottages were erected in the 1830s (probably replacing old ones on the same site) and can be identified as the cottages faced with round flints, at the junction of an old lane and the coast road towards the east end of the village. A date stone of 1831

on one of them corresponds with a payment in the accounts to Guy Hagon, a local bricklayer frequently employed by the estate, for work which included building a cottage for himself, described a few years later as a 'very comfortable little house'. In 1834–36, two more double cottages (bricklaying by Hagon, carpentry work by William and Joseph Savage) were almost certainly those next door, set a little further back from the coast road on either side of the track.[80] These brought the total number of cottages built or converted at the staithe in T. W. Coke's time to about forty-eight. Some were replacements for dilapidated purchases but, even so, in the thirty years from 1807 to 1837 the size of the village had been doubled.

As these last cottages were completed, attention turned to the last major building projects in the time of T. W. Coke: the infants' school and a new public house, both built in 1837. The infants' school, supplementing the mixed school built in 1822, was built on the other side of the park road, again under the auspices of T. W. Coke's wife. It fulfilled a clear need as the census four years later showed that there were 208 children aged eleven or under in the parish. A public house at the staithe was not listed among estate properties after 1778 but by the early 1830s John Lack, a carpenter, had opened the *Albemarle Arms* (named in honour of Mrs Coke's family) in one of the four cottages that he owned, probably just south of the present *Victoria Hotel* car park. They had been bought by his great-grandmother, passed down through his grandfather and father, both cordwainers, and by the 1830s were

The last cottages built in T. W. Coke's time, 1830s, photographed in 1978.

The Infants' School, built 1837, extended 1882, now used as retail premises.

The school pupils *c.*1890–1910.

one of the few remaining properties not owned by Coke. In 1836, however, Lack and his wife sold the *Albemarle Arms*, three adjacent cottages and land to Coke for £600. In return, Coke covenanted 'to build for the same John Lack a public house near the Wells-next-the-Sea road with stables, bowling green

Chapter 14 Overview: The Village **415**

The Victoria Hotel, built 1837, north elevation, photographed in 1978.

and other suitable premises, at the cost of £600 and to give the same John Lack possession of the same at Midsummer now next ensuing and to grant him a lease of the same for 21 years'.[81] Lack's tenancy began in September 1837 at £30 per annum and the inn was soon known as the *Victoria Inn*, in honour of the Queen who had visited Holkham as Princess two years earlier, acceded to the throne in June and under whose first ministry Coke had at last received the title of Earl of Leicester. It became the only inn in the parish less than fifteen years later, with the closure of the *New Inn* (built fifty years earlier) at the western edge of the park, a much larger inn that had lost its *raison d'être* with the end of the Shearings.

By 1841, there were about one hundred households in the village and thirty-eight elsewhere in the parish, at Longlands, the lodges, the Temple, garden cottage, steward's house, *New Inn* and the warrener's house.[82] There were no independent farmers left in the parish. About eighty-one parish residents (15%) were farm labourers and ten more were general labourers. There were twenty-seven building craftsmen, wheelwrights and blacksmiths, sixteen woodsmen and gardeners, a brick maker, rope maker, warrener, estate architect and estate engineer, a butcher, baker, tailor, dressmaker, scavenger, two inn keepers, two shopkeepers and four school teachers and assistants.

One of the grooms at the Hall lived in the Octagon Cottage and the butler in North Lodge; gamekeepers and the kennel man lived in other lodges and a shepherd in the Temple. Three fortunate residents had independent means but eight villagers were described as paupers and four (including two in the almshouses) as infirm. The new chaplain, Alexander Napier, wrote home in the same year that 'if the people are not happy it is their own fault, for there could not be more care taken of them'.[83]

*

In 1842, Holkham was inherited by the young 2nd Earl. The estate finally achieved complete ownership of all village properties with the purchases of one last cottage still owned by the Lack family and eventually, in 1855, from the successors of Tuttell Moore, a house divided into three tenements that had slipped through the net twenty-four years earlier.[84] For some years, the focus was on cosmetic improvement in the village. In the spring of 1845, Napier, now the vicar, described a week of 'great bustle' there:

> My lord along with myself and some of the upper servants visited the village last week to inspect its condition. He has many improvements in his mind ... He much wishes to reduce the number of the inhabitants of the village, which are far too many for the size of the farm and the other work about the place ... He is very anxious too to beautify the place, and I am to encourage the people to plant suitable shrubs and flowers to cover the walls of their houses. On Thursday, the head gardener, a canny Scotchman by the way, is to accompany me on an excursion through the village to point out the different aspects for the various plants ... I hope in about two years not a yard of brick will be visible in the village, so green do we propose to make it.[85]

The building of the almshouse entrance into the park in the following year, to a design by Teulon, highlighted the need for a more suitable approach through the village. This was achieved by demolishing the houses built by the Earl's father in 1805–9, south of the old village centre. The road from the new *Victoria Hotel* could then be widened and straightened as far as the last-minute bend that was needed to take it between the almshouses. The wide verges along the southern stretch were lined with ilex trees, as they are today.[86] The only hint that remains of the earlier shape of this part of the village is provided by Chapel Yard, whose alignment, divorced from the earlier line of the road, now became slightly incongruous.

In 1849 a vicarage for Napier was built on the coast road west of the village, designed by Henry Bolger, the estate architect or clerk of works, with five bedrooms, drawing room, dining room and library.[87] It was soon

enlarged and Napier occupied it until his death in 1887; it is now known as Park House. A major restoration of the church was undertaken in 1869, becoming a memorial to the Countess, who died in 1870. It was completed by a new peel of six bells made by the well-known London bell foundry of John Warner, and a man was paid to give twelve weeks instruction to the Holkham bell ringers.[88]

Although the coming of the railway in the 1860s resulted in the northern route through the village becoming the principal approach to the Hall, the changes of the 1840s and early 1850s sufficed for many years. Evidently the cottages fronting the park road, glimpsed by royal and other visitors to the Hall, were considered sufficiently presentable without major alteration. In 1851 there were approximately eighty-five village cottages. About forty-two were old cottages, the others were the remaining cottages built in T. W. Coke's time. Twenty-four had three bedrooms and forty had two bedrooms. A few were badly overcrowded, with one room shared by a family of five, or two ground floor bedrooms for ten people.[89] Priority was given, however, to buying or building hundreds of cottages in the estate villages elsewhere in Norfolk, where the agent acknowledged in 1871 that some labourers were 'not housed in such a way as they ought to be, and as it is Lord Leicester's desire they should be ... By using every exertion only a certain amount of work can be accomplished in any one year'.[90] It was not until the 1880s that Holkham village took on its modern appearance in what the architectural historian, Sir Nikolaus Pevsner, described as 'a vague Tudor style'.[91]

The timing of this major restructuring proved to be unfortunate. When building work started in 1879, estate finances were buoyant but the

The Vicarage, subsequently Park House, built in 1849 for Alexander Napier and photographed by a member of his family.

Plan of the village, 1858, showing Park Road widened and straightened all the way from the Victoria Hotel to the North Gates. Re-orientated to place north at the top.

introduction of professional designers for the next phase of improvement, three or four years later, coincided with the beginning of a drastic drop in farm rents as the effects of agricultural depression took hold. The result was several years of tension between practicality, economics and ambition. The first stage in 1879–82 was the replacement of existing cottages by four pairs of much larger two-storey houses. The first pair (modern numbers 17 & 18) was at the top of Chapel Yard, opposite the school house, replacing a block

of two or three 'old bad' cottages, possibly those sold to the estate by Lack before the *Victoria Inn* was built.[92] The other three pairs (modern numbers 27/28, 29/30 and 31/32) were built on the other side of the park road, replacing single-storey cottages from T. W. Coke's time and an older row of three cottages round the corner on the coast road. The new two-storey houses were set further back from the road and in larger gardens than those they replaced. Each had an entry porch and hall, separate sitting room and kitchen, attached washhouse or scullery, and three or four bedrooms. They were designed by the estate's new clerk of works, George Peddar, and were built by local builders.[93]

The next move was to extend the infants' school to accommodate the older children, almost certainly because plans for widening the road made the position of the original school unsuitable. A few years earlier, a list of schoolchildren invited to a tea on the occasion of the Earl's second wedding had shown sixty-five at the mixed school (much the same number as thirty years earlier) and forty-three infants, plus fifteen at New Holkham. The 1881 census recorded a slightly larger total of 141 children as scholars.[94] The original school building, sixty years old, was soon put to use as a Methodist chapel, giving Chapel Yard its modern name.

Houses designed by the clerk of works and built in 1879–82.

Proposal for a new village layout, c.1881–83.

At this point, it was apparently decided that the village required more considered development. A landscape architect, Reginald Upcher, was brought in to plan 'the new village' in 1883. No details of Upcher's brief survive but early proposals were presented in block plans of the village.[95] The village centre was to be entirely cleared for new houses by demolishing all the buildings (about ten houses and the shop) on the east side of the park road, south of the recently-built houses and newly-extended school, leaving only Widows' Row. A new side road, aligned neatly at a right angle to the park road, would lead eastwards to new plots carved out of open land for additional houses. The clearance of a row of cottages, formerly the staithe farm barn, would enhance a site destined for a reading room.

It is unclear why the style of the houses only recently erected at the north end of the village was not continued for this next phase of building, especially as the same draughtsman had already drawn plans, but a London architect, Zephaniah King, apparently came on the scene as a result of having been 'consulted by Mr Upcher in his capacity as a landscape gardener'.[96] Their association with Holkham was not entirely felicitous for they were carried away by enthusiasm. King gained the impression that Lord Leicester 'contemplated rebuilding the entire village with the exception of the

Two of the houses designed by Zephaniah King and built in 1884.

new cottages and one or two old buildings' and had difficulty in reconciling the practical requirements of the village with his desire to display novel and rather flamboyant ideas. Upcher also 'went into it *con amore*', although King dropped him a hint, so he told Lord Leicester, that 'however satisfied he may be that his efforts have safely served his clients' interests', clients preferred to have everything laid before them to judge for themselves, especially 'anyone possessing the unusual practical experience which your lordship is well known to have'.[97]

The original instructions relayed from Upcher to King were to build during 1884 a 'tower with reading room' for a maximum price of £700; two pairs of four-bedroom cottages, known as blocks A and C, not exceeding £700 and £600 respectively; a pair of three-bedroom cottages, block B, not to exceed £600; and a block of four dwellings for old people, each with two bedrooms, for £800.[98] King wanted to introduce 'an entirely new feature' in one of the blocks but was told that 'Lord and Lady Leicester each fear for the timber construction, which must be abandoned'. He was particularly keen on cladding the upper floor of another block with Lascelles slabs, a concrete tile patented a few years earlier by a London builder and enjoying a certain vogue, but the Earl refused after Lady Leicester had seen them on cottages at Sandringham, 'already displaced, and there is nothing more objectionable than ornamental work being of a merely temporary character'.[99]

Looking north from near the Reading Room, *c*.1915.

The internal layout of the proposed cottages was also closely scrutinised. The Earl told the architect that 'with certain alterations they promise to be sufficiently ornamental and what is of more importance adapted to the wants and requirements of the inhabitants' but he alerted him to other features that would not meet 'the local wants of our Norfolk labourers'. His criticisms included the siting of the oven in the wash house rather than in the kitchen, the introduction of earth closets in place of the preferred pail closets, passages and stairs too narrow, a living room (twelve feet by thirteen feet) too small and the attic storey proposed for one pair 'objected to by cottage tenants'.[100] Eventually only three blocks (A, C and D) went out to tender and were built in 1884 by James Rounce of Blundeston, near Lowestoft in Suffolk.[101]

Despite indecision about continuing with the village project, Lord Leicester went ahead in the following year with a reading room and the restoration of the old farm house, soon known as the Ancient House. The Reading Room had been proposed two years earlier but, as in the case of the cottages, the designers ran ahead of the owners' ideas. Upcher was insistent that it should have a tower, 'an unusual but beautiful and striking feature in a village', but the Countess, who was closely involved in planning the village, thought it out of character, too ornamental, ecclesiastical and pretentious.[102] It is difficult to judge from the surviving plans and the building

Plan of the Reading Room, architect Zephaniah King, 1885.

The Reading Room, undated postcard (after 1918). Infants' School on the left.

itself whose opinion prevailed. It was built with its attached cottage for a cost of £1,341 9s 6d, nearly double the sum originally allocated.[103] It was opened with a 'musical and dramatic entertainment' whose audience included the Earl and Countess and their guests. The Earl's children and grandchildren formed a band, there were songs and recitals by many local worthies, including the schoolmaster, the clerk of works and the Wells-next-the-Sea solicitor, and as the finale, 'the Holkham peep show … in which were sketched the Earl of Leicester and the leading members of his lordship's family and establishment' which 'provoked the greatest amusement'. The Reading Room was provided with a library of books and newspapers and, when initial interest flagged, equipment for bowls, cricket, bagatelle and games, but it was not long before the room was used primarily for winter events such as whist drives, dances and concerts.

The Ancient House, despite its varying fortunes since the demise of the staithe farm, was the oldest and still most prominent feature in the village. Its restoration in 1885 cost over £827, considerably more than a pair of new cottages. The floor plan still largely matched that shown on an unusually early plan of about 1730; the most noticeable alterations were the addition of bow windows on the west front and the use of all six styles of decorative mock-Tudor chimney stacks produced by the estate brickworks.[104] Isaac Julings, tenant since 1869 of the house and the attached bakehouse, enjoyed the results of the renovation until 1914.

Chapter 14 Overview: The Village 425

Ancient House, plans and elevations for alterations by Zephaniah King, 1885.

Postcard of the Ancient House, pre 1914.

A further pair of semi-detached cottages, postponed in 1884, was shelved again until 1887, when Lord Leicester told the architect that his attendance was not needed as he had 'himself selected the spot and set out the new cottages'.[105] There was talk later in the same year of more cottage building but King sent in plans that were found to be 'far too expensive for the position they would occupy, not being in the front of the village' and it was soon decided that no more cottages were needed.[106] A total of nineteen had been built in the eight years since 1879, at least half replacing older cottages on the same sites.

The 1881 census gives a snapshot of the village residents as the last major remodelling gathered pace. The total parish population, falling for at least the past forty years, was 559, of whom about 323 lived in the village. The Hall accounted for twenty-eight live-in servants, of whom eight were Holkham born, much the same proportion as in previous census years. More striking was the wide range of origins among the village residents. Forty years earlier, nearly all had been natives of Norfolk. In 1881, however, only about a third of the heads of households (forty-four out of 127) had been born at Holkham and they rubbed shoulders with neighbours born in Scotland, Germany (probably a former governess at the Hall, now married to an estate office clerk) and twenty-one different English counties. Some of these, of course, had been long established in Holkham: one of the Scots was Hugh Girvan, the retired head gardener, who had lived at Holkham for nearly fifty years. Some of the incomers were servants who in earlier years would have

lived in the Hall, including the butler, born in Devon, and his wife, from Middlesex, who lived in one half of the Octagon Cottage with their seven children. Three of the four gardeners came from outside Norfolk, as did two of the gamekeepers, and it was not surprising that the clerk of works, his assistant, an Estate Office clerk and the village schoolmaster had all been recruited from further afield. The continuous decline in the rural population, and that of Holkham in particular, was reflected in the fact that many of those born in other counties were grandchildren either living with or visiting native Holkham residents: their places of birth reveal that members of the intervening generations, perhaps starting with the young men who had moved away for work in the 1830s, had scattered as far as Durham, Birmingham, London, Essex, Suffolk, Northamptonshire, Scotland and Somerset.

The 2nd Earl's remodelling of the village was completed in 1890–91 with 'a small residence or lodging house', soon known as the Red House, reflecting the fact that the coast was attracting increasing numbers of holidaymakers.

Marjorie Beesley's school boot club card, *c.*1910. Her father was a clerk in the Estate Office.

Initial plans by a Chester architect, John Douglas, proved too elaborate and C. S. Beck of Norwich was instructed to design 'a superior kind of cottage' to contain three sitting rooms and, 'as number rather than size of bedrooms is considered desirable, as many bedrooms as are consistent'.[107] By 1911 the Ancient House had also become a lodging house but the Holkham agent warned a prospective tenant that the letting season was short.[108] The last new building in the village was a row of four houses built in 1911 south of the old allotment gardens, near the almshouses.[109] Henceforth, in outward appearance, the village remained unchanged. Early in the century, the chauffeur at the Hall, Joseph Scrivener, caused a stir when he set up a generator to light his house; mains electricity arrived only in the 1930s.[110] The provision of a mains water supply in the 1960s immediately signalled the gradual modernisation of the village houses by the estate to provide bathrooms and indoor toilets.[111] The village mirrored many other rural villages as it lost its school, shop and post office. By the early 1960s there were only sixteen juniors and six infants at the school, the older pupils having already transferred to a new school in Wells-next-the-Sea, and the school closed in 1965.[112] At the end of the twentieth century, most of the village houses were still occupied by estate staff or retired employees.

The whole process of change from the two old villages to one estate village had taken 200 years. Increasing concentration of land ownership and the emergence of a pre-eminent family in the seventeenth century did

The last houses built in the village, 1911.

Plan of the village in 1911, annotated to show the dates of buildings.

Looking along the coast road in 1965 from the north-east. The buildings in view represent four hundred years of village development. Top right, the back of the oldest survivor, the Ancient House; nearby, double cottage facing east, pre-1778, rebuilt in 1784; bottom centre, flint-faced houses from the 1830s; far left, pre-1778 cottages; top left, the Red House, 1890.

not directly affect the villages, although pointing the way to future developments. The building of the Hall transformed the character of Holkham town but still it survived, a small village of select dwellings, farmhouses and inn, almost at the gates of the Hall. It was the determined expansion of the park and the Hall farm that finally cleared Holkham town, ended the traditional role of tenanted farms in the community and transformed the settlement at the staithe into a village entirely owned by the estate, as it remains today. Fortunately, however, the combination of centuries of small private owners, the acquisitiveness of the lords of Holkham and their subsequent control of the village resulted in the accumulation and preservation, in one place, of thousands of property documents, whose contents record so much of village history that is no longer visible on the ground.

Chapter 15

Overview: Marsh, Sand and Sea

Before the second half of the twentieth century, Holkham's location on the North Norfolk coast seems almost an irrelevance. The neighbouring small port at Wells-next-the-Sea was useful in the days when overland transport of goods was expensive but it was not a decisive factor even in building the Hall. Villages within three or four miles produced Admiral Lord Nelson, John Fryer of the *Bounty* and Captain Woodgett of the *Cutty Sark*, but Holkham can claim no great seafaring sons. Other than the Hall and its hospitality, the factors that made Holkham an attractive destination were the proximity of other great houses, agricultural gatherings and good shooting. It needs only a cursory glance at a map, however, to see that about a quarter of Holkham parish lies north of the coast road that follows the slight contour between land and marsh. On the ground, except for the fact that fields are separated by drainage ditches rather than hedges, the area now appears as flat but otherwise unremarkable farmland, while sea banks and wooded dunes are distant features, long accepted as part of the landscape. Four hundred years ago, however, the coast road ran alongside a creek and the whole area to the north was salt marsh, regularly flooded by a network of tidal creeks that met freshwater streams running from the land. At the northern edge, between the marshes and the beach, a line of bare sand hills shifted at the mercy of wind and sea. Astute and wealthy landowners, such as the Cokes, were unlikely to forego the opportunities offered by such an extensive tract, particularly when pasture for sheep was at a premium, but mastering this distinctive landscape has challenged nearly every generation of the owners of Holkham.

The difference between salt marsh and reclaimed freshwater marsh can be seen clearly where salt marshes still exist close to Holkham, such as on the seaward side of the bank at Burnham Overy Staithe and to the east of the Wells channel. At high tide the salt marshes are often under water and crossing them on foot at low tide involves negotiating countless irregular

The bank of 1659 covered in cowslips.

channels, detours through samphire and sea lavender and alertness for the turn of the tide that quietly but rapidly fills the creeks. Such marshes yielded fish and birds for the table, rushes, reeds and osiers for thatching and basket making and a varying amount of grazing for sheep, but their full potential depended on permanently excluding the regular influx of salt water and controlling the drainage of fresh water. The owners of Holkham achieved the transformation from wild salt marsh to useful agricultural land by three major embankments, reclaiming the western marshes in 1659, the central southern stretch in 1719 and the remaining large eastern area in 1859. The dunes were exploited to a lesser extent but became of crucial importance in the second half of the nineteenth century, when they were strengthened by means of an innovatory and sustained campaign of tree planting.

To a large extent, it was the geography of the marshes that dictated the chronology of these successive reclamation schemes. The dominating features were Holkham Gap, a distinctive break in the dunes that separate the marshes from the wide sands of Holkham Bay, and two separate major creek systems through the marshes, one to the west and the other to the east. Holkham Gap had acquired its present name by 1780. Since at least

The marshes in 1590.

1823, when the private road, Lady Anne's Drive, was built to improve access to it from the coast road, it has been the normal route, sandy and grassy, for people heading on foot through the dunes to the beach.[1] In 1637, however, it was called 'the new gush or sea breach', a name that gives a vital clue to the nature of the creeks and marshes to the west. The only map to show these marshes before the earliest embankment is Thomas Clerke's map of 1590 but he sacrificed the area around Holkham Gap (in which his employer had no interest) to a decorative title panel. Nevertheless, it is clear that the 'new gush' already existed and that it was the source of the principal creek, the Borough Channel, that ran through the western marshes.[2] Various clues suggest, however, that the tidal flow and ebb through the Gap was not unduly strong. In the 1630s these western salt marshes of about 350 acres formed a foldcourse capable of supporting 400 sheep belonging to the lord of the manor and 160 more that his shepherd had feeding with them, well above the number of sheep per acre that could be depastured on the wetter marshes east of Holkham Gap. Moreover, close to the shore, the foldcourse included a particularly valuable area of pasture called the Borough, an ancient and distinctive feature that gave its name to one of the Holkham manors, Burghall, and to the major creek, Borough Channel. It was later known as the Danish camp and is now thought to be an Iron Age fort but in the early-seventeenth century it was described as a 'spetiall peece of ground' because it was 'at every high and springe tide … compassed with the sea but never overflowen'.[3] A further clue to the topography of the area is the existence of Salts Hole, a saline pond whose particular ecology, combined with the evidence of eighteenth-century maps and modern aerial photography, suggests that it is the last remnant of the mouth of the Borough Channel at Holkham Gap.[4] Tucked under the southern edge of the dunes and now replenished only by salt water seeping through the dunes from the saturated sands on the shore, its isolation from the open sea suggests that the mouth of the creek became cut off as an arm of the constantly-shifting dunes curved inland. It becomes clear why the western marshes were the first to be embanked and drained: already used as grazing land, not too wet, and with sluggish creeks fed by a relatively recent inlet from the sea that was probably already losing the contest with the creeping dunes.

It was these marshes that John Coke acquired in 1659 as part of his purchase of the manor of Burghall. By that date he already had knowledge of marsh reclamation schemes, including 'the great dyke of improvement' at neighbouring Burnham Overy and embankments constructed by a Dutchman further along the coast at Titchwell, as well as, possibly, a smaller scheme by his neighbour, Newgate, at Holkham itself.[5] Further afield, the large-scale

The iron age fort known as 'the Borough'.

draining of the Fens by Dutch specialists was well under way. Having bought the reversion to Burghall manor some twenty-five years earlier, Coke had planned ahead so that, when the life tenant died in March 1659, he was poised to set about embanking and draining the marshes. Immediately his account book recorded payments to dykers. Soon James Hunt (who was later

responsible for a surviving map of Wells marshes) was paid for surveying and in October Messrs Peach and Palmer were paid £268 'for the new banke makeinge as by a book particularly appeare', a book that unfortunately has not survived. Work continued during the following year when Peach completed the bank, a keel and a boat carried materials down to the meals or dunes and a bricklayer and carpenters worked on a sluice.[6] The bank ran southwest from the dunes near Holkham Gap to a point roughly in line with the church, thus cutting off the Borough Channel from Holkham Gap. The bank still stands, although no longer the first line of defence against the sea, and the marshes it protected were identified on later maps as 'the old marshes'.

To the east of Holkham Gap, the creek system was longer and stronger, with the result that attempts to drain these marshes came much later. The area was described in detail in a document of 1637.[7] The principal creek was Mickle Fleet, open at its eastern end to the main sea channel at Wells-next-the-Sea and feeding several sizeable creeks that branched off southwards as it crossed the marshes. The largest of these was the Holkham Common Channel, heading south to the edge of higher ground where it turned west to run along Holkham staithe and, beyond the staithe village, met the freshwater stream flowing out of the Clint, the long marshy depression running north from Holkham town. The eastern boundary of the dunes where they met the Wells channel was identified, probably anachronistically, as 'the harbour of Holkham' and it must have been along Mickle Fleet and the Common Channel that smaller boats had once transferred goods from that outer harbour to the staithe.[8]

The whole of the sand hills, marshes and creeks east of Holkham Gap, together with all associated rights such as foldage (grazing for sheep), fishing, hunting and anchorages, and the power to enclose the marshes against the sea, were granted in 1637 by the Crown to Edmund Newgate, owner of a large estate in the north of the parish. There had been some dispute over the title to these marshes and Newgate obviously thought the consideration money of £150 well worthwhile.[9] The area he gained, north of the coast road, stretched from the parish boundary with Wells-next-the-Sea on the east as far as a line roughly north of Holkham church, beyond which the western marshes belonged to Burghall manor. Newgate must have acted immediately to drain a small area of marsh, or had already done so while his title was still disputed, for in 1640 he was liable for tithes on wheat, rye and oats grown on fifty acres 'in the marsh', but most of it was used, depending on the state of the tides, as part of his foldcourse for grazing sheep.[10] John Coke acquired these marshes when he bought the whole of Newgate's estate

in 1659, at the same time as he was draining his newly-acquired Burghall marshes to the west.

John Coke died only two years later and his successors, all relatively short-lived and lacking his degree of attention to the estate, did not initiate any further land reclamation. The existing bank was maintained, for it was noted that 'had not Humphrey Smith at his first comeing to live at Holkham raised ye Marsh Wall all ye whole levell had been drowned & ye wall blown up for by reason of ye great wind never so great a tide was known in ye memory of man'.[11] Smith's employers, Thomas Coke's guardians, considered the possibilities offered by more reclamation, perhaps influenced by Coke's grandfather's suspicions that the sickness that had plagued the family had been caused by Holkham's location, 'lying so open to ye sea'.[12] One of their earliest instructions was that Smith should 'inform himself of the manner of inclosing Holkham marshes, of the charge it will amount to, and upon what terms any person will undertake it, either upon their own accounts, or upon the account of the guardians'.[13] They did not pursue the matter, however, and reclamation was limited to 'taking in the Clint from the sea, being a salt marsh'. It was then let for £5 and, so the steward reported, 'in a few years will be worth double the money'.[14] He could not foresee that, some fifteen years later, Thomas Coke would dam the fresh water stream that still ran through it, in order to create his lake.

At this period, most of the western marshes (those drained in 1659) were let to Smith as the guardians' steward and tenant of the Hall farm. Totalling 170 acres, they were a valuable part of the farm, nearly equalling its arable acreage (189 acres) and with the same rental value of £75. The six tenants of the other Holkham farms each had from 12 to 24 acres of feeding marsh. The salt marshes further east, still undrained, were also used for grazing sheep: 'depasturing on the salt marsh of Newdigates conteining about 700 acres' supported a flock of 500 sheep.[15]

Sixty years after John Coke had reclaimed the western marshes, Coke undertook the next major reclamation. In December 1719, during his first visit to Holkham after taking possession of his inheritance, he personally inspected the salt marshes, tipping the labourers who were in attendance, and paid Mr Bateson, the author of a pamphlet published some years earlier on draining marshes in Norfolk, 'for his trouble in viewing and giving his advice in inclosing ye salt marshes'.[16] They were inspecting work already under way by Nathaniel Kinderley (or Kindersley), who in later years made a name for himself in drainage and reclamation schemes but at this date is known only to have had some experience with a drainage engine in the Fens and to have proposed schemes (not implemented) for improving the River

The marshes in about 1719, showing the lines of the 1659 and 1719 banks.

Dee, near Chester, and the harbour at King's Lynn.[17] He was paid a total of £2,000, the first instalment in September 1719 and a second in February 1720, for 'embanking Holkham marshes'. This was the southern part of the marshes bought from Newgate by John Coke sixty years earlier. The new bank ran in a south-easterly direction from the dunes near Holkham Gap, cutting off the Holkham Common Channel and two other sizeable creeks, Schutt Creek and Bartle Creek, from the much larger Mickle Fleet, some way south of their confluence. There must have been considerable cooperation with Sir Charles Turner, of Warham, who at the same time continued the scheme through his land, eastwards, nearly as far as Wells quay.[18]

The new marshes were let to Kinderley for £400 a year, by far the largest individual rent for land at Holkham.[19] Within a few years, however, Kinderley had fallen into arrears, probably because he had turned his attention to work elsewhere, not least as a conservator (responsible for proper drainage of the Fens) of the Bedford Level in the Isle of Ely.[20] Humphrey Smith benefitted from his experience in reclamation work at Holkham in similar manner, moving on to surveying and draining work in the Fens after he was dismissed from Holkham in 1722.[21] In 1728 Coke (now Lord Lovell) took the marshes

View towards the marshes, dunes and sea from the south.

back in hand.[22] Perhaps both Coke and Kinderley had overestimated the ease of bringing these particular marshes into production, for expenditure continued on repairing the bank, widening the delphs or drains, scouring ditches, supplying materials (and ale) for the bankers and making bridges, all of which often amounted to a considerable proportion of total expenditure under the heading of estate improvements in the parish. In 1735 there was additional expenditure 'for repairing the bank that the great tide washed down'.[23] At this period, most of the new marshes were still in hand but, as they were secured and improved, increasing areas were let to tenants.

There is little specific evidence for Thomas Coke's motives in undertaking the reclamation. It may be that, incubating ideas for the transformation of Holkham, he found it undesirable to have salt marshes so close. In the early 1720s, the new bank enabled his uncle to reassure his grandfather that 'Holkham is as healthfull as most other places, it stands in a very clear air, and no fenns within twenty miles of it. Its neighbourhood to the sea can't make it unwholesome since the coast is not muddy and several scituations near the sea coast are allow'd to be as healthfull as any part of England. There is a marsh indeed near us but that is inclos'd and the water draind of. Mr Coke likes this place so well now that I believe if ever he builds it

> To Clem: Seel & Partners for delphing
> & Scowring ditching in the Marshes
> by Bill .. 13:13:0
> To Thō Clements & partners for ditto
> by Bill .. 22:8:8 42:18:9
> To Ditto for ditto by another bill 4:8:6
> To Wᵐ Richardson & Partners for
> ditto by Bill .. 2:7:10
> To Wᵐ Metcalfe & Partners for
> filling Sand for repairing the Banks
> the great tide washed Down in Feb 1735 .. 5:11:8
> To Wᵐ Rust for Ale delivered to
> the Bankers .. 0:10:9
> To Mʳ Curtis for Deals for the
> Bankers use .. 11:16:11 181:12:11
> To Thō Wallar for making wheel
> Barrows for ditto 2:15:0
> To John Philip & Partners for 652
> floors of Banking in the new Marshes .. 160:16:1
> To Ditto for Ale by my Lords order 0:2:6
>
> Carried over 224:11:8

Maintenance of banks and ditches, in the Audit Book or estate account for 1735.

will be here.'[24] Given the high rent that initially appeared feasible for the newly-drained marshes, another incentive was the opportunity for Coke to increase his all-year grazing land and his rental. It is also possible, however, that Coke fully intended the sea and the marshes to play a supporting role in the setting of his new hall. He had known the area from childhood, his parents had enjoyed it and they had not shared his grandfather's suspicion

of the coastal setting. As he developed the designed landscape from the 1720s onwards, the absence of architectural features to the north of the Hall (other than, eventually, the North Lodge) was possibly no more than a reflection of the fact that most of the staterooms would face south and that the principal route towards the Hall would be from the south. It was not Coke's style, however, to allow part of his grand design to happen by default. Much more likely was a deliberate and positive decision by Coke to make the northern aspect of his new house and park speak strongly of the coast and the sea, intensifying yet further the masterpiece of high drama achieved by the insignificant central door in the austere north front as it opened into the astonishing Marble Hall. The sea was not visible from that door but, upstairs on the principal floor, 'from the apartments there are many and different pleasing views: some command the sea, which is often enriched by the number of ships that pass that way'.[25] The surveyor, Biedermann, mapping Holkham some years later, was not given to unnecessary flourishes but thought it appropriate to show several ships on the sea. Even when guests strolled out to the Obelisk Wood and the Temple to the south, or to the lake on the west, they found vistas or lines of view, all labelled on the map, designed to draw their gaze back to the north, to Holkham staithe, Wells harbour or along the length of the lake to the sea.[26] The effectiveness of these vistas delighted visitors. Lady Grey found that from Obelisk Hill there were 'the prettiest Views down to the House & the most extensive Prospects of the Sea … that can be seen anywhere' and Lady Beauchamp Proctor, a few years later, discovered that 'from one of the temples you discover two harbours, I forget their names, and they have often a prospect of whole trade fleets going out and coming in'.[27]

Coke took pride and pleasure in showing how his lake was being created from the natural stream that ran along the Clint into the marshes, instructing

The marshes *c.*1744–59.

The marshes *c*.1780. Key: 12 Borough Hill, 13 decoy, 22 road to the seaside, 23 old bank [1659]. Marsh names include 29 Near High Bridge, 42 Between Bridges, 43 & 44 East and West Drawbridge. Salts Hole is shown but not named adjacent to 18, a marsh called New Delph. The marsh house shown between 47 and 48 was replaced in the 19th century by Meal House west of Holkham Gap.

at an early stage, 'I would not have the head of the great water raised so high as to hinder its running when my guests come down, for I would have them see it as running water'.[28] In comparison with the later fashion for a sinuous naturalistic lake, his lake presents itself on maps as a straight canal but its apparent formality obscures the fact that he formed it by damming the Clint stream at the most northerly point possible, thus preserving a visible link between the lake and the remnants of the marsh creeks. Had he not desired this effect, he could have taken advantage of the old stew ponds, much nearer the Hall, fed by the same streams from the south, to create a lake that boasted no such relationship with the marshes and the sea. It was only in future generations, as the fashion for vistas passed, the peripheral belt of trees grew to maturity and the late-nineteenth century plantations of pinewoods on the dunes finally obscured the view, that the strength of this early connection between Hall, park and coast was lost.

The marshes *c.*2000, including the Wells bank of 1859.

Keeping out the sea did not turn reclaimed marshes into ordinary farmland. The channels, controlled by sluices, were not only crucial to the efficient drainage of the reclaimed land but also gave it added attractions. In the eighteenth century the 'navigable water' and the marsh channels were regularly cleared of rushes and weeds 'for the convenience of fishing' and there were thatched boathouses on the marshes and the Borough Channel.[29] A local fisherman was often paid in the house accounts for fish for the kitchen but fishing also appeared in the 'hunt' account. In the 1720s, for example, a boat in the marshes was repaired so that Coke's friend, Mr Bedingfield, could go fishing and there were frequent payments for purchases of drag nets and for setting grates (gratings) in the marshes 'to preserve the fish'.[30] In 1759, so it was recorded many years later, two pike were caught in the marshes, one weighing 45 pounds (20 kg) and the other 37 pounds, the latter with a carp in its belly that weighed five pounds.[31] In 1740, a decoy man, Thomas Skeet, was brought over from Herringfleet, near Great Yarmouth, where there was a well-established duck decoy, to construct a similar arrangement in the Borough channel.[32] John Skeet, perhaps his son, was subsequently employed as decoy boy. A typical decoy was a piece of open water, from one to three acres, off which led tapering net-covered ditches, known as pipes. Wild ducks, reassured by the behaviour of tame decoy ducks, were induced, by grain or by judicious use of a trained dog, to enter and continue along the pipes, their retreat to the pond then being cut off by the decoy man, so that they were trapped in the closed end or tail net. Traces of

the Holkham decoy can still be seen on the marshes, half a mile north of the church, but it was believed to have fallen out of use by the beginning of the nineteenth century.[33]

By about 1780, while the Hall farm still occupied the western marshes, most of the new marshes (those reclaimed in 1719) were let to farmers and smaller tenants, many of whom had lost land within the park, or were soon to lose it, to T. W. Coke's landscaping and his extension of the home farm. There were about fifty-five marsh fields of various sizes, let to seventeen individuals including all the Holkham farm tenants; the tenant of the staithe farm had over eighty-five acres while the smallest holding was little more than three acres.[34] By the time of a survey in 1851, however, the absorption of all the old farm tenancies into the Hall farm or the park meant that, apart from Model Farm, it was tenants of estate farms in neighbouring parishes who now rented the largest areas of grazing marsh. The smaller marsh tenants were Holkham villagers, described by the agent some years later as 'little people, mechanics and labourers, who possess the much vaunted privilege of a piece of pasture and a cow'.[35] The enduring financial value of the marshes reclaimed in 1659 and 1719 was shown by the same 1851 survey: totalling 555 acres, the marshes comprised not quite ten per cent of the total parish acreage but yielded more than twenty per cent of the parish rental.[36]

There was no reclamation of marshes at Holkham between Thomas Coke's in 1719–20 and the 2nd Earl's in 1859, despite the claim by Mrs Stirling, the descendant and biographer of T. W. Coke, owner of Holkham from 1776 to 1842, that he 'laboriously, and at enormous cost, reclaimed 700 acres which had previously been covered by the ocean'.[37] According to Coke's agent, writing a couple of years after Coke's death, Coke 'frequently spoke of it as a thing which ought to be done' but had promised Mr Bloom, a Wells-next-the-Sea merchant, not to do it in his lifetime and after Bloom's death thought it too late to start such a large undertaking.[38] The estate accounts show that the marshes that had already been reclaimed demanded constant attention. Breaches in the banks had to be promptly repaired and there were frequent payments to gangs of labourers for regular maintenance, cleaning channels and 'bottom foying and brinking' of the delphs (the smaller drains or ditches at the foot of the banks). One of the marsh tenants was paid for mowing and raking the sea bank. From 1808, there was a designated estate engineer.[39] The post was created for Jonathan Crook, probably formerly the foreman of the famous West Country geologist and land drainer, William 'Strata' Smith, who had recently advised T. W. Coke on land drainage and the creation of water meadows elsewhere on the Norfolk estate.[40] On Crook's death in 1821, his son, John, succeeded him in the post.

The eastern marshes and the Wells channel in 1780, showing the large expanse of undrained salt marsh.

A large part of their work was repairing sea banks, planting marram grass on the dunes, making a new road across the marshes and planting osier beds and a reed hearth (or bed) in the marshes.

The idea of reclaiming the remaining marshes, known as Wells West Marshes, was resurrected in the 1840s by the 2nd Earl, with the agreement of the Wells Harbour Commissioners, soon after he succeeded to Holkham. This was a much larger project than the earlier embankments, covering an area of about 600 acres, much of it in Wells-next-the-Sea parish. It required the construction of a substantial bank to cut the link between the major creek (Mickle Fleet) and the Wells channel, and to protect from the Wells channel all the marshes to its west, from the dunes in the north to Thomas Coke's and Sir Charles Turner's banks (those built in 1719) in the south.[41] A survey and report in 1844 by J. M. Rendle, a prominent member of the Institution of Civil Engineers, caused the Earl to postpone the embanking project because of the excessive cost, but about eight years later he went ahead with a limited amount of work.[42] As some of the salt marshes still belonged to

the Crown, a necessary prelude was the purchase of about forty-seven acres, mostly along the southern bank of Mickle Fleet.[43] Work on the main bank started at last in April 1857 to plans by Arthur Saunders, a civil engineer based in King's Lynn, and Lord Leicester wrote during 1858 that he hoped 'to shut out the sea' in December.[44] The revised line of the bank, further east than originally proposed, was 'entirely with a view to improve the navigation of Wells harbour' but it necessitated the purchase from the Crown of another 118 acres between high and low water marks.[45] At this date, the agent estimated that embanking the original area would cost about £9,000, or £18 per acre, and the additional area would add £4,500, or £45 per acre. In fact, the total cost over the three years 1857–59 reached about £18,700.[46]

For the first ten years after the completion of the bank, separate accounts were kept for the Wells West Marshes while the land there was gradually brought under cultivation. Unlike the earlier grazing marshes, where field boundaries still followed the line of old ditches, it was divided into rectangular fields to enable cultivation by a steam plough, purchased specifically for this purpose at a cost of £776. Horses and working oxen from Park Farm were also used. By 1861, sales of oats, Devon cattle, peas, barley, wheat and pigs were bringing in small receipts, although far short of providing any profit over the farming costs.[47] The purpose of this mixed farming was to bring the land into a fit state for laying down to grass, a process only completed some twenty years after the building of the bank.[48] The bank was breached in December 1862 over a length of about 400 yards and, as the agent wrote, 'the land a second time reclaimed' by June 1863: 'during the intervening time it was twice a day covered by the tide, the crops sown were entirely destroyed and to some extent the land was reduced to its original state, although it was capable of being … brought into a state of cultivation at less cost'.[49] The Earl

Making a bank to shut out the sea, 1906.

himself was said to have joined the working gangs in times of emergency: 'for hours he has been seen on Wells Bank, a tall, powerful figure in an old shooting suit and top boots, superintending pile driving or other protective operations, and utterly indifferent to a soaking rain'.[50] The bank, now followed by a road and miniature railway from Wells quay to the beach, remains a vital part of local coastal defences, although no longer the responsibility of the Holkham estate.

*

The dunes, known locally as meals, between the marshes and the beach offered less development potential than the marshes but always formed a protective line against the sea, a role that became pre-eminent when the marshes were reclaimed. In the early-eighteenth century, their value was as a rabbit warren, for which a tenant paid £10 a year for 'the coney house, merum hills & about 100 acres of land lying next the sea stock't with coneys'.[51] Rabbit meat and fur were beginning to lose their earlier luxury status but the domestic accounts of the Hall reveal that, for example, '84½ couple' (169) rabbits were used in the kitchen in one three-month period in 1750. In the 1770s the warren was sufficiently important for the widowed Lady Leicester to accuse the Wells Harbour Commissioners of damaging it while gaining access to their navigation light on Holkham meals.[52] It was still a going concern a century later in the hands of John Crook, the former estate engineer, now in his seventies and living at Meal House, where the rabbit warren was his principal source of income. By 1891, however, one of

Meal House, 1870s.

Meal House, c.2000.

his many sons, although still living at Meal House, was described only as a farmer, reflecting not only the general decline in rabbit warrens but also the estate's primary concern for the stability of the dunes and the protection of the pine tree plantations.[53]

The sand dunes were already called 'merrum hills' early in the eighteenth century. Systematic planting of marram, a tall, tough, creeping grass, in order to strengthen the dunes appears in the estate accounts in Thomas Coke's time and more frequently under T. W. Coke. In 1775, for example, 1,281 floors (twenty square feet to the floor) were planted at four pence per floor, and 923 floors in the following year.[54] After the building of the Wells sea bank in the middle of the nineteenth century, the dunes became additionally important as the northern link in the sea defences and the 2nd Earl of Leicester, who was keenly interested in forestry, conceived the idea of planting the pinewoods that are now such a distinctive feature along the three miles of dunes between Holkham and Wells-next-the-Sea. First attempts at growing pines in the sand were made in the 1850s (anticipating the completion of the Wells bank at the end of the decade) by means of pine seeds planted in balls of clay, which proved unsuccessful. Small saplings, however, thrived when planted in favourable situations and protected by marram grass. Large-scale planting at set distances began in the 1870s, using Corsican, Austrian, Scotch and Maritime varieties of pines. They were raised in a nursery within a mile of the sand hills in order to acclimatise

Watercolour view across the marshes to the dunes, by Robina Napier, the vicar's wife, 1868.

A similar view. 2016.

them and were moved every year, for two to four years, in order to make sturdy plants with plentiful roots. They were planted out in spring, needed no after care apart from keeping rabbits down, and the Corsican pines, in particular, spread by self-sowing. Opinions varied as to whether the trees served a practical purpose. The Holkham agent, Wood, giving evidence to

the Royal Commission on Coast Erosion in 1907, considered marram grass more effective in fixing the dunes and thought the trees 'were planted for shelter and ornament only'. The 4th Earl, however, writing in 1948, was convinced that the Wells bank, costly to build and requiring constant attention to maintain, 'would not have been embarked on if my grandfather had not had some further scheme in mind for strengthening the already existing barrier afforded by the lines of sand dunes'. Even in the early 1950s, it was said that the coastal plantations at Holkham 'must rank among the most interesting and exciting things in British forestry'.[55]

The sea featured less often than the marshes and the dunes in the estate records. There were mariners living at Holkham in the late seventeenth century but it is likely that they sailed out of Wells-next-the-Sea; the tenant of the staithe farm was a merchant as well as a farmer but when he died in 1730, his ship, the *Providence*, was lying in Wells harbour.[56] The estate's direct connection with the sea was through wrecks. In 1731 Thomas Coke purchased 'the office of feodary and wreck of sea in the county of Norfolk' from the Duchy of Lancaster but in practice this probably yielded less benefit than rights to wreck as lord of the manor.[57] A group of lords of Norfolk coastal manors successfully united in 1811, at the prompting of the lord of Salthouse and Kelling, to force a modification of a recent Act that gave rights of wreck to a new post of local deputy vice-admirals.[58] The manorial lords declared that they were 'almost universally entitled by grant or prescription to wreck of the sea within their respective manors, and it has been the immemorial practice and usage for such lords by their bailiffs or sea reeves and others to secure and preserve the goods cast on shore'. They would then either claim a salvage payment from the owner or retain the goods. They added that this right enabled them to prevent breaches of the peace among local inhabitants, 'over whom the lords of the manor have hitherto possessed considerable influence which they constantly exerted for the assistance of ships in distress and the preservation of goods cast on shore'.[59] There was no designated bailiff or sea reeve at Holkham, probably because the owner and the agent were so close at hand, but local men were rewarded for reporting and guarding wrecks. In December 1741, for example, there were payments to Thomas Clements for securing a wreck on the shore and several men for watching throughout the night to prevent it being plundered. Edmund Peckover, merchant, then paid for the salvage of 308 firkins (77 barrels) of butter and six casks of tallow, to resume their interrupted journey to London.[60] In 1823, servants, workmen and labourers benefited when the *Albion* foundered on shore with a cargo of coal, much of which was retrieved and sold to them at well below the normal price.[61]

The estate paid duty on the salvaged coal but other legalities were not always observed, for an intriguing reference to smuggling, evidently an acceptable local activity, crept into the estate records in 1817. The Estate Office received a request through the Custom House at Wells-next-the-Sea from Captain Hanchett, national Comptroller General of the Water Guard, to allow a flat-bottomed boat to be hauled up at Holkham Gap for the preventive boat's crew to live in. The end of the Napoleonic Wars had swelled the numbers of smugglers with unemployed soldiers and sailors and had opened up European ports for them; as a counter measure, the preventive Water Guard, established a few years earlier to operate close inshore to tackle smugglers who evaded the revenue cruisers, had recently been placed under Captain Hanchett, brought under the control of the Treasury and given power to operate from the shore as well as at sea.[62] The Holkham agent, Blaikie, promptly referred this 'blocking up' of Holkham Gap to Coke, who took it up with 'the promoter of what is termed the preventive system' and received the desired promise from the Treasury that 'the preventive smuggling system, as far as relates to Holkham Meals and Gap, was abandoned'.[63] Faced with the local interests of a long-standing Member of Parliament, Captain Hanchett must have despaired.

From time to time the proximity of the sea placed the Holkham neighbourhood in the front line of invasion threats, from the Dutch in the late-seventeenth century to the Germans during the 1939–45 World War.[64] The threat from France during the Seven Years War (1756–63) was the indirect cause of a 'phantom duel' involving the 1st Earl early in 1759. Disparaging remarks made by Lord Leicester about the new county militia scheme provoked his neighbour, George Townshend, a much younger and hot-blooded man, a professional soldier, to challenge him to a duel. Lord Leicester replied with mature good sense, pointing out to Townshend that he 'could get no honour by vanquishing a man older than your father and grown quite unwieldy and unfit for such encounters' and for his part declining to 'turn duellist in my grand climacterick'. Townshend ungraciously accepted Lord Leicester's explanation but the possibility that a duel had taken place, and might have contributed to the Earl's death three months later, proved irresistible to Coke family biographers in the early twentieth century.[65]

Forty years later, the renewed threat of invasion during the Napoleonic Wars led to an Act of Parliament authorising the establishment of local yeomanry forces. T. W. Coke, although initially slow to warm to the idea, in 1798 founded the Holkham Yeoman Corps, under his command as major and numbering sixty to seventy men. The standard was consecrated in the Hall

Part of the Holkham Yeomanry Corps standard used as a fire screen.

chapel and then, in a ceremony on the south lawn, presented by Mrs Coke who, like her husband, wore uniform complete with 'plated chain epaulettes'. A sergeant from the Prince of Wales Regiment had already arrived from London, with his wife and child, to spend forty weeks at Holkham teaching 'Military Exercise' to the Corps. He was provided with lodgings in the village; a military jacket, waistcoat, greatcoat, doeskin pantaloons, helmet and sword belt were bought for him; and he was paid 10s 6d per week and a present of £9 8s when he returned to his regiment in the following spring. Thomas Moore, a farm tenant at Warham, often attended musters in Holkham park, rather more frequently in the summer than at harvest time or in winter. Social occasions cemented the solidarity of the Corps, for Moore enjoyed dinners with the troop at the *Golden Fleece* in Wells-next-the-Sea to celebrate Major Coke's birthday and an outing to see a play at Walsingham, while the estate accounts recorded sixteen guineas for another 'dinner and wine to the Holkham Yeomanry' at the *New Inn*. With the Peace of Amiens in 1802, the Corps was disbanded and Moore 'attended at Holkham with the cavalry to deliver up all our arms'. It was re-established at the end of 1803 as the threat of invasion by Napoleon returned; once again, uniform was bought for Mr Coke and for a drill sergeant. The Corps was finally disbanded after the Battle of Trafalgar.[66]

During the 1939–45 War, the marshes, dunes and beach were requisitioned by the War Department and heavily fortified. At the foot of the dunes, the beach was defended with barbed wire attached to scaffolding poles sunk

in the sand. Their incomplete removal after the war by prisoners of war left a tangled mass of partly-buried wire and the remains of base poles over an area of beach at least thirty-five yards wide (more at Holkham Gap) for the full length of the beach. There was an artillery position in the dunes as well as concrete 'pill boxes' in various places, six weapon pits in the grass verges of Lady Anne's Drive and minefields 'dotted here and there'. As negotiations for reparations after the war dragged on, the surveyor employed by the estate resorted to a dramatic description of wartime traffic on the old livestock tracks: 'heavy army lorries and Bren gun carriers charging down Bone's Drove, along the woodland rides and out the other end of the woods. Continuous heavy military traffic driving at speed down all the roads to the woods. A bulldozer was driven into the drain in Bone's Drove; 3 lorries were bogged at the same time in the woodland ride near Meals House … all the contractors' vehicles going to High Cape to make the gun emplacements and camp site; all the vehicles going down Lady Ann's Road to take the tubular scaffolding and wire on to the beach for the defence works'.[67]

The Holkham estate's claim for reparations after the war included clearance of the defences and making good the damage to roads and marsh drains, but the overriding concern was the amount of damage from wind erosion, caused by the erection of artillery structures on the dunes and exacerbated by the failure of the War Department to heed local advice about

WARNING

VISITORS ARE WARNED of the presence, both above and below the surface of the **SANDHILLS** and **BEACH**, of **BARBED WIRE** and other Defence Works Material which have been left uncleared by the War Department.

NOTICE IS HEREBY GIVEN that the Holkham Estates Company accept no responsibility for injury to or damage sustained by anyone visiting the area.

ESTATE OFFICE, HOLKHAM,
 1st June, 1950.

Holiday hazards: notice to visitors, 1950.

maintenance of the dunes. Although the area was officially derequisitioned in 1945, the estate was not given full possession for another three years and the rapidly deteriorating situation soon required a double line of faggots over 1,100 yards of dunes. When the War Office demanded details of pre-war expenditure against erosion, for comparison with the reparation claims, the agent, who had been at Holkham for nearly forty years, explained that 'accretion rather than erosion' had been the norm. The combination of regular faggoting at the foot of the dunes, the growth of marram on the seaward side and the increasing height of the pine trees had produced an unprecedented development of the dunes which, before the war, had attracted the world-wide attention of practical engineers engaged in the fixation of coastal sand dunes.[68] Negotiations with the War Office for reparations continued until the autumn of 1952, by which time the claims amounted to over £100,000, a compromise being reached around £65,000.

Shortly afterwards, this demonstration of the precarious balance on the dunes between nature and man was followed by severe flooding during the night of 31st January 1953, revealing both the crucial role and the ultimate frailty of the sea banks. A combination of high tides and north winds channelled a surge of water down the North Sea, flooding large areas of the east coast, the Thames estuary and Holland, with considerable loss of life. The banks at both Wells-next-the-Sea and Burnham Overy broke, leaving

The floods of 1953: the junction of Lady Anne's Drive and the coast road.

The floods of 1953: the end of the railway across the marshes.

Holkham exposed to the full force of the sea as it swept in from both directions and through Holkham Gap, covering the marshes from which it had been largely excluded since 1659, 1719 or 1859. The railway line across the marshes was swept away, ending nearly a century of the railway link along the coast, and the family in the station house was rescued by boat after eighteen hours in the bedrooms. Meal House was not flooded but the family occupying it was marooned for nearly two days. Cattle and sheep on the marshes were drowned. The water was five feet deep on the coast road and the force of the water as it reached the park wall was sufficient to breach it in three places, flooding eleven acres of woodland within the park. About thirty acres of the pinewoods on the dunes, mainly at the Wells end, were destroyed, initially covered by up to ten feet of sea water and then inundated by each tide until the last of the breaches in the sea wall at Wells-next-the-Sea was closed fifteen months later. A total of one hundred acres of the pinewoods was affected to some extent. Part of the cost of clearing and replanting was met by a grant of £3,100 from the Lord Mayor's National Flood and Tempest Fund.[69]

*

The modern focus on Holkham beach and pinewoods as a public leisure amenity is a product of the last sixty years. At Wells-next-the-Sea, the sea bank rapidly became popular with locals and visitors; even before its completion in 1859, a police constable had to be employed to protect it on Regatta Day.[71] During the summer of 1922, the Holkham estate office noted the amount

of traffic heading along the bank to Wells beach, culminating on the August Bank Holiday with forty-one two-wheeled vehicles, seventy-six four-wheeled vehicles, twenty waggons, twenty-nine motor cars and twenty-two motor lorries.[72] This situation was avoided at Holkham, however, by strictly limiting access to the beach and pinewoods. As late as the 1930s, no public access was allowed to the sand dunes, pinewoods and the drive behind the dunes, and only limited motor car access along Lady Anne's Drive to reach the beach. The *Victoria Hotel* was allowed twelve seasonal passes, at ten shillings each, for use by guests, a privilege also granted to certain other people, 'for example local bank managers'. Otherwise a toll of 2s 6d was charged during the summer, 'with the sole purpose of preventing our foreshore becoming a popular resort to all and sundry, and incidentally to protect the property'.[73]

Later in the century the emphasis could not have been more different. Attitudes to public access changed. The former carriage drive along the southern edge of the dunes from Holkham to Wells-next-the-Sea became part of the Norfolk Coastal Path and advertising material for the Hall highlighted its proximity to the beach. The caravan and camping site at the north end of the Wells bank, originally established in 1926 and subsequently leased

THE HOLKHAM ESTATES COMPANY

Lady Anne's Road, Holkham

MOTOR PASS

MESSRS. TRUST HOUSES LTD.

(For use of **RESIDENTS** Victoria Hotel and Ancient House only)

Speed Limit 15 miles per hour.

This Pass is the Property of The Holkham Estates Company and must be produced on request.

THE HOLKHAM ESTATES COMPANY

PASS to HOLKHAM PARK

MESSRS. TRUST HOUSES LTD.

(For use of **RESIDENTS**, Victoria Hotel and Ancient House only)

MOTOR CARS NOT ADMITTED.

This Pass is the Property of The Holkham Estates Company and must be produced or given up on request.

Access to the beach by motor car was strictly controlled in the 1930s.

Chapter 15 Overview: Marsh, Sand and Sea

to the District Council, was taken back in hand in 1996 and transformed by investment in landscaping and facilities. Car parking on Lady Anne's Drive and at the beach car park at Wells was recognised as a highly significant source of estate revenue. During the same period, however, increasing recognition of the national importance of the distinctive landscape and ecology of the North Norfolk coast resulted in the creation of the Holkham National Nature Reserve. In 1967 the Holkham estate granted the Nature Conservancy Council (later Natural England) the management of salt marshes,

HOLKHAM ESTATE.

Visitors to the Parish of Holkham are asked kindly to observe the following.

1. The Sand Dunes from Burnham Overy to Wells are private property and are maintained at considerable expense, Visitors are requested to refrain from disturbing the sand slopes to the shore.

2. Visitors are also warned that to maintain the Sand Hills the shooting of rabbits and vermin is necessary, and owing to the nature of the Dunes there is considerable risk attended in walking or resting on the Hills of being in the line of fire of the staff instructed to carry out this work.

3. The Pine Walks immediately behind the above Dunes are strictly private, and Visitors are prohibited from entering same.

4. In view of the highly inflammable nature of the Marrum Grass on the Dunes, and the Fir Trees, Visitors are requested to exercise particular care and on no account to light any fire within 50 yards of the Sand Hills.

5. Visitors are particularly requested to refrain from entering the area immediately in front of the Private Beach House erected on the Sand Hills, West of Holkham Bay, such area being marked by two Notice Boards lettered "PRIVATE."

6. Visitors staying in the Parish are prohibited from bringing Dogs with them.

7. Holkham Park is open to Visitors who are requested to keep to the hard Roads. Motor Cars are not admitted.

8. The Pleasure Gardens attached to the Mansion and the Kitchen Gardens are open to the Public on Wednesdays, from 9 a.m. to 5 p.m. during the summer months.

(Signed) ARTHUR E. W. TOWER,
Agent to the Earl of Leicester.

Estate Office, Holkham,
1st July, 1924.

Notice to visitors, 1924.

dunes, foreshore and agricultural land along an eight-mile stretch, including Holkham, in return for partial exemption from Capital Transfer Tax arising on the death of the 4th Earl of Leicester. Some of the marshes had been ploughed in the 1940s to increase wartime food production and arable use had increased after the War but, from the late 1980s, under the Nature Reserve scheme, water levels were allowed to rise. This encouraged a dramatic increase in birds such as lapwing, snipe, avocet, shoveller, redshank and marsh harrier, including several species that in previous centuries would have graced Thomas Coke's table or the 2nd Earl's display cases. Summer grazing by cattle, designed to maintain the turf at the optimum length for wintering wild fowl, resulted in record numbers of pink-footed geese, Brent geese and wigeon. The part of the National Nature Reserve owned by Holkham was taken back in hand in 2012, with a view to enhancing its varied habitats and rare species and minimising the impact on them of the thousands of holidaymakers drawn to the beach. Although its focus has shifted, the long history of estate investment in the marshes, embankments, dunes and pinewoods continues.

Chapter 16

Overview: Holkham and the Public

Sightseeing at Holkham around 1750 was a strange experience. The Hall was already well known, as Lady Grey, from Bedfordshire, acknowledged when she described her visit for a friend who had 'often heard talk of the house', but the building that people travelled considerable distances over poor roads to see was little more than one completed wing and the southern range of the main house, 'not quite cover'd in'. Visitors apparently did not notice the paraphernalia of a building site, the distant presence of workmen or even the old house, still the main family home, linked by a passage to the new wing. Some description of these would have been of immense interest to later generations but visitors had eyes only for the work in progress. Lady Grey thought that 'if ever the schemes are completed, nothing in England I believe can equal it' but her impressions were based entirely on the unfinished external appearance, for 'the rooms we could not judge of, as it is merely a shell'.[1]

Visitors wishing to see the house and grounds started arriving, unannounced, in early June, although a few might turn up as early as March. In July and August, no week went by without several visits: twelve groups, for example, during the two summer months in 1748 and fourteen in 1751. There was no set day for visits. On Wednesday 6 July 1748 the house was shown to 'Mr Bolders with six in company, Capt. Hodges & Mrs Strafford with 8 more in company', the following Tuesday there came 'three gentlemen to see the house', on the next day 'Mr Bedingfield, Mr Lee with ten more in company' and two days later 'Mr Gibbs, Mr Able and several tenants with their wives to see the house and gardens'. A week later, on a Saturday, came 'Lord Carr, Sir William Gage and Sir John Burlew with eight more in company to see ye house'.[2] Some visitors arrived in groups of a dozen or more but the house was equally open to individuals. Some were local people or tenants known by name to the butler or housekeeper but others were listed simply as 'company to see the house'. Some were noted in the butler's

Open air concert by *Status Quo*, 2007. Photo by Fisheye Images.

Typical entries in the butler's Wine Book, 1748, when people came to see the Hall under construction.

book as coming from Norwich, King's Lynn or Wisbech; others, like Lady Grey, were touring the eastern counties and visiting all the notable houses and sights or, like Caroline Girle and her family in 1756, enjoying a day's excursion while staying with friends in the area.

It says much about the mid-eighteenth century 'visitor experience' at Holkham that most details about people arriving unannounced to see the house are furnished by the butler's record of the wine served to them as refreshment.[3] The housekeeper was adept at providing such fleeting hospitality, greatly impressing Caroline Girle, aged eighteen: 'We had a breakfast at Holkham in the genteelest taste, with all kinds of cakes and fruit, placed undesired in an apartment we were to go through, which, as the family were from home, I thought very clever in the housekeeper'.[4] Whoever showed the house to Lady Grey's group in 1750 was articulate and knowledgeable, describing the overall plan for the house and in particular the Marble Hall, whose construction had not yet started. He or she not only gave details of its size and its kinship to 'an ancient temple' but then went on to explain the intended effect of its design, in which 'the eye is to be led through a colonnade of pillars on each hand to a statue of Jupiter, placed on a sort of tribune at the upper end'.[5]

Visitors probably introduced themselves at the old house and were taken through the connecting passage into Family Wing, occupied since 1740. John Price, Keeper of the Bodleian Library in Oxford, visiting in 1753, mentioned that his group 'enter'd thro ye Old Building' but his subsequent description shows that the starting point for the tour itself was the anteroom at the other end of the wing's principal floor. In this way, he saw the wing exactly as intended for the future, when it would be entered from the state rooms. He was shown all the main rooms in the wing, including the bedchamber.[6] By the time that Caroline Girle visited in 1756, three years later, the house was just ready for occupation and, although she did not mention it, the old house was being demolished, so her group would have been admitted directly into the new house by the newly-appointed house porter. The room under the portico was not yet ready to act as an assembly point for casual visitors, as it did later, and many of the staterooms were incomplete but, for the first time, visitors were able to marvel at the brand new kitchen and the equally impressive dairy.[7]

Once the whole house was occupied, opportunities for viewing it inevitably had to be more organised. Mrs Poyntz of North Creake, who knew the widowed Lady Leicester, wrote to her daughter, Lady Spencer, 'Tuesday is the day they show the house, Thursday is her publick day, and it is her delight to show the house; she told me if my lord and you ever come to Norfolk, she flattered herself she would see you some Thursday; you will find an elegant good dinner, for she is very well served, and there is no fuss'. A description by Lady Beauchamp Proctor of her second visit in September 1772, eight years after she had first seen it, reveals how popular the Hall had become:

> When we came to the House the Servant told us we could not see it for an hour at least as there was a party going round … we were obliged to submit to be shut up with Jupiter Ammon [the statue in the Portico Room] and a whole tribe of people, till the housekeeper was ready to attend us, nothing could be more disagreeable than this situation, we all stared at one another, and not a Creature opened their mouths.

She did, however, find out that the other party was 'the whole family of the Swailes, going the Norfolk tour'.[8]

In fact, the first guide to Holkham appeared in that same year, 1772, as part of the *Norfolk Tour or Traveller's Pocket Companion, being a concise description of all the noblemen's and gentlemen's seats, as well as of the principal towns and other remarkable places in the county of Norfolk*, published by Richard Beatniffe, a Norwich topographer and bookseller. A second edition in the following year coincided with the publication for a more specialist audience of the enlarged

The first separate guide to Holkham, by Beatniffe, 1775.

edition of the *Plans and Particulars* of Holkham by Matthew Brettingham junior. The *Norfolk Tour* went through at least five editions in the next twenty years. Said to be based on 'the most authentic historians and modern travellers', it drew heavily on Arthur Young's book, *A Six Weeks Tour throughout the Southern Counties of England and Wales*, published in 1768, in which he had described in detail his first visit to Holkham. Young was usually accurate and observant but the power of print was such that his misunderstanding of the location of the widowed Countess's rooms was regularly repeated in the guide books and persisted into modern times.

In 1775, by permission of Wenman Coke, who had just succeeded Lady Leicester, Beatniffe brought out a separate guide to Holkham, *A Description of Holkham House … with a particular of the Pictures, Statues, Bustos and other marbles therein*. A mere fifteen pages long, it did little more than list the rooms, their sizes and the statues and paintings. Tuesday continued to be the open day, although later editions of the *Norfolk Tour* mentioned that it 'may be seen any

day of the week, except Sunday, by noblemen and foreigners'. There is no record of the numbers seeking access to the house but strolling in the park was so popular that on open days T. W. Coke ordered the temporary removal of the wooden bridge across the serpentine river, 'so that visitors could not trespass beyond the south lawn unbidden'.[9]

It was 1817 before a fresh and more informative guide book appeared, compiled by a local man, J. Dawson of Burnham Market, who was alert to the fact that previous guides had been 'materially erroneous, from their having been successively copied … without reference to those changes which have taken place'. These changes included T. W. Coke's additions of some 'highly esteemed painting and other works of art' and the conversion of his dressing room to form the Manuscript Library. The anteroom next door was still in the process of being furnished with bookcases for the 'very early and valuable editions of the classics, selected from the north and south tower libraries'. Holkham still attracted considerable numbers of casual visitors, for Dawson specified with some emphasis that 'Holkham House is open for general inspection, on Tuesdays ONLY, except to *Foreigners and Artists.* Strangers or Travellers who wish to view the House on other Days, can only do so by particular application to Mr Coke, who has never refused his permission'. It was still the practice that 'when the person who shows the House is engaged, the Company is conducted into the Vestibule', the room beneath the portico in the centre of the south front. Here they signed a visitors' book, recording names and places of residence, which unfortunately has not survived. It was also possible, on application to the plate burnisher, to see the family plate or silver, and 'the gardens will also on proper application be shown'. Further editions of a *New Description of Holkham,* published by H. Neville of Wells-next-the-Sea, appeared in 1826, 1835 and 1838.

In the middle of the nineteenth century, as improvements in transport opened up new possibilities for the public to enjoy increasing amounts of leisure time, Holkham was typical of many great country houses in experiencing, and to some degree welcoming, the growth of mass tourism. There was no commercial element involved, simply an acceptance that public access should be allowed. Visitors had always explored the park and gardens as well as the house but now the emphasis was increasingly on access to the park. The young 2nd Earl showed the way in spectacular fashion in 1845, opening the park to celebrate the foundation stone ceremony for the Monument to be erected in memory of his father, 'Coke of Norfolk'. At this date the railway had not yet reached even Fakenham, ten miles away, but a heated public meeting at Norwich, two years earlier, to decide whether the monument (paid for by public subscription) should be built there or at Holkham,

had been well aware of the burgeoning value of popular tourism on the coast. A local newspaper reported an allegation at the meeting that 'a large number of new subscribers, many small amounts, had been just added, and brought up from Wells-next-the-Sea for the express purpose of swamping the original subscribers'. This allegation was met with 'noise and hisses' but supporters of Holkham won the day and the editor of the *Norwich Mercury* was scathing about 'the very disgraceful expedient resorted to by the inhabitants of Wells' who would be 'necessarily benefited by the access of visitors to that noble mansion'.[10] On the day of the foundation stone ceremony, the procession of tenants, clergymen and gentlemen on horseback, ladies in carriages and ranks of workmen carrying banners and flags, interspersed with bands of musicians, stretched for two miles from Longlands to the site of the Monument. After the ceremony, a thousand subscribers and their families were entertained to a lavish banquet in a huge marquee on the south lawn. As they dispersed to stroll or drive in the park and pleasure grounds, several hundred workmen and 'numbers of peasantry' took their place: 'before sunset the park must have entertained 10,000 people'.[11]

By 1851 the estate was inserting regular announcements in the Norwich papers that the park was open on Tuesdays in the summer, no doubt with the intention of making it clear that access was not allowed on other days. From 1858, the year after the Dereham and Fakenham Railway was extended to Wells-next-the-Sea, the railway authorities arranged cheap summer excursion trains to Wells every Tuesday to coincide with the park open day. For the Wells Regatta in that year, two trains brought 900 people from Norwich and intermediate stations, 'decked in summer attire and intent on killing two birds with one stone by going to Holkham and attending the regatta'. In the following year, the opening of the Wells sea bank (constructed by the Holkham estate to reclaim the Wells west marshes) and the 'promenade' along it attracted 1,100 'excursionists' or day trippers to the town. Many flocked to Holkham, where the gardens were crowded by ten o'clock, to fill the time before returning to Wells-next-the-Sea for the midday parade, afternoon regatta and evening fireworks. During the same summer, an intrepid group of trippers arriving by boat (perhaps from King's Lynn) went aground before reaching the quay at Wells but, having safely reached the shore, nothing daunted, went on to Holkham.[12]

Not surprisingly, a new guide to Holkham, published in 1861 by Henry W. Stacy of Norwich, noted in the very first sentence that the house 'stands at a distance of a little less than two miles from the terminus, in the seaport town of Wells, of the Fakenham and Wells railroad'. This guide, prompted by the 'outdoor alterations' of the past decade which had given Holkham 'an

almost entirely new appearance', was expressly aimed at 'those numerous parties of Summer Excursionists, who may avail themselves of the opportunities when kindly permitted of inspecting the Gardens and Grounds' as well as 'the many persons who may happen from time to time to be Visitors at the House'. More specifically, it was brought out to coincide with another great spectacle in the park, a Review of the Norfolk Volunteers. It was said that no one 'had taken more interest or had done more for the Volunteers of this county than the Earl of Leicester' and the Holkham review fulfilled the dual purpose of demonstrating the role of the aristocracy in the defence of the realm while showing off the massive new terraces, fountain and conservatory to the south of the house and the modern domestic offices and stables to the east. Two thousand Volunteers took part, including the Holkham company which had been assembled and trained during the past two years. It consisted of a captain, ensign, five sergeants, a bugler, nine musicians, a pioneer and thirty-six rank and file, making it the sixth largest corps in the county. Invitations to the review were sent 'far and wide to the ladies and gentlemen of

Review of the Norfolk Volunteers at Holkham, 1861.

the county' and it was estimated that 20,000 spectators gathered in the park. After the review, there was a display of skirmishing and firing round the lake. Then the Volunteers, having piled their arms on the north terrace, marched through the Marble Hall up to the Saloon, from where they emerged onto the portico, in full view of the crowds on the south lawn, before descending by means of temporary steps to the terraces. Here long tables, groaning under 4.000 pounds of beef and mutton, a bottle of wine to every three men and rows of barrels of Holkham ale, awaited them.[13]

The opening of the Wells-next-the-Sea to Heacham stretch of the West Norfolk Railway in 1866 gave a direct route for passengers from King's Lynn and Wisbech, with the added benefit that they could alight at the new Holkham station, part way along the beach road. This prompted the Earl almost immediately to alter the public day to Wednesday, 'in order to suit the convenience of persons living in that neighbourhood. Upon that day the park and grounds are entirely open to the public, and his lordship has not authorised ... them to be open to parties upon any other day'.[14] The open day was limited to July, August and September, extended to include October later in the century.[15]

On occasion, advance arrangements could be made to see the Hall, even for large parties. An excursion train, consisting of twenty-two carriages pulled by two engines, brought a party of 700 people from Peterborough, March and Wisbech in August 1860. This was before the direct rail link came into being, so they briefly explored Wells-next-the-Sea, where some cast an envious eye on the tram line from the railway to the quay, 'an acquisition which the port of Wisbech has been trying in vain to obtain', before walking through to Holkham. The visit was reported in the *Wisbech Advertiser*:

> Arrived at the park, the excursionists appeared thoroughly to enjoy themselves in rambling about, and observing the surrounding landscape. The house was open to them on payment of a shilling each person, and all appeared eager to see the state which an English nobleman maintains at his country seat. The beautiful gardens were open freely to all, and the fountains played during the afternoon.

The *Lynn News*, however, reported that the entrance fee of one shilling had caused 'great grumbling and dissatisfaction'. The Holkham agent, Keary, was quick to respond. He was emphatic that 'no charge was or ever is made when Holkham Hall is thrown open to visitors'. It was the organiser of the trip who had proposed the charge (an arrangement he had already adopted for a similar excursion to Burghley, a particularly popular destination) and who handed over the proceeds to the servants on duty in the Hall. Keary

added that he did not think it 'an unreasonable remuneration to them for the very great trouble incurred by them from the visit of a very large party'.[16]

A rather different type of group visit, an excursion to Holkham for 200 people, was included in the programme for the British Association meeting at Norwich in August 1868. In the morning they were shown round the Hall in five groups, conducted by the agent, the retired chaplain, the clerk of works, an Estate Office clerk and the latter's brother, with twenty maidservants on duty in the rooms. A lunch of roast beef, boiled beef, lamb, mutton, pies, chickens, ducks, hams, tongues, beef and veal patties, tartlets, cheesecakes, creams, jellies, grapes and biscuits ('scarcely enough', noted the agent for future reference), washed down with claret, sherry and beer, was served in the Audit Room and three large tents. Afterwards the visitors could see the library or opt for visits to the church, Monument and kitchen garden, the East Lodge, Great Barn and Obelisk, or 'minor excursions in the deer park' before departing at half past six.[17]

The Cambridge Reform Club came more than once. The Earl had 'no objection' to their picnic in the park on a non-open day and also offered to have his gardens and pleasure grounds 'thrown open to the party' but he wanted to know how many and 'what class of persons they will be' before answering their request 'to see the pictures'. They passed muster and were allowed in the Hall between 10 am and 1 pm, in groups of twenty-five and no more than two parties at a time.[18]

Throughout the second half of the nineteenth century, the estate continued to advertise the park open days and the Holkham Cricket Club season in the Norwich papers but access at other times was increasingly controlled. The park had long been closed on one day a year in order to demonstrate the owner's 'exclusive right and privilege to Holkham Park and the roads therein' but in the mid-1850s the agent wrote that Lord Leicester had issued 'fresh rules' to the gatekeepers, 'which forbid the entrance of anybody except on the public day, Tuesday, and he has not authorised me to make exceptions in favour of those persons who have previously possessed tickets of entrance'.[19] Restricted access applied to local people and tenants as well as excursionists, prompting irritated letters to the agent. He reiterated the Earl's strict instructions in the 1870s 'that no wagons, vans or square carts are to be admitted into the park' and that no one should be allowed into the park 'merely to make a short cut from one place to another', although the Earl 'would be sorry to prevent anyone driving in the park, in the principal roads, who may desire to do so, as any one residing in the neighbourhood has hitherto been at liberty to do'.[20] Pity the poor gatekeepers who had to judge such niceties.

Notice from one of the park gates, 1868.

Although casual access was controlled, organised groups were still welcome in the park. During one year it hosted 200 children from Wells-next-the-Sea on their Sunday school treat, 449 children from the Norwich Sunday School Union, brought by special train to Wells and then in tradesmen's wagons to Holkham, and the Wells Independent Sunday School treat. The Wells Chapel Sunday School children, on the other hand, made use of the wide grassy verges outside the park gates for a picnic of rice pudding and plum cake, followed by sports.[21] Early in the twentieth century, Watts Naval Training School boys put on performances in the park and were treated in return to lunch and tea, laid out in tents.[22]

On numerous occasions, there was a merging of large-scale local festivities and public access. When the tenants presented the Countess with a portrait of the Earl in 1858 it was an excuse for festivities in the park, as was the second wedding of the Earl, celebrated with a 'dinner to the labourers' and children's tea in 1875, and the wedding of the Hon. T. Coke, the future 4th

Earl, in 1905.[23] Queen Victoria's Jubilees were all celebrated in style. For the Diamond Jubilee in 1897, the villagers were entertained to dinner in tents in the park, for which Ramm, the butcher in Wells-next-the-Sea, provided cold roast beef, cold boiled beef, cold roast mutton, cold plum puddings and cold

Invitation card to Queen Victoria's Golden Jubilee celebrations, 1887.

Bill from Ramm, the butcher in Wells-next-the-Sea, for food supplied for the Coronation Fête in the park in 1902.

mashed potatoes, washed down with a pint and a half of beer for men, one pint for women and lads. This was followed in the afternoon by sports, music by Brightmer's band from Wells, more refreshments (tea, ginger beer, lemonade and buns), a schoolchildren's tea of bread and butter, boiled ham, cake and tea, and a fireworks finale. The coronation of the Earl's old friend, Edward VII, in 1902 was celebrated with a hearty 'meat tea' for 302 adults and 100 children, and a fête with hired amusements, sports and, of course, Brightmer's band. Although this was primarily a village celebration, it was expected to attract many outsiders to the park because neighbouring parishes had held their own fêtes on the previous day, and so local tradesmen

Sports and gymkhana during the Militia Camp, 1900.

were given permission to set up refreshment stalls for the 'strangers'.[24] The same pattern was repeated for George V's coronation in 1911. Celebrations for the coronation of Elizabeth II in 1953 were the first to be organised by a village committee rather than by the Estate Office and they were held on the wide grass verges near the village rather than in the park.

The 2nd Earl of Leicester, although not a military man himself, had brothers and sons who enjoyed long military careers and at the turn of the century the park was often the setting for a military camp, invariably combined with public sports. His eldest son, Viscount Coke (later 3rd Earl), having retired from the Scots Guards in 1892, subsequently served as commanding officer of the Prince of Wales Own Norfolk Artillery Militia. He led his men on a route march through Norfolk in September 1900, covering 150 miles in twelve days, during which 170 men camped in Holkham Park. The camp was for only one night but Estate Office staff were heavily involved beforehand, organising the layout of the camp between the Monument and the cricket pitch, liaising with the quartermaster, and arranging for wood for

The 2nd Earl, as Lord Lieutenant, and the Countess, with their youngest son, Billy, attend a Norfolk Militia Review in 1901.

the camp fires, bread, and a supply of cash for the men's wages, which were paid daily. It took a committee of sixteen men to organise the 'horse and cycle gymkhana' held in the afternoon. Estate expenditure on such occasions included provisions, hire of chairs and earthenware, preparing the ground, carting chairs and flags, putting up advertising bills, the services of police officers and waiters, and prizes for the sports.[25] In the following year, a similar occasion was held during a visit by the King's Own Imperial Norfolk Yeomanry and again for a Yeomanry Camp in 1911.[26] Alec Napier, son of the former clergyman and librarian, wrote, 'We have had a very gay season here, what with yeomanry camp, Flower Show, Tennis Tournament, Coronation Sports, Harvest Festival etc – rather too gay for me and I am not sorry they are all over'.[27]

Harvest celebrations involved sports and sideshows as well as the harvest tea, served in tents in the park. The annual Horse and Flower Show, again including sports, roundabouts and fireworks, was expected in 1913 to draw up to 5,000 people to the park. The Earl told his son that they were to be confined to the area between the Monument and the cricket ground: 'I want the rest of the park kept as quiet as possible, as so many people ... might do a lot of harm at this time of year.'[28] The next year's show, combined with a gymkhana and sports for the Norfolk and Suffolk Infantry Brigade, went

Norfolk Yeomanry Camp in the park, 1911.

The Holkham Horse Show, 1913.

Chapter 16 Overview: Holkham and the Public 475

Overtaken by War.

ahead despite the gathering clouds of war. In the following month, the Great Eastern Railway Company arranged special excursion trains for the crowds who were expected to flock to a bazaar in the park in aid of the Wells Church Room on 6th August, but a stock of unused posters bears silent witness to the fact that it was overtaken by the declaration of war against Germany two days earlier.

A fête in the park, 1920s.

The attitude to more casual access to the park and gardens continued to be ambivalent. The station master at Wells-next-the-Sea, acting on instructions from his superintendent in London, wrote each year to seek confirmation of the arrangements prior to 'the getting out of notices etc for the coming season'.[29] The estate, however, had no interest in further promoting it. No guide book to Holkham had been published since 1861. When Messrs Jarrold of Norwich proposed to publish a guide to Wells, Holkham and Fakenham in 1894, Lord Leicester was 'agreeable' to their taking photographs but declined to help in any other way. On the other hand, the estate recognised that increasing numbers of holidaymakers wished to stay in Holkham village. The Earl's agent had long kept a close eye on the *Victoria Hotel* and did not hesitate to reprimand the landlord for overcharging, 'as his lordship desires that the inn should be conducted for the advantage of the public'.[30] The Red House in the village was built by the estate in 1891 as a lodging house, the Ancient House also became a lodging house and the Jarrolds guide mentioned that many village houses let rooms in the summer. Access to the park on days other than Wednesdays, however, remained discretionary and even idiosyncratic. At least some visitors and holidaymakers understood that it was necessary to seek permission. One of them, a lecturer at the University of Leeds, intending to spend two summer months at Holkham in order to study, had heard that the former 'privilege' of being able to ramble in the park had been abused and so 'to some extent withdrawn'. A request by the

landlord at the *Crown* in Wells-next-the-Sea to take his visitors into the park 'either walking, driving or cycling, for pleasure only' was granted for August and September but Mr Rose, ironmonger at Wells, was told that he could 'bring any one to the cricket matches in your motor but it will not be allowed into the park with parties of visitors for the purpose of sightseeing'.[31] The crucial difference was apparently the mode of transport.

Another Wells shopkeeper wanted permission to take photographs of the chief objects of interest in the park because, having acquired the chemist's shop of the late Mr Rump, he intended selling 'photographic requisites for amateurs' and wanted to show 'what work can be done'. Thomas Moore Hudson, a former tenant, had a unique reason for asking permission for his sons and their wives to enter the park: they were 'desirous of seeing my effigy on the Monument', where he was depicted as a young boy in the panel showing the signing of a lease.[32] The headmaster of Burnham Market school, on the other hand, sought to restrict access, asking that the gatekeepers should be given orders 'to admit no children for nutting except on Saturdays in the park. We have seven absent today'.[33] Access to the pinewoods was equally strictly controlled. In the 1920s, however, organised parties of Scouts and Guides were given permission to camp in a field next to the sand dunes at Holkham Gap and the landlord of the *Golden Fleece* in Wells was allowed, for a nominal fee of two shillings for the season, to place a small stall at the entrance to the beach, for the sale of minerals, biscuits, chocolate and ice creams and (on public holidays only) teas.[34]

It was the mid-twentieth century, as for many country houses, before Holkham sought to encourage visitors on a regular basis in return for an admission fee. In 1950 it opened its doors for the first time to paying visitors for three hours every Thursday afternoon in July and August, part of the first widespread public opening of privately-owned houses.[35] Lord Leicester announced his decision to the local press in June 1950 on the day that the Gowers Report was published; it was already clear that the report would fully embrace the desirability of preserving country houses and the Earl said that 'the action he was taking was in anticipation of its recommendations'. He added that he was confident that 'people would find Holkham of great educational value'. The press report was probably nearer the mark when its opening paragraph introduced Holkham Hall first as 'the scene of many royal visits' and only secondly as 'one of the art treasure houses of Britain'. The Holkham agent had a third point of view, noting that, as the significance of the Gowers Report lay in its proposals for wide-ranging tax reductions, exemptions and repair grants, 'any suggestion that the opening of the Mansion to the public is from altruistic motives for the enjoyment or

BAS-RELIEF—GRANTING A LEASE.

1. Mr. Blomfield. 3. Mr. Hudson, jun. 5. Mr. Baker. 7. The present Earl of Leicester. 9. Mr. Blaikie.
2. Mr. Overman. 4. Mr Hudson, sen. 6. Sir W. Foster, Bart. 8. The late Earl of Leicester.

The panel on the Monument depicting a tenant, Mr Hudson, signing a lease. John Hudson of Castle Acre was a highly successful farmer and one of the leading promoters of the Monument in memory of his landlord.

instruction of the public will not cut any ice with the Treasury from a taxation point of view. The operative words were, with the view to the realisation of profits'.[36]

In the first year of opening, Lord Leicester 'particularly wished to give local people the opportunity of seeing the Hall and to that end no special efforts were being made to attract people from further afield'. During the

nine open days in 1950, visitor numbers reached 8,539 at 2s 6d for adults, 1s 6d for children, plus 130 employees who did not pay, giving an average of 960 visitors per day. Nearly 4,000 leaflets, at 3d each, and 5,320 postcards were sold. Cars entering the park (total 1,621) were charged one shilling, redeemable against the Hall entrance fee, and four coach permits were issued. Total receipts for the season were about £1,170. Teas were available at the *Victoria Hotel*. Useful lessons were learnt and enshrined in instructions to the room stewards for the beginning of the following season:

> Experience last year showed that on the heaviest days some 1,500 visitors passed through the House and that at times great difficulty was experienced in maintaining a steady flow through the State Rooms resulting in congestion in the Marble Hall and vestibule. His lordship is anxious that the maximum number of visitors shall be able to view the State Rooms with the minimum of inconvenience to themselves and to this end it is essential that Lady Attendants should refrain from engaging in conversation with visitors by way of amplification of the published short guides, and should use their best endeavours to keep the flow of visitors steadily moving forward and dispose of any hold up which may occur in their rooms. Visitors must be confined to the roped in gangways.[37]

In the following year, a wider response was expected as the Festival of Britain promoted tourism throughout the country, and the season was extended to include June and September. Total admissions rose to 14,049 and receipts to £2,061.[38]

A guide book was commissioned, the first for ninety years, with Lord Leicester taking a personal role in the choice of photographs, cover and text. Ten thousand copies were printed, to sell at 3s 6d, a great step up from the threepenny leaflet of the first year.[39] For the first time, teas were available on the terrace outside Kitchen Wing, served through a window from the kitchen, an arrangement that continued for about thirty years until a tea room was created in a disused building. By the time that the recommendations of the Gowers Report were enshrined in legislation in 1953, enabling Holkham to tap into repair grants in return for public access, the Hall opening was well established. An additional attraction was provided by Holkham Pottery, established in the old laundry and bowling alley in 1951 by the Countess after she had seen a German prisoner of war throwing pots on a wheel at the estate brickyard. One of her motives was to provide her two elder daughters with an occupation. At its height, the pottery employed nearly a hundred people but it succumbed to foreign competition in 2007.

The first guide book for 90 years, 1951.

By the mid-1960s, the Hall was open on twenty-one days a year, principally two days a week in July and August, bringing in 19,000 visitors. From a financial point of view, the aim was 'to secure revenue equal to the claimable expenses' as any surplus would be taxed. Any increase in open days also had to be weighed against the privacy of the family.[40] In 1976, the government somewhat unexpectedly extended tax exemptions and subsidies. Hitherto, only repair grants had been linked to public access but now a similar arrangement allowed tax exemption on funds devoted to the maintenance of a heritage property.[41] The feasibility of increased opening was greatly helped by the appointment of a resident security officer and the succession of Viscount Coke (later the 7th Earl of Leicester) to the sole direction of Holkham on his predecessor's death in 1976, with the result that Holkham sought designation under the scheme in 1979–80. The Capital Taxes Office, however, demanded at least sixty open days between May and September, whereas the Hall was now open to the general public on thirty-eight days, bringing in 44,900 visitors. Lord Coke's response outlined the balancing act involved in deciding public access. Nine extra days had already been added during July and August to avoid overcrowding (that is, more than 1,500

Chapter 16 Overview: Holkham and the Public 481

> HOLKHAM HALL
> WELLS, NORFOLK
>
> ## STATE ROOMS AND TERRACES
> Open To Visitors
> EVERY THURSDAY
> JUNE to SEPTEMBER (inclusive)
> ALSO
> EVERY MONDAY in JULY and AUGUST
> (BANK HOLIDAY EXCEPTED)
> 2 p.m. to 5 p.m.
>
> Only Entry to Park - ALMSHOUSE GATES, HOLKHAM VILLAGE
> CAR PARK 2/-
> Charge for Admission to View Hall and Terraces
> Adults 5/- Children 2/6
> NO DOGS ADMITTED TO HALL
> Light Refreshments—Served on Terrace
> Teas may be had at Mayshiel Restaurant, Staithe Street, Wells-next-the-Sea
> Eastern Counties Buses—Stop Victoria Hotel, Holkham
> (10 minutes walk from Hall)
>
> HOLKHAM HALL home of the Right Honourable The Earl of Leicester, M.V.O., D.L
> 18th Century Palladian Home of COKE OF NORFOLK was erected in 1734
> On View to the Public—
> THE MARBLE HALL AND STATE ROOMS
> containing the Extensive Collection of
> Pictures Tapestries Statuary and Furnishings
> Also on View—
> THE HOLKHAM STUDIO POTTERY
>
> W. P. Seeley, (Printer), Wells, Norfolk

A publicity leaflet, 1960s.

visitors) on each of the busiest days but, as most visitors were holidaymakers staying in the area, there was little prospect of significantly increasing visitor numbers at the beginning and end of the season. At the height of the season, numbers fluctuated according to the weather, rising on a dull day but suffering on a 'beach day'. Day trips were limited by the distance from large centres, as coach operators considered that eighty miles was the maximum acceptable journey. It was beginning to appear that annual numbers varied little, regardless of how many days per week the Hall was open. At least a third of the visitors came only for the park, lake and cricket. Nevertheless, open days were increased in 1981 to sixty-one days, including Spring Bank Holiday Monday, two afternoons a week in June, four in July and August and one in September. Large-scale public events in the park were revived by country fairs, including one in 1978 in honour of the 'bicentenary' of the first Holkham Sheep Shearings, but these professionally-organised occasions, with a large commercial presence in addition to displays of country pursuits, were forerunners of a new tradition.

HOLKHAM POTTERY SHOP
Holkham · Wells · Norfolk
Telephone Wells 275

OPEN TO VISITORS
Monday to Friday 9.00 a.m. to 5.00 p.m.
Saturday 9.00 a.m. to 12 noon

In addition to an Exhibition of Pottery in Current Production, Sub-standard Pottery at greatly reduced prices may be purchased

Demonstrations on work in progress are given on official open days of Holkham Hall, every Thursday 2 p.m. to 5 p.m. June to September (inclusive)

Also EVERY MONDAY IN AUGUST
(August Bank Holiday Excepted)

Special works' visits for Parties may be arranged by appointment

Demonstrations by Cyril Ruffles and other staff were a popular feature in the Pottery Shop.

Viscount Coke moved his family into the Hall in 1982. If the actual effect of domestic life on the public areas of the Hall was indefinable, at least the room stewards could confidently tell tourists that it was still a family home. Soon the staterooms were freed of ropes and adorned with fresh flower arrangements. A deliberate policy saw the removal of signs and labels that might give any hint of a museum atmosphere and instead the number of room stewards, who were paid employees rather than volunteers,

Preparing the kitchen for a re-enactment, Christmas 2011.

was increased and they were encouraged (in contrast to the first year of opening) to talk to visitors. The problem of varying degrees of accuracy in the information and anecdotes that they imparted was reduced in later years by assembling a folder of information, the Blue Book, which became increasingly comprehensive as knowledge of the Hall and its contents was enhanced by research. By the end of the twentieth century, the house was open on five days a week in the summer and visitor numbers settled at around 33,000. Further compliance with tax exemption requirements was met by opening the Family Wing libraries, part of Strangers Wing and the Chapel gallery in 2003. The approach to the state rooms up the sweeping flight of stairs from the Marble Hall posed problems in the provision of disabled access but a stair-climbing machine for wheelchairs, installed in 2004, proved a great success, providing full access along the normal route without requiring any structural alteration.

The retirement of the 7th Earl in 2005 in favour of his son, Lord Coke, ushered in a new policy for marketing the Hall to the public. The Hall became the centrepiece of a new company, Holkham Enterprises, embracing visitor and retail operations. Regular open days in the summer were reduced to three days a week but, in recognition of the increasing appeal of the North Norfolk coast for short visits throughout the year, the open

season eventually extended from Easter to the end of October. The policy of presenting the staterooms much as they would have appeared in the eighteenth century was modified in favour of adding free-standing themed displays on such topics as the history of the family, the role of the ladies of the family, royal connections (on the anniversary of the accession of the Queen), dresses designed by Lady Coke's mother (the society dressmaker Belinda Bellville) and the part played by the family and the estate in the Great War. Although they might for the connoisseur detract from the rooms and the works of art, most exhibitions gave an opportunity to illuminate lesser-known aspects of Holkham's history and all were designed to increase the attraction of the Hall to the non-specialist, to families and to returning visitors. From 2011, special Hallowe'en tours, when the cellars were transformed as never before, and Christmas open days, for which the staterooms were submerged under a sea of decorations and peopled by characters unknown in Holkham's history, extended the commercial season still further. Activity in the park also expanded widely under the influence of a cycle hire business, boating on the lake, 'buggy' tours of the park, a children's play area, outdoor theatre, a weekly 'park run' and sponsored runs and cycle rides organised by charities. Identifying new features that would attract the public to Holkham and exploiting commercial possibilities to subsidise the costs of running the Hall were the new priority. The Hall, as ever, adapted to the challenge.

Room stewards in the 1980s.

Chapter 17

Survival and Revival 1909–2000

For the first half of the twentieth century, the future of Holkham was precarious. Despite the outward appearance of traditional country house life, its financial foundations had been crumbling for decades and a relentless combination of national economic depression, falling income, government policy and insufficient reduction of expenditure put the future of the house in jeopardy. These factors coincided with the old age of the 2nd Earl, who was eighty-six when he died in 1909, and of his successor, who was sixty when he inherited and ninety-three when he died. The latter's son was frequently

An early aerial view.

OPPOSITE 'Holkham Hall' by John Piper, 1939.

```
                    Thomas William Coke
                    3rd Earl of Leicester
                         1848–1941
            ┌─────────────────┴─────────────────┐
    Thomas William Coke                    Arthur Coke
    4th Earl of Leicester                   1882–1915
         1880–1949                              │
             │                                  │
    Thomas William Coke              Anthony Louis Lovel Coke
    5th Earl of Leicester              6th Earl of Leicester
         1908–76                            1909–94
             │                                  │
   ┌─────────┼─────────┐                        │
  Anne     Carey     Sarah            Edward Douglas Coke
                                       7th Earl of Leicester
                                            1936–2015
                              ┌─────────────────┼─────────────┐
                    Thomas Edward Coke        Rupert         Laura
                    8th Earl of Leicester
                           b. 1965
              ┌───────────┬──────────┬──────────┐
          Hermione      Juno       Edward    Elizabeth
           b. 1998     b. 2000     b. 2003    b. 2006
```

The line of succession, highlighting in bold the principal occupiers of Holkham.

reminded that his father 'was an old man (a piece of information that has been imparted to me for the last thirty years!) and that he could not be expected to alter his way of living'. As a result, when he died in 1941 it was doubtful whether his successors could afford to live in even part of the Hall. With the added anxiety that the direct line of succession was coming to an end, there was a brief and reluctant conviction in the middle of the century that the only future for the Hall lay in its transfer to the National Trust. The 4th Earl was one of many contemporary country house owners who had come to believe that there was no future for the country house.[1] Then in the second half of the century the emphasis of government policy shifted, land values recovered dramatically and public interest in preserving country houses revived. It was too late to save numerous houses from abandonment and demolition but Holkham was able to pull back from the brink. Ultimately, too, the passing of the title, estate and Hall to a junior branch of the family, far from fulfilling fears of successors who knew and cared nothing about Holkham, introduced an heir who met the challenge by applying himself to a thorough grounding in farming and estate management and by embracing his cultural inheritance.

*

The 3rd Earl, although well aware of impending financial difficulties when he inherited in 1909, embarked immediately on renovation and modernisation work, just as his father had done in more prosperous times sixty years earlier. He spent £45,000 during the next three years on improvements to the Hall, double what he had intended, so he told his heir a few years later, 'but for different reasons it was difficult to control the expenditure'. Wide-ranging

The 3rd Earl of Leicester, by Sir William Orpen.

Footmen's dress livery, 1910.

refurbishment and redecoration work by two well-known London firms, Cowtan & Co and Lenygon & Co, included sanitary and hot water work, renovation of oak floors, painting and gilding, an electric bell system and reupholstery of stateroom furniture. His son, Viscount Coke, wrote to his wife in October 1909, 'The house is really making great headway; the long gallery is finished, all the scaffolding is down, and it really looks a dream of beauty; the statues are wonderful, and the whole effect and blending of the soft shades of cream and green are perfect.'[2]

A specialist firm, Morris & Co, using French craftsmen, cleaned and repaired the tapestries in five rooms. 'I believe we may claim', wrote the head of the firm, H. C. Marillier, 'that we have rescued the valuable State Room tapestries from absolute ruin, and that the restoration is considered a remarkable feat by the experts who have seen it.' Following a report and recommendation to replace the wall coverings in three other staterooms, the Earl decided at the last minute to leave untouched the South Dining Room and the Saloon and to replace only the brittle velvet brocade ('very rich quality, pure silk, and probably of old French make') in the Drawing Room.

The red silk damask of the Landscape Room was repaired in place, ensuring its survival for another ninety years. The tapestries in the North State Bedroom were moved into the adjoining Dressing Room, where the satin on the walls was beyond repair. Three carvers and gilders, Romeo, Lingi and Leoni, were brought from Italy to spend seven months refurbishing furniture. They were a major attraction at a lunch party for the late Earl's old friends, Edward VII and Queen Alexandra in October 1909: 'The queen', wrote Lord Coke to his wife, 'was really too funny, she spent nearly three quarters of an hour gilding a chair with Romeo, rubbing the brush on his whiskers and then on her hair to make the gold stick, the king could not get her away.' A few months later, during another royal visit, one of the Italians tucked a note under the upholstery of a chair to record that the Princess of Wales (soon to be Queen Mary) and her daughter had also tried their hand at gilding: *'I reali lavorato di doraturo in queste canapé.'*[3]

The first telephone at Holkham was installed in the Estate Office, with an extension to the Hall in a corridor near the porter's door: for many years any private phone conversation, as one of the Earl's granddaughters later recalled, was a difficult and chilly undertaking. External changes included a glass and iron washing shelter in the south-east corner of the stable yard for the sake of the motor cars (a Panhard in 1902 and a Daimler in 1904) that had joined the pony carriages, phaeton, Victoria and Brougham in the coach houses. One of the 2nd Earl's grandsons, a naval cadet, wrote home in about 1902 that he was 'awfully surprised to hear Grandpapa had gone to

The stable yard, 1904, accommodating a Panhard, a Daimler, a Lagonda motorcycle and a small car built by the chauffeur, Scrivener, for his own use.

Castle Acre in a motor car. I hope he will get one now'. By 1909, Viscount Coke could regret that his parents had taken the new Siddeley so that he had to use the Panhard, 'which I hear takes two and a half hours getting to Norwich!!' There were no major changes in the park but, like his father and grandfather before him, the Earl tackled the lake, employing a specialist firm to dredge it and remove one of the islands created sixty years earlier. The lake was restocked with over 3,000 trout and fishing remained popular for many years, both by permit holders and occasionally by the family and visitors.[4]

Daily life in the refurbished Hall was maintained in traditional style. In 1913, at a time when the 3rd Earl was lecturing his son on the financial difficulties of running Holkham, there were thirty-five indoor servants, considerably more than had been normal in the nineteenth century. Even outdoor mansion staff had increased from nine to fifteen, only partly accounted for by the new posts of electricians and chauffeurs. The annual cost of running the house was over £9,900 at a time when the income from the estate was between £15,000 and £16,000, from which between £6,200 and £7,600 went on estate duty instalments. As the Earl wrote to his son, 'You will see that it is not so very easy to finance an estate like this, and keep it up to the mark, on the present income.' Nevertheless, the scale of entertaining was such that the housekeeper or Hall secretary kept a supply of printed forms listing all guest rooms; a few surviving completed forms show that, on occasion, up to twenty-seven guests occupied all the rooms in Strangers Wing and Chapel Wing (except for maids in a couple of the ground floor rooms of Chapel Wing), the two State Bedrooms, two rooms in Nelson Wing (the east front of the house) and the south-east and north-west Tower Rooms. Hermione, wife of Arthur, the Earl's younger son, described how 'everyone came down to breakfast and wore long dresses, then changed after to go out shooting, changed again into tea gowns and again for dinner'. Guests at a large house party for a four-day royal visit in August 1913 'all brought maids, loaders and valets and the day they left there were three special trains to take them away'.[5]

The 1914–18 War brought temporary changes in both Hall and park. For a few months during the summer of 1915, Model Farm was used as a convalescent home for officers, under the auspices of the Countess, helped by her daughter Bridget (who married the Earl of Airlie in 1917) and her daughter-in-law, Hermione, whose husband had been killed at Gallipoli in May. By the end of August it was full, accommodating eleven officers, a few of them 'quite helpless' and several whose nerves were 'utterly shattered'. The two younger women learnt to cook there and went on to spend three months

BEDROOMS.	VISITORS.	Date Arrive.	Date Depart.
FAMILY WING.	**FAMILY WING.**		
Lady Bridget Coke's Room			
The Hon. Roger Coke's Room			
Lady Leicester's Room			
Lord Leicester's Room			
STRANGERS' WING.—TOP FLOOR.	**STRANGERS' WING.**		
Left Mahogany Room	Mrs White		
Right White and Green Room	Lady Roze		Monday
Left Maid's Room			
Right Maid's Room			
FIRST FLOOR.			
Red and Yellow Room	Mrs Sassoon	Saturday	
Blue Tapestry Room	The Lord Mayor of Norwich	Saturday	
Red Bedroom	Lady Gurney	Saturday	
Red Dressing Room	Sir Eustace Gurney	Saturday	
North Bedroom	Sir G. Claude Phillips	Saturday	
Brown and Yellow Bedroom	Comtesse Isabella Bentinck	Saturday	motor
Brown and Yellow Dressing Room	Count Bentinck	Saturday	motor
GROUND FLOOR.			
No. 1 Office Bedroom	Lady M. Hamilton		
No. 2 Office Bedroom	Mr Hamilton	Saturday	
North-West Bedroom	Mr Harry Milner	Friday 14-15	
South-West Bedroom	Mr Harry Lindsay	Saturday	
Maid's Room for No. 1			
Maid's Room for No. 2			
CHAPEL WING.—TOP FLOOR.	**CHAPEL WING.**		
Lady Coke's Nursery			
Hon. Mrs. Arthur Coke's Nursery	Mr Stephenson		Saturday
FIRST FLOOR.			
The "York" Room	Mr A. Coke	Saturday	
The "Canterbury" Room	Mrs A. Coke	Saturday	
The "Unicorn" Room	Hon S. Henry Coke		
The "Nottingham" Room	Lady Coke		
The "Warwick" Room	Lord Coke		
GROUND FLOOR.			
The "Chester" Nursery			
2 Maids' Bedrooms			
STATE ROOMS.	**STATE ROOMS.**		
Green State Bedroom	Mrs Edgar Brassey		
Green State Dressing Room			
Brown State Bedroom	Mrs Ernest Furnand	Saturday	
Brown State Dressing Room	Mr Ernest Furnand	Saturday	
NELSON ROOMS.	**NELSON ROOMS.**		
Lord Nelson's Room	Capt. Armand Ype		
Lord Spencer's Room	Captain Cerry		
TOWER ROOMS.	**TOWER ROOMS.**		
South-East Tower Room	Captain Griffs	Saturday	
North-West Tower Room			
South-West Tower Room			

Allocation of guest rooms, *c.*1912.

Viscount Coke, the future 4th Earl with his son, the future 5th Earl, in 1914.

working in a canteen in Normandy. An army camp in Church Paddock put the Earl, always concerned to protect the game, in 'a baddish humour … he is trying to put all sorts of restrictions on them' but the Countess rather regretted its closure when the men (the Worcestershire Yeomanry) departed for billets in local towns: 'the Park will look very desolate – we shall miss the life and noise and Holkham will be very quiet'. The chauffeur, footman and scullery boy enlisted; footmen were replaced with parlour maids and one man served as both butler and valet. The Earl fretted 'over the turnips and pheasants … Zeppelins and bombs over the Saloon' but his granddaughter, Silvia, who with her brother Tommy and their nanny spent much time at Holkham during the War, vividly remembered 'the sight of a Zeppelin caught in searchlights flying over Norfolk and the treat it entailed of our going into our grandmother Alice's bedroom and being given cocoa and biscuits, and climbing up the four posters on her bed'.[6]

*

Serious concerns about the future ability of the estate to support the Hall had been voiced as early as the 1880s, when the national agricultural depression reached Holkham. The 2nd Earl, writing in 1884, had thought it 'most

desirable' that his heir should be able to live in the Hall (a statement in itself suggesting this could no longer be taken for granted) but he considered that a minimum net income of £30,000 from the estate was necessary to enable him to do so and he feared that this would soon be unattainable. Despite reassurances by his agent, he was proved right: when his son inherited in 1909, annual net estate income was about £20,000 and it continued to plummet until, during the 1930s, it averaged little more than £11,000. Nevertheless, by means of a bank loan and the sale of the Sparham property, twenty-three miles from Holkham, and some railway stock, the 3rd Earl managed in 1922 to buy Lord Orford's Burnham estate, 'an excellent agricultural property' (and excellent partridge country) whose proximity to Holkham made it irresistible. Then increased demand for farm produce during the 1939–45 War removed the need for rent abatements and even cleared outstanding arrears: by 1941, although dwarfed by overdrafts on the personal and farm accounts, the estate account was in credit. It was only from the 1950s, however, that there was any steady increase in rental income.[7]

Initially, falling estate income was balanced by investment income from stocks and shares; the 2nd Earl's grandson naively commented in 1905 that 'for years and years, Grandpapa has not touched one penny of his [estate] income, and he lives only on the interest from his investments ... so I don't think there can really be so very much to complain of'. Soon, however, such income was drastically reduced by legacies, sales and falling values; it usually remained higher than estate income but was inevitably affected by the international depression and suffered a catastrophic fall in the 1930s. There were particularly large investments in the Canadian Pacific Railway to which the 3rd Earl added, investing £40,000 in 1931 from the sale of a painting (*Venus and the Lute Player*, attributed at the time to Titian) to provide for a settlement on the occasion of his grandson's marriage.[8] His son, however, who had long since lost his youthful optimism about investment income, warned the next generation years later, 'My father [the 3rd Earl] had the most elementary ideas about finances, and always imagined that his separate account at Coutts was a nest egg, which nobody could touch!! In leaving it all to you, he no doubt felt that the future of Holkham was safe, anyhow during your lifetime. I knew, many years ago, that this was not the case.'[9]

An even greater problem than the fall in both estate and investment income was posed by government policy towards landed wealth. In the 1894 Budget, the Liberal government replaced the old death duty with a much wider estate duty, falling on realty (land) as well as personalty (non-landed personal wealth), and including land subject to family settlement. The only ray of hope was that the Budget allowed for settled estate duty to be incurred

Ashill 1590–1912	North Elmham 1598–1946	Quarles leased 1719, bought 1880, to present
Billingford and Bintry 1606–1968	Flitcham 1604–1910	Sparham 1611–1923
The Burnhams 1742/1922 to present	Fulmodestone 1626–1945/1952	Tittleshall 1576–1946/1958
Castle Acre 1614 to present (Wicken Farm sold 1955)	Godwick 1590–1958	Warham 1785 to present
	Holkham 1609 to present	Waterden 1606 to present
Creake 1605/1746/1898–1944/1946 and to present	Kempstone 1597–1909	Weasenham 1592–1909
	West Lexham 1596–1945	Wellingham 1592–1946
Dunton 1595–1946	Longham 1610–1954	Wells 1758 to present
Egmere 1811 to present	Massingham 1598–1946	Wighton 1758 to present

The Coke estate in Norfolk. The dates cover the maximum period during which the estate owned an entire manor (land and cottages) or a farm or smaller property in each parish.

only once, rather than on each successive death. This prompted the 2nd Earl, who had held the estate free of settlement since his succession in 1842, to re-settle it by his will, coming into effect when he died in 1909. His successor was relieved that he had inherited just before taxation was increased by the People's Budget of 1910 and that he had succeeded, so he thought, in paying the estate duty on the settled land, 'otherwise my successor could not possibly live at Holkham'. Rumours of a new land bill, however, 'far worse than anything that has gone before, and which will go a long way to break up landed proprietors', proved well founded: the 1914 Finance Act removed the exemption of settled land from repeated estate duty. An attempt was made to circumvent this by creating the Holkham Estates Company in 1928 but discussions prior to the formation of the company cautioned that this advantage would be lost if, yet again, the law regarding estate duty were to be altered, in which case it was envisaged that it might not be possible to retain the estate intact.[10]

This was exactly the situation that arose on the death of the 3rd Earl in 1941. The saving of estate duty was frustrated by the Finance Act of the previous year, with highly significant consequences: duty on the settled estate would have to be raised by the sale of £50,000 of securities, £100,000 of timber and 'sufficient outlying land' to meet the remaining £100,000, all

sales that would unavoidably reduce future income. In earlier centuries, both Thomas Coke and T. W. Coke had gradually sold all the properties outside Norfolk, either to clear debt or to release funds for Norfolk purchases, and a few Norfolk properties had left the estate earlier in the twentieth century, either by sales or as provision for the 2nd Earl's second family. Now, however, a major part of the Norfolk estate was under threat for the first time. Over the next few years, the 4th Earl had countless meetings with his financial and legal advisers: 'desperate problems to settle', he noted in his diary. The result was a string of sales in 1944–46 in a dozen Norfolk parishes, nearly all of them properties centred on purchases that had been made in the early seventeenth century by Sir Edward Coke. With a few additional sales in the 1950s, the effect was to reduce the estate from 45,000 acres to a core estate of 25,000 acres, concentrated (with the exceptions of Castle Acre, Billingford and Bintry) in parishes around Holkham.[11]

Death duties were only one aspect of government taxation policy. Towards the end of his life in 1940–41, the 3rd Earl's total taxable income from all sources (dividends from the Estate Company, his army retired pay and dividends from investments) was just over £23,000, but wartime rates of income tax and surtax reduced his disposable income to £3,786. His agent concluded, 'Present day legislation is such that it is well nigh impossible to circumvent provisions made which, one can only suspect, have as their aim the annihilation of all large incomes.'[12]

*

Reduction of expenditure struggled and failed to keep pace with the combination of falling income and rising taxation. The need for it was unprecedented: previously there had been times of great indebtedness, such as during the building of the Hall, and short-lived periods of anxiety and retrenchment, such as in the early 1820s, but the resources of the estate, whether as income, capital or security, had always proved sufficient to recover the situation. A striking feature of Holkham in the 1920s and 1930s, and lingering into the early 1950s, was the fact that expenditure on elements for which it had long been famous – farming, forestry and game – now contributed to its financial problems. The balance between them had required vigilant management aided by favourable economic circumstances: when these failed, the situation deteriorated rapidly. Park Farm was as much a victim of agricultural depression as were tenanted farms, consistently making a loss throughout the 1920s and 1930s. There was no lack of interest by the Earl: his role as a working farmer was exaggerated for the benefit of the Inspector of Taxes but 'he did as his father did before him actually manage and direct the affairs of his home farm … His farming operations were his own business and conducted

VEGETABLES SUPPLIED TO HOUSE.

September 1931

		1st Week.	2nd Week.	3rd Week.	4th Week.	No.	@	£	s.	d
Artichokes		18				18	6		9	
Asparagus										
Aubergines										
Broccoli										
Beans Broad	P/lb	10	14	8	8	40	1/6	3	–	
Beans French and Runner		32	42	42	44	160	2/–	16	–	
Brussels Sprouts										
Beetroot		100	126	84	88	398	2	3	6	4
Cabbage		144	140	140	198	622	2	5	3	8
Carrots	Bunch	20	24	18	26	88	4	1	9	4
Cauliflower		120	126	126	198	570	3	7	2	6
Celery		20	28	22	44	114	3	1	8	6
Cress	B/lb	20	28	14	22	84	4	1	8	
Chicory										
Cucumbers		28	46	38	56	168	6	4	4	–
Chervil	B	10	14	14	22	60	4	1	–	
Endive										
Herbs	B	36	42	42	44	164	4	2	14	8
Horseradish		6	8	8	10	32	1/–	1	12	
Kale										
Lettuce		110	112	126	198	546	2	4	11	
Leeks										
Mushrooms										
Mustard	B/lb	24	28	14	22	88	4	1	9	4
Onions Large	P/lb	14	22	22	34	92	2/6	11	10	–
Onions Green	B	24	28	14	24	90	4	1	10	
Onions Button			2	4	8	14	1/–		14	
Parsley	B	24	28	28	32	112	4	1	17	4
Parsnips										
Peas	P/lb	24	28	28	30	110	2/6	13	15	
Potatoes	Bush	14	16	12	16	58	5/–	14	10	
New Potatoes										
Rhubarb	B	6				6	4		2	
Radish		12	8	6	12	38	3		9	6
Seakale										
Sorrel	B	12	14	14	16	56	3		14	
Spinach	P/lb	36	42	28	30	136	1/6	10	4	
Shallots										
Salsify										
Savoys										
Scorzonera										
Tomatoes	lb	54	60	62	58	234	6	5	18	
Tarragon	B	12	14	14	16	56	4		18	8
Turnips	B	24	28	28	16	96	6	2	8	
Vegetable Marrows		14	16	16	14	62	4	1	–	8

Vegetables supplied to the Hall from the walled gardens in great quantities, 1931.

by him as such'. However, insistence on a traditional crop rotation with heavy livestock investment to improve light land – the policy that had made Holkham farming so famous – was disastrous when livestock prices collapsed in the 1930s. The situation was exacerbated by local circumstances, such as

FRUIT SUPPLIED TO HOUSE.

September 1931

			1st Week.	2nd Week.	3rd Week.	4th Week.	No.	@	£	s.	d.
Apples	Dessert		180	168	140	136	624	1ᵈ	2	12	-
	Cooking	Pkt	24	42	28	28	122	2/-	12	4	-
Apricots	Dessert		400	168			508	2ᵈ	4	4	8
	Cooking	ilr	40	24			64	1/-	3	4	-
Blackberries		Bkt		6	14	18	38	8	1	5	4
Cherries											
Currants	Black										
	Red										
	White										
Cape Gooseberries											
Damsons		ilr		80	24	28	132	6	3	6	-
Figs			200	200	140	128	668	4	11	2	8
Filberts		Bkt	6	6	8	10	30	1/4	2	-	-
Grapes			30	36	28	30	124	4/-	24	16	-
Gooseberries	Dessert										
	Cooking										
Loganberries											
Medlars											
Melons	Dessert		12	14	12	14	52	4/-	10	8	-
	Cooking										
Mulberries		ilr	16		2	18	1/-		18	-	-
Nectarines			200	90	24	84	398	6	9	19	-
Peaches	Dessert		144	168	126	96	534	6	13	7	-
	Cooking		120	144	140	140	544	3	6	16	-
Passiflora											
Pears	Dessert		90	84	90	48	312	3	3	18	-
	Cooking	Pkt	16	14	16	18	64	2/6	8	-	-
Plums	Dessert		580	440	250	210	1480	1ᵈ	6	3	4
	Cooking	ilr	108,54	52	32	40	286	6	7	3	-
Quinces											
Raspberries	Dessert	Bkt			6	6	1/-		6	-	-
	Cooking			6	6	6	18	1/-		18	-
Strawberries	Dessert										
	Cooking										
Walnuts											
Wineberries (Jap.)											
	TOTALS							£			

Flowers		10 13 bushels at £1-0-0 each	10	-	-	
do.		20	10 0	10	-	-
do.		10	5 0	2	10	-
do.						
do.						
do. London	Flowers	£8-0-0	8	-	-	
Plants		6-0-0	6	-	-	

Fruit supplies to the Hall, 1931.

failure to control deer and rabbits, wooded areas for game in and around arable fields, the diversion of farm labour to the kitchen garden or shooting, the introduction of paid holidays, lack of investment in equipment and the burden of interest on the overdraft, for which 'a century of farming cannot

Month of _December_ 1929.

MEALS PROVIDED:—

		No.		Nursery
HOUSE.	Breakfasts	280	½	Nurses
	Luncheons	244	41	54
	Dinners	295	45	52
Shooting Luncher		105	40	57
SERVANTS.	Breakfasts	1006	2) 186	163
*Keepers Meat Luncher — 6 **	Dinners	1022	93	
*do — Suppers — 13 **	Suppers	1050		4059
Keepers & Beaters — 404	*Extra* Tea	39		93
Servants Dance — 98				163
	TOTAL	4059	for month. 3)	6
				13
				4334
				1445

Divided by 3 = number of persons provided for = 1445

PARTICULARS.	PURCHASED.			SUPPLIED BY OTHER DEPARTMENTS.			TOTAL.			DIVIDED BY.	COST PER HEAD.	
	£	s.	d.	£	s.	d.	£	s.	d.		PER DAY d.	PER WEEK d.
Bread and Confectionery	14	15	5½	—	—	—	14	15	5½			
Butcher and Bacon	78	13	8	—	—	—	78	13	8			
Butter, Milk, and Cream	—	—	—	23	5	5	23	5	5			
Fishmonger	16	14	10	—	—	—	16	14	10			
Game and Rabbits	—	—	—	12	1	9	12	1	9			
Groceries	61	6	3½	—	—	—	61	6	3½			
Poultry and Eggs	—	—	—	12	18	4	12	18	4			
TOTALS	£ 171	13	3	48	5	6	219	18	9			

Cost per head per day £ — : 3 : = ½.

Ditto per week £ 1 : 1 : 3½.

In December 1929, a total of 4,334 meals (with the children's counted as half meals) were provided by the Holkham kitchen. Calculation of the cost did not include meat from the farm and vegetables and fruit from the kitchen gardens.

meet the bill'. When the Earl gave up Branthill Farm, which he had also farmed for some years, a family member commented, 'It's a mercy he's given up farming, it was too much of a luxury.'[13] Park Farm became briefly profitable thanks to wartime demand in 1939–45 but when the agent and farm manager proposed measures to rehabilitate the exhausted land after the war, they battled against outmoded attitudes: a friend of the new Earl advised him that their opinions, although sound, should be disregarded, 'if Holkham is

'Grandpapa and all his grandchildren and great-grandchildren, 1934.'

to have a real Home Farm, which I think is what you desire, and which I feel sure would give you a great amount of interest and a reasonable chance of profitable business'. Although the Estates Company subsequently took over the farm, its traditional relationship with the house continued, maintaining two cows solely to provide milk for the Hall and supplying eggs, poultry, pork and paraffin at little or no charge. It was a relationship, the agent repeatedly argued, that was no longer viable: 'whilst the service to the Mansion may be a pleasant adjunct to the amenity services of the farm, it must inevitably be an expensive one to the farm ... If Park Farm is to cease to be a drain on the estate resources, it must forthwith be handled in a husbandlike manner ... the net income of the Estate must remain inviolate to ensure that Holkham Hall shall remain in occupation'.[14]

Forestry, too, made a loss until the 1939–45 War intervened. The 3rd Earl, maintaining his father's and grandfather's personal interest in forestry, planted over 500 acres of woodland but, according to his agent, 'has always shown a predilection for planting and a definite aversion to felling'. The outbreak of war in 1939 brought a new market for softwood but even then trees were 'subject to his personal scrutiny before felling'. The hidden costs involved in the Earl's passion for shooting were equally frustrating for the agent and farm manager, particularly as he insisted on traditional arrangements under his personal supervision. These included allowing rabbits to the keepers as a perquisite to make up for low wages, with the result that they

virtually farmed them. It was only in 1939–40, with added persuasion from the War Agricultural Committee, that the Earl agreed to the appointment of a head keeper, allowed the farm manager to take over the destruction of rabbits on the farm and finally waged 'a relentless war on rabbits'.[15] Another traditional feature that the agent struggled to bring under control was 'that appendage to the establishment, the Kitchen Garden'. At the beginning of the century the gardens employed sixteen gardeners, labourers and boys. Fruit, early vegetables and tens of thousands of bedding-out flowers were raised under heat. The fruit and vegetables delivered to the Hall every day were entirely at the discretion of the head gardener which, the agent noted, was 'not calculated to restrict either the quantity or variety of deliveries to actual requirements'. By 1939 the gardens were making a loss of £1,800 a year; ten years later, despite attempts at retrenchment, when other house-keeping expenses (mostly food) in the Hall totalled £546, garden produce still far exceeded them at £761.[16]

Within the Hall, however, life continued between the Wars (1918–39) in traditional style, as recorded by the Earl's granddaughter:

> My grandparents entertained at Holkham during August and September and had a family party every Christmas ... The summer guests dined in the North Dining Room in full splendour, men in white ties and ladies in their best evening dresses. The Statue Gallery was used as a meeting place before dinner when the men armed the ladies into the dining room. Dinner was at 8 and a dressing bell went at 7.30 and the dinner bell at 5 to 8. ... Dinner consisted of soup, fish, entrée, roast, pudding, savoury and fruit and lasted at least an hour or more ... After dinner the guests went into the drawing room for coffee and some played bridge and the rest returned to the gallery to dance. Tommy my eldest brother [later the 5th Earl] played the drums, Uncle Joe [Airlie] the banjo and myself the piano, while Granny and any hapless young men danced away – foxtrots and the Charleston, which was all the rage in 1928.

The Earl wrote to his grandson one summer in the 1930s in anticipation of a family gathering, 'Am opening the upstairs rooms, so we shall be dining in the north dining room, so you will want your white tie.' A letter from the former librarian when the next Earl inherited in 1941 alluded to the use of other rooms when there were no guests: 'I can't help wondering if you will dine, as of yore, in the Ms Library, or stick to the Audit Room.' In the winter, 'there were bachelor shooting parties when no ladies stayed in the house, when the guests dined in the Audit Room and lived in the Smoking Room'. This was the cue for the Countess, who disliked shooting, to depart

The male servants in the 1920s.

for her London flat. Christmas parties often included a dozen grandchildren; the nursery, as always, was in Chapel Wing, under the care of Nanny Langran, who for many years to come was 'the family's staunchest and most loyal friend'. The hall boy brought their meals from the kitchen to the Wing in a heated trolley. The children enjoyed playing along the passages and cellars and the heir to Holkham was horrified that the Airlie grandchildren, descending on their parents in the Green State Bedroom on Christmas morning, were allowed to frolic on the State Bed.[17]

As it became clear that estate income could not be maintained and the agent attempted to rein in losses from traditional aspects of Holkham life, the focus switched, for the first time to any sustained degree in Holkham's history, to reducing the cost of running the Hall. The agent strove to enforce a separation between estate and domestic finances and to persuade the Earl to reduce domestic expenditure, but by the end of 1939 the mansion wages bill (indoor and out) was higher than ever and the Hall was still costing over £8,000 to run. The agent urged the need for 'any remedy, however revolutionary, drastic or apparently insignificant'. Two months before the Earl's death, the agent was still pressing for 'a further drastic revision of your personal affairs'.[18] The inability of greatly reduced estate income to support traditional aspects of life at Holkham threw into focus the personal role of the 3rd Earl. His preferences held greater sway than management expertise and the respect that he commanded made him difficult to advise. The next Earl later told his daughter-in-law,

> Many years ago, when the banks were worrying over the large scale borrowings of my father, but were too frightened to tell him the truth, I was asked whether I would guarantee his debts on my succession and so

avoid the possibility of his immediate bankruptcy!! In those days my father had it in his power to reduce his expenses very considerably and by taking advice and living within his means, he could have paid off a very large part of his debts to the bank ... I refused ... [as I] did not relish the idea of succeeding to what might easily have been a debt of gigantic proportions.

The agent appointed in 1936 (after twenty years' experience in the Estate Office) highlighted another problem: 'Lord Leicester's aversion to any member of the family being apprised of Estate matters'. This meant that the agent had not dared to send any written reports to the heir, Viscount Coke, and it was only a year before the Earl's death that the agent and legal adviser agreed that Lord Coke should and could be more fully informed.[19]

Aged over 90 when World War II broke out, the 3rd Earl took a lively interest in its progress. His letters to his youngest son, Roger, serving as a naval staff officer at Ismailia on the Suez Canal, and grandsons Tommy, in Egypt with the Scots Guards, and David, serving in the RAF, switched rapidly between the war abroad and the shooting season at home. During the invasion scare in the summer of 1940, Roger was amused to hear from him that 'the only thing that was worrying them in Norfolk was the question whether

Telegram from King George VI to the 3rd Earl on his 90th birthday, 1938.

504 HOLKHAM

there would be enough Germans to go round, as everybody wanted to shoot one..!' The Earl wrote in similar vein to Tommy, 'Everything is made ready, especially all roads from the sea, to give them a warm reception, if they come, so I hope they will make the attempt but I am afraid no such luck.' He may well have known of the existence in the park of a secret Auxiliary Unit, ostensibly part of the Home Guard, with an operational base in a well-concealed underground shelter near Scarborough Clump, one of a network of such units established by Winston Churchill in case of invasion.[20] By the autumn he had 'quite given up all hopes of a German invasion, a bitter disappointment to everybody; if we could have got a few Germans to our bag out shooting, it would have been a great addition to our days sport'. The nearest the war came to Holkham was a bomb falling on farm buildings at Burnham Market, 'a nuisance', wrote the Earl, 'as I had lately spent some money on improving them'. He was a powerful character to the end but the abiding impression left by his occupation of Holkham is one of staunch adherence to a way of life that was impossible to maintain.[21]

*

The 3rd Earl died on 19 November 1941, aged ninety-three. His son, inheriting at the age of sixty-one, was a less robust figure than his predecessors. He had served with the Scots Guards early in the century in South Africa and again during the 1914–18 War, mostly on the staff in England, but in the 1940s he was greatly relieved when he was able to retire from the Home Guard at Holkham. His first love was music. He was 'a highly cultivated gentleman and brilliant musician' and never happier than when playing violin in concert with celebrated musicians at Holkham or in public concerts in Norwich and King's Lynn. He also took a particular delight in the outstanding collection of Old Master drawings purchased in Italy by the 1st Earl. Just at the time that he succeeded to Holkham, his younger son, David, serving in the RAF, was reported missing over Libya and early in the New Year his death was confirmed. Even before that blow fell, the former Holkham librarian, C. W. James, wrote to the new Earl, 'Well can I believe what a tremendous task lies before you in gathering up the threads of House & estate & family matters … knowing something of the conditions at Holkham, I own I am aghast when I think of all the labour, and I will add sorrow, that you will have now to meet.'[22] James, who had known Holkham since early in the century, realised that changes were inevitable: 'You won't be engaging five footmen and a Groom of the Chambers but I own I should like to know if you are keeping Surridge [butler since 1920] & Patterson [head gardener since 1910] and the good housekeeper.' Although the Earl's income of £10,000 would be subject to £6,000 surtax, the agent hoped that

'the 4th Earl, with rigid economy and some reduction in the household staff, can probably afford to live in part of the Mansion house'. Some thirty years after the days of thirty-five domestic servants, the Hall now functioned with a modest dozen. Even Surridge, described by the Earl as 'the mainstay of the house for 26 years', eventually gave notice, unable 'to carry on under present circumstances'.[23]

The 4th Earl had talked before his succession of closing the great kitchen and turning either the stillroom or the butler's pantry into a more practical family kitchen. As it happened, the War decided the question. In January 1942, less than two months after the Earl had succeeded to Holkham, Chapel Wing (except for the chapel itself), Kitchen Wing, the bowling alley, stables, laundry and drying green were requisitioned for army use, mostly by the Royal Engineers.[24] The few remaining servants dined for the last time in the Servants' Hall. Henceforth they joined the butler and housekeeper in the Steward's Room, a breach of traditional hierarchy that would have been unimaginable even ten years earlier. The original kitchen, in use for

Two servants who maintained pre-war traditions into the 1940s: Surridge, butler from 1920 to 1946, carving the Christmas turkey in 1940, watched by the 3rd Earl, and Donald Paterson, head gardener from 1910 until his death in 1949, who was often called upon to play his bagpipes when there were guests at the Hall.

200 years, became the army cookhouse and a smaller kitchen for the family was equipped in the old stillroom on the east front of the hall. The new Esse stove installed there 'looks very nice', noted the Earl in his diary. An Esse representative who serviced it a few months later reported, 'There is a great deal of cooking to be done and the cook has her work cut out to get it all done on the Premier alone. The numbers are 16 and over, consisting of dining room, nursery and servants' hall, and for lunch there were five vegetables beside a roast venison, a partridge and two steamed puddings, one for the dining room and one for the hall, and milk pudding for the nursery.' She added, however, that although 'the cook must have the heat for all that cooking' her work was made difficult by the Earl, in his anxiety to economise, visiting the kitchen in her absence to turn down the thermostat. Their suspicions were corroborated by an entry in the Earl's diary: 'Had a serious accident with my teeth, top plate smashed, fell in Esse stove!!'[25]

The reduction in domestic staff impinged seriously on the maintenance of the house and contents. The new librarian, W. O. Hassall, discovered 'wet' books and manuscripts in 1938 which were dried out with the help of an electric fire and Lady Leicester's cooperation in leaving book cases open while she sat in the room. A British Museum report subsequently found that the books generally were in a 'very creditable' state. Many of the manuscripts, books, prints and drawings were deposited with the Museum for the duration of the war and retrieved from its quarry store in 1945. Strangers Wing, closed up and unventilated during the war, was later found to have suffered an alarming degree of dampness, threatening its contents and its structure. Maintenance and improvements generally were hindered by wartime limitations on materials but the Earl managed to make modest alterations. In common with his successors (the 5th and 7th Earls) he disliked the large plate glass windows installed by his grandfather in the 1850s and he restored some of the original eighteenth-century appearance by attaching false glazing bars, noting in his diary in April 1945, 'Windows in the [Marble] Hall finished, a wonderful improvement.'[26]

Although acutely anxious about army occupation of parts of the Hall, the Earl enjoyed contacts with the units quartered on the estate. A Battle School based at the Ancient House in the village gave him the opportunity to watch a company of the Scots Guards, his old regiment, do the battle course on the sand hills ('rather slow', he thought). He enjoyed showing the house to a Canadian battery that was bivouacked in the park for firing practice. The Royal Engineers, who were 'exemplary tenants', frequently participated in cocktail parties, cricket matches and concerts, organised a children's Christmas party in the Bowling Alley and cleaned out the fountain. Italian

prisoners of war, treating the park with scant respect, were less welcome. His daughters, Mary Harvey and Silvia Combe, enjoyed dances at the new airfield at nearby Egmere, climbing back into the Hall late at night through their father's ground-floor bedroom window. Evacuee children were housed in the village and in the porter's lodge near the Hall: 'sorry to lose them, a very well behaved little family', the Earl wrote in his diary on their departure. The estate set up a soup kitchen at Longlands 'to maintain the stamina of workpeople and their families, thereby ensuring maintenance of maximum output'. It was run by the wives of estate employees, with deliveries to workers in the fields made by pony cart by the Land Army Girls who were billeted at Longlands. It was succeeded by a 'Cash and Carry British Restaurant'. The Ministry of Food, hitherto disappointed by a lack of cooperation in rural areas, hoped that this 'pioneer effort' by Holkham would serve as a pattern for other large agricultural estates.[27]

In July 1944, recording in his diary the birth of a third daughter to his son, the Earl concluded, 'Must now give up all hopes of an heir to Holkham'. In the following year he made overtures to the National Trust. Lord Esher, a leading Trust committee member, was invited to Holkham to discuss the possibilities for handing over the Hall and some land. As Lord Leicester and his son held only life interests, the consent of the next heir would be needed. This was the Earl's cousin, Anthony Coke, born in 1908, whose father (Arthur, younger son of the previous Earl) had been killed in action at Gallipoli in 1915. Anthony had been a wayward teenager, 'sacked' from

Entry in the 4th Earl's diary, July 1944.

Mayo Ranch, about 150 miles east of Salisbury (Harare) in Southern Rhodesia (Zimbabwe), where Anthony Coke was the manager when his children were born in the later 1930s.

Gresham's school and sent at the age of seventeen to southern Africa, where he had successfully made a life for himself and eventually, according to his mother's second husband, got over his 'socialistic and rather critical phase'. He was now married, with three children including two sons, and although he had no interest in returning to England, it rapidly became clear that he would veto any transfer to the National Trust. 'What beats me', wrote Lord Esher to Lord Leicester 'is to think of an argument that will convince a man to sacrifice large assets to preserve a house about which he cares nothing.' The matter had to be shelved and the Earl became convinced that the 1946 Budget 'spells the death knell of Holkham after my death'. The National Trust resurrected discussions eighteen months later after a visit to Holkham by James Lees-Milne, secretary to its Country Houses Committee, who wrote, 'I had of course always realised that Holkham was among the first rate national monuments but I had not previously understood how much it is a concentrated work of art. It is stupendous.' Lord Esher and Lees-Milne now suggested a private Act of Parliament to overcome the difficulty of the settlement. The Earl still saw transfer to the National Trust as the only way 'to save Holkham and all its treasures from ultimate dispersal' but, as Lees-Milne later wrote, he 'could never make up his mind'.[28]

In the meantime, when the army handed back the occupied parts of the Hall, the Holkham agent again confronted the problems posed by its continuation as a privately-owned house. 'One thing is patent', he noted, 'it is quite

The 3rd Earl with Eddy, the future 7th Earl, at Holkham in 1937.

impossible for Lord Leicester to occupy the entire mansion and gardens as his father did before him, and temperamentally he could not abide the closing up of wings or apartments as is evidenced by his acute discomfort during the army occupation of the Chapel and Kitchen Wings.'[29] Compensation payments partly met the cost of renovations but annual running costs, dramatically reduced to between £2,000 and £3,000, approximately half the amount of five years earlier, were still beyond the Earl's disposable income after tax.[30] The Earl was eventually persuaded to agree to a restructuring of the ownership of the estate and the Hall through the creation in 1948 of a second company, giving a greater role to his heir, Lord Coke, then aged forty and recently retired from the Scots Guards. Apart from financial considerations, one intention was to reduce the pressures on the Earl of the 'rough and tumble' of daily estate business while preserving his right to be consulted on matters relating to the Hall and park. On both counts, the agent considered it 'of paramount importance both to Lord Leicester, Lord Coke and the estate that Lord Coke should reside at Holkham'.[31] Negotiations ensued with a view to Lord and Lady Coke moving into the Hall, with Lady Coke to have control of all the household accounts, but even in a house the size of Holkham it proved difficult to agree on the division of accommodation. The Earl had 'a certain reticence ... to surrender a part of the Hall to the use of another' and the situation was complicated by his wife's frail mental health, for which she was receiving treatment abroad. Eventually a trial period was

agreed. Lord and Lady Leicester took over Chapel Wing and Lord and Lady Coke with their three daughters took up residence in Family Wing, with staff rooms and a kitchen in Strangers Wing, in September 1948.

Shortage of staff and the need for economies soon saw the arrival of two Italian maids. The butler was to undertake their 'gradual guidance into English ways … and, should it be necessary, to give active and kindly help to the cook'. The other girl was to be trained as a house parlourmaid and to assist the butler in the dining room, bedrooms and Steward's Room. The wife of the house electrician would continue to help with housework and washing-up while her husband saw to boilers and fires. Ethel Butcher, a long-standing stillroom and sewing maid, continued in attendance on Lady Leicester, who had returned from a clinic in Switzerland. The dozen full-time staff of eight years previously, itself a drastic drop from earlier years, had become four.[32]

Less than a year after the start of the shared occupancy scheme with his son, the 4th Earl of Leicester died suddenly in August 1949. Only eight years after the last occasion, the estate was again faced with estate duty. It was decided that several sales of land already under discussion, including the family's earliest home territory of Tittleshall, would proceed, accompanied by the sale of investments to raise about £65,000 and the sale of heirlooms to raise the remainder. Consideration of using heirlooms to raise finance was a new factor. The young 2nd Earl had sold 'duplicates' from the Library in the 1850s but it was only from the 1920s that serious consideration was given to converting heirlooms (and in particular books and manuscripts) either into a 'perpetual trust fund' for the upkeep of the Hall or to meet future estate duty. The auctioneers, Sothebys, were keen to proceed quickly, while the librarian, W. O. Hassall, opened communications with Yale University in the United States for a private sale that would preserve a large portion of the library as an entity. In the meantime, the National Trust approached the new Earl to broach the possibility that, without requiring the consent of the heir, the Hall and a certain amount of land might be accepted by the Treasury, and thence pass to the Trust, in part payment of death duties.[33]

At this point, however, everything was put on hold. A friend (probably Tom Harvey) wrote to the Earl from Windsor Castle that he had just discovered that Anthony Blunt, Surveyor of the King's Pictures (and, as it turned out years later, Soviet spy) was 'on the committee investigating the preservation of houses and possessions of historic interest. He tells me that Holkham is outstanding among those whose entire preservation they will recommend – and the point is that it is the *private* retention of these collections that they are anxious to preserve. I am sure, therefore, that you should do

The 5th Earl inherited Holkham in 1949.

nothing until every aspect of the development has been examined.' The Earl and Blunt soon met to exchange information. Lord Crawford, chairman of the National Trust and a great admirer of Holkham ('the hall must be the noblest and the library the cosiest room in England') also urged waiting for the Gowers Committee report, adding, 'I can from my own experience realise the sort of dilemma you are in and the sense of hopelessness and helplessness one feels.'[34]

From this low point in 1950, survival and recovery slowly emerged. At a period when demolition of abandoned houses was higher than ever, Holkham benefitted from several intrinsic advantages. The estate was large enough to bear the sale of outlying land and was regarded by each generation, even at periods when income from it plummeted, as the basis of the

family's fortunes. Each generation wished to continue to occupy the Hall, there was in any case no obvious alternative such as a secondary seat or a London house, and the terms of the family settlement cut short the flirtation with the National Trust. Too old for military service in 1939, the 4th Earl had maintained continuity of occupation throughout the war, albeit cheek by jowl with the army, at a time when institutional use of many other country houses sealed their post-war fate. His elder son had survived the war and succeeded him in 1949 at a pivotal time, better equipped than his father by both age and temperament to face the post-war challenges. Crucially, too, the national outlook was more propitious, with the Gowers Report of 1950 reflecting a greater appreciation of country houses by both government and the public.[35]

Few of these hopeful signs were immediately obvious. The urgent issue was still the fact that, 'after taxation, the net income from the estates is barely sufficient to support the family in residence'. Ostensibly the cost of running the Hall had been greatly reduced during the past ten years but the real cost included maintenance and internal improvements which were concealed within the estate company's building

The Holkham Pottery, opened in 1951 by the Countess of Leicester and her daughters in the former bowling alley.

The Duchess of York (later Queen Elizabeth, wife of George VI) with her daughters, Princess Elizabeth and Princess Margaret, at Holkham in 1935, with Marion, Viscountess Coke, her granddaughter, Lady Anne, and the latter's cousins, David, Angus, and Griselda Ogilvy, children of the Earl of Airlie and his wife, Bridget, who was a daughter of the 3rd Earl of Leicester.

account, the labour costs of the kitchen gardens and other substantial hidden expenses. One of the new Earl's earliest responses was to embrace the idea of opening the Hall to the paying public, part of the first widespread opening of country houses in 1950. Nine open afternoons in July and August brought in receipts of just over £1,000, a figure that doubled the next year. This income was taxable but expenses that could be set against it included domestic staffing costs. There were benefits to be found in the Hall's enforced reliance on part-time staff, as the Earl explained in response to an enquiry by the National Institute of Houseworkers about the shortage of skilled domestic staff a few years later: 'We are, perhaps, fortunate here in being able to call on a number of "daily women" in the form of wives of employees on the Estate. They also assist in showing round visitors in the summer months and therefore take a more unusual pride and interest in the House and its contents.' By 1954 the only resident members of staff were 'an Italian couple who are … quite inexperienced and require a good deal of supervision. Nevertheless they seem interested enough to learn and appear to be settling down'.[36]

The coronation of Elizabeth II in 1953 was a reminder that, however straitened life in the Hall had become compared with earlier generations, the family retained close links with the royal family. In 1914–17 Lady Marion Coke, whose husband became the 4th Earl in 1941, had been the

object of possibly the first emotional fixation of the Prince of Wales, whose later affair with Wallis Simpson led to his abdication after he had succeeded to the throne as Edward VIII. Viscount Coke (the future 5th Earl) served as the Duke of York's Equerry in the mid-1930s and as Extra Equerry when he became George VI, and the King joined the shoot at Holkham in most years throughout the 1940s. The 5th Earl's wife, Lady Elizabeth, was Lady in Waiting to Queen Elizabeth II from her accession in 1952. Their eldest daughter, Anne, was one of the maids of honour at the Queen's coronation in 1953, giving rise to the unusual situation of both mother and daughter taking part in the Coronation procession, and Anne became a lady-in-waiting and lifelong friend of the Queen's sister, Princess Margaret. The Queen's eldest son, Prince Charles, spent time at Holkham as a young boy convalescing from chicken pox and stayed in close touch with the Holkham family as he grew up.[37]

The coronation, 1953. The Countess of Leicester is second from right at the top, and her eldest daughter, Lady Anne, the third train bearer from the right.

Prince Charles fishing on Holkham lake with a gamekeeper, 1957: from film footage shot by a member of the Coke family.

Although the sale of large parts of the library in order to pay estate duty had been postponed in anticipation of the Gowers Report, several smaller sales went ahead in the early 1950s, when government grants enabled the British Museum and the Bodleian Library in Oxford to secure important books and manuscripts. The major turning point for the Hall came in July 1953 when the Gowers Report was at last implemented. The legislation established Historic Buildings Councils with the power to award grants for the maintenance of buildings. The Ministry of Works's architect gave enthusiastic support to Holkham from the start, recommending that grants should be sought for all the original buildings and for some of the nineteenth-century features. The hard white brickwork of the Hall was never a cause for concern but the initial survey revealed that its stone parapets, cornices and balustrades were in urgent need of repair, particularly where affected by iron cramps and dowels, and thirty chimney stacks were suffering the effects of Victorian alterations. An initial grant of £10,000 was made and for some years Chapel Yard became a stonemasons' yard, redolent of the same work in earlier centuries. This was the beginning of what turned into a ten-year campaign of renovation. A further 'rather alarming' survey in 1955 revealed dry rot and deathwatch beetle in the roof and other parts of the Hall, resulting in a second grant of £10,000. This stage of the work involved replacing defective main roof timbers with steel girders and stripping walls almost entirely of plaster, for example in the Classical Library, to treat dry rot. An intriguing contrivance of 'nails and string' reinforcement was discovered behind brackets in the portico and stripping the plaster in the north

vestibule temporarily exposed the original appearance of the external north wall of the Marble Hall, previously concealed for a hundred years. At the same period, despite the recommendation of his architect to demolish the Victorian conservatory, Lord Leicester decided, partly on the grounds of cost, only to remove the glass and the defective iron roof and to make safe the remaining structure: one of the more recent buildings thus became the only one to bear any resemblance to a picturesque ruin. Two years later, work on Kitchen Wing drew a third grant to meet just under half its cost. The award took into account that the Earl had already contributed at least £20,000 in less than four years on rewiring, removing the conservatory roof, redecorating after repairs and his agreed share of the grant work. According to the Ministry of Works, the combined total of the three grants made it 'one of the largest so far offered for the repair of any historic building in the country and reflects the building's outstanding interest to the public'. In

Repair work in the Classical Library, 1950s.

Restoration of the Temple, 1950s.

Inspecting the wheat sheaf that crowns the Monument, early 1960s.

1958, despite the Earl's feeling that he had been 'treated very well by the Historic Buildings Council', the government architect encouraged him to apply for a fourth grant for repairs to the Temple, which had suffered badly from wartime use, and the Triumphal Arch. A detailed photographic record of the work reveals further details. Further external repair work extended to the Obelisk, Estate Office, Monument and a substantial rebuilding of the terrace walls. The final touch was the restoration of the kitchen, closed since the war but now added to the end of the public tour.[38]

Other work was undertaken for which there was no grant aid. An attempt to insure the contents against fire revealed that rewiring had become a

matter of extreme urgency; the work took four years (1953–57) and cost over £11,600. In 1954 a report on the condition of the furniture in the staterooms revealed that almost every item of upholstered furniture had been attacked by woodworm; this was tackled in-house, accompanied by gradual repair or replacement of curtains and upholstery. An inventory some ten years later shows that the emphasis in the rooms was on comfort at the expense of historical authenticity. The Statue Gallery and its Tribunes, for example, had carpets and crimson silk curtains with draped valances, while blue coco-fibre matting and a crimson corridor carpet attempted to imbue a hint of cosiness into the splendour of the Marble Hall. During the 1960s attention turned to the pictures; at least a dozen were cleaned and restored and a partial rehang in 1968 was declared 'an enormous improvement'.[39]

This type of expenditure reflected the fact that an unexpected and dramatic nation-wide rise in the value of agricultural land, after seventy years of depression, was resulting in a significantly higher rental income from the estate. At the beginning of the 1950s, the total estate of 32,624 acres yielded a rental of £36,000; ten years later, from a slightly reduced acreage, rents were just over £84,000. When the sale of Tittleshall, proposed in the 1940s, eventually went through in 1958, it brought in an unexpectedly large sum that became available for investment, soon followed by another unexpected windfall when ten years' negotiations over estate duty resulted in a refund. By 1967 the 5th Earl was 'in the satisfactory position of knowing that the whole of your properties are not subject to any charge or mortgage', with a modest overdraft equivalent to £2 per acre. His accountants, however, advised diversification, as 'with a total capital in excess of £14,000,000, your income, before taxation, was only £27,000'. Achieving a balance between land, investments and sales of heirlooms remained the characteristic preoccupation of the twentieth century.[40]

The problem of the succession remained, becoming more pressing each year. When the Earl had married in 1931, he had been persuaded by his grandfather, the 3rd Earl, to join in a re-settlement of the estate, against the advice of his father; he wrote to his mother while on his honeymoon that 'what I did was the only thing to be done under the circumstances. I feel so sorry for my father.' His father later alluded to this situation: 'Knowing what the situation would be at his [the 3rd Earl's] death, and the improbability of being able to carry on at all, I was so terribly anxious that you should not saddle yourself with the intolerable burden caused by the entailment of the Estates, and that at your succession you would have a free hand to do what you liked … However it is no good worrying about that now.' As he foresaw, the settlement was to prove a deciding factor in the future of the

Hall, although he could not have anticipated that its effects would be compounded by his heir's marriage producing three daughters and no sons.[41] In June 1950, the year after his succession, the 5th Earl held a coming-out ball at the Hall for the eldest of those daughters, Lady Anne; his youngest daughter was then aged six. It was now almost inevitable that the Hall, estate and title would pass to Tony Coke, his father's cousin, a situation that presented two problems: Tony was much the same age as the Earl, raising the spectre of again incurring two lots of estate duty in quick succession, and he had lived in South Africa for many years. Attention soon centred on his elder son, Edward, known as Eddy, born in 1936, now in his late teens, almost completely unknown to the Holkham family and consequently causing them considerable perturbation. The Earl apparently fought shy of a direct approach to the South African family. His lawyer, visiting them in 1955 to propose a scheme for settling the future of Holkham, succeeded only in giving the impression that the Earl wished Eddy to make a long visit to Holkham but might even then 'turn him down'. Eddy's step-grandfather suggested that completing his education in England and paying short visits to Holkham would better enable him to 'assimilate the different ways of life between his present circumstances and those of England'. Eddy's grandmother, apparently the only member of the family who had met him fairly recently, spoke warmly of his character and school reports but deplored his South African upbringing and urged the Earl that, 'if ever he is to become worthy of Holkham, should he succeed you, it would be wise to give him a chance by bringing him over here'. Even her optimism faltered, however, as she contemplated possible failure: 'Couldn't some arrangement be made for Anne to have Holkham? I too should hate to think of Holkham in the hands of a completely unsuitable person.' The newest trustee of the family settlement envisaged another scenario, repeatedly mentioning the risk of Eddy, on inheriting Holkham, 'selling up the whole estate, lock, stock and barrel'.[42]

Eventually it was settled that Eddy, then aged twenty-one, should spend a few months in England in 1957. As events turned out, he arrived not at the family's behest but on a management course arranged by the agricultural chemical company for which he worked. The Earl's lawyer met him before his first visit to Holkham and was favourably impressed. He told the Earl that Eddy was 'intelligently inquisitive about Holkham without I think being at all prying' and despite being 'obviously and extremely South African' seemed likely to 'easily develop in the way you hope'. A year later, when he was due to return to South Africa, it was Eddy who raised the question of the tax-saving and succession scheme that had come to naught in 1955, showing that he was aware, probably rather more than had occurred to the Holkham family,

Eddy Coke in 1957.

that it was a two-sided situation: 'as ultimately things may fall on my shoulders ... even if this scheme does fail, I will at least know that we explored every possible avenue'.[43]

The subsequent 'Design for Living and Death Duty Memorandum' was discussed at length but allowed to rest for several years until threats of a penal gift tax in 1965, combined with the great increase in land values in the intervening years, prompted its revival. Anthony Coke was summoned from South Africa to thrash out the details. Eddy had been working in England since 1961 and was now married with a son (that is, an heir) and Anthony had declared his intention definitely to remain domiciled abroad, both factors that eased progress towards arranging a discretionary trust, although it was to be three more years before it was implemented. The major aim was, yet again, the avoidance of death duties, the Earl's accountants emphasising that 'if no action were taken ... your successor would have difficulty even in maintaining an emaciated estate'. A deciding factor for the Earl was the successful outcome of proposals for 'the future employment and way of life' for Eddy, including arrangements for him to give up his job, live on the estate, be provided with an income and undertake some form of training. The Earl himself organised the latter: a year to learn about English farming

The 5th Earl of Leicester in 1968. Portrait by Julian Barrow.

on a non-estate Norfolk farm, followed by two years as a pupil under the new agent at Sandringham. Before that period was completed, he gave Eddy the tenancy of an estate farm at Burnham Norton. It was only then, in 1968, that the resettlement of the estate was finalised.

Within five years, as the Earl's health failed, Eddy started 'to look after Holkham'. His initial challenge was the modernisation of some 300 houses

The 7th Earl of Leicester, 1936-2015

on the Norfolk estate: ten years earlier the clerk of works had described them as 'appalling' but the priority so far had been the modernisation of cottages at Holkham village itself. Park Farm, too, received immediate attention: as he later recounted, 'in the early 1970s every farm in the country was profitable, except Park Farm. Everything on the farm was subordinate to shooting'. Eddy Coke took full control on the Earl's death in 1976 and moved into the Hall with his family in 1982. At this period he was Viscount

Chapter 17 Survival and Revival 1909–2000 523

Coke, becoming the 7th Earl of Leicester only on the death of his father (who had remained in South Africa) in 1994.[44]

The last occasion that the Hall and estate had passed sideways in the family, rather than from father to son, had been in 1775, 200 years earlier. The intervening generations had repaired where necessary and modernised when desirable but otherwise had largely accepted their ancestral home as a matter of course. Eddy Coke, on the other hand, coming to the Hall from a completely different background, developed an understanding and feeling for its original creation to a greater extent than had any of his predecessors since the builder Earl's widow. He was helped by a revival of interest in eighteenth-century country houses by government, public and scholars but he also contributed an attitude untrammelled by tradition yet receptive to history. Like his predecessors, he tackled practical aspects such as updating the central heating systems and installing additional bathrooms but he also made major contributions to illuminating the historical integrity of the Hall and its contents. In Family Wing, the original rustic parlour or dining room again became the family dining room and the maid's room next door, occupied for many years by the late Earl's old nurse, Nanny Langran, was converted to form a modern family kitchen, thus making the wing virtually a self-contained family home. An important picture rehang in the late 1980s restored so far as possible Thomas Coke's original hang in the Saloon

The east side (Nelson Wing) during replacement of the 19th century large window panes, 1988.

The Statue Gallery in the 1960s and 1970s, and restored to its 18th century simplicity in the 1980s.

(including the two pictures by Procaccini and Chiari that had languished in the attics for nearly two centuries) and in the Landscape Room. In the 1990s, the replacement of the nineteenth-century large-paned plate glass windows in order to restore the original style (as started on the north front by the 5th Earl) was completed along the south, east and west fronts. After Eddy's second marriage in 1986, his wife, Sarah, played a major part in revitalising decorative aspects of the house. The staterooms were cleared of inappropriate items and, where reupholstery was necessary, it was undertaken as authentically as possible. Dark blue leather for the Statue Gallery suite, for example, accorded with entries in the earliest inventories, corroborated by a scrap of leather caught under later upholstery. Major paintings were cleaned and restored. New carpets were specially woven for the South Drawing Room, Saloon, South Dining Room and Green State Bedroom; fabrics for the Landscape Room walls and the Saloon furniture were commissioned from an Essex silk weaver; statues were cleaned and, in the case of the colossal statue of Lucius Verus, rescued by major repair. Determined to breathe life into the whole house, the Earl and Countess lived in Family Wing in the winter

The Green State Bedroom bedspread under repair and conservation by 'the ladies from NADFAS' (the National Association of Decorative and Fine Arts Societies).

and moved to Chapel Wing for the summer. The staterooms were frequently used for parties and dinners and they took on a livelier appearance even during the open season, thanks to the new carpets, the removal of ropes and the addition of fresh flowers in every room. The Marble Hall became the scene for regular classical music concerts. Strangers Wing, retrieved from its post-war distress, was well-used for guests.

A full-time resident security officer, F. C. Jolly, appointed in 1975, was soon designated Hall Administrator and oversaw the return of much of the management of the Hall from the Estate Office back to the house itself. Self-contained staff flats for the administrator, his deputy and the butler were formed from the ground floor of Strangers Wing, the kitchen servants' rooms on the east side of the kitchen and the original housekeeper's rooms (the upper stillroom and dessert room) along the ground floor of the east front. The latter flat was occupied for a time by Lord Leicester's widowed mother, who did sterling work indexing the parish registers. A series of six staff group portraits commissioned from Andrew Festing over a period of several years from 1993 formed a distinctive historical record for future generations. In the park, a life-size bronze of Lord Leicester, seated on a bench overlooking the Hall as if on the eighteenth-century 'Seat on the Mount',

The 7th Earl enjoyed using the Saloon and other staterooms for special occasions, in this case a dinner for heads of department and other staff when the Earl retired from running the estate in 2005.

Picture lights were fitted throughout the staterooms. The bright colour of the original wall covering in the Saloon was revealed under the frame of the Rubens painting.

The Hall staff, by Andrew Festing, 2004. Seated, from left: (foreground) the manuscript librarian, archivist, Hall manager and (behind) two cleaners; standing, from left, the cook, cleaner, laundry helper, butler, cleaner, librarian, houseman, deputy Hall manager, assistant houseman (on steps), electrician, carpenter and cleaner.

The 7th Earl of Leicester with his son, Tom, who became the 8th Earl in 2015, and grandson, Ned, in 2005.

was given by his wife to commemorate his sixtieth birthday and his first twenty-five years' dedication to Holkham.

In 2005, when nearly seventy, the Earl handed over direction of the estate to his son, Tom. The handover of the Hall was completed two years later, when Lord and Lady Leicester moved to the restored Model Farm on the western edge of the park and, after alterations and refurnishing in the Hall, Lord and Lady Coke with their young family moved into Family Wing and the old Audit Room. Under the Succession Business Plan, the Hall became the centrepiece of a new company, Holkham Enterprises, whose primary purpose was to develop the visitor and retail operations that were increasingly overtaking the agricultural estate in financial importance. 'Everything we do at Holkham,' wrote Lord Coke, 'must be for the benefit of the Hall and its amazing collection. It is the centrepiece of the estate … we must always remember that and base our decisions around it.'[45]

Appendix 1
Thomas Coke's architecture lessons in Rome during his Grand Tour

The following extracts are from the Grand Tour accounts compiled by Edward Jarrett, the valet, reference F/TC4.

Coke's first stay in Rome, 7th February to 6th June 1714, aged 16

17th May *'Paid for Royale paper 2 rules and to larne articeche'* 28 pauls [p.71]
21st May *'Paid the architecture master for a month'* 33 pauls [p.71]
 This was the same rate as for daily tuition by other masters, such as those teaching language and flute.
1st June *'Paid for instrements to larne architecture'* 28 pauls [p.73]
 'Paid for paper quiles and a broush'
5th June *'Paid the architact master a month and for a book'* 66 pauls [p.74]

Total daily lessons: more than 2 months.
No time spent in Rome during 1715.

Second stay in Rome, 2nd June to 12th September 1716, aged 18–19

31st July *'Paid Signor Giacomo the Architect master'* 3 crowns 3 pauls 5 baiocchi [p.156]
 This was the same amount as payments to the flute, language and mathematics masters 'for a month'.
29th August *'Paid to Mr Jacomo the Architeck master'* 3cr 3p 5ba [p.161]
 Again the same as for other masters 'all a month'.
11th Sept, the day before leaving Rome for the last time,
 'Gave to Signor Giacomo 7 louidors as a present for goeing about the town with my master and larning of him Architacture' 23cr 1p 0ba [p.166]
 This entry suggests that 1 louidor was equivalent to 3 crowns 3 pauls, which was virtually the normal monthly rate for masters.
 The next entry on the same day, *'Paid to Signor Giacomos bill'* 27cr 6p 0ba [p. 166]

Total daily lessons: two months, plus informal tuition and visits, and additional unspecified goods or services (possibly including more formal tuition). By comparison, the flute master received a present of only 4 louidors in addition to his monthly rate, while the language master received only his normal monthly pay.

3rd stay in Rome, 8th January to 5th April 1717. aged 19

14th March *'Paid to Signor Jacomo for teaching my master Architact'* 10cr 0p 5ba [p.193]
 Payments to other masters (the flute master for 3 months, the dancing master for 2 months) indicate that this amount was for 3 months tuition, that is, throughout the whole stay.

Total daily lessons: three months.

Thus, over the course of three years, Thomas Coke received daily individual tuition in architecture for a total of between seven and eight months. In addition, the benefit he gained from informal tuition from the same architect while visiting the buildings of Rome, during two months in 1716, was recognised by a gift equivalent to seven months pay.

Appendix 2
Time Line: Creating the Park

Date	Farms, park and hall	Designed landscape and pleasure grounds	Kitchen gardens
1719	Sub-lease of Quarles		
1722	New estate steward Hall farm taken in hand Village road closed		
1723		New head gardener	
1724		South lawn begun	
1726		Obelisk Wood begun	Kitchen gardens begun
1727–33	Longlands Farm created		
1729	Thorogoods Farm absorbed	Clint dam	Kitchen gardens completed
1729–31		Clint canal or Great Water	
1729–34		South basin (intermittently)	
1730	Old house: removing garden walls and trees, levelling gardens	Obelisk begun Drain from basin to old ponds	
1731		Orange ground/orangery	
1732		Obelisk & O. Wood completed Temple begun	
1732–35		Orangery greenhouse Pavilions	
1733	Longlands Farm let Staithe Farm reorganised	Avenue	
1734	Hall: Family Wing begun Park paling begun	Temple completed South basin completed Avenue planted	
1735–37	South Lodge built		Ananas house
1736	Home Farm reorganised Boundary Wood begun	Gardener Oram consulted	
1736–38	Branthill Farm created		
1737		Enlarging drain from canal to Wall Pond	
1738	Felling trees on Hall site	More work on basin	
1738–42		New Slope or Mount	
1739		Making island in Shoulder of Mutton pond	
1739–42		Work on 'Great Water'	
1740	Party held in orangery	Demolishing wall at Wall Pond Stone bridge	
1741	Hall: central part begun	More work on Avenue	
1742			Ice house and Menagery
1743		Seat on the Mount 'Serpentine River'	Survey of fruit in kitchen gardens

Date	Farms, park and hall	Designed landscape and pleasure grounds	Kitchen gardens
1745	New Home Farm premises in village	Triumphal Arch begun 'Waters & Fishery' completed	Dove house
1748	Lucar Hill plantation		
1749	Fence round park completed		
1751–53	North Lodge built		
1752		Triumphal Arch pointed	
1753		Levelling North Lawn	
1756	Almshouses built		
1757		Final work on Triumphal Arch	
1759	Death of Lord Leicester		
	Lady Leicester		
1762–64	'Capability Brown' at work		
1764	Hall declared complete		
1766		Thatching 'the seat in the Chalk Pit'	

Appendix 3
Time Line: Expansion and Change in the Park

Date	Farms and park	Designed landscape	Pleasure grounds & Kitchen gardens
1776	T. W. Coke takes possession		
1778	Four-year plan begins New farm bailiff Edmund Wright		
1779	Home Farm tenant Winn leaves: land divided, part let to Brett Hunclecrondale tenant Tann leaves: farm taken in hand		
1780	New southern boundary road. Demolition of South Lodge?		Western flower garden in progress, with conservatory New kitchen gardens begun
1781	Hunclecrondale land divided, part let to Sharpe	Tree planting campaign starts	
1782		Coast road altered	
1783	Home Farm remnant: tenant Brett leaves, land in hand		
1783–87	Palmer's Lodge built		
1784–86		Lake extended, north end	
1785	Church Lodge built		
1786		New Inn at Hunclecrondale	
1787	Hunclecrondale land all in hand: tenant Sharpe moves to Staithe Farm	New Inn opens	
1789			Repton's lakeside scheme
1791	Longlands added to Hall farm		
1791–99	New premises at Longlands		
1792	Great Barn ready for roof		
1795–97	Old farmyard in village demolished		
1798	Sheep Shearings in local press		
1800		Lake extended, south end	Probable removal of basin & serpentine river
1801	Octagon Cottage built with park entrance adjoining		
1803–5	Lodges: Scarborough, West, Wells/Greenway & Branthill		
1808	Staithe Farm in hand: house & premises converted to cottages		
1813	Wells Enclosure Award		
1813–33	Buying up 'allotments' on Wells heath		

533

Date	Farms and park	Designed landscape	Pleasure grounds & Kitchen gardens
1821	Last Sheep Shearing		
1822	T. W. Coke re-marries		
1828	Cuckoo Lodge on Wells heath		
1831	Plantation on Wells heath		
c.1832			New eastern pleasure garden ('arboretum')
1833–39	Park wall built		
1837	T. W. Coke becomes 1st Earl of Leicester of 2nd creation		
1841		Cricket ground on north lawn	
1842	Death of 1st Earl		Mushroom house
	2nd Earl of Leicester		
1845–50	Monument	Lake altered	
1845		Deer brought from Elmham	
1846	North Gates; South Lodge		
1849–54			Terraces and parterres
1851	Golden Gates Lodge		
1854			Conservatory Alterations to arboretum
1856			Fountain plumbed in
1862	Wells Lodge		
1872			Glass houses

Sources in the Holkham Archive

Primary sources at Holkham are cited by their archival reference. The following are the principal categories used in this work.

A/ Accounts (domestic, estate and building)
A/Au Audit Books (annual rentals and estate accounts)
A/V Vouchers or invoices
C/ Persons (other than family) connected with Holkham
 /AG Appleyard, George
 /AN Alexander Napier
 /BMs Brettingham, Matthew, senior
 /BMj Brettingham, Matthew, junior
 /SS Former servants and staff
D/ Deeds and manorial records
 DA/ Deeds of alienated estates:
 /ML Minster Lovell (Oxon)
 DD/ Deeds catalogued by Davidson:
 /FD Family Deeds
 /GE General Estate
 /H Holkham
 /Bi Bintry and Billingford
 /Em Elmham
 /F Fulmodestone
 /Ma Massingham
 /Qs Quarles
 /Ts Tittleshall
 /Ws Wells
 DM/ Miscellaneous Deeds
 DS/ Supplementary Deeds
E/ Estate records:
 /EA Alienated estates
 /C Correspondence and Letter Books
 /F Farms
 /G General
 /Gar Gardens
 /WF Woods & Forestry
F/ Family Records:
 /G General
 /EC Edward (1676–1707)
 /HC Henry (1827–1916)
 /LCJ Lord Chief Justice Sir Edward
 /JC John (1590–1661)
 /JCY John the younger (1636–71)
 /RC Robert (1651–79)
 /Rg Roger (1886–1960)
 /SC Silvia Combe (née Coke) (1909–2005)
 /TC Thomas, 1st Earl
 /TWC Thomas William, 1st Earl of 2nd creation.
 /2E 2nd Earl
 /3E 3rd Earl
 /4E 4th Earl
 /4E/M Marion wife of 4th Earl (1882–1955)
 /5E 5th Earl

H/ Household:
 /CT Contents
 /EL Electricity
 /EO Household records from Estate Office
 /Ga Gas
 /Inv Inventories
 /JS J. Sibary's papers
 /Ser Servants
 /Wi Wine Books
M/ Maps
P/ Plans (architectural)
 /M Mansion [Hall and environs]
 /HV Holkham Village
Ph/ Photographs
T/ Tenants' papers
 /B Baker
 /M Moore, Thomas

Notes

Chapter 1
1 F/4E/M/1(82)

Chapter 2
1 James, *Chief Justice Coke*, 305–6. F/LCJ3
2 Habakkuk, *Marriage*, 99–100. A seventh son did not long survive birth; the eldest died soon after 1600.
3 Neales is spelt as in the early Audit Books; elsewhere it was also spelt Neeles or Neel.
4 M/64, map 'The description of the lordshippe or mannor of Holkeham ... beinge a percelle of the possessions of Dame Anne Gresham widdowe ... by Thomas Clerke of Stamforde St Martins, Northants, gent' 1590. The name clynt or clint was a Middle English term for an outcrop of rock or, as here, a ravine in a hillside, although the Holkham clint is a gentle depression rather than a ravine. The slopes on either side were sometimes called 'the breasts of the Clint'.
5 The inscription is in Holkham Hall above the entrance door into the Marble Hall.
6 Young, *General View* 2–3, 238; Allison, 'Sheep Corn Husbandry' 679
7 DD/H656 tithe accounts
8 Burghall also known as Boroughall and occasionally Burrow Hall; Neales also known as Lucas.
9 Kiralfy, *Potter's Introduction* 490; Heal & Holmes, *Gentry* 144–5
10 DM/3795
11 DD/H506, 507, 518, 535a, 536a, 536b. Meriel was then aged twelve, the legal age of marriage for girls.
12 DD/H536b, 537–539. James, *Chief Justice* 305, followed by others, wrongly gives the year of purchase as 1610.
13 DD/H536b. Hassall and Beauroy, *Lordship* 10
14 DD/FD3, p.66; E/G15, p.13
15 Norfolk RO, Tittleshall parish register, August 1609
16 Unsorted papers of Sir Edward Coke, 1605 bills pinned together, 'Mr Golde his bills exhibited by Robt. Baker' 2nd item, 31 Dec. 1605. Hilary Ritchie at the Suffolk RO kindly checked parish registers to find that Robert Golde was rector at Thorington from 1561 until at least 1612, and died 1620.
17 James, *Chief Justice* 93. Habakkuk, *Marriage* 100, 113
18 DD/H506. Norfolk RO, NCC 218 Gardyner, and DN/INV17/8, will and inventory of Anthony Wheatley, 1600. DD/H1101 undated map of fold courses
19 F/JC8 petition to the Lord Keeper 1636
20 M/64. Norfolk RO, DN/INV17/8. Cliffe, *World* 24, 27–30
21 The descent of the manor was outlined in DD/H495: Ann Gresham had been previously married to William Reade as his second wife; their elder son, William Reade, left a life interest in Burghall manor to his own second wife, Mary, who later married Sir Edward Spencer. The reversion of the manor after her death would pass down through Sir William's daughter and sole heir by his first wife, to his three married granddaughters and co-heirs, Janet wife of Sir William Withipole, Elizabeth wife of the 8th Lord Berkeley and Bridget wife of Lord Fielding. The first two sold their reversionary interest to Coke in 1634, the third in 1647.
22 DD/H640,641
23 DD/H639
24 The valuation was based on £140 p.a. at 18 years purchase.
25 DD/H732. F/JC34, J. Burry to Coke 17 Mar. 1658/9
26 DD/FD3, f.74r, settlement of 1626. Fulmodestone rent was £250 in 1614 and nearly £377 in 1667: E/G15, f.31v. F/JC81 accounts of John More; F/JC80, pp.60, 70
27 DD/FD3
28 Habakkuk, *Marriage* 11. Sir Edward's deed lacked the later legal device of appointing trustees to preserve the contingent remainders (the unborn sons of John, the second life tenant).
29 DD/FD3; F/JC9; F/JC6. English and Saville, *Strict Settlement* 41–2
30 F/JC 8. On the strain of providing for marriage portions, see Heal & Holmes, *Gentry* 51, 142.
31 DD/H837
32 Habakkuk, *Marriage* 92–95
33 Berkeley Castle Muniments, General Series Letters 4/2/11: I am indebted to David Smith, Berkeley Archivist, for a transcript.
34 DD/H837. James, *Chief Justice* 80
35 Tomalin, *Pepys* 10–11. The present house at Durdans is not the 17th century house.
36 DD/FD17b, DD/H837
37 DD/FD17b,17c
38 Habakkuk, *Marriage* 11–12. James, *Chief Justice* 84. E/G15; F/JC17; DD/Ts114; DD/FD22a. The Stubbe brothers were not, however, acting as trustees to preserve contingent remainders in unborn sons, the new element in the classic strict settlement that was developing around this time: John Coke took as an 'alternative contingent remainder', that is, a gift over to a living person, contingent on there being no issue to Sir Robert.
39 Carthew, *Launditch* III, 106, commented on the fact that Sir Edward's settlements did not mention his grandson, John, second son of John of Holkham, but he confused the grandson of that name who died in 1633, and the eventual heir, born after Sir Edward's death, for whom the name John was re-used.
40 Carthew, *Launditch* III, 540–541. DD/Em132 mortgage 1655; DD/Em138 & 139 writ and particulars of partition 1662–63
41 E/G16, p.28 'to Pepys with speed', apparently from Sir Edward Coke, undated
42 James, *Chief Justice* 50 et seq, 82 et seq, 112 et seq
43 Ketton-Cremer, *Civil War* 150, 154. Heal & Holmes, *Gentry* 172
44 F/JC73a
45 Ketton-Cremer, *Civil War* 171–72, 264
46 Ketton-Cremer, *Civil War* 154, 221. Heal and Holmes, *Gentry* 172, 220. F/JC54–57, 66
47 DM/3802 Robert Earl of Warwick to John Coke, 31 Jan. 18 Chas.I; DD/HD695,696, Letters Patent, 2 Feb. 19 Chas.I. Heal and Holmes, *Gentry* 172–3. F/JC58–61,74
48 Both Wise and Brewster later worked for the Hobart family at Blickling: Cliffe, *World* 113, 204.

49 F/JC4; DD/H781,785,790. Linstead was 'taking the accompts' but was possibly subordinate to the estate steward. DD/GE30 lists of papers 1653; DD/H822 account book 1657–6; F/JC80 Palgrave's accounts 1657–60
50 F/LCJ5, deed establishing LCJ Coke's library as an heirloom 1630. F/JC11; F/JC24. Hassall, *Catalogue* vi. Some legal manuscripts were apparently lost after being sent to printers.
51 DD/H809, 21 Oct. 1659; M/64; DD/H1101 undated map of fold courses
52 L/2/1/1, June 1638
53 Young, *General View* 10: 'Along the coast, from Holkham, westward, towards Hunston, there is a tract between the marshes and the sand, from half a mile to a mile broad, of a singularly fertile sandy loam.'
54 Hassall and Beauroy, *Lordship* 514. DD/H649a Letters Patent 4 Dec. 1637; DD/H656 particulars of corn grown 1640. DD/FD26
55 DD/H794–799; DD/GE49
56 DD/FD20, 21, 24. Margaret's marriage portion was £700: F/G2/4 f.23
57 DD/Ts107 inventory 1661, discovered in recent years among papers relating to Godwick and identified by internal evidence as relating to Holkham. DD/GE33 pp.19, 23, 33, 43, 68. East Riding of Yorkshire Archives, DDBL/19/4 [reference from A2A website]
58 James, *Chief Justice* 104. Heal and Holmes, *Gentry* 69–70. Norfolk RO, PD 608/56. DD/Ti92. DD/GE33 pp.19, 23, 4; F/JC80 pp.4, 39, 40, 59–61, 95–7
59 Thomas, *Anecdotes* 61. The anecdote confirms that Coke has been pronounced 'cook' since at least the 17th century. Dr Robert Smith has pointed out that this is an interesting early example of insistence on a standard spelling.
60 F/JC28 Burry to Coke, 29 June 1654. F/JC80 pp.21, 68. DD/H822
61 F/JC30 Lushington to Coke and Pulleyn to Lushington 21 Aug. 1654; DD/H786 Lushington to Coke, 11 Mar. 1656. This letter indicates that Lushington was still writing controversial theology while in semi-retirement at Burnham: cf. Huntley, 'Dr Thomas Lushington', 21. The tract has not survived in Coke's papers.
62 DD/FD26 will of John Coke 21 June 1661. The books were 'a Davila, Grotius, Biblia Grece and Raynaud'. The Holkham Library contains two books by Enrico Caterino Davila on the French civil wars (1644 & 1647), several by Hugo Grotius and two by Theophilus Raynaudus / Théophile Reynaud (1629 & 1653).
63 Sir Edward Coke's uncle, George Knightley, in 1610 left a bequest to his 'cousin' Michael Haydon: DM/3838. Norfolk RO, MC2494 (household accounts). F/JC34, J. Burry to Coke 17 Mar. 1658
64 F/JC5 letter addressed to Holkham Hall
65 F/JC80, pp.58–72, 74, 122–124, 128; E/G15 State of the Manors, pp.28, 45
66 Cooper, *Houses* 282. DD/GE75 & 76 (1707). For Wythe, see DD/H834
67 Heal & Holmes, *Gentry* 301. DD/Ts107
68 DD/H822; F/JC80. A slightly earlier domestic account book is in Norfolk RO, MC 2494.
69 F/JC(Y)1, w/e 17 July, 13 Sept., 28 Sept. 1661, 27 Sept. 1662. The gathering and cleaning process was performed once every few years: see Harrison, *Description* 348–53: I am indebted to Sarah Booker for this reference.
70 DD/Ts107
71 F/JC(Y)10, w/e 25 Sept. 1661

72 James, *Chief Justice* 98, 102; no source was cited by James. The family at Longford, descended from John's youngest brother, Clement, had received a baronetcy in 1641.
73 *Norfolk Hearth Tax Assessments* Michaelmas 1664 & Lady Day 1666, Norfolk & Norwich Genealogical Society, vol.15 (1983) 9, 84; vol.20 (1988) 15, 39. Agnew, *Whirlpool* 4

Chapter 3
1 The following account is based on a 19th-century transcript of legal documents in E/G16, pp.118–133. See also Kiralfy, *Source Book* 270–78 on Cook v. Fountain 1676. I am grateful to Mike Macnair for sight of his draft article, Coke v Fountaine, for *Landmark Cases in Equity*, ed. C. Mitchell & P. Mitchell (Oxford, 2012) 33–62.
2 Meriel Wheatley's maternal aunt Susan Armiger had married John Fountaine of Salle: memorial in Holkham church.
3 F/JCY/47,48
4 DD/FD26 will of John Coke, 21 June 1661; F/JCY88, letter to Christopher Savory
5 *History of Parliament*, under John Coke, suggests on the strength of a name in Philip Skippon's diary that Coke was at Florence in 1664, en route for Constantinople, but there is no evidence to identify this J. Coke with John Coke of Holkham. Robert Paston reported another 'cosin Cooke' in Saumur, en route for Italy in 1675: Agnew, *Whirlpool* 148.
6 F/JC(Y)23,25,57, all 1662, and unlisted letters from John Fish 21 July 1668, Gwavas to Savory, 9 Aug. 1668
7 F/RC10,11; the legacies were, however, apparently unpaid 21 years after his death.
8 This account continues to be based on E/G16, pp.118–33. As tenant-in-tail in possession, Coke used the legal device of common recoveries to make himself tenant in fee. Rent charge is defined thus: 'if one seised of land, grants by deed any yearly rent issuing out of it to another person in fee, fee-tail, for a term of life, or years, with clause of distress, it is a rent-charge': Jacob, *Law Dictionary* under Rent.
9 DD/FD28; Farnham rent was £231 in 1691(E/G16), £252 in 1698 (DD/GE40). E/G2, p.123
10 James, *Chief Justice* 106–7. Unnumbered ms F/JY(Y) Gwavas to Savory, 6 March 1666; F/G2(1) ff.81 et seq. Gwavas's son, however, recorded that his father's lawsuits as Coke's executor left him impoverished: I am grateful to Mike Macnair for this reference from W. C. Borlase, 'Autobiographical Notice of William Gwavas, extracted from his Common Place Book, 1710', *Journal of the Royal Institution of Cornwall*, 6 (1878–81) 176–81 at p.178. Thomas Coke's guardians negotiated the end of the lease in 1707: F/TC1, p.40.
11 Captain Robert Coke was the only surviving son of Clement Coke of Longford, the youngest of the Lord Chief Justice's sons; he was married to another cousin, Theophila, daughter of Arthur.
12 DD/FD28 abstract of John Coke's settlement
13 English and Saville, *Strict Settlement* 54
14 DD/FD28. Habakkuk, *Marriage* 30; Bonfield, *Marriage Settlements* 66
15 *History of Parliament* under John Coke. Agnew, *Whirlpool* 126, quoting Thomas Henshaw to Sir Robert Paston 12 Aug. 1671
16 F/RC7, Articles of Agreement, 26 June 1672; James, *Chief Justice* 126, states that Coke took the degree of MA in 1673. DD/FD28, abstract of Mr John Coke's settlement and later documents

Notes to pages 1–51 537

17 'Rough proof' of printed genealogy in box of genealogical papers compiled by J. Wood (an early 20th century Holkham agent): marriage licence dated 25 Nov. 1674. Coke's uncle Roger offered to account for his handling of Robert's affairs in 1671–72 to the Lord Treasurer, presumably because Robert was still a minor: the Lord Treasurer was not, however, Robert's future father-in-law Danby but his predecessor in the post (F/RC6). Browning, *Osborne* 63

18 Ketton-Cremer, *Portraits* 39, 41, and *Essays* 107. James, *Chief Justice* 126. Agnew, *Whirlpool* 209. *History of Parliament* under Robert Coke, quoting Sir Richard Wiseman

19 F/RC9. Rosenheim, 'Party Organisation', cited a printed copy of the Subscription in the Historical Manuscripts Commission report on the Lothian (Blickling) papers and a partial ms copy in uncatalogued papers at Raynham Hall, the Townshend seat; he was unaware of the copy at Holkham, which has come to light in recent years.

20 Dunn, *Lieutenancy Journal* 151, 155; Agnew, *Whirlpool* 245

21 F/G2(1) ff.84 et seq, bills of Robert Coke; F/RC/1. 'Downing Street (Hampden House)', in *Survey of London vol. 14, part III: Whitehall II* (1931) pp.105–112. Agnew, *Whirlpool* 196, 198, 298. Hampden House had a sizeable garden for which Coke bought an impressive range of vegetable seeds, mistakenly believed by James to have been intended for Holkham: James, *Chief Justice* 130.

22 Agnew, *Whirlpool* 209–10. National Archives, C24/1078, Coke et al v. Danby et al, 1683

23 E/G16, p.35, copy of Tittleshall church memorials: Robert died 16 Jan. 1678/9 'in the 29th year of his age'. Agnew, *Whirlpool* 366. F/G2(3) f.10, Thomas Coke to Sir John Newton, 28 Jan. 1712/13

24 Agnew, *Whirlpool* 366. Lincs RO, Monson 7/12, no. 129, Edward Northey 1708; this and subsequent references to the Monson papers are from a transcript at Holkham by W.O. Hassall.

25 Browning, *Osborne* 46

26 The National Archives [subsequently TNA] C24/1078 and 1056. I am indebted to Maureen Harris for information about Dewes's activities from the ledgers of Child's bank, Royal Bank of Scotland Archives; he continued to make payments to Lady Ann Walpole (presumably after collecting rents) until 1701 but by then, when Edward had inherited and his mother had remarried, he was probably responsible only for her jointure estates.

27 TNA, C24/1078

28 I am grateful to the late Charles Fountaine of Narford for giving me access to his archives. Narford Archives, box B, notes concerning Mr Coke & Mr Fountaine, June 1694; indenture 8 Feb. 1695/6; untitled and undated note re Fountaine's claims, and agreement for purchase of Narford 17 Mar. 1696/7. Andrew junior (c.1677–1753) was knighted 1699, aged only 21 or 22: pedigree, Narford Archives, boxes K, L

29 DD/FD28 Abstract of Mr John Coke's settlement; F/G2(1) f.192 Mr Coke's case as to the demands of the widow and daughter of Capt Robert Coke decd.

30 F/RC1 account book 1673–75; DD/FD35 copy will of Lady Catharine, 1688. Lady Catharine was the mother of Sir Edward Coke, who became one of the guardians of Edward and Cary's son, Thomas. Smith's first wife came from Nether Thurvaston, near Longford, reinforcing the probability that Smith originated from that area: see memorial in Holkham church 1712 to Anne aged 36 wife of Humphrey Smith.

31 DD/GE40 rental 1698

32 E/G16, p.134 et seq. Lady Anne's jointure was said to be unusually large relative to the estate income: *History of Parliament*, entry for Robert Coke. Thomas Coke's guardians took care to secure the surplus profits of the jointure: A/1 pp.100, 101.

33 Lincs RO, Monson 7/12/129

34 F/G2(2) pp.292, 294–5

35 F/G2(2) p.345, 26 Mar. 1707

36 Lincs RO, Monson, 7/14/83. F/EC1, passim; F/G2(2) ff.196–258. Tyttenhanger House, built in 1654 to replace an earlier house, still stands, now used as commercial premises.

37 Lincs RO, Monson 7/13/11, 3 May and 7/13/6, 23 May 1704. F/G2(2) pp.305, 389, 353; F/G2(8) f.208 Cary Coke to Sir John Newton, 24 Nov. 1706

38 Coke, *Cokes of Trusley* 5. During a later journey to Sir Edward at Longford, the young Thomas Coke was accompanied by John Coke and they dined at Melbourne with John Coke's brother, the Vice Chamberlain: I am indebted to Mary-Anne Garry for tracing the following reference, Gloucester RO, D1844 C/11, H. Smith to Sir John Newton, 31 Mar. 1711, and linking it with F/TC2, p.36.

39 F/TC1 guardians' minutes; A/1

40 F/TC1, pp.21, 24, 38; F/G2/3 p.106, F/G2(5) p.137; F/TC1, pp.20, 53

41 F/G2(2) ff.393, 395, 413, 442–3

42 A/Au1, pp.21, 33; F/TC1, pp.11, 33, 39, 63; DD/GE75,76

43 F/TC1, pp.10, 11

44 A/1, pp.98, 127; it is difficult to verify contemporary estimates of income or debt and the 1707 figure is considerably lower than the 1698 figure cited above. F/TC1, pp.11, 15, 77; A/Au1, extra folio pasted at end of 1709 section

45 F/G2(2) pp.409–10, 413, 418, 422, 442–3, 446–7; F/TC2, ff.44r et seq; F/TC1, p.143

46 F/G2(2) pp.450, 454–457, undated, 1712; F/G2(8) p.204, 14 June 1712. Ingamells, *Dictionary* 242. The introduction came about through the Bishop of Chester and the guardians' lawyer, Peniston Lamb.

47 F/TC2, f.48r; F/G2(2), pp.451, 453

48 F/TC2, pp.48–50; F/TC4, p.1

49 Gloucester RO, D1844/11, Coke to Newton, 11 Sept. 1712; I am grateful to Mary-Anne Garry for this reference. For masterly biographies of Hobart and Ferrari, see Reynolds, *Catalogue of Manuscripts*, 2–8, 13–14.

50 F/TC4 and 5 Grand Tour account books. Moore, *Grand Tour* 126

51 F/G2(3) pp.10, 84

52 F/G2(2) p.463

53 F/G2(2) p.450

54 F/TC4, pp.71, 73, 74. The lessons can be identified as daily because the language master was paid 66 pauls for 'a month twice a day' when the architecture master was paid 33 pauls for a month.

55 F/G2/2, p.467

56 Wilson, *Kent* 3 et seq, 25. Connor Bulman, 'Moral Education' 29. Brettingham, *Plans* 2 (Chiari, Continence of Scipio, with Coke as Alluccius), 11 (Procaccini, Numa Pompilius, since lost, with Coke as a young senator), 16 (Conca, Elysian Fields, with Coke as Orpheus)

57 F/TC4, p.73; F/G2(2) p.472

58 F/G2(2) p.463–4

59 A/Au1, 1715–16. Wyvill had married Coke's sister Cary.

60 Murdoch, ed. *Noble Households* 227
61 F/G2(2) pp.477, 487, 489
62 F/TC4, pp.156, 157, 161, 166. Mariari was identified by Wilson, *Kent* 18
63 F/G2(8) p.105; Wilson, *Kent* 20
64 F/TC4, pp.191, 193. The meaning of 'adjusting' drawings is unclear: it may refer to non-architectural drawings and to mounting or framing them on paper.
65 See appendix 1.
66 A/1, p.118; F/G2(2) pp.495, 499

Chapter 4

1 The title quotation is the margin heading for 'New Passage' section in A/37, p.107. A/5, loose sheet infolded, H. Smith's expences; A/7, pp.1–2
2 F/TC7, copy marriage settlement; Casey: F/G2(2) f.487, 1 Mar. 1716, Coke to Newton
3 A/7, p.64, list of servants' wages
4 F/G2(2) f.497-8
5 H. Smith was no longer resident at Holkham, having married the widow of Henry Blyford of Burnham Overy: DS/Bm1/3.
6 A/22, pp.12, 43, 50
7 e.g A/4, p.43; A/32, pp.7, 10, 11
8 A/4, pp.59–61; A/32, pp.8–10; A/35, p.17; A/34, p.43. Young, *General View*, 304–5
9 F/TC1
10 Lincs RO, Monson Papers 7/13/87, Michael Newton to Sir John Newton, 18 Nov. 1721, from transcript at Holkham by W. O. Hassall
11 A/7, pp.90, 135–138. Hounds are traditionally counted in couples.
12 Edward Spelman, *The Expedition of Cyrus* (London, 1842) quoted in Schmidt, ed. *Holkham* 33
13 A/5, passim. For Pelletier, see Tessa Murdoch, 'Jean, René and Thomas Pelletier, a Huguenot family of carvers and gilders in England, 1682–1726', part II, *The Burlington Magazine* 140, no. 1143 (June 1998) 363–74, at 370, 740.
14 The manuscript is Library Ms. 501, the printed edition is BN1066. See Bruno Gialluca and Suzanne Reynolds, 'La pubblicazione del De Etruria Regali' in *Seduizione Etrusca*
15 A/5 pp.102 (Campbell), pp.109, 117 (instruments), p.138 (Palladio). The instruments were supplied by Coggs, probably John Coggs, a London instrument maker, and a Monsieur Gerard.
16 A/7a, pp.30–31; A/7, pp.106, 130, 170, 190
17 Parker, *Coke* 13–19. A/7a, pp.47–47. The latter is the volume cited by Parker in *Coke* 21, but his figure of £7802 net income taken from p.47 of the manuscript had been mis-copied by the clerk from p.9. Reclamation of the marshes is discussed in Chapter 15.
18 A/Au5, f.24r; A/Au11; A/Au12; C/AG1–5. He held Huntingfield Park Farm, Suffolk, and later Fulmodestone, Norfolk. On total rents, see Parker, *Coke* 22, 23, 26. Appleyard continued to manage the Derbyshire estate when it passed in turn to Coke's younger brothers.
19 Lincs RO, Monson Papers, 7/13/87, 18 Nov. 1721, from transcript by W. O. Hassall
20 Parker, *Coke* 22
21 A/13, front endpaper
22 A/Au7, f.44r
23 e.g. A/8, f.9; A/25, ff.15v, 19r, 134r; A/21, f.34v. Cf. Girouard, *Life* 139
24 A/24, 1732 1st qter, f.6 and 1733 4th qter, f.2; A/25, f.73r
25 e.g. A/25, ff.7r, 7v, 134r; A/31, ff.29v, 30r
26 e.g. A/4, p.43; A/22, p.34; H/Wi1, passim. Cf. Horn, *Flunkeys* 69
27 Pencil note inside front cover of parish register no. 5 (1723–80) re Saunder's burial, 1762. F/TC1, p.98. For a full account of the Holkham household, see Garry, *Wealthy Masters.*
28 James, *Chief Justice Coke* 272; Schmidt, *Holkham* 37, quoting Charles Hanbury Williams, *The Works of Charles Hanbury Williams* (London, 1822), vol. I, 85ff
29 A/24, 1729, w/e 12th April, f.4; 1729, w/e 10th May, f.12; 1730, w/e 5th Dec, f.11; 1730 [ns 1731] w/e 13th Mar, f.11; 1731, 4th quarter, annual abstract, f.14. A/Au12, 1732–3, pp.19, 42; A/15, f.151r
30 See Chapter 6 on craftsmen
31 Cf. Horn, *Flunkeys* 68, 245
32 A/Au5, f.48v; A/Au12, 1733–34 in Account Current and 1734–5 in Wellingham section
33 A/33, p.85; A/34, p.16; A/37, p.23
34 Information from website www.bloodlines.net citing Gloucester RO, D1844/E26, 'List of horses in stud of Sir Mich. Newton' 1731. A/7a, p.5; A/32, pp.8–10; A/35, p.16. Cf. Mortlock, *Aristocratic Splendour* 157
35 Historical Manuscripts Commission, *Diary of Viscount Percival afterwards 1st Earl of Egmont* (1920) vol. I, 10
36 Parker, *Coke* 22–23
37 A/34, p.34. The Obelisk was completed in 1732: A/37, p.7.
38 M/66
39 A concise review of the debate is given in Salmon, 'Our Great Master Kent' 63–7.
40 Saumarez Smith, *Castle Howard* 39; Ayres, *Building* 8–12; Wilson & Mackley, *Creating Paradise* passim
41 Brettingham, *Plans* (1773) preface v
42 Worsley, *Classical Architecture* 112
43 Ilchester, ed. *Lord Hervey* 70, 72, 73, 186
44 Hiskey, 'Building of Holkham Hall' 147–8, no. 2, and 153, no. 10. Worsley, *Classical Architecture* 126
45 Wilson and Mackley, *Creating Paradise* 118–119
46 For a detailed consideration of the elevations, see Salmon, 'Our Great Master Kent' 71–3, 76–78. The lengthy detail with which Coke wrote about a particular design difficulty, for which Kent was devising an 'expedient', suggests that Kent's elevations incorporated elements proposed by or discussed with Coke: see Hiskey, 'Building of Holkham Hall' 151–2, no 7, 15 May 1736.
47 A/15, f.27r. The entry did not re-appear in the building account.
48 Catherine Arbuthnot and Julius Bryant in Weber, ed, *William Kent* 81, 184, 212
49 Brettingham, *Plans* (1761) preface
50 A/33, p.53
51 A/24, pp.30, 32, 19 July & 2 Aug. It is possible that the two payments for 'earnest' for seats in the King's Lynn coach referred to a return journey, in which case Campbell must have spent two weeks at Holkham. For the debate on Campbell's contribution (if any) to the final design of Holkham, see Schmidt, *Holkham* 88–92 and Salmon, 'Our Great Master Kent' 71, 75.
52 A/24, f.4 of 1730. Only one other payment to Kent is recorded, in 1737.
53 A/24, f.7 of 1731; Ilchester, *Lord Hervey* 73
54 A/24, w/e 2 Sept. 1732, ff.10, 13 and 3rd qter, Nov, f.8; A/25, w/e 30 June 1733
55 Hiskey, 'Building of Holkham Hall' 147–8, no. 2. A/37, p.31
56 Young, *Six Week Tour* 13; Brettingham, *Plans* (1773) preface vii; Chambers, *Treatise* 308. Chambers, however, attributed the plan to Kent.
57 Salmon, 'Our Great Master Kent' 73
58 Wilson, *Kent* 180 expressed a similar reservation.
59 Young, *Six Week Tour* 8

60 Brettingham, *Plans* (1773) preface v, viii
61 Worsley, *Classical Architecture* 127, 139, 229
62 Hiskey, 'Building of Holkham Hall' 147–8, no. 2, 13 Mar. 1734
63 Brettingham, *Plans* (1773) preface vi. Salmon, 'Our Great Master Kent', 74, takes the alternative view, that the stairs were part of Kent's contribution.
64 Worsley, *Classical Architecture* 234; Brettingham, *Plans* (1773) 2. H/Inv6,7,9. Cf. Schmidt, *Holkham* 138, 176
65 Quotation from Brettingham, *Plans* (1761) preface
66 This did not, however, imply any reduction in the amount spent on housekeeping: Parker, *Coke* 21–2.
67 A/24, f.13
68 Hiskey, 'Building of Holkham Hall' 155, no. 13 [undated]. A/37 p.110. I have revised my earlier analysis of the effect on building expenditure: there were dips in 1740 and in 1742.
69 Hiskey, 'Building of Holkham Hall' 152–3, nos. 9, 10
70 Hiskey, 'Building of Holkham Hall' 151, 155, nos. 5, 6, 13
71 Hiskey, 'Building of Holkham Hall' 155, no. 13
72 DA/ML5/5, Appleyard to Coke, 15 Feb. 1737
73 Hiskey, 'Building of Holkham Hall' 155, no.13, pre Aug. 1742
74 A/25, 1st qter 1734, p.5; A/37, p.30
75 A/Au7, f.44r; A/25, f.144r; A/25, f.153v
76 Hiskey 'Building of Holkham Hall' 148, no. 2, p.151, no. 6
77 Brettingham, *Plans* (1773) preface v; Parker, *Coke* 27. A/Au13,14
78 A/25, ff.31, 48, 79; C/AG8, Tomley to Appleyard, 8 May 1736; A/21, ff.146–147
79 A/37, p.107
80 A/V3(6), (8), Oct. 1756. This room was probably the 'guard room' mentioned in accounts in 1739: A/37, p.82.
81 Schmidt, *Holkham* 112–13, figs. 70–73
82 Girouard, *Country House* 194–5. The following description is based on the 1760 inventory, H/Inv4, printed in Murdoch, *Noble Households* 209–212.
83 Ketton-Cremer, *Country Neighbourhood* 212–3. A/21, f.121v. James, *Lord Chief Justice* 233–4 quoting Le Neve newscutting
84 A/28,w/e18 Dec. 1742; A/V6(3,4). Mortlock, Holkham Library, 85
85 Memorial in Holkham church. E/G16, p.180
86 A/28, f.73v, 21 May 1744
87 A/26, f.83v; A/37, pp.116, 132
88 Worsley, *Classical Architecture* 223–4. DS/FD supplementary family deeds in course of listing. A/37, pp.145, 161
89 A/37, pp.65, 142, 205, 218, 230
90 Cf. Mowl, *Kent* 222
91 Bedfordshire and Luton Archives and Record Service, Archive of the Grey Family of Wrest Park, ref. L 30/9a/2; I am indebted to Mary-Anne Garry for a transcript.
92 A/20, pp.79, 81
93 Lees Milne, *Earls of Creation* 246
94 A/28, Oct 1742 – Oct 1743, passim. Partridges at 4 pence each were far more numerous than pheasants at 9 pence.
95 E/Gar1; A/37, p.226
96 H/Wi1 & 2; A/24, w/e 25 Sept. 1731, f.14 et seq
97 A/26, f.25v; A/30, f.104r . Average for hunt 1722–32 worked from figures in annual abstracts in A/32, 33, 34; average for dogs 1746–50 worked from annual abstracts in A/37. F/TC11 copy letters between Leicester and Townshend, 1759
98 Lewis, ed, *Walpole Correspondence*, vol. 30, p.37, Horace Walpole to Lord Lincoln, 22 June 1743
99 Lincs RO, Monson 7/13, no.13, Newton to Cary Coke, 8 Sept.1705. A/37, pp.104, 128; A/25, f.108r; A/40 f.5r. Felus,'Boats and Boating' 24
100 A/37 pp.116, 140, 197; A/21, f.32v; A/24, 1730, 2nd qter, f.9
101 e.g. A/33, p.59; A/28, w/e 25 June 1743
102 A/11, pp.48, 64, 75; A/29 f.98v
103 A/37 pp.128, 141; A/28, w/e 25 Sept. 1742; A/29, f.96v, 1749; A/29 f.100v; A/30, f.38v. Ketton-Cremer, *Tour* 9
104 Stirling, *Coke* 2nd ed, 364
105 Stirling, *Coke* I, 49–61. DD/FD52, marriage settlement
106 e.g. Beard, *Craftsmen* 181; Schmidt, *Holkham* 115
107 DD/FD54; DS/GE11,12,14
108 Parker, *Coke* 25–30
109 A/41, p.39
110 Cf. Schmidt, *Holkham* 114
111 H/Wi4, 24 Apr. 1753
112 Parker, *Coke* 25. Annual totals are given in the yearly abstracts in the account books A/37, A/39, A/40, A/44.
113 The Wine Books show that the household was in town from late Feb. to 18 June 1755, and end of March to end of June 1756. *The East Anglian*, Dec. 1864, pp.132–33. A/38, p.100
114 A/40
115 C/BMs14, Coke to Brettingham, 11 Dec. 1753

Chapter 5
1 James, *Chief Justice* 270
2 Brettingham, *Plans* (1773) preface x
3 It was sometimes listed in the accounts as Wells kiln but this was with reference to its previous owner, the Rev. John Wells, not its location. A/Au1, 1717 section, f.5r; DD/H1060; A/Au7, 1727–8
4 A/34, p.33; A/Au11, 1731–2, A/37 p.83. On brick makers, see Wilson and Mackley, *Creating Paradise* 187–88. The 7th Earl of Leicester remembered farming a field at Burnham Norton called Bric-o-longs [*c.*1970s].
5 Kiln built 1732, A/37, p.6; in use for example in 1748, A/37, p.206–7. Brettingham, *Plans*, 1773, preface, x.
6 E/C1/7, p.78, 1820
7 Hiskey, 'Building of Holkham Hall' 151, no. 6, 1 April 1736
8 A/37, p.41
9 Schmidt, *Holkham* 128. Brettingham in *Plans* (1773) preface x, said 'not less than 30 different sizes were required to complete the figure of one single rustic'.
10 Schmidt, *Holkham* 128. A/37 passim: red and white bricks 7s 0d per thousand, large coping bricks 25s 0d per hundred, other coping bricks 2s 6d per hundred, arches 5s 0d each, rustic bricks 14s 0d per thousand
11 References have been found to coal used for burning bricks in 1758 but only at the clamps: A/38, ff.106r, 111r. Wilson and Mackley, *Creating Paradise* 188, 387 note 158.
12 Schmidt, *Holkham* 128. A/41, p.35; DD/Fd42
13 Ayres, *Georgian City* 102–3. A/37, p.122; A/43, p.55
14 E/C1/11, p.35–6; DD/H 1126
15 M/73 and schedule M/73a, 1843. Young, *Annals of Agriculture* XIX 450
16 A/Au12, 1732–33, f.42v ; A/40, pp.98, 275; A/37, pp.107, 140
17 Brettingham, *Plans* preface x
18 Hiskey, 'Building of Holkham Hall' 150, no. 4
19 Cf. Wilson and Mackley, *Creating Paradise* 192: production at Heacham in 1775 was 86 chaldrons.

The chaldron was a measure of volume that varied according to the locality; according to Wilson & Mackley, 189, f.n.184, the imperial London chaldron in the 18th century was 1.32 tons.
20 A/V1(35), A/38, ff.96r, 111r
21 Brettingham, *Plans* (1773) preface x. See Ayres, *Georgian City* 63 for later examples of mortar engines. A/37, pp.121, 143. A/V2(50) Apr. 1757
22 A/41, p.11–12; A/33, p.12. His firm was later known as Messrs Margaret & Robert Curtis, apparently run by his widow.
23 A/39, f.97v. The meaning of mergents has not yet been traced.
24 A/37, pp.53, 65, 95, 177.
25 A/41, pp.15–16. I am grateful to Jasper Weldon for pointing out to me the quality of the flooring, and for a most illuminating conversation about hardwood floors in general and those at Holkham in particular.
26 A/34, p.34; A/35, p.12
27 Hiskey, 'Building of Holkham Hall' 149, no. 3
28 A/35, p.13, 1731; A/37, p.65; A/38, f.104v; A/39, f.99r
29 A/37, p.9, 1732; A/43, 1735
30 Beard, *Craftsmen* 27. Howell, mason, was paid 'on account of work' by a payment of £6 6s 0d to John Tucker for nine tons of Portland stone, although Tucker was also paid for 72½ tons supplied directly: A/41, p.133.
31 A/37, p.31
32 e.g. H/Wi4, pp.110, 116, 118
33 A/20, p.140; A/38, f.94v; A/39, f.86r
34 E/A/L1 Longford Audit Book. Wenman changed his name from Roberts to Coke on inheriting Longford.
35 Saunders, *Pickford*, 10, 18
36 A/V5(1) and (5). Samuel Taborer did stone work at Longford Hall in 1730: see E/A/L2, p.3.
37 DA/ML5/5, Appleyard to Coke, 15 Feb. 1737
38 A/41, p.57; A/V1(4)
39 A/37, p.132; A/39, f.43r. Fitzgerald also worked with Brettingham on Norfolk House in London: Howell James, *Account Book* 171.
40 A/38, f.89v; A/40, p.64; A/38, f.110r; A/39, f.117v; A/44, p.36
41 Ministry of Works file, 5th Earl's papers, report Oct. 1954
42 A/38, f.110r; A/37, pp.54, 218
43 Hiskey, 'Building of Holkham Hall' 152, no. 8 [1737]
44 Ministry of Works file, 5th Earl's papers, report Oct. 1954. On roof lead, see Ayres, *Georgian City* 179–80.
45 A/41, p.172. Probably Thomas Bonnick, glass grinder of Saint James Clerkenwell, Middlesex: TNA, PROB11/984/39108, Feb. 1773 will. On plate glass, see Beard, *Craftsmen* 33, and Ayres, *Georgian City* 192.
46 Hiskey 'Building of Holkham Hall' 150, no. 4
47 A/V1(35)
48 e.g. A/37, p.143
49 Hiskey 'Building of Holkham Hall' 155, no. 13

Chapter 6
1 A/33, p.106; A/34, p.34; A/35, p.13
2 e.g. A/V1(2) i, xi, xv
3 A/Au11, pp.82–3; A/37, p.9
4 A/35, p.12; A/37, pp.7, 8, 9; A/25, f.79r; A/21, w/e 18th June 1737
5 A/35, pp.30, 43, 52, 53, 65, 81, 96, 107 ; A/Au14, 1738; A/Au16, 1740
6 A/Au13; A/21, ff.146v–147r
7 A/37, pp.143, 147
8 DD/Ws716, 753 ; DD/H1114 copy will of John Elliot
9 A/Au28; A/30, f.134v
10 Howell James, 'Account Book' 171–3
11 A/V1,2,3,4 and passim
12 A/40, p.8
13 A/V1(32) xi
14 A/V1(25) ii
15 Howell James, 'Account Book'
16 DD/H1114
17 A/V1(10), A/V1(44)
18 A/43 passim; A/46, p.68; A/47, pp.149, 19 A/35 p.12
20 Hiskey, 'Building of Holkham Hall' 155, no. 12
21 A/Au28
22 A/Au15, Holkham section, 1739
23 Stabler, *Norfolk Furniture Makers* 173–4
24 A/V1(5),(9). Day rate of 1s 8d at Wolterton in 1738 cited in Wilson and Mackley, *Creating Paradise* 173
25 F/TC12
26 A/44, pp.5, 33, 42
27 A/V1(27)
28 Stabler, *Norfolk Furniture Makers* 230, identifies 3 apprentices. For Morehouse, A/41, p.298
29 A/40, p.12 et seq, A/44 pp.4, 26
30 Gunnis, *British Sculptors* 292–3
31 A/34, p.34. Hiskey, 1997, 148, no. 2
32 Hiskey, 'Building of Holkham Hall' 148–9, nos. 2, 3. A/37 passim; A/36, pp.73, 120
33 A/37, p.231. Howell James, 'Matthew Brettingham' 347
34 DD/H1114
35 Hiskey 'Building of Holkham Hall' 155, no. 12
36 A/V3(15),(26),(28). Louis-François Roubiliac (1702–62)
37 Hiskey, 'Building of Holkham Hall' 153, no. 9
38 Brettingham *Plans* (1773) preface vi; Beard, *Craftsmen* 250; Lees-Milne, *Earls of Creation* 254
39 DA/ML5/5, Appleyard to Coke, 15 Feb. 1737
40 A/37, p.81
41 A/41, p.134; A/38 ff.89v, 94v, 104v; A/44 pp.5, 15, 28, 35
42 A/41, p.134
43 Beard, *Craftsmen* 188
44 Murdoch ed, *Noble Households* 223
45 I am indebted to Mary-Anne Garry for this information from Sarah Staniforth's will, TNA Prob.11/980.
46 A/31, f.29v, 1757. John Hardy found drawings by Vardy for furniture for Holkham: see article in *Country Life* 11 Aug. 1988.
47 Beard, *Craftsmen* 67
48 Hiskey, 'Building of Holkham Hall' 152–4, nos. 9, 10; A/36, p.106. Gunnis, *British Sculptors* 443 lists Gloucestershire sculptor Edward Woodward but the Holkham carver was named John: A/37, p.83.
49 A/37, p.95
50 Hiskey 'Building of Holkham Hall' 152, 154, nos. 9, 12. Woodward also carved picture frames in 1743, probably in London: A/28, f.59v.
51 A/26, f.148
52 A/16, f.105v; A/37, pp.123, 178, 204; A/Au24. Wilson and Mackley, *Creating Paradise* 173
53 A/37 pp.205, 231; A/40, pp.40–41
54 A/43, pp.6, 10, 28, 30. Information kindly supplied by John Stabler
55 Saunders, *Pickford* 10–12. The DNB wrongly identifies the carver as his nephew, Joseph Pickford (1734–82) which is not chronologically possible.
56 Hiskey 'Building of Holkham Hall' 154, no. 12; Brettingham, *Plans* (1773) 12
57 Gunnis, *British Sculptors* 85; *Dictionary of National Biography*

58 A/36, p.123; A/40, p.60
59 Brettingham, *Plans* (1773) 2, 3, 5, 8, 9, 10; A/40, pp.55, 56, 79
60 A/37, pp.65, 96, 108; A/40, pp.56, 60, 79; no entry traced for Saloon
61 Brettingham, *Plans* (1773) 15–17. A/44, pp.41, 48. Gunnis, *British Sculptors* 21, makes no mention of William Atkinson working at Holkham and attributes the Holkham work to Charles Atkinson, who does not appear in the Holkham accounts, but see footnote below.
62 TNA, CO107/67 Chancery Master exhibit, microfilm at Holkham. The volume covers only two years, 1757–59.
63 This is the only known reference to a named alehouse at this period in the staithe village.
64 Gunnis, *British Sculptors* 22
65 Murdoch ed, *Noble Households* 222
66 A/44, p.2; A/43, p.9 of 1761
67 A/44, p.48
68 James Stourton has pointed out that the mark on the Tittleshall monument is 'G' not 'C' Atkinson' and indicates 'Guillelmus', that is, William. Cf. Gunnis, *British Sculptors* 21
69 A/7, p.219 [original pagination]; Beard, *Craftsmen* 174; A/37, pp.7, 54
70 Beard, *Craftsmen* 237, 256. A/37, p.120
71 A/37, p.20
72 Hiskey 'Building of Holkham Hall' 153, no. 9
73 A/37, p.80; A/V1(26); F/TC12
74 Wells parish burials register, 1761, entry 37 from microfilm (original in Norfolk RO)
75 A/46 passim
76 A/40, p.64; A/43, p.30–1; A/44 p.47. Petworth House Archives 6624, 6615 (references from The National Archives website)
77 A/31, f.38r; Beard, *Craftsmen* 183
78 A/Au12, p.1 of 1733–4
79 A/34, p.34; A/35 p.11
80 E/A/L2; A/Au11, pp.82–3
81 Hiskey 'Building of Holkham Hall' 154, no. 10. A/44, p.5
82 A/43, p.12; A/47, p.13
83 A/13 list at front; A/21, f.66r; A/37, p.54, 67, 83; A/25, f.159v
84 A/28, 1743, 3rd qter, 7th week [no pagination]; A/Au19, p.1. Norfolk RO, Holkham baptisms register, 9 Apr. 1744
85 A/36, p.106; A/37, p.82, 95, 96; A/15, f.77r, w/e 13th Jan. 1739/40
86 A/29, f.26v
87 Howell James, 'Account Book' 173
88 A/38 ff.95r, 100r, 105v, 115r; A/39 f.97v
89 William Salmon, quoted in Ayres, *Georgian City* 212
90 Keating identified in Ayres, *Georgian City* 213
91 A/37, pp.23, 82, 96
92 A/43, pp.8, 12
93 A/44, p.44; A/43, p.28
94 Cf. Ayres, *Georgian City* 37; Wilson and Mackley, *Creating Paradise* 173. Townson: A/V1(27). Griffin: A/35, p.12
95 Parsons: A/34, p.34; Jelf's man: A/36, p.120; Rathbone: A/43, p.12
96 On drawing plans on floors, see Ayres, *Georgian City*, 23. A/V1(9)iv; A/39, f.109r.
97 A/V1(9), (36)
98 A/37, p.143; TNA, CO107/67
99 A/44, p.14
100 A/V1(32)xi
101 e.g. A/V2(13), A/V2(22); Lillie: A/40, p.31
102 A/37, pp.54, 65; A/40, p.14
103 e.g. A/V2(49),(61); A/40, pp.6, 7; A/V1(20),(23)

Chapter 7
1 Earlier versions of this chapter were published in *Construction History* 22 (2007) 3–25 and in Barnwell and Palmer, eds. *Country House Technology* 22–36.
2 C/BMs19
3 A/36 p.19; A/25 w/e 24 August 1734; A/36 p.84. Brettingham, *Plans* (1773) 1
4 A/40, pp.56, 59, 61. An earlier well and engine house apparently were demolished: A/40, pp.28, 32.
5 West Sussex RO, PHA 8046, 6618 [references from Access to Archives website] A/40, f.56v.
6 Scarfe, *Frenchman's Year* 196
7 A/40, p.61, July 1755. Octagonal wall to enclose the larder in Kitchen Court built in 1757: A/V2(41)
8 Most recently in Schmidt, ed. *Holkham* 197, where the engine house is attributed as a game larder to the 2nd Earl, a century later.
9 H/Inv9, f.17r, inventory, 1774
10 Girouard, *Life* 253–56; Baker, *Life and Circumstances of James Brydges* 307, 324–325. *Desaguliers*: A/28, 10 Sept. 1743; A/25, ff.80r, 89v. Moore ed. *Houghton Hall* 25, 28. A/7, p.219
11 Ware, *Complete Body of Architecture* 328
12 A/37, pp.46, 120. Hiskey, 'Building of Holkham Hall', 154, no. 10
13 A/25, ff.84v, 102v, 153v; A/50 p.174. Hiskey, 'The Building of Holkham Hall', p.152, no. 9. H/Inv4. A/28, w/e 11 Sept 1742; Franklin, *Gentleman's Country House* 113–4
14 Brettingham, *Plans* (1773) 1; A/40 p.32 (Apr. 1754) re Chapel Wing. P/M 26
15 Girouard, *Life* 254–55
16 A/43, p.31
17 A seat with a hinged lid concealing a chamber pot.
18 On 'slop chutes', see Hardyment, *Behind the Scenes* 213: only one at Calke Abbey was then known (1997).
19 H/Inv4, H/Inv9. Similar gullies to take rain water were built in the roof spaces of urban terraces: see Ayres, *Georgian City* 185; on country houses using rain water for water closets see Girouard, *Life* 265.
20 Ware, *Complete Body of Architecture* 284
21 A/V2(37), A/V2(64)
22 A/V1(2)ix, A/V2(41)ii, A/V2(51)
23 A/39 f.107v
24 P/M136
25 Mrs Boscawen to Mrs Delany, from Holkham, 15 Nov.1774, in Llanover, ed. *Autobiography* II, 63
26 Brettingham, *Plans* (1773) 1. Wearing, *Georgian Norwich* 60, quoting advertisement from *Norwich Mercury*, February 9, 1754
27 e.g. A/39, f.2r, alterations to stoves, greenhouse and firewalls, 1743. C/MB 15, 11 Dec. 1753; A/20, p.164, w/e 4 Jan. 1754; A/V2(11) and (12) building vouchers, 15 and 22 Jan. 1757
28 'List of rooms with fireplaces', unlisted file, undated, *c*.1914; H/Inv4, inventory 1760; A/39, ff.98r, 117r. Franklin, *Gentleman's Country House* 108
29 Climenson, ed. *Passages* 8
30 Building the stoves 1756: A/V 3(3,5); purchase of '13 stoves for the kitchen': A/39, f.96v
31 Leaflet about the kitchens at Harewood by P. Brears, 1996. I am grateful to Gillian White, Curator at Hardwick, Jane Sellars, Curator at Harewood, and Peter Brears for information and photographs.
32 A/46, p.86
33 A/V3(3) bill covering Jul. to Sept. 1756
34 A/V2(3) voucher, Dec. 1757. Hardyment, *Behind the Scenes* 147
35 A/38, f.105r; A/39, ff.108v, 112r; A/49, p.238
36 Hardyment, *Behind the Scenes* 110

37 A/V3(3). The original bakehouse in the late 20th and early 21st century was used as the men's mess room.
38 Climenson, *Lybbe Powis* 8
39 A/37, pp.132, 248; A/40, f.51r, A/V2(55)
40 A/37, pp.91, 132; A/28 f.93v; A/16, f.121r, Feb.1743/4; A/37, p.248; A/40, f.51r .
41 A/Au37, Account Current
42 A/41, p.12
43 A/31, f.38r; A/39, ff.100r, 107r, 109v. Beard, *Craftsmen* 183. According to Girouard, *Life* 219, bell systems began to appear in the 1760s and 1770s, and wires and cranks were introduced in the following decades.
44 Scarfe, *Frenchman's Year* 196 quoting Maximilien de Lazowski

Chapter 8
1 Estimated by comparing Wheatley Hill Hall grounds with Neales grounds, known to be 14 acres, on the 1590 map; there is no evidence that the grounds had increased during the 17th century.
2 The name Hall Farm was used in the Audit Books before the new Hall was built.
3 A/Au4, 1715; A/Au5, 1723–24; A/Au7, 1727–8, 1728–9, 1730–1 under Holkham and Fulmodeston (Clipstone Farm)
4 DD/H865
5 A/Au12, 1733–4 and 1735–6; M/67; DD/H1072, lease to William Lee of Brisley: 'he shall at no time take above four crops without laying the land down with proper grasses for two years'. The rent was 9 shillings per acre for land already marled; total rent was £230 pa.
6 DD/Qu4
7 A/Au12, 1733–34
8 A/Au12, 1734–5 and 1735–6
9 A/Au5, 1724–25; A/Au7, 1728–29 and 1730–31; A/Au12, 1735–36; A/Au29, 1753. Robert (d. by 1748) was tenant at Peterstone; his son, Robert junior (died 1768) inherited two messuages at the Staithe from his uncle Henry.
10 DD/Qu7
11 A/Au13,14
12 M/67
13 A/Au12
14 M/69; H/Inv9, f.38v (1774 inventory)
15 A/Au36
16 Williamson, *Polite Landscapes* 75, 85
17 A/Au5, Account Current, f.48r ; A/37, p.6
18 A/6, p.178
19 Blanche Henrey, *British Botanical and Horticultural Literature before 1800*, II, pp.341–2, accessed 8 Jan. 2013. *The Southampton Guide*, 25th ed (Southampton, E. Skelton & Co, 1823) p.98 accessed 8 Dec. 2013
20 e.g. A/33, p.104; A/34, p.40; A/37, p.189
21 A/25, w/e 25 Nov. 1733, 5 Apr. 1735, 22 Mar. [1736]. One of these might be Philip Miller, *The gardener's kalendar* (1734) which is in the Holkham Library. The others, including Furber, are not known in the Library.
22 Hiskey, 'Building of Holkham Hall' 148, no. 2; 153 no. 10; 153, no. 11
23 DD/Qu4, observations on the Earl of Leicester's treaty for renewal of Quarles lease 1748. Cf. Williamson, *Archaeology* 66–67
24 Cf. Wilson, *Kent* 220; Mowl, *Kent* 222; J. Dixon Hunt in *Designing Georgian Britain* 373; John Harris, ibid, 401. There is no justification for Wilson's statement that 'The overall planning and layout of the park ... is shown by estate maps to have conformed remarkably closely to Kent's intentions' simply because Kent's intentions cannot be known. Mowl makes similar assumptions and confuses the chronology; Hunt states 'Holkham parkland was initiated in about 1730'; Harris imagines a Kent 'master plan'. On the owners' role, see Williamson, *Polite Landscapes* 7.
25 Raynham Archives. F/G2(4) p.83, 18 Nov. 1748
26 A/33, Dec. 1723; A/37, p.50; A/Au21 under Account Current 1745; maps M/66 & M/68. No payment has been traced for the earlier map, suggesting that it was the work of an employee. Aram was possibly related to Peter Aram, gardener and poet, originally also from Nottinghamshire. He is known to have surveyed Coke estates at Martham and Burnham Sutton (Norfolk), Kingsdown (Kent) and Shillington (Dorset).
27 On late geometrical landscapes, see Williamson, *Polite Landscapes* 35–36
28 A/33, p.52. The acreage is from E/G1a, 1778.
29 A/33, A/34 passim
30 A/34, p.34 et seq. Brettingham (1773) preface ix
31 P/M2,8. Brettingham (1773) preface viii. The obelisk and temple still stand.
32 A/33, p.80; A/34, pp.7–8. The term 'canal' was prevalent at this period for a long thin stretch of water: Currie, *Fishponds* 27.
33 M/66
34 Currie, *Fishponds* 30, 38
35 A/34, pp.8, 38
36 A/37, p.48. Map in E/G1a
37 Walk A/34, 1729–30; boats A/24, 1730, 3rd qter, f.15; flower walk A/37, p.243; thatching 'the seat in the Chalk Pit' 1766, A/45, p.101. Brettingham, *Plans* (1773) seat in a chalk pit
38 A/40, p.23; A/39, pp.113, 115
39 M/68 (probably 1745); A/37, pp.7, 28, 40. Woods & Warren, *Glass Houses* 39, 64. Williamson, *Archaeology of the Landscape Park* 68–70, was mistaken in thinking that the orangery or wilderness dated from *c*.1738 and therefore formed part of a new Kentian scheme.
40 A/37, pp.7, 28, 40 and passim; E/Gar1. Hiskey, 'Building Holkham Hall' 154, no. 10
41 James, *Chief Justice* 234
42 Photocopy (undated) of typescript copy (then at Forthampton Court) of letter from Lady Beauchamp Proctor to her sister Lady Agneta Yorke, p.4.
43 E/Gar1
44 A/37, pp.39, 50
45 Brettingham, *Plans* (1761) plate 33. A/37, pp.128, 168; M/69, E/G1a
46 Jacob, *Law Dictionary*, under Park; Shirley, *Deer Parks* 51
47 A5, p.169
48 A/37, p.51
49 A/37, p.73
50 A/37 passim. Stirling, *Coke* II, 149–50
51 See, for example, Jonathan Finch, 'Pallas, Flora and Ceres: Landscape Priorities and Improvement on the Castle Howard Estate 1699–1880' in *Estate Landscapes* 24
52 DD/Qu1, agreement to assign, 28 May 1719; DD/Qu4, observations on the Earl of Leicester's treaty for renewal of Quarles lease 1748; A/44, p.45
53 Brettingham, *Plans* (1761); Young, *Six Weeks* 4
54 A/37, pp.6, 19, 20, 29
55 Hiskey, 'Building Holkham Hall' 151, 152. A/37, pp.64, 165, 226; A/Au13, p.35. Gloucester RO, D2700/QJ5/3 (reference from online catalogue). Harvey, 'Stocks held by Early Nurseries' 33: William Oram gardener of Brompton subscribed 1733 to 'The Practical Husbandman and Planter'.

56 A/37 pp.70 and passim, p.143. The terms cost £38 10s 0d
57 P/M9, P/M10; M/68. The map can be dated 1744–45 by a previously-cited payment to John Aram.
58 Williamson, *Archaeology* 68–70
59 Schmidt, ed. *Holkham* 111; F/G2(4) p.80, 23 June 1750
60 Cf. Williamson *Polite Landscapes* 59, 60; Williamson in Schmidt, ed. *Holkham* 63
61 A/37, pp.60, 90, 104. On walls and wooden foundations in the construction of fishponds, see Currie, 'Fishponds' 35, quoting J. James, *The Theory and Practice of Gardening* (London, 1712). For 1909, see E/C5/2(4).
62 Stirling, *Coke* II 149
63 A/37, pp.132, 140
64 Cf. Williamson *Polite Landscapes* 75
65 A/37, p.248. Sketch by Eliza Blackwell, 1818
66 A/44, pp.46, 47; DD/Qu6. The estate succeeded in buying the whole of the Quarles land only in 1880.
67 A/40, pp.5, 21. Scarfe, *Frenchman's Year* 158
68 Brettingham, *Plans* (1761). P/M13; A/Au27–29 passim, e.g. A/Au27, Account Current 1751, 'ye new lodges building on ye north side Holkham Park'. A/40, f.14v (1753); E/Gar2, Repton Red Book.
69 A/37, pp.41, 66, 83; M/68, Brettingham *Plans* (1761 and 1773). It is significant that, in the 1773 edition, the East Lodge plans were relegated to a later position in the volume, following plans for a building intended for Church Wood but not built, and preceding a West Entrance which was also probably not built.
70 Maps M/64 and M/67 (Staithe Farm)
71 P/M46, plan by Teulon 1847 showing existing almshouses
72 Brettingham *Plans* (1761)
73 The contract sum possibly covered the purchase of requisites and allowed for the sale by the gardener of surplus produce, an arrangement that was followed in the early 20th century. A/37 passim; Garry, *Wealthy Masters* 117
74 A/44, p.37; map M/70 by Biedermann
75 Stirling, *Coke* 2nd ed, 38, original source not given

Chapter 9
1 A/39, ff.89r, 100v; H/Inv8, f.7; A/V2(23),(55),(56); A/V3(15),(28)
2 A/V3(15)
3 A/21, f.15r. The following description of the servants' areas is based on H/Inv4, the 1760 inventory published in Murdoch, ed, *Noble Households* 207–226.
4 Mary-Anne Garry in *Holkham Newsletter* no.14 (Summer 2007) p.5
5 A/31, f.44r, 1757. The ground floor, below the staterooms but above the cellars or basement rooms, was known as the 'rustic basement' from the rough or 'rustic' design of the exterior brickwork at that level.
6 The housekeeper's room is *c.*2010 the library office. The dessert room, breakfast room and steward's bedroom were formed into a flat *c.*1980s, when the door onto the east corridor was closed off.
7 A/30, f.23r
8 H/Wi5. The Steward's Room *c.*2010 is a picture store.
9 The butler's pantry is *c.*2010 a kitchen and his bedroom, until fairly recently the library office, a staff mess room.
10 H/Wi/5, 12 Jan. 1757
11 A/20, pp.212, 262

12 A/40, f.11r. Climenson, *Lybbe Powys* 5
13 A/39, p.111
14 A/40, f.27r; elevations P/M7,17. Future generations resorted at times to temporary external stairs, as seen in photographs.
15 Schmidt, *Holkham* 116. A/V3(3)
16 A/39, ff.107v, 109r; A/V2(20),(30); A/40, f.85r
17 Hiskey, 'Building of Holkham Hall' 152–3, nos. 9, 10
18 H/Inv4, Murdoch, *Noble Households* 211
19 A/21, f.147r; A/16, f.57r; A/28, f.9r
20 A/16, f.57r
21 A/15, ff.47v, 62r
22 A/21; A/16, f.45r; A/28, f.44v. Hinchliffe was a mercer in Covent Garden, mentioned in Rathbone, *Letters* 158. For Columbine, see Stabler, *Norfolk Furniture Makers* 118–119.
23 A/16, ff.57v, 93r
24 A/20, p.162 and H/Inv1, f.2v; A/20, p.178 (Crowe & Pattison); p.200 (Schellenger); A/20, pp.8, 12, 15, 23
25 A/20, p.197, H/Inv1, f.3r; A/20, p.78
26 H/Inv1, f.7v; A/20, pp.81, 125
27 A/20, pp.197, 201, 207, 215, 240; H/Inv1, f.4r
28 H/Inv1, f.8v; DD/FD 62, Cauldwell's accounts
29 A/V6(15); A/31, f.66r; Murdoch, *Noble Households* 216
30 A/31, f.20r; A/V6 (15); H/Inv1, f.8v
31 A/31, ff.20r, 66r; A/V6(17) infolded. The pictures were 'Coriolanus' by Cortona and 'Scipio and the Spanish Bride' by Chiari. They were both removed in the early 19th century and subsequently sold.
32 A/31, f.55v
33 A/39, f.122v
34 H/Inv1, f.8r; A/31, ff.4r, 5r, 7v, 59v
35 H/Inv2, f.9
36 Angelicoussis, *Holkham Collection* 31–40; C/BMs 14–16, letters from Lord Leicester; C/BMj1, Brettingham's Rome Account Book
37 H/Inv1, ff.9, 13v–14v
38 Matteveli A/V3(150, A/V6(11),(20); Zuccarelli A/V6(5),(12),(21); Roubiliac A/V3(28); Casali A/31, f.84r; Collivo A/31 f.62r
39 DD/FD62. Gunnis, *British Sculptors* revised ed, 434–7, does not mention the bust of Lady Leicester. Angelicoussis, *Holkham Collection* 115. Journal of Lady Beauchamp Proctor: photocopy of document at Forthampton Court
40 DD/FD56b(1) office copy of will dated 25 May 1756, proved 2 June 1759. No such signed general plan or design survives.
41 *The East Anglian*, Dec. 1864, 132–33; A/43, p.6
42 A/43 pp.9, 10, 22. The maker of the ironwork has not yet been traced.
43 A/39, f.123r
44 Amy Boyington, 'Lady Margaret, Countess of Leicester: a re-evaluation of her contributions to Holkham', M.St. thesis, Cambridge, 2013, pp.45–6
45 A/43, p.25
46 Murdoch, *Noble Households* 217
47 Portico steps A/40 f.27r, columns A/40 f.85r, stairs A/39 f.109r, engine house A/40, f.61r, cupola A/39 f.121v
48 A/44, pp.41–2, 45, 47. The balustrade on the east was probably in line with the back of the 19th century laundry building that still stands. Gardeners fashioning a shrub bed between the west wings in 2012 uncovered a small area of substantial foundations for the balustrade on that side.
49 A/39, f.116v, 117v
50 e.g. F/TC1, p.69; A/44, p.12
51 A/44, f.116v et seq; A/43, p.18; map M/68; H/Inv6, p.22; Brettingham, *Plans* (1773) 19. This

Counting House was probably demolished by T. W. Coke before the publication of the 1817 guide book, by which date the Roubiliac bust had been moved to its present position in the Marble Hall, above the door into the Saloon.
52 A/44, pp.39–49
53 H/Inv1,2,7. Mary-Anne Garry discovered that in 1734 Lady Margaret had inherited over £23,000 from her aunt, Elizabeth, Duchess of Montagu: Berkshire RO, D/EMP F2/2.
54 This happened after the official inventory made in January 1760 (H/Inv4 in Murdoch, ed. *Noble Households* 220–1) and before 1765 (H/Inv8, ff.4–5). It was still the case in 1774 (H/Inv9, ff.20–21). Young, *Six Weeks* 10–11; James, *Chief Justice* 280. I am grateful to Amy Boyington for drawing my attention to entries relating to the north staterooms.
55 Schmidt, ed. *Holkham* 126 wrongly states that the rooms 'had their decoration, furniture and works of art in place, with sculptures and paintings positioned by Thomas Coke'.
56 e.g. A/40, f.55v; P/M26, plan 1744–59; H/Inv4 in Murdoch, ed. *Noble Households* 216
57 H/Inv1, ff.10v, 14v
58 The coronets were found in a cupboard, restored and replaced on the bed *c*.2006.
59 H/Inv8, ff.10v, 19v
60 H/Inv8, ff.12, 13; Murdoch, *Noble Households* 236
61 Murdoch *Noble Households* 216, 227, 230. H/Inv8, f.10v
62 Murdoch, *Noble Households* 227, 229; H/Inv6, p.10. Cf. Schmidt, ed. *Holkham* 161, 163
63 Murdoch *Noble Households* 227, 229; H/Inv6, pp.7, 10
64 A/44, p.4 (March 1760); H/Inv8, f.11; DD/Bi1011 letter among Billingford deeds, Henry Carrington [to Wenman Coke?] 21 Dec. 1775. According to Carrington, he had also written the inscription for Lord Leicester's funerary monument at Tittleshall and shortly afterwards had been presented by Lady Leicester to the rectory of Billingford.
65 H/Inv8, ff.2v, 11r; A/7, p.85; H/Inv9, f.23r; H/Inv5, p.12. The bedspread is still impressive despite the gilt thread now appearing a dull green.
66 H/Inv8, ff.9–10, 25
67 Ketton-Cremer, *Tour* 14; H/Inv8, ff.1, 25r
68 DD/FD58 Lady Leicester's will, copy
69 DD/FD58. James, *Chief Justice* 293–4
70 DD/Bi1011; A/Au202 (1766–76)
71 James, *Chief Justice* 291, 295; Stirling, *Coke* 2nd ed, 61
72 James, *Chief Justice* 294; Stirling, *Coke* 2nd ed, pp.58–61
73 Lady Jane Wharton married 1733 Robert Coke of Longford, younger brother of Thomas Coke of Holkham. Rathbone, *Letters* 66, 73, 98
74 A/20, p.126
75 DD/FD62, p.8
76 E/G16, p.189, copy letter, Lady Leicester to Cauldwell, 3 July 1759
77 DD/FD56b, copy will; E/G16, p.189
78 DD/FD56d, exemplification; DD/FD58, copy will
79 A/44, p.39
80 Stirling, *Coke* 2nd ed, 51
81 Stirling, *Coke* 2nd ed, 56–57
82 DD/FD58
83 Stirling, *Coke* 2nd ed, 88–89. Stirling's assumption that T. W. Coke took up residence at Godwick Hall after his marriage is ruled out by the fact that it was under lease to Cauldwell.
84 A/Au37, 38, 39
85 A/Au38, Account Current; A/Au44
86 John Martin Robinson, *Wyatts* 28

Chapter 10
1 John Harris in Moore, ed. *Houghton* 24; Rosenheim, *Townshends* 177, 187
2 Stirling, *Letter Bag* II, 44
3 This figure is the number of farms worth over £35 rental, listed in Audit Book 1775–76, A/Au38. The acreage is that calculated by Parker, *Coke* 83.
4 DD/FD56b, DD/FD58, wills
5 E/G16, p.191. Cauldwell was tenant of Godwick Hall until 1780: A/Au37,42.
6 A/Au37
7 DD/FD62, infolded, counsel's opinion, 17 May 1777; A/Au43
8 Stirling, *Coke*, 2nd ed, 118–124; Parker, *Coke* 64
9 Inventories DD/FD119, p.4; DD/FD120, p.13. The old counting house possibly survived for some years as the house of Blaikie's assistant and successor, Baker, who wrote that his house was near where the old village stood (E/C1/34, p.105). The guide book of 1775 mentioned a bust of Thomas Coke in the Steward's Lodge or counting house but by the time of a guide book published in 1817 this building was not mentioned and the bust was almost certainly the one that had been moved to the Marble Hall, above the door into the Saloon (1817 guide, p.31). One of the rooms in Strangers Wing was still identified as Mr Blaikie's in 1842, ten years after he had retired.
10 DD/FD58, Lady Leicester's will; A/Au37, Account Current charge
11 Young, *Farmer's Tour* I, 171, 173; Wade Martins, *Coke* 84–85
12 A/46, p.78–80: £52 in 1783. Memorial in Holkham church
13 F/TWC11, p.44, news cutting *Norfolk Chronicle* 9 July 1842, quoting Lord Spencer in *Journal of the Royal Agricultural Society*, Vol. 3, Part 1
14 Pigg at Waterden, Mallet at Dunton, Coulsey at South Creake, Carrington at Tittleshall, Tenant at West Lexham, Heard at Kempstone, Seyer at Longham, Blomfield at Billingford, Fisher at Sparham
15 DD/Ma236, letter to Carr [from Cauldwell?] 1747; Young, *Farmer's Tour* 1–6. Dates of tenancies from audit books, A/Au
16 F/TWC11, p.44
17 Cf. P. Burman in Schmidt, ed. *Holkham* 192: 'the family were so deeply in debt that there was simply no money for costly changes to the house'.
18 DD/FD62 Cauldwell's copy accounts as executor 1771
19 Parker, *Coke* 126–132.
20 Pickering, *Memoirs* 47
21 A/16, f.60v. According to *The Norfolk Tour* (1808) 323, the Griffier was still in place, but it is possible that such details had not been updated: see Chapter 16.
22 Guidebooks 1835 and 1861, and 1909 inventory H/Inv10 attributed the bas relief 'Death of Germanicus' to Nollekens, a misapprehension possibly not corrected until 1936: letter in box of unsorted correspondence to the Holkham librarians, Napier and James.
23 Stirling, *Coke*, 2nd ed, 149, quoting Shard
24 *The Norfolk Tour* 5th ed (1795) 189, referring to 1777; Stirling, *Coke*, 2nd ed, 149. A/49, pp.105, 115, 140. *New Description*, 1835
25 Stirling, *Coke*, 2nd ed, 144. The published Journal of Lady Mary Coke ends in 1774.
26 E/C1/13, p.16. Their eldest son became the 1st Earl of Lichfield.

27 F/TWC24, 26, 27
28 Stirling, *Letter Bag* 55–56
29 Stirling, *Coke* 2nd ed, appendix, 617–8; Wade Martins, *Coke* 38–39
30 On the Shearings, see Wade Martins, *Coke* 114–118.
31 Wade Martins, *Coke* 114–119. Young, *Farmer's Tour* vol.2, 162
32 Wade Martins, *Coke* 111–114
33 A/48, pp.11, 48, 71, 100, 140; T/M1,2, diaries of Thomas Moore; H/Wi7. Stirling, *Coke* 2nd ed, 290, 435, 438, 440
34 Stirling, *Letter Bag* II, 72; Baring, *Diary* 71
35 F/TWC1/3, item 41, James Barbour, 20 Sept. 1829; T/M6, 1809 ; H/Wi7, 24 July 1819, 18 July 1820; E/C1/5, p.84; E/C1/3, p.5. Pickering, *Memoirs* 255
36 Stirling, *Letter Bag* II, 36; Albemarle, *Fifty Years* II, 231
37 A/46, pp.153–4; A/47, pp.95, 122. Carr, *Fox Hunting* 33–41; Stirling, *Coke* 2nd ed, 152–3; Coke, *Rolling Stone* 33; A/47, pp.95, 122
38 A/46, pp.78–80, 173, 193; A/56, p.124
39 Stirling, *Letter Bag* II, 27
40 Stirling, *Letter Bag* II, 48, 53
41 Angelicoussis in Schmidt ed. *Holkham* 169; Stirling, *Coke* 2nd ed, 445, 446. The late 7th Earl of Leicester told the author that the most people he could seat comfortably for a meal in the Audit Room, exactly the same size as the Statue Gallery, was 100.
42 Girouard, *Life* 218–20; Wade Martins, *Coke* citing Gore, J. ed, *The Creevey Papers* (London 1963) 436. E/C1/4, p.245
43 Stirling, *Coke*, 2nd ed, 322. Girouard, *Life* 231–2
44 Baring, *Diary* 71
45 Pickering, *Memoirs* 251
46 Rush, *Memoranda* 136. On libraries in general, Girouard, *Life* 234
47 H/Inv9, p.9, inventory 1774: one north and one south tower rooms were still bedrooms, the others were library rooms.
48 Baring, *Diary* 72
49 Stirling, *Coke* 2nd ed, 367
50 F/TWC/11, newscutting from *Norwich Mercury* 9 July 1842, in album
51 Stirling, *Coke* 2nd ed, 177
52 Pickering, *Memoirs* 132
53 Stirling, *Letter Bag* II, 56
54 Wake, *Sisters of Fortune* 115, 148
55 Holkham Archives, Caton letters, 22 Feb. 1818, 28 Oct. 1819, 24 Nov. 1819. I am greatly indebted to Mary Jeske, editor, Charles Carroll of Carrollton Papers, for generously sharing her transcripts.
56 E/C1/9, p.35
57 Albemarle, *Fifty Years* vol 2, 125; Stirling, *Letter Bag* II, 59
58 Stirling, *Coke* 2nd ed, 82, 91, 146
59 These figures are calculated from entries for board wages in the account books.
60 F/TWC5, f.211
61 Coke, *Tracks* 2
62 A/51, p.88; E/C1/6, p.52
63 A/46, pp.78–80, 199; A/47, pp.4, 32, 205; A/51, p.48; A/54, p.59
64 E/C1/14, p.120; A/56, p.77
65 DD/FD119, 120
66 E/C1/5, p.242–3
67 The model was still in place in the early 21st century. H/Inv4, p.14; H/Inv15, p.21; 1842 inventory DD/FD120, p.15
68 A/50 passim; E/C1/3, p.164
69 E/C1/11, p.47
70 E/C1/11, p.22; E/C1/12, p.176
71 E/C1/10. p.44
72 E/C1/12, p.60; E/C1/17, p.48
73 E/C1/17, p.88; E/C1/9, pp.161, 170
74 A/50, p.28; A/47, pp.2, 198. Wilder from 1789 was working as a picture restorer under Walton, the Keeper of the King's Pictures: see W. G. Strickland, *Dictionary of Irish Artists* (1913) online edition.
75 A/48, passim and pp.226, 256; A/49, pp.46, 77
76 H/Inv11, p.2; 1817 guide book
77 C/AN14, 3 Sept. 1841
78 Passavant, *Tour* 48–51
79 Op. cit. 48–51
80 For a full description of Roscoe's important role, Reynolds, *Catalogue of Manuscripts* 19–28
81 A/51, pp.5, 136, 169. Coke's wife having died in 1800, her sitting room or dressing room was available for his use.
82 DD/FD120, inventory 1842. Gillen, *Royal Duke* 171
83 Passavant, *Tour* 48–51. *The Stranger's Guide to Holkham* (1817) annotated by Dawson Turner, Apr. 1827, 109; references from an old photocopy at Holkham. The original annotated copy is now in the Wren Library, Cambridge.
84 1817 annotated guide as above, 46, 70, 98, 107, 131
85 E/C1/5, p.169. Another Opie portrait, of Rev. Samuel Parr, was presented to Coke by Parr.
86 The artists included T. Margetts, G. Morley, Henry Calvert and William Carmichael Baker. A/48, p.124; A/54, p.117; A/55, pp.19, 181
87 1817 annotated guide as above, 102. The Chiari and Cortona were found rolled up in an attic passage in 1846 and probably sold soon afterwards for £80: E/C1/34 p.46
88 Hassall and Perry, 'Political Sculpture' 207–211. Westmacott was also paid for 'moving plates for statuary in the Gallery etc,' probably a short-lived innovation: A/52, pp.178, 188.
89 E/C1/3, p.273; abbreviations have been expanded.
90 E/C1/6, pp.11, 144, 148, 174; E/C1/10, p.181; E/C1/13, p.2
91 E/G9, p.27
92 E/G19
93 Baker: E/C1/30, p.29
94 E/C1/4, p.21; E/C1/33, pp.8, 41
95 Stirling, *Letter Bag* II, 54–55. E/C1/6, p.148 (1819); E/C1/8, p.4; A/52, pp.18–19; A/Au84. Total wages were certainly reduced.
96 E/C1/9, p.33–35
97 E/C1/9, pp.100–1, 126–7
98 Parker, *Coke* 175, 193–195
99 Lovell, *Jane Digby* 5
100 H/Wi7
101 Stirling, *Coke*, 2nd ed, 480
102 C/AN20, 18 Oct 1841. Stirling, *Coke*, 2nd ed, 496. F/TWC1/3, items 23, 29, 31
103 Stirling, *Letter Bag* II, 100, 124; Pickering, *Memoirs* 154
104 Pickering, *Memoirs* 153
105 Coke, *Tracks* 53. A/56, p.54. Joseph Manton (1766–1835), gunsmith, introduced flintlock shotguns with much lighter barrels, using a combination of steel and iron, an improvement which made it possible to shoot a flying bird or running rabbit.
106 Holkham Game Book (1837–44) p.1; C/AN1(20),(22), Napier to his father, 18 & 27 Oct. 1841
107 Pickering, *Memoirs* 42
108 Wade Martins, *Coke* 151, 180. Maxwell, ed. *Creevey Papers* II, 294

109 C/AN16, 24 Sept. 1841; C/AN22, 27 Oct. [1841]. The re-created title was qualified by the addition 'of Holkham' (rarely used in practice) because the original title had been granted in 1784 to the rival Townshend family at Raynham, who held it until 1855.
110 Wade Martins, *Coke* 4–5

Chapter 11
1 E/G1a
2 F/TWC/11, p.91, details of a conversation with Coke in 1830
3 Parker, *Coke* 77. E/C1/1, p.137–9. A/Au37, A/Au41, A/Au46
4 Tann had taken the tail end of Peterstone Farm lease in 1754 when he married the widow of the previous tenant, Robert Knatts, and he then held Hunclecrondale 'at will' from 1758, with an 18 year lease from 1761. A/Au30,36,37
5 DD/H1096 rough plan showing altered lines of roads, signed Charles Foster, Clerk of the Peace; A/Au44, A/Au49, A/Au50. The widow of the last Staithe tenant moved to an estate manor house in Wells-next-the-Sea.
6 Stirling, *Coke* II, 150, quoting Shard
7 Robinson, 'Estate Buildings' p.1555. Estate accounts in the 1780s mention only a slater at work on Wyatt's account, A/46.
8 The house ceased to be an inn in 1851, when the renowned agricultural architect, G. A. Dean, converted the house into a residence for the new agent, Keary, and built farm premises which were models of their kind, giving rise to the relatively modern name of Model Farm [E/C1/39, pp.56, 80; E/G12, p.9. Cf. Wade Martins, *Great Estate* 173–4].
9 Williamson, *Polite Landscapes* 83
10 DD/FD76, debts unpaid at Wenman Coke's decease, £12 11s 6d; A/46, p.191
11 E/WF1; M/70, M/73 and schedule M/73a. Arthur Young reported that over 1 million trees, covering 1,000 acres at 1,000 trees per acre, had been planted between 1781 and 1791: *Annals of Agriculture*, XIX, pp448–9.
12 Stirling, *Coke* 2nd ed, 149. M/73
13 B.Lib, Add.Ms. 14823, Craven Ord, *Journal of Tours in the Counties of Norfolk & Suffolk 1781–97*, from a transcript at Holkham by W.O. Hassall
14 Stirling, *Coke* 2nd ed, 150
15 *New Description* (1826) 77–78. The pleasure grounds must have skirted the remnants of the old village, for the inn survived until later in the 1780s, the farmyard operated for ten years after that, and the guide made no mention of any glimpse of the lake, whose southern end was extended westwards in 1800.
16 M/73 and schedule M/73a
17 E/Gar2, Repton's Red Book; A/48, pp.51, 56, 70
18 A/Au53,54,57. This was the same farm, Clipstone, to which Thomas Coke had moved a tenant sixty years earlier.
19 A/47, pp.9, 13, 39, 45, 113, 169 and passim; E/G12, p.4. A barn that stands today at Longlands, having survived heavy re-development of Longlands in the 1850s when extensive estate workshops were added, appears to have been the setting for a famous painting of the Shearings: see Wade Martins, *Coke* caption to plate 11.
20 A/47, pp.71,79, 81, 136; E/Gar2, Repton Red Book, f.24
21 E/G20, p.67
22 A/48, pp.195, 203, 221, in Brick Kiln Nursery
23 E/G20, p.67
24 A/48, p.29 and passim. On Webb: Williamson in Schmidt, ed. *Holkham* 66. A/48, pp.51, 56

25 *New Description* (1826) 80
26 Charles Shard, 1780, quoted in Stirling, *Coke* II, 149
27 Stirling, *Coke* II, 204; the visitor was William Windham. The basin was not, however, mentioned by de la Rochefoucauld when describing the southern outlook in 1784: *Frenchman's Year* 196.
28 Stirling, *Coke* II, 521. E/C1/4, p.245
29 Michaelis, *Ancient Marbles* 322. Ph/E/Bu/1 photo of house in Burnham Overy with Jack Satchell, and letter dated 1971 from Bernard Phillips, recounting story by Satchell that the stone 'terms' had been given to his wife's grandfather, a vet, in payment of a bill.
30 A/Au71,72,74. Widow Sharpe moved to Weasenham, where her two daughters for many years ran a school, an interesting light on the status of a tenant farmer as reflected in the education of his children.
31 A/Au74 to 77, A/54 p.182
32 M/73 and schedule
33 Stirling, *Letter Bag* II, 47. A/52, pp.106, 198; A/53, p.8. *New Description* (1826) p.27
34 A/54, p.182 [payment in 1834 to executors]
35 Re George Thurtell: A/54, pp.57, 77, 97. Re Girvan: Ledger 1871–2, p.107
36 A/54 pp.75, 78. *New Description* (1835) 69. A building, presumably this conservatory, can be seen on the 1843 map towards the east end of the pleasure grounds or arboretum.
37 Stacy, *Guide* 73, footnote
38 E/C2/1, p.858
39 A/46, p.195; A/47, p.45
40 For example, the engine house near the south-east wing of the Hall, a short-lived larder in Kitchen Court and the dovecote. Cf. Robinson, 'Estate Buildings', pp.1556–57
41 *Description of Holkham* (1826) 82. Robinson wrongly gives 1799 as the date for the lodge. A/46, pp.86, 99 and passim; A/47, pp.207, 258
42 Branthill had been entered in the accounts as Reeder's Lodge.
43 *New Description* (1835) 73
44 M/70, M/72
45 E/C1/26, p.95; Williamson in Schmidt, ed. *Holkham* 71. The south lodge appeared on the 1780 road closure order, copy in DD/H 1096, but not on Biedermann's 1781 map M/70. Accounts in 1804 mentioned 'old scite of South Lodges' A/48, p.153. *The Norfolk Tour* mentioned it in 1786 (p.107) and 1795 (p.195) editions but was possibly merely copying earlier editions. For park wall: E/G20
46 A/56 p.114 and passim
47 For a detailed account of the Monument, see Hiskey, 'A Greater Splash'.
48 M/73. Stirling, *Letter Bag* 220. P/M42–6
49 E/C1/34, p.145. Teulon's surviving plans P/M39 and 40 incorporated an upper storey and tower.
50 E/C1/39, p.55. Tithe Map M/72, 1839, shows a building already on the site of Golden Gates Lodge, about which nothing else is known.
51 A/132, p.76
52 A/141, p.104
53 Williamson, *Polite Landscapes* 163
54 Stirling, *Letter Bag* 218; E/C1/35, pp.40–41
55 E/C1/35, p.47
56 E/C2/1, p.76. Burn repeated his mistake in his initial plan for the north vestibule in 1855: E/C2/2, p.29.
57 E/C1/39, p.149, Keary to Watson, 22 Dec.1851
58 E/C1/37, p.94–5
59 E/C1/37, p.94–5. The earliest surviving plans by Nesfield at Holkham are dated 1851.

60 Hiskey, 2001, 2011. During the 20th century and later, the fountain was often described at Holkham as depicting Perseus and Andromeda, which seemed a suitable classical subject, but the account books, which would have followed the sculptor's invoices, and the 1861 guide book referred to it as 'the St George fountain'.
61 *The Gardeners' Chronicle* 16 October 1858
62 A/65, p.26
63 The building was always called a conservatory in contemporary documents. Woods and Warren, *Glass Houses*, 156. E/C1/1, p.777; P/M100 plan and south elevation, 1854.
64 E/C2/7, p.70; P/M120; A/56, p.131
65 5th Earl's file, uncatalogued, 'Woods 1941–61', Dick Coke to Tom [Leicester] 19 Dec. 1945
66 West Sussex RO, Petworth Mss. PHA 1695
67 E/C1/1, p.171. Feed on north lawn: letter from Baker, agent, in DD/Bu326
68 F/4E/5(8)
69 E/Gar2, Red Book; C/SS1, memoirs of Kitty Munro
70 E/C1/4, p.117. Uncatalogued papers of C. W. James and the 5th Earl
71 E/C1/3, p.51
72 A/55, p.75
73 E/C1/34, pp.3, 40; E/C1/35, p.17
74 Uncatalogued file formerly in Estate Office filing cabinet
75 They produced 400 to 500 fawns a year. Information from Glyn Ingram, then deer keeper
76 DD/H1101
77 A/Au7, 1726–27; A/37, p.50; DD/H1056; M/73
78 F/TWC10, p.2

Chapter 12
1 F/HC1, Collyer to H. Coke, 20 June 1842; F/TWC11, Lady C. Garnier and Wenman Coke to T. Keppell, 27–29 June 1842; E/C1/29, p.80, 5 Aug. 1842, Baker to various; p.83, 12 Aug. 1843, Baker to Messrs Gurney
2 Stirling, *Letter Bag* 174; Pickering, ed. *Memoirs* 298–99
3 A/57, p.18. *Eastern Daily Press* 25 Jan. 1909, p.8, obituary of 2nd Earl. Mackie, *Norfolk Annals* I, 427
4 Pickering, *Memoirs* 302
5 C/AN1(32) A. Napier to his father, 22 Nov. 1843
6 Plymouth & West Devon RO, 1259/3/215, Barbara Lady Dacre to Lady Morley, 3 Jan. 1844
7 Wade Martins, *Coke* 118
8 Stirling, *Letter Bag* II, 199, 219, 220
9 E/C1/30, p.29, Baker's replies to questions.
10 The legacies were converted into personal debts of the earl, in order to close the executors' accounts. DD/FD136,138,140,141,134
11 This situation explains apparent borrowing by the 2nd Earl: cf. Wade Martins, *Great Estate* 59. E/C1/31, p.48; E/C2/5, pp.173, 334; DD/FD135. William was correctly another Thomas William Coke.
12 DD/FD127, 11th April 1843; DD/FD128,129, 26th April 1844; E/C1/31, p.81, Foster to Baker, 3rd April 1844
13 'Holkham Estate Income at Michs. 1842, 1878 and 1891', 23rd Nov. 1892; 'rental of the Estate from 1851 to 1871', unlisted papers in miscellaneous box of Estate Office papers.
14 F/TWC11, Keppell's memoir: unnamed Norwich news cutting, August 1845
15 Stirling, *Letter Bag* II, 199–200
16 A/57, p.103, A/58 p.63, A/59 f.68
17 E/C1/32, pp.4, 12, 19. This would have been a third of all windows in the house: A/58, tax on 301 windows.
18 Girouard, *Victorian Country House* 21; Louw, 'Window Glass making', 64
19 E/C1/32, p.4
20 E/C1/33, p.27; P/M38, elevations of windows by Teulon, Jan. 1846; E/C1/34 p.51, Baker to Dowbiggin, 26 Mar. 1846; p.142, Baker to Teulon, 4 Dec. 1846. A/59 passim.
21 E/C1/34, pp.20, 30, 51
22 Stirling, *Letter Bag* II, 217. The account books indicate that Watson's received a total of around £15,600 in 1844–48. A/57, pp.70, 103; A/58, p.168; A/59, pp 18, 65.
23 Stirling, *Letter Bag* II, 216–7. The iron balustrade was eventually replaced, leaving traces of the alteration in its fixings and even a suspicion that the present balustrade might not be the original.
24 C/AN1(41), Napier to his father, 29 Dec. 1845. 'Enumeration of duplicate copies of Works from the Holkham Library which will be submitted to sale by public auction, 4th and 5th December 1851', Holkham Library BN10231. Mortlock, *Holkham Library* 118–19
25 Described in the Chapter 13
26 A/57, pp.36, 70, 103
27 E/C1/31, p.44; P/M41, plan for carriage porch, Teulon, 1846; P/M47–51 plans for terraces on south, west and east, Teulon, 1847; E/C1/35, p,47, Teulon to Baker, 30th June 1847; E/C1/35, p.40–41; E/C1/38, pp.20, 26 re Buckler's plans for terraces, which do not survive at Holkham.
28 Wade Martins, *Great Estate* 96
29 A/58, p.66, 22 May 1845, Guy Hagon building new offices to kitchen and laundry courts and pulling down old walls, £114 14s 2d.
30 E/C2/1, pp.455, 460.
31 P/M79–83
32 E/C2/1, pp.118
33 The counter in the main office was removed only in 2012
34 A/55, pp.72, 79, new porter's lodge, 1836; A/67, p.11
35 From 2016 it accommodated a new ticket office and reception area for visitors.
36 Stirling, *Letter Bag* II, 220. P/M84–8
37 E/C2/4, p.712; E/C2/54, pp.22, 336
38 P/M109
39 E/C2/5, p.428
40 A/64, p.51; P/M73–78
41 P/M38, window elevations by Teulon, 1846; A/65 p.26; E/C2/2, p.68, Keary to Burn, 18 July 1855
42 E/C2/1, p.824, Shellabear (as instructed by Keary) to Burn, 18 July 1854
43 Cowtan, *Holkham Hall* 5
44 A/134, p.74
45 A/136, p.78; P/M113–115.
46 The firm appears in a Manchester trade directory of 1853 but not in the previous year: information from County Archivist, Greater Manchester County Record Office.
47 E/C1/32, p.19, Baker to Dowbiggin, 3 Aug. 1844
48 A/131, p.64; E/C1/1, p.532, Keary to Burn, 25 July 1853
49 William Bunn Colling (1813/14–1886) information from DNB under William Burn
50 A/137, p.82
51 E/C2/2, p.7, Keary to Kent & Watson, 9 Apr. 1855
52 E/C1/39, pp.59, 60
53 A/139, p.87; E/C2/4, p.144, 23 May 1864.
54 University College London, Brougham Mss, HB/16723, Le Marchant to Brougham, 19 October 1862
55 E/C1/31, p.54; E/C1/33, p.94; E/C2/1, p.622

56 Strangers Wing A/139, p.84; bowling alley A/146, pp.96–97; H/Ac4, 25.1.1913
57 E/C1/37, p.42
58 E/C2/4, p.317
59 E/C2/4, p.533, 11 Dec. 1865; C/AN2(10) photocopy, Harry Napier to Mac Napier, 18 Mar. 1866 (from original owned by Mrs Robina Plowman). Cohen, *Lady de Rothschild* 136
60 A/151, p.112; Ledger 1873–74, pp.81, 99. Painting the Marble Hall cost £243, the silk curtains £361.
61 Cowtan [decorators] uncatalogued papers, 30 Oct. 1909, account rendered
62 A/56, p.179–180; A/58, p.57; H/Ser8
63 E/C2/3, p.507; H/Ser9
64 A/135, p.67 and passim; A/146, p.93
65 E/C2/4, p.716
66 E/C1/4, pp.272; A/144 p.9
67 E/C2/51 pp.355, 373, 438, 470
68 P. Brears, *The Harewood Kitchen* (leaflet, Harewood, 1996)
69 A/131, pp.66 and passim; General Payments 1888–9, p.34 and passim
70 Pickering, *Memoirs* p.302
71 E/C1/34, pp.56, 102
72 E/C1/34, pp.56, 84
73 H/Ser8
74 A/130, pp.70, 89; www.cricinfo.com website; local news cutting, *c.*1950–51, re events of 1851, in Family Album no. 18, p.34
75 E/C2/1, p.697
76 E/C2/1, p.842; Game Book 1853–72
77 H/Ser9 pencilled notes at front; E/C2/5, pp.188, 208
78 F/TK/1(iii),(iv) Coke to T. Keppel, 3 &16 Apr.1841; E/C1/28, p.90, Baker to T. Scarr, 19 Oct 1841; A/56, p.170
79 Holkham Game Books
80 Stirling, *Letter Bag* II, 226
81 H/Ser9; E/C2/4, pp.437, 443; H/Ser4
82 A/142, p.85
83 E/C2/4, p.114; H/Ser9, p.58 and pencil notes; H/Ser8; A/135, p.66
84 E/C2/3, p.507
85 E/C2/6, p.188
86 E/C2/51, pp.99, 111
87 H/Ac1
88 A/56, p.43; A/130, p.79
89 E/C2/3, p.772; E/C2/4, p.123
90 E/C2/52, p.97; E/C2/53, p.4; E/C2/54, pp.43, 63
91 e.g. E/C2/50, pp.113, 251, 253, 444, 450
92 A/137, p.77; A/139, p.81
93 A/ 142, p.86; A/146, pp.88, 93, 115; A/154, p.80; A/155, p.87
94 Cohen, *Lady de Rothschild*, p.138
95 H/Ser8, pencilled note at front
96 Obituary of 2nd Earl, *Eastern Daily Press* 25 Jan. 1909. H/Ser9
97 Details kindly supplied 2009 by Elisabeth Stuart, archivist to the Duchy of Cornwall, from Patents and Warrants.
98 H/Ser9, pencilled note on first page
99 The Earl had recently bought the tail end of a lease on 39 Grosvenor Square; the house at 19 Grosvenor Square was sold in 1886 to Count Corti for the Italian embassy. E/C2/5, pp.629, 669; E/C2/6, p.687; E/C2/13, pp.596, 601
100 E/C2/50, p.303
101 H/Ser3
102 H/Ser4, H/Ser3
103 Battersea, *Reminiscences* 340. A/154, p.65
104 Stirling, *Life's Little Day* 264
105 E/C2/51, p.358; H/Ser11; family album 'Children's Journal'
106 F/4E/M3(4). The Earl's son Wenman (1855–1931) was known to the family as 'Young Wenny' to distinguish him from his uncle, Old Wenny.
107 E/C2/52,53
108 General Payments passim; West Sussex RO, Petworth Mss, PHA 1695, diary of visits to Holkham, 1899 and 1900
109 e.g. *Eastern Daily Press*, 24, 25, 26 Aug.1899
110 Note by W.O. Hassall of comment by Lady Mabel Luddington, 'green book' p.420; E/C4/18, bundle 2
111 *Letter Bag* II, 201, 218, 230–1
112 Cohen, *Lady de Rothschild* 138–40
113 *Illustrated Times* 14 Jan. 1865, p.26
114 West Sussex RO, Petworth Mss, PHA 1695. Georgie was the Countess, Mabel her daughter, born 1878.
115 H/Inv11,12. West Sussex RO, PHA 1695 as previously cited
116 DD/FD119, 120; H/Inv11, 12
117 This room was later converted into a bathroom.
118 Bell board in south corridor. Cohen, *Lady de Rothschild* 137. These were probably the former office rooms in Strangers Wing.
119 Stirling, *Letter Bag* II, 199. H/Inv/B1; brief details of the stuffed bird collection are in C. Hiskey, 'Notes from the Holkham Archives', in Wells Local History Group Newsletter, no. 48, Sept. 2011.
120 *Eastern Daily Press* obituary. F/2E/12, Leicester to 'Juey', undated [1864]; E/C2/8, p.785
121 E/Wi9, 1844; A/AN1(42)
122 Wade Martins, *Great Estate*, 72, 173
123 E/C2/5, p.607
124 E/C2/6, pp.598, 694, 731,750; E/C2/7, p.28
125 E/C2/3, p.780
126 E/C2/3, p.783; E/C2/6, p.607
127 University College London, Brougham HB/16723, D. le Marchant to Brougham, 19 Oct. 1862
128 E/C2/13, p.189–90
129 E/G13, Report upon the Holkham Estate by H.W. Keary, pp.119–124
130 DD/Qs1, 3
131 E/C2/9, p.392
132 E/C2/5, p.536; Estate Office bundle, temporary no. 28
133 Wade Martins, *Great Estate*, pp.218, 224 et seq. E/C2/1, p.403, E/C2/5, p.419
134 On the general farming depression, F.M.L. Thompson, An Anatomy of English Agriculture 1870–1914, in eds. B.A. Holderness and M. Turner, *Land. Labour and Agriculture 1700–1920, Essays for Gordon Mingay* (London, 1991) pp.211–254
135 'General Statement of the Rental of the Holkham Estate from Michs 1841 to Michs 1891' (copy) enclosed in copy of letter from Lord Leicester to H. Chaplin, 29 Nov. 1892.
136 F/4E1/5(1), 2nd Earl to S. Shellabear, his agent, 2 Apr. 1884
137 General Statement as cited above; valuation of securities 1909 in unlisted file of death duty valuation papers
138 *Eastern Daily Press* obituary. The Earl invested his donation of £15,000 for the new hospital in Indian railways: E/C2/12, p.25.
139 F/4E1/5(1); A/204 and 221, general balance of account
140 F/4E/5(3) epitome of the will and codicils
141 F/4E/1/4(9)
142 F/3E/A/1(7)
143 F/4E/M/1(28a)

Notes to pages 311–359 **549**

144 F/4E/M/1(31) transcript by Lady Silvia Combe of letter, Viscount Coke to Lady Mary Trefusis, 1 Oct. 1904, from a copy made by Lady Trefusis, 'original letter lost'. Internal evidence, such as the Earl's serious illness in May, suggests that it was written in 1905 rather than 1904. The Earl made one further codicil to his will at the end of December 1906, adding an immediate legacy to his widow of £2,000.

145 Obituary, *Eastern Daily Press*, 25th Jan. 1909, p.8. Jones, *Victorian Boyhood*.

Chapter 13

1 A/50, p.28; DD/FD120, 1842 inventory
2 P/M36; H/Ser8
3 E/C1/4, p.68; E/C1/1, p.60–61; E/C1/3, p.28; E/C1/18, p.56; E/C2/5, p.382
4 H/JS/1(i) 'capacity of coal cellars in mansion'
5 Progress Report 1975–85 by F.C. Jolly, Hall Administrator
6 P/M144
7 E/C1/34, p.56, 2 Apr. 1846; p.102, 24 July. 1846; A/130–134, passim. C/SS10, letter from Mrs J. Rattenbury, Sept. 2002. Information on Wright & Co. kindly supplied by Rotherham Archives and Local Studies Section.
8 A/47, p.212; A/48, p.290
9 A/57, p.103, 1846 abstract
10 Obituary of James Easton 1871, http://www.greenandcarter.com/main/obituary.htm accessed 10 Mar. 2016
11 P/M106; E/C2/1, p.882
12 Reports, estimates and in-letters have not survived; this account is based on copy out-letters in Estate Office letter books, particularly E/C2/1, p.983–4; E/C2/2, pp.26, 31, 159; E/C2/5 pp.57, 362, 428; A/63, p.71. A smaller reservoir, built to supply the Great Barn cattle yards, was later used as a duck decoy.
13 E/C2/4, pp.144, 242. Unlisted fire engine file, letter from Merryweather, 14th March 1935. The site of the suction tank has not yet been traced on the ground, although it is shown on a plan of the sewers, P/M132; another underground tank receiving a pipe from the lake, to supply fire brigade hoses, is situated further north, level with Family Wing.
14 E/C2/4, pp.242, 282, 338, 350, 682, 721.
15 E/C2/4 p.760; E/C2/5 pp.146, 347–8, 428. *Proceedings of the Norwich Geological Society*, vol.1, 1878, p.16–17
16 E/C2/5, p.428. Unlisted Estate Office bundle re water supplies at Castle Acre and other places, Taylor's report. H/EO1/1, Shellabear to Owen, 26 Apr. 1881. H/EL1, p.1. The arrangement described in C. Hiskey, 'A Bigger Splash: the Holkham Fountain', *Norfolk Gardens Trust Journal*, Spring 2001, pp.19–24, has since been superseded.
17 E/C2/2 p.216; E/C2/5, p.428; H/EO1/1 and 1/4; the use of waste steam must have ceased when the steam engine was replaced by electric pumps a year or so after this report. On domestic laundries, Franklin, *Gentleman's Country House* 97
18 e.g. A/130, p.85, A/131, p.6; E/C2/13, p.110
19 From conversation with Mrs Daphne Taylor, Holkham employee, Feb. 2006
20 e.g. A/50 p.287; DD/FD120; unpublished memoirs of Hermione Coke, quoted in typescript 'Four Generations at Holkham' by Silvia Combe, p.110. Franklin, *Gentleman's Country House* 112
21 P/M50, plan of east end, 1846; P/M108, plan of proposed building, 1856
22 C/SS10 letter from Mrs J. Rattenbury, Sept. 2002
23 E/C1/5, p.193; E/C1/10, p.169; E/C2/1, p.983–4
24 Franklin, *Gentleman's Country House* 96. A/194, 195
25 A/136, p.75; E/C2/50, p.192; E/C2/51, pp.15, 92; E/C2/52, pp.224, 302
26 P/M166
27 Estate Office papers, temporary bundle 37, A. Ramm, 20 Aug.1913
28 Information from M. Thompson, Hall maintenance, and M. Daley, Hall administrator, 2001
29 H/Ser9
30 E/C2/4, p.470,14 Aug. 1865
31 E/C2/4, p.346; P/M119
32 Dillon, *Artificial Sunshine* 130
33 E/C2/5, p.21, 29 Oct. 1866
34 A/143, p.93, £107 9s 1d, *Illustrated Times*, 14 Jan. 1865, p.26
35 H/Ac16 housekeeper's accounts 1882–85
36 Girouard, *Victorian Country House* 24. H/EO1/4, report by Messrs Porter & Co., Lincoln, 29 April 1905, unlisted 'Mansion' bundle in Estate Office correspondence box
37 Printed advertisement and letter from J. Wood, 20 Jan. 1909 in H/Ga1,2; Franklin, *Gentleman's Country House* 116
38 H/Ga2, 3 Sept, 13 Nov, 24 Nov. 1908.
39 P/M155,156. The following account, except where otherwise noted, is based on a typescript explanation, 1989, by George Seeley, electrical contractor of Wells-next-the-Sea, who had known the system since childhood.
40 Dillon, *Artificial Sunshine* 178–180
41 F/4E/M2(1), T. Coke to his wife Marion, Oct. 1909
42 Estate Office General File 144
43 Unlisted file re electricity supply, letter to General Manager of East Anglian Electric Supply Co, 12 Jan. 1945
44 C/SS19 written notes by Lou Bailey, electrician, on permanent secondment from the firm of Kings and Barnham, Fakenham, January 2006
45 A/26 f.103v, no. 6].
46 A/30, f.16r; A/49 p.267; E/C1/16
47 E/C2/1, pp.855, 904
48 E/G20
49 Information from M. Daley, Hall administrator, Holkham, 2006

Chapter 14

1 M/64. No schedule survives, although some houses are numbered on the map and in a short key.
2 Hassall & Beauroy, *Lordship* 36
3 By comparison, the owner of Claydon House, at Middle Claydon, Buckinghamshire, an exact contemporary of John Coke, in similar circumstances transformed his parish into a closed estate within forty years: J. Broad, *Transforming English Rural Society, The Verneys and the Claydons, 1600–1820* (Cambridge, 2004) pp.4, 48.
4 DD/H1001,1017,1019,1022,1027,1041
5 DD/H1042
6 A/Au1 (Franklin's house, 1710), A/Au12 (no distinction between town and staithe)
7 A/Au24, 1748 audit
8 A/Au11, A/Au7. Nettleton's farmhouse, bought in 1716
9 M/66; no schedule survives
10 DD/H1068,1069
11 DD/H1063,1069,1070,1071,1075; A/Au12,15,17
12 A/Au13,14
13 DD/H1022,1051
14 DD/H1041
15 A/Au21
16 A/Au15, 1739; A/Au23, 1747; E/Gar1

17 A/Au28
18 H/Inv9, f.38v
19 DD/H1056
20 Goodwyn, *Selections* 71–74
21 DD/H1056
22 A/Au31
23 Extract from trust deed, 4 Apr. 1755, in E/C4/12/18 bundle 3
24 A/Au1, 1715. Large barns were a traditional feature of Norfolk farms : Wade Martins, *Great Estate* 138.
25 DD/H1062, Jolly's will 1727 ; A/Au1, 1712; A/Au5, 1721–2; A/Au11, 1730–31
26 A/Au20
27 Norfolk RO, 23/24/1486, inventory of Wilfrid Browne, 1754
28 A/Au21, A/Au24. Holkham parish registers. Quarter Sessions alehouse licensing records do not survive for the relevant period. Widow Nevill later married Peter Moor but there is no record whether he also took over the inn.
29 TNA, CO107/67 Chancery Master exhibit, microfilm at Holkham. Young, *Six Weeks* 282
30 *Norfolk Chronicle*, 23 Mar. and 13 July 1776. Expenditure on the inn does not appear in the audit book for 1776 and general estate accounts do not survive for that year.
31 A/Au44, 1782. The reversion to 'The Ostrich' is perhaps because, after the Countess's death and the succession of Wenman and then T. W. Coke, the name 'Leicester Arms' lost its relevance.
32 *Norfolk Chronicle*, 22 Nov. 1783; A/Au46,48,50
33 Hassall & Beauroy, *Lordship* 560
34 Blomfield v 809
35 J. T. Brighton, 'William Peckitt's commission book', *Walpole Society*, 54 (1988) 334–453, commission no. 153. There is no surviving account book at Holkham to record Peckitt's commission.
36 A/Au37
37 E/G1a map and schedule
38 A/Au44 'Separate Estate' section; DD/H1097,1103
39 Rigby, *Holkham* 78–9. Holkham baptism and burial register 1791–1812, loose sheet infolded, 'State of the population of the parish of Holkham Dec. 30th 1794'. The parish registers are now at the Norfolk RO. Matchett, *Remembrancer* 236, 1821 census 'Index Villaris'. F/TWC/11, p.91
40 E/C1/11, pp.43–5
41 C/AN38, 5 May 1845. 1851 census
42 Modern house numbers 49/51 (formerly block of 3 cottages) and 52 (formerly pair of cottages). Shown on 1778 plan E/G1(a) as plot 229. Coulsey's cottages, facing the back of the Ancient House, still stand and also predate 1778 but were rebuilt by T. W. Coke. Other buildings are safely identified as later, with the exception of Hill Farm, at the east end of the village, whose history has proved elusive.
43 In 1851 the agent, Keary, described one of them as a 'small bad cottage' and it was probably soon afterwards that a planned extension was built. E/G12, p.20; P/HV/2/1
44 A/46, p.109; DD/H1097. Modern house no. 42/43
45 A/Au70, p.70; A/Au74, p.68
46 E/C1/11, p.35
47 DD/H1126
48 E/C1/8, p.50; E/C1/10, p.145
49 E/C1/16, p.137; E/C1/17, p.2
50 Wade Martins, *Great Estate* 212
51 A/Au80. 1841 census
52 M/73
53 A/48; A/52, pp.67, 77. Cf. Robinson, *The Wyatts* 31–33, cites the Octagon Cottage as an example of Wyatt's handling of geometric space but, in addition to the engine house, there had been an octagonal larder in Kitchen Court, a dovecot and octagonal rooms in the Hall.
54 Rigby, *Holkham* 33–34
55 E/G1a, M/73, house nos. 102–108 in schedule M/73a
56 A/48, p.258; A/49, p.54, 55
57 M/73 and 73a, house nos. 94, 96 and 81, 82, 83, 84, 86
58 It has proved impossible to identify the building of Widows' Row in the accounts; it does not appear on the 1778 map but was present in 1843. M/73 & 73a, 1843; M/76, 1858
59 Modern nos. 3 & 6
60 M/73, no. 123; no. 115 in 1851 survey
61 A/51, pp.122, 140, 154, 175 et seq
62 *Report … from the Poor Law Commissioners on an Inquiry into the Sanitary Conditions of the Labouring Population of Great Britain* (London, 1842) 264–5 and plans
63 *Report … from the Poor Law Commissioners* cited above
64 A/52, p.141, 1824
65 A/53, p.6; E/G12, 1851 Keary's report.
66 EC1/4, p.14. The archivist at Barclays Bank, the successor to Gurney's, has been unable to trace any further information.
67 E/C1/1, p.143
68 A/49, p.88; E/G10, p.134
69 Sarah Biller, *Holkham, the Scenes of My Childhood and Other Poems* (Foster & Hextall, London, 1839)
70 F/TWC/11, p.91, unidentified newscutting 'Recollections of Holkham, 1830'
71 E/C1/10, p.166
72 TNA, CO107/67, as previously cited; E/G1a; DD/GE77, *c.*1780. This house no longer stands.
73 A/Au50, 81, 87, 89. Stephen Emerson: E/C1/36, pp.26, 34, 48
74 A/Au31; A/46, pp.98, 119, 159. Note inside baptism register 1781–1813
75 A/51, pp.152, 153; A/55, pp.40, 97, 155
76 Rigby, *Holkham* 69–70, 78–79
77 E/C1/9, p.99
78 F/TWC/11, Memoir and Cuttings, unidentified writer
79 1841 census. A/55, pp.75, 76
80 A/55, pp.6, 50, 51
81 DD/H1133. Widow Lack of Wells, who purchased the staithe cottages in 1743, was possibly the same Widow Lack who left Holkham town in the same year; if so, her descendant John Lack, in opening an inn, was following in her footsteps as an innkeeper.
82 Author's calculation from 1841 census
83 C/AN13, 24 Aug. 1841
84 DD/H1136, 1138
85 C/AN38, 5 May 1845
86 Plan in E/F6/39
87 Norfolk RO, DN/DPL2/3/96.
88 A/148, pp.69, 70, 113
89 E/G12, Keary's report, pp.16–18.
90 E/C2/6, p.566, 1871
91 Pevsner, *Buildings of England* 411
92 M/73 & 73a. These were possibly the cottages sold to the estate by Lack before the *Victoria Hotel* was built.
93 A/Au152, 153, 154. Pedder was appointed in Feb.1878: E/C2/9, p.724. Horatio Hinson, carpenter; Thomas Platten, bricklayer; Robert Platten, painter. Village block plans P/HV/1/1&5 show the new houses superimposed on the old.

Notes to pages 360–420 551

94 H/EO7/3, list of children invited to tea on the Earl's second wedding.
95 E/F6/39 (1856); P/HV/1/1 & 5
96 P/HV/2/6 & 7, plan E, a 3-bedroom pair, undated, and plan G, 3-bedroom single storey, dated 1883. E/C4/12/16/31(i)
97 E/C4/12/16/1(i), 10 Aug. 1883
98 E/C4/12/16/1(ii)
99 E/C4/12/16/3(ii); EC4/12/16/50 29 Mar 1884. Exwood, *Lascelles* 3–5
100 E/C4/12/16/3(i). As late as the 1950s, pail closets were considered far superior to privies or earth closets, as they could be emptied at least daily into a shallow garden trench, where the waste would 'rapidly decompose and be converted into garden mould with the minimum of offence': C. Walmsley, *Rural Estate Management* (London, 1953) 484.
101 Surviving plans by King are the revised plans for blocks A (modern nos. 25 & 26), C (nos. 38 & 39) and D (nos. 34–37).
102 E/C4/12/16/1(ii),(iii); E/C2/13, p.159
103 P/HV/7/1; A/267, p.32. The builder was James Rounce.
104 P/HV/5/3 & 4; A/267, p.32
105 E/C2/13, pp.867, 969; houses modern nos. 23 & 24.
106 E/C2/14, pp.8, 354; P/HV/2/15,17,18
107 P/HV/8/1–22; E/C2/15, pp.53, 414
108 E/C2/39, p.87
109 A/293, p.28. Modern house nos. 90–93
110 C/SS2
111 P/HV/3/1–30
112 Unlisted former Estate Office file

Chapter 15
1 Lady Anne's Drive was named in honour of T. W. Coke's second wife, Lady Anne Albemarle, whom he married in 1822.
2 DD/H649, Letters Patent 1637; M/64
3 DD/H639, valuation of Boroughall 1634. The foldcourse included a small amount of additional pasture.
4 Hunt, *Holkham Salts Hole*
5 F/JC37
6 M/136, 137 (1668); F/JC80, pp.51, 80, 122, 128–9
7 DD/H649
8 The map evidence is insufficient to indicate if Abraham's Bosom, the present boating lake near Wells beach, can be identified as the remnant of the outer harbour.
9 DD/H649. The grant was 'done by warrant from His Majesty's Commissioners for defective titles'.
10 DD/H656(ii)
11 F/TC1, p.157
12 Lincs RO Monson 7/13/13, J. Newton to Cary Coke, 8 Sept. 1705
13 F/TC1, p.11
14 A/Au1
15 A/Au4
16 A/8, f.33. P. Bateson, *Some papers relating to the general drainage of marsh-land in the county of Norfolk, with Mr Berner's objections and proposals, as also an answer to those objections and proposals* (1710)
17 *Kindersley Family* 57–58; Kinderley's work at Holkham was apparently unknown to the author.
18 M/65, *c.*1719; A/3, pp.14, 20. The payments were entered in the accounts of the guardians' London cashier, now accounting to Coke, and it may be, therefore, that it was the guardians who had eventually initiated this reclamation project.
19 A/3, pp.14, 16; the total rental for Holkham was £1731.
20 *Kindersley Family* 58–9, 63

21 Website *a2a,* citing Lincs RO, Monson Papers, survey by Smith of estates of Duke of Newcastle in Lincs; Ancaster Papers, view of Deeping Fens by Smith & another; Lambeth Archives, Theobald Papers, letters from Smith as engineer for draining the fens.
22 A/Au7, 1727–28 section
23 A/Au12
24 Lincs RO, Monson, 7/13/87, M. Newton to J. Newton, 18 Nov. 1721. Michael Newton was step-brother to Coke's mother, Cary, but only about six years older than Coke.
25 *Vitruvius Britannicus* (reissued 1967, New York) vol. 2, containing John Woolfe & James Gandon (1771) vol. 2, p.7
26 M/70, 1781
27 M/68. Bedford RO, L30/9a/6, transcript by Mary-Anne Garry. Photocopy (undated) of typescript copy (then at Forthampton Court) of letter from Lady Beauchamp Proctor to her sister Lady Agneta Yorke, p.4
28 Hiskey, 'Building of Holkham Hall', 154, no. 11
29 A/37, pp.104, 128; A/25, f.108r; A/40 f.5r
30 A/32, A/33
31 This was recorded retrospectively in a 19th century Book of Observations, E/G20, p.29
32 A/21, f.128v
33 Payne-Gallwey, *Duck Decoys* 17 et seq, 136
34 E/G1a; E/G4, p.1–2
35 E/C2/8, p.8, 1873
36 E/G 12, Keary's Report, pp.22–23; rent of the marshes (555a.0r.18p.) £834 17s 6d; total parish rent (5815a.0.21) £3,948 17s 6d (including figures for area in hand and Park Farm).
37 Stirling, *Coke of Norfolk* 2nd ed, 165. In 1808, however, Coke built a new sea bank at Warham: A/49, p 6.
38 E/C1/31, p.54–5. Bloom perhaps feared that the changes would affect the trade of Wells-next-the-Sea.
39 A/49, p.191
40 Torrens, ed. *Memoirs* xxvii, 35. Smith visited Holkham in 1800 and again in 1804 to advise on land drainage and the creation of water meadows at Wighton, West Lexham and elsewhere. The 1851 census shows that Crook's son, John, had been born in Somerset, confirming the West Country connection.
41 Also a short stretch of Freeman Street, the road leading west from Wells quay.
42 E/C1/33, p.94; E/WH14 and 15, contract plans by W. D. Harding, 1852
43 DD/Ws1054, 23 Feb. 1854; purchase price £185
44 E/WH17–24, contract plans by Saunders; E/C2/3, p.45
45 E/WH35/6, Leicester to Lord Digby, 6 Apr. 1858; DD/Ws1070, 24 Aug. 1858
46 A/136, 1857, p.98; 1858, p.69; 1859, p.69
47 A/140, section entitled Wells West Marshes: receipts £1,264, costs £3,593
48 Retrospective report, undated, in file of 5th Earl's papers, 'Memoranda since 1943'
49 E/C2/4, p.28
50 Obituary, *Eastern Daily Press,* 25 Jan. 1909, p.8
51 A/Au4, 1715
52 Williamson, *Rabbit Warrens* 10. A/30, ff.27–8; DD/H1094, 1772
53 E/C2/8, p.8. 1891 census. Williamson, *Rabbit Warrens* 11
54 A/Au21 (1745); A/Au37,38
55 President's Address by the 4th Earl of Leicester, *Proceedings of the Norfolk and Norwich Naturalists Society,* 8th May 1948, pp.335–338. J. D. U. Ward, 'From a Forest Notebook', *Country Life,* 7 Nov. 1952, p.1485

56 Norfolk RO, ANW 23/19/58, inventory of Richard Porter
57 A/Au11, p.168
58 49 Geo.III, cap. 122
59 DD/WS969
60 A/Au17
61 A/52, p.130
62 Carson, *Customs* 162–3
63 E/C1/4, pp.61, 69, 77
64 A/47, p.267 (Sea Fencibles)
65 Stirling, *Coke*, 2nd ed, 38–40; James, *Chief Justice* 261–2. The story was examined and refuted by Ketton-Cremer, *Portraits* 147–151. F/TC11 copy letters between Townshend and Leicester, originally at Felbrigg, given by Ketton-Cremer to Holkham in 1936.
66 A/47, pp.178–208 passim, A/48, pp.48, 124; T/M1,2
67 Uncatalogued former Estate Office files, reparation claims
68 Uncatalogued former Estate Office files, 1953 flood damage reparation claims, copy letter, F. Sydney Turner [Holkham agent] to G. M. Appleton, 22 Mar. 1950
69 Uncatalogued former Estate Office files, 1953 flood damage reparation claims; Holkham Parish Council Minutes, 23 Mar. 1953
70 Lord Leicester [5th Earl] 'My thoughts and views on the North Norfolk Coast', typescript, 30 Mar. 1967. Unlisted legal files, box N.
71 A/137
72 E/G20, p.130
73 Estate Office correspondence file 443, letters 1 May 1932, 1 July 1932, 12 May 1936, memo 6 May 1936

Chapter 16
1 Bedford RO, L30/9a/6. I am indebted to Mary-Anne Garry for a transcript.
2 H/Wi4
3 H/Wi4
4 James, *Chief Justice* 294
5 Bedford RO, L30/9a/6
6 Norfolk RO, COL/11/7. I am indebted to Mary-Anne Garry for a transcript.
7 James, *Chief Justice* 294
8 James, *Chief Justice* 294. Photocopy (undated) of typescript copy (then at Forthampton Court) of letter from Lady Beauchamp Proctor to her sister Lady Agneta Yorke
9 Stirling, *Coke of Norfolk* II, 521–3
10 *Norwich Mercury*, 28th January 1843, cutting in F/TWC11, p.89
11 Leamon, *Narrative* passim
12 *Norwich Mercury*, 29 May 1858, 24 July 1858, 16 July 1859, 25 June 1859
13 *Volunteer Reviews, Holkham, Kimberley and Gunton, 1861*, printed at the *Norwich Mercury* office, 1861, pp.1–6
14 E/C2/5, p.189
15 E/C2/11, p.578; E/C2/17, p.870
16 E/C2/3 pp.383, 391–93. *Wisbech Advertiser* 30 Aug. p.2, 13 Sept. p.2, 20 Sept. p.2. Burleigh was attracting 2,000 visitors a year in the 1850s: Mandler, *Fall and Rise* 88.
17 H/EO/7/2
18 E/C2/9, pp.565, 813
19 E/C1/3, p.51 [1813], EC2/2, p.297
20 E/C2/6, p.779; E/C2/8, p.693
21 *Norfolk News*, 17 July 1858, 9 July 1859, Sept. 1859
22 e.g. A/223,233 (1910–11, 1920–21)
23 E/C2/3, p.26; H/EO/7/2; A/218
24 H/EO/7/4,5,7
25 H/EO/7/6
26 A/213, p.9; A/214, p.9; A/224, p.21

27 Unsorted, J. Wood's papers re Roberts family, 1911 letter from Napier
28 F/4E/M3(14)
29 e.g. H/EO/2/4, June 1903, June 1904, in Estate Office bundle temp. no. 24
30 E/C2/5, p.2 (1866); E/C2/8, p.331 (1874)
31 E/C2/33, p.774
32 H/EO/2/4
33 E/C4/18 bundle 2
34 E/C2/44 p.49, 683; E/C2/44 p.73
35 Mandler, *Fall and Rise* 343, 371
36 5th Earl's papers, 'House Opening' file [unnumbered]
37 Unlisted 'Public Admission to View' file ex filing cabinet
38 ibid
39 By James Laver, possibly Keeper of Prints, Drawings and Paintings at the Victoria and Albert Museum
40 5th Earl's papers, 'Estate Scheme' accountants' letter to Lord Leicester 20 Oct. 1967
41 Mandler, *Fall and Rise* 407

Chapter 17
1 Mandler, *Fall and Rise* 317
2 F/4E/M3(14), 4 July 1913; A/223, pp.54–55; Cowtan bills [unlisted] 1/92; F/4E/M2/1
3 H/CT1(2); F/4E/9(1) & (2); A/223, pp.54–55; F/4E/M2(2). The rooms (some in Strangers Wing) were named as the North State Room, Red & Yellow Bedroom, Brown & Yellow Bedroom, Green State Bedroom, Brown & Yellow State Bedroom and Blue State Sitting Room. Marillier published *English Tapestries of the 18th Century* in 1930.
4 E/C2/32, p.708; memory as recounted in 2012 by Lady Anne Glenconner; P/M177; F/RgC4(20), F/4E/M2(1); H/EO3/3; E/G20, p.126. The lake work was done by Bomford & Evershed of Salford Priors at a cost of £1,375.
5 H/JS9/1; H/JS6/1; F/4E/M3(14); H/JS6/4, undated [pre 1914]; F/SC3/1, Lady Silvia Combe, 'Four Generations at Holkham' unpublished typescript, p.110a
6 F/SC3/1, pp.116, 118–19 (quoting Bridget to Roger, 12 July and 22 Aug. 1915), 126 (quoting Lady Leicester to Roger, 1 Feb. 1915), 131 (quoting Lady Leicester to Roger, undated, Oct. 1915)
7 F/4E/5(1); F/4E/1/3(16); agent to Bateson, 30 Sept. 1940 in unlisted file labelled 'Finances 1940–41'
8 The picture had been purchased by Thomas Coke in 1718. A copy made before its sale to Sir Joseph Duveen hangs in the South Dining Room; the original (attributed to Titian and workshop) is now in the Metropolitan Museum, New York.
9 F/4E/M1(82); F/4E/5(17) report & graph; F/5E/2(1)
10 Mandler, *Fall and Rise* 163; F/4E/5(3); F/4E/M3(14); F/4E/4(6)
11 F/4E/6(3); 1894 acreage from F/2E/21(10); F/4E/13, 24 Mar. 1943. Flitcham and Ashill had been sold; Weasenham and Kempstone passed to the 2nd Earl's second family; new sales were South Creake, Dunton, Elmham, Fulmodestone, a minor part of Burnham, Great Massingham, West Lexham, Mileham & Grenstein, Elmham Old Park, Fulmodestone and Wellingham.
12 F/4E/5(22)
13 Gunston, farm manager, to Turner, the agent, June 1939, and Turner to Gould, accountant, 31 May 1943, in unlisted 'Farm Accounts 1941–42' file; F/4E/M3(22) 11 Apr. [1940]
14 Unsigned letter from West Barsham Hall, 1 Nov. 1944, in unlisted 'Farms / Inland Revenue' file; memo 2 Oct. 1948 in unlisted 'Park Farm Finance' file

Notes to pages 420–501 553

15 19 Jan. & 27 Sept. 1939, 20 Sept., 30 Sept. & 15 Oct. 1940, woodlands memo Oct. 1940, all in unlabelled former Estate Office file on finances 1930–39
16 Unlisted file on rearrangement of Holkham Estate Co. 1948; unlisted 5th Earl's 'House' file, Earl of Leicester "P" account; unlisted file on Park Farm finance, 1950; 'Holkham Estate Co. Taxes, Claims [etc]' box, 'Sundry Confidential Papers' file, memo on "P" Account Finance
17 F/SC3/1, Lady Silvia Combe, 'Four Generations', unpublished typescript, pp.134, 137–39 ; F/4E/14; F/5E/1(2)
18 F/4E/5(17), F/4E/6(3), F/4E/5(22)
19 F/5E/2(2); agent to Bateson, 4 Dec. 1940 in unlisted 1940–41 file
20 I am grateful to James Bamford for alerting me to the existence of such a unit and for providing a reference to Evelyn Simac and Adrian Pye, *Churchill's Secret Auxiliary Units* (2013) p.74
21 E/4E/M 3(23); F/5E/1(12), (13), (14)
22 F/4E/13, 10 Apr. 1944; Lloyd, ed. Popham, *Old Master Drawings* preface by W. O. Hassall, p.xiii; F/4E/14
23 F/4E/6(3); F/4E/14; house servants Xmas gifts list 1941 [unlisted]; F/4E/13, 25 May 1946
24 P/M192
25 F/4E/14 [10 Dec. 41]; F/4E/13, 10 June & 11 July 1943; unlisted file re stillroom kitchen
26 Unlisted file 'Library under W.O. Hassall', W.O. Hassall March 1938; unlisted file on electricity supply, 1945, memo by F.S. Turner, 1 May 1946; F/4E/13, 11 Apr. 1945
27 F/4E/13 various dates; F/SC 3/2, Silvia Combe ms 'Memories of Holkham volume III', p.28; unlisted 5th Earl file 'Memoranda since 1941' nos. 11, 12
28 F/4E/13, 23 Aug. 1945; unlisted 5th Earl's 'Lawyers and Trustees' file, Howard-Vyse to 5th Earl 20 Sept. 1955; F/4E/23(6) Esher to 4th Earl, 8 Dec. 1945; F/4E/13, 10 Apr. 1946; F/4E/23(8), Lees Milne to 4th Earl, 25 June 1947; National Trust Archive, 4th Earl to Lees Milne, 6 July 1947, memo by Lees-Milne, 24 Jan. 1950, Esher to 4th Earl 1 July 1947
29 Turner to Bateson 23 Sept. 1945 [copy] in loose papers in Estate Office files
30 Turner to Walters & Co 16 Dec. 1947 [copy] in file on re-arrangement of Holkham Estates Co.
31 Ibid and Turner to Bateson, 27 May 1948 [copy]
32 5th Earl's 'House' file, 'Notes on reorganisation on advent of Italian maids'
33 F/4E 4(3) and undated unsigned memo, pre 1937, re sale of heirlooms. Longham was sold in 1954, Wicken Farm 1956, Tittleshall 1958.
34 5th Earl's 'Sale of Heirlooms' file, 'Tom' to 5th Earl 1949, Crawford to 5th Earl 1 Mar. 1950
35 Robinson, *Country House at War* 131, 157, 169; Mandler, *Fall and Rise* 359
36 5th Earl's 'Sale of Heirlooms' file, draft letter, undated; 'Holkham Estate Co. Taxes, Claims [etc]' box, 'Sundry Confidential papers' file, memo on "P" Account Finance; 5th Earl's 'House' file
37 Godfrey, ed. *Letters* xix–xx, 301
38 5th Earl's 'Ministry of Works' file; Library Office file, 'Library under WHO', Leicester to WHO, 29 Sept. 1958. Maurice Bray, apprenticed in the building department in the 1950s and still working in 2012, remembered Chapel Yard as the stonemasons' yard.
39 5th Earl's file 'Burns, Jermyns, T. Page, Fraser'; 5th Earl's file 'Agnews', Geoffrey Agnew to Leicester, 15 July 1968
40 Cannadine, *Decline and Fall* 650; unlisted Estate Office files on rent increases 1951–53 and rent revisions 1959, 1960; 5th Earl's file 'Rawlinson & Hunter, Savills, Estate Scheme', 24 July 1967, 20 Oct. 1967
41 F/4E/M3(19); F/5E/2(1)
42 5th Earl's 'Lawyers, Trustees' file, letters from Tony [Coke], 25 Aug. 1955, 'Wombat' and Hermione [Howard-Vyse] 20 Sept. 1955, Angus Ogilvy, Apr. 1957
43 5th Earl's 'Grove Farm House' file, 18 Nov. 1957; 5th Earl's 'Lawyers, Trustees' file, Eddy [Coke] 5 Dec. 1958
44 5th Earl's 'Rawlinson & Hunter Estate Scheme' file, 20 Oct. 1967; 5th Earl's 'Walters & Hart' file, Sept. 1965, 30 Dec. 1965; 5th Earl's 'Clerk of Works' file, General Report 14 Aug. 1963; written summary of career by Lord Leicester [unlisted] 2012; Lord Leicester in *Holkham Newsletter* no. 10, Summer/Autumn 2006
45 *Holkham Newsletter* no. 11, Winter/Spring 2006, and no 16, Summer/Autumn 2008

Archival image references

Abbreviations for non-archival sources:
 FA Family Album
 Lib. Holkham Library
 OMD Holkham Old MasterDrawings

Chapter 1
p.5, FA, David Coke

Chapter 2
p.15, F/LCJ3
pp.16 & 20, M/64
p.22, DD/H1101
p.24, DD/FD3
p.31, F/JC37
p.34, F/LCJ6
p.35, DD/H795
p.38, F/JC5
p.41, F/JC80
p.42, DD/Ts107

Chapter 3
p.44, Lib.
p.47, F/JCY/57(i)
p.48, F/JCY/25
p.55, Lib, BN 2259
p.61, F/TC1
p.62, F/P1
p.67, F/TC4
p.70, F/G2/2, p.467
p.75, OMD, framed & glazed

Chapter 4
p.81, A/3
p.82, F/TC1

p.84, F/TC3
p.87, A/13
p.90, M/66
p.92, C/BMs3
p.93, P/M5
p.94, P/M7, P/M22
p.100, P/M3, P/M20
p.102, P/M29
p.113, P/M8
p.116, P/M28

Chapter 5
p.121, A/3
p.122, E/C4/18 bundle 3

p.126, A/V3(18)
p.129, E/Wi4
p.130, A/V5(6)
p.134, A/V2(61)

Chapter 6
p.139, A/40, f.59r
p.141, A/V1/9ii
p.146, A/V1/19
p.150, A/V3/28
p.153, H/Inv4
p.155, A/V2 (73)
p.157, A/V2(68)

Chapter 7
p.164, P/M24
p.168, A/37
p.176, A/V3(3)

Chapter 8
pp.183–187, M/67
p.188, M/68
p.191, M/66
p.193, A/33
p.194, P/M10
p.197, Lib.
p.199, E/Gar1
p.205, P/M9
p.206, E/C5/2(4)
p.207, P/M14
p.208, F/EB2
p.209, P/M11

Chapter 9
p.216, H/Inv4
p.224, A/31
p.226, H/Inv8
p.230, F/TC12
p.239, A/Au203
p.240, DD/H1056

Chapter 10
p.248, Lib.
p.254, A/25
pp.256, 257, F/TWC28
p.260, H/Wi7
p.261, Lib. *Narrative of Proceedings*
p.265, A/51
p.282, F/G/1(4)

Chapter 11
p.286, E.G1a
pp.289, 297 & 302 aerial photos Ph/C/1
p.290, E/W1
p.291, FA12 p.4
p.292, unlisted
p.294 top, F/EB5
p.294 bottom, M/73
pp.295, 296, E/Gar2
p.298, Ph/E/4/1
p.300, Ph/C3
p.303, F/EB3
p.304, Ph/B14/2/1 digital

p.305, M/73
p.306, P/M42
p.307, part of P/M37, framed & glazed
p.308, P/M39
p.309, P/HV/14/4; Ph/B14/4/1
p.310, Ph/B14/3/1
p.312 top, P/M55
p.312 bottom, digital, Penrose FA
p.313, FA, David Coke
p.314, FA 12, p.13
p.316, unlisted
p.317, Ph/C3

Chapter 12
p.325, P/M50
p.327, H/X10
p.328, P/M86
p.329 top, digital, Penrose FA
p.329 bottom, P/M80
p.331, P/M75
p.335, digital, Ryan FA
p.336, H/X9
p.338 digital, Mrs M. Kearn
p.339, H/Ser9
p.342, unlisted
p.346, digital, Ryan FA
p.348 top, FA 4
p.348 bottom, Penrose FA
p.349, E/S11(2)
p.350, digital, Penrose FA
p.358, FA 12, p.27
p.360, digital, Penrose FA

Chapter 13
p.362, P/M108
p.364, P/M36
p.367, PP/M144
p.372, P/M108
p.373, H/EL1/5
p.374, digital, Mrs Campbell
p.375, P/M166
p.376, Ph/B/8/1
p.377, P/M119
p.378, H/Ga1
pp.380–381, 383, P/M155 and H/EL1/5
p.382, FA 3, p.10
p.384, H/X11
p.385, still from archival film

Chapter 14
pp.386, 405 & 431, Ph/C/1
p.388, M/64
p.389, DD/H1043
p.390, A/Au24
p.392, M/68
p.394, DD/H1056
p.395, P/M44
p.399, M/64, M/66
p.406, E/G1a
p.407, M/72
pp.414, 416, PH/C/2
p.419, M/76

p.421, P/HV/1/2
p.424, P/HV/7/1
p.426, P/HV/5/3&4
p.428, E/C4/18 bundle 3
p.430, M/80

Chapter 15
p.434, M/64
p.439, DD/H1047
p.441, A/Au12
p.442, M/68
p.443, E/G1
p.444, digital, Jonathan Holt, Nature Reserve
p.446, E/WH4
p.447, FA
p.448, unlisted
p.449, digital, Nature Reserve
p.450 top, digital, Mrs Robina Plowman
p.450 bottom, digital, Andrew Bloomfield
p.454, E/P5
p.456, Ph/E unnumbered
p.457, E/P3 & 4
p.458, E/P2

Chapter 16
p.462, H/Wi4
p.464, Lib.
p.467, framed and glazed
p.470, E/X6
p.471, H/EO7(4)
p.472, H/EO7(7)
p.473, H/EO7(6)
p.474, digital, Penrose FA
p.475 top, FA
p.475 bottom, T/B
p.476, E/P1
p.479, Lib. *Narrative of Proceedings*
p.481, PP/1/4
pp.482, 483, PP/unlisted
pp.485, digital, Carol Cox

Chapter 17
p.490, H/Ser21
p.491, digital, J. Scrivener
p.493, H/JS6/4
p.494, FA3, p.5
pp.498, 499, E/Gar4
p.500, H/Ac 1
p.501, digital, Ogilvy FA
p.503, digital, Hutchinson
p.504, family papers in course of listing
p.506, FA 10
p.508, F/4E1
pp.509, 510, John Coke FA
p.514, digital, Lady Glenconner FA
p.516, still from archival film
p.517, Ph/R1/11
p.518, Ph/R1/18
p.521, digital, Valeria, Lady Coke

Archival image references 555

Bibliography

Agnew, Jean, ed. *The Whirlpool of Misadventures: Letters of Robert Paston, First Earl of Yarmouth, 1663–1679* (Norfolk Record Society, LXXVI, 2012)
Albemarle. George Thomas, Earl of Albemarle. *Fifty Years of My Life* (London, 1876)
Allison, K. J. 'The Sheep-Corn Husbandry of Norfolk in the 16th and 17th Centuries' *Agricultural History Review* 5 (1957), 12–30
Angelicoussis, Elizabeth. *The Holkham Collection of Classical Sculptures* (Mainz, 2001)
Ayres, James. *Building the Georgian City* (London, 1998)
Baker, C.H. Collins & M.I. Baker. *The Life and Circumstances of James Brydges, First Duke of Chandos* (Oxford, 1949)
Baring, Mrs. H., ed. *The Diary of the Rt Hon William Windham 1784–1810* (London 1866)
Barnwell, P. and M. Palmer, eds. *Country House Technology* (Shaun Tyas, 2012)
Battersea, Constance. *Reminiscences* (London, 1922)
Beard, G. *Craftsmen and Interior Decoration in England 1660–1820* (London, 1981)
Bonfield, L. *Marriage Settlements 1601–1740: The Adoption of the Strict Settlement* (Cambridge, 1983)
Brettingham, Matthew. *The Plans, Elevations and Sections of Holkham in Norfolk* (London: J. Haberkorn, 1761)
Brettingham, Matthew. *The Plans, Elevations and Sections of Holkham in Norfolk ... to which are added, the ceilings and chimney pieces; and also a descriptive account of the statues, pictures and drawings not in the former edition* (London: B. White and S. Leacroft, 1773)
Browning, A. *Thomas Osborne, Earl of Danby and Duke of Leeds* (Oxford, 1913)
Cannadine, David. *The Decline and Fall of the British Aristocracy* (London, 1990)
Carr, Raymond. *English Fox Hunting* (London, 1986)
Carson, Edward. *The Ancient and Rightful Customs* (London, 1972)
Carthew, G. A. *The History of Launditch* (1897)
Chambers, Sir William, ed. W. H. Leeds. *A Treatise on the Decorative Part of Civil Architecture* (London, 1862)
Cliffe, J. T. *The World of the Country House in Seventeenth Century England* (London, 1999)
Climenson, Emily J., ed. *Passages from the Diaries of Mrs Philip Lybbe Powis 1756–1808* (1899)
Cohen, L. *Lady de Rothschild and her Daughters 1821–1931* (London, 1935)
Coke, Henry. *Tracks of a Rolling Stone* (London, 1905)
Coke, John Talbot. *The Cokes of Trusley in the County of Derby and Branches Therefrom: A Family History* (privately printed, 1880)
Connor Bulman, Louisa M. 'Moral Education on the Grand Tour: Thomas Coke and His Contempories in Rome and Florence', *Apollo*, CLVII, 493 (2003), 27–34
Cooper, N. *Houses of the Gentry* 1480–1680 (London, 1999)
Cowtan, A. Barnard. *Holkham Hall, Norfolk, A Paper Read before the Incorporated Institute of British Decorators* (London, 1914)
Currie, C. K. 'Fishponds as Garden Features *c.*1550–1750', *Garden History*, 18, no.1 (1990), 22–46.
Dillon, M. *Artificial Sunshine: A Social History of Domestic Lighting* (National Trust, 2002)
Dunn, R. M., ed. *Norfolk Lieutenancy Journal 1660–76* (Norfolk Record Society, xlv, 1977)
English, B. and J. Saville. *Strict Settlement* (Hull, 1983)
Exwood, M. 'Lascelles' Patent', *British Brick Society Information*, 50 (Oct. 1990)
Felus, K. 'Boats and Boating in the Designed Landscape 1720–1820', *Garden History*, 34, no.1 (Summer 2006) 22–46
Finch, Jonathan and K. Giles, ed. *Estate Landscapes: Design, Improvement and Power in the Post-Medieval Landscape* (Boydell & Brewer for the Society for Post-Medieval Archaeology, Woodbridge, 2007)
Franklin, J. *The Gentleman's Country House and Its Plan, 1835–1914* (London, 1981)
Garry, Mary-Anne, *Wealthy Masters, Provident and Kind: the Household at Holkham 1697–1842* (Guist, 2012)
Gillen, Mollie. *Royal Duke, Augustus Frederick, Duke of Sussex (1773–1843)* (London, 1976)
Girouard, Mark. *Life in the English Country House* (London, 1978)
Girouard, Mark. *The Victorian Country House* (London, 1979)
Godfrey, Rupert, ed. *Letters from a Prince, Edward, Prince of Wales, to Mrs Freda Dudley Ward, March 1918 – January 1921* (London, 1998)
Goodwyn, E. A. *Selections from Norwich Newspapers 1760–1790* (Ipswich)
Gunnis, R. *Dictionary of British Sculptors*, revised ed. [post 1951]

Habakkuk, J. *Marriage, Debt and the Estates System: English Landownership 1650–1950* (Oxford, 1994)
Hardyment, C. *Behind the Scenes: Domestic Arrangements in Historic Houses* (National Trust, 1997)
Harold, Ron. 'Holkham Grazing Marshes NNR', *Norfolk Bird and Mammal Report 1993* (Norfolk and Norwich Naturalists Society) 123–130
Harrison, William. *The Description of England 1587*, ed. G. Edelen (New York, 1994)
Harvey, John H. 'The Stocks held by Early Nurseries', The Agricultural History Review, 22, no. 1 (1974), 18–35.
Hassall, W. O. *A Catalogue of the Library of Sir Edward Coke* (London, 1950)
Hassall W. O. and J. Beauroy. *Lordship and Landscape in Norfolk, 1250–1350: The Early Records of Holkham* (British Academy, 1993)
Hassall, W. O. and N. B. Perry. 'Political Sculpture at Holkham', *Connoisseur*, (1977), 207–211
Heal, F. & C. Holmes. *The Gentry in England and Wales, 1500–1700* (London, 1994)
Hiskey, Christine. 'The Building of Holkham Hall: Newly Discovered Letters', *Architectural History*, 40 (1997) 144–158
Hiskey, Christine. 'A Bigger Splash, the St George and the Dragon Fountain at Holkham Hall', *Norfolk Gardens Trust Journal*, (Spring 2001), 19–24
Hiskey, Christine. 'The Leicester Monument', *Norfolk Gardens Trust Journal*, (Spring 2005), 6–16
Hiskey, Christine. 'Holkham's Walled Gardens', *Norfolk Gardens Trust Journal*, (Spring 2011) 41–51
Hiskey, Christine. 'Palladian and Practical: Country House Technology at Holkham Hall' in Barnwell, P. S. and Marilyn Palmer, ed. *Country House Technology* (Rewley House Studies in the Historic Environment, 2, Shaun Tyas, 2012) 22–36
Horn, Pamela. *Flunkeys and Scullions: Life Below Stairs in Georgian England* (Stroud, 2004)
Howell James, D. E. 'Matthew Brettingham and the County of Norfolk', *Norfolk Archaeology*, 33, part 3 (1964) 345–350
Howell James, D. E. 'Matthew Brettingham's Account Book', *Norfolk Archaeology*, xxxv, (1971) 170–182
Hunt, O. D. 'Holkham Salts Hole, An isolated salt-water pond with relict features', *J. Mar. Biol. Ass. UK* (1971) 717–741
Huntley, F. L. 'Dr Thomas Lushington, Sir Thomas Browne's Oxford Tutor,' *Modern Philology*, vol. 81, no. 1 (1983) 14–23
Ilchester, Earl of, ed. *Lord Hervey and His Friends 1726–38* (London, 1950)
Ingamells, J. *A Dictionary of British and Irish Travellers in Italy 1701–1800* (London, 1997)
Jacob, Giles. *A New Law Dictionary* (London, 1736)
James, C. W. *Chief Justice Coke, His Family and Descendants at Holkham* (London, 1929)
Jones, L. E. *A Victorian Boyhood* (London, 1955)
Ketton-Cremer, R. W. *Norfolk Portraits* (London, 1944)
Ketton-Cremer, R. W. *A Norfolk Gallery* (London, 1948)
Ketton-Cremer, R. W. *Country Neighbourhood* (London, 1951)
Ketton-Cremer, R. W. *The Norfolk Tour* (privately printed, 1954)
Ketton-Cremer, R. W. *Forty Norfolk Essays* (London, 1961)
Ketton-Cremer, R. W. *Norfolk in the Civil War* (London, 1969)
Kindersley, A. F. *A History of the Kindersley Family* (privately printed, 1938)
Kiralfy, A. K. R. *A Source Book of English Law* (London, 1957)
Kiralfy, A. K. R. *Potter's Historical Introduction to English Law*, 4th ed. (London, 1958)
Leamon, R. *A Narrative of the Proceedings regarding the Erection of the Leicester Monument* (Norwich, 1850)
Lees-Milne, James. *Earls of Creation* (London, 1962)
Lewis, W. S., ed. The Yale Edition of Horace Walpole's Correspondence (New Haven,1937–1983) electronic version
Llanover, Lady, ed. *Autobiography and Correspondence of Mary Granville, Mrs Delany* (1861–62), 2nd series, vol. 2
Louw, Hentie. 'Window-Glass Making in Britain *c.*1660–*c.*1860 and its Architectural Impact', *Construction History*, Vol.7, 1991, 47–68
Lovell, Mary S. *A Scandalous Life, The Biography of Jane Digby* (London, 1996)
Mackie, Charles. *Norfolk Annals* (Norwich, 1901)
Mandler, Peter. *The Fall and Rise of the Stately Home* (London, 1997)
Marr, Maureen. *Some Notes on the Parish Church of St Withburga, Holkham* (2003).
Mason, R. H. *History of Norfolk* (London, 1884)
Matchett and Stevenson. *The Norfolk and Norwich Remembrancer and Vade Mecum* (Norwich, 1822)
Maxwell, Sir Herbert, ed. *The Creevey Papers* (London, 1903)
Michaelis, A. *Ancient Marbles in Gt. Britain* (Cambridge, 1882)
Mitchell, Leslie. *The Whig World* (London, 2005)
Moore, Andrew, ed. *Houghton Hall, the Prime Minister, the Empress and the Heritage* (London, 1996)
Moore, Andrew. *Norfolk and the Grand Tour* (Norfolk Museums Service, 1985)

Mortlock, D. P. *Holkham Library, a History and Description* (Roxburghe Club, privately printed, 2006)
Mortlock, D. P. *Aristocratic Splendour: Money and the World of Thomas Coke, Earl of Leicester* (Stroud, 2007)
Mowl, T. *William Kent, Architect, Designer, Opportunist* (London, 2006)
Murdoch, Tessa, ed. *Noble Households, Eighteenth Century Inventories of Great English Houses* (Adamson, Cambridge, 2006)
New Description of Holkham, 1826 (H. Neville, Wells-next-the-Sea, 1826)
New Description of Holkham, 1835 (H. Neville, Wells-next-the-Sea, 1835)
Parker, R. A. C. *Coke of Norfolk, A Financial and Agricultural Study* (Oxford, 1975)
Parkin, Charles. *Blomefield's History of Norfolk: An Essay Towards A Topographical History of the County of Norfolk* vol. V (1775)
Passavant, M. *Tour of a German Artist in England* (London, 1836)
Payne-Gallwey, Sir Ralph. *The Book of Duck Decoys* (London, 1886)
Pevsner, N and B. Wilson, *The Buildings of England: Norfolk 2, North-West and South* (London, 2002)
Pickering, Spencer, ed. *Memoirs of Anna Maria Wilhelmina Pickering* (London, 1903)
Popham, A. E., ed. Christopher Lloyd. *Old Master Drawings at Holkham* (Chicago, 1986)
Rathbone, F. A. M. *Letters from Lady Jane Coke to her friend Mrs Eyre, at Derby, 1747–58* (London, 1899)
Reynolds, Suzanne. *A Catalogue of the Manuscripts in the Library at Holkham Hall, Volume 1. Manuscripts from Italy to 1500 – Part 1. Shelfmarks 1–399* (Turnhout, 2015)
Rigby, E. *Holkham and its Agriculture* (Norwich, 1818)
Robinson, John Martin. 'Estate Buildings at Holkham, I', *Country Life*, 21 Nov. 1974, pp. 1554–57; 'Estate Buildings at Holkham, II' ibid, 28 Nov. 1974, pp.1642–45
Robinson, John Martin. *The Wyatts, An Architectural Dynasty* (Oxford 1979)
Robinson, John Martin. *The Country House at War* (London, 1989)
Rosenheim, J. M. 'Party Organization at the Local Level: The Norfolk Sheriff's Subscription of 1676', *The Historical Journal*, 29, no. 3 (Sept. 1986) 713–22
Rosenheim, J. M. *The Townshends of Raynham* (Middletown, Connecticut, 1989)
Rush, Richard. *Memoranda of a Residence at the Court of London.* (Philadelphia, 1845)
Salmon, Frank. '"Our Great Master Kent" and the Design of Holkham Hall: A Reassessment', *Architectural History*, Vol. 56 (2013), pp. 63–96
Saumarez Smith, Charles. *The Building of Castle Howard* (London, 1997)
Saunders, E. *Joseph Pickford of Derby* (Stroud, 1993)
Scarfe, N. *A Frenchman's Year in Suffolk, 1784* (Boydell Press, Suffolk Record Society XXX, 1988)
Schmidt, Leo, ed. *Holkham* (Prestel, 2005)
Seduizione Etrusca, Dai segret di Holkham Hall alle meraviglie del British Museum exhibition catalogue (Skira, 2014)
Shirley, E. P. *Some Accounts of English Deer Parks* (London, 1867)
Stabler, John. *Norfolk Furniture Makers* (Regional Furniture Society, 2008)
Stacy, Henry W. *Guide to Holkham* (Norwich, 1861)
Stirling, A. M. W. *Coke of Norfolk and His Friends*, 2 vols. (London, 1908)
Stirling, A. M. W. *Coke of Norfolk and His Friends* 2nd ed. (London, post 1913]
Stirling, A. M. W. *The Letter Bag of Lady Elizabeth Spencer Stanhope* (London, 1913)
Stirling, A. M. W. *Life's Little Day* (London, 1924)
Tomalin, Claire. *Samuel Pepys, the Unequalled Self* (London, 2002)
Thomas, W. J. *Anecdotes and Traditions* (Camden Society, 1839)
Torrens, H., ed. *Memoirs of William Smith by John Phillips* (Bath, 2003)
T. W. F. 'Matthew Brettingham, the Architect of Holkham', *The East Anglian* II (Dec. 1864) 131–134
Wade Martins, Susanna. *A Great Estate at Work: the Holkham Estate and its Inhabitants in the Nineteenth Century* (Cambridge, 1980)
Wade Martins, Susanna. *Coke of Norfolk, 1754–1842, A Biography* (Woodbridge, 2009)
Ware, Isaac. *A Complete Body of Architecture* (1756)
Wearing, S. J. *Georgian Norwich and Its Builders*, (Norwich, 1926)
Weber, Susan, ed. *William Kent: Building Georgian Britain* (Yale, for the Bard Graduate Centre, 2013)
Williamson, T. *The Archaeology of Rabbit Warrens* (Princes Risborough, 2006)
Williamson, T. *Polite Landscapes: Gardens and Society in Eighteenth-century England* Stroud, 1995)
Wilson, Michael. *William Kent* (London, 1984)
Wilson, Richard and Alan Mackley. *Creating Paradise, the Building of the English Country House 1660–1880* (London, 2000)
Woods, M. and A. Warren. *Glass Houses* (London, 1988)
Worsley, Giles. *Classical Architecture in Britain: The Heroic Age* (London, 1995)
Young, Arthur. *A Six Weeks Tour through the Southern Counties* (1768)
Young, Arthur. *The Farmer's Tour through the East of England* (London, 1771)
Young, Arthur. *General View of the Agriculture of the County of Norfolk* (London, 1804)

Index

References to illustrations are shown in *italics* with caption page in brackets if not on the same page as the illustration, e.g. *44* (45). References to endnotes consist of the page number followed by the letter 'n' followed by the number of the note. When the author or subject mentioned in the endnote is not directly identified in the main text, the text page is added in brackets, e.g. 546n78 (271) refers to endnote 78 on page 546, and the note number is to be found in the main text on p. 271.

accounts
 account book pages *41, 67, 81, 121, 129, 139, 193, 239, 254, 260, 265*, 44
 account books 267
 accounting system re-arrangements 102–6, 278
 accounts department (20th century) 330
 Audit Books 103, 239, 441, *441*
 see also bills
agriculture/farming
 under John Coke (*c.*1612–1661) 40–1, 43
 under T. Coke's guardians (*c.*1707–18) 63–4
 under T. Coke (1718–59) 106–7, 181, 184, 210
 under T. W. Coke (*c.*1776–1842) 7, 247, 251–2
 under 2nd Earl (*c.*1842–1909) 353–6, 400
 under 3rd Earl (*c.*1909–41) 497–501
 see also Sheep Shearings
Airlie, A. M. Bridget Ogilvy, Countess of Airlie (née Coke) 492, 494
Albany, Princess Louise of Stolberg-Gedern, Countess of *250*
Albemarle, William Charles Keppel, 4th Earl of Albemarle 264, 266, 274
Albemarle Arms 414–15
Albert Edward, Prince of Wales (later Edward VII) 336–7, 340, 345, 351, *360*, 376, 472, 491
Alexandra, Princess of Wales (later Queen) *335*, 336–7, 351, 491
Allen, Ralph 126, 143
almshouses 210, 240, 305, 306, *386* (387), 395–6, *395*
Alston, Rev. Dr 198, 393
'America' tapestry (Green State Bedroom) *212* (213), 236

American connections 259, 263, 270, 280
 American War 256–7
 Declaration of Independence 266
ananas house 112, 154, 200
Ancient House
 aerial view *431*
 base for Battle School 507
 bought from Newgate 35
 as farm house 184, 299, 387, 398, 412
 as lodging house 429, 477
 restoration 423, 425, *426*, 427
Andover, Jane, Lady (née Coke) 255, 266, 275–6, 280
Anger, Roger 184
Anne, Lady *see* Osborne, Anne, Lady
Anne, Queen 71
Anson, Ann, Lady (née Coke) 255, 264, 266, 267, 268, 276
Anson, Thomas, 1st Viscount Anson 255
Apollo statue 144, *145*, 325
Appleyard, George
 appointed estate steward 85, 86, 252
 death 109, 111
 focus on estate accounts 103–4
 Holkham farms re-structuring 182
 Holkham town home 393
 on lime kiln 123
 modernisation of estate 249
 on organizing landscaping work 105–6
 on plaster supplies 132
 on plasterer Thomas Clark's team 144
Aram, John 190–1, 203
Aram, William 210
arboretum 195, 292, *294*, 300–1
architecture
 development of profession 89–90
 Palladianism 1, 90–1, 95, 99, 112, 150, 195, 263
 Thomas Coke's (1697–1759) passion for 68, 71, 73–4, *84*, 92, 530
Armiger, Mansuer 32
Armiger, William 18, 19
Armoury (or Guard) Room 218, 352
Astley, Bridget (née Coke) 36
Astley, Isaac 36
Atkinson, William 150, 151–2, 154
Audit Books 103, 239, 441
audit dinners 259, 354
Audit Room 217, 259, 263, 351, 352, 469, 529
Auxiliary Unit (WWII) 505
the Avenue 202–3, *202*
Awdley, Hugh 29

bakehouses
 at Holkham Hall 178, *366*, 412
 village bakehouse/bakery 412, 425
Baker, William (estate office/agent) 278, 322, 324, 326, 342
Baker, William Carmichael, North Devon ox painting *274*
Bakewell, Robert 259
ball (1865) *351*, 352, 376
 see also Glorious Revolution Centenary Ball (1788)
Banks, Joseph, 1st Baronet 271
Banks, Thomas, *Death of Germanicus* (marble relief) *254*
Barber, Thomas 274
barns 396
 'Great Barn' (*c.*1733) 183
 Longlands Field Barn (or Great Barn) 257, 296–7, *297*
Barrett, Ian *143*
Barrow, Julian, portrait of T. W. E. Coke, 5th Earl of Leicester *522*
Bartoli, Francesco, *Church of the Gesù in Rome 75*
basin 192, 194, *194*, 195, 206, 298–9, 547n27 (299)
 see also lake (or 'Broad Water')
Bascubee, George 115
Bateson, Mr 438
bathrooms 167–9, 332, 371–2, 429, 524
Bathurst, Henry, Bishop of Norwich 271, 274
Baton, Mme 281
Batoni, Pompeo, portrait of Thomas William Coke (1754–1842) *250*, 253
beach
 embankment to Wells 334
 private bathing 349–50
 road to 435, 448, 468
 tourism 456–8, 459, 478
 Holkham estates passes *457*
 notice to visitors (1924) *458*
 WWII defence works 453–4
Beatniffe, Richard, first guides to Holkham 463–5, *464*
Beauchamp-Proctor, Laetitia, Lady 114, 198, 228, 238, 442, 463–4
Beck, C. S. 429
Beck Hall 54, 58, 65, 83, 112
Bedford, Francis Russell, 5th Duke of Bedford 271
Bedford, John Russell, 6th Duke of Bedford 315
Bedingfield, Mr 63, 444
Bedingfield, Thomas 43
Beefsteak (or Mutton) Room 269
Beesley, Marjorie, school boot club card *428*
Belcher, William 345
bell systems 155, 179, 368
Bellville, Belinda 485
Bender, Philip 88
Berkeley, Theophilia 26

Index 559

Bernisconi, Frances 302
Bertie, Charles, Sir 60, 62
Bevis Marks (City of London) 244–5
Biedermann, H. A. 285, 442
Biller, Sarah 411
Billiard Room *see* Smoking Room (previously Portico Room/ Billiard Room)
bills 47, 48, 472
 building *126*, *130*, *134*, *141*, *146*, *150*, *155*, *157*, *168*, *176*
 see also accounts
Bircham, James 182
bird collection 353, *354*
Blackwell, Anne 268
Blackwell, Elizabeth
 Triumphal Arch sketch *208*
 'Walk to garden' *294*
 West Lodge *303*
Blaikie, Francis
 on animal breeds and true patriotism 268
 cottage building 410
 on cottagers' allotments 410–11
 on local tradesmen 269, 270
 management of Holkham estate 277–9
 on poor children's education 412
 portraits of 274, *278*
 on purchase of Staithe cottage for Coke 402
 on the Shearings 279
 on the sheepfold 315
 on smuggling system and Holkham Gap 452
 on T. W. Coke's (1754–1842) second marriage 266
Blickling Hall 43
Blockley, Thomas 155–6, 179
Bloom, Mr 445
Blue Book 484
Blunt, Anthony 511–12
boating and fishing 113
Boehm, Joseph, lion and lioness sculptures 337, *338*
Bolger, Henry 333, 417
Bolton, James 345
Bonnick, Thomas 133
Borough (later Danish camp) 21–2, 435, *436*
Borough Channel 435, 437, 444
Boscawen, Mrs 241
bowling alley 334, *335*, 506, 508, *513*
Bradshaw, George Smith 221, 223–4
Bradshaw, William 221, 223–4
Bramah water closets 271, 363
Bramall and Buxton (building firm) 311, 332, 333, 334
Branthill farm 138, 185, 188, 189, 299, 500
Branthill Lodge 303
Brathwayt, Richard, *The English Gentleman* 44 (45)
Bray, Maurice *142*, *143*
bread oven *366*, 367–8, *367*
Breakfast Room 352
see also South Dining Room (or Breakfast Room)
Brett, Thomas 285, 286, 288, 396, 397

Brettingham, Matthew (1699–1769)
building supervision role 105
connections with
 John Elliot 138
 John Parsons 143
 Joseph Howell 144
 Mr Oram 203–4
contribution to design of Holkham Hall 92, 93–6, 97, 99
 chapel 231
 dove house plan *200*, 201
 East Lodges design 209
 garden thatched seat design 195
 kitchen 175
 Marble Hall *100*
 South Front, Holkham Hall *94*
 west entrance to park 210
 decreasing role 115, 116
 dismissed by Margaret Coke 231
 Euston Hall (Suffolk) work 158
 on furnace beneath Marble Hall floor 172
 furnishing and furniture 221, 222, 224–5
 intermediary role for carvers' work 149
 Landscape Room referred to as state dressing room 102
 letters from Thomas Coke (1697–1759) *92*, 99, 135
 lodging in Kitchen Wing 152, *153*
 on London craftsmen 105
 on planting and agriculture 106
 Mr Brettingham's room 231–2, 383
 technology and practical aspects 163
 transition to architect 90
Brettingham, Matthew (1725–1803)
description of Holkham
 on chimneypieces in Strangers Wing 151
 on 'commodiousness' of plans 96
 on his father's publications of the plans 99
 on Holkham bricks 119, 123, 124
 no mention of kitchen 174
 on paintings commissioned by Thomas Coke (1697–1759) 68
 on practical aspects of Hall 163
 on water supply 163, 165
 on William Kent's contribution 90, 91, 192–3
 on father's dismissal by Margaret Coke 231
 partially replacing father at Holkham 115
 Plans and Particulars (1773) 68, 151, 464
 arch gate to garden *293*
 Drawing Room griffins *220*
 East Lodges design 209

Family Wing principal floor *109*
North Lodge *211*
Obelisk and Seat on the Mount *192*
seat in orangery *198*
South Lodge *204*
Steward's Lodge *234*
Temple section view *196*
purchasing art works for Thomas Coke (1697–1759) 227
brewhouse 177, 213, *330*, 368, 372–4
Brewster, John 33, 40
Brindley, John 83
Broadbent, John 165
Bromwich (London upholsterer) 222
Brooks, Mr 59, 65
Brown, Lancelot 'Capability' 210, 285
Browne, Wilfrid 396
Buck, Jonathan 301
Buckler, J. C. 326
Bullin, John 154, 155, *155*, 156, 159
Bulling, John 279
Bulling, Miles 279
Burghall Manor 18, 21–3, *22*, 34, 36, 388, 435–6, 437–8
Burlington, Richard Boyle, 3rd Earl of Burlington 90–1, 92, 95–6, 99, 106, 150, 200
Burn, William
 and clerk of works 332–3
 domestic quarters (south) 330–1, *330*
 Estate Office 326–7
 Golden Gates Lodge 306, *309*
 new laundry and servants' washhouse plan 372, *372*
 north vestibule 331, *331*
 Saloon and Marble Hall windows 331–2
 stables plan *328*
 terrace walls 311
Burnet, of London 223
Burnham and Burnham Market 115, 138, 291, 316, 336, 465, 478, 505
 Lord Orford estate at 495
 Norton 38, 120, 522
 Overy 133, 299, 344, 363, 387, 391, 433, 435, 455
 Westgate 141

Caldecourt, William 341
Camden, William 62
 Coke family pedigree *62*
Campbell, Colen 94–5
 Vitruvius Britannicus 84
Campbell, General Sir James 228
Campbell, Mary, Lady *see* Coke, Mary, Lady (née Campbell)
candles 179, 376
Cannon Hall (Yorkshire) 267
Cannons (Middlesex) 167, 170
Capper, Mr (well sinker) 163
Carr (farm tenant) 251–2
Carr, Robert (silk mercer) 223
Carrington, Henry, Rev. 238
Carroll, Charles, of Carrollton 266

560 HOLKHAM

Carter, Thomas 150, *150*
Casali, Andrea 227
 portrait of Margaret Coke *242*
 portrait of Thomas Coke (1697–1759) *98*
Casey, John 61, 80, 85
Castle Hay quarries (nr Tutbury, Staffordshire) 127, *135*
Castle Howard 203
Caton, 'Bessy' 266
cattle 263, 268, 274, *274*, *297*, 299, 315, 355, 447, 459
Cauldwell, Ralph
 estate steward 105, 109–10, 111, 148, 190
 Godwick estate tenancy 249
 his house at Holkham 198
 his house at Hilborough 249
 inspection of completed works 249
 Margaret Coke's instructions to burn account books 238–9
 and Matthew Brettingham's dismissal 231
 modernisation of estate 249
 removal of by T. W. Coke (c.1776–1842) 249
 salaries 249
Cavendish, Georgiana *see* Coke, Georgiana, Lady (née Cavendish)
chairs and settees (18th century) 221, 223–7
 detail of blue leather *225*
 pattern chair *222*
chamber pots (close stools) 170–1, *170*
Chambers, William, Sir 96
Chantrey, Francis 301, 325
 Signing of Magna Carta 276–7, *276*
Chapel Wing
 alabaster in dairy 130
 bathroom 332
 bricklaying 140
 cellars 214, 218–19
 chapel 141, 147, 150, 219, 231, *232*, 235, 323–4
 chimneypieces 154
 domestic offices 326
 guest rooms 264
 ice-making plant 374–5, *375*
 laundry 178, 213, 371
 Margaret Coke's move to 102, 235, 238
 nursery rooms 255, 337, 347, 503
 requisitioned in WWII 506, 510
 as self-contained family home 526
 servants' rooms 214
 slating work 133
 Tapestry Bedroom 238
 water closet 169
Chapel Yard 406, 407, 408, 410, 411, 417, 419–20
 plan and photograph *409*
chaplains 39, 40, 48
Charles, Prince of Wales 515, 516
Charles I, King 14, 27
Charles II, King 43
Chatsworth (Derbyshire) 167, 170, 177, 324
Chesham, William Cavendish, 2nd Baron Chesham 347

Chiari, Giuseppe 68, 525, 544n31
 Perseus and Andromeda 274
 Scipio 276
chimneypieces *149*, 150, *151*
Church Lodge 302, *302*
Church Wood 195
Civil War 2, 27, 29, 31–2, 33, 38, 43
Clark, Thomas (plasterer) 144, 146–8, 231
 bill for plaster work *146*
 lodging in Kitchen Wing 152, *153*
 Marble Hall ceiling plaster work *136* (137)
 Statue Gallery plaster work *147*
Clark, Thomas (well sinker) 369
Clarke, Charles 411
Classical Library 272, *272*, 516, *517*
Clerke, Thomas, of Stamford, Holkham map (1590) *16*, 388, *388*
the Clint 14, 21, 113, 184, 207
 and lake 193–4, 195, 206
 and marsh embankments 437, 438, 442–3
Clinton and Owens 369
coach houses 330
 see also stables
Cobb, Elizabeth (née Coke) 36
Cobb, Jeffrey 36
Cobb, William 36
Cobb, Winifred (née Coke) 36
cockings 89, 112
Coke (family)
 family mausoleum 63, *63*, 283, 397
 family trees
 pedigree by William Camden 62
 from Edward Coke (1552–1634) to Thomas Coke (1697–1759) *77*
 highlighting Holkham branches *8*
 showing John Coke senior and junior's succession *29*
 showing T. W. Coke's (1754–1842) two marriages *280*
 from Thomas Coke (1697–1759) to T. W. Coke (1754–1842) *244*
 from Thomas William Coke (1848–1941) *488*
 line of descent and Holkham Hall 5–10
 map of Coke estate in Norfolk *496*
 spelling of family name 38
Coke (family, of Melbourne and Trusley, Derbyshire) 60
Coke, Alice (née White) 358, 492, 494
Coke, Ann *see* Anson, Ann, Lady (née Coke); Roberts, Ann (née Coke)
Coke, Anne *see* Sadleir, Anne (née Coke)
Coke, Anne, Lady *see* Glenconner, Anne, Lady (née Coke)
Coke, Anne, Lady (née Anne Keppel) 248, 266–7, 276, 300, 301, 319, 412, 414

Coke, Anthony Louis Lovel, 6th Earl of Leicester 10, 508–9, 520, 521, 525
Coke, Arthur George 508
Coke, Bridget *see* Airlie, A. M. Bridget Ogilvy, Countess of Airlie (née Coke); Astley, Bridget (née Coke)
Coke, Cary (b. 1698) 59
Coke, Cary (née Newton) 55, 58–9, 60, 61
 The English Gentleman (R. Brathwayt) *44* (45)
 library list 55
 portrait by Michael Dahl *57*
Coke, Catharine, Lady 58
Coke, Clement 20, 32
Coke, David 5
Coke, Edward (1552–1634), Sir
 biographical details 13–14
 book of family settlements 23–5, *24*, 27
 chief estate steward house 40
 founder of family fortunes 5
 Great Book of Conveyances 14, *15*
 his library 33–4
 library catalogue on parchment roll *34*
 Holkham property purchases 13, 17–19
 Longford estate 60
 Lord Chief Justice office 14
 portrait by Marc Geeraerts the younger *12* (13)
 Thorington property 51
Coke, Edward (1613–53) 28–9
Coke, Edward (1648–1727) 59–60, 61–2, 64–5, 70–1, 80
Coke, Edward (1676–1707)
 death 59
 debts 58
 Holkham estate inheritance as minor 53–4
 household and lifestyle 58–9
 library 61
 marriage to Cary Newton 55, 58
 portrait by Michael Dahl *56*
 settlement with Andrew Fountaine 54, 58
 unresolved inheritance issues 54–5
Coke, Edward (1702–33) 59, 77, 89
Coke, Edward (1719–53) 105, 108–9, 111, 114, 221, 227, 241, 243
Coke, Edward (1758–1837) 271, 283
Coke, Edward (1824–89) 280, 319
Coke, Edward Douglas (1936–2015), 7th Earl of Leicester
 central heating improvements 365, 524
 family's move to Hall 483
 handover to son 529
 heritage designation scheme 481–2
 inheritance of Holkham 10, 520–2, 523–4
 life-size bronze statue 526, 529
 modernisation of estate houses 522–3
 on Park Farm 523

Index 561

photographs 510, 521, 523, 529
retirement dinner for staff 527
staff portraits 9, 526, 527
windows 324
Coke, Elizabeth see Cobb,
 Elizabeth (née Coke);
 Spencer-Stanhope, Elizabeth
 (née Coke)
Coke, Elizabeth (née Yorke), Lady
 480, 510–11, 513, 515, 515
Coke, Georgiana, Lady (née
 Cavendish) 347, 349, 352,
 357, 359–60, 422, 423
 with husband and children
 348
 at Norfolk Militia Review 474
Coke, Gertrude, Lady see
 Dunmore, Gertrude (née
 Coke), Lady
Coke, Henry (1591–1661) 20,
 29, 32
Coke, Henry (1827–1916) 280,
 281, 319
Coke, Hermione (née Drury)
 492, 550n20 (372)
Coke, Jane see Andover, Jane, Lady
 (née Coke)
Coke, Jane (née Jane Dutton)
 244, 255, 266, 268, 274, 300
Coke, John (1590–1661)
 breakdown of relationship with
 son 34, 43, 46
 Burghall Manor 21, 23, 34
 Christmas celebrations 37
 Civil War 29, 31–2, 43
 daughters 36–7
 daughters and sons, St
 Withburga's church 37
 death 43
 Fulmodestone Manor 23
 High Sheriff office 32, 43
 Hill Hall (or Wheatley) manor
 acquisition and size of estate
 19–20
 description of manor house
 20–1
 extension and improvements
 39–40, 43
 household servants 39
 inventory (1661) 42
 Philip Palgrave's accounts
 41, 43
 working farm 40–1, 43
 'Holkham Hall' used as address
 38
 Holkham property, expansion of
 13, 34–6, 64
 inheritance and family lines of
 descent 5–6, 23–8, 33
 inheritance and management of
 estate 33–4
 legal and property records 88
 marsh embankment 34, 434,
 435–8
 Neales Manor 19, 20, 21, 23, 24
 Newgate's 35–6
 parliamentary taxation receipt
 31
 personality and interests 38–9
 portrait by Henry Stone 30, 31
Coke, John (1636–1671)
 breakdown of relationship with
 father 34, 43, 46
 death and funeral 50

Hill Hall (or Wheatley)
 manor
 house improvements 46
 household and bills 47–8,
 47, 48
Holkham estate extension and
 strict family settlement
 49–50, 64
 inheritance settlement rejection
 45–6, 48, 322
John Coke's youngest son 5–6,
 28
member of parliament for
 King's Lynn 50
personality 49
purchase of Lushers farm 183
relationship with Andrew
 Fountaine 46, 48–9, 50, 53,
 54, 58
Coke, John (1678–1736) 60,
 62, 71
Coke, Julia, Lady see Powerscourt,
 Julia (née Coke), Lady
Coke, Juliana (née Whitbread)
 319–20, 322, 337, 341–2, 345,
 346
 photo collage 346
 portrait by Sir Francis Grant
 321
Coke, Mabel (b. 1878) 329, 352
Coke, Margaret see Rokeby,
 Margaret (née Coke)
Coke, Margaret (née Lady
 Margaret Tufton)
 accounts
 account books 238–9, 239,
 267
 household accounts 85,
 102–3
 payment to William Kent 92
 almshouses, building of 210,
 240, 395–6, 395
 birth of only child to survive
 80, 85
 birth of other children 85
 and Brettingham's publication
 of Holkham plans 97
 bust, Tittleshall church 227
 death 6, 241
 dowry 89
 fond of pheasants 112
 furniture and furnishings 221,
 227, 234–6, 238
 furniture list for staterooms
 226
 husband's will and building
 work 230–4
 life at Holkham after husband's
 death 238–41
 marriage 79
 monument to husband and
 son 154
 move from Family to Chapel
 Wing 234–5, 238
 paintings added after husband's
 death 236–8
 personality 241
 portrait by Casali 242
 provisions for the poor 239–40,
 393–5
 record pages 240, 394
 quotes
 on being cold in Holkham
 Hall 172

 on Holkham built on 'open,
 barren estate' 14–15
 on Triumphal Arch 207–8
 on universities 244
 on Wenman Roberts (later
 Coke) 243
 servants, attitude towards 88,
 214
 St Withburga's Church repairs
 397–8
 and Thomas William Coke 241,
 243–4
 water closets 167
 will 241, 243, 244, 249, 251
Coke, Marion (née Trefusis) 349,
 359–61, 502–3, 510, 511,
 514–15, 514
Coke, Mary see Le Strange, Mary
 (née Coke)
Coke, Mary, Lady (née Campbell)
 241, 243, 255
 ghost of 2, 114
Coke, Meriel (née Wheatley) 18,
 19, 28, 36
 daughters and sons, St
 Withburga's church 37
 monument to, St Withburga's,
 Holkham 28
Coke, Richard 315
Coke, Robert (1587–1653) 23,
 25–7, 28, 29, 32–4
Coke, Robert (1623–81), Captain
 49, 52, 54
Coke, Robert (1651–79) 50–3, 58
Coke, Robert (b. 1704) 59
Coke, Rupert, gilding renovation
 work 159, 160
Coke, Sarah (née Forde) 525
Coke, Silvia see Combe, Silvia (née
 Coke)
Coke, Theophilia see Legard,
 Theophilia (née Coke)
Coke, Thomas (1674–1727) 60
Coke, Thomas (1697–1759),
 1st Earl of Leicester (1st
 Creation)
 birth 59
 boating and fishing 113
 bust 233, 249, 325
 cockings 89, 112
 death 228
 death of heir 114
 debts 85–6, 89, 115, 185, 252,
 356
 descent from Edward Coke
 6, 77
 education 64–5
 estate management 82–3, 85–6
 notes and queries about 82
 expansion of Holkham property
 106–7, 115, 389–93
 first purchase document 389
 friendships
 2nd Duke of Grafton 138
 Andrew Fountaine (c.1677–
 1753) 54, 158
 fruit garden orders 199, 200
 funeral expenses 230
 Grand Tour of Europe (1712–
 18) 1, 2, 65–77, 79, 274
 architecture lessons 530
 Grand Tour accounts 67
 his guardians 45, 59–64, 389
 guardians' minute book 61

562 HOLKHAM

Holkham Hall
 concern for practical excellence 163, 179
 designing and planning 89–97, *90*, 99–102, *102*, *116*
 financial constraints and management system 102–8, 110–11
 heir's death and increase in building pace 114–16
 work on Family Wing 108–10, *109*, 115
 work on guest rooms 111–12
 work on landscaping 112–13
 work on Statue Gallery and rustic floor 116–17
household 79–82, 85, 86–9, 102–4
 food consumed (1719) 81, *81*
 household orchestra 86–7
 'The Number in Family at Holkham' (1730–31) *87*
hunting 83, 104, 112
interests
 architecture 68, 71, 73–4, 84, *84*, 92, 530
 art works 72–3, 76, 83, 227–8
 books 61, 69
 literary manuscripts 71, 76, 83
 paintings 68–9, 83, 227–8
 technology and practical excellence 163, 179
Landscape Room design *6*
landscaping and re-structuring of farm tenancies 181–9
landscaping plans and vision 36, 86, 189–91, 210–11
lead coffin 154
lead from London house 133
letters
 to his grandfather from Rome *70*
 to Matthew Brettingham *92*, 99, 135
marriage to Lady Margaret Tufton 79
marsh embankment 64, 83, 189, 434, 438–45
The Obelisk *78* (79), 89
offices and titles
 Freemason Grandmaster 88
 Knight of the Bath 89
 office of feodary and wreck of sea 451
 peerage 89, 97
 Postmaster General post 95, 126
personality 88
'phantom duel' 2, 452
portraits
 by Andrea Casali *98*
 in Bartoli's *Church of the Gesù in Rome 75*
 in Conca's *Vision of Aeneas in the Elysian Fields* 69
 by Francesco Trevisani *66*
 by Godfrey Kneller *104*
purchases
 Diana statue 73, *74*
 Jupiter statue 73, *73*
 Lucius Verus bust 71, *72*

Thomas Dempster's *De Etruria Regali* 83–4
Van Dyck's *The Duc d'Arenberg 76*, 77
quotes
 on Brettingham's talents 105
 on carpenter Lillie's rates 140
 on carver John Woodward 148
 on grandfather Robert Coke's marriage 53
 on having 'ate up all my neighbours' 211
 on heating from below 173
 on marble carver Joseph Pickford 150
 on masons' rates of pay 143
 on Mr Oram 203
 on orangerie and fruit 196, 198
 on plaster Thomas Clark 144
race horses 89
servants, attitude towards 214
South Sea stock speculation and debts 85–6, 356
stone supplies 126
visit to alabaster pits 127, 129
water closets 167
will 230–1
Coke, Thomas Edward (b. 1965), 8th Earl of Leicester 10, 483, 484–5, 529, *529*
Coke, Thomas William (1754–1842), 1st Earl of Leicester, 2nd Creation
 agricultural reformer 7, 247, 251–2
 bust 325
 Counting House, demolition of 544n51
 death and funeral procession 283, 319
 debts 252–3
 domestic life 279–81
 Earl of Leicester title second creation 247, 281–2, 416
 Royal charter granting title (1837) *282*
 estate management 248–9, 251
 friendship with 'Bessy' Caton 266
 Grand Tour 244, 251, 252, 254
 Holkham Hall improvements 253–5
 Holkham property, expansion of 182, 398–402
 Holkham property, inheritance of 244, 245, 247
 Holkham Staithe village building campaign 404–10, 413–14, *414*
 Holkham Yeoman Corps 452–3, *453*
 hosting skills 265–6
 hunting and shooting 262–3
 Knight of the Shire for Norfolk 248
 landscaping 251, 285–8, 291, 292, 297–300
 lifestyle 267
 and Margaret Coke, meeting with 241
 marriage to first wife 251
 marriage to second wife 266–7

marshes maintenance 445–6
member of parliament 7, 248, 255, 256
Monument in memory of *261*, 304, *307*, 311, 465–6, 478, *479*, *518*
paintings and other art works commissioned by 273–7
personality 271
portraits
 by Pompeo Batoni *250*, 253
 by R. R. Reinagle 274
 by Thomas Gainsborough 256, *258*, 274
quotes
 on full employment in parish 413
 on minimum income from estate to live in Hall 495–6
 on smuggling system and Holkham Gap 452
 on visitors not allowed to 'trespass' 299, 465
Sheep Shearings 257, 259, 263, 266, 273, 279
 as depicted on Monument in memory of T. W. Coke (1754–1842) *261*
 Longlands Field Barn (or Great Barn) 296–7, *297*
 Sheep Shearings (George Garrard) *7*
 Wine Book showing consumption at *260*
stables, removal of cupola from 233
Wells Enclosure Award 299
Whig politics 248, 255–7, 276–7
 1782 Commons' address against American War 256–7
Coke, Thomas William (1793–1867) 322
Coke, Thomas William (1822–1909), 2nd Earl of Leicester
 birth 280
 children 337, 345, 346, 347, *348*, 349
 completion of village property purchases 417, 418
 cottage improvement 355
 cricketer 341, 342
 dancing, whist and charades 351
 death 361, 487
 deer park at Holkham 64
 Estate Office 327
 farming and land acquisition 353–6
 forestry management 315, 449
 game book 281
 Holkham, contribution to 320, 324–5
 Holkham, inheritance of 7, 9, 319, 322–3
 investments 356–7, 361, 495
 Keeper of Duchy of Cornwall's Privy Seal 345
 landscape gardening 310
 landscaping 301, 304
 lifestyle 340–2
 marriage to first wife 319–20
 marriage to second wife 347, 471

Index 563

marsh embankment 446–8
Monument in memory of T. W. Coke (1754–1842) 261, 304, *307*, 311, 465–6, 478, *479*, 518
note from agent re. school master post 349, 350
photographs of *11*, *348*, *356*, *360*, *474*
portrait by George Richmond *318* (319)
portrait of in Saloon 274–5
quotes
 on cottages' internal layout 423
 on Law Library of Sir Edward Coke 326
 on village population size and farming 400
railway 336, 356
royal connections 336–7, 340, 345
shooting 315, 342–3
stuffed bird collection 353, *354*
terraces and parterres 310
will 357–61
windows 324, 507
Coke, Thomas William (1848–1941), 3rd Earl of Leicester
birth 337
death 488, 496, 497, 505
farming 497–501
financial problems 492, 495, 503–4
forestry 501
George VI's telegram on 90th birthday 504
Harrow and military career 345
Holkham, inheritance of 9, 358–60, 487–8
Holkham Hall, improvements to 489–92
investments in estate 495
lifestyle 492, 502
marriage 359–61
military camp and public sports 473–4
photographs of *11*, *358*, *501*, *510*
portrait by William Orpen *489*
on Queen Alexandra and Italian craftsman 491
shooting 501
on World War II 504–5
Coke, Thomas William (1880–1949), 4th Earl of Leicester
death 511
deer park 316
diary entry (July 1944) *508*
financial problems 497
inheritance 9, 505–6
marriage 471–2
National Trust discussions 508–9
open roasting range film 368
personality 505
photographs of *11*, *494*
quotes
 on being reminded of father's old age 487–8
 on country houses' lack of future 488
 on electric light at Holkham 379
 on father's attitude to finances 495, 503–4
 on father's improvements to Hall 490
 on motor cars 492
 on teeth falling in Esse stove 507
 on Wells bank 451
 on windows restored to 18th century appearance 507
Coke, Thomas William Edward (1908–76), 5th Earl of Leicester
death 523
Equerry 515
on Gowers Report 478
Holkham, inheritance of 511–12
Holkham during 1914–18 War 494
paintings in Saloon 274–5
on partridges 315–16
photographs of *11*, *382*, *494*, *512*
playing the drums 502
portrait by Julian Barrow *522*
shared occupancy scheme with father 510–11
succession issues 10, 511–12, 519–22
windows 324
Coke, Wenman (1717–76, formerly Roberts)
debts 252
Holkham, Beatniffe's guide to 464
Holkham, inheritance of 6, 233, 243, 244–5, 251
Longford estate 129, 241, 291
Samuel Wyatt connection 301
Thanet House furniture 237
Coke, Wenman (1828–1907) 280, 319
Coke, Wenman (1855–1931) 337, 345
Coke, Winifred *see* Cobb, Winifred (née Coke)
Coleshill Hall (Berkshire) 172
Colling, A. W. 332
Colling, William Bunn 332
Collivoe, Isaac 227
Collyer, Robert, Rev. 281, 325
Columbine, Paul 221–2, 223, 226
Combe, Silvia (née Coke) 300, 379, *382*, 494, 502, 508
Common Channel 437, 439
Conca, Sebastiano 68
Vision of Aeneas in the Elysian Fields *69*
Coney Hall 317
Congham, Robert 36
Conisborough estate (Yorkshire) 58
stone supplies 127, *135*
conservatories/glasshouses
conservatories 292–3, 301, 311, 313, 517
conservatory and parterres *312*
conservatory before removal of roof and glass (1950s) *316*
conservatory interior (*c.*1911) *314*
greenhouse 116, 137, 143, 154, 197
heated glasshouses in walled gardens 313–14
Jupiter statue 73, *73*
new glasshouses in kitchen gardens 337
see also orangerie, vineries
cooks
female cooks 340
French cooks 80, 86, 175, 218, 268, 340, 344
Copeman, Edward 140, 221, 392
Copping, John 412
Cortona, Pietro da 544n31
Coriolanus 276
cottagers' allotments 410–11
cottages
cottage improvement 355, 402, 408, 410
cottage tenant lists 388, 390
see also the village
Coulsey cottage 398, 400–1, *401*
Counting House 154, 233, 249
Country Accounts 239
country houses
building slump (1740s) 110
history of 3–4
water closets 167
Court of Wards 18
Cowtan & Co 490
craftsmen
alabaster masons 151–2, 154, 159
blacksmiths 154, 156
bricklayers 137–40
 building accounts for work on Kitchen Wing (1755) *139*
carpenters/joiners 140–1, 143, 161
 Dining Room chimney piece *141*, *142*
 Lillie's bill *141*
 replica of Family Wing external door (Maurice Bray) *142*
carvers 148–50
 Library chimney piece frame by Marsden *149*
 Saloon chimneypiece *151*
consistency of workmanship 137
glaziers 154
interdependence of trades 160–1
Italian craftsmen 491
lesser local craftsmen and labourers 161
management of men and materials 106
marble carvers/masons 150–1
 bill for Saloon chimneypiece work *150*
 Saloon chimneypiece *151*
painters/gilders 156–8
 gilding renovation work *159*, *160*
 John Neale's bill for gilding work *157*
plasterers 144, 146–8
 bill from Thomas Clark *146*
 Marble Hall ceiling plasterwork *148*
 Statue Gallery niche by Thomas Clark *147*
plumbers 154–6
 John Bullin's bill for glazing and plumbing *155*
senior craftsmen's rooms 152, *153*

stone masons 143–4
wages and measured work rates 159–60
Crawford, David Lindsay, 28th Earl of Crawford 512
Creevey, Thomas 263
Cremer, Edward 183
Crick, Francis 209, 249, 277, 410
cricket/cricket ground 304, 320, 341, 342, 350, 469
'Croitch' plaster (Derby) 132, 135
Crook, John 412, 445, 448
Crook, Jonathan 445
Crossley, Savile, 1st Baron Somerleyton 377
Cuckoo Lodge 299, 303
and Haylett family 304
Cumberland, Duke see William, Prince, Duke of Cumberland
Curtis, Richard 36, 124

Dacre, Barbara, Lady 548n6 (320)
Dahl, Michael
portrait of Cary Coke (née Newton) 57
portrait of Edward Coke (1676–1707) 56
dairy 127, 130, 178
Danby see Osborne, Thomas, Earl of Danby and Duke of Leeds
Danish camp 21
see also Borough (later Danish camp)
Daplyn, Mathew 341
Dawson, J. 465
Day, William 172–3, 176
Dean, G. A. 332
death duties 497, 511, 521
deer parks
Elmham 29, 64, 88, 316
Holkham 64, 316–17
Dempster, Thomas, De Etruria Regali 83–4
Denny, Mr 274
Derby, 'Croitch' plaster 132, 135
Desaguliers, Dr John 167
Devall, George 133, 154, 167–8, 170
bill for water closets and baths in Family Wing 168
Devall, John 154
Dewes, William 54
Diana statue 73, 74
Digby, Henry, Sir 280
Digby, Jane 280
Dining Room
chimneypieces 141, 142, 150
large-scale hospitality 263
painting/gilding 158, 219
plaster work 146, 146
serving room behind 166, 217
Discalced Augustinian manuscripts 71
distilling equipment 217
Doggett, John 344
Donthorn, William, watercolour of Monument in memory of T. W. Coke (1754–1842) 307
Douglas, John 429
dove house 200, 201, 404
Dowbiggin (decorators) 323, 324, 332

Drawing Room
ball (1865) 352
busts 271
chimneypieces 150, 151
furnishing and furniture 225, 237, 352
griffins 220, 235
large-scale hospitality 263
painting/gilding 219
paintings 275–6
plaster, carving and glazing work 116
refurbishing 490
whist playing 351
duck decoy 444–5
duel ('phantom duel') 2, 452
Dunbar, Robert 221, 222
dunes (or 'meals')
marram planting 449, 451
pinewoods 434, 449–51, 456
rabbit warren 448–9
watercolour of marshes and dunes (Robina Napier) 450
Dunmore, Charles Murray, 7th Earl of Dunmore 345
Dunmore, Gertrude (née Coke), Lady 336, 345
Durno, John 173
Dutton, James, 1st Baron Sherborne 244

East Anglian Electric Supply Company 379
East Drawing Room (later South Dining Room) 150, 219, 220, 235
see also South Dining Room (or Breakfast Room)
Eastern Association 31–2
Easton, James 368
Easton and Amos 368, 369
Edge, John 39
Edward VII, King see Albert Edward, Prince of Wales (later Edward VII)
Edward VIII, King 515
Edwards, William 124
Egmere property 252, 274, 332
Egyptian Hall (or Marble Hall) 337
see also Marble Hall
electric fire alarm 385
orders in case of fire (c.1912–30) 384
electric lighting 375, 377–9, 381–3
battery room 381
generating engines room 382
generating system diagramatic plan 380
mercury arc rectifier 381–3, 383
power house building 379
rewiring 518–19
twin generating engines 381
village 429
Elizabeth, Queen Mother 514
Elizabeth II, Queen 473, 514
coronation 514–15, 515
Ellett, James 161
Elliot (furnishing tradesman) 222–3
Elliot, John (bricklayer) 115, 138–40, 141, 159, 171, 173, 393
Elmham see North Elmham estate

Emerson, Edward 156, 403, 406, 410
Emerson, Richard 410, 412, 413
Emerson, Russell 412, 413
Emerson, Stephen 333, 410, 412
Emes, William 291, 298
Emos (or Emon), Mr 222
The English Gentleman (Richard Brathwayt) 44 (45)
Esher, Oliver Brett, 3rd Viscount Esher 508, 509
Essex, Robert Devereux, 2nd Earl of Essex 13
estate duty legislation 495–6
Estate Office
building 326–30, 491, 518
functions 339, 344, 346, 364, 473–4, 526
Euston Hall (Suffolk) 138, 140, 158, 190
evidence chambers/rooms 33, 63

Family Wing
bathrooms 167–9
building of
brick making 124
bricklaying 138
design and plans 91–2, 108–10, 109
duration of building project 106, 115
glazing 154
marble pieces 131–2
plastering 132, 144
chimneypieces 150, 151
furnishing 221, 222, 223
gallery of communication 99
laundry 371
Margaret Coke's move from 234–5
outside view 107
portraits of T. W. Coke and family 274
replica of external door (Maurice Bray) 142
re-slating 133
as self-contained family home 524, 525, 529
servants' rooms 213–14
sewer system 171, 172
staircase 156
underground passage 231
views of ports of Sicily 71
water closets 167, 168, 169, 170
water supply 163, 165
farm tenancies
and landscaping plans 181–9, 285–6, 288, 299–300
park and farms (1745) 188
plans of farms created/restructured 183, 185, 186, 187
tenanted farms and expansion of park (1778–1809) 287
see also the village
Farmhouse 291
see also Model Farm (previously Hunclecrondale farm/ Farmhouse/New Inn)
farming see agriculture/farming; saffron farming; Sheep Shearings
farming parties 260

Index 565

Farnham Royal
 (Buckinghamshire) 48, 114
Feetham & Co 333, 365, 366, 368
fernery 301
 grotto in *300*
Ferrari, Domenico 66, 86
Ferrari, Giovani Battista, classical
 orangery drawing *197*
ferry boat (on lake) 296, *296*
Festing, Andrew, staff portraits *9*,
 526, *528*
fire safety 383, 385
 Fire King steam engine 385, *385*
 orders in case of fire (*c*.1912–30)
 384, 385
fishing and boating 113
Fitzgerald, Gerald 133
Fitzroy, William, General 277
Flitcroft, Henry 90
floods (1953) 455, *455*, *456*
flooring 124–5, *125*
Fodder, William 397
foldcourses 15–16, 20, 21, *22*
forestry *see* tree planting
fountain 311, *313*
Fountaine, Andrew (*c*.1637–1707)
 46, 48–9, 50, 53, 54, 58
Fountaine, Andrew (*c*.1677–1753)
 54, 158
Fountaine, Brigg 46
Fountaine, James 50
Fox, Charles James 248, 255, 256,
 271, 274
fox hunting 53, 83, 112, 262
Fulmodestone 23, 121, 124, 355,
 496
Furber, Robert 190
Furnis, James 133

Gainsborough, Thomas 273
 portrait of T. W. Coke (1754–
 1842) 256, *258*, 274
game larder (by Samuel Wyatt)
 166, *262*, 330
Ganeron, Mrs 238
gardens *see* conservatories/
 glasshouses; cottagers'
 allotments; kitchen gardens;
 pleasure gardens
Gardiner, Richard 249
Garrard, George, *Sheep Shearings* *7*
Garry, Mary-Anne 545n53
gas lighting 334, 375–7
 gas house photograph *376*
 gas house plan *377*
 Loco Vapour Gas 377, *378*
 producer gas area *380*
Geeraerts, Marc, the younger,
 portrait of Edward Coke
 (1552–1634) *12* (13)
George III, King 256–7, 282
George V, King 473
George VI, King 515
 telegram to 3rd Earl on his 90th
 birthday *504*
George Wright Ltd 367
ghost, of Lady Mary Coke (née
 Campbell) 2, 114
Gibson, Robert 341
Gibson, S. 341
Girle, Caroline (later Libbe
 Powys) 174–5, 177, 219, 462,
 463
Girouard, Mark 3

Girvan, Hugh 301, 311, 427
glasshouses *see* conservatories/
 glasshouses
Glenconner, Anne, Lady (née
 Coke) 514, 515, *515*
Glorious Revolution Centenary
 Ball (1788) 255–6
 newspaper report 257
 replies to invitations 256
 see also ball (1865)
Godwick estate
 bought by Sir Edward Coke 14,
 17, 25
 breeding mares and foals 83
 church repairs 62
 under Robert Coke (1587–1653)
 33
 under Robert Coke (1651–79)
 51, 52–3
 tenancy to Ralph Cauldwell 249
Golden Gates Lodge 306, *309*
Goodison (cabinet maker) 224,
 225
governesses 340
Gowers Report 478–9, 480, 512,
 513, 516
Grafton, Charles FitzRoy, 2nd
 Duke of Grafton 138, 235
Grant, Sir Francis, portrait of
 Juliana Coke *321*
Great Barn 257, 296–7, *297*
Great Book of Conveyances (Sir
 Edward Coke) 14, *15*
Great Hall *see* Marble Hall
Green State Bedroom *236*, 353,
 503, 525
 'America' tapestry detail *212*
 (213)
 bedspread repair 526
 Gavin Hamilton's *Juno and
 Jupiter* 229
Gresham, Ann, Lady 18, 21
Grey, Jemima Yorke, 2nd
 Marchioness Grey 111, 442,
 461, 462
Griffier, Jan, the younger 253
Griffin, Thomas 137–8
grotto (in fernery) *300*
Guard (or Armoury) Room 218,
 352
Guelphi, Giovanni Battista 150
Guest's Lodge (later Scarborough
 Lodge) 303
guide books 463–5, *464*, 466–7,
 477, 480, *481*
Gunpowder Plot 13–14
Gwavas, William 49, 52, 54, 58

Hacket, Richard 221
Hagon, Guy 410, 414
ha-has 195, 203, 288
Hall, Thomas 156
Hall Farm (later Park Farm)
 malthouse 396
 sheep breeding 259
 under T. Coke (1697–1759)
 182, 185, 187–8, 189
 under T. W. Coke (*c*.1776–1842)
 251, 279, 288, 296, 297, 298,
 299–300
 under 2nd Earl (*c*.1842–1909)
 354
 under 3rd Earl (*c*.1909–41)
 497–9

under 4th Earl (*c*.1941–49)
 500–1
under 7th Earl (*c*.1976–2005)
 523
Hallett, William 222
Hamilton, Gavin 227, 236
 Juno and Jupiter 227, *229*, 236,
 238
Hanchett, Captain 452
Harding, Chester, portrait of
 Francis Blaikie *278*
Hardwick Hall (Derbyshire) 175
Harewood Hall (Yorkshire) 175,
 340
Harris, John 543n24
Hart, John 156
Harvey, Mary (née Coke) 508
Harvey, Tom 511
Harvey, William 273
Hassall, W. O. 507, 511
Hastings, Francis Edward Rawdon-
 Hastings, 1st Marquess of
 Hastings 271
Haydon, Benjamin 273
Haylett (family) 304
Hayter, George, Holkham Hall
 from the south (1820s) *248*
heating
 central heating 363–5, 524
 leaflet re. central heating
 system *364*
 oil boilers (1997) 365, *365*
 fireplaces and stoves 173–4
 hot air heating 172–3
 wood cellar 173
Henrey, Blanche 543n19 (189)
Henshaw, Thomas 537n15 (50)
heritage designation scheme
 481–2
Hervey, John, 2nd Baron Hervey
 91
Hewittic (mercury arc) rectifier
 381–3, *383*
Heydon, Susan 39, 43
Hibbert (family) 310
Hibbert, George 273
Hill Hall (or Wheatley) manor
 acquisition by Sir Edward Coke
 and size of estate 18, 19–20
 demolition and replacement
 with Holkham Hall 79,
 108, 213
 description of manor house
 14, 20–1
 evidence room 63
 extension and improvements
 39–40, 43
 foldcourses 22
 household and bills under John
 Coke the younger 47–8,
 47, 48
 household servants 39
 improvements to house under
 John Coke the younger 46
 inventory after John Coke's
 death 42
 John Coke's inheritance issues
 23, 25
 Philip Palgrave's accounts *41*, 43
 stylised view *20*
 surrounding land 181
 working farm 40–1, 43
Hinchcliff (London mercer) 221
Hobart, John 43

566 HOLKHAM

Hobart, Thomas, Dr 65, 66, 67, 68, 69, 72, 83
 in Bartoli's *Church of the Gesù in Rome* 75
Holkham Country Fair (1977) 460 (461)
Holkham cricket team 341
Holkham deed (1658), Norfolk yeoman 35
Holkham Enterprises 484–5, 529
Holkham Gap 434–5, 437, 439, 452, 454, 456
Holkham Hall
 brief history 1–5
 Hill Hall known as 38, 39
 map of Norfolk 3
 number of rooms 172
 outside views
 aerial photograph from south-west 5
 early aerial view 487
 from the north (W. Watts, 1782) 246 (247)
 from the south (George Hayter, 1820s) 248
 south front 96–7
 south front (1816) 4
 south front (2006) 2
 South Front by Matthew Brettingham 94
 South Front by William Kent 94
 south front showing 1840–50s window panes 323
 from the south towards marshes and sea 440
 from the South with park *x* (1)
 with stables 233
 see also craftsmen; Holkham Hall (1722–76); Holkham Hall (1776–1842); Holkham Hall (1842–1909); Holkham Hall (1909–2000); materials; modernisation (19th–20th centuries)
Holkham Hall (1722–76)
 1722–56 under Thomas Coke
 designing and planning 89–97, 90, 99–102, 102, 116
 financial constraints and management system 102–8, 110–11
 heir's death and increase in building pace 114–16
 work on Family Wing 108–10, 109, 115
 work on guest rooms 111–12
 work on landscaping 112–13
 work on Statue Gallery and rustic floor 116–17
 1756–59 under Thomas Coke
 building activity 218–21
 furnishing and furniture 221–7, 222, 225
 Margaret Coke's list of furniture for staterooms 226
 purchases of state room furniture 224
 servants and servants' rooms 213–18, 215, 216, 218
 Thomas Coke's death and funeral expenses 228, 230
 works of art 227–8, 228, 229

1759–75 under Margaret Coke
 account books 238–9, 239
 building activity 230–4
 furnishing and furniture 234–6, 238
 guests and visitors 241
 household size 239
 paintings 236–8
 relations with poor and tenants 239–41
 succession issues 241, 243–5
Holkham Hall (1776–1842)
 debts 252–3, 279
 domestic life 279–81
 estate management 248–9, 251, 277–9
 size of estate 248
 farming 247, 251–2
 Sheep Shearings 257, 259, 261, 263
 hospitality 247, 282–3
 audit dinners 259
 and design/facilities of Hall 263–4
 farming parties 260
 Glorious Revolution Centenary Ball 255–6, 256, 257
 and owners' hosting skills 265–6
 Sheep Shearings house parties 259, 260
 summer hospitality 260, 262
 winter (hunting and shooting) 262–3
 household
 servants 267–8
 supplies 268–70
 improvements
 libraries 271–3
 nursery rooms 254–5
 paintings and other works of art 253–4, 271, 273–7
 window bar gilding account page (1810) 254
 Whig politics 247–8, 255–7
Holkham Hall (1842–1909)
 2nd Earl's marriage 319–20
 2nd Earl's wealth 322–3
 alterations and improvements 323–4, 326, 334–7
 bowling alley 334, 335
 Chapel Wing bathroom 332
 domestic quarters (south) 330–1, 330
 Estate Office 326–30, 339, 344, 346
 gas lighting 334
 kitchen 326
 library 323, 326
 Marble Hall 324–6, 337
 north vestibule 331, 331
 porter's lodge 328–30, 329
 portico floor 332
 refurbishing 337
 Saloon 337
 stables 328, 329, 330
 water supply new system 334
 windows 324, 507
 windows in Saloon and Marble Hall 331–2
 ball (1865) 351, 352, 376
 changes in use of rooms 350–3
 cricket 341, 350

family life 345–50, 352
farming developments 353–6
general building contractors 332–3
household
 servants 322, 337, 338, 339–40, 341–2, 343–4, 346–7
 supplies 344–5
inheritance issues 357–61
measured work system 333
railway 336–7
 Holkham station 337
 train information for guests 336
royal visits 336–7, 340, 345, 351, 360
shooting 342–3
Holkham Hall (1909–2000)
 decline and revival 487–8
 under 3rd Earl (*c*.1909–41)
 allocation of guest rooms 493
 entertaining and large parties 492, 502–3
 falling income and estate duty 494–7
 WWI-related changes 492, 494
 household 492
 kitchen gardens making a loss 502
 lake 492
 list of meals provided (1929) 500
 list of vegetables and fruit from gardens (1931) 498, 499
 male servants (1920s) 503
 motor cars 491–2, 491
 refurbishing 489–91
 secret Auxiliary Unit during WWII 505
 telephone 491
 unaffordability of lifestyle 503–4
 under 4th Earl (*c*.1941–49)
 alterations to windows 507
 discussions with National Trust 508–9
 household 505–7, 506, 511
 shared occupancy scheme with heir and family 509–11
 succession issues 511–12
 WWII-related arrangements 506, 507–8, 510
 under 5th Earl (*c*.1949–76)
 financial problems and National Trust 511–13
 Gowers Report and renovation grants 516–18
 income from estate 519
 opening to paying public 514
 renovation work 517–18
 rewiring and refurbishing 518–19
 royal connections and 1953 coronation 514–15
 succession issues 519–22
 under 7th Earl (*c*.1976–2005)
 improvements to Hall 522–3
 Park Farm restructuring 523
Holkham manor house *see* Hill Hall (or Wheatley) manor

Holkham National Nature Reserve 458, 459
Holkham Park (1719–1872)
　creation time line (1719–66) 531–2
　expansion and change time line (1776–1872) 533–4
Holkham Park (1722–64)
　1st development phase (1722–34) 191–201
　　account book page *193*
　2nd development phase (1734–53) 201–10
　ananas house 112, 154, 200
　Avenue 202–3, *202*
　basin 192, 194, *194*, 195, 206, 298–9
　Church Wood 195
　dovecot *200*, 201
　enclosure and Royal licence 201
　farms restructuring 181–9
　　farms created/restructured *183*, *185*, *186*, *187*
　　park and farms (1745) *188*
　greenhouse 116, 137, 143, 154, 197
　ha-ha 195, 203
　icehouse *162* (163), 178–9, *178*, 200–1
　kitchen gardens 112, 137, 173, 182, 184, 198, 200
　　survey of fruit grown *199*
　　Thomas Coke's (1697–1759) orders re. garden *199*, 200
　lake (or 'Broad Water') 113, 193–4, 195, 205–6, *206*, 210, *233*, *422–3*
　Lawn 192, 195
　　North Lawn 172, *172*, 208, *209*
　long views and walks 195
　menagerie house 113–14, 201
　north gate almshouses 210
　North Lodge 208–9, *211*
　Obelisk 89, 95, 137, 143, 156, 182, 208
　　drawing *192*
　　photograph *78* (79)
　　William Kent design 190, 192–3
　Obelisk Hill 195, 203
　Obelisk Wood 89, 175, 192, *193*, 195, 203, 204
　orangerie 109, 126, 143, 197–8, 204
　　classical orangery (Giovani Battista Ferrari book) *197*
　　seat drawing *198*
　park and farms (1745) *188*
　pavilions
　　gravelled walk 195
　　William Kent design 190, 192–3, *194*
　　pleasure gardens 195, 197
　Seat on the Mount
　　construction 204–5
　　drawing *192*
　　gravelled walk 195
　　William Kent's proposal *194*, 204–5, *205*
　Serpentine River 206, 207
　Shoulder of Mutton Pond 194–5, 205–6, *206*

South Lodge 203, *204*, 209
Staithe Wood 195
Temple
　building of 120, 126, 137, 140, 143, 154, 158, 192
　furnishings 195
　and Obelisk Wood 204
　original feature 182
　photograph *196*
　section view *196*
　William Kent design 190, 192–3
Thomas Coke's (1697–1759) landscaping plans 189–90
　landscaping design on large planning map *191*
tree planting 201
Triumphal Arch 123, 144, 204, 207–8
　Eliza Blackwell sketch *208*
　William Kent design *207*
view from south-east *180* (181)
Walled Pond 194–5, 205–6
Holkham Park (1776–1842)
　cricket ground 304
　expansion of park to south-east 299
　expansion of park to west 251, 285–6, 288
　expansion of park (1778–1809) *287*
　park boundary *286*
　Great Barn 296–7, *297*
　ha-ha 288
　lake 251, 291, 298
　lodges 301–4, *302*, *303*, *304*
　Model Farm (previously Farmhouse/New Inn) 291, *291*
　new kitchen gardens 251, 288, *289*
　park from the north-west *284* (285)
　park plan (1843) *305*
　park wall 304
　pleasure gardens 292–5
　　arboretum 300–1
　　arch gate to garden design *293*
　　glasshouse/conservatory 292–3
　　grotto in fernery *300*
　　map (1843) *294*
　　'Walk to garden' by Eliza Blackwell *294*
　pleasure gardens by lake 295–6, 297, 300
　Repton's designs *295*, *296*
　Temple 292
　　occupants (1922) *292*
　tree planting campaign 251, 291–2, 315
　John Sandys' tree planting record *290*
　vinery 288, *289*, 293, 295
Holkham Park (1842–)
　Coney Hall and rabbit warren 317
　conservatories/glasshouses 311, 313
　　conservatory before removal of roof and glass (1950s) *316*
　　interior of conservatory (*c.*1911) *314*

　parterres and conservatory (late 19th century) *312*
deer park 316–17
forestry and shooting 315
gardens
　fountain 311, *313*
　heated glasshouses in walled gardens 313–14
　parterres with conservatory *312*
　terraces and parterres 310–11
　west parterre drawing *312*
lake 310
lodges 306–10
　Golden Gates Lodge 306, *309*
　South Lodge 306, *308*
　Wells Entrance Lodge 306, *310*
Monument in memory of T. W. Coke (1754–1842) 304, *307*, 311
North Gates 304–5, *306*, *307*
notice for sports and gymkhana (1900) *473*
notice from park gate (1868) *470*
reservoir 331, 369, 385
sheep, cattle and partridges 315–16
Holkham Pottery 480, *513*
　publicity leaflet *483*
Holkham Staithe
　aerial view of oldest surviving cottages *405*
　building campaign under T. W. Coke (*c.*1776–1842) 404–10, 413–14, *414*
　Chapel Yard 406, *407*, *408*, 410, 411, 417, 419–20
　plan and photograph *409*
　cottage tenants employed to build the Hall 393
　maps (1590 and *c.*1745) *399*
　medieval history 388
　Octagon Cottage 303, 305, *386* (387), 404, *405*, 406, 411, 428
　plan of village (1778) *406*
　purchase and demolition of cottages under T. W. Coke (*c.*1776–1842) 398–402
　surviving village 387
　Tithe Map (1839) *407*
　treated as estate village 394
　Widows' Row 406–7, *408*, 421
　see also Ancient House; Staithe Farm
Holkham station *337*, 468
Holkham town
　carpenter's shop 396
　craftsmen living in 392–3
　demolition of manor house (1756) 398
　disappearance of 285, 387, 391, 403, 431
　farm tenancies and landscaping plans 182, *183*, 189
　Holkham walled kitchen garden site 198, 210
　location 14
　map (*c.*1745) *392*
　map and occupiers (1590) *388*
　medieval history 388–9
　smithy 156, 396

Holkham Yeoman Corps 452–3
 part of standard used as fire
 screen 453
Holland, sand supplies from 124,
 135
Hope, Michael 152
The Horse and Farrier 152, 412
Horse and Flower Show 474, 476
 programme 475
hot air heating 172–3
Houghton Hall 43, 154, 167,
 247–8, 391, 413
household orchestras 86–7
Howell, Joseph 127, 144, 152, 159
 mason's bill *126*
Hudson, John 479
Hudson, Thomas Moore 478, *479*
Hughes, Christopher 280
Hughes, Richard 133
Hunclecrondale Farm 188, 288,
 291, 396, 397
 plan (later re-built as New Inn/
 Model Farm) *187*
 see also Model Farm (previously
 Hunclecrondale farm/
 Farmhouse/New Inn)
Hunt, J. Dixon 543n24
Hunt, James 436–7
hunting 53, 83, 104, 112, 262–3
 see also shooting
Huntingfield Hall 49, 52, 58

icehouse 162 (163), 178–9, *178*,
 200–1, 213, 374
ice-making plant 374–5
 plan *375*
Ince, Philip 156
Interregnum 37
invasion threats and precautionary
 measures
 1939–45 War and reparation
 claims 453–5, *454*
 Napoleonic Wars and Holkham
 Yeomanry Corps 452–3
 Seven Years War 452
Ives, Edward 133, 154–5, 160, 170
Ivory, John 154

Jackson, Robert 137, 393
James, C. W. 49, 505
James I, King 14, 18
Jarrett, Edward 67, 80, 85, 530
Jarrolds guide 477
Jelf, Andrews 143, 144, 160
Jenny Lind children's hospital 357
Johnson, Edward 406
Johnson, Thomas (and sons) 152
Jolly, Frederick C. 526
Jolly, William 161, 391, 396
Jones, Inigo 150
Jones, John 272
Jones, William 262
Julian, John 36
Julings, Isaac 425
Jupiter statue 73, *73*, 221, 227–8,
 311, 313, *314*

Keary, H. W. 326, 328, 354, 468–9
Keating, Robert 158
Kent, William
 contribution to Holkham Hall
 91–2, 96–7
 contribution to Holkham Park
 95, 190, 192–3, 211, 301

The Designs of Inigo Jones 150
John Vardy assistant to 148
meeting with Thomas Coke in
 Italy 68, 71, 73
from painting to architecture
 91, 93
plans and designs
 chimneypiece design for
 Margaret Coke's dressing
 room 150
 chimneypiece designs for
 Family Wing 150
 clumps on North Lawn 208,
 209
 The Library in Family Wing *93*
 The Marble Hall, exploded
 plan by *100*
 Marble Hall plans with
 fireplaces 172
 Marble Hall stairs 99
 North Lodge and North Lawn
 design 208–9, *209*
 Obelisk design 95, 190, 192–3
 pavilions designs 190, 192–3,
 194
 Seat on the Mount proposal
 194, 204–5, *205*
 south basin and pavilions
 drawing *113*
 South Front *94*
 South Lodge design 203
 stone bridge 207, 298
 Temple design 190, 192–3
 Triumphal Arch design 204,
 207, *207*
Keppel, Anne, Lady *see* Coke,
 Anne, Lady (née Anne
 Keppel)
Kinderley (or Kindersley),
 Nathaniel 438–9, 440
King, Gregory 62
King, Zephaniah 421–3
 houses designed by *422*
 plan of Reading Room *424*
 plans for restoration of Ancient
 House *426*, 427
Kitchen Court 166, 171, 178, 232,
 331, 372
kitchen gardens
 as built under Thomas Coke
 (*c*.1728) 112, 137, 173, 182,
 184, 198, 200
 survey of fruit grown *199*
 Thomas Coke's orders re.
 garden *199*, 200
 as built under T. W. Coke
 (*c*.1780) 251, 288, *289*
 and demolition of cottages 391
 heated glasshouses 313–14
 heating systems for hot houses
 334
 list of fruit supplies from (1931)
 498
 list of vegetables from (1931)
 498
 making a loss 502
 new glasshouses 337
Kitchen Wing
 bakehouse 178
 building of 117
 bricklaying expenditure
 (1755) *139*
 slating work 133
 domestic offices 326, 372

fireplaces 163
fish larder 178
kitchen
 with 19th-century fitments
 174
 bricklayer's bill for fitting
 out *176*
 charcoal stoves 175
 description 174–7
 preparation for re-enactment
 (2011) *484*
 refit (1840s/early 1850s) 326,
 365–8, *366*
 restoration work 518
 steam kitchen 363
 stillroom kitchen *175*, 507
 kitchen yard plan (Teulon) *325*
 renovation work 517
 requisitioned during WWII
 506–7, 510
 salting larder 178
 senior craftsmen's rooms 152,
 153
 servants' bathroom 372
 servants' rooms 217, 218
 teas for visitors 480
Knatts *see* Knotts (or Knatts)
Kneller, Godfrey, Sir, portrait of
 Lady Margaret *104*
Knight, Richard Payne 273
Knightley, George 18
Knotts (or Knatts), Henry 184–5,
 186–7, 189, 288, 392, 393, 396
 plan of restructured farm *186*
Knotts (or Knatts), Robert 156,
 184, 391, 396

Lack, Francis 140, 156
Lack, John 396, 414–16
Lack, Widow 393, 396
Lack, William 140, 156
Lady Anne's Drive 398, 410, 434,
 454, *455*, 457, 458
lake (or 'Broad Water')
 Repton's lakeside pleasure
 gardens 295–6, *295*, *296*,
 300, 310
 under Thomas Coke (*c*.1720–
 40) 113, 193–4, 195, 205–6,
 206, 210, *233*, 442–3
 under T. W. Coke (*c*.1782–1800)
 251, 291, 298
 under 2nd Earl (*c*.1845) 310
 under 3rd Earl (*c*.1910) 492
 see also basin, Clint
Lamb, Matthew 110, 114, 233
landscape gardening 189, 285
Landscape Room
 also called 'state dressing room'
 102
 chimneypieces 150, 151
 completion of decoration work
 219
 high-quality floor boards *125*
 paintings *6*, 273, 524–5
 refurbishing 323, 491, 525
Langran, Nanny 503, 524
laundry
 Chapel Wing laundry 178,
 213, 371
 Family Wing laundry 371
 laundry maids 334, 343, 371
 on drying ground (1920s)
 374

Index 569

laundry yard plan (Teulon) 325
purpose-built (1856) 371
 building 373
 inside (c.1910) 373
 plan detail 362 (363)
 William Burn's plan 372
 requisitioned in WWII 506
Laundry Court 171, 232, 331
Laver, James, guide book 481, 553n39 (480)
Lawn 192, 195
 see also North Lawn
Lawrence, Thomas, Sir 273
Le Strange, Mary (née Coke) 36, 37, 38
Le Strange, Nicholas, Sir 31, 38
Le Strange, Nicholas, Sir (son) 36, 38
Leeds, Duke of see Osborne, Thomas, Earl of Danby and Duke of Leeds
Lees-Milne, James 509
Legard, Charles 36
Legard, Theophilia (née Coke) 36, 37
The Leicester Arms 396–7, 412
 see also *The Ostrich*
Lenygon & Co 490
Leo X, Pope, portrait of 276
Leonardo da Vinci 83
library
 Classical Library 272, *272*, 516, *517*
 collections
 appreciated by guests 264–5
 Cary Coke's books 58
 Civil War and Protectorate publications 38
 deposited at British Museum during WWII 507
 The gardener's kalendar (Philip Miller) 543n21
 rare items sold (1851) 326
 reorganising and cataloguing 272
 Sir Edward's library 33–4
 Sir Edward's library catalogue on parchment roll *34*
 small sales (1950s) 516
 Soccinian works 39
 from Thanet House, London 236–7, 238
 Thomas Coke's (1697–1759) books on architecture listed *84*
 Thomas Dempster's *De Etruria Regali* 83–4
 library at top of house 238, 265, 272–3
 Long Library
 building of 108, *109*
 chimney piece frame by Marsden *149*
 enfilade to Chapel *103*
 four book-lined rooms leading to 272
 mosaic of lion 253, *253*
 photograph *110*
 plastering work 144
 refurbishing 323, 326
 William Kent's drawing of library *93*
 Manuscript Library 167, *169*, 272

lighting (18th century) 179
 see also electric lighting; gas lighting
Lillie, James 115, 127, 140–1, 148, 159, 221, 225, 393
 joinery work bill *141*
Linstead, Will 33
lion and lioness sculptures (Joseph Boehm) 337, *338*
lion mosaic 253, *253*
Liverpool, slate supplies from 132, *135*
Loads, William 154
Lob's Hole 268
local currency 410
local suppliers 269–70, 344
Loco Vapour Gas 377, *378*
lodges 301–4, *302*, *303*, *304*, 306–10
Long Library see under library
Longford estate (Derbyshire)
 acquired by Sir Edward Coke 60
 bailiff and alabaster accounts 129–30
 heirs to 241, 243
 left to the dowager for life 319
 modernising of Hall 271
 'Norfolk husbandry' principles 251
 servants/stewards supplied by 58, 67, 79–80, 85, 88–9
 T. W. Coke's (1754–1842) alternative country seat 283
 Wenman Coke (1717–76) home 129, 241, 291
Longlands Farm
 building of 183–4, 189, 202, 203, 288
 foldcourses 22
 G. A. Dean's alterations 332
 'Great Barn' (1733) 183
 Land Army Girls 508
Longlands Field Barn (or Great Barn) 257, 296–7, *297*
 photograph (1965) *333*
 plan *183*
 size 188
 soup kitchen during WWII 508
 under T. W. Coke (1776–1842) 257, 296, 297
 timber yard fire 385
 under 2nd Earl (c.1842–1909) 354
Longlands village see New Holkham (previously Longlands village)
Longstreth, Matthias 60
Lorrain, Claude 83, 102
Lowestoft, battle of 46
Lucius Verus bust 71, *72*, 525
Lushers farm 183
Lushington, Thomas 38–9
Luti, Benedetto 68
Lyttleton, Sarah, Lady 264

Magna Carta 14
 Signing of Magna Carta (Francis Chantrey) 276–7, *276*
Mallet, Benoni 251–2
malthouses 396
Manton, Joe 281
Manuscript Library 167, *169*, 272

Marble Hall
 alabaster columns 127, *131*, 151–2, 243
 alterations under 2nd Earl (c.1842–1909) 324–6, 337
 ball (1865) 352
 bust of Thomas Coke (1697–1759) 249
 ceiling plasterwork by Thomas Clark *136* (137)
 changes in design 220–1
 chimneypieces 154
 classical music concerts 526
 as described to 18th-century visitors 462
 furnace under floor 172
 gilding and painting 158, 219
 joinery work 141
 large-scale hospitality 263
 mahogany rail 143, 231
 marble reliefs 253–4, 276
 masterpiece of high drama 442
 Matthew Brettingham's version *100*
 models for 231–2
 new windows 331–2
 vs north vestibule 331
 photograph *101*
 plaster work 147, *148*
 renovation work 517
 State Water Closet 169, *170*
 unfinished at Thomas Coke's death (1759) 231
 William Kent's contribution 91, 99, 172
 William Kent's exploded plan *100*
Margaret, Princess, Countess of Snowdon *514*, 515
Mariari, Giacomo 71, 73–4
Marillier, H. C. 490
marram planting 449, 451
Marsden (London carver) 149, 221
 Library chimney piece frame *149*
marshes
 the Borough (later Danish camp) 21–2, 435, *436*
 channels
 Borough 435, 437, 444
 Common 437, 439
 Mickle Fleet 437, 439, 446, 447
 creeks
 Bartle 439
 Schutt 439
 duck decoy 444–5
 embankment (central southern, 1719) 434, 438–45
 embankment (eastern, 1859) 434, 446–8
 embankment (western, 1659) 434, *432* (433), 435–8
 bank of 1659 covered in cowslips *432* (433)
 freshwater vs salt marshes 433–4
 Holkham Gap 434–5, 437, 439, 452, 454, *456*
 maintenance of banks and ditches in Audit Book (1735) *441*
 maintenance of marshes under T. W. Coke (c.1778–1842) 445–6

making a bank *447*
management by Nature Conservancy Council 458–9
marshes map (1590) *434*, 435
marshes map (*c.*1744–59) *442*
marshes map (*c.*1780) *443*
marshes map (eastern, 1780) *446*
marshes maps (1719 with lines of 1659 and 1719 banks) *439*
marshes maps (with Wells bank, *c.*2000) *444*
Nature Reserve scheme 458, 459
Salt Hole 435
smuggling 452
view towards marshes and sea *440*
watercolour of marshes and dunes (Robina Napier) *450*
Wells bank 355, *444*, 449, 451, 457–8
Wells West Marshes 446, 447
see also beach
Marshalsea 37
Martinelli (fireworks and illuminations) 255–6
Mary, Princess of Wales (later Queen) 491
materials
 bricks 119–21, 123–4
 expenditure on brickmaking from building accounts (1750) *121*
 exterior rustic brickwork detail *118* (119)
 Peterstone brickyard price list (1888) *122*
 carriage of materials 133
 John Sowter's bill *134*
 glass 119, 133
 lead 119, 133
 lines of supply diagram *135*
 mortar 119
 nails, hinges, locks 133
 plaster 119, 132
 roofing slate 119, 132–3
 Bangor (Welsh) slate 133
 Westmorland slate 132, 133
 sand from Holland 124, *135*
 stone 119, 125–33, 143
 alabaster 119, 127, 129–30
 alabaster bill of lading *130*
 alabaster detail, Marble Hall *131*
 Bath stone 119, 120, 127, *135*, 143
 Bremen paving 127
 exterior stone work *128*
 marble 131–2
 mason's bill *126*
 Newcastle flagstones 127
 Portland stone 127, 152
 Purbeck paving 127
 timber 119, 124–5
 mahogany 124
 oak 124–5, *125*
 Scandinavian timber 124, *135*
 wooden workmen's sheds 135
Matteveli, Bartolomeo 227
May, Henry 113, 123
May, Robert 113, 141
Meal House 448–9, *448*, *449*, 454, 456

measured work system 159–60, 333
menagerie house 113–14, 201
mercury arc (Hewittic) rectifier 381–3, *383*
Merryweather 383, 385
Miller, James 150, 231, 233
Miller, Philip, *The gardener's kalendar* 543n21
Minster Lovell property (Oxfordshire) 19, 48, 52, 110, 252
Mixed School and school house 411–12, *412*, 429
Model Farm (previously Hunclerondale farm/Farmhouse/New Inn)
 convalescent home during 1914–18 War 492
 G. A. Dean's alterations 332
 as home for Coke family 358, 529
 location 397
 as *New Inn* 281, 291, *291*, 403, 412, 416, 453
 as tenant farm 344, 445
 see also Hunclerondale Farm
modelling room 231–2
modernisation (19th–20th centuries)
 bathrooms 371–2
 bell system 368
 bread oven 366, 367–8, *367*
 brewhouse 372–4
 fire safety 383, 385
 Fire King steam engine 385, *385*
 orders in case of fire (*c.*1912–30) *384*, 385
 heating
 central heating 363–5, 524
 leaflet re. central heating system *364*
 oil boilers (1997) 365, *365*
 ice-making 374–5
 plan *375*
 kitchen 365–8, *366*
 laundry purpose-built building 371
 building *373*
 inside (*c.*1910) *373*
 laundry maids (1920s) *374*
 plan detail *362* (363)
 William Burn's plan *372*
 lighting, electric 375, 377–9, 381–3
 battery room *381*
 generating engines room *382*
 generating system diagramatic plan *380*
 mercury arc rectifier 381–3, *383*
 power house building *379*
 rewiring 518–19
 twin generating engines *381*
 lighting, gas 334, 375–7
 gas house photograph *376*
 gas house plan *377*
 Loco Vapour Gas 377, *378*
 producer gas area *380*
 water supply system 368–71
 pumps in artesian well *370*
 see also comfort and convenience

Monument in memory of T. W. Coke (1754–1842) *261*, 304, *307*, 311, 465–6, 478, *479*, *518*
Moor, Peter 141
Moore, Thomas 259, 268, 453
Moore, Tuttell 402, 417
Morecraft, Thomas 88
Morehouse, Thomas 141
Morris & Co 490
motor cars 491–2, *491*
Mowl, T. 543n24
Mutton (or Beefsteak) Room 269

Napier, Alexander 283, 320, 326, 354, 417–18
Napier, Alexander (Alec), the younger 350, 352, 474
Napier, Robina, watercolour of marshes and dunes *450*
Napoleonic Wars, and Holkham Yeomanry Corps 452–3
National Trust 2, 488, 508–9, 511–12, 513
Nature Conservancy Council (later Natural England) 458–9
Nature Reserve scheme 458, 459
Neale, John 88, 156, 157–8, 159, 226, 393
 bill from for gilding work *157*
Neale, Thomas 158
Neales Manor
 acquired by Sir Edward Coke 18–19
 and building of walled gardens 391
 farm restructuring 184, 185, *186*, 187
 house as centre of Hall Farm 187, 393
 inherited by John Coke 20, 23, 24
 leased by John Coke the younger 49
 location 14
 size and value 20, 21, 36
 stables 233
Nelson Wing 170, 268, *524*
Nesfield, William Andrews 301, 310–11, 334
 west parterre drawing *312*
Nevill, John 396
Neville, H. 465
New Holkham (previously Longlands village) 387, 402–3, 404, *404*
New Inn 281, 291, *291*, 403, 412, 416, 453
 see also Model Farm (previously Hunclerondale farm/Farmhouse/New Inn)
Newgate, Edmund 35–6, 184, 437
Newgate's estate 22, 35–6, 181, 389, 396
 see also Ancient House
Newton, Abigail 55
Newton, Cary *see* Coke, Cary (née Newton)
Newton, John, Sir 55, 58, 60, 61, 65
Newton, Michael 83, 89, 552n24 (441)
Nollekens, Joseph 271

Norfolk
 Civil War 31–2
 fox hunting 53
 map of 3
 sheep-corn husbandry 15–17
Norfolk and Norwich Hospital 357
Norfolk House (London) 140
 Music Room 147
Norfolk Subscription 51–2
Norfolk yeoman (1658 Holkham deed) 35
Norfolk Yeomanry Camp (1911) 475
North Dining Room 99, 116, 167, 323, 351
North Elmham 19, 29, 51, 52, 64, 88, 262, 316
North Gates 304–5, *306*, *307*
North Lawn
 clumps proposed by William Kent 208, *209*
 cricket ground 304, 320, 341
 sewer running under *172*
 tennis game 317
North Lodge 208–9, *211*, 296, 303, 304, 417, 442
North State Bedroom
 chimneypiece 150
 'ducal stockings' in 264
 furnishings 235, 236, *237*, 353, 491
 gilding work 219
 location 99
 service door through closet into Kitchen Wing 235
 water closets 169
North State Dressing Room 99, 150, 235, *237*, 491
 window after renovation of gilding *160*
North State Sitting Room 236, 353
North Tribune 71, *72*
north vestibule 331, *331*
nursery rooms 255, 280, 337, 347, 503

The Obelisk
 building of 89, 137, 143, 156
 drawing *192*
 north–south axis 208
 original feature 182
 photograph *78* (79)
 repair work 518
 stone supplies 125, 143
 William Kent's design 95, 190, 192–3
Obelisk Hill 195, 203, 303, 442
Obelisk Wood 89, 175, 192, *193*, 195, 203, 204, 291–2
Octagon Cottage 303, 305, *386* (*387*), 404, *405*, 406, 417, 428
Octagon Room 151
oil lamps 179
Oliver, Henry 138, 144
Opie, John, portrait of C. J. Fox 274
Oram, Mr 203–4
Oram, William 203, 210
orangerie 109, 126, 143, 197–8, 204, 292
 classical orangery (Giovani Battista Ferrari book) *197*
 seat drawing *198*
Ord, Craven 292–3
Ormson of Chelsea (horticultural builders) 313–14
Orpen, William, portrait of T. W. Coke (1848–1941) *489*
Osborne, Anne, Lady 51, 53–4, 58
Osborne, Thomas, Earl of Danby and Duke of Leeds 51, 52, 53, 54, 58, 60
The Ostrich 152, 291, 396–7, 412
ostrich crest 270
ovens
 bread oven 366, 367–8, *367*
 'perpetual ovens' 175–6
Oxburgh Hall 43
Oxnead Hall 43

Paine, Mr 281
paintings
 under Margaret Coke 236–8
 restoration and rehang 519, 524–5
 under Thomas Coke (1697–1759) 68–9, 83, 102, 227–8
 under T. W. Coke (*c*.1776–1842) 273–7
 see also Landscape Room
Pakenham Hall (Ireland) 172
Palgrave, Phillip 33, 40, 43, 46
 page from accounts for John Coke (1660) *41*
palisades (or balustrades) 232
Palladianism 1, 90–1, 95, 99, 112, 150, 195, 263
Palladio, Andrea 95
 Four Books of Architecture 84
Palmer's Lodge 301–2, *302*, 306
Pantry Court 165, 179, 217, 332
park *see* Holkham Park (1719–1872); Holkham Park (1722–64); Holkham Park (1776–1842); Holkham Park (1842–); public
Park Farm *see* Hall Farm (later Park Farm)
Park House (former vicarage) 417–18, *418*
Parker, James 301–2
Parker, John 119–21, 123, 402
Parker, R. A. C. 286
Parnell, William 412
Parsons, John 143–4
Parsons, Robert 143
partridges 315–16
Passavant, M. 546n78 (271), 546n83 (273)
passes (issued by Holkham estates) *457*
Paston (family) 43
Paston, Robert, 1st Earl of Yarmouth 52, 53
Paterson, Donald 505, *506*
pavilions
 gravelled walk 195
 William Kent design 190, 192–3, *194*
Peach and Palmer 437
Peckitt, William 398
Peddar, George 420
Pelham, Henry 204–5
Pelletier (carvers and gilders) 83
Pelletier, Jean (cook) 340
Pepys, John 18, 26, 33
Pepys, Samuel 26
Perry & Co 376
Peter (white pony) 315, *350*
Peterstone brickyard, price list (1888) *122*
Petition of Right 14
Pevsner, Nikolaus 418
'phantom duel' 2, 452
Phillips, Thomas 273
Pickford, Joseph (1684–1760) 130, 150, 151–2, 154
 lodging in Kitchen Wing 152, *153*
Pickford, Joseph (1734–82) 130
Piper, John, *Holkham Hall 486* (*487*)
pleasure gardens 195, 197, 292–5
 arboretum 195, 292, *294*, 300–1
 arch gate to garden design *293*
 fernery 301
 grotto in fernery *300*
 lakeside gardens 295–6, *295*, *296*, 300
 map (1843) *294*
 terraces and parterres 310–11
 fountain 311, *313*
 parterres with conservatory *312*
 west parterre drawing *312*
 'Walk to garden' by Eliza Blackwell *294*
ponds
 Shoulder of Mutton Pond 194–5, 205–6, 206
 Walled Pond 194–5, 205–6
Pontifex and Wood 372
the poor
 Margaret Coke's provisions for 239–40, *240*, 393–5
 record page *394*
 under T. W. Coke (*c*.1776–1842) 400, 410, 413
Poor Law Commissioner's report (1842) 408, 410
 Chapel Yard cottages plans *409*
Porter & Co. 375–6
porters 218, 328–30, 339–40
 daily record of servants dining in Servants' Hall *339*
 porter's lodge *329*
Portico Room *see* Smoking Room (previously Portico Room/Billiard Room)
Powerscourt, Julia (née Coke), Lady 337, 345, 349
Powerscourt, Mervyn Wingfield, 7th Viscount Powerscourt 345
Powys, Libbe *see* Girle, Caroline (later Libbe Powys)
Poyntz, Mrs 239, 463
Price, H. C. 363
Price, John 463
Prince of Wales *see* Albert Edward, Prince of Wales (later Edward VII); Charles, Prince of Wales
Princess of Wales *see* Alexandra, Princess of Wales (later Queen); Mary, Princess of Wales (later Queen)
Procaccini, Andrea 68, 525
 Rape of Lucretia 274, *275*

Protectorate 38
public
 18th century 461–5
 first guides (by Richard Beatniffe) 463–5, *464*
 19th century to mid-20th century
 access to park 466–7, 469–70, *470*, *473*, 477–8
 fête in park (1920s) *477*
 group visits to Hall 468–9
 guide book by Henry W. Stacy 466–7
 guide book by J. Dawson 465
 Horse and Flower Show 474, *475*, 476
 Jarrolds guide book 477
 large-scale local festivities in park 470–3, *471*
 military camp and public sports 473–4, *473*
 Monument to T. W. Coke ceremony 465–6
 Review of the Norfolk Volunteers (1861) 467–8, *467*
 1950–2016
 Blue Book 484
 first Holkham Country Fair (1977) *460* (461)
 Gowers Report and paying visitors 478–81
 heritage designation scheme and increased public access 481–5
 Holkham Enterprises 484–5, 529
 Holkham Pottery 480, *483*, *513*
 James Laver's guide book 480, *481*
 kitchen preparation for re-enactment (2011) *484*
 publicity leaflet (1960s) *482*
 room stewards (1980s) 485
 access to beach and pinewoods 456–8
 Holkham estates passes *457*
 notice to visitors (1924) *458*
publicity leaflet (1960s) *482*
Pulleyn, Octavian 39
Purbeck paving 127

Quarles 184, 202–3, 207, 355
Quarles farm 355

rabbits 342, 501–2
 rabbit warrens 317, 448–9
race horses 89
railway 305, 336, 356, 418, 456, 466, 468, 476
 Holkham station *337*, 468
 train information for guests *336*
Raleigh, Walter, Sir 13
Ramm, Arthur 374–5, 471–2
 bill for food (Coronation Fête, 1902) *472*
Ramsey, John 53
Rathbone, Charles 158, 160
Raynham Hall 247–8
Reading Room 387, 423, 425
 photographs *423*, *425*
 Zephaniah King's plan *424*
Red House *405*, 428–9, *431*, 477
Reform Bill (1832) 277

Reinagle, R. R. 273
 portrait of T. W. Coke (1754–1842) 274
Rendle, J. M. 446
Reni, Guido, *The Assumption of the Virgin* 232
Repton, Humphrey
 garden thatched seat suggestion 195
 on lake walk and cattle 315
 lakeside gardens 295–6, *295*, *297*, 300, 310
 design for chain ferry on lake *296*
 on North Lodge 209
 reservoir 331, 369, 385
Review of the Norfolk Volunteers (1861) 467–8, *467*
Reynolds, Joshua, Sir 273
ribs of beef plaster model 268–9, *269*
Richmond, George, portrait of T. W. Coke (1822–1909) *318* (319)
Rigby, Edward 404
Ripley, Thomas 90
Roberts, Ann (née Coke) 59, 71, 241
Roberts, Philip 71, 243
Roberts, Wenman *see* Coke, Wenman (1717–76, formerly Roberts)
Roberts, William 149
Robinson, Thomas (ironmonger) 176
Robinson, Thomas Robinson, 1st Baronet 112
Robiquet, Jean 109
Rogers, John 58
Rokeby, Alexander 36
Rokeby, Margaret (née Coke) 36
Roman Cement 301–2
room stewards (1980s) *485*
Roscoe, William 267, 272, 274, 276
Rose Cottages 402, 403, *403*, 404
Rothschild, Annie de 336–7, 353
Rothschild, Anthony de, 1st Baronet 353
Rothschild, Constance de 353
Roubiliac, Louis-François 144, 227, 233
Rounce, James 423, 552n103 (425)
Royal charter granting Earl of Leicester of Holkham title (1837) 282
royal connections 10, 336–7, 340, 345, 351, 379, 491, 514–15
 see also Albert Edward, Prince of Wales (later Edward VII)
Rubens, Peter Paul, *The Return of the Holy Family from the Flight into Egypt* 228, *528*
Ruffles, Cyril *483*
Rush, Richard 263, 264–5
rustic floor 107, 115, 117, 147, 151, 214–15, 221
 plan *116*, *215*
 see also Audit Room (or Beefsteak/Mutton Room); Smoking Room (previously Portico Room/Billiard Room)

Sadleir, Anne (née Coke) 29
saffron farming 40–1, 43
St Withburga's Church, Holkham 397–8, *397*, 412–13, 418
 memorial with John and Meriel Coke's children *37*
 monument to Meriel Coke *28*
Salmon, William 542n89 (158)
Saloon
 ball (1865) *351*, 352
 carpentry work 116
 chimneypieces 150, *150*, *151*
 completion of decoration work 219
 furnishing and furniture 225, 352
 Gainsborough's portrait of T. W. Coke (1754–1842) 256, *258*
 large-scale hospitality 263
 lighting 376
 location 99
 music and dance 351
 new windows 331–2
 Opie's portrait of C. J. Fox 274
 paintings 238, 274–5, *276*
 photograph *219*
 picture frames 225
 picture rehang (1980s) 524–5
 plaster work 146
 refurbishing 525, *528*
 Van Dyck's 'The Duc d'Arenberg' 77
Salt Hole 435
Sanderson, John 115
Sandys, John *290*, 291, 299, 300–1
Satchell, Jack *298*
Saunders, Mrs 88
Saunders, Arthur 447
Saunders, Mun 88
Saunders, Paul 223–4, 225, *225*
Savage, Henry 410
Savage, Joseph 414
Savage, William 414
Scandinavian timber 124, *135*
Scarborough Lodge (formerly Guest's Lodge) 303
Scarfe, N. 123, 542n6 (166), 543n44 (179), 544n67 (208)
Scatchard, Matthew 158
Scheemakers, Peter 204
school dames 38, 47
 school dame's bill (1662) *48*
schoolroom 255, 411
schools
 adult evening school 412
 infants' school 414, 420
 photographs *415*, *425*
 school pupils (*c*.1890–1910) *415*
 Marjorie Beesley's school boot club card *428*
 Mixed School and school house 411–12, *412*, 429
Scilla, Agostino, *Winter* and *Summer* 238
Scott, Rev. 238
Scrivener, Joseph 429, *491*
Seat on the Mount
 carved stone heads *298*, 299
 construction 204–5
 drawing *192*
 gravelled walk 195
 William Kent's proposal 194, 204–5, *205*

Index 573

Second Anglo-Dutch War (1665–67) 46
Seeley, George 550n39 (378)
Seels, Clement 393
Seguier, William 271–2, 273
Serpentine River 206, 207, 298–9
servants
 bell systems 179, 368
 butler's Day Book 129
 butler's pantry 218
 chamber pots and two-seater earth closets 170–1
 Edward Coke's (1676–1707) household 58, 59
 footmen's dress livery (1910) 490
 housekeeper's rooms (1760 inventory) 216
 John Coke's (1590–1661) household 39, 43
 John Coke's (1636–71) household 48
 laundry maids 334, 343, 371, 374
 male servants (1920s) 503
 Margaret Coke's household 239
 medical attendance 343–4
 move to new Hall 213–18
 servants' regulations 327
 servants' rooms 102, 108, 213–14, 215, 216, 217–18, 218, 268
 Thomas Coke's household (c.1718–1759) 61, 67, 79–80, 86–9
 T. W. Coke's household (c.1776–1842) 267–8
 2nd Earl's household (c.1842–1909) 322, 337, 338, 339–40, 339, 341–2, 343–4, 346–7
 3rd Earl's household (c.1909–41) 492
 4th Earl's household (c.1941–49) 506–7, 511
 Donald Paterson (head gardener) 505, 506
 Surridge (butler) 505, 506, 506
 5th Earl's household (c.1949–76) 514
 7th Earl's household (c.1976–2005) 526, 527, 528
 wash house and bathroom 372
Servants' Hall
 April 1753 building workmen's meeting 115
 changes in use of (1860s) 343
 last dinner (1942) 506
 Newcastle flagstones 127
 porter's responsibility for 218, 329–30, 339, 339
Seven Years War (1756–63) 452
sewerage and drainage system 171–2, 213
Shard, Charles 254, 293
Sharpe, Jeremiah 288, 299
Shee, M. A. 274
Sheemaker (sculptor) 204
sheep 40, 259, 261, 273, 274, 298, 315, 433, 437–8
sheepfolds see foldcourses
Sheep Shearings 257, 259, 263, 266, 273, 279
 as depicted on Monument in memory of T. W. Coke (1754–1842) 261

Longlands Field Barn (or Great Barn) 296–7, 297
Sheep Shearings (George Garrard) 7
Wine Book showing consumption at 260
sheep-corn husbandry 15–17
Shellabear, S. 311, 548n42 (332)
shooting 112, 262–3, 281, 315, 317, 341, 342–3, 501
 royal shooting party (1860s) 342
Shugborough Hall (Staffordshire) 255, 267
Simpson, Wallis 515
Skeet, John 444
Skeet, Thomas 444
Smith, Charles Raymond, fountain 311, 313
Smith, Edward 80, 85, 184
Smith, Humphrey
 estate steward 58
 Hall farm tenancy 61, 182
 marsh embankment 438
 purchase of lands for Holkham 64
 reclamation work 439
 replaced by George Appleyard 85
 and Thomas Coke's Grand Tour 65–6, 79, 80
 Thomas Coke's instructions to 82–3
Smith, James Edward, Sir 265–6
Smith, Nurse 61, 65, 80
Smith, Sarah 88
Smith, William 'Strata' 445
Smoking Room (previously Portico Room/Billiard Room) 151, 154, 172–3, 231, 259, 352
smuggling 452
Soccinian theology 39
Socrates 276
Somering, Hiero 87
Somering, Jerrry 88
South Dining Room (or Breakfast Room) 150, 271, 276, 352, 525
 chamber pot niche 170
 see also East Drawing Room (later South Dining Room)
South Drawing Room 525
South Lodge 203, 204, 209, 306, 308
South Sea stock speculation frenzy 85–6, 356
South Tribune 117, 272
Sowter, John, carriage of materials bill 134
Spelman, Edward 83
Spencer, Mary, Lady 21, 23
Spencer-Stanhope, Anna Maria Wilhelmina 281
Spencer-Stanhope, Elizabeth (née Coke)
 birth 255
 on encouraging good conduct among cottagers 411
 on Holkham Hall alterations 324–6, 330
 on household responsibilities at Holkham 266–7
 on Juliana Coke 320, 322
 marriage and children 280–1, 300
 on shooting at Holkham 342

Spencer-Stanhope, John 280–1
stables 147, 231, 233, 233, 271, 328, 329, 330
Stacy, Henry W. 466–7
staff portraits (Andrew Festing) 9, 526, 528
Staithe Farm 184, 185, 188, 201, 288, 299, 395, 408
Staithe Wood 195
Staniforth, Sarah 148, 213–14
State Bedchamber 99, 150, 225, 235, 237, 238
State Water Closet 169, 170
staterooms
 building of 111
 chimneypieces 151–2
 designs 99
 floors 124–5
 furnishing and furniture 223–6
 gilding 158
 Margaret Coke's list of furniture 226
 purchases of furniture (1757) 224
 refurbishing 323, 525, 526, 527
 tapestry restoration 490
 use of during 19th century 352–3
 William Kent's contribution 92
Statue Gallery
 1960s–70s 525
 Apollo statue 144, 145
 ball (1865) 352
 blue leather furniture 225, 225
 chimneypiece carving 150, 151
 Diana statue 73, 74
 furnishing and furniture 223, 352
 heating 173
 large-scale hospitality 263
 location 99, 108, 109
 niche by Thomas Clark 147
 painting/gilding 158, 219
 plaster work 116, 146
 plaster work bill 146
 plate glass 133
 refurbishing 323, 519
 restored to 18th century simplicity 525
Steward's Court 165, 169, 170
Steward's Lodge 234, 249
Steward's Room 115, 215, 280, 506
stillroom 175, 214, 214, 507
 bread oven 366, 367–8, 367
 charcoal stoves 175
Stimpson, Susan 334
Stirling, Mrs 445
Stone, Henry, portrait of John Coke (1590–1661) 30, 31
Strangers' Beer 343
Strangers Wing
 Blaikie's office 279
 building of 111, 219, 231
 chimneypieces 151, 154
 dampness during WWII 507
 estate management offices 249, 251, 319, 328
 fire grates 213
 furnishing 236
 guest rooms 264, 526
 heating apparatus 334
 location 99

574 HOLKHAM

painting/gilding 158, 231
papering 271
plaster work 147
self-contained staff flats 526
sewer system 171, 172
slating work 133
underground passage 231
water closets 169
water supply 165
William Kent's contribution 92
strict family settlements 50
Stubbe, John 33
Surridge (butler) 505, 506, *506*
Sussex, Prince Augustus Frederick, Duke of Sussex 264, 271, 273–4, 280

Taborer, George 130
Tann, Thomas 285, 288
Tapestry Bedroom (Chapel Wing) 238
Taylor, Professor Alfred 370
telephone 491
Temple
 building of 120, 126, 137, 140, 143, 154, 158, 192
 furnishings 195
 housing estate workers 292
 and Obelisk Wood 204
 occupants (1841) 417
 occupants (1922) *292*
 original feature 182
 photograph *196*
 restoration work (1950s) *518*
 section view *196*
 vistas 442
 William Kent design 190, 192–3
tennis game *317*
Teulon, S. S. 305, 306, 310, 326, 331, 417
 kitchen and laundry yards proposals *325*
 North Gates proposal *306*
 South Lodge proposal *308*
Thanet, Thomas Tufton, 6th Earl of Thanet 79, 89
Thanet House, London
 manuscript cases 83
 move of contents to Holkham 236–7, 238, 265
 refurbishment 80, 107–8, 138
 reverted to Margaret Coke's father's estate 239
Thomas, Abraham 80, 87, 88, 104, 105, 110, 156
Thorington property (Suffolk) 20, 32, 50–1, 52
Thorogood, Robert 36
Thorogoods Farm 182–3, 396
Tilley, Thomas 369
Titian 495
Tittleshall 80, 262, 511, 519
 St Mary's, Tittleshall
 Coke family mausoleum 63, *63*, 283, 397
 Margaret Coke's bust 227
 monument to Thomas Coke (1697–1759) 154
Tomley, Will 88, 107
tourism 1, 465–6, 480
see also public
Townsend, Benjamin, *The Complete Seedsman* 189

Townshend, Audrey Ethelreda, Lady 317
Townshend, Charles, 2nd Viscount Townshend 247
Townshend, George, 1st Marquess Townshend 112
Townshend, Horatio, 1st Viscount Townshend 52
Townson, William 141, 143, 159, 223, 226–7, 231
tree planting 201, 251, 291, 315, 501
 John Sandys' tree planting record *290*
 pinewoods on dunes 434, 449–51, 456
Trefusis, Katherine ('Kate') 349
Trefusis, Marion *see* Coke, Marion (née Trefusis)
Trefusis, Mary, Lady 359
Trevisani, Francesco, portrait of Thomas Coke (1697–1759) *66*
Triumphal Arch 123, 144, 204, 207–8, 306, 308, 310, 518
 Eliza Blackwell sketch *208*
 William Kent design *207*
trustees, and family settlements 27
Tufton, Margaret, Lady *see* Coke, Margaret (née Lady Margaret Tufton)
Turner, Charles, Sir 439, 446
Turner, Dawson 273
Turner, Richard 311
Turner, Thomas 311
tutors 59, 60, 64, 65, 281

Unitarianism 39
Upcher, Reginald 421–3

Van Dyck, Anthony 83
 The Duc d'Arenberg 76, 77, 273, 276
Vanneck, Joshua, Sir 114
Vardy, John 148
 Some Designs of Mr Inigo Jones and Mr Wm Kent 150
Vardy, Thomas 148
vicarage (now Park House) 417–18, *418*
Victoria, Queen 282, 311, 416, 471–2
 invitation card to Golden Jubilee celebrations *471*
Victoria Hotel 414, *416*, 417, 457, 477, 480
Victoria Inn 416, 420
Vile, William 223
the village
 cottages under Thomas Coke (*c*.1718–1759)
 Holkham town and craftsmen's' homes 392–3
 purchase and demolition of cottages 389–92
 tenants employed to build the Hall 393
 cottages under T. W. Coke (*c*.1776–1842)
 cottagers' allotments 410–11
 increased intervention in village life 410–11
 new cottages and new Holkham 402–3, *403*, *404*
 new cottages in Staithe village 404–10, *405*, *408*, *409*, 413–14, *414*
 number of households and occupations (1841) 416–17
 prosperity and employment levels 413
 purchase and demolition of Staithe cottages 398–402, *399*
 cottages under 2nd Earl (*c*.1842–1909)
 completion of village property ownership 417, 418
 new houses (1879–84) 418–23, *420*, *422*, 425, *426*, 427, *427*
 number of residents, origins and occupations (1881) 427–8
 plan (1858) *419*
 proposal for new village layout (*c*.1881–83) *421*
 electricity supply 429
 initial villages 10–11, 13, 14–15, *17*
 1590 drawing *16*, 388, *388*
 disappearance of Holkham town 285, 387, 391, 403, 431
 medieval history 388–9, *388*
 last new houses (1911) 429, *429*
 late 20th century changes 429
 Margaret Coke's building of almshouses 395–6, *395*
 Margaret Coke's provisions for the poor 393–5, *394*
 other buildings
 bakery 412, 425
 barns 396
 infants' school 414, *415*, *420*, *425*
 malthouses 396
 Mixed School and school house 411–12, *412*, 429
 public house 412, 416–16
 Reading Room 387, 423, *423*, *424*, 425, *425*
 Red House *405*, 428–9, *431*, 477
 St Withburga's Church restoration 397–8, *397*, 412–13, 418
 vicarage 417–18, *418*
 village inn 396–7
 Widows' Row 406–7, *408*, 421
 photographs *10*, *431*
 plan of village (1911) *430*
 water supply 429
 see also Ancient House; Holkham Staithe; Holkham town; New Holkham (previously Longlands village)
village inns *see* Albemarle Arms; The Horse and Farrier; The Leicester Arms; New Inn; The Ostrich; Victoria Inn
vineries
 Ormson of Chelsea vinery 313–14
 Samuel Wyatt vinery 288, *289*, 293, 295, 313

Walpole (family) 43, 391
Walpole, Anne, Lady 59, 86
Walpole, Colonel Horatio 54
Walpole, Horace 112–13
Walpole, Robert, 1st Earl of
 Orford 54, 104, 247
Walsingham 88
War of Austrian Succession 110
Ware, Isaac 90, 167, 171
Warham 252, 259, 263, 268, 413
Warner, John 418
Warwick, Robert Rich, 2nd Earl of
 Warwick 32
water closets 167, 169–70
 Bramah water closets 271, 363
 off Thomas Coke's dressing
 room (later Manuscript
 Library) 169
 plumber Devall's bill for water
 closets and baths in Family
 Wing 168
 State Water Closet 169, 170
 'two seater' off Marble Hall
 gallery 169, 170
water engine house 165–6, 177,
 231, 330–1, 368–9, 404
 former horse-walking room
 165
 game larder by Samuel Wyatt
 262, 330
 outside view 164
water supply
 built under Thomas Coke
 (c.1740–56) 163, 165–7
 bathrooms 167–9
 plans of the vaults 164
 plumber Devall's bill for water
 closets and baths in Family
 Wing 168
 water closets 167, 169–71,
 169, 170
 water engine house 164, 165
 built under Thomas William
 Coke (c.1854–68) 334,
 368–71
 pumps in artesian well 370
 village 429
Watson's (masons) 311, 332, 333,
 334, 548n22 (324)
Watts, W., Holkham Hall from the
 north (1782) 246 (247)
Weasenham (Norfolk) estate 315,
 357, 413
Weaver, Thomas
 Head of a ram 273
 T. W. Coke inspecting sheep
 261
Webb, John 298
Wells-next-the-Sea
 bazaar (1914) 476
 poster 476
 channel 437
 connections with craftsmen 138,
 143, 144, 334, 402
 cricket 341

Custom House 452
doctor 343
Enclosure Award 299
gas 375
the Lyng 19
manor Wells-late-the-Dukes
 299
marshes 437, 446, 447
merchants, tradesmen 124, 133,
 154, 269–70, 300, 349, 374,
 425, 445, 471–2
Monument, attitude to 466
port 40, 82, 120, 124, 126–7,
 130, 132–3, 161, 173, 270,
 344, 363, 447, 451
 map 135
railway 336, 356, 466, 468, 477
sea bank 332, 355, 444, 449,
 451, 457–8
smallpox 141
theatre 341
visitors from 470, 478
welcome for Thomas Coke 65
West Lodge 303
 sketch by Eliza Blackwell 303
West Norfolk Railway 305, 336
Westmacott, Richard, *Trial of
 Socrates* 276
Wharton, Lady Jane 545n73 (243)
Wheatley, Anthony 18, 20
Wheatley, Meriel *see* Coke, Meriel
 (née Wheatley)
Wheatley manor *see* Hill Hall (or
 Wheatley) manor
Whig politics 248, 255–7, 276–7
 busts of Whigs 271
Whitbread, Julia 319
Whitbread, Samuel Charles 319
Widows' Row 406–7, 408, 421
Wighton 115
Wilder, James 271
Wilkins, Mr (tutor) 64, 65
Wilkins, Thomas (bailiff) 129–30,
 137
William, Prince, Duke of
 Cumberland 97, 238, 241
Williamson, Tom 543n39
Wilson, Michael 543n24
Wilton, Joseph 227
Winch, Nicholas 161, 393
Windham, William 259, 264, 265,
 271, 547n27 (299)
windows 324, 507
 gilding of exterior of window
 bars 254
 large window panes (1840–50s)
 323, 524, 525
Wine Book (1748) 462
wine cellar 177, 178
Winn, Henry 288
Wise, Edmund 33, 39
Woburn Hall (Bedfordshire)
 172
Wolverhampton, nail supply 133,
 135

Wood, John M. 359, 450–1
Wood, Mrs (Holkham agent's
 wife) 349
Wood, John, the elder (builder)
 143
wood cellar 173, 178, 365
Woodward, John 148–9
World War I, Holkham during
 492, 494
World War II
 Auxiliary Unit 505
 books deposited at British
 Museum 507
 fortifications of dunes and
 reparation claims 453–5,
 454
 Longlands Farm soup kitchen
 508
 requisitioning of Chapel Wing
 506–7, 510
 T. W. Coke (1848–1941) on
 504–5
wrecks 451
Wright, Edmund 251, 279
Wyatt, Samuel
 Bevis Marks properties (City of
 London) 245
 contribution to Holkham park
 301
 game larder 166, 262, 330
 lodges 301–2, 302
 Longlands Field Barn (or Great
 Barn) 257, 297, 297
 New Holkham 403, 404
 New Inn 291
 Octagon Cottage 404
 Rose Cottages 402
 vinery 288, 289, 293, 295, 313
Wythe, Edward 40
Wyvill, Marmaduke 71, 89

Yarmouth, Lord *see* Paston,
 Robert, 1st Earl of Yarmouth
Yorke, Charles 241
Young, Arthur
 first guide to Holkham based on
 his book 464
 on Holkham Hall 96, 97
 on Holkham soil 15, 36
 on The Leicester Arms 396
 on Margaret Coke's move from
 Family Room 234–5, 464
 on Norfolk Horn sheep 259
 on 'Norfolk husbandry'
 principles at Longford
 estate 251
 on oats and farmers' trade 82
 on Peterstone brickyard 123
 on rich Norfolk farmers 320
 on the South Lodge 203
 on tree-planting campaign at
 Holkham 547n11 (291)

Zuccarelli, Francesco 227
 Four Seasons 238